WHISTLER

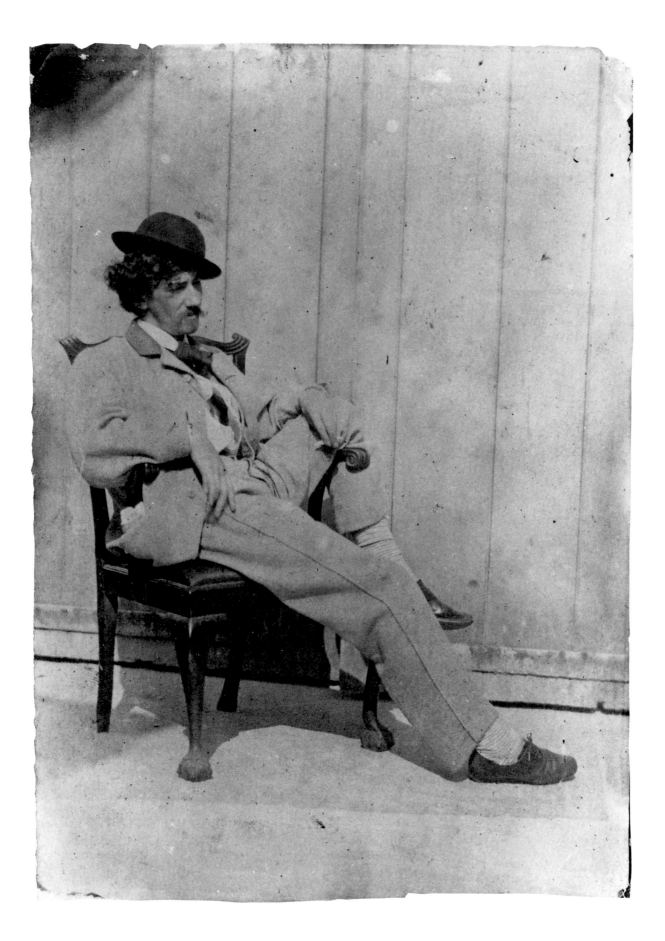

James McNeill Whistler

RICHARD DORMENT

MARGARET F. MACDONALD

With contributions by
Nicolai Cikovsky, Jr
Ruth Fine
Geneviève Lacambre

TATE GALLERY PUBLICATIONS

The exhibition at the Tate Gallery is sponsored by Reed Elsevier

REED ELSEVIER

Reed Elsevier is an award winner under the Business Sponsorship Incentive Scheme for its support of the *Whistler* exhibition. The BSIS is a Government Scheme administered by ABSA (Association for Business Sponsorship of the Arts).

Matched

This catalogue is published to accompany the exhibition organised jointly by the Tate Gallery, London, the Réunion des Musées Nationaux and the Musée d'Orsay, Paris, and the National Gallery of Art, Washington

Tate Gallery, London, 13 October 1994 – 8 January 1995
Musée d'Orsay, Paris, 6 February – 30 April 1995
National Gallery of Art, Washington, 28 May – 20 August 1995

Cover:
'At the Piano' 1858–9 (no.11)

Frontispiece:
Whistler, *c.*1860 *Freer Gallery of Art,*
Smithsonian Institution, Washington

ISBN 1 85437 145 2

A catalogue record for this publication is available from the British Library

Published by order of the Trustees of the Tate Gallery 1994
by Tate Gallery Publications, Millbank, London, SW1P 4RG
Copyright © Tate Gallery and contributors 1994
All rights reserved
Designed by Caroline Johnston
Typeset by ICON Colour, London and Tate Gallery Publications
Printed in Great Britain by Balding + Mansell, Peterborough, Cambridgeshire

Contents

Foreword

James McNeill Whistler is an international artist with special ties with the United States, France and England. We are delighted therefore that we have been able to join together on such a major exhibition which will be shown in each of these three countries.

Painter, printmaker, designer, teacher, critic and polemicist, Whistler was one of the most influential figures in the visual arts of the nineteenth-century. During a period of so many great artistic movements – Realism, Neo-Classicism, Pre-Raphaelitism and Impressionism – his work also fascinated many poets and writers from Baudelaire to Mallarmé and Proust, and from Swinburne to Oscar Wilde. The present exhibition reveals the full range of the quality and variety of Whistler's achievements.

It is the most important Whistler exhibition to be mounted since the great memorial shows in London, Paris and Boston following the artist's death in 1903. Until recently the problems of organising such a major show seemed insoluble as so many of Whistler's important paintings are in collections that are legally prevented from lending. However, extensive research by Richard Dorment and Nicolai Cikovsky, assisted by Margaret MacDonald, revealed a substantial body of significant works for which there were no such restrictions.

We offer our deepest gratitude to the many lenders both private and public who responded so enthusiastically to our requests and were ready and willing to extend their loans for many months so they could be seen in each venue. Their exceptional generosity ensures the success of the show. In particular, we are indebted to the Hunterian Art Gallery at the University of Glasgow for allowing us to borrow so many works from their collection.

The curators of the exhibition are Richard Dorment, writer and critic; Margaret F. MacDonald, Research Fellow at the Centre for Whistler Studies, the University of Glasgow; Nicolai Cikovsky, Jr, Curator of American and British Paintings, National Gallery of Art, Washington; and Geneviève Lacambre, conservateur général du patrimoine at the Musée d'Orsay, Paris. We should like to thank them most warmly for their dedication over several years both to Whistler research and in particular to this project. Joined by Ruth Fine, Curator of Modern Prints and Drawings at the National Gallery of Art, Washington they have also contributed the essays and entries for this catalogue, which both complements the exhibition itself and makes an important contribution to Whistler scholarship.

The exhibition has been organised as a collaboration between our three institutions, the Tate Gallery, London, the Réunion des Musées Nationaux and the

Musée d'Orsay, Paris, and the National Gallery of Art, Washington. It has been a rewarding joint venture and has involved a great many people in all three places, who have individually contributed towards the successful realisation of this project. We offer them our sincere thanks.

Exhibitions of this importance are becoming increasingly difficult to mount without additional help, so we would particularly like to acknowledge with gratitude the generous corporate support that has helped make *James McNeill Whistler* possible. Reed Elsevier is the exhibition's sponsor in London, and we would like to thank its chairmen Ian Irvine and Pierre Vinken. In Washington, the exhibition is supported by the NYNEX Foundation; at NYNEX Corporation, we would like to thank William C. Ferguson, chairman, Ivan G. Seidenberg, president, and Suzanne A. DuBose, executive director of corporate philanthropy and corporate responsibility.

Nicholas Serota
Director
Tate Gallery

Françoise Cachin
Directeur des Musées de France
Président de la Réunion des
Musées Nationaux

Earl A. Powell
Director
National Gallery of Art,
Washington

Sponsor's Foreword

Reed Elsevier's association with James McNeill Whistler stretches over a century. In 1890 our imprint William Heinemann published Whistler's *The Gentle Art of Making Enemies*. One hundred and four years later we are sponsoring *Whistler* — extraordinarily, only the second large show of Whistler's work in the United Kingdom since his death in 1903 and the first since 1905.

This sponsorship gives us particular pleasure. As one of the world's leading publishing and information businesses, with principal activities in the USA and UK, we are delighted to make possible such a wide-ranging display of the creativity of this Anglicised American, who was as sharp with his pen as he was brilliant with his paintbrush.

We hope you enjoy this exhibition and the permanent reminder provided by this excellent catalogue.

Ian Irvine and Pierre Vinken
Chairmen, Reed Elsevier plc

Acknowledgments

We are deeply grateful to all the owners of Whistler's works, including private collectors (many of whom wish to remain anonymous), dealers, and public collections, for their generosity in showing us their collections and their records.

At the University of Glasgow, we should like to thank the University Library and University Court, holders of Whistler's copyright, for giving permission to publish excerpts from Whistler's letters and documents from their collection. Our particular gratitude goes to: Martin Hopkinson and Christopher Allan, Curators, and Brian McKerracher, Technician, and all staff at the Hunterian Art Gallery; Dr Nigel Thorp, Director, and Margaret Fox and Katharine Mooney, Research Assistants, in the Centre for Whistler Studies; Dr Timothy Hobbs, Keeper, and the staff of Special Collections, University Library; and Dr Joy Newton, French Department.

Linda Merrill, American Art, Jan Stewart, Oriental Department, and Martha Smith, Conservator, and all staff at the Freer Gallery of Art, Washington, were unfailingly helpful in answering all our queries.

Many other people have helped in all sorts of ways with this exhibition and its catalogue. We would especially like to thank the following: Jane, Lady Abdy; Helen Alexander, The Fan Museum, London; Kevin Avery, Metropolitan Museum of Art, New York; Clare Bains; Cathleen Baldwin, Biltmore Estate, Asheville, North Carolina; Judith Barter and Martha Tedeschi, Art Institute of Chicago; Anthony Beeson, Central Library, Bristol; Maria E. Berho, Embassy of Chile, London; Avis Berman; Charles Brock, Eric Denker and Sarah Greenough, National Gallery of Art, Washington; Penelope Byrde, Costume Research Centre, Bath; Peter Calvacoressi; Thomas Colville; Roger Davey, County Archivist, East Sussex County Council; Oliver Davies, Royal College of Music, London; Hope Davis; Roy and Cecily Langdale Davis; Mr and Mrs Francis Dineley; Kris Dockx, Belgian Embassy, London; Ellen D'Oench, Davison Art Centre, Wesleyan University; Rafael Fernandez and Steven Kern, Sterling and Francine Clark Art Institute, Williamstown; Jonathan Franklin, National Portrait Gallery, London; Betsy Fryberger, Stanford University Museum and Art Gallery; Peter Gatacre; Robert Getscher; Janet Green, Sotheby's; Alastair Grieve; The Rt Hon. Lord Gilmour; Marie Christine Gray; Robert Gray; John Greencombe, Survey of London; Avril Hart and Timothy Stevens, Victoria & Albert Museum, London; Dr John Hayes; J.F. Heijbroek, Rijksmuseum, Amsterdam; Sinclair Hitchings, Boston Public Library; Susan Hobbs; Julia Ionides; Susan Jackson; The Hon. Victoria Joliffe; Charles Kelly, Library of Congress, Washington; Mrs Dorothy Kemper; David Kiehl; David Le Lay; Sarah Levitt, Gunnersbury Park Museum;

Suzanne Lindsay; Katherine Lochnan, Toronto Art Gallery; J. Robert Maguire, Executor of the estate of Mrs John B. Thayer; Paul G. Marks; Michael Marshman, Library and Museum Service, Wiltshire County Council; Melissa de Medeiros, Knoedler's, New York; Rodney Marrington; Hamish Miles; Michael Milkovich, St Petersburg Art Gallery; Brody Neuenschwander; Barry Norman, Theatre Museum, London; Richard Ormond; Carol Pullin; Robert Rainwater and Roberta Waddell, New York Public Library; Jeremy Rex-Parkes, Christies; Andrew Saint, English Heritage; Wendy Samet; Barbara Shapiro, Museum of Fine Art, Boston; Nicholas Smale; Jeremy Smith, Guildhall Library; Robin Spencer; Nesta Spink; Miriam Stewart, Fogg Art Museum, Cambridge, Mass.; Joyce Hill Stoner; David Sylvester; Judith and Daniel J. Terra; Sarah Walden; Michael Whiteway; Timothy Wilcox, Hove Museum and Art Gallery; Judith Zilczer, Hirshhorn Museum and Sculpture Garden, Washington.

Nicolai Cikovsky would also like to thank: Ellen Schall Agnew, Maier Museum of Art, Lynchburg; D. Scott Atkinson, Terra Museum of American Art, Chicago; Georgeanna Bishop, The Baltimore Museum of Art; Doreen Bolger; David Brooke; Cheryl Brutvan, Albright-Knox Art Gallery, Buffalo; Margaret Conrads, Nelson-Atkins Museum of Art, Kansas City; Daniel Dubois; Richard Field, Yale University Art Gallery, New Haven; Hilliard Goldfarb, Isabella Stewart Gardner Museum, Boston; Robert Johnson, Achenbach Foundation for Graphic Arts, The Fine Arts Museums of San Francisco; Robert Koenig; Elizabeth Kornhauser, Wadsworth Atheneum, Hartford; Adrian Le Harivel, National Gallery of Ireland, Dublin; Louise Lippincott, The Carnegie Museum of Art, Pittsburgh; Barbara MacAdam, Hood Art Museum, Hanover; Henry Matthews, Muskegon Museum of Art; Betty Monkman, The White House, Washington; Anne Morand, Gilcrease Institute of American History and Art, Tulsa; Linda Muehlig, Smith College Museum of Art, Northampton; Maureen O'Brien, Museum of Art, Rhode Island School of Design, Providence; Carol Pulin; Joseph Rishel, Philadelphia Museum of Art; Martha Severens; Nancy Rivard Shaw, Detroit Institute of Arts; Kristin Spangenberg and John Wilson, Cincinnati Art Museum; Susan Strickler, Worchester Art Museum.

Geneviève Lacambre would additionally like to express her gratitude to Luce Abéles, Peter and Christine Cooke and Dominique Lobstein.

Margaret MacDonald is grateful to her family, Norman, Katharine and Helen MacDonald for their unfailing support and assistance.

A special thank you to the staff of the Tate Gallery and all who have helped to create this catalogue.

Richard Dorment
Margaret F. MacDonald

James McNeill Whistler 1834–1903

RICHARD DORMENT

On 2 November 1855 the twenty-two year old James Whistler arrived in Paris, in time to catch the last two weeks of the Exposition Universelle's encyclopedic survey of contemporary French, British and European painting.[1] At the French pavilion he could saturate himself in the art of the Romantic colourist Eugène Delacroix and the classicising draughtsman Jean-Auguste-Dominique Ingres. At the British Pavilion, he saw the brilliantly coloured paintings of the Pre-Raphaelites William Holman Hunt and John Everett Millais. But the artist who made the most immediate impression on Whistler was Gustave Courbet, who, in the Pavilion du Réalisme, was defiantly according himself his own retrospective.

Two years later, in 1857, Whistler travelled from Paris to Manchester to see the *Art Treasures Exhibition*, where some one thousand old master paintings, including works by Velázquez and the Dutch masters Frans Hals and Jan Vermeer competed for attention with seven hundred works of the British school. Whistler himself summed up the dangers of so all-embracing a visual education when, late in his life, he told his pupils that in his youth he found 'no absolute definite facts, and … fell in a pit and floundered.'[2]

But he floundered, in part, because his was no ordinary artistic background. Born in Lowell, Massachusetts, in 1834, between the ages of nine and fourteen he lived in St Petersburg, where his father worked as an engineer for the Czar. He took drawing lessons at the Imperial Academy of Fine Arts. On visits to London he pored over Rembrandt's etchings in the collection of his brother-in-law Francis Seymour Haden, attended lectures at the Royal Academy, and saw Raphael's cartoons at Hampton Court. At fifteen, he returned to New England and followed in his father's footsteps to West Point. There he mastered the medium of watercolour and excelled at draughtsmanship and French. A collection of prints after Renaissance masters, as well as contemporary prints after artists such as J.M.W. Turner, were available for studying and copying by the pupils. Dismissed from the Military Academy in 1854, he entered the office of the Coast Survey in Washington, where he acquired the thorough knowledge of etching techniques which formed the basis of his later development as an artist.

In Paris, he entered the atelier of the Swiss neo-classical painter Charles Gleyre. Through his teaching methods Whistler absorbed the French painting techniques of the 1830s, the controlled application of opaque pigments over a dark ground, that *bonne peinture* against which he was later to rebel, but which he never totally abandoned.

Whistler became friendly with a clique of young British art students, including Edward Poynter and George Du Maurier (later his colleagues on the London illustrated periodical *Once a Week*). His fluent French also enabled him to fraternise with the French Realists, including Henri Fantin-Latour and Alphonse Legros, with whom he formed the Société des Trois in 1858. This was not an attempt to found a new artistic movement, but an informal band of friends dedicated to mutual support and to marketing each other's work on both sides of the Channel. Edgar Degas, who met Whistler in the early 1860s, tells us a great deal about their aspiration to paint simple scenes from daily life when he recalled 'In our beginnings, Fantin, Whistler, and I, we were all on the same road from Holland' (see no.11).

On that road, Whistler soon bumped into Gustave Courbet. The older artist admired Whistler's 'At the Piano' when it was exhibited at François Bonvin's studio after its rejection from the Salon (no.11). Whistler was never Courbet's pupil, but one has only to look at the degradation Whistler depicts in the etching 'Soupe à Trois Sous' (no.2) or the sexual transaction casually taking place in 'Wapping' (no.33) to realise that, as Courbet descended into the lower depths, the young American was not far behind him.

It was Whistler's British brother-in-law, the amateur etcher and collector Francis Seymour Haden, who in 1858 urged Whistler to work from nature. His encouragement led to the production of the 'French Set' of etchings, which were started in the Rhineland in that year, printed by Auguste Delâtre in Paris, and marketed by Haden in London. In 1859 Whistler settled in London, in part because Haden and his wife provided him with the atmosphere of high literary, musical, and visual culture depicted in a number of early paintings and etchings ('Reading by Lamplight', 'The Music Room', 'At the Piano', nos.9–11). Particularly important were Haden's collections of old master prints, and the enigmatic photographs by his friend Clementina, Lady Hawarden (fig.1).[3]

Whistler owed both his awareness of photographic processes and his interest in the science of optics to Haden, a surgeon and man of science. In the gently curving space and dual points of focus in 'At the Piano' (no.11) he attempted to imitate the three-dimensional effects of a Victorian stereoscope. In 'Harmony in Green and Rose: The Music Room' (fig.2; YMSM 34) he constructed a complex interior space in which his niece Annie Haden is approached by a figure seen reflected in a mirror, as in Velázquez's 'Las Meninas' (Prado, Madrid).

Whistler's views of London in the 'Thames Set' are indebted to Charles Meryon's etched views of Paris, but they also reveal the young artist's understanding of contemporary developments in the science of optics. Different areas in the prints 'Black Lion Wharf' (no.32), the 'The Pool' (K 43) and 'Longshoremen'

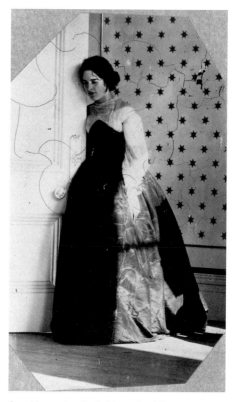

fig.1 Clementina, Lady Hawarden 'Clementina Maude' *c*.1862 Albumen print from wet collodion negative *Victoria & Albert Museum, London*

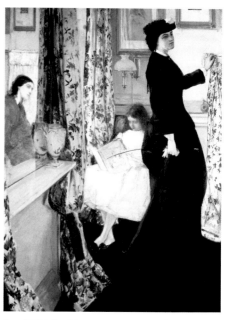

fig.2 Whistler 'Harmony in Green and Rose: The Music Room' 1860–1 Oil on canvas *Freer Gallery of Art, Smithsonian Institution, Washington, DC*

(K 45) are shown in and out of focus, mimicking the way the eye actually functions, with objects in the distance and foreground clearly delineated, while the middle distance and peripheral areas of the foreground are left indistinct.[4]

Whistler also chose to live in London because the climate for the acceptance of new art was more favourable there than in Paris. On a practical level, several early patrons were based in London, including the Ionides and Cavafy families (see nos.30, 35, 36, 41), and he was able to sell his work through his widespread family connections in London, the north of England, and America.[5] No such patronage existed in Paris. In the early 1860s he shuttled back and forth between the two cities, a one-man conduit between Fantin, Manet and Courbet on the one hand, and Millais, Rossetti and the British illustrators on the other.

The picture that serves to symbolise Whistler's identity as a Franco–British painter is 'Symphony in White, No.1: The White Girl' (no.14), which had the distinction of being utterly misunderstood on both sides of the Channel. If critics felt compelled to project their own narratives on to the portrait of Whistler's Irish mistress Joanna Hiffernan, describing her as a bride or somnambulist, it is because in their eyes the picture had no subject – or rather, because its ostensible subject, a woman in a simple white dress posed against a white curtain, serves as a vehicle for the exploration of purely formal pictorial values.

fig.3 John Roddam Spencer Stanhope 'Thoughts of the Past' 1859 Oil on canvas *Tate Gallery, London*

The longer Whistler lived in London, however, the more a tendency towards literary or narrative painting, absorbed both through his work as an illustrator for *Once a Week* and through daily contact with English painters, began to make itself felt in his art. In 'Symphony in White, No.2: The Little White Girl' (no.15), Jo is shown displaying a wedding ring as she gazes into a looking-glass. Exhibited with a poem by Swinburne attached to the frame, the picture tells a story of love and loss such as Rodham Spencer Stanhope had provided in 'Thoughts of the Past' (fig.3), but without neglecting the painterly values on which Whistler's French art training had been based. These were reinforced through his friendship with Edward Manet, whom Whistler met in 1861 (see no.14). The writings of the critics Charles Baudelaire and Théophile Thoré (pseudonym for Willem Bürger) continually drew him back to the art of Delacroix, Velázquez and Hals. They reminded him that the vitality of a painting depends not on its subject but on a respect for the picture's surface, and on the colour, tone, brushstroke, texture and composition which are intrinsic to it alone.

This was a lesson the receptive young American, well versed in the critical writings of Edgar Allen Poe and the 'art for art's sake' aesthetic of Théophile Gautier, was ready to learn. In his cultural baggage one might have found a copy of Henri Murger's *Scènes de la vie de Bohème* (1845), in which the characters discuss the composition of a 'Symphonie sur l'influence de bleu dans les arts'. Walking through the streets of Paris, Manet noticed a wall collapsing in a cloud of white dust under the wrecker's ball and exclaimed, 'There it is, the symphony in white major that Théophile Gautier speaks of'.[6] When the critic Paul Mantz described the 'White Girl' as a 'Symphony in White' he was simply parroting synaesthetic jargon then fashionable in some avant-garde circles (no.14).

On the other hand, Courbet – among others – considered art for art's sake a 'trivial goal'.[7] Steering his way through these aesthetic debates, Whistler tried to have it both ways, exploring two parallel artistic paths simultaneously. He painted naturalistic landscapes in 'The Coast of Brittany' (no.39) and his early views of the Thames (nos.30, 33, 35); but developed towards 'art for art's sake' in the 'Symphonies in White', Nos.1, 2, and 3 (nos.14–16).

Sometimes he combined the two in one painting. In 'Variations in Flesh Colour and Green: The Balcony' of 1864–5 (fig.45; YMSM 56) he posed geisha girls on a Chelsea balcony overlooking a perfectly recognisable view of Battersea coal slags and factory chimneys (see nos.23–4). Though not overtly erotic like Baudelaire's poem of the same title in 'Les Fleurs du mal' (1857), 'The Balcony' brings the rich colour and heavy perfume of Delacroix's 'Women of Algiers' (fig.4) to a bleak urban setting.

In 'The Balcony' Whistler synthesises the conflicting elements in his style through a composition derived from a woodcut by the Japanese artist Torii Kiyonaga (fig.5). As an American who had followed with interest his countryman Admiral Perry's opening of Japan in 1855, Whistler was the first Western artist to react in a profound way to the Japanese artifacts that reached Western Europe a few years later. At the Parisian shop La Porte Chinoise where he competed with James Tissot, Edouard Manet, Félix Bracquemond and Alfred Stevens for prints, textiles and porcelain, he was first exposed to the principles of Eastern aesthetics.[8]

At the International Exhibition in London of 1862, Whistler could see works of art from China and Japan, and contemporary decorative arts, then undergoing a revolution at the hands of Morris, Marshall, Faulkner & Co.. The Western lady who sits patiently painting a Chinese porcelain vase in the 'Lange Leizen of the Six Marks' (no.22) epitomises Whistler's ambition to unify the decorative arts of East and West. However, without minimising the importance of Japanese and Chinese influence on his art, one should remember that Whistler never abandoned Western perspective, and that in the 'Lange Leizen of the Six Marks', 'The Golden Screen' (fig.6; YMSM 60) and 'La Princesse du pays de la porcelaine' (fig.7; YMSM 50) the models are clearly Victorian women surrounded by Japanese and Chinese accoutrements. Until his purely decorative work in the Peacock Room of 1876–7 (see pp.164–5), Whistler used Japanese art selectively, and more to distance himself from the toga-clad Romans popularised by the *pompier* artists Jéan-Leon Gérôme or Lawrence Alma-Tadema than to explore pictorial space, as Paul Gauguin or Edouard Vuillard were to do later in the century.

By the mid-1860s in England, Pre-Raphaelite realism was out of date and a full-scale neo-classical revival under way. Avant-garde English painters such as Edward Burne-Jones and Albert Moore were painting rhythmic friezes of toga-draped ladies, stimulated by the rearrangement of the Elgin marbles in the British Museum.

The three-way debate between Classicists, Romantics and Realists also reflected differences in national tastes. Among his English friends, the art of Ingres was

fig.4 Eugène Delacroix 'Women of Algiers in their Apartment' 1834 Oil on canvas *Musée du Louvre, Paris*

fig.5 Torii Kiyonaga 'The Fourth Month' from 'Twelve Months in the Sun' 1784 Woodcut *British Museum, London*

fig.6 Whistler 'Caprice in Purple and Gold: The Golden Screen' 1864 Oil on panel *Freer Gallery of Art, Smithsonian Institution, Washington, DC*

held in high esteem, while the work of the realists Courbet and Manet was lumped indiscriminately together and considered, in Dante Gabriel Rossetti's words, 'simple putrescence'.[9] By contrast, both Manet and Baudelaire, from their respective positions as Realist and Romantic, maintained that Ingres was not a painter.[10]

Whistler's allegiance in this debate is signalled by his appearance alongside Manet and Baudelaire in Fantin-Latour's group portrait, 'Homage to Delacroix' of 1864, which also included portraits of Alphonse Legros and the Realist novelist and art historian Jules Champfleury (fig.24). A year later, in the autumn of 1865 Whistler was painting *plein air* landscapes alongside Courbet at Trouville (pp.111–2 and nos.40–2), but by now he was also trying to transcend the older artist's uncompromising Realist aesthetic. This he hoped to do in a ten foot high canvas he intended to paint in response to Fantin's group portrait: 'Whistler in his Studio' (see YMSM 63). Here Whistler, Fantin and Albert Moore were to be depicted in the artist's studio surrounded by models dressed in white, with arrangements of Japanese fans and blue and white porcelain on the walls.[11] Such a subject painted on such a scale was intended to recall Courbet's 'The Painter's Studio: A Real Allegory' 1854–5 (Musée d'Orsay, Paris), but the languid atmosphere and Japanese accessories belonged to the world of the Chelsea aesthetes.

fig.7 Whistler 'La Princesse du pays de la porcelaine' 1863–4 Oil on canvas *Freer Gallery of Art, Smithsonian Institution, Washington, DC*

Whistler's picture represented an attempt to add to Courbet's paintings of modern life the one ingredient critics like Baudelaire and Thoré-Bürger complained they lacked: imagination.[12] This Whistler had found in the Baudelairian theory of the 'correspondence' between the arts of music and painting, and it accounts for Albert Moore's presence in the picture. Moore's gorgeously coloured, subjectless studies of classically draped women proved to Whistler that painting could aspire to the abstract condition of music. He formed the theory, expressed in his article 'The Red Rag' of 1878, that 'Art should be independent of all clap-trap – should stand alone, and appeal to the artistic sense of eye or ear, without confounding this with emotions entirely foreign to it, as devotion, pity, love, patriotism'.[13]

There is no record that Whistler ever started his large canvas, though two smaller works relating to it survive (YMSM 62–3). It may be that he doubted his ability to work successfully on this scale. In any case, on his return to London in 1867, after a dramatic dash to Valparaiso to help the Chileans in their war against Spain (see pp.115–16 and nos.43–5), he wrote to Fantin-Latour utterly rejecting the influence of Courbet, who, in encouraging Whistler to spurn the classical tradition and work from nature, had taught him to paint but not to draw. He wished he had studied with Ingres.[14]

In practical terms, this meant that in the very years leading up to the first Impressionist exhibition Whistler turned his back on *plein air* naturalism. Over the next few years he attempted to rebuild his art from its very foundations. He began a decorative frieze in which he sought to unite the drawing of Ingres with the colour of Delacroix, and British neo-classicism with French romanticism. He added a synaesthetic dimension to the pictures by giving them musical titles of

which Murger and Baudelaire no less than Swinburne would have approved (see pp.92–4). The series is unfinished: Whistler had simply been too ambitious.

In the late 1860s Whistler became aware of the painting techniques of Thomas Gainsborough and the English school of painters in watercolours. He taught himself a distinctly English way of glazing and staining the canvas with thinned pigment (see pp.23–8). He learned to work more quickly, covering the whole canvas in one session to achieve the exquisite unity of effect at which he aimed. By 1871 Whistler had arrived at a successful synthesis of realist and formalist elements to create a new kind of art which he called Impressionism but which we would label Aestheticism.

He began by simplifying his compositions, and limiting his portraits to the single figure. In 'Arrangement in Black and Grey: Portrait of the Painter's Mother' (no.60) the rigid compositional structure and domestic subject reverts back to a picture he had painted before he had met Courbet, 'At the Piano' (no.11). The use of a limited range of colours, low tone, and a severe composition reflects the continuing influence of Frans Hals and his contemporaries, but the picture is painted in a technique utterly different from the Dutch old masters. Pigment was directly applied onto a water-based grey ground spread over raw, absorbent canvas. As a result, the medium has seeped into the fabric of the canvas like a stain.[15]

In the Nocturnes he employed a broadly similar technique over a variety of grounds. He worked mostly from memory (see pp.120–2). The mnemonic systems used by artists from William Hogarth to Paul Lecoq de Boisbaudran finally freed him from the tyranny of Courbet's *plein air* realism and drew him ever closer to an understanding of a picture as, first and foremost, an *objet d'art*. Even a landscape was not a view of the real world, but an artificial arrangement of shapes and colours, a formal 'problem to be solved'. Simplicity and economy of expression are the essence of Whistler's mature art. In pastels and drawings his pencil searches for form even as it reveals it, hovering, darting, and glancing off the page almost as soon as it makes its mark. It is a style developed from the absolute precision required of the etcher. One student, Otto Bacher, says simply that 'delicacy seemed to him the keynote of everything, carrying more fully than anything else his use of the suggestion of tenderness, neatness, and nicety'.[16] Certainly his attraction to the technique of lithography after 1878 is partly explained by the way that lithography relies on this soft, glancing touch of the crayon (nos.53–5). He exploited his delicate touch to the full in the Venetian pastels of 1880–1 where he uses light strokes of chalk to transform the outlines of buildings and bridges into evocations of Venetian light and colour (see nos.102, 108). In pastel Whistler had at last found a medium in which colour and draughtsmanship were one.

Encouraged by his friendship with the architect E.W. Godwin, Whistler had designed and painted his own frames in the 1870s.[17] In the 1880s he ordered frames in shades of gold chosen to harmonise both with the picture and with the other pictures in the exhibition. But these frames in turn needed a sympathetic background colour, necessitating the redecoration of the entire room in which the exhibition of his work was to be held (see nos.93–5). The sparely hung exhibi-

tions, and rooms painted in white and yellow designed by Whistler anticipate the twentieth-century taste for light, uncluttered spaces.[18]

In his own studio he liked to show his pictures one at a time, but if this was not possible Whistler sought total control over how his paintings were exhibited.[19] 'The painter must … make of the wall upon which his work is hung, the room containing it, the whole house, a Harmony, a Symphony, an Arrangement, as perfect as the picture or print which becomes part of it.'[20] His follower Mortimer Menpes describes Whistler stepping back from a wall he had just hung at Dowdeswell's gallery. 'There is only one thing lacking, gentlemen, to complete the picture which this gallery should create. And that is the butterfly – a large painted butterfly on the wall.' And, Menpes continues, 'There and then a ladder was brought. Whistler wished the butterfly to be almost on the ceiling'.[21] Whistler had discovered that Japanese art makes no clear distinctions between fine and decorative art, between the arts of the tea ceremony, garden design, fan painting and print making. One observer after another describes the long days spent painting, etching and printing, and the endless pains Whistler took to ensure that the wall colours, lighting, invitations, and even the colour of the uniform of the guard at the entrance to his exhibitions were all perfect.[22]

In this exhibition we can see the studies for dresses Whistler designed for Mrs Leyland (nos.70–2), as well as designs for mats, a trellis, and a parasol (nos.73, 91–2). He also designed and arranged porcelain and suggested colour schemes for the Alexanders' London home (no.80). Above all, in the Peacock Room, designed for Frederick R. Leyland in 1876–7, Whistler created a giant lacquered box of swirling peacocks and showers of golden feathers, derived from the magnificent blue and white china copied in watercolour for Sir Henry Thompson's catalogue, and from the porcelain both he and Leyland collected (fig.8; nos.81–90). Even the famous breakfasts and dinners held at Whistler's exquisitely decorated house at Lindsey Row, with their carefully designed menus, and the food chosen to harmonise with the blue and white china on which it was served, ultimately depend on the Japanese attitude towards beauty.

In the small landscapes, seascapes and shop fronts of the 1880s and 1890s, it is as though Whistler is encouraging his viewers to share with him a fully conscious aesthetic response to all life. In Whistler's view the dimensions or medium of a work were of little importance, so that a tiny landscape or a painted screen might be works of great art. Since the early 1880s Whistler had begun to work in oil on the same relatively small scale as in his prints, pastels and watercolours. Far from being lesser works of art, these later landscapes, seascapes and shop fronts have a formal daring sometimes absent from the earlier works (nos.151–2, 171). Whistler worked on a small scale so that he could return to the *plein air* methods of his youth. He was able to complete a picture in one or two sessions, just as a watercolourist did, catching transient effects of light or water that sometimes eluded him on a larger scale.

His pupil Walter Sickert, who considered the tiny panel paintings Whistler's supreme achievement as an artist, explained that in them he was 'on the ground

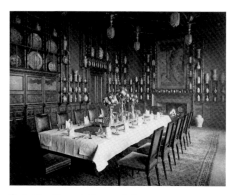

fig.8 The Peacock Room 1876–7
Photo: Private Collection

of the early Corot. He was using the traditional technique of oil-painting inherit-
ed from Ingres via Gleyre ... only to this inheritance he added the exquisite and
swift draughtsmanship of the improviser in copper.'[23]

Whistler found beauty in the most ordinary urban scene, in an empty stretch
of water, in night, in fog: in phenomena most of his contemporaries would have
denied were there to be seen at all.[24] Thus, in *Bleak House* of 1852–3 Charles Dick-
ens treats fog as no more than a sinister, unhealthy pollutant; by 1893, when Emile
Zola visited London, he saw the fog, in the words of one writer, as 'the most
interesting aesthetic experience the capital had to offer'.[25] This was Whistler's
doing. Oscar Wilde understood that Whistler changed the way men and women
saw the world. In 1889 Wilde asked,

> Where, if not from the Impressionists, do we get those wonderful brown fogs
> that come creeping down our streets, blurring the gas-lamps and changing the
> house into monstrous shadows? To whom, if not to them and their master
> [i.e. Whistler], do we owe the lovely silver mists that brood over our river, and
> turn to faint forms of fading grace curved bridge and swaying barge? The
> extraordinary change that has taken place in the climate of London during the
> last ten years is entirely due to a particular school of Art.[26]

It is a mistake, however, to assume that Whistler abandoned realism for a purely
decorative formalism. The Nocturnes are accurate depictions of the river at
night. Whatever else it may be, 'Arrangement in Grey and Black: Portrait of the
Painter's Mother' (no.60) represents a portrait of an indomitable widow, patiently
enduring her lot on earth, and constantly praying for a better world.

Whistler was not always adept at catching a sitter's likeness.[27] He insisted that
his portraits were no more than 'arrangements' of line and colour, and that the
identity of his sitters was of no possible interest to the spectator. And yet
Whistler contrives to tell us through costume and gesture an extraordinary
amount of information about the people he paints.

Thus, Cicely Alexander is frankly cross and obviously tired of endless stand-
ing for her portrait (no.62). Thomas Carlyle is lonely, depressed, and perhaps
confused (no.61). Lady Meux, who has been called a Victorian *grande dame*, was in
fact a former dance-hall hostess who had ensnared a weak-willed young baronet.
Whistler shows her in all her vulgarity, flashing the pelts of fur and diamonds
with which her husband had just presented her (no.124). Compare her to the aris-
tocratic Americans Mrs Cassatt and George Vanderbilt (nos.128, 199), the fiery
intelligence he conveys in the portrait of Lady Archibald Campbell (no.130), or
the mixture of innocence and sexual allure he suggests in the portrait of the
twelve year old Olga Carraciolo (no.136), and one realises that Whistler was capa-
ble of making highly sensitive distinctions between the characters and relative
social positions of his sitters.

Whistler was one of the most eminent of all Victorians, a man comparable in
the range of his ambitions to John Ruskin, to Thomas Carlyle, or to William
Morris. There is no Victorian painter of his moral stature. The story of his treat-

ment by the British artistic fraternity and critical establishment, as personified by Ruskin and the famous trial for libel, is told elsewhere in this catalogue (pp.136–7). It was a bankrupt, humiliated forty-five year old failure who fled to Venice in November 1880. Years later Whistler told Elizabeth and Joseph Pennell, when they were gathering material for their great biography of him, that the English artists 'hoped they could drive me out of the country, or kill me! And if I hadn't had the constitution of a Government mule, they would.'[28]

Once there, Whistler produced fifty prints, one hundred pastels, and seven or eight paintings that are among his most innovative works (nos.100–22). The etchings in particular broke new ground. Whistler would take one image, then through wiping more and more ink from the plate show the scene from the first light of dawn to the depths of night (no.122).[29] Such effects were to inspire Whistler's close friend Claude Monet, whose study of the effect of changing light on grain stacks and cathedral fronts depends directly on Whistler's example.

Returning to London to exhibit his Venetian work at the Fine Art Society, Whistler was met with the familiar British incomprehension, but now he fought back. Before the trial Whistler had written two letters to the press. After it, he bombarded his critics on their foolish strictures on his work, he gave interviews and pursued vendettas. He mounted attack after attack in the press, in his catalogues, and in pamphlets. A self-publicist of genius, he established a position as the undisputed leader of advanced taste in England, the epitome of everything fresh and new in art – a butterfly with a sting in his tail.

As President of the Society of British Artists between 1886–7 Whistler stood opposed to everything insular and intransigent in the Royal Academy. During the second half of his career he adopted a pose of suave contempt for British artists and critics, but in the words of Théodore Duret 'his heart ulcerated with resentment at seeing his art despised'.[30]

In February 1885 he took to the stage. In his 'Ten O'Clock' lecture he explained to a fashionable audience of patrons, painters, critics and writers the difference between art and nature. Drawing heavily upon Baudelaire's essay 'The Painter of Modern Life'[31] he attacked both Ruskinian photo-realism and Oscar Wilde's vulgarisation of Whistlerian ideas on decoration and dress. Buried deep in the lecture is a rebuttal to William Morris's denunciation of 'Impressionists who delight in the wreath of steam that floats from the funnel of a locomotive [while ignoring] the defiling coal that produced it'.[32] Those wreaths of steam are precisely what Whistler now urged his audience to see as beautiful.

The theatrical manager D'Oyly Carte organised the 'Ten O'Clock' lecture. Whistler hoped to emulate the success of Wilde's American tour by taking the lecture 'on the road' to the country of his birth.[33] He never did so. Nevertheless, eager to preach his doctrine to an ever wider audience, he published his celebrated collection of thoughts and reflections on art and art critics, *The Gentle Art of Making Enemies* (no.97).

In the 1880s Whistler began to cultivate his European reputation. He sent pictures to the Salon, which he had neglected since 1867. He exhibited in Dublin

(1884–5), Munich (1888), New York (1889) and with the Belgian avant-garde Société des XX (1884 and after). Whistler never turned down requests for the loan of his pictures abroad, winning medals in Amsterdam (1889), Chicago (1892), Philadelphia (1894) and at the first Venice Biennale of 1895.

In 1890 the Corporation of Glasgow purchased the portrait of Thomas Carlyle (no.61), the first work by Whistler to enter a public collection. In 1895 the City of Philadelphia acquired 'Arrangement in Black: La Dame au brodequin jeune – Portrait of Lady Archibald Campbell' (no.130). Most important of all, after a public campaign in which the poet Stéphane Mallarmé, Théodore Duret, and Monet joined forces, in 1891 the Musée du Luxembourg purchased 'Arrangement in Grey and Black: Portrait of the Painter's Mother' (no.60), ensuring that it would become in time the first work by an American artist to enter the Louvre. In the following year Whistler was made an Officer of the Légion d'honneur. Once again he felt the pull of Paris.

In 1888 Whistler had married the widow of E.W. Godwin, and they settled in a small house in the rue du Bac in Paris. He became an intimate friend of Mallarmé (see no.186) and began to move in a select circle of Symbolist poets, painters, and critics who regularly attended Mallarmé's famous Tuesday evening soirées. Through Comte Robert de Montesquiou-Fezensac, he entered into the very circle of aristocrats on whom Marcel Proust based the characters in *A la recherche du temps perdu* (Remembrance of Things Past): the Duchesse de Clermont Tonnere, Duc d'Aumale, Viscountess Greffuhle, Prince de Polignac and Mme de Montebello. Whistler himself was becoming something of a legend, appearing in that same book as part of a composite character, the landscape painter Elstir. Indeed, he appeared as one of Henry James's most attractive minor characters, the sculptor Gloriani in *The Ambassadors*, whose personality, way of life, and even home are closely based on Whistler.

Americans flooded now to Whistler's studio to be painted, to buy paintings, or to be taught painting. In the 1880s the American industrialist Charles Lang Freer began to amass his extraordinary collection of Whistler's work. Bequeathed to the nation in 1923, it is preserved today in the Freer Gallery of Art in Washington, DC. Even the English began to acknowledge his stature when a retrospective of his work was held at the Goupil Gallery in March 1892, attracting a thousand visitors on the last day. According to the *Times*, 'Mr Whistler is becoming the fashion at the least it is becoming the correct thing to pretend to admire him'.[34]

But by then it was in some ways too late. As portrait commissions poured in, Whistler asked plaintively, 'where were they when I wanted to paint them?'[35] Whistler in private was less confident than his public image suggested. Indeed, it is the self-doubt, so apparent in his late self-portraits (nos.203–5), that makes him one of the most complex figures in nineteenth-century painting. The searching, questioning quality of his art, his need constantly to experiment and expand beyond what he had already achieved meant courting the failure and eventual destruction of a picture. What survives of his work today represents only a fraction of what he produced. He died in 1903.

Whistler and British Art

RICHARD DORMENT

According to J. Comyns Carr, by the end of his life Whistler's resentment at his treatment by the English 'had quickened into something approaching absolute dislike towards this country'[1] – itself quite an understatement when one considers that Whistler bequeathed the entire contents of his studio to his executrix with the 'expressed wish that none of them should ever find a place in an English Gallery'.[2]

Everything Whistler said or wrote about his work after the Ruskin trial, and particularly everything he told his biographers Elizabeth and Joseph Pennell, was coloured by his wish to dissociate himself from the English school of painting – not only from the real and numerous enemies he had made among the Royal Academicians, but also from those artists to whom he had been close in the 1860s. What is more, by disguising his debts to the British old masters, Whistler created the impression that he belonged to no school of art. Yet he is the one Victorian painter who may be said to have placed the revitalisation of the grand manner of British painting at the very heart of his work.

This was not always so. It was an artist seeped in Parisian painting techniques and art theory who arrived in London in 1859 and attempted to plant the seed of French Realism in English soil. This phase of his development and its cross-fertilisation with the British artists Rodham Spencer Stanhope (no.15), Robert Ridley (no.33), William Clark Hook (no.39), Edwin Edwards (no.60) and Rossetti (no.19) has long been recognised,[3] and is discussed in many of the catalogue entries.

But by 1867 Whistler was struggling to redefine his artistic personality, attempting to cast off the early influence of Courbet and to free himself from the cumbersome painting technique he had been taught in Paris. At first he sought an antidote to French *plein air* naturalism in the contemporary British school of neo-classicism.

In the 'Six Projects' (1867–70) he had hoped to paint a classical frieze in the manner of Edward Burne-Jones, but in a palette ultimately derived from Delacroix (see pp.92–4), thereby striking a harmonious balance between the rival claims for the superiority of colour versus those of draughtsmanship.[4] When his ambitious project of uniting French romanticism with English neo-classicism failed, his art was thrown into crisis. It became necessary to choose. Was he a

French artist or an English one? Whistler emerged from the stylistic confusion of the 1860s because he consciously chose to paint like an English artist. The catalyst for this change in painting technique was a series of three historic exhibitions of British portraiture from the seventeenth and eighteenth centuries, held at the South Kensington Museum in 1866, 1867 and 1868.

Paralleling his exploration of the British grand manner of portraiture, in his Nocturnes he discovered the creative potential of a medium all but synonymous with the British school of painting: the watercolour. Both sources of inspiration enabled Whistler to paint his first mature masterpieces, the Nocturnes (nos.46–54), and the portraits of his mother (no.60), Cicely Alexander (no.62) and Frances Leyland (fig.74).

Though he was not to work extensively in watercolour until the 1870s, Whistler had achieved complete mastery over the medium as early as 1854, when he was still a cadet at West Point.[5] Living in London, he was of course surrounded by painters in watercolour and by exhibiting societies devoted exclusively to the medium. One figure in particular may have had a crucial importance for his art, George Price Boyce, a minor artist in the Rossetti circle who was painting watercolour studies of the Thames at night from the balcony of his flat near Blackfriars Bridge as early as 1863 (fig.9).[6] Put at its simplest, through Boyce's nocturnal views Whistler gradually came to realise that by diluting his oil paints to the consistency of watercolour, he would be able to work much more quickly and spontaneously.

Professional Victorian watercolourists tended to treat their medium as though it were indistinguishable from oil painting. David Cox (Senior) and Peter De Wint painted formal exhibition pictures on thick, roughly textured paper, building up opaque layers of pigment, exactly like an oil painting, then hanging their works in heavy frames under glass for exhibition.

Whistler's genius was to reverse this process, treating oil as though it were 'pure' (that is, transparent) watercolour by 'staining' certain canvases in much the same way as the watercolourist allows paper to absorb the runny pigments (see no.60).[7] Whistler's pupil Walter Sickert, who could be scathingly critical of these painting techniques, instantly spotted the source for them: 'The staining of a white canvas in the manner of a water-colour is not "la peinture".'[8]

But Whistler's highly experimental techniques differ from canvas to canvas. In one Nocturne, he leaves an area of dark ground or underpaint untouched to create the shadowy form of a bridge silhouetted against the night sky, much as a watercolourist will leave areas of paper bare to suggest clouds, reflections in water, or distant buildings (no.54). In another, he paints in long wet, highly visible brushstrokes over a prepared ground (no.46). But in a third, he achieves his effects through staining the canvas with fields of colour modulating from dark blue to black (no.50). Whichever method he used, the ground is of crucial importance for creating the translucence essential to the hybrid medium he had invented.

The use certain British old masters made of the relationship between a painting's ground and the paint layer is precisely the lesson Whistler learned from the

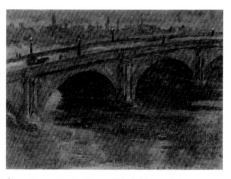

fig.9 George Price Boyce 'Blackfriars Bridge: Moonlight Sketch' 1863 Watercolour on paper *Tate Gallery, London*

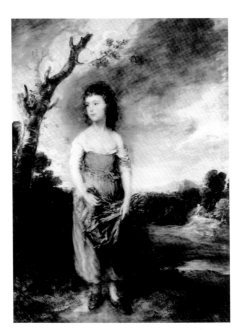

fig.10 Thomas Gainsborough 'A Peasant Girl
Gathering Faggots in a Wood' 1782 Oil on canvas
Manchester City Art Galleries

exhibitions of British portraiture at the South Kensington Museum. The scale of
these three exhibitions is striking even today, with a total of 2,846 portraits on
view, including, for example, eighty-one Van Dycks, sixty-four Lelys, thirty-nine
Hogarths and seventy-eight Gainsboroughs.[9]

In particular, his exposure to the portraits of Thomas Gainsborough in the
very years when he was struggling with both the medium and his artistic identity
helped turn his art away from the high-pitched colour of the 'Six Projects' and
enabled him to develop a new painting technique derived from British portrai-
ture. The importance for him of the National Portrait Exhibitions can hardly be
overestimated. Before 1870, there are no full-scale commissioned portraits by
Whistler. Thereafter, they are at the centre of his work.

Walter Sickert published several accounts of his master's working methods in
which he excoriates him for departing 'from the sounder method he had learned in
France'[10] for what he saw as the flimsy and ultimately disastrous painting tech-
niques used in the portraits of the 1870s and 1880s. Sickert dated the change to the
mid-1860s, when Whistler abandoned 'the art of oil-painting, of which he was just
getting a real grasp'[11] to paint 'with coat upon coat of paint, considerably thinned
with oil and turpentine'.[12] This is the British technique of glazing or the laying of
a darker colour over a lighter, and the francophile Sickert detested it. He contrast-
ed it with the French method of applying areas of opaque paint to canvas, which
Whistler learned in Paris and used in 'At the Piano' (no.11) and 'La Mère Gérard
(Private Collection; YMSM 26). Sickert described the 'muffling-up of the painting
in the indecision of universal glaze' as 'the vice of English painting'.[13] But it is also
the technique of no less an artist than Gainsborough, who primed his canvases
with light grey or yellow paint and then glazed his portraits with 'paint so thin
and liquid that his palette ran over unless he kept it on the level'.[14]

Whistler's pupil Mortimer Menpes tells us that he 'used very flowing colour;
and even the most solid part of a picture such as the whites in linen, were suffi-
ciently transparent for the ground underneath to show. Whistler never loaded his
pictures with pigment, but worked in thin films of colour.'[15] Whistler told anoth-
er student, Otto Bacher, that 'paint should not be applied thick. It should be like
breath on the surface of a pane of glass!'[16]

As with the Nocturnes, the thinned paint enabled Whistler to work quickly,
bringing every area of the picture up to the same degree of finish in one session.
In successful pictures he achieved a tonal harmony which even Sickert called 'the
exquisite oneness that gives his work such a rare and beautiful distinction'.[17]
Compare Whistler's technique with the famous passage in Sir Joshua Reynolds's
fourteenth Discourse where he marvels at Gainsborough's 'manner of forming all
the parts of his picture together; the whole going on at the same time, in the same
manner as nature creates her works'.[18]

Though Whistler rarely paid homage to the old masters, his portrait of Eli-
nor Leyland, 'The Blue Girl' (destroyed 1879; YMSM 111) was painted in emulation
of Gainsborough. 'From certain remarks [Whistler] made to me' wrote Thomas
R. Way, 'Gainsborough's "Blue Boy" was in his mind when he determined to

attack this difficult problem.'[19] Visually, Gainsborough is the source of inspiration for a number of Whistler's most successful paintings. Compare, for example, the magnificently painted dresses of both Cicely Alexander and Frances Leyland to those worn by Gainsborough's 'Mrs Philip Thicknesse' 1760 (Cincinnati Art Museum) or 'Mary, Countess Howe' c.1765 (Iveagh Bequest, Kenwood). Whistler's 'Cremorne Gardens, No.2', 1872–7 (no.57) is closely related to Gainsborough's 'The Mall in St James's Park' of 1783 (fig.66). And it is tempting to describe Whistler's portrait of a coster girl in 'The Chelsea Girl' (no.129) as his own version of one of Gainsborough's 'fancy pictures' – those portraits of rustics or beggar children painted to the scale of life which, until well into the nineteenth century, were his most popular works (fig.10). Typically, where Gainsborough is sentimental, Whistler is bracingly unemotional.

But much more important for Whistler's aesthetic than any one picture or type of picture by Gainsborough is the example of his working method. Gainsborough worked by candlelight, even in the daytime keeping his studio in a 'kind of darkened twilight'.[20] Compare this to the Pennells' description of Whistler's studio as 'curtained to a low tone of light'[21] or to Thomas Robert Way's of the 'Indian muslin curtains [which hung] over the windows of the rooms he used for painting in at Lindsay [sic] Row, [through which] he got a very diffused light without any definite shadow'.[22]

For his portraits, Gainsborough used brushes up to six feet long, enabling him to view the whole composition from afar as he worked. A caricature of Whistler painting his portrait(s) of Lady Meux shows him painting with brushes several feet long (fig.83). This was to 'make the figures stand … as far within their frames as he stood from them when he painted them, and at this problem he worked as long as he lived'.[23] If Whistler failed to acknowledge his debt to Gainsborough when talking to the Pennells at the turn of the century, it is because by that date the condition of a number of portraits painted in the 1870s had deteriorated, and he himself had become far more interested in Hogarth's painting techniques, such as used in 'The Shrimp Girl' (fig.11), than in Gainsborough's (see p.274).[24]

But Whistler's study of the old masters is only half the story of his identity as an artist of the British school. Far from choosing to be an outsider, as the reader of the Pennells' biography might assume, Whistler aspired to a conventional career in the Victorian art world. The young Whistler exhibited at the staunchly conservative Royal Academy throughout the 1860s, and sought election there at a time when most of the avant-garde artists with whom he was in contact made no attempt to do so.[25] Despite his rejection by the Academy, and the critical failure of his own retrospective at the Flemish Gallery in Pall Mall in 1874, Whistler did not then choose to abandon London to exhibit in Paris.[26] This seems inexplicable unless he was seeking to establish a practice in London as a portrait painter in the British grand manner while at the same time building a second career as a designer in projects like the Peacock Room (no.81) and the decoration of Aubrey House (nos.80).

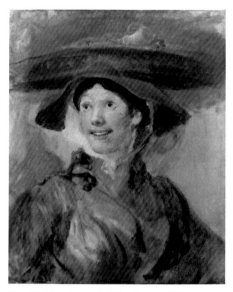

fig.11 William Hogarth 'The Shrimp Girl' c.1745
Oil on canvas *The Trustees, The National Gallery, London*

After 1879, when the Ruskin libel trial finally put an end to his hopes of finding a place in the Victorian art establishment, Whistler conducted a highly creative guerilla war against Ruskinians and Royal Academicians, even leading his own battalion for the brief period in 1886–7 when he was President of the Society of British Artists. Whistler was at his most inventive when at his most competitive. His delicate Venetian pastels, for example, were conceived in deliberate reaction to the prosaic photographs-in-paint admired by Ruskin (see no.59). The 'Ten O'Clock' lecture is, among other things, a response to the success of Oscar Wilde's American lecture tour. In the remainder of this essay, I want to take two examples of how aspects of Whistler's art were stimulated by his negative reactions to the work of much more successful British artists.

Whistler had been aware of the work in the decorative arts of William Morris since the International Exhibition at South Kensington in 1862, when Morris, Marshall, Faulkner & Co. received medals of commendation and for 'artistic qualities of colours and design'.[27] The fledgling firm's prestigious commission to decorate the Tapestry Room and Armoury of St James's Palace in 1866 was precisely the kind of worldly success Whistler admired and sought to emulate in his own career. Indeed, it was the frieze based on the life of St George executed by Burne-Jones as part of Morris, Marshall, Faulkner & Co.'s ambitious scheme of interior decoration for the watercolourist Miles Birket Foster's house which stimulated Whistler to begin the 'Six Projects' in 1867.[28]

This is not the place to discuss all of Whistler's designs for fabrics, furniture, and interior decoration. But Whistler's activities as a designer can certainly be seen as a direct response to William Morris's success in obtaining commissions from clients who might otherwise have employed Whistler. Though he had just created the most beautiful room in Victorian England for Frederick Leyland, in the 1880s two of Whistler's richest patrons, Alexander Ionides and Percy Wyndham, used Morris & Co. for the decoration of their houses in London and Wiltshire, respectively.

In his exhibition designs, Whistler's characteristically spare decor and emphasis on soft, restrained colour may have been conceived in a spirit of critical rivalry with Morris's relatively dark and heavily patterned fabric and wallpaper designs. And where Whistler does create a darkly glowing decorative ensemble in the Peacock room, it is interesting to compare his colours with the rich blues and greens Morris achieved in the animal or vegetable dyes developed between 1872–7 for woven textile designs such as 'Peacock and Dragon'.[29]

Certainly Whistler took note of the commercial success Morris enjoyed after the opening in 1877 of his showroom at 264 (later 449) Oxford Street. Always aware of his 'competition' from mainstream Victorian artists, Whistler opened the Company of the Butterfly in 1897, hoping to sell his own exercises in sophisticated good taste directly to middle-class customers, who never materialised (no.170).

In the 1860s and 1870s Whistler's response to the paintings of Courbet and Manet manifests itself in paintings directly inspired by their works (see nos.41,

44). But later in his career Whistler tended to react just as strongly to art he despised, creating work which might almost be said to parody a trite subject or prosaic style. Something like this may be happening in Whistler's late pastels and watercolours on the theme of the mother and child (nos.176–9). In 1891 Whistler was invited to hang the annual Liverpool exhibition (fig.12). Here is his hilariously exaggerated recounting of a practical joke he played on the academicians who had submitted typical Victorian narrative pictures featuring what Whistler called 'the great British baby':

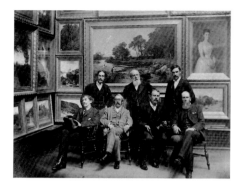

fig.12 The Hanging Committee of the Liverpool Art Society, 1891 *Whistler Collection, Glasgow University Library*

> You know, the Academy baby by the dozen had been sent in, and I got them all in my gallery – and in the centre, at one end, I placed the birth of the baby – splendid – and opposite, the baby with the mustard-pot, and opposite that the baby with the puppy – and in the centre, on one side, the baby ill, doctor holding its pulse, mother weeping. On the other, by the door, the baby dead – the baby's funeral – baby from the cradle to the grave – baby in heaven – babies of all kinds and shapes all along the line … And on varnishing day, in came the artists – each making for his own baby – amazing! … And they all shook my hand, and thanked me – and went to look – at other men's babies – and then they saw babies in front of them, babies behind them, babies to right of them, babies to left of them.'[30]

Whistler's amused contempt for the great Victorian subject picture (see, for example fig.13) did not end there. His own interest in the subject of the mother and child in the 1890s becomes explicable if one sees these pictures as Whistler's attempt to take the most sentimental of Victorian subjects and show how it could be transformed into an exquisite arrangement of line and colour. These images of models in diaphanous draperies cradling small children appeal not to our hearts, but to our eyes.

fig.13 Frank Bramley 'A Hopeless Dawn' 1888 Oil on canvas *Tate Gallery, London*

Such pastels and watercolours are of a piece with Whistler's earlier reinterpretations of the most sacred Victorian subjects: his scowling Cicely Alexander parodies those little angels in pinafores by Millais or Kate Greenaway; his portrait of his own mother is impossible to read as a hymn of filial piety, as most Victorian depictions of motherhood would demand. 'Satire' is certainly not the right word to describe these paintings, but it is not too much to suggest that in all these works Whistler is consciously working against the grain, allowing himself to participate in the mainstream of Victorian painting, even as he is criticising it.

Whistler and America

NICOLAI CIKOVSKY, JR

WITH CHARLES BROCK

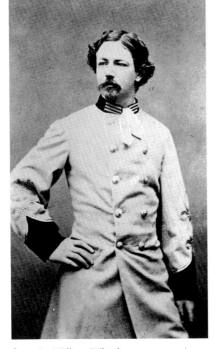

fig.14 Dr William Whistler as a surgeon in the Confederate army, c.1862 *Library of Congress, Prints and Photographs Division, Pennell Collection*

Two months before he died, Whistler spoke of America, to another American, as 'my home'.[1] He had not set foot in America for nearly fifty years, not since he left in 1855 at the age of twenty-one. He threatened to return, was eagerly expected several times, and was routinely urged to visit by American admirers. He never did, although the simple eloquence of 'my home' expresses a deep attachment, deeper than a mere accident of birth, that survived the long separation of time and distance, and sometimes strained national allegiance.

Whistler spent comparatively little time in his homeland. Three years after he was born in Lowell, Massachusetts, his family moved to Stonington, Connecticut; six years after that to St Petersburg, Russia; and six years after that, following the death of his father in Russia (he was a railroad engineer whose relocations were the cause of his family's movements), to Pomfret, Connecticut. After two years in Pomfret, Whistler entered the United States Military Academy at West Point, which his father had also attended. He was discharged during his third year, after which he worked for a few months in Baltimore, and then for a further few months in Washington, at the United States Coast and Geodetic Survey. It is telling, perhaps, that in later life his most frequently recalled American experience was West Point. Although his career there was far from distinguished, he took great pride in it, perhaps because, however irksome he found military discipline at the time he experienced it, his years at West Point were the most ordered, tradition-bound, and rooted period of his life in America.

Whistler's parents took pains to instil a sense of patriotism in their children, and his father bore the greatest of all American national names, George Washington. But the Civil War tested the strength and unity of Whistler's patriotism. He did not experience the war at first hand, but it profoundly shaped his national identity. His sympathies, like those of his mother (who was born in North Carolina), and younger brother, William (who served as a medical officer in the Confederate army; fig.14), were with the South. He chose to regard himself, and was regarded by others, as a Southern American. Henry James, for example, described him in 1878 as 'a queer little Londonized Southerner.'[2] His Southernness was completely fictitious, of course. When in 1900 he gave his sister-in-law Nelly advice about the wording of his brother William's obituary notice he recom-

mended the same kind of self-invention he himself had practised for years. Omit such 'parochial' factual details as dates and places, he told her, and 'Let Baltimore be his home, and generally The South be his country'.[3] Neither was any more William's home or country than it was James's. James had chosen to regard Baltimore as his birthplace[4]; Lowell, a New England industrial city, was an intense and persistent embarrassment to him, and he denied any association with it, not so much because 'the taint of Lowell,' as he described it,[5] affronted his aesthetic sensibility but because, in his Southern persona, it offended his national feeling.

Whistler's Southernness had another model: the writer Edgar Allan Poe. One of the reasons Whistler selected Baltimore as his birthplace, as he wrote in notes for possible memoirs, was because of its association with Poe.[6] Furthermore, although he was raised and lived largely in the South, Poe, like Whistler, was born in New England,[7] and like him attended, and was also discharged from, West Point. Whistler's friends understood that connection. Swinburne believed that Whistler, as 'a fellow Southerner', was an admirer of Poe,[8] and Stéphane Mallarmé compared Whistler to him.[9]

But Whistler's Southernness was just one part of his Americanism, and seems to have been more apparent in his early life. The fact is that people were not quite sure what Whistler was. In 1886, one writer said he is 'an out-and-out Yankee, if ever there was one', who 'speaks in a high key with a strong nasal accent'.[10] But in 1897 his 'nonchalant southern drawl' was commented upon.[11] In the 1880s the American critic Charles De Kay described a more complex blend of national traits: 'a pronounced American face, with an American voice very slightly overlaid by an English hesitancy of speech, and with an American manner.' 'It would be hard', he concluded, 'to say to what nationality he belongs.'[12] In 1879, probably on the basis of J.E. Boehm's portrait bust rather than from first-hand knowledge (fig.15), someone spoke of his 'sharp American face',[13] and at about the same time a writer in the *New York World* said 'he has something of the active nervous character of a Frenchman, but yet his face is truly of the American type'.[14]

Others noticed his Gallic traits. In 1879 one correspondent in the *New York Times* said that he 'combines much of his native American openness and love of fair play with the ease, grace, and finesse of a Frenchman'.[15] Another wrote in 1885 that 'he is an American by birth, as all the world knows', but 'he has forgotten everything American, even to accent'.[16] The critic Arthur Symonds wrote of his 'strange accent, part American, part deliberately French'.[17] In 1882 a critic said Whistler had 'the American inventor in him',[18] which is also an apt description of Whistler's almost chameleon-like capacity for self-invention. Whistler spoke French fluently, and moved easily and often, between life in England and France. With similar ease he affected different vernaculars: speaking to an American, 'his choice of language, and in some cases his accent, would become markedly English in form; while in addressing an Englishman he would adopt the Yankee drawl, sometimes adding a touch of local slang'.[19] In a letter to Marian Draughn, one of his American sitters, telling her of his portrait of the 'Florida Girl', he wrote: 'I have done wonders to the picture today – but dat gurl is calling out for mo' gold

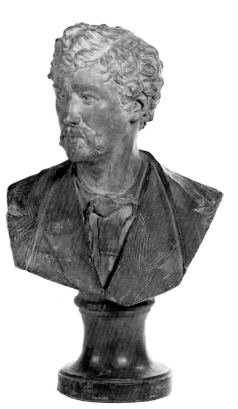

fig.15 Sir Joseph Edgar Boehm 'James Abbott McNeill Whistler' 1872 Terracotta *National Portrait Gallery, Smithsonian Institution, Washington. Transfer from the National Gallery of Art. Bequest of Albert E. Gallatin*

and rose leaves – and don't you disappoint her!'[20] There are examples, too, of his awareness of American usage: to his friend and publisher William Heinemann, for instance, he wrote in 1899, 'Every morning I have been disappointed with what Americans call my "mail"'[21]; to Mrs F.R. Leyland he referred to the 'dreamy uncertainties of a thriftless and what they call in America an unreliable fellow';[22] and the collector Louisine Havemeyer told how, speaking to Whistler, she said of one of his Venetian pastels, 'I have been there myself, have stood upon that bridge, and have felt just what I guess you felt! Do you know that lovely American word? I got it from our Yankee dialect.' Whistler answered, 'I guess I do', and fell into dialect himself.[23]

William C. Brownell, the American critic who wrote the earliest important article on Whistler for the American magazine *Scribner's Monthly*, answered most succinctly the complicated question of Whistler's nationality: 'Mr. Whistler is more of an American than anything else'.[24] A catalogue of Whistler's many Americanisms is easily compiled. It includes American food, most notably the famous Sunday breakfasts in London with their 'inevitable buckwheat cakes, and green corn'.[25] Otto Bacher reported that at lunch in Venice they frequently had 'patate Americane', for which Whistler apologised, saying that although they were large and sweet, 'the nice, golden-yellow of the real American sweet potato is lacking'.[26] To Heinemann, about to leave for America in 1898, he wrote, 'What a lot of good things you will be getting to eat over there! I have been having lately of the American cooking again, and really think there are endless good things!'[27] He liked American cocktails, too, often drinking them with his American dealer, Edward G. Kennedy.

American products and inventions also intrigued him. 'He was a true American, particularly in his liking for [indoor] heat', Kennedy observed in 1896[28]; Joseph Pennell said 'He delighted in American mechanical toys',[29] and he kept an American rocking chair in the garden of his house in the rue du Bac.[30] In 1896, he fervently admired John C. Van Dyke's long, pointed shoes, then the American fashion, 'their point carried to a degree of fineness no English bootmaker could rival',[31] and to the American artist John W. Alexander and his wife he 'exhibited the intricacies of a cane umbrella – the first one he had ever seen. "Look at that; and that; and that! It is perfect, What! Made in New York – New York! That's the way they do things over there."'[32]

After a breakfast in Paris in 1899 he made his guests 'listen to a Fourth of July spread-eagle oration squeaked out of a primitive gramophone that somebody had presented him with, to his enduring amusement'.[33] Another record of which he never tired, playing it for George Vanderbilt and Heinemann, 'gave an American quack's patter in praise of a patent drug, every sentence ending with "It costs a little more, but what of that?"'[34] Mortimer Menpes described a supper when Whistler, in high spirits, swung a toy policeman's rattle to the tune of Yankee Doodle.[35] He also read Bret Harte stories to his guests, and quoted Mark Twain (whom he knew personally)[36] and Abraham Lincoln ('As old Abe Lincoln said, "the middle of a river is no place to swap horses!"'[37])

Whistler's Americanness, however, was at no time an artistic Americanness. He chose to be identified with American art in showing (though not invariably but as it suited him) in American sections of international exhibitions. And after they had overcome their early reservations, Americans claimed him as one of their own, so much so, in fact, that by the 1880s Whistler and John Singer Sargent were described as 'representative Americans'.[38] But the special concerns of American art, uniquely bound up with nationality, had no claim upon him. When Whistler left America in 1855 the country was gripped by a fervent artistic nationalism, reflected in a series of 'Letters on Landscape Painting' published by painter Asher B. Durand. In what was virtually a national theory of art, Durand urged two principles upon American artists with the force almost of a moral imperative: first, work from nature, not art, and imitate it with 'scrupulous fidelity', and second, 'go not abroad … in search of material for the exercise of your pencil, while the virgin charms of our native land have claims on your deepest affection'.[39] But they had no claims on Whistler. His American work never appeared to reflect the national responsibilities that most serious American artists readily accepted (even Whistler's slightly younger contemporary, Winslow Homer, echoed the beliefs that ruled American art in the 1850s when he said 'If a man wants to be an artist, he should never look at pictures'[40]).

Whistler did not feel any guilt in leaving America for France as soon as possible, to study and to look at pictures (the most conspicuously native thing he took with him was an American straw hat; fig.16). If in the 1860s he had to choose between being a French or an English artist, he never considered being an American one. His mature artistic belief, formulated by 1878 in 'The Red Rag' article, that feelings of nationalism ('patriotism'), together with devotion, pity, and love were the sort of 'clap-trap' of which art should be independent, and that 'the imitator is a poor kind of creature' was a refutation of the ideology that guided American artists at the time he left. 'Mr. Whistler will not allow us to use the phrase "American art"',' George Smalley wrote in 1902. 'He long since announced that art is of no nationality.'[41]

Perhaps this was the reason that Americans were not sure what to make of Whistler and whether they could claim him as an American – or even if they should, for Whistler's whole being, everything they knew about his art and his behaviour, touched the tender nerve of American artistic morality. It is audible in the qualified praise for the first of Whistler's paintings to be seen in America, 'Wapping' (no.33), shown at the Artists' Fund Society exhibition in New York in 1866. A writer for the *New York Commercial Advertiser* said, 'though an American by birth, he has won a reputation of a wilful, eccentric, delicate, and vigorous artist' – as if a truly and properly American artist could be none of these things.[42] Some years later, a reviewer in the *New York World* was quite willing to give him up entirely: 'Mr. Whistler is of American parentage, 'but he is essentially an English artist, and if we wished to do so we should have no right to call him an American painter'. This reviewer was not alone; in 1877 a critic for the *New York Times* said Whistler 'appears to have become an Englishman',[43] and the following year a

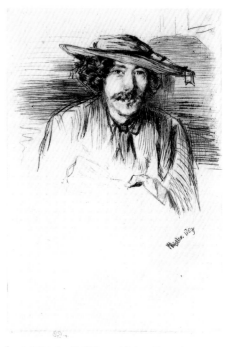

fig.16 Whistler 'Self-Portrait' 1859 Drypoint
National Gallery of Art, Washington. Rosenwald Collection

critic for *Scribner's Monthly* said he was 'almost tired of calling Mr. Whistler an American artist'.[44]

Moral issues aside, there was a perfectly good reason for this uncertainty and indecision. When Whistler's 'Arrangement in Grey and Black: Portrait of the Painter's Mother' (no.60) was shown in Philadelphia in the autumn of 1881 one newspaper noted that it was 'the first occasion on which his compatriots have had an opportunity to examine his works on this side of the ocean', and as another pointed out, 'though a native born American' Whistler 'had been known hitherto, in the land of his birth, by reputation only – at most by transcripts in black and white of works that have caused no little discussion in Europe'. This was substantially true (although a few of his paintings – many of them owned by the family of Whistler's stepbrother George, in Baltimore – were to be seen earlier).

In 1874 Harold Blackburn, in London, wrote that in America 'Mr. Whistler's name was a household word in art circles',[45] and in 1876 the *New York Evening Post* said his 'peculiar style of painting is well known in New York'.[46] When the young Edwin Austin Abbey first met Whistler in 1879, he told Whistler that he had a great many admirers in America.[47] Nevertheless, for the first twenty years or so of Whistler's artistic maturity all that most Americans knew about him they knew at second-hand, from reports in English newspapers and journals reprinted in America, and from reproductions of his work. William C. Brownell, in his key article on Whistler in *Scribner's Monthly* in 1879, thought Whistler's etching 'Jo' (no.13), the title of which he gave as 'Joe', was 'a portrait of the artist's brother, Mr. Joseph Whistler'. The fact that it was actually of Whistler's mistress Joanna Hiffernan is an amusing measure of the current ignorance.[48]

Words travelled more freely and quickly than pictures, and Americans understood more, as a critic said in 1875, 'by the titles of his pictures than by any acquaintance they have with them'.[49] They were aware that he called his paintings symphonies, harmonies, nocturnes, and arrangements, and knew something – probably from 'The Red Rag' of 1878, augmented by reports, including Whistler's own, of the Ruskin trial – of the 'very curious theories' that lay behind those titles, principally Whistler's intention 'to produce effects similar to those of musical compositions'.[50] The 'nomenclature of Mr. Whistler's pictures',[51] began to be used as a device of ridicule. A painting by the conservative landscape painter Jasper Cropsey was described as 'what Whistler would style "a harmony in green and yellow"'.[52] In 1879 a reviewer of Homer D. Martin's 'Sand Dunes on Lake Ontario' remarked disparagingly that the artist 'is evidently aiming to be the Whistler of America, and this work might, perhaps, have been more opportunely termed a symphony in pea green, raw umber, and white'.[53] In Cropsey's case, nothing could be less like Whistler than his garish landscapes. Martin, however, who was part of Whistler's circle in London in the 1870s, did paint some Whistlerian landscapes (it was roughly at this time that 'Whistlerian,' 'Whistlerish,' and 'Whistler-like' started to enter the vocabulary of American criticism) such as his 'Evening on the Thames' (whereabouts unknown) shown in the Society of American Artists exhibition in 1879.

In any event, Whistler's influence was not felt forcefully in America until the 1880s. Until the exhibition in 1881 of 'Symphony in White, No.1: The White Girl' (no.14) and, in the following year, 'Arrangement in Grey and Black: Portrait of the Painter's Mother' (no.60), both at the Society of American Artists, the only significant paintings seen in New York – where seeing them counted the most – were 'Wapping' (no.33) and 'The Coast of Brittany' (no.39).[54] By 1881, these works were twenty years old or more, so that Americans who saw the paintings not only had a partial view of Whistler's art, but an increasingly dated one as well.

The exhibition of 'Symphony in White, No.1: The White Girl' and 'Arrangement in Grey and Black: Portrait of the Painter's Mother' gave Whistler's art a new authoritative presence. Even if Americans had difficulty with the aggressive originality of treatment, as one Philadelphia newspaper put it,[55] they nevertheless could not easily dismiss their importance. The 'Portrait of the Painter's Mother' 'vindicates Whistler's right to be eccentric', the *Independent* wrote in 1881, and went on in the sort of rhapsodic terms that would lead to its canonisation as America's most famous picture: 'This sweet, calm woman, who sits unaffectedly looking toward the sunset of life, has in it every grace of old age and motherhood. It is a religious picture, expressing higher things than most pictures of saints and martyrs.'[56]

Artists responded immediately. 'The White Girl', particularly, caused an epidemic of emulation. The Society of American Artists was America's most advanced artistic organisation. Its founding in 1877 by an insurgent group of young artists coincided closely with a similar clash of generations in the Whistler–Ruskin trial, and Whistler had a great, if distant, influence upon it (he was described as its 'demiurge' in 1879 and elected a member in 1880[57]). Of certain pictures in the Society's 1882 exhibition a critic for *Art Amateur* wrote: 'Mr. [J. Alden] Weir follows the fashion with his lady in white wreathing white roses into a garland against a white wall' (whatever Weir had learned from Whistler, it was not his essential lesson of simplicity) and, he continued, 'Last year Mr. [William Merritt] Chase painted his queer "Woman in White", who looked like Oscar Wilde's grandmother in her teens, and here is Mr. [George W.] Maynard with his "Inventor," in summer duck—all of them experiments in Mr. Whistler's original vein'.[58] It was a vein that American artists continued to mine for many years. And if not every profile portrait of a seated woman can be attributed to the influence of Whistler's 'Mother', paintings like Cecilia Beaux's 'The Last Days of Childhood' of 1883–5 (Pennsylvania Academy of the fine Arts) and Dennis Bunker's 'Portrait of Anne Page' of 1886–7 (private collection), seem clearly to have accepted that influence. More inventively and therefore less clearly, Chase's 'Portrait of Dora Wheeler' of 1884 (The Cleveland Museum of Art), and Thomas Eakins's portrait of his wife, 'Lady with Setter Dog' of 1885 (Metropolitan Museum of Art, New York) revealed the same influence.

Two closely occurring events made Whistler's influence in America irreversible. One was the *Arrangement in Yellow and White* exhibition held in New York

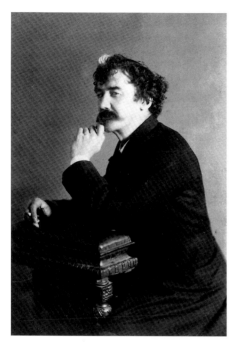

fig.17 Whistler, photograph by the London Stereoscopic Company, 1878 *Whistler Collection, Glasgow University Library*

fig.18 John W. Alexander 'Why Do you Tarry, Mr. Whistler?', *Evening Telegram – New York*, 20 December 1886 *A.E. Gallatin Collection, Miriam and Ira D. Wallach Division of Art, Prints and Photographs, The New York Public Library, Astor, Lenox, and Tilden Foundations*

in the autumn of 1883, which subsequently toured to Baltimore, Boston, Philadelphia, Chicago, and Detroit. A reconstitution of the fine Art Society exhibition of Whistler's Venetian etchings, it was, as the *New York Evening Post* said, 'the most important exhibition of [Whistler's] work yet seen in this city'.[59] With its white fabric-covered walls, yellow mouldings and borders, yellow tiled mantelpiece, yellow furniture, yellow vases, yellow and white roses, yellow matting on the floor; a page dressed in yellow and white livery; an invitation with Whistler's yellow butterfly insignia; the catalogue, *Etchings & Drypoints: Venice: Second Series*, subtitled *Mr. Whistler and his Critics*; hanging in a room by itself, the notorious painting 'Nocturne in Black and Gold: The Falling Rocket' (no.58); and even a photograph of Whistler showing his famous white forelock (fig.17) that, one writer observed, 'attracts, perhaps, as much attention as the prints',[60] altogether, the exhibition gave a concrete, up-to-date experience of the full dimension of Whistler's achievement. Americans found it eccentric, and it confirmed what they had heard of Whistler's aggressive self-promotion; but on the whole they received it seriously and respectfully.

The *Arrangement in Yellow and White* exhibition also caused a flurry of imitation. 'We have a whole tribe of Americans singing a refrain to Mr. Whistler's song', a critic said of works in black and white shown at the Salmagundi Club in New York in 1884.[61] Another asked testily of a painting called 'A White Study' in the exhibition of the American Watercolor Society the same year, 'why these Whistlerish affectations of title?'[62] It also, apparently, influenced exhibition design. At the Society of American Artists exhibition in 1884 a writer noted the 'room to spare between and above the frames',[63] so very different from the customary crowding of pictures in nineteenth-century installations. Another put the dominant influence of William Merritt Chase's contribution to that exhibition, which included its Whistler-inspired hanging, as 'a symphony in the key of – Chase'.[64]

The second event was Whistler's 'Ten O'Clock' lecture. Delivered first on 20 February 1885, in Prince's Hall, London, it was widely reported in the American press (fig.18). What the *Arrangement in Yellow and White* exhibition did for Whistler in America as an etcher, painter, decorator, typographer, and (through his photograph) dandy, so the 'Ten O'Clock' lecture did to enhance public perception of his thought and his wit more fully by far than anything before. As importantly, it gave Americans reason to expect a more bodily substantiation. In 1886, a series of newspaper notices announced Whistler's visit to America, under the management of D'Oyly Carte, to deliver the 'Ten O'Clock' lecture in a number of American cities, on the pattern of recent lecture tours by English celebrities such as the critic Matthew Arnold, the etcher Francis Seymour Haden (Whistler's despised brother-in-law), and the notorious Oscar Wilde (as Whistler would have it, his despised plagiarist). The visit was first announced in January. By February it had been postponed. By June a time in the autumn was hinted at. In September it was 'definitely settled' that he would come, probably in November. Whistler himself said, in a letter printed in the *New York Tribune* on 12 October, 'that December has been fixed upon by the fates for my arrival in New York'. 'This is no time for

hesitation', he wrote, adding, 'One cannot continually disappoint a continent'.[65]

He never went to America, then or later. In his *Tribune* letter he suggested three reasons for his hesitation. One was the poor reception of earlier lecture tours by Englishmen (Matthew Arnold, Whistler wrote, 'whispered truth exquisite, unheeded in the haste of America'.) Another was the hostility of the American press ('in the papers, where naturally I read only of myself, I gather a general impression of offensive aggressiveness'.) And a third was the 'wicked' image of him given by William Merritt Chase's as yet unexhibited portrait (fig.19) painted in London in the summer of 1885, which, depicting him as a mincing fop, was a 'monstrous lampoon' that, he feared, 'prepared me for the tomahawk on landing'. Though he did not say it, it may have cast him too much in the mould of Oscar Wilde (in 1884, the *Philadelphia Press* said that Whistler 'has been regarded by people who knew nothing of him and who took their cue from the English press as a sort of eccentric young idiot, such as Oscar Wilde pretended to be').[66]

No one really knows why Whistler never returned to America. Perhaps he feared competing with Haden and Wilde. He felt generally neglected and misunderstood in America, and, almost obsessively, ill-treated by the American press ('The American papers … make it their pleasure and their duty I suppose, to be as grossly impertinent, abusive and disloyal to me as possible').[67] He objected to American duties on imported pictures, and protested against them by his absence[68]; and as he got older it simply became more difficult for him to travel.

But also, by about 1880, when he began seriously to entertain the notion of a visit, America had become a very different country to the one that he remembered, an unfamiliar and somewhat forbidding place. He spoke of its 'vast far-offness',[69] and to his friend the American sculptor Frederick MacMonnies he implied that the prospect of an encounter with America after years of absence would be an unpleasantness he would have to 'face'.[70] When asked what his attitude to America was, he replied, expressing a sense of its inconceivable vastness, 'how can a man have an attitude toward a continent'.[71] He once said that if he came to America he would go to Baltimore and to West Point and then return to England, in other words going only to those places for which he had the greatest attachment and associations of stability, as though in that way to keep the strangeness at bay.[72]

He also said that America was 'a country where I could never be a prophet',[73] by which he meant that, like many prophets, he was accorded no honour in his own land. Moreover, the kind of 'prophecy' he delivered so unrelentingly in England did not serve the same need, or have the same effect, in America. The American mind was not closed, Whistler said, implying that the English mind was.[74] A writer in the *Boston Transcript* in 1889 agreed: 'The Whistlerian theory of art is not new, nor do we believe it necessary for him to set it forth in this country. It is easy to see he has lived in England, where his doctrine may need argument and satire for its support. Good wine needs no bush; we are willing here to judge him by his pictures, without discussing theories.'[75] A writer in the *Critic*, speaking of the other form of Whistler's 'prophecy,' his paintings, commented: 'it is pleasant to

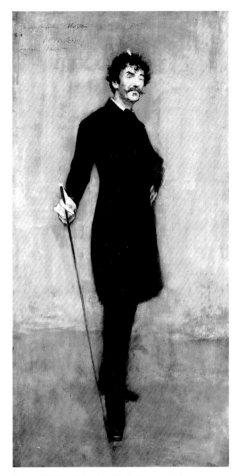

fig.19 William Merritt Chase 'James Abbott McNeill Whistler' 1885 Oil on canvas
The Metropolitan Museum of Art, New York. Bequest of William H. Walker, 1918

find [Whistler] exhibiting with his countrymen this year [in the Columbian Exposition in 1893], for his work is not antagonistic to theirs as it is to the English'.[76]

In any event, it became unnecessary for Whistler to come to America, for by the late 1880s Americans, in steadily increasing numbers, came to him. They came to admire, to adore, to study, and, most importantly, to buy, with the result that if Whistler never returned physically to America, he certainly returned artistically. By far the largest number of his collectors were Americans, and by far the largest number of his pictures went to America, most of them during his lifetime. This was partly because of Whistler's campaign to divest England of his paintings, prompted by his anger at the sale of his pictures by English owners profiting from his growing fame and increasing value.

By the early 1890s Americans flocked to buy Whistler's work, all moral and aesthetic reservations and uncertainties behind them: the publication of *The Gentle Art of Making Enemies* in 1890 had added to their knowledge of Whistler, his importance as an artist had been confirmed by the acquisition of the portrait of his mother by the French government in 1891, and there was a major representation of his work at the Columbian Exposition in Chicago in 1893.

They commissioned portraits by him. Alexander J. Cassatt of Philadelphia (the brother of the painter Mary Cassatt, who reported that John Singer Sargent told their mother 'it is a good thing to have a portrait by Whistler in the family'[77]) commissioned one of his wife Lois, begun in 1883 (no.128); Edward W. Hooper of Boston, of his daughter Ellen Sturgis Hooper, in 1890 (private collection; YMSM 391); Arthur J. Eddy of Chicago, of himself, begun in 1893 (Art Institute of Chicago; YMSM 425); Thomas Kinsella, of his daughter Louise, in 1894 (Terra Museum of American Art; YMSM 420); George W. Vanderbilt, of himself, begun in 1897 (no.199), and of his wife, commissioned in 1898 (private collection; YMSM 515); Richard A. Canfield of New York, of himself, commissioned in 1901 (no.202); and about a dozen others besides. Other important American collectors of Whistler were Mr and Mrs John Lowell Gardner of Boston (see no.41), John G. Johnson of Philadelphia (see nos.22, 50, 130), Mrs Potter Palmer of Chicago, A.A. Pope of Cleveland (see no.35), Samuel Untermeyer of New York (who in 1892 bought 'Nocturne in Black and Gold: The Falling Rocket', no.58), and by far the greatest collector of them all, Charles Lang Freer of Detroit.

Freer acquired about forty of Whistler's paintings, as well as hundreds of watercolours, drawings and prints for what became, as Whistler hoped it would and as he put it, *the* collection of his art.[78] Samuel P. Avery and Howard Mansfield of New York and James Claghorn of Philadelphia were major collectors of Whistler's prints (see nos.1–13).

In an act of public patronage, Whistler was offered a place in one of the great decorative projects in late nineteenth-century America, a mural in the new Boston Public Library on Copley Square, designed by the architects McKim, Mead, and White. Two of Whistler's expatriate American friends, Sargent and Abbey, each completed elaborate mural schemes for the library, but Whistler went no further with his than an oil sketch on the subject of the landing of Columbus (Boston

Public Library; YMSM 396). The panel assigned to him in the Library's main reading room, Bates Hall, remains eloquently empty.[79]

By about 1880 Whistler's influence in America was pervasive. In very different ways, two cases may represent the force, sometimes insidious in its effect, of Whistler's influence upon American artists. Among those who unabashedly idolised Whistler were the American photographers who gathered around Alfred Stieglitz at the turn of the century. Anxious to legitimise photography as high art instead of an amateur pastime, Gertrude Käsebier, Clarence White, F. Holland Day, Alfred Langdon Coburn, Edouard Steichen, and even Steiglitz himself, frankly imitated Whistler in subject and style. In *Camera Notes* and later in *Camera Work*, in which Stieglitz as editor relentlessly argued the cause of progressive pictorial photography, no artist was invoked more than Whistler. He was for them the principal model of advanced pictorial art, and from him their blurry photographic pictorialism chiefly derived (figs.20, 21). As the photographer Paul Strand said of his pictorial period, he 'Whistlered with a soft-focus lens'.[80] And in the 'Ten O'Clock' lecture they found a theory of non-representational art that justified their own photographic purposes.[81] They affiliated themselves with Whistler's style and theory with an openness that was at once naive and, in its blatancy, had the function and the force of a modernist manifesto.

It was altogether another matter for the painter Thomas Eakins. Eakins was a fierce moralist. When he spoke of 'big' artists, when he said Rubens was vulgar and nasty and Velázquez strong and reasonable, and when he termed '"cowardly" those paintings that left much to the imagination',[82] he was not speaking of aesthetic values but of the almost heroic morality of great art, and of the severe artistic probity to which he held himself. It was by that stern moral standard that he judged Whistler's art: 'it is a very cowardly way to paint', he said.[83] But Eakins, like many moralists, could not resist temptation. In 1904 he painted 'Music' (fig.22) in which he included Whistler's portrait of the violin virtuoso Sarasate (which had been acquired by the Carnegie Institute, Pittsburgh, in 1896; YMSM 315).[84] Eakins's other depictions of instrumental musicians, called 'The Oboe Player', 'The 'Cello Player', and 'The Violinist', refer to their performance. 'Music' refers to a condition, that abstract condition with which, as everyone knew, Whistler associated the art of painting, and, at the same time, to Whistler's practice of making that association by musical titles. With characteristic literalness and reserve, 'Music' is Eakins' essay in – or version of – Whistlerism. Painted as it was the year after Whistler's death and surely prompted by it, 'Music' may also be Eakins's homage to him. If so, it was an honour that Eakins paid no other artist, even those he more openly admired.

In 1915, Whistler's acquaintance and younger contemporary, Henry James, an expatriate American of the same artistic stature and pan-nationality as Whistler, renounced his American citizenship. Whistler never did. The artist, Whistler said in the 'Ten O'Clock', 'is born to pick and choose', and in the essentially artistic project of his own self-creation that engaged Whistler for his entire life, he chose to die an American.

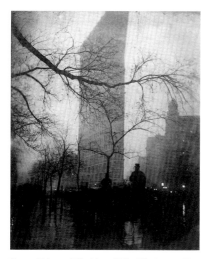

fig.20 Edouard Steichen 'The Flatiron – Evening' Greenish-blue pigment gum-bichromate over gelatine silver, 1909 print from 1904 negative *The Metropolitan Museum of Art, New York, The Alfred Steiglitz Collection, 1933*

fig.21 Gertrude Kasebier 'Mother and Child' (Mrs Ward and Baby) c.1903 Gum bichromate print *Library of Congress, Prints and Photographs Division*

fig.22 Thomas Eakins 'Music' 1904 Oil on canvas *Albright-Knox Art Gallery; George Cary, Edmund Hayes, and James G. Forsyth Funds, 1955*

Whistler and France

GENEVIÈVE LACAMBRE

Whistler, Wistler, Wisler, Whister, Wisthler, Whisthler, even Whisten (N.), and
finally Elstir – such were the various written forms used in France for this Ameri-
can artist who pursued part of his career in Paris and made many friendships
there. 'Whisten (N.)' appeared in the catalogue of the 1888 Salon des artistes
français as the artist responsible for two frames of etchings (nos.5518–9), which
went unnoticed except by the anonymous columnist of *La Revue Indépendante*,[1] and
'Elstir', of course, was the near-anagram of his name invented by Proust in *A la
recherche du temps perdu* for the artist who shared some of Whistler's characteristics.

Whistler, according to Stéphane Mallarmé, was 'A rare Gentleman, a prince',
an expression taken up by Charles Morice in an article in the *Mercure de France*[2] in
June 1904, the year after Whistler's death. Morice concluded: 'Is he not, such as
he is, the modernist *par excellence*, this artist so unaffected by the beating of his
heart, this powerful, exquisite man, elegant to the point of diabolical flamboy-
ance, subtle to the point of imponderability, such as he is revealed in his great
works and such – can I be wrong? – as the very syllables of his several names
foreshadow? *James Mac Neil* [*sic*] – therein lie the impertinent gestures, the sarcastic
tone, the pride and scorn verging on brusqueness – and all the ethereal genius of
the soul lies in the sweet-sounding surname, in the two emanations of breath of
which this name of feather and silk are composed: *Whis-ler* [*sic*], in which you
surely must sense, opening and closing, palpitating, the two painted wings of the
butterfly – his signature.'[3]

Both the man – whose name was so difficult for a French speaker to pro-
nounce and so evocative – and his work were well known in France at the time,
and it was in French in 1904 that the first monograph on him was published.
L'Histoire de J. Mc N. Whistler et de son oeuvre was written by Théodore Duret, a cham-
pion of Manet and the Impressionists, an acknowledged expert on Japanese art
and, in 1883, one of Whistler's models (no.127). Reissued in 1914 and translated
into English in 1917, this book was finally overshadowed by the official biography
by Elizabeth and Joseph Pennell, which went into many editions between 1908
and 1920. Its index includes a good hundred French personalities: Courbet,
Fantin-Latour, Rodin, and many others.

Whistler's cosmopolitan childhood, and the knowledge of French he acquired
in Russia, which was noticed by his classmates at West Point where he was a

cadet between 1851 and 1854, must have facilitated his entry into the art world in Paris where he arrived in 1855, hoping to live *la vie de Bohème*, like one of Henri Murger's heroes (fig.23).

Whistler began his career as an etcher. There is nothing surprising about this, as he reached Paris in the midst of a revival of that medium, at a time when departments of etchings and lithographs by living artists were being opened in the galleries of the Musée du Luxembourg. The idea was mooted at the beginning of the Second Republic, but only put into practice in 1852. The department expanded, but was discontinued in 1857. At the time of Whistler's arrival in Paris, however, the Luxembourg contained lithographs by Delacroix, Devéria and Gavarni, and etchings by Daubigny, Decamps and Martinet, among others. Achille-Louis Martinet also owned a gallery in the boulevard des Italiens, where he encouraged the activities of the Société nationale des beaux-arts which warmly welcomed Whistler and his friends in 1861, 1862 and 1863, and which put on the posthumous exhibition of the *Oeuvres d'Eugène Delacroix* in 1864.

Even so, the Salon – then held biennially – had not lost its prestige, and to have one's work accepted there, not only etchings but more ambitious works, such as paintings, was the dream of every artist arriving to try his luck in Paris.

From this point of view, the refusal of 'At the Piano' (no.11) by the 1859 Salon was a setback, even though, like Fantin-Latour (whom he had got to know a few months earlier), Legros and Ribot, Whistler was able to hang his painting in François Bonvin's 'Flemish' atelier, 189 rue Saint-Jacques, where it was noticed by Courbet.

Whistler was gradually acquiring a circle of friends. Although he was too late to submit his new etchings to the jury of the 1861 Salon,[4] in January 1862 Martinet exhibited the 'Thames Set'. This series had been prepared in London but printed in Paris by Auguste Delâtre, whose remarkable skill played a significant part in the development of original etching and of the Société des aquafortistes which was founded at the time. As early as April 1862, Baudelaire remarked: 'Decidedly, etching is becoming fashionable', and added: 'Quite recently, at the Galerie Martinet, a young American artist, M. Whistler, was showing a series of extremely subtle etchings, of lively improvisation and inspiration, representing the banks of the Thames'.[5] In the following year, when Nadar was leaving for London to publicise his ballooning experiences, Baudelaire recommended him to Whistler, to whom he wrote: 'Give my regards to Legros and don't forget to show Nadar your marvellous etchings'.[6]

Even when he had settled in London – although he still made frequent visits to France – Whistler did all he could to keep up his contacts with the country. He served as an intermediary for Dante Gabriel Rossetti and Swinburne. He made every effort to ensure that his pact with Legros (who was now living in London) and Fantin-Latour, who called themselves the Société des Trois, would help each of them to become known and to find patrons on both sides of the Channel. He played a vital part in advancing Fantin's career by encouraging him to paint the flower pictures that were so highly prized by the London Greeks.

fig.23 Whistler 'Fantin au lit' 1859 Chalk and pencil *Musée de Louvre / Fonds de Musée d'Orsay, Paris*

But this circle of friends, which included Bracquemond, and soon Manet, did not achieve any real fame in the Paris of the Second Empire. Ironically, it was the rejection of Whistler's submission to the 1863 Salon that brought him fame. In 1882, Henry Houssaye in the *Revue des Deux Mondes* remembered that it was with 'The White Girl' (no.14) that Whistler had 'achieved celebrity in Paris'.[7] Ernest Chesneau at the time of the 1867 Universal Exposition, recalled that 'this rejection made M. Whistler famous overnight',[8] and congratulated himself on having at the time described the work as 'absolutely remarkable',[9] despite its strangeness.

His correspondence with Fantin-Latour shows that Whistler, from London, was daily following the development of the situation. He dismissed the solution of exhibiting with Martinet when he heard that Napoleon III had announced the creation of a rival Salon des Refusés, which was to open on 15 May 1863 in the Palais de l'industrie, alongside the official Salon.

The influence of the Académie des Beaux-Arts on the Salon jury was so absolute that it was giving rise to an increasing number of hostile reactions. Artists such as Courbet, who had been awarded Second Republic medals, had an automatic right to exhibit, but the generations who had not benefited in this way too often found themselves excluded from the Salon.

After the State took over the Salon – and from 1864 made it once again an annual event – the Salon des Refusés became a reminder of all that was unsatisfactory with the Institute, whose power diminished when elected members were added to the juries of the following years. Nevertheless, the artists who agreed to exhibit in the auxiliary Salon risked attracting the attention of those who came to scoff, of which there was no shortage. Ludovic Halévy, for instance, wrote in his notebooks of 'the comic, indecent horrors; a certain Dame blanche'.[10]

It was under the title of 'Dame blanche' (changed to 'La Fille blanche' at the 1867 Universal Exposition) that the now famous 'The White Girl' was exhibited. The hero of Duranty's *La Simple Vie de Louis Martin* (1877) praised the 'Dame blanche' when he visited the Salon des Refusés, and Emile Zola remembered her in 1886 in *L'Oeuvre* when he recalled 'the especial gaiety' that reigned in that exhibition where the picture rails were covered in green serge 'around the *Dame en blanc*, a very curious vision from the eye of a great artist'.[11]

Castagnary, the theorist of naturalism, devoted an entire page to the picture in his review of the 1863 Salon. He had no hesitation in seeing in it 'the bride on the morning after', a kind of more serene version of Jean Baptiste Greuze's '*The Broken Pitcher*', although he admitted that 'no one else agreed with my interpretation'.[12]

Having tested the importance of Paris in his bid for recognition, Whistler continued to exhibit at the Paris Salon – or to try to exhibit there, for in 1864, once again his work arrived too late. He was regularly represented almost every year until his death – and even afterwards in 1904 – except during the period between 1868 and 1881, when his work was only seen in Paris twice: in 1873, at the Durand-Ruel gallery, and then, with E.W. Godwin, in a somewhat marginal fashion, at the 1878 Universal Exposition. Like many other artists of his generation, headed by Manet, he refused to participate in the first exhibition of the Impres-

sionists (1874) – and also in subsequent ones – despite a plea from Degas. In 1874 he opted instead for a one-man show in London, thus following the great examples of Courbet and Manet, the efficacity of whose shows he had been able to appreciate in 1867 in Paris, where they were peripheral to the Universal Exposition.

After his return to the Paris scene in 1882 – and it should be noted that from 1881 he was given ever-increasing coverage in the columns of the art journals – he remained faithful to the Parisian habits of his early years. His participation in the Salon did not prevent him from showing in smaller group exhibitions with Georges Petit or Durand-Ruel, or in print exhibitions such as the *Centenaire de la lithographie 1795–1895*, to which he sent six items in 1895, and the *Exposition générale de la lithographie* at the Ecole des Beaux-Arts in 1891,[13] thanks to a loan of three sheets from the Beurdeley collection. In the latter case, he probably did not have to become personally involved.

It seems that he was anxious not to compromise his chances with the Salon, and it was the only place he exhibited in 1882, the second year of the new system when, after the State had pulled out, it was being run by the Société des artistes français. He remained loyal to it until 1890, and only participated in the secessionist Salon of the Société nationale des beaux-arts when Puvis de Chavannes became its president in 1891, a year after it was founded. Both men were former members of Martinet's ephemeral Société nationale des beaux-arts under the Second Empire.

But let us return to Whistler's early years and to his personal and aesthetic relations with the French artists of his time. The most striking evidence of this is to be found in Fantin-Latour's great painting 'Homage to Delacroix' (fig.24), which was exhibited in the 1864 Salon. Delacroix had died on 13 August 1863, and had not received any official homage. Fantin, who had attended his funeral with Manet (the other celebrity of the Salon des Refusés with his 'Le Bain' or 'Le Dejeuner sur l'herbe' (Musée d'Orsay)), and a few others, including Baudelaire, Champfleury and Castagnary, conceived the idea of paying tribute to the dead artist in the form of a painting. By 11 September 1863, Fantin was already planning to include Whistler and Legros, and they do in fact appear with him, just to the left of the portrait of Delacroix. This, then, provided an occasion to keep the members of the Société des Trois together. At the extreme left is Duranty, who defined the picture as 'some controversial artists paying homage to the memory of one of the great controversial artists of our time'.[14] On the right, the main figures are Champfleury and Baudelaire sitting in front of Manet and Bracquemond. This was a manifesto in favour of the young school which, supported by the writers, represented the future of art. Polemics were given full rein, but people remembered Whistler and his 'Dame blanche', and Fantin-Latour was already famous. Nevertheless, Fantin felt that he had been misunderstood, and decided to develop his theme in other compositions of the same kind. The actual result was just one new painting, 'Le Toast! (Hommage à la Vérité)'. Both Whistler and Manet were given a special place in it. It was finished in time for the 1865 Salon,

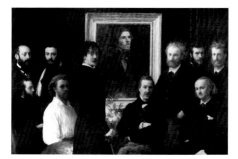

fig.24 Henri Fantin-Latour 'Homage to Delacroix' 1864 *Musée d'Orsay, Paris*

where it was not well received. Soon only two fragments remained, the portraits of Vollon (Musée d'Orsay) and Whistler (Freer Gallery of Art, Washington, DC). Whistler had posed in a kimono, the symbol of his passion for all things Japanese, which he indulged, during his visits to Paris, at the curiosity shop run by a couple named Desoye at 220 rue de Rivoli. Later, when Whistler was again living in London, there was no reason for him to be represented in Fantin-Latour's 'Atelier aux Batignolles' (Musée d'Orsay), which was shown in the 1870 Salon.[15]

By this time, the Société des Trois had broken up. Legros had left it in 1865, and Fantin was no longer in a position to follow his friend's artistic development, finally showing stubborn incomprehension of Whistler's work in the 1873 exhibition at the Durand-Ruel gallery in Paris.[16] But Fantin was not the only artist whose search for new outlets had been facilitated by Whistler's presence in London. Manet had visited London in 1868[17] with this in mind, as had Degas in the autumn of 1871 at an even more favourable moment, in that the dramatic events of the Franco–Prussian War of 1870–1 had forced a good many Parisians into temporary exile there. Paul Durand-Ruel arrived in January 1871 and found Daubigny, Monet and Pissarro, and it was in London that the decisive encounter took place between the dealer and these young artists, many of whose works he began to buy and exhibit. His Bond Street gallery, which was managed by Charles Deschamps, gave space to the Society of French Artists and welcomed not only Manet, Monet, Degas, Pissarro and Renoir, but also Whistler.

All these artists, greatly influenced by Courbet when they started out, had found their own personal style and yet still retained some common features. To give just one example: it will be remembered that Whistler's variations in white belong to the great French tradition, and that his painting in the Salon des Refusés comes after Manet's 'La Maitresse de Baudelaire couchée' and before the same artist's 'Lecture' and Renoir's 'Lise', not forgetting Degas's copy of a sketch, given him by Fantin in August 1865, of what was later to become Whistler's 'Symphony in White, No.3' (no.16).[18]

Whistler was working alongside Courbet in Trouville in the autumn of 1865, but in a letter to Fantin in 1867 he made it quite clear — with some justification — that he was distancing himself from Courbet. His fluid style, in the Trouville seascapes, is very different from Courbet's realism, which is characterised by concentration on the physical qualities of the paint he used. The works Whistler later painted in Valparaiso, and afterwards on the banks of the Thames (nos.45–7), only accentuated the gap between them, and this was further increased by a subtle Japanese touch in Whistler's work, reminiscent of the horizontal shading in the landscape prints of Hiroshige and his contemporaries. Around 1869, Degas painted a series of pastel seascapes inspired by the Normandy coasts, and the allusive aspect of the delicately coloured areas of these seascapes indicated a similar approach (fig.25). A little later, Degas wrote to Henri Rouart from Louisiana that Whistler 'has really struck a chord in his demonstration of the mysterious fusion of the earth and the water'.[19]

fig.25 Edgar Degas 'Seascape' 1869 Pastel
Musée d'Orsay, Paris

It is perfectly possible that there is some relation between the works shown by Whistler at Durand-Ruel's rue Laffitte gallery in January 1873 and the mauve and orange pictures Monet painted in Le Havre later that year: 'Morning Sunrise',[20] which was knocked down to Henri Rouart on 24 March 1875 for the modest sum of seventy-five francs, and his famous 'Impression: Sunrise' (fig.26). It was the latter that gave rise to the name of Impressionism; it was coined by a jeering journalist when Monet and his friends held their first group exhibition at Nadar's gallery in 1874. The least one can say is that both Whistler's and Monet's landscapes were misunderstood and unappreciated.

But while the first Impressionist exhibition did at least provoke many comments in 1874, the same cannot be said for Whistler's Durand-Ruel exhibition in 1873. Whistler kept a few press-cuttings which tell us that it contained 'views of the banks of the Thames during a fog or at nightfall. Everything is strictly monochrome, either greenish-blue or pale yellow'.[21] We also learn that this exhibition contained his 'Arrangement in Grey: Portrait of the Painter' (now in Detroit; YMSM 122), and 'The Balcony' (now in the Freer Gallery of Art, Washington, DC; see no.24). But an article by Ernest Chesneau in the *Musée Universal*[22] listed the titles of the seven paintings exhibited side by side with some 'charming drawings'. Chesneau, a former champion of Whistler, was terribly disappointed:

> 'If something drastic does not occur to jolt the artist out of his morbid, self-indulgent reveries, he will be lost to art... M. Whistler is showing seven frames. He wanted M. Durand-Ruel to put a label over each of them showing the titles he had given them. M. Durand-Ruel was reluctant to do so. Why? The answer lies in the titles themselves. They are:
> 1. Harmony in Flesh Colour and Grey
> 2. Variations in Flesh Colour and Green
> 3. Nocturne in Blue-Green
> 4. Nocturne in Blue-Silver
> 5. Harmony in Grey
> 6. and 7. Arrangements in Grey and Black.[23]

No.2 is 'The Balcony' (or its sketch (no.24), for Chesneau speaks of 'women with two heads, real fairground freaks', which refers more particularly to the sketch, but on the other hand he says that in the 'little Japanese Women on the Balcony (variations in flesh colour and green)... there is a distant reminder of Whistler's former gifts as a colourist'). No.6 and 7 are is the self-portrait (YMSM 122) which Chesneau describes as 'the portrait of the artist, one of whose hands – a skeletal hand – appears at the bottom of the painting although it is impossible to tell which of his two arms it is attached to', and is presumably the 'Portrait of the Painter's Mother' (no.60). It is not easy to identify the other pictures with any certainty; they are probably landscapes.

A letter written by Whistler to George A. Lucas on 18 January 1873[24] shows the importance he attached to this exhibition – both for the frames, which he designed to harmonise with the works, and for the titles he gave them – and that

fig.26 Claude Monet 'Impression: Sunrise' 1874
Oil on canvas *Musée Marmottan, Paris*

he hoped that it would provide a striking illustration of his research into colour and of his theory of art. Landscapes (the Harmonies and the Nocturnes) alternated with figure paintings, and one of the two 'Arrangements in Grey and Black' was very certainly the 'Portrait of the Painter's Mother (no.60). We may find it surprising that there was no specific mention of the presence of this great work, which had been shown at the Royal Academy a few months earlier. Among Chesneau's remarks, the term 'funereal'[25] might have applied to it.

In 1876, at the time of the second Impressionist exhibition, which was held at Durand-Ruel's gallery, Edmond Duranty mentioned the same exhibition: 'Three years ago, in these same Durand-Ruel galleries, another artist, an American, exhibited some surprising portraits and variations of infinite delicacy in crepuscular, diffused, vaporous shades which are neither day nor night'.[26]

Even though Fantin had not been won over, and Chesneau had been severe, it is possible that artists like Monet – or Manet, when for instance he was painting 'Bateaux en mer, soleil couchant' (Musée du Havre)[27] – took a more positive opinion, and realised that Whistler had discovered a new way of seeing. Otto Scholderer, a confidant of Fantin at this key period, was totally enthusiastic – on 26 November 1872 he wrote to him from London: 'I like Whistler's landscapes more than I used to, and also his portrait that he calls *Harmony in Black and Grey*, it is very delicate, and has a magnificent background'.[28] He must have been referring to the 'Portrait of the Painter's Mother', as the reference to the 'magnificent background' cannot be applied to the 'Self-Portrait'.

This exhibition was, to say the least, a commercial failure, which may well explain why Whistler waited nine years – and for a different artistic climate – before he once again sent his works to Paris.

It was through Manet that Duret made Whistler's acquaintance at the end of 1880. To encourage Whistler to return to the Paris scene Duret informed the readers of the *Gazette des Beaux-Arts* on 1 April 1881 of Whistler's most recent activities in London and of his libel action against Ruskin, which from then on took its place beside the 'Dame blanche' in the imagination of the French. But the link with his artist friends had already been re-established: as early as 20 December 1880 Whistler had asked Duret to make sure that Pissarro's etchings were sent to London.[29] In reply to a question about Ruskin from his niece Esther on 20 March 1882, Pissarro confirmed his admiration for Whistler: 'all I know is that he has a very poor opinion of Whistler's works, which is serious, very serious, because this American artist is a great artist, and the only one of whom America can be justly proud'.[30]

From the 1882 Salon onwards, Whistler's painting was to shatter all preconceived ideas of art. From white he turned to black. The portrait of Valerie Meux surprised many people. In the very serious *Revue des Deux Mondes* of 15 June 1882, Henry Houssaye wondered: 'Why, instead of an Englishwoman, did M. Whistler not use some negress from the Congo as a model?' to make a thorough job of his 'symphony in black'? Paul Leroi, in *L'Art*, observed that it was a deserved failure, since the 'very eminent etcher Whistler' indulges 'exclusively in the cult of the

approximate and the pure smudge', thus reducing the painting to a 'dirty-looking, blackish smudge'.[31]

The reviews remained lukewarm until 1883, when Whistler sent the 'Portrait of the Painter's Mother' (no.60) to the Salon, which earned him the timid recognition of his peers with a third-class medal (which can be compared with the second-class medal awarded to Manet in 1881). Some writers commented that the work had gone unnoticed. Others, such as Guillaume Dubufe and Roger Ballu, in a dialogue in the *Nouvelle Revue*, while appreciating the golden patina of this painting, which was already some twelve years old, made the slightly disillusioned observation that 'the Impressionists adore that'[32] – and so they did!

His respect for the institution led Whistler to content himself with naming the model, rather than giving the work a title that merely alluded to the colours used. He did the same in the following years, and it was not until the 1886 Salon that the catalogue printed: 'Arrangement en noir' (no.9); – 'Portrait du Señor Pablo de Sarasate' (Carnegie Institute, Pittsburgh, YMSM 315). Octave Mirbeau protested vehemently that it had been hung in a bad place, and he went into detail about 'the complicated gymnastics' necessary in order to avoid reflections … and to discover 'one of the three most beautiful works in the Salon'[33] (the others being by Fantin and Puvis de Chavannes).

Whistler felt more free in small shows, such as Georges Petit's 1883 *Exposition internationale de peinture*, to which he sent Arrangements, Harmonies and Nocturnes, which French critics still described as a strange fantasy. Although appreciated by, among others, Degas, Pissarro, Rodin and Octave Mirbeau, Whistler still, in 1884, aroused, 'general indifference'. Huysmans tried to analyse Whistler's lack of success, and attributed it to the fact that he didn't use bright colours or complementary tones.[34]

At the time of Georges Petit's 1887 *Exposition internationale de peinture et de sculpture*, in which Whistler exhibited etchings and small paintings alongside works by Renoir, Sisley, Caillebotte, Boudin and a few others, Dargenty wrote peremptorily in the *Courrier de l'Art*: 'If the works shown by M. Pissaro [*sic*] are bad, those of M. Renoir are distressing … The fifty notes by M. Wistler [*sic*] are adorned with the most attractive titles in the world. *Nocturne en gris et or, Rose et nacre*, etc: it is only the titles that are disturbing'.[35] Only Sisley and Rodin found favour in his eyes. At the same moment, Huysmans was writing enthusiastically: 'The landscapes and portraits of that extra-lucid artist M. Wisthler [*sic*] have always reminded me of some of Verlaine's vague, cautiously tender poems'.[36] At the 1889 Universal Exposition Whistler was awarded a gold medal and made a Chevalier of the Legion of Honour, but 'Variations in Flesh Colour and Green: The Balcony' (see no.24), which earned him this medal, was an old work, dating back to 1865. It was as if it took a generation to learn how to see Whistler's works.

This was the time it took before the Musée du Luxembourg decided, in 1891, to buy the 'Portrait of the Painter's Mother' for a knock-down price, shortly after it had acquired Manet's 'Olympia'. For Whistler, who had once again moved to Paris in 1892, it seemed that this gave him a chance of realising his hopes of one

fig.27 Eugène Carrière 'Nelly Carrière'
Musée d'Orsay, Paris

day being hung in the Louvre, and that it was worth his while to make financial concessions. And when a department of foreign paintings was being set up in the Luxembourg, he claimed his place in the French school. Léonce Bénédite, the curator of the Luxembourg and the *rapporteur* for the Fine Arts at the 1900 Universal Exposition, was delighted to recall that: 'When the celebrated portrait of his mother was given a place in the Luxembourg, Whistler himself protested at the classification which included it among the foreign artists. So we did not fail to group him with our school, in the midst of the realists surrounding Courbet such as Fantin-Latour and Legros, with whom, if we examine his early works carefully, he had closer affinities than may be thought'. 'A singular harmonist', 'a brilliant abbreviator', 'a musician' – for Bénédite it was a great mistake 'to enrol him among the Impressionists'[37]; in his opinion he could only be compared with Degas. Such was the official French truth, which limited Whistler's art to his early works. This was to ignore the fascination he exercised, both as a person and by his works, over young artists like Jacques-Emile Blanche or Paul Helleu, to ignore his friendship with Mallarmé which began in 1888, and his profound affinities with Eugène Carrière in his figure paintings (fig.27) or Bonnard in his small urban landscapes.[38]

When Whistler became a visiting professor at the Académie Carmen,[39] which had been opened in October 1898 by a former model, Carmen Rossi, at 6 Passage Stanislas, his main contribution during its brief life (it closed in 1901) was to send messages about art to be read to the students, but his indirect influence had been felt much earlier. In 1891, in *La Plume*, Edouard Rod wrote of him: 'It was he, I think, who taught our young artists to seek rare and delicate effects in uniformity of tone'.[40] Nevertheless, in 1904 Charles Morice, who had met Whistler at Mallarmé's house, felt justified, in the midst of the chorus of praise that followed Whistler's death, in pointing out the danger that lay in following him on the path of 'virtuosity',[41] as an artist like Albert Besnard had done. People too often imitate merely the superficial aspects of Whistler's work. He alone, 'by dint of seeking the real ... managed to find the essence', and the phrase 'To Symbolism by way of Realism'[42] was appropriate to him, as it was to Carrière and Rodin.

Revered by the aesthetes – did not Comte Robert de Montesquiou pose for him? – and finally officially recognised in France – the sale of the 'Portrait of the Painter's Mother' brought him promotion to the rank of Officer of the Legion of Honour, and the 1900 Universal Exposition awarded him two *grands prix* for painting and etching – Whistler tirelessly continued to build up an international network for the dispersal of his works of art. In 1898 he was made president of the brand-new International Society of Sculptors, Painters and Gravers which had been founded by some of his English admirers, and he was surely in some way responsible for the presence of works by Cézanne, Degas, Monet, Renoir, Redon, Bonnard and Vuillard in their first exhibition in London during the summer of 1898. He remained president until his death, when he was replaced by his old friend Rodin.[43]

Very naturally, the committee set up in 1905 – the year of the commemorative

exhibitions in London and Paris – for the erection of a monument to Whistler in London, agreed that the commission should be given to Rodin. A victory, symbolising the triumph of Whistler, the triumph of art over its enemies, was never realised in either marble or bronze. The colossal figure of the Muse climbing the mountain of Fame, for which the model was Gwen John, a student of Whistler's at the Académie Carmen in 1898, was still unfinished when Rodin died in 1917 (fig.28). The project was definitely abandoned in 1918.[44] Yet it would have been a perfect illustration of this extract from Whistler's 'Ten O'Clock' lecture (which Mallarmé had translated into French):

> Through [the artist's] brain … is distilled the refined essence of that thought which began with the Gods … Set apart by them to complete their works, he produces that wondrous thing called the masterpiece, which surpasses in perfection all that they have contrived in what is called Nature.[45]

Translated by Barbara Wright

fig.28 Auguste Rodin 'The Muse: Monument to Whistler' 1908 Plaster *Musée d'Orsay (dépot du Musée Rodin), Paris*

Whistler for President!

MARGARET F. MACDONALD

When Whistler first exhibited at the Royal Academy in 1860, he could have expected to rise through the Academic ranks. By 1872, when he exhibited there for the last time, it was clear this was not to be. Instead he exhibited with various exhibiting societies and in dealers' small exhibitions, and in 1874 held his first one-man exhibition, where he had more control over the presentation of his work.

A wide need for an alternative venue to the Royal Academy led to the establishment of the Grosvenor Gallery in 1877. Whistler exhibited there until Ruskin's disastrous review of his work in 1879 when it became clear that he needed a new market. After 1880 he concentrated on marketing his work and spreading his ideas. Three one-man exhibitions – Venice etchings in 1881, pastels in 1883, and 'Notes' – 'Harmonies' – 'Nocturnes' in 1884 – received wide coverage, but modest financial rewards. His election to membership of the Society of British Artists (SBA) appeared a godsend, both to him and to the Society. The SBA, founded in 1823 to promote the interests of artist, patron and student by encouraging exhibitions of a high standard independent of the Royal Academy, was not a revolutionary or dynamic body. It had lapsed, said Whistler, 'into a sort of crèche for the Royal Academy' and was in deep financial trouble.[1] On 21 November 1884 Arthur Hill proposed that Whistler should be invited to become a member.[2] Whistler attended his first meeting on 1 December, and sent to their winter exhibition a recent watercolour, 'A Little Red Note: Dordrecht' (Freer Gallery of Art, Washington, DC; M 969), and his stately portrait of Mrs Huth (no.63). A month later, at the suggestion of Wyke Bayliss, he was elected to the committee.[3] Bayliss soon regretted his proposal, and led the opposition to Whistler's policies. Popular for his rosy paintings of cathedral interiors, Whistler called him 'Bayliss the Middlesex Michel Angelo!'[4] But he was shrewd and self-restrained, and when he succeeded Whistler as President, he was not wholly ineffective, although lacking in originality.

To the summer show in 1885 Whistler sent his newly completed portrait of the violinist, 'Arrangement in Black: Portrait of Señor Pablo de Sarasate' (Carnegie Institute, Pittsburgh; YMSM 315). It was greeted with rare critical acclaim. The success of these first exhibitions confirmed his initial support in the SBA. On 1 June 1886 he was elected President. 'You elected me', said Whistler, 'because I was much talked about and because you imagined I would bring noto-

riety to your gallery'.[5] He took office in December. 'J'y suis, j'y reste!' he wrote to his sister-in-law triumphantly.[6]

For the Society the urgent need was money. Expenditure of £1,800 a year, including the lease of the Suffolk Street galleries, exceeded the income from commissions on works sold. In 1884 sales had approached £8,000 but a year later they had halved. 'Old fashioned pictures', said Whistler, 'had ceased to become saleable wares'.[7] To help the financial situation, Whistler printed fifty impressions of 'The Fish-Shop, Busy Chelsea' (K 264) to be sold by lottery for the benefit of the SBA. Barely solvent himself, he lent the Society £500 to help balance their books, having borrowed the money from the impressario Richard D'Oyly Carte. He offered three portraits as security, inluding that of his mother (no.60).[8]

At the time Whistler was elected the SBA consisted of about eighty members, and some honorary members, including Frederic Leighton, William Powell Frith and Lawrence Alma-Tadema – although in 1886 Whistler failed to persuade Leighton to exhibit. Each member showed up to six works, with Whistler having no control in the selection. He could – and did – reject work submitted by outsiders. 'We want clean spaces around our pictures.' said Whistler, 'We want them to be seen, The British Artists must cease to be a shop.'[9] He pruned the total number of works exhibited from 800 to 500. The *Magazine of Art* registered the improvement: 'You may be rejected by the SBA, but you cannot be skied', referring to the usual practice of hanging pictures high up the walls.[10]

Nevertheless, members gathered forces against Whistler, claiming fewer pictures meant less income.[11] On 6 June 1887 they carried a motion that 'the experiment of hanging the pictures in an isolated manner be discontinued' and the space below, on and above the line should be filled.[12] For the next exhibition the hanging committee had to increase the number shown but by decreasing the size of works accepted the rooms still seemed relatively spacious.[13]

Whistler also refused to limit the exhibitions to British work; 'what you call British art', he said, 'is not art at all – but produce for the market'.[14] He invited Claude Monet to exhibit, although Monet warned him, quite correctly, that this would be unpopular with the members.[15] Monet sent four works in December 1887, including recent paintings of the coast of Belle Ile. His work was little known in London, and as a leading Impressionist he was viewed with suspicion by many, but reviews were enthusiastic. The *Spectator* found 'qualities of truth in the reproduction of light such as have never before been obtained'.[16]

Whistler also brought new blood into the SBA. His pupil, the Australian-born Mortimer Menpes, and William Stott of Oldham, another of his protégés, were elected in 1884, Sidney Starr in 1886, Theodore Roussel, and two old friends, the American sculptor, Waldo Storey, and the Belgian painter, Alfred Stevens, in 1887.[17] In 1885 Whistler failed to gain control over the selection of members. In 1888 he was also unsuccessful in his attempt to exclude eleven members who would, he thought 'endanger the position of the Society'.[18]

In 1886 Menpes exhibited 'Dolce Far Niente' (Hunterian Art Gallery), a small portrait of Whistler's mistress Maud Franklin in Oriental robes. He made little

impact on the SBA, and nothing distinguished him so much as the manner of his leaving. Instead of supporting Whistler in May 1888 when opposition was mounting against him, Menpes resigned, earning the name of 'the early rat that leaves the sinking ship'.[19] Roussel's work – portraits of Menpes and Maud, and a 'Bathers' described by a critic as an 'arrangement in flesh-colour and green'[20] – was recognisably Whistlerian, as was that of Starr, whose portrait of the actor G.S. Willard exhibited in 1886–7 was seen as an exercise in the 'Sarasate' vein, although less subtle than Whistler's portrait.[21]

Stott wrote, 'Whistler has busily woven and created for our delight works of marvellous beauty, from his fairy-like etchings of Venice to his soul-appealing Carlyle and Sarasate of today'.[22] Maud posed nude for Stott's 'Birth of Venus' (fig.29), which met with savage reviews: 'Stott instead of a goddess has given us a red-haired topsy' was a typical comment.[23] In 1887 Stevens sent 'the sketch of a baby, from M. Stevens unregenerate days – hanging there among the notes and nocturnes by which he enrols himself among the followers of the new Velasquez'.[24] His other exhibits were tentative atmospheric studies totally unlike the sophisticated genre studies of women on which his reputation was based. Another supporter was Albert Ludovici (junior) who had become a member in 1881. He exhibited flashy little landscapes and genre subjects (like his father, who was treasurer of the Society) under Whistlerian titles, like 'Harmony in gold and flesh tint'. Whistler particularly liked his 'dainty dancing girl' ('Terpsichore').[25]

Walter Sickert, although he had exhibited at the SBA 1885–6 as a 'pupil of Whistler', now refused to join. 'I do not mean to throw myself on your good nature', he wrote, 'but take my chance and peddle my work where and how I can.'[26] He exhibited 'Clodgy, Cornwall' (Hunterian Art Gallery) in 1885 – a Whistlerian study painted when he and Menpes were in St Ives with Whistler in 1884 and 'Le Mammoth Comique' (Cottesloe Trustees) a bold, illusionistic painting of a music-hall showing Sickert's newly independent style.[27]

Whistler exhibited at seven SBA exhibitions works ranging from an early picture of 'Chelsea in Ice' (private collection; YMSM 53) to recent paintings of London and Holland, which although commended received less coverage by the critics than his large works. However, a pastel of a nude, a 'Note in Violet and Green' (Freer Gallery of Art; M 1074) exhibited in December 1885 benefited from a current controversy. J.C. Horsley had lectured on the degrading effects of modelling in the nude: Whistler, who disliked Horsley, added to his pastel a note reading 'Horsley soit qui mal y pense' – which the committee made him remove.[28]

He also sent several recent portraits. In 1886–7 he showed a portrait of the fashionable Lady Colin Campbell (YMSM 354) in a dress specially designed by Worth for the occasion. The painting was exhibited unfinished, suggesting that Whistler was fighting against time to complete it before Lady Campbell's sensational divorce case came to court. The work attained a sort of notoriety, which Wyke Bayliss deplored, urging the SBA to remove it from exhibition. This was an extraordinary suggestion to make about the President's work and the proposal was dropped.[29]

fig.29 William Stott of Oldham 'Birth of Venus' 1887 Oil on canvas *Oldham Art Gallery*

With remarkable lack of consideration for the feelings of the sitters, Whistler also sent portraits of both his mistress, Maud Franklin, 'Harmony in Black No.10' (whereabouts unknown; YMSM 357), and of his future wife, the recently widowed Beatrice Godwin, 'Harmony in Red: Lamplight' (fig.30; YMSM 253). Each showed the women in slightly aggressive poses, hands on hips, as if in confrontation. Bernard Partridge reflected these undercurrents when he caricatured Whistler in the costume of Beatrice (fig.31).[30]

Both Maud and Beatrice had exhibited as 'Pupils of Whistler'.[31] Menpes praised Maud, 'We thought her work very fine ... we placed her high because she painted on grey panels and in sympathy with Whistler.'[32] Thus work by Maud hung in the SBA as well as portraits of her, both clothed and nude. But the press did not approve of Whistler's portrait any more than of Stott's 'Birth of Venus'. The *Magazine of Art*, while admiring Maud's 'suppressed vivacity', considered 'however great the technical skill lavished on such a problem, however artful may be the gradations ... a vast sheet of black paint must always remain *per se* undecorative and unlovely'.[33] Whistler asked £800 for the portrait, but it remained unsold until he destroyed it – or possibly threw it out, with the sitter, when he married Beatrice in 1888.

The pictures by Whistler and his followers changed the overall look of exhibitions, but his most important innovations concerned the redecoration of the gallery. The dull red walls and patterned papers were changed to a neutral brown, the doors draped with Liberty material in fawn. Doors and mantelpieces were primrose yellow. A pale orange muslin canopy, the 'velarium' designed by Whistler (see no.93), softened the light and directed it on to the pictures. The staircase was painted with pink dados and white walls as a setting, in 1887, for the prints of Whistler, Menpes, Frank Short and Sickert.[34]

By 1888, the anti-Whistler clique had control. Whistler was asked to remove his 'temporary decorations'[35] – which he promptly did. Arguments about who owned the velarium rumbled on for months (see no.93). On 5 March 1888 Whistler said that he would neither interfere nor exhibit in the next exhibition, nor authorise the exhibition of his work originally planned for that summer.

However, the SBA did approve of one of Whistler's achievements during his final year as President. In 1887 Britain celebrated Queen Victoria's Golden Jubilee, the fiftieth anniversary of the monarch's accession to the throne. The Society decided to spend the unhandsome sum of one guinea on a loyal (short) Address, not knowing that an elaborate Address, written by Edward Mitchell at the Herald's College, illuminated by Whistler and bound by Zaensdorf in a yellow morocco album, had already been presented by the Secretary of State, Henry Matthews, to the Queen on the Society's behalf (fig.32).[36] (It has now, unfortunately, disappeared.) The Queen admired 'the beautiful and artistic illumination of the Album in which the address was enclosed'[37] and commanded 'that the Society should be called Royal'. Whistler announced this to a meeting that up till that moment had been stormy. 'They jumped up and rushed towards me with outstretched hands', said Whistler, 'the meeting over, I sent for champagne.'[38]

fig.30 Whistler 'Harmony in Red – Lamplight' 1884–6 Oil on canvas *Hunterian Art Gallery, University of Glasgow, Birnie Philip Bequest*

fig.31 G.B. Partridge 'Caricature of Whistler as Beatrice Godwin', from *Judy*, 8 December 1886, p.267 *Glasgow University Library, Birnie Philip Gift 1955*

fig.32 Whistler, *Address to Queen Victoria* 1887
Watercolour (whereabouts unknown) from E.R.
and J. Pennell, *The Life of James McNeill Whistler*,
London 1908

fig.33 Whistler, *Design for lion for RBA*
Glasgow University Library, Birnie Philip Gift 1955

fig.34 Whistler, *Album containing the Jubilee set*
of etchings presented to Queen Victoria in 1887
Hunterian Art Gallery, University of Glasgow,
Birnie Philip Gift 1935

The Society thus became the Royal Society of British Artists (RBA).

Whistler designed a royal lion for the new RBA notepaper and catalogues, which was in use by January 1888 (fig.33).[39] 'My little red lion – isn't he splendid and well-placed?' he wrote to Menpes.[40] He painted a lion and a royal butterfly in vermilion and gold on the signboard outside the RBA's galleries. On his departure, his arch enemy Wyke Bayliss had the sign painted out.[41]

As President, Whistler attended the Naval Review at Spithead on 27 July 1888. He produced a set of etchings (K 317–28) which he presented to Queen Victoria in another sumptuous album (fig.34).[42] (If he hoped to earn a knighthood, it did not work. It was Wyke Bayliss who was knighted, after replacing Whistler as President.)

Whistler proposed that now the Society was Royal its members should withdraw from membership of other societies, including the Royal Academy.[43] To many members this was an intolerable suggestion and Whistler's proposal was defeated. Battle for leadership was joined, the feud within the Society having paralysed all normal activities. On 4 May 1888 nine members wrote asking Whistler to call a special meeting to demand his resignation.[44] He wrote to Alfred Stevens, 'La Société est en plein revolte – Les cris de démission! démission!'[45] At the meeting eighteen members voted for Whistler, nineteen against and nine abstained. Whistler decided to stay. His opponents resigned, but were entitled to vote at the annual general meeting on 4 June, when, said Whistler, 'they brought up the maimed, the halt, the lame, and the blind – literally – like in Hogarth's Election'.[46] He was defeated, his opponents re-elected, and Wyke Bayliss became President. Whistler and twenty-five supporters resigned: 'So you see', said Whistler, 'the "Artists" have come out, and the "British" remain and peace and sweet obscurity are restored to Suffolk Street'.[47] It was a triumph for mediocrity and a disaster for British art, leaving the Royal Academy to reign unchallenged.

It was ten years before Whistler was again tempted to run for the presidency of a society of artists. Meanwhile he exhibited in major exhibitions throughout Europe and America, gaining honours and awards, and building up international support. In 1891 a group of Scottish artists, led by E.A. Walton, successfully campaigned to persuade the City of Glasgow to buy Whistler's portrait of Thomas Carlyle (no.61). Walton also led the artists – John Lavery, Joseph Crawhall, James Guthrie and Joseph Farquharson – who founded the International Society of Sculptors, Painters and Gravers (ISSPG). It was intended that members of the Society and honorary members would have their work hung together, irrespective of nationality. The name was suggested by Whistler, who won unanimous support as their first President.[48] 'Although we in Glasgow worked with a richer palette than his', wrote Lavery, ' we recognised in him the greatest artist of the day'.[49]

Lavery and Francis Howard, smarting from rejections at the Royal Academy, agreed to be Vice-President and Secretary.[50] Howard alienated Whistler by his 'don't care a damn' attitude, leaving the indefatigable Lavery to mediate between

the absentee President in Paris and his strong-minded committee.[51] The autocratic Whistler sent precise instructions, demanded reports of 'all tiresome details' and minutes of meetings.[52] Jealousies arose, and after Whistler's death Lavery resigned, to the dismay of the new President, the sculptor Auguste Rodin.

The first meeting was held on 23 December 1897 in London. The first exhibition opened in May 1898 at the Princes' Skating Club in Knightsbridge, with over two hundred and fifty works on view. Whistler designed the typesetting and a monogram for the catalogue.[53] His velarium hung from the ceiling, as it had at the RBA. He commended the committee for 'the harmonious result I intended, and you have achieved.'[54] A deficit of only £300 meant that the exhibition was not far short of financial success in the first year, but the proprietor, Admiral Maxse, demanded guarantees which were difficult to meet in subsequent years.[55]

George Sauter and T. Stirling Lee were active members, as was Ludovici, who had followed Whistler from the RBA, while Aubrey Beardsley, Charles Conder and Walter Crane were among exhibitors. The 'survivors of Suffolk Street' were allowed to join, but not Menpes whom Whistler had not forgiven for his earlier lack of support, nor 'amateurs', such as H.B. Brabazon and McClure. Sickert, estranged from Whistler, did not exhibit, nor did Steer.

Whistler eventually succeeded in excluding members of the RA from the committee. J.J. Shannon and Alfred Gilbert had to resign, although Shannon was elected an honorary member. John Singer Sargent disapproved of Whistler's censorship and refused honorary membership.[56]

Scottish artists naturally figured large – D.Y. Cameron, Robert Burns, D.S. MacColl; the Glasgow Boys and Glasgow Girls, Fra Newbury from Glasgow School of Art, Bessie MacNicol, and Margaret MacDonald and C.R. Mackintosh in 1901.

French artists were contacted directly by Whistler or by the faithful Ludovici: Puvis de Chavannes, Monet and Degas, of course, and other Impressionists, Gustave Moreau and Jean-Louis Forain, Milcendeau, Harpignies, Edouard Vuillard and Pierre Bonnard, and even (after protests from Whistler) Paul Cézanne.[57] In particular, Whistler arranged with Durand Ruel in Paris to borrow Manet's 'The Execution of Maximilian' (fig.35).[58]

Whistler made use of his international contacts to invite the Italian artists G. Segantini and Pietro Fragiacomo from Venice (who in return asked Whistler and Lavery to join the Corporazione dei Pittori e Scultori Italiani)[59]; Albert Baertsoen, Fernand Khnopff, Meunier and Dillens from Belgium; Fritz Thaulow, Boecklin and Franz Stuck, Von Uhde and Gustav Klimt from Austria (who had invited Whistler to join the Austrian Sezession)[60]; Max Klinger in Dresden, and Max Liebermann in Berlin. He contacted friends in Holland – Josef Israels, Jacob and Isaac Maris, van Rysselbergh, W. Mesdag and van Toorop – and enlisted Anders Zorn in Sweden.

Rodin and Whistler had possibly met as fellow students at the Ecole Impériale et Spéciale du Dessin et de Mathématiques in 1855. The rue de Varenne where Rodin had his studio ran into the rue du Bac, where Whistler lived at no.110.

fig.35 Edouard Manet 'Execution of Maximilian' 1868–9 Oil on canvas *Städtische Kunsthalle, Mannheim*

Whistler had a 'profound admiration' for Rodin's more conventional sculpture, while Rodin appreciated Whistler's understanding of form and space 'de la manière des bons sculpteurs'.[61] However, Rodin now lent a flying angel from 'The Gates of Hell', which Whistler did not like. He told Ludovici to 'stick it up in some corner' but 'luck was in our way' (according to Ludovici) and it was broken in transit. The committee wanted to reject one figure, 'the one with the legs apart'.[62] Finally, Rodin's casts were returned, broken, and Whistler commended 'the ingenuity of the British packer … without a moment's hesitation, he summarily sawed off a *leg at the ankle!* and so brilliantly reduced the recalcitrant limb to immediate submission *and the fit of* the box!'[63] Not discouraged, Rodin continued to exhibit at the ISSPG, achieving through it recognition in Britain. He was eventually elected President, in 1903.

Whistler also persuaded three American sculptors, all old friends, to join – Waldo Storey, Frederick MacMonnies and Auguste St Gaudens. MacMonnies had taught with Whistler at the Académie Carmen in Paris. Joseph Pennell – as argumentative as Whistler – was on the executive committee, and William Merritt Chase an honorary member, while J.W. Morrice sent Whistlerian studies from Paris.[64] However, the North American content of the ISSPG shows was minimal. The range was typical of the Continental secessions, but not completely international.

Whistler had introduced graphic work to the RBA: at the ISSPG it competed on equal footing. Pennell organised the hanging of prints by, among others, Matthew Maris and Whistler, alongside works in other media. In 1899 Whistler had a room for his marvellous etchings of Paris and Amsterdam (see no.164), and the Naval Review etchings done as President of the RBA.

To each exhibition Whistler sent a mixture of work. In 1899 he also sent pastels of Venice, and a fine drawing of a nude (private collection; M 686) drawn over thirty years before: in 1901, two pastels of figures, one of which – 'The Captive' (Indiana University Art Museum, Bloomington; M 1524) – was comparatively recent. He sent figure studies and seascapes in oil, both old and new. In 1898 he came over to hang his own 'panel' – early works like 'At the Piano' (no.11) and his recent self-portrait, 'Gold and Brown' (no.204). A photograph in the *Art Journal* shows Whistler's pictures carefully spaced 'on the line', in accordance with instructions sent to Ludovici (fig.36). Others hung two or three deep (depending on their size), but none was 'skied'.[65] By this mixture of media and periods Whistler expressed his belief in the constant and enduring quality of his work: 'The artists' work is never better, never worse, it must always be good, in the end as in the beginning, if he is an artist, if it is in him to do anything at all'.[66]

Whistler was as critical of his own as he was of others' work, and it was perhaps this, as well as the sheer quality of his output, which inspired loyalty in his followers, and enabled him to carry out his uncompromising ideas of organisation and exhibition design which distinguished both the RBA and ISSPG under his presidency.

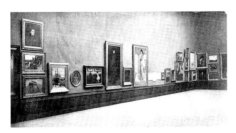

fig.36 Exhibition of International Society of Sculptors, Painters and Gravers, *Art Journal*, 1898, p.249

Catalogue

Note on authorship

Entries on works in oil written by Richard Dorment.

Entries on works on paper are by Margaret MacDonald.

Entries on prints are by Ruth Fine with contributions from Margaret MacDonald.

Nos.60, 187 and 188 are by Geneviève Lacambre.

Introductory texts have been initialed to indicate authorship.

Explanations

Details of medium, support, size, inscriptions and provenance are given as fully and accurately as possible, combining our own observation and research with collection and museum records.

TITLES. The first exhibited or published titles are given wherever possible, or Whistler's titles where known. Descriptive titles are given in lower case.

MEASUREMENTS. Height is given before width, centimetre size before inches (the latter in parentheses); for irregularly shaped surfaces, the maximum extent is cited.

INSCRIPTIONS are by the artist unless otherwise stated.

EXHIBITION HISTORY ('EXH'). Exhibitions during Whistler's lifetime are listed. After his death only major Whistler exhibitions are cited.

LITERATURE ('LIT'). The literature cited is selective. The catalogue raisonné (YMSM) and subsequent important references are listed.

NOTES. For text of notes see pp.293–304.

FIGURE ILLUSTRATIONS. Illustrations appear on pp.286–92.

Unless otherwise stated, works in the catalogue will be exhibited at all three venues.

Abbreviations: General

BM	British Museum
bt	bought
exh.	exhibited
exh. cat.	exhibition catalogue
GUL	Glasgow University Library, Whistler collection
ISSPG	International Society of Sculptors, Painters and Gravers
K	see Kennedy 1910 in literature abbreviations, below
LC	Library of Congress, Washington
LC PC	J. & E.R. Pennell Collection, Library of Congress, Washington
M	see MacDonald 1994 in literature abbreviations, below
NYPL	New York Public Library, E.G. Kennedy collection
RA	Royal Academy
RBA	Royal Society of British Artists
repr.	reproduced
SBA	Society of British Artists
W	see Kennedy 1914 in literature abbreviations, below
YMSM	see YMSM 1980 in literature abbreviations, below

Abbreviations: Exhibitions

Aberdeen 1896
Eighth Exhibition of Works of Modern Artists and Old Masters, Aberdeen Artist's Society, Oct.–Nov. 1896

Amsterdam 1889
Tentoostellung van Kunstswerken van Levende Meesters, 1889

Ann Arbor 1978
Whistler: The Later Years, University of Michigan Museum of Art, 27 Aug.–8 Oct. 1978 (catalogue by Nesta Spink and John Holmes unpublished, checklist published)

Antwerp 1894
Exposition Universelle de Beaux Arts, US section, 1–12 Nov. 1894

Baltimore 1876
Academy Charity Exhibition, Academy of Music, 16–30 March 1876 (catalogue untraced)

Berlin 1969
James McNeill Whistler (1834–1903), Nationalgalerie, 1 Oct.–24 Nov. 1969 (catalogue by R. Spencer)

Boston 1898
Loan Exhibition of Pictures by Modern Painters, Copley Hall and Allston Hall, 7–27 March 1898

Boston 1904
Oil Paintings, Water Colors, Pastels and Drawings: Memorial Exhibition of the Works of Mr. J. McNeill Whistler, Copley Society, Copley Hall, Feb. 1904

Brighton 1875
Second Annual Exhibition of Modern Pictures, Corporation of Brighton, Royal Pavilion Gallery, opened 9 Sept. 1875

Brussels 1884
Société des Vingts, Jan. 1884

Brussels 1888
Société des Vingts, opened 1 Feb. 1888

Brussels 1890
Exposition Générale des Beaux-Arts, May–June 1890

Buffalo 1901
Pan American Exposition, Fine Arts section

Chicago 1893
World's Columbian Exposition, Department of Fine Arts, 1893

Chicago & Utica 1968
James McNeill Whistler, Art Institute of Chicago, 13 Jan.–25 Feb. 1968; Munson-Williams-Proctor Institute, Utica, N.Y., 17 March–28 April 1968 (catalogue by Frederick A. Sweet)

Claremont 1978
Whistler: Themes and Variations, Montgomery Art Gallery, Pomona College, Claremont, Cal., 16 Jan.–26 Feb. 1978; Crocker Art Gallery, Sacramento, Cal., 11 March–16 April 1978; Stanford University Museum of Art, 2 May–18 June 1978 (exhibition organised by Betsy Fryberger)

Dublin 1884
Annual Exhibition of Sketches, Pictures, & Photography, Dublin Sketching Club, Leinster Hall, 35 Molesworth Street, opened 1 Dec. 1884

Dublin 1888
Exhibition of Paintings, British Dental Association, Aug. 1888

Dublin 1899
A Loan Collection of Modern Paintings, Leinster Hall, 35 Molesworth Street, 1–29 April 1899

Dundee 1895
14th Fine Art Exhibition, Albert Institute, opened 13 Nov. 1895

Edinburgh 1884
Loan Exhibition, Scottish National Portraits, Royal Scottish Academy, Board of Manufacturers, Summer–Oct. 1884

Edinburgh 1886
International Exhibition, Fine Art Section, English Loan Collection, opened 6 May 1886

Edinburgh 1902
76th Exhibition of the Royal Scottish Academy of Painting, Sculpture and Architecture, Royal Scottish Academy, 1902

Edinburgh 1904
78th Exhibition of the Royal Scottish Academy of Painting, Sculpture and Architecture, Royal Scottish Academy, 1904

Glasgow 1888
International Exhibition, May–Oct. 1888

Glasgow 1889
28th Exhibition of Works of Modern Artists, Glasgow Institute of the Fine Arts, 4 Feb.–29 April 1889

Glasgow 1891
South Side Art Exhibition, Corporation Gallery, 150 Main Street, Gorbals, 1891 (no catalogue)

Glasgow 1893
Boussod, Valadon & Cie., of the Goupil Gallery, London at Wellington Studios, 147 Wellington Street, Nov. 1893 (catalogue untraced)

Glasgow 1896
Burns Exhibition, Glasgow Institute of the Fine Arts, 1896

Glasgow 1899
38th Exhibition of Works of Modern Artists, Glasgow Institute of the Fine Arts, 6 Feb.–8 May. 1899

Glasgow 1901
International Exhibition, Fine Art Section, Glasgow Art Galleries, May–Oct. 1901

Glasgow 1984
Whistler Pastels, Hunterian Art Gallery, University of Glasgow, 25 May–3 Nov. 1984 (catalogue by M.F. MacDonald)

Liverpool 1900
30th Autumn Exhibition of Pictures, Corporation of Liverpool, Walker Art Gallery, 1900

LONDON

London 1905
Memorial Exhibition of the Works of the late James McNeill Whistler, First President of The International Society of Sculptors, Painters and Gravers, New Gallery, Regent Street, 22 Feb.–15 April 1905 (catalogue by John Lavery, A. Ludovici, J. Pennell)

London, Berners Street 1862
Morgan's Gallery, 14 Berners Street, 1 June–2 Aug. 1862 (catalogue untraced)

London, Campden House 1896
(catalogue untraced)

London, College for Men and Women, 1889
Exhibition of Whistler's work at 29 Queen's Square, Bloomsbury, College for Working Men and Women, opened 2 May 1889; arranged by Walter Sickert (no catalogue)

London, Dowdeswell 1884
'Notes' – 'Harmonies' – 'Nocturnes', Messrs Dowdeswell, 133 New Bond Street, May 1884 (61 oils, watercolours and pastels in Whistler's one-man show; catalogue designed by Whistler)

London, Dowdeswell 1886
'Notes' – 'Harmonies' – 'Nocturnes', second series, Messrs Dowdswell, May 1886 (75 oils, watercolours, pastels and drawings; catalogue designed by Whistler)

London, Dowdeswell 1888
Messrs Dowdeswell, July 1888 (no catalogue; review *New York Tribune* 31 July 1888)

London, Dudley Gallery 1871
5th Winter Exhibition of Cabinet Pictures in Oil, Egyptian Hall, Piccadilly, 1871

London, Dudley Gallery 1872
6th Winter Exhibition, 1872

London, Dudley Gallery 1875
9th Winter Exhibition, 1875

London, FAS 1881
Venice Pastels, The Fine Art Society, 148 New Bond Street, Jan.–March 1881

London, French Gallery 1867
15th Annual Winter Exhibition of Cabinet Pictures of British and Foreign Artists, French Gallery, 120 Pall Mall, Jan. 1867

London, Goupil 1892
Nocturnes, Marines & Chevalet Pieces, Boussod, Valadon & Cie., Goupil Gallery, 116–17 New Bond Street, March–April 1892 (retrospective exhibition of Whistler's paintings; catalogue designed by Whistler incorporating a judicious selection of earlier press reviews of his work)

London, Goupil 1897
Water-Colour Drawings by C.E. Holloway, Feb. 1897

London, Goupil 1898
A Collection of Selected Works by Painters of the English, French and Dutch Schools, opened 5 March 1898

London, Grafton Galleries 1893
1st Exhibition, 8 Grafton Street, opened 18 Feb. 1893

London, Grafton Galleries 1894
Fair Women, Jan. 1894

London, Grafton Galleries 1895
Fair Children, May 1895

London, Grafton Galleries 1897
Dramatic and Musical Art, April 1897

London, Grosvenor Gallery 1877
I Summer Exhibition, 1 May–31 July 1877

London, Grosvenor Gallery 1878
II Summer Exhibition, 1 May–5 Aug. 1878

London, Grosvenor Gallery 1879
III Summer Exhibition, 1 May–2 Aug. 1879

London, Grosvenor Gallery 1881
V Summer Exhibition, 2 May–31 July 1881

London, Grosvenor Gallery 1882
VI Summer Exhibition, 1 May–31 July 1882

London, Grosvenor Gallery 1883
VII Summer Exhibition, 1 May–30 July 1883

London, Grosvenor Gallery 1884
VIII Summer Exhibition, 1 May–31 July 1884

London, Grosvenor Gallery 1888
Exhibition of Pastels, Oct. 1888

London, Guildhall 1894
Loan Collection of Pictures, Corporation of London Art Gallery, 2 April–30 June 1894

London, Guildhall 1896
Loan Collection of Watercolour Drawings, Corpora-tion of London Art Gallery, 21 April–31 July 1896

London, Guildhall 1900
Loan Collection of Pictures by Living British Painters, Corporation of London Art Gallery, 10 April–10 July 1900

London, Int. Exh. 1872
International Exhibition, Fine Art Department, South Kensington Museum, 1872

London, ISSPG 1898
Exhibition of International Art, International Society of Sculptors, Painters and Gravers, Princes Skating Rink, Knightsbridge, May 1898

London, ISSPG 1899
2nd Exhibition, Pictures, Drawings, Prints and Sculptures, Knightsbridge, May–July 1899 (catalogue designed by Whistler)

London, ISSPG 1901
3rd Exhibition, at the Galleries of the Royal Institute, 191 Piccadilly, 7 Oct.–10 Dec. 1901

London, Marchant 1903 &
London, Marchant 1904
Watercolours, Pastels, Drawings in Black and White, Sculptures and Bronzes by British and Foreign Artists Including a Selection of Works by H.B. Brabazon, and a Group of Works by the Late James McNeill Whistler, exhibition opened Dec. 1903 with additional works added on 15 Jan. 1904, closed 30 Jan. 1904

London, Marks 1878
Sir Henry Thompson's Blue and White Nankin Porcelain, private view, 30 April 1878, Murray Marks, 395 Oxford Street

London, New Gallery 1891–2
The Victorian Exhibition Illustrating Fifty Years of Her Majesty's Reign, 1837–1887, exhibition ended beginning of April 1892

London, Pall Mall 1874
Mr. Whistler's Exhibition, Flemish Gallery, 48 Pall Mall, opened 8 June 1874 (Whistler's first one-man exhibition – 13 oils, 50 etchings and dry-points, 36 drawings and a painted screen, catalogue designed by Whistler)

London, RA 1862
94th Exhibition of the Royal Academy of Arts, 1862

London, RA 1863
95th Exhibition of the Royal Academy of Arts, 1863

London, RA 1864
96th Exhibition of the Royal Academy of Arts, 1864

London, RA 1865
97th Exhibition of the Royal Academy of Arts, 1865

London, RA 1867
99th Exhibition of the Royal Academy of Arts, 1867

London, RA 1872
104th Exhibition of the Royal Academy of Arts, 1872

London RBA 1887
64th Annual Exhibition, Royal Society of British
Artists, Suffolk Street, Pall Mall East,
March–Aug. (catalogue designed by Whistler,
President of the RBA)

London, RBA 1887–8
Winter Exhibition, Royal Society of British
Artists, Suffolk Street, Pall Mall, opened Nov.
1887

London, RSPP 1903
13th Exhibition, Royal Society of Portrait
Painters, New Gallery, Nov.–Dec.1903

London, SBA 1884–5
Winter Exhibition, Society of British Artists,
Suffolk Street, Pall Mall East, Nov. 1884–Feb.
1885

London, SBA 1885
62nd Annual Exhibition, Society of British
Artists, March–Aug. 1885

London, SBA 1885–6
Winter Exhibition, Society of British Artists,
Nov. 1885–Feb.1886

London, SBA 1886–7
Winter Exhibition, Society of British Artists,
Arthur Tooth & Sons, 5–6 Haymarket, Nov.
1886–Feb. 1887 (catalogue designed by
Whistler, and used thereafter by RBA)

London, Society of French Artists 1873
6th Exhibition, Deschamps Gallery, 168 New
Bond Street, opened 21 April 1873

London, Society of French Artists 1875
11th Exhibition, Nov. 1875

London, Society of French Artists 1876
12th Exhibition, Spring 1876

London, SPP 1891
1st exhibition, Society of Portrait Painters, at
Royal Institute of Painters in Watercolours,
Piccadilly, 1891

London, SPP 1899
8th exhibition, Grafton Galleries, 1898

London, Whitechapel Gallery 1903
Spring Exhibition, Whitechapel Gallery, 1903

London, Willis's Rooms 1863
The Artists' and Amateurs' Conversazione, 26 March
1863 (no catalogue)

London, Liverpool & Glasgow 1976
*Whistler, The Graphic Work: Amsterdam, Liverpool,
London, Venice*, T. Agnew & Sons Ltd, London,
6–30 July 1976; Walker Art Gallery, Liverpool,
20 Aug.–26 Sept. 1976; Glasgow Art Gallery
and Museum, 7 Oct.– 11 Nov. 1976 (catalogue
by M.F. MacDonald)

London & New York 1960
James McNeill Whistler, Arts Council Gallery,
4 St James's Square, London, 1–24 Sept. 1960;
Knoedler Galleries, 14 East 57th Street, New
York, 2–30 Nov. 1960 (catalogue and introduc-
tion by A. McLaren Young)

Munich 1888
III Internationale Kunst–Austellung, Münchener
Jübiläums-Austellung, Königlichen Glaspalast,
July 1888

Munich 1892
VI International Kunst-Austellung (3rd ed. of cata-
logue), 1 June–end Oct. 1892

NEW YORK

New York 1866
Artists' Fund Exhibition (catalogue untraced)

New York 1874
49th Annual Exhibition, National Academy of
Design, 1874

New York 1878
1st Annual Exhibition, Society of American
Artists, Kurtz Gallery, 6 March – 5 April 1878

New York (I) 1881
Loan Collection of Paintings, Metropolitan Muse-
um of Art, May–Oct. 1881

New York (II) 1881
The Union League Club, Oct. 1881 (catalogue
untraced)

New York 1882
5th Annual Exhibition, Society of American
Artists, at American Art Gallery, 6 April–
5 May 1882

New York 1883
50 Etchings and Drypoints (Venice Second Series), H.
Wunderlich & Co., 868 Broadway, Oct. 1883

New York 1889
'Notes' – 'Harmonies' – 'Nocturnes', H. Wunder-
lich & Co., March 1889 (Whistler's first one-
man show in America)

New York (I) 1894
Loan Collections, Metropolitan Museum of Art,
1894

New York (II) 1894
*Portraits of Women, Loan Exhibition for the Benefit of
St. John's Guild and the Orthodaedic Hospital*,
National Academy of Design, 1 Nov. –1 Dec.
1894

New York 1898
20th Annual Exhibition, Society of American
Artists, 19 March–23 April 1898

New York 1898–9
*Loan Exhibition of Portraits for the Benefit of the
Orthopaedic Hospital*, National Academy of
Design, 14 Dec. 1898 – 14 Jan. 1899

New York 1902
24th Annual Exhibition, Society of American
Artists, 28 March–4 May 1902

New York 1984
Notes, Harmonies, Nocturnes, M. Knoedler & Co.,
30 Nov.–27 Dec. 1984 (catalogue by M.F.
MacDonald)

New York & Philadelphia 1971
From Realism to Symbolism: Whistler and his World,
Wildenstein, 19 East 64th Street, New York,
4 March–3 April 1971; Philadelphia Museum
of Art, 15 April–23 May 1971

Newcastle 1887
*The Newcastle-upon-Tyne Royal Mining Engineering
and Industrial Exhibition*, Jubilee Year, 1887

Paisley 1901–2
26th Exhibition of Paisley Art Institute, Dec.
1901–Feb. 1902

PARIS

Paris 1905
Oeuvres de James McNeill Whistler, Palais de
l'Ecole des Beaux-Arts, Quai Malaquais, May
(memorial exhibition organised by L.
Bénédite, Musée du Luxembourg)

Paris 1961
Prélude à Whistler, Centre culturel américain,
3 rue du Dragon, Paris, 17 April–10 June 1961

Paris, Durand-Ruel 1873
Exposition, Galerie Durand-Ruel, 11 rue Le
Péletier, January 1873

Paris, Durand-Ruel 1888
Exposition, Galerie Durand-Ruel, 25 May–
25 June

Paris, Exp. Univ. (I) & (II) 1867
Exposition Universalle, US section, opened 1
April 1967 (two editions of catalogue give
different numbering and titles)

Paris, Exp. Univ. 1889
Exposition Universalle, British Fine Art Sec-
tion, 1889

Paris, Exp. Univ. 1900
Exposition Universalle, Fine Arts Exhibit of
the United States of America, May 1900

Paris, Goupil 1891
Boussod Valadon & Cie. of the Goupil
Gallery, autumn 1891

Paris, Grand Palais 1974
Le Musée du Luxembourg en 1874, 31 May–18 Nov.
1974 (catalogue by Geneviève Lacambre)

Paris, Petit 1883
Exposition Internationale de Peinture, Deuxième
année, Galerie Georges Petit, 8 rue de Sèze,
11 May–10 June 1883

Paris, Petit 1887
Exposition Internationale de Peinture et de Sculpture,
Sixième année, Galerie Georges Petit, 8 rue de
Sèze, 8 May–8 June 1887

Paris, Salon des Refusés 1863
*Oeuvrages de peinture, sculpture, gravure, lithographie et
architecture, refusés par le Jury de 1863, et exposés, par
décision de S.M. l'Empereur, au salon annexi,* Palais de
Champs Elysées, 15 May 1863

Paris, Salon 1882
100th exhibition, *Oeuvrages de peinture, sculpture,
architecture, gravure et lithographie des artistes vivants,*
Palais des Champs-Elysées, opened 1 May 1882

Paris, Salon 1883
101st exhibition, opened 1 May 1883

Paris, Salon 1884
102nd exhibition, opened 1 May 1884

Paris, Salon 1885
103rd exhibition, opened 1 May 1885

Paris, Salon 1890
105th exhibition, opened 1 May 1890

Paris, Soc. Nat, 1861
Société Nationale des Beaux-Arts, Martinet's
Gallery, Boulevard des Italiens, Oct 1861

Paris, Soc. Nat. 1862
Société Nationale des Beaux-Arts, Dec. 1862

Paris, Soc. Nat. 1863
Société Nationale des Beaux-Arts, July 1863

Paris, Soc. Nat. 1891
1st exhibition, Société Nationale des Beaux-
Arts, Champs de Mars, opened 15 May 1891

Paris, Soc. Nat. 1892
2nd exhibition, opened 7 May 1892

Paris, Soc. Nat. 1894
4th exhibition, opened 25 April 1894

Paris, Soc. Nat. 1897
7th exhibition, opened 24 April 1897

Perth 1898
*Exhibition of Loan Pictures Shown in the Sandeman
Gallery on the Occasion of the Opening of the Sandeman
Public Library by Lord Roseberry,* 22 Oct. 1898

Philadelphia 1881–2
*Special Exhibition of Paintings by American Artists at
Home and in Europe,* Pennsylvania Academy of
the Fine Arts, 7 Nov. – 2 June 1882

Philadelphia 1893–4
63rd Annual Exhibition, Pennsylvania Academy
of the Fine Arts, 18 Dec. 1893–24 Feb. 1894

Philadelphia 1900
69th Annual Exhibition, 15 Jan.–24 Feb. 1900

Philadelphia 1901
70th Annual Exhibition, 14 Jan.–23 Feb. 1901

Philadelphia 1902
71st Annual Exhibition, 20 Jan.–1 March 1902

Philadelphia 1903
72nd Annual Exhibition, 19 Jan.–28 Feb. 1903

Pittsburgh 1897
2nd Annual Exhibition, Carnegie Institute, 10
Jan.–22 Feb. 1897

Pittsburgh 1902–3
7th Annual Exhibition, 6 Nov. 1902–1 Jan. 1903

Tokyo 1987–8
James McNeill Whistler, Isetan Museum of Art,
Tokyo, 24 Sept.–6 Oct. 1987; Hokkaido
Museum of Modern Art, Sapporo, 17 Oct.–
15 Nov. 1987; Shizuoka Prefectural Museum,
21 Nov.– 20 Dec. 1987; Daimaru Museum,
Osaka, 13–25 Jan. 1988 (catalogue by M. Hop-
kinson, selection & ed. D. Sutton, essay by
Prof. Senzoku)

Venice 1895
*I Esposizione Internazionale d'Arte della Città di
Venzia,* 1895

Venice 1899
III Esposizione Internazionale, 22 April–31 Oct.
1899

Washington 1984
James McNeill Whistler at the Freer Gallery, Freer
Gallery of Art, Smithsonian Institution,
Washington, 1984 (catalogue by Dr David
Park Curry)

Wolverhampton 1902 *Art and Industrial
Exhibition,* Fine Art Section, 1902

Abbreviations: Literature

Bacher 1908
Otto H. Bacher, *With Whistler in Venice,* 2nd ed.,
New York 1908 (1st ed. 1906 was suppressed
for publishing facsimiles of Whistler's letters)

Barbier 1964
Carl P. Barbier (ed.), *Correspondance
Mallarmé–Whistler,* Paris 1964

Bénédite 1905
Léonce Bénédite, 'Artistes Contemporains:
Whistler', *Gazette des Beaux-Arts,* vol.33, 1905,
pp.403–10, 496–511; vol.34, 1905, pp.14–58,
231–46

Curry 1984
David Park Curry, 'Whistler and Decoration',
Antiques, vol.124, no.5, Nov. 1984, pp.1186–99

Du Maurier 1951
Daphne Du Maurier (ed.), *The Young George
Du Maurier: A Selection of his Letters, 1860–67,*
London 1951

Duret 1904
Théodore Duret, *Histoire de J. McN. Whistler et de
son oeuvre,* Paris 1904 (2nd ed, Paris 1914; 3rd
ed., trans. Frank Rutter, London and Philadel-
phia 1917

Eddy 1903
Arthur J. Eddy, *Recollections and Impressions of
James A. McNeill Whistler,* Philadelphia and
London 1903

Fine (ed.) 1987
Ruth Fine (ed.), *Studies in the History of Art,*
vol.19, Centre for Advanced Studies in the
Visual Arts, Washington, Symposium Papers
VI, 1987

Getscher 1991
Robert H. Getscher, *James Abbott McNeill
Whistler: Pastels,* New York 1991

Getscher and Marks 1986
Robert H. Getscher and Paul G. Marks, *James
McNeill Whistler and John Singer Sargent,* New York
and London 1986 (definitive bibliography)

Grieve and MacDonald 1994
Alastair Grieve and Margaret F. MacDonald,
Whistler in Venice (forthcoming book on
Whistler's pastels and etchings)

Heijbroek 1988
F. Heijbroek, 'Holland van het water: de
bezoeken van James Abbott McNeill Whistler
aan Nederland', *Bulletin Rijksmuseum,* 1988,
vol.36, no.3, pp.225–56

Ionides 1925
Luke Ionides, *Memories,* Paris 1925

Kennedy 1910
Edward G. Kennedy, *The Etched Work of Whistler, Illustrated by Reproductions in Collotype of the Different States of the Plates*, New York 1910

Kennedy 1914
Edward G. Kennedy, *The Lithographs by Whistler: Arranged According to the Catalogue by Thomas R. Way*, New York 1914

Lochnan 1984
Katherine A. Lochnan, *The Etchings of James McNeill Whistler*, New Haven and London 1984

MacDonald 1975
Margaret F. MacDonald, 'Whistler: The Painting of the "Mother"', *Gazette des Beaux-Arts*, vol.85, Feb. 1975, pp.73–88

MacDonald 1988
Margaret F. MacDonald, 'Whistler's Lithographs', *Print Quarterly*, vol.5, no.1, March 1988, pp.20–55

MacDonald and Newton 1987
Margaret F. MacDonald and Joy Newton, 'Correspondence Duret–Whistler', *Gazette des Beaux-Arts*, Nov. 1987, pp.150–64

MacDonald 1994
Margaret F. MacDonald, *James McNeill Whistler: Drawings, Pastels and Watercolours, A Catalogue Raisonné*, New Haven and London 1994 (forthcoming)

Mansfield 1909
Howard Mansfield, *A Descriptive Catalogue of the Etchings and Drypoints of James McNeill Whistler*, Chicago 1909

Menpes 1904
Mortimer Menpes, *Whistler as I Knew Him*, London 1904

Merrill 1992
Linda Merrill, *A Pot of Paint: Aesthetics on Trial in Whistler v. Ruskin*, Washington and London 1992

Mumford 1939
Elizabeth Mumford, *Whistler's Mother*, Boston 1939

Newton and MacDonald 1984
Joy Newton and Margaret F. MacDonald, 'Whistler, Rodin, and the International', *Gazette des Beaux-Arts*, March 1984, pp.116–23

Pennell 1908
Elizabeth Robins Pennell and Joseph Pennell, *The Life of James McNeill Whistler*, 2 vols., London and Philadelphia 1908

Pennell 1921
Elizabeth Robins Pennell and Joseph Pennell, *The Whistler Journal*, Philadelphia 1921

Rossetti 1903
William M. Rossetti (ed.), *Rossetti Papers, 1862–1870*, London 1903

Sickert 1947
Osbert Sitwell (ed.), *A Free House: . . . the Writings of Walter Richard Sickert*, London 1947

Spencer 1989
Robin Spencer (ed.), *Whistler: A Retrospective*, New York 1989

Starr 1908
Sidney Starr, 'Personal Recollections of Whistler', *Atlantic Monthly*, vol.101, April 1908, pp.528–37

Terra 1987
Terry A. Neff (ed.), *A Proud Heritage: Two Centuries of American Art*, Terra Museum of American Art, Chicago, 1987

Thomas 1874
Ralph Thomas, *A Catalogue of the Etchings and Dyrpoints of James Abbott Mc Neill Whistler*, London 1874

Thompson 1878
A Catalogue of Blue and White Porcelain Forming the Collection of Sir Henry Thompson, Illustrated by the Autotype Process from Drawings by James Whistler, Esq, and Sir Henry Thompson, London 1878

Way 1896
Thomas R. Way, *Mr. Whistler's Lithographs: The Catalogue*, London 1896; 2nd ed., London and New York 1905

Way 1912
Memories of James McNeill Whistler, the Artist, London and New York 1912

Way and Dennis 1903
T.R. Way and G.R. Dennis, *The Art of James McNeill Whistler: An Appreciation*, London 1903

Wedmore 1886
Frederick Wedmore, *Whistler's Etchings: A Study and a Catalogue*, London 1886

Whistler 1877
James McNeill Whistler, *Harmony in Blue and Gold: The Peacock Room*, London 1877 (pamphlet)

Whistler 1878
James McNeill Whistler, *Whistler v. Ruskin: Art and Art Critics*, London 1878 (reprinted in Whistler 1890, see below)

Whistler 1890

James McNeill Whistler, *The Gentle Art of Making Enemies*, London and New York, 1890

Whistler 1892
James McNeill Whistler, *The Gentle Art of Making Enemies*, 2nd ed., London and New York 1892 (includes catalogue of *Nocturnes, Marines & Chevalet Pieces* and five more letters)

Whistler 1899
James McNeill Whistler, *Eden versus Whistler: The Baronet and the Butterfly. A Valentine with a Verdict*, Paris and New York 1899

Williamson 1919
George C. Williamson, *Murray Marks and his Friends*, London and New York 1919 (a unique copy in the Victoria and Albert Museum Library, Res. coll., Q.4,5, contains the original letters reproduced in the book)

YMSM 1980
Andrew McLaren Young, Margaret F. MacDonald, Robin Spencer with the assistance of Hamish Miles, *The Paintings of James McNeill Whistler*, New Haven and London 1980

Early Prints and the 'French Set'

In the 1840s and 1850s, the caricatures of Gavarni and Daumier turned public attention to the possibilities of lithography, in particular in conveying the immediacy of the artist's ideas. While he was still at West Point in 1854 Whistler drew caricatures based on theirs. Baudelaire's essay on 'Some French Caricaturists' of 1857, discussing Gavarni's influence on his contemporaries, consolidated this influence on Whistler's choice of figure subjects for drawings and etchings.

Charles Meryon's first etchings, exhibited at the Salon in 1849, and his *Cahiers d'eaux fortes* published in 1851, were an immediate success. Felix Bracquemond, then working as a commercial lithographer, had taught himself etching, and with the master printer, Auguste Delâtre, passed on his expertise to others. Whistler, who had learnt the basic techniques of etching when working at the US coast survey in Washington, arrived in Paris in 1855 and was immediately attracted to the etching revival. Compared to engraving, the variety of line possible in etching, combined with its freedom of handling, and spontaneity, fitted it for the Romantic tradition.

While studying at the Sorbonne in Paris, Whistler's brother-in-law Francis Seymour Haden, physician and obstetrician, attended drawing classes to train eye and hand for surgery. On his return to London in 1844 he began to collect etchings — the work of Rembrandt and Van Dyck, Adriaan van Ostade and Karel Dujardin — and showed them to the young Whistler.

In 1845 Baudelaire in his essay 'On the Heroism of Modern Life' had urged painters to work from nature and draw subjects from ordinary life. In 1856 – the year after Whistler arrived in Paris – Duranty founded the review, *Réalisme*. At the biennial Salon in Paris in 1857 the preponderance of genre subjects was noticeable, with a marked shift towards domestic interiors and landscapes.

Both Haden and Whistler were aware of the new movements. When Whistler came over from Paris to visit the Hadens, he and Haden experimented on etching portraits of the children. Haden strongly urged Whistler to work from nature. The immediate effect was that Whistler took copper plates and sketchbooks with him when he set off in the autumn of 1858 with an artist friend, Ernest Delannoy, on a sketching trip through France and the Rhineland. This resulted in his first published set, *Douze eaux-fortes d'après nature* (Twelve Etchings from Nature), popularly known as the 'French Set', which was, significantly, dedicated to Haden.[1] Several of the images were drawn directly onto the copper plates and some developed from sketches made on the trip. For variety, subjects from both rural and city life, several figure studies, and portraits of two of the Haden children, Arthur and Annie, were included in the set. The 'French Set' also includes Whistler's first Nocturne, 'Street at Saverne' (K 19).

Later that year the twelve etchings (thirteen, including the title-page etching) were first issued in France, in white wrappers with the 171 rue St Jacques address of Auguste Delâtre, who printed the plates. Publication in London came soon after from Haden's address at 62 Sloane Street. The London edition was enclosed in pale

blue wrappers with a title list printed on the back. Not many copies of the 'French set' were printed, according to Frederick Wedmore, who lists 'the trifling sum of two guineas' as the price per set in 1858.[2]

M.M.

1 La Mère Gérard 1858

Etching printed in black ink on off-white wove card
Plate: 12.6 × 9 (4⅞ × 3½)
Sheet: trimmed to platemark
Signed in plate: 'Whistler'
Signed and inscribed in pencil: 'First State | La Mère Gérard. | Whistler' followed by butterfly
PROV: Gift of Samuel Putnam Avery
LIT: Mansfield 1909 (13); Kennedy 1910 (11 I/IV); YMSM 1980 (26–7)
S.P. Avery Collection, The Miriam and Ira D. Wallach Division of Art, Prints and Photographs, The New York Public Library, Astor, Lenox and Tilden Foundations

Published in *Douze eaux-fortes d'après nature* (Twelve Etchings from Nature).

This is a full-length standing portrait of La Mère Gérard, whom Whistler also depicted in the etching, 'La Mère Gérard, Stooping' (K 12). The choice of subject reflects Whistler's interest both in portraiture and in the lives and environments of working-class subjects. The artist probably met Mère Gérard at the dance-hall bal Bullier, where, almost blind, she was selling flowers at the door. She was, however, an educated woman who earlier in life had written verse and run a small lending library. She was a picturesque character, and Whistler, to ensure that he had first claim on her as a model, would take her for outings.

He painted an oil portrait of her in the winter of 1858–9, which was much admired by Gustave Courbet, and at least one other oil (YMSM 26–7). He had promised her the first portrait, but then thought it was too good for her and painted a copy. Disgusted, she described Whistler as 'une fameuse canaille de moins'.[1]

In this etching, Whistler depicted the old woman within the Realist mode associated with Gustave Courbet, using techniques he may have admired in the etchings of the Barbizon artist Charles Jacques. It is a study of character and costume, and in the tradition of eighteenth- and nineteenth-century prints like Carle Vernet's 'Marchande d'oranges, mon Portugal, mes fines oranges' in the *Cris de Paris* of about 1820. Vernet's prints[2] are the immediate

precursor of engravings after Gavarni, like 'Le Portugal et le banc de terre neuve' from *Les Gens de Paris*, which was cited by Lochnan as a possible influence on 'La Mère Gérard'.[3]

This rare, possibly unique, first state impression allows us to see the start of the etching process. Mère Gérard's head is essentially complete; but Whistler's delicate blocking in of her cape, apron, and skirt, and their subtle modelling as they drape around her figure, was significantly altered in two of the three later states. With prints, each state documents further work on the copper plate, both additions and/or subtractions. In this case, the striped robe she holds in her left hand, and her cape, were darkened in later states, and her chequered apron was altered to tartan. Most important of all, she was given a space: her shadow fell against a wall behind. For the last state of this image (the fourth state) when it was published in the 'French Set', the only addition was the address of the printer, Delâtre.

As completed, 'La Mère Gérard' was composed of dense networks of lines which not only suggested the intensity of the old woman's gaze, but also the conglomeration of fabrics, differing in texture, pattern, colour and weight, that make up her dress.

The spare openness seen here, however, relates strongly to Whistler's later etchings, from the Venice prints onwards (see no.104), and suggests that, as a novice, he felt a need to explore the medium by working as fully as he might. Having done so, in later work he used etching more selectively and personally.

In looking at etchings by an artist such as Whistler who saw each impression as an individual work of art, it is essential to study every nuance. Because of the character of the inking and printing or the particular state of the plate, some impressions are far more beautiful than others.

Whistler did not develop his butterfly monogram until 1869. This impression, which predates the published set, was signed and inscribed by Whistler, probably at the request of the print collector, Samuel Putnam Avery, about 1870–4. Avery started collecting Whistler's etchings about 1867 and acquired many special early proofs including nos.3, 5).

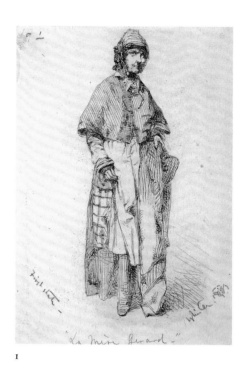

1

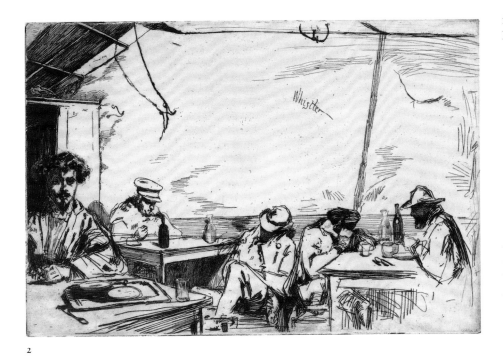

2

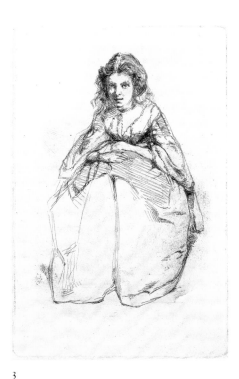

3

2 Soupe à Trois Sous 1859

Etching and drypoint printed in black on
Japanese paper
Plate: 15.2 × 22.7 (6 × 8¹⁵⁄₁₆)
Sheet: 23.1 × 29.8 (9 × 11¾)
Signed in plate: 'Whistler'
PROV: Gift of William Loring Andrews
1883
LIT: Mansfield 1909 (49); Kennedy 1910
(49 only state)

*The Metropolitan Museum of Art, New York. Gift
of William Loring Andrews, 1883*

'Soupe à Trois Sous' was drawn in Paris late in
1859, after Whistler had spent some months
working in London along the Thames. It is
related in spirit to 'Longshoremen' (K 45), pub-
lished in the 'Thames Set'. Most of the Thames
prints are outdoor scenes along the river, but
'Longshoremen', like 'Soupe à Trois Sous',
emphasises working-class pub habitués. 'Soupe
à Trois Sous' goes one step further, into the real
'lower depths', depicting an all-night
bar/restaurant in Paris frequented by down-
and-outs, alcoholics, the homeless and drifters
of the city. It was the most extreme of
Whistler's Realist subjects.

Whistler's first cataloguer, Ralph Thomas,
described Whistler at work: 'while [Whistler]
was etching this (Paris, 1859), at twelve o'clock
at night, a gendarme came up to him and want-
ed to know what he was doing. Whistler gave
him the plate upside down, but officialism
could make nothing of it.'[1]

This work reflects his immersion in *la vie de
bohème*, which he sought when he left America

for Paris. According to the critic Théodore
Duret the work depicted

un pauvre restaurant fréquenté par les
misérables. Le jeune homme qui le tenait,
nommé Martin, placé sur la gauche de la
gravure, s'était acquis de la célébrité, en
combattant comme garde mobile, pendant
la bataille de juin 1848, à Paris. On l'avait
décoré pour faits d'armes et les journaux
avaient répandu son nom; mais à la suite
d'affaires malheureuses, il avait après cela
perdu toute position et s'était vu réduit a
diriger cette gargote.[2]

Anonymous figures huddle around the walls of
a bleak and cheerless room. The empty soup
plate on a tray, the bottles on the tables, the
lack of any decoration, show this as the poorest
and meanest of drinking dens. However, Mar-
tin, with his dark curly hair and dissipated good
looks, is a romantic, somewhat Byronic figure,
and his intense gaze dominates the scene. His
humanity softens the harsh realism of the set-
ting.

It is therefore less surprising that Thomas
could ignore the squalor of the subject and
speak admiringly of 'the charming simplicity of
execution … and the largeness of the disposi-
tion of light … which in less masterly hands
might have been frittered away in minute
detail.'[3]

'Soupe à Trois Sous' was not included in any
of Whistler's published sets and is relatively
rare.

3 Fumette 1858

Etching and drypoint printed in black on
off-white card
Plate: 16.3 × 10.9 (6⅜ × 4¼)
Sheet: 22.8 × 15.5 (9⅛ × 6⅛)
Signed and inscribed in pencil: '"Fumette"
Whistler– | 1st State–'. Inscribed in
another hand, 'Before background'
PROV: Gift of Samuel Putnam Avery
LIT: Mansfield 1909 (15); Kennedy 1910 (13
I/IV)

*S.P. Avery Collection, The Miriam and Ira D.
Wallach Division of Art, Prints and Photographs,
The New York Public Library, Astor, Lenox and
Tilden Foundations*

Published in *Douze eaux-fortes d'après nature*
(Twelve Etchings from Nature).

Fumette (or Eloise or Héloise[1]) was the first of Whistler's European liaisons. She was a milliner, a 'grisette' in the Latin Quarter, who used to carry about with her a little basket containing her crochet work, and a volume of the poems of Alfred de Musset, which she knew by heart. She and Whistler lived at a hotel on the rue St Sulpice. According to the Pennells, Whistler and Fumette were together for two years, not always happily; one day Fumette destroyed a cache of Whistler's drawings in a fit of anger' (she was nicknamed 'the tigress' in keeping with her hot temper). She later lived with a musician, and at the end of her life was living in South America, where she had set up as a *modiste*.

She posed for several etchings, 'Fumette', 'Fumette Standing' (K 56), 'Fumette's Bent Head' (K 57), and possibly for the superb nude study, 'Venus' (no.4).

Here, Whistler carefully delineates Fumette's dark eyes, sensuous mouth, and shoulder-length hair, sympathetically conveying both the vulnerability of her personality and her quiet mood of the moment. The details of her dress, with its lace collar, may convey her skills in her craft. Fumette always let her hair hang loose, not braided in the usual manner, which excited much comment at the time, and suggested that she was a bohemian or gypsy – beyond the pale of bourgeois respectability.

Etchings like 'La Mère Gérard' (no.1) and 'Fumette' show women of a recogniseably low class, working women and beggars. Their clothes and attitudes define their status. In subject and treatment these etchings fit the new Realism of the time.

The final states of this and other 'French Set' etchings were printed by Auguste Delâtre with nuanced tonal wiping or, as appropriate, an overall residual film of ink that provides an effect of warmth to the surface. This rare and possibly unique first state proof, like the first state of 'La Mère Gérard', shows Whistler's initial response to his sitter, before the addition of chiaroscuro effects which mark the final version.

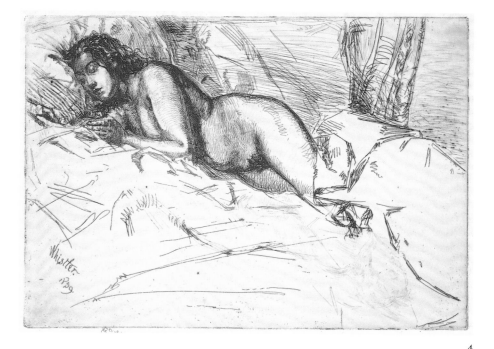

4

4 Venus 1859

Etching and drypoint printed in black ink on cream wove paper paginated '79' on recto and '80' on verso
Platemark: 15 × 22.2 (5⅞ × 8¾)
Sheet: 24.6 × 31 (9⅞ × 12¼)
Signed in plate: 'Whistler | 1859'
Signed with butterfly and inscribed 'imp'
Collector's marks of a lion and unidentified mark
PROV: Lessing J. Rosenwald; given to the National Gallery of Art 1943
LIT: Wedmore 1886 (56); Mansfield 1909 (59); Kennedy 1910 (59 I/II)

National Gallery of Art, Washington. Rosenwald Collection

The model has been presumed to be either Fumette or Finette, who inherited Fumette's role in Whistler's life. Whistler etched Finette in a black dress in 1859 (K 58). She was a can-can dancer at the bal Bullier and later appeared in music-halls in London as 'Mme. Finette'. The two women had similar features and dark curly hair.

'Venus' is one of Whistler's few etchings of nudes, although he studied the female figure, nude or lightly draped, extensively later in life, particularly in pastel. The title, which Whistler used subsequently for other works, of course alludes to a classical theme.[1] The treatment of the figure reveals the great admiration for Rembrandt's graphic art which is apparent throughout Whistler's etched oeuvre. Rembrandt's 'Jupiter and Antiope' (B 285) with its explicit

voyeurism, and heavy chiaroscuro, is a possible influence on this etching.[2] However, the style and content of the print suggest other forces at play. The closely observed reclining figure reveals the artist's place within the Realist tradition of Courbet. Wedmore described it as a 'nude seen by Mr. Whistler with rather common eyes, for once'.[3]

The rumpled bed and the strong lighting enhance the sense of reality. The open whiteness of the bed plane serves to emphasise Whistler's highly articulated modelling of the figure, whose hand and facial features are particularly lovely in this rare first-state impression. The plane is interrupted, however, by the ghost image of a previously drawn reclining figure, which Whistler cursorily scraped out but did not fully remove, even in the subsequent and final state. Although this is an early impression, it was signed by Whistler in the 1890s, possibly when it was sold.

5

5 La Marchande de Moutarde 1858

Etching and drypoint printed in black on dark cream laid paper from a book, with crown watermark
Plate: 15.7 × 8.9 (6³⁄₁₆ × 3½)
Sheet: 24.7 × 18.2 (9¾ × 7⅛)
Signed in plate 'Whistler'
Inscribed on plate 'Imp. Delâtre, Rue St.Jacques, 171'
Signed and inscribed in pencil: 'La marchande de moutarde' | 'Whistler' followed by butterfly
PROV: Gift of Samuel Putnam Avery
LIT: Mansfield 1909 (22); Kennedy 1910 (22 III/V); MacDonald 1994 (272–3)

S.P. Avery Collection, The Miriam and Ira D. Wallach Division of Art, Prints and Photographs, The New York Public Library, Astor, Lenox and Tilden Foundations

Published in *Douze eaux-fortes d'après nature* (Twelve Etchings from Nature).

'La Marchande de Moutarde' was accepted for the Paris Salon of 1859, the year 'At The Piano' (no.11) was rejected. In the first catalogue raisonné of Whistler's etchings, Ralph Thomas referred to it as 'one of the most perfect specimens' of Whistler's work of the period.[1] It remains among Whistler's most captivating early etchings.

The etching is derived from two sketches now in the Freer Gallery of Art, Washington,

DC, one of which identifies the scene as Cologne.[2] The basic composition and the figures were rather faithfully translated from this sketch, 'La Marchande de Poterie à Cologne' (M 272; fig.38) onto the copper plate. When printed, the image appears in reverse of the drawing. The second sketch, 'La Marchande de Moutarde' (M 273; fig.37), was the source for aspects of the counter top and cupboard. The woman appears to be covering the pots for sale or storage.

The etching 'La Marchande de Moutarde' is prescient of Whistler's later facades developed around multiple vignettes of activity viewed through doorways and windows, often conveying a muted sense of mystery that captivated the artist's imagination. Here, however, a single incident is described with considerable detail and clarity.

In the 'French Set' architectural settings, Whistler started to develop patterns of marks to differentiate between surface, texture and colour. For example, the horizontal openwork of the exterior archway sets up a contrast with the vertical emphasis in the shutter at the far right.

Whistler greatly admired seventeenth-century Dutch genre pictures. Lochnan pointed out that Whistler attended Charles Robert Leslie's lectures at the Royal Academy schools in March 1849, which were also published in the *Athenaeum*. Leslie suggested studying Pieter de Hooch's interiors, his close vantage point and horizontal perspective.[3] The work of de Hooch seems particularly relevant to 'La Marchande de Moutarde'.

In addition to its publication as part of the 'French Set', in 1886 an edition of two hundred impressions of 'La Marchande de Moutarde' was printed by Frederick Goulding for inclusion in *English Etchings*. According to Frederick Wedmore they were printed on Whatman paper of 1814, with a few extra impressions for Whistler himself on seventeenth-century Dutch papers.[4]

6 The Unsafe Tenement 1858

Etching printed in black ink on chine
appliqué to white card
Plate: 15.5 × 22.5 (6⅛ × 8¾)
Sheet: 24.4 × 31 (9⅝ × 12¼)
Signed in plate: 'Whistler—' (with 's'
reversed)
Inscribed in plate: 'Imp. Delâtre. Rue
St.Jacques, 171'
Signed in pencil: 'Whistler' followed by
butterfly
PROV: Gift of Samuel Putnam Avery
LIT: Mansfield 1909 (17); Kennedy 1910
(17 IIb/IV)

S.P. Avery Collection, The Miriam and Ira D.
Wallach Division of Art, Prints and Photographs,
The New York Public Library, Astor, Lenox and
Tilden Foundations

Published in *Douze eaux-fortes d'après nature*
(Twelve Etchings from Nature).

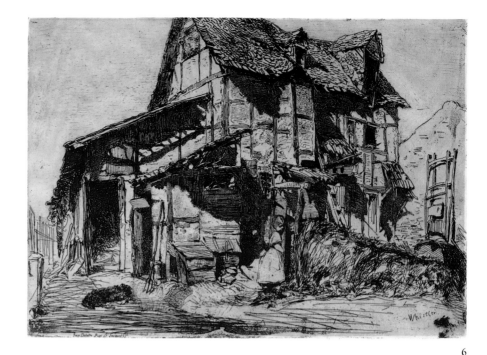

6

This scene in Alsace-Lorraine was observed
during Whistler's 1858 walking tour with
Ernest Delannoy. The dilapidated farmhouse is
an unusually imposing architectural image for
Whistler (whose alternative title was 'l'habita-
tion dangereuse').[1] In subject and style of draw-
ing it reflects his awareness of the prints of the
Barbizon artist Charles Jacques, in for example
Jacques's 'Maison de paysan à Cricey' (G 14).[2]
But if the image itself is unusual, Whistler's
emphasis on light as an essential subject
remains a constant: dark shadows dance across
the building, defining and highlighting the
complexities of its structure.

The composition underwent major changes
as Whistler developed it: a woman originally at
the left was replaced by the pitchfork. The
moody sky in early states was removed before
publication, possibly by Francis Seymour
Haden, who may also have made adjustments
to the shadows.[3]

Whistler's use of a golden-toned chine collé,
characteristic of many of the 'French Set'
impressions, adds an overall warmth to the
scene. For some plates a blue sheet is used
instead of the gold, to quite different effect.
Whatever the colour, the thin chine sheet is
extremely receptive to the ink and accentuates
the nuances of the etched lines. The schematic
butterfly is of an unusual form but probably
dates from 1870–4.

Most of Whistler's early etchings were print-
ed in fairly small editions, but they must have
sold well. When Frederick Wedmore wrote the
introduction to his 1886 catalogue of etchings
he noted the collections he had used in gather-
ing information. Among them was the collec-
tion of the artist himself, 'but that, unfortu-
nately, is very incomplete. It consists chiefly of
the later etchings.'[4]

7 Bibi Lalouette 1859

Etching and drypoint printed in dark
brown ink on pale blue-grey laid paper
with watermark of bricked arch
Plate: 22.6 × 15 (8⅞ × 6)
Sheet: 23.3 × 22.7 (9³⁄₁₆ × 8¹⁵⁄₁₆)
Signed in plate: 'Whistler | 1859'
PROV: Bequest of Lessing J. Rosenwald
1981
LIT: Wedmore 1886 (30); Mansfield 1909
(51); Kennedy 1910 (51 II/II)

National Gallery of Art, Washington. Ailsa Mellon
Bruce Fund

Among the most charming elements in
Whistler's prints are his depictions of children.
The earliest examples were portraits of his
nieces and nephews, the offspring of his half-
sister Deborah and her husband Francis Sey-
mour Haden (K 8–10). He also etched a few
plates like this one, portraying the children of
friends. Later, Whistler shifted to less specific
images of babes in their mothers' arms, and
swift, gestural notes of children at play or walk-
ing along the street (nos.179, 164).

'Bibi Lalouette' was the child of a restaura-

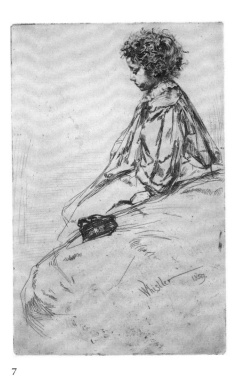

7

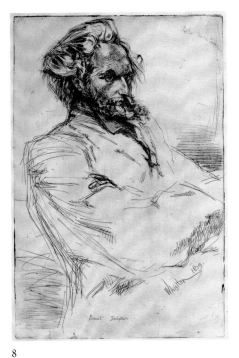

8

teur whose pension, near the rue Dauphine, was frequented by Whistler and his Société des Trois comrades, Henri Fantin-Latour and Alphonse Legros. Whistler apparently spent a good deal of time there, enough to become deeply indebted to the owner, and to develop an affection for his child. Perhaps this etching was made in partial payment of debts. They remained on good terms after Whistler left Paris, and a year later, Lalouette wrote praising 'votre courage et votre assiduité au travaille' and told him 'Bibi ... parle souvent de vous'.[1]

Bibi Lalouette's tangled hair, in particular, reveals Whistler's consumate control of his medium, even at this early stage of his career. Such detail is at its most beautiful in this rich, unusual impression on bluish-green paper, with an overall surface tone of colour which imparts a special warmth to the subject.

Whistler's sympathetic touch in portraying his young friends, 'Bibi Lalouette' and 'Bibi Valentin' (K 50), is in stark contrast to his rigorously incisive adult portraits in drypoint, such as 'Drouet' (no.8), dating from the same year.

The artist employed drypoint as well as etching here. He juxtaposed the tightly modelled areas with an open plane, filling the lower register of the sheet, similar to his approach in composing 'Venus' (no.4). At the bottom are the shadowy vestiges of two heads that had appeared in the first state of the print, like the ghostly figures still visible in 'Venus' and 'Weary' (no.19).

This impression of 'Bibi Lalouette' is on bluish-green paper; 'The Unsafe Tenement' (no.6) on gold; 'Jo' (no.13), on a fairly heavy tan oatmeal sheet; 'Weary' on a Japanese tissue so thin that a stamp on the verso is clearly visible from the front. These are only a few of the papers to be seen in Whistler's prints. The variety is important because the weight, texture, and colour of the sheet have enormous impact on the character of the printed lines and thus the appearance of the image. This is especially important with prints by Whistler, who varied his inking methods as well as the papers used for an edition, making each impression a unique object.

8 Drouet 1859

Etching and drypoint printed in black ink on ivory oriental paper
Plate: 22.5 × 15.2 (8⅞ × 6)
Sheet: 24.4 × 32.7 (9⅝ × 13)
Signed and inscribed in plate: 'Whistler 1859' and 'Drouet Sculpteur'
Signed and inscribed in pencil: 'Drouet – Whistler'
Signed and inscribed by Drouet: 'Ch. Drouet | 3 juillet 1873' and probably by Avery, 'signed for S.P.A.'
PROV: Gift of Samuel Putnam Avery
LIT: Mansfield 1909 (55); Kennedy 1910 (55 I/II)

S.P. Avery Collection, The Miriam and Ira D. Wallach Division of Art, Prints and Photographs, The New York Public Library, Astor, Lenox and Tilden Foundations

Charles Drouet (1836–1908) was both sculptor and collector, and among his bequests to the Louvre was the dramatic and realistic 'Head of an Old Man Smoking' (YMSM 25) painted by Whistler about the time of this portrait. According to Drouet, his portrait was done in two sittings, of two and a half and one and a half hours.[1]

The dynamism of Whistler's free-flowing drypoint strokes provides bulk to the briefly suggested figure of the sculptor. These bold strokes present a marked contrast to the tightly wrought dash upon dash technique that the artist used to develop his subject's intense gaze, strong nose, fluffy beard, and jagged architectonic mane of hair. Strength and vitality are among the attributes with which Whistler invested his friend, one of several artistic and literary figures he portrayed on copper in 1859.

This three-quarter length, three-quarter view portrait is reminiscent of paintings by Velázquez, whom Whistler greatly admired. In addition, its focus on the head recalls the first states of Van Dyck's etched portraits for his 'Iconographia', and in particular, as Lochnan points out, that of Lucas Vorsterman (D 13),[2] which Whistler could have seen at the *Art Treasures Exhibition* in Manchester in 1857 or in Seymour Haden's collection.

Even writers critical of Whistler's 1874 exhibition at the Flemish Gallery, Pall Mall – his first solo show – gave high praise to his etchings and drypoints, praising them for their 'truth and beauty ... their marvellous technical skill'. One critic singled out 'some fine portrait heads, notably that of M. Drouet, the French sculptor'.[3]

In 1880 Whistler sold to the Fine Art Soci-

ety the plate for 'Drouet', which he had can-
celled the previous year. In 1886, Frederick
Wedmore, in the second catalogue of
Whistler's etchings, wrote that the print was
'scarce'.[4] Perhaps that accounts for the fact that
at some point the cancellation was removed,
and further impressions were printed. The later
prints are distinguished from the earliest ones
by details of Drouet's nose, and the lack of rich-
ness in the character of the drypoint burr
throughout; but they are often difficult to iden-
tify.

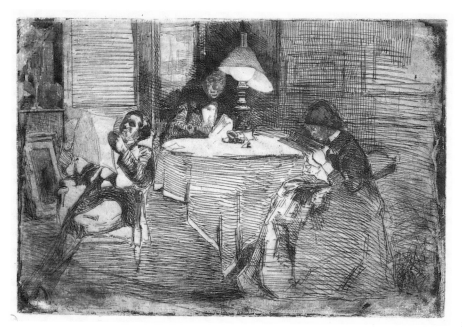

10

9 Reading by Lamplight 1858

Etching and drypoint printed in black ink
on ivory laid paper
Plate: 15.8 × 11.8 (6³/₁₆ × 4⁹/₁₆)
Sheet: 28.9 × 21.3 (11³/₈ × 8³/₈)
Signed in plate: 'J Whistler'
Signed in pencil: 'Whistler'
PROV: Gift of Samuel Putnam Avery
LIT: Thomas 1874 (25); Mansfield 1909
(30); Kennedy 1910 (32 I/III)

*S.P. Avery Collection, The Miriam and Ira D.
Wallach Division of Art, Prints and Photographs,
The New York Public Library, Astor, Lenox and
Tilden Foundations*

This is a portrait of Whistler's half-sister, Deb-
orah Delano (1825–1908), who had married
Francis Seymour Haden, and was drawn in
their London home at 62 Sloane Street.

In 'Reading by Lamplight', an intimate
domestic interior dramatically lit, like 'The
Music Room' (no.10), the shapes of dark and
light are relatively large, building a composition
of heroic scale that is especially appealing to a
modern sensibility. As in 'The Music Room',
Deborah Haden is reading, with the book held
close to her face, presumably to compensate for
her poor eyesight (she eventually went blind).
Even after Whistler's break with Deborah's
husband, Whistler and his half-sister remained
in sympathetic contact, both through corre-
spondence and surreptitious meetings.

In essentially the same pose as seen here,
Deborah was the subject of one of Haden's
etchings of the same year (H 9), probably drawn
on copper simultaneously with Whistler's. A
portrait of her daughter, Annie, seen in an early
state in Haden's etching of 'Deborah', seems
based on Whistler's etching, 'Annie, Seated'
(K 30).[1]

This first state of 'Reading by Lamplight'
was noted by Thomas as being very rare. In the

second state, Deborah's hairstyle and the shape
of her nose have been revised, and the shadow
areas have been adjusted, some with additions,
others with areas of darkness removed.

10 The Music Room 1859

Etching and drypoint printed in brown
ink on off-white laid paper
Plate: 14.2 × 21.5 (5¹¹/₁₆ × 8⁵/₁₆)
Sheet: 27.8 × 41.2 (10¹⁵/₁₆ × 16¼)
Inscribed by Francis Seymour Haden:
'This is the first rude impression pulled
from the plate from *wh*. as will be seen,
the ink is scarcely wiped off. W[histler]
gave it to me & I gave it to Burty –
F.S.H.'
PROV: Francis Seymour Haden; Philippe
Burty; gift of the estate of Lee Friedman
1958
LIT: Mansfield 1909 (31); Kennedy 1910
(33 I/II)

*Museum of Fine Arts, Boston. Gift of the Estate
of Lee M. Friedman 1958*

'The Music Room' captures a scene in a corner
of the room at the home of Deborah and Sey-
mour Haden which was the setting for two of
Whistler's paintings, 'At the Piano' (no.11) and
'The Music Room' (Freer Gallery of Art,
Washington, DC; YMSM 34). Whistler was liv-
ing at the Haden home at the time these works
were made. Deborah is reading a book; Haden
is reading a newspaper; and his medical associ-

ate, the surgeon James Reeves Traer, at the far side of the table, is also reading.

Various proofs document Whistler's careful development of light and shadow to structure his image. This proof is particularly dramatic. Haden's collection of etchings by Rembrandt, considered by many to be the greatest artist ever to have worked in etching and drypoint, was available for Whistler's careful study; and Rembrandt's use of dramatic chiaroscuro had a profound effect on Whistler's understanding of the etching medium. Certainly Rembrandt's prints would have been the inspiration for Whistler's illuminated interiors.

The peaceful relationship documented here was not long-lasting. Traer, unhappy in the partnership, took to drink and died quite young, in 1867, by which time Whistler and Haden's relationship had become fragile. Haden's handling of arrangments for Traer's burial infuriated Whistler, and during the course of an argument Whistler pushed Haden through a plate-glass window. The break between Whistler and Haden was final, much to the sorrow of Whistler's mother and sister.

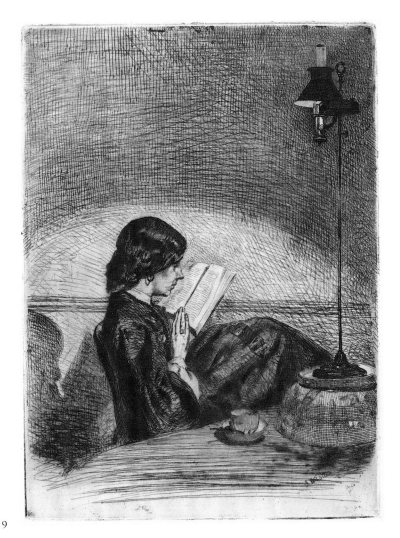

9

11 At the Piano 1858–9

Oil on canvas 67 × 91.6 (26⅜ × 36⅛)
Signed 'J Whistler'
PROV: With Francis Seymour Haden 1859–60; bt from the artist in 1860 by John Phillip, RA, (d.1867); Francis Seymour Haden 1867; Alexander Reid, Glasgow (dealer) 1897; J.J. Cowan, Edinburgh 1897; Sir Edmund Davis, London 1899; Davis sale, Christie, London 7 July 1939 (99), bt Knoedler, London and New York (dealers); Scott and Fowles, New York (dealers) 1939; Mr and Mrs W.T. Semple, Cincinnati 1940; Louise Taft Semple Bequest 1962
EXH: Paris, studio of François Bonvin, May 1859; London, RA 1860 (598); London, Morgan's Gallery 1862 (no cat.); Paris, Salon 1867 (1561); London, ISSPG 1898 (177); Edinburgh, RSA 1899 (143); London 1905 (75); Paris 1905 (2 *bis*); New York and Philadelphia, 1971 (4)
LIT: YMSM 1980 (24); MacDonald 1994 (292)

The Taft Museum, Cincinnatti, Ohio. Bequest of Mrs Louise Taft Semple

Whistler began this painting in November 1858. It shows the same room as depicted in no.10, with Deborah at the piano, watched by her ten year old daughter Annie (later Mrs Charles Thynne). They both also posed for 'The Music Room' of 1860–1 (Freer Gallery of Art, Washington, DC; YMSM 34).

'At the Piano' was finished by the spring of 1859, when Whistler sent it with two etchings to the Paris Salon. Though the etchings were accepted, the painting was not. To make amends for this injustice, the still-life painter François Bonvin hung the picture in his studio at 189 rue St-Jacques, where it was seen and admired by Gustave Courbet. At a stroke, this solemn domestic scene placed Whistler in the camp of the most avant-garde elements in French painting, the Realist followers of Courbet.

The following year 'At the Piano' was hung 'on the line' at the Royal Academy, an indication of the more open attitude towards innovative painting prevailing in mid-Victorian London. There, as in Paris, it was warmly admired by younger artists. No less than three members of the original Pre-Raphaelite Brotherhood – John Everett Millais, William Holman Hunt and William Michael Rossetti – remarked on its rich colour.[1] The President of the Royal Academy, Sir Charles Eastlake, was observed to steer the Duchess of Sutherland to

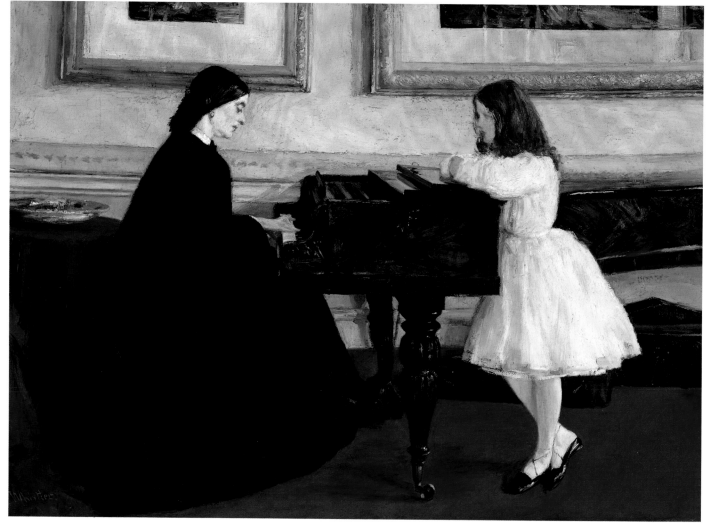

11

the picture with the words, 'There Ma'am, that's the finest piece of painting in the Royal Academy'.[2] In July 1860 the Royal Academician John Phillip purchased the picture from Whistler for £30.

In 'At the Piano', Whistler experiments with both composition and colour. The intimate subject and the compositional grid formed by the horizontal dado and the verticals of the picture frames reflect his close association with Fantin-Latour ('Two Sisters' 1859, fig.39), while the severe use of profile and the shallow pictorial space may owe something to the religious genre subjects of Alphonse Legros, his other colleague in the Société des Trois.

But equally important, the space seems to curve gently inwards at the edges, as Whistler creates two parallel centres of visual interest in the figures of Deborah and Annie. In this way Whistler sought to imitate the principle of the stereoscope (two photographs set side by side viewed through two lenses producing the illusion of three-dimensional perspective).[3] The reviewer for the *Athenaeum* noticed this effect,

remarking that 'if the observer will look for a little while at this singular production, he will perceive that it "opens out" just as a stereoscopic view will'.[4]

In May 1867, after it was finally exhibited at the Paris Salon, the French art critic and art historian Théophile Etienne Joseph Thoré (writing under the pseudonym of Willem Bürger) wrote to Manet asking whether 'At the Piano' was for sale. Thoré, who is credited with the rediscovery of both Frans Hals and Vermeer, explained that the picture would 'go well with my Van der Meer der Delft and other masters'.[5] And surely Degas was thinking of 'At the Piano' when he remarked to Paul Poujaud 'In our beginnings, Fantin, Whistler, and I we were all on the same road from Holland'.[6]

Portraits of women at the piano by both Degas and Manet from the mid-1860s appear to reflect their knowledge of Whistler's picture, as in Manet's 'Mme Manet at the Piano' 1867–8 (Musée d'Orsay, Paris) and Degas's 'Edouard Manet and Mme Manet' c.1865 (Kitakyushu City Museum of Art).

Colouristically, the black and white of the two sitters' dresses is offset by the crimson carpet and deep green of the violin case under the mahogany coloured piano. The green of the painted dado is picked up in the green tint of the walls, relieved by the gold of the frames and blue-green of the dish on the table to the left. Even at this date Whistler creates an overall tonal harmony, a unity of effect quite unlike most paintings to be seen in the Royal Academy.

But to see this painting as though it were merely a formal arrangement of shapes and colours would be misleading. 'The Piano Picture', as Whistler himself called it, refers in a very specific way to the Whistler family and their time together in Russia a decade earlier. Major George Washington Whistler (1800–49) played both piano and flute.[7] Of his surviving children, the only one to inherit his musical talent was Deborah, who played both piano and harp. The journals and letters of Anna McNeill Whistler contain many references to her stepdaughter Deborah's musical performances in St

Petersburg. She noted the 'delightful duets' Deborah played to an 'enraptured' audience on the piano accompanied by her father on flute.[8]

The piano Deborah is playing in the picture seems to be the one on which she played duets with her father in Russia. Immediately after her husband's death in July 1849, Anna shipped the piano to England, presumably to Deborah, while the rest of her household furniture was sent directly to America.[9]

Deborah is depicted wearing mourning, as is Annie, whose short white frock was the appropriate colour of mourning for Victorian children. The look of gravity and solemn concentration in the faces of both mother and daughter, as well as the exquisite tension between the two figures, suggests a mood of reverie cast by the spell of music and memory. In a letter to Deborah in 1859, immediately after painting no.11, James Whistler mentioned that he was 'trying to make a portrait of Father' for his half-brother (Deborah's full brother) George.[10] The location of this portrait is not now known, but its existence confirms that the Whistler children wished to keep their father's memory alive.

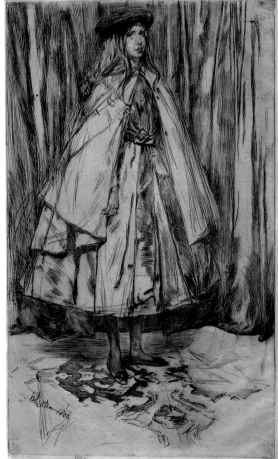

12

12 Annie Haden 1860

Etching and drypoint printed in black ink on buff Japan paper
Plate: 35 × 21.5 (13¾ × 8⅜)
Sheet: 35.9 × 22 (14⅛ × 8⅝)
Signed in plate: 'Whistler 1860' (the 6 reversed)
Signed and inscribed in pencil: 'Rare proof' and butterfly
PROV: Howard Mansfield, New York; Harris Whittemore; gift of William Emerson 1949
LIT: Mansfield 1909 (62); Kennedy 1910 (62 III/III)

Museum of Fine Arts, Boston. Gift of William Emerson 1949

'Annie Haden' is the last of Whistler's four etched portrayals of his niece, born in 1848 to his half-sister Deborah and Seymour Haden. She would have been about twelve years old at the time of the portrait.[1]

The print remained among Whistler's favourites: he annotated an early proof in the New York Public Library as 'one of my very best'; and Kennedy records the artist's comment that he would be willing to rest his reputation as an etcher on 'Annie Haden'. Whistler never cancelled the copper plate, which is preserved at the Hunterian Art Gallery, University of Glasgow.

Whistler's gentle touch reveals not only his affection for Annie, but also his growing interest in describing the character of a model's attire.[2] In his 1886 catalogue Frederick Wedmore referred to Annie's clothing as 'the ugly dress of 1860 ... a soup-plate hat, and her cloak and frock [which] assume the shape of a pyramid ... slight shoes with rosettes.'[3] The importance Whistler placed on details of dress continued to develop, and a decade later, he titled similar standing portraits, not by the name of the models, but by the fabrics of their dress: as for example, 'The Velvet Dress' (no.75).

Here, however, emphasis is given not only to Annie's clothing, but also to the weighty drapery behind her and the patterning of the Oriental rug that establish her environment. It is a similar approach to that taken in the brilliant painting started the following year, 'Symphony in White, No.1: The White Girl' (no.14).

Jo

Joanna Hiffernan was Whistler's model and mistress in the early 1860s. According to the Pennells, Jo's father Patrick Hiffernan, was 'a sort of Captain Costigan' (a drunken Irishman in Thackeray's *Pendennis*), ' "a teacher of polite chirography", who used to speak of Whistler as "me son-in-law" '.[1]

Jo was 'Irish, a Roman Catholic … a woman of next to no education, but of keen intelligence, who, before she had ceased to sit to Whistler, knew more about painting than most painters, had become well read, and had great charm of manner'. Walter Greaves told the Pennells she had a son, Harry, but if so there is no further record of him.[2]

She first posed to Whistler in Paris in 1861, for 'Symphony in White, No.1: The White Girl' (no.14). On their return to London, George Du Maurier described Jo as 'got up like a duchess, without crinoline – the mere *making up* of her bonnet by Madame somebody or other in Paris had cost 50fr. And Jimmy describes all the Parisians on the boulevard as aghast at "la belle Anglaise"!'[3] She remained Whistler's mistress and model for at least five years, posing for some of his most famous pictures (see nos.14–16) etchings, such as 'Weary' (no.19), woodcuts such as 'The Morning before the Massacre of St Bartholomew' and for many beautiful drawings.[4]

Whistler's family had mixed feelings about Jo: Haden objected to the relationship, and when Whistler's mother came over from America, he had to find a *buen retiro* for Jo.[5] His mother begged Whistler to use a bequest from his aunt to settle Jo in independent respectability.[6] She was not received by family or patrons, because they believed that anyone who modelled in the nude, and who was unmarried, was a prostitute. Jo was, however, accepted into artistic circles. The red hair matched the temperament – Du Maurier called her 'the fiery Joe' and she seems to have been the cause of Whistler's quarrel with Legros in 1863.[7]

Whistler was proud of her looks and described her hair to Fantin-Latour as 'le plus beaux que tu n'est jamais vue! d'un rouge non pas doré mais *cuivre* – comme tout ce qu'on rêve de Venitienne!'[8] He let down her hair to show Courbet, who painted her, with hair spread out, looking in a mirror, as 'La Belle Irlandaise' in Trouville in 1865. He painted four versions of the picture, including ones in the Nelson Gallery-Atkins Museum, Kansas City, and in Stockholm. Years later Courbet wrote to Whistler, 'Do you remember Trouville and Jo who clowned around to amuse us? In the evenings she used to sing Irish songs so beautifully, she had a feeling and talent for art' (see no.41). In 1867, when Whistler was away in Valparaiso (having made a will in Jo's favour) Jo went over to Paris and posed as one of the two nudes in Courbet's erotic painting 'Le Sommeil' (Musée du Petit Palais, Paris). It is assumed she had an affair with Courbet – and certainly, shortly after Whistler's return from Valparaiso, they parted, apparently without bitterness.

She remained in London, and the Pennells say that she adopted Whistler's son 'John', whom Whistler called 'an infidelity to Jo'.[9] His son, Charles Hanson (not 'John'), was born in 1870, and apparently went to live with Jo in Thistle Grove. Jo

was still looking after Charlie in 1880 while Whistler was away in Venice with her successor, Maud Franklin.[10]

Information on Jo's later years is conflicting. On 18 December 1882, Juliette Courbet wrote from Nice, in the South of France, that she had seen 'the beautiful Irish girl ... who sells antiques and has some of Gustave's pictures'. This woman had lived in the south ever since the Franco–Prussian war of 1870, was married and kept open house 'for artistic celebrities from Paris'.[11]

There are also stories of Jo becoming or calling herself 'Mrs Abbott'.[12] Whistler's second name was Abbott, but he had given up using it, and Maud Franklin, who succeeded Jo, later married R.H.S. Abbott, an American, and went to live near Cannes. Stories of Mrs Abbott and someone selling Whistler drawings in the South of France may refer to Maud rather than Jo.

After Whistler's death in 1903, his body was laid out in his house in Cheyne Walk. The great American collector Charles L. Freer recorded that he was asked to receive visitors. The bell rang and he opened the door to let in a woman: '[she] raised her veil and I saw the dark eyes and the thick wavey hair, although it was streaked with gray. I knew at once that it was Johanna ... She stood for a long time beside the coffin – nearly an hour I should think. I noticed that she was richly dressed and I felt that the world had gone well with her.'[13]

R.D. and M.M.

13

13 Jo 1861

Drypoint printed in black ink on oatmeal wove paper
Plate: 22.7 × 15 (8^{15}/$_{16}$ × 5^{7}/$_{8}$)
Sheet: 38.2 × 27.8 (15^{1}/$_{8}$ × 10^{15}/$_{16}$)
Signed in plate: 'Whistler | 1861'
Signed in pencil: 'Whistler' followed by butterfly
PROV: Gift of Samuel Putnam Avery
LIT: Kennedy 1910 (77) (only state)

S.P. Avery Collection, The Miriam and Ira D. Wallach Division of Art, Prints and Photographs, The New York Public Library, Astor, Lenox and Tilden Foundations

'Jo' is surely one of Whistler's most dazzling portraits in any medium. This is a very different rendition from two other etchings of her, 'Weary' (no.19), and 'Jo's Bent Head' (K 78). Here we see Jo in full face, up close, with suggestions of the effervescent personality that drew not only Whistler to her, but also Courbet.

A sense of immediacy is beautifully portrayed in drypoint, the process by which Whistler drew with a needle-sharp tool, incising his lines directly into the copper. Moving swiftly, as with pencil on paper, the pressure demanded by the hard metal contributes to the specific energy of the drypoint line. Here, in one of the earliest impressions, the burr of copper that encloses each line of the incised likeness is at its strongest, and prints with a velvety blackness.

The overall composition of 'Jo' gives added weight to the richness of drypoint effects, highlighting her strongly defined lips and nose, her piercing gaze, and the glorious waves of her long reddish hair, that are portrayed in full colour in 'Symphony in White, No.1: The White Girl' (no.14).

According to Wedmore, 'very few impressions of what would have been quite a favourite subject had been taken when the plate was destroyed'.[1] The uniqueness of this print is amplified by the oatmeal paper, a type admired in Rembrandt's prints, but one Whistler rarely used. The pencil signature was added later, about 1875.

14 Symphony in White, No.1: The White Girl 1862

Oil on canvas 214.6 × 108 (84½ × 42½)
Signed and dated 'Whistler, 1862'
PROV: Bt from the artist by his half-brother George Whistler 1866, but not delivered at the time of his death in 1869; by descent to Thomas Delano Whistler, Baltimore, Maryland 1875; Boussod, Valadon & Co., New York (dealers) 1895; Harris Whittemore, Naugatuck, Conn. 1896; his father, John Howard Whittemore 1897; J.H. Whittemore Co. 1910; Harris Whittemore Jr and his sister Mrs Charles H. Upson 1941; presented to the National Gallery of Art, Washington 1943
EXH: London, Berners Street 1862 (42); London, Willis's Rooms 1863; Paris, Salon des Refusés 1863 (596); Paris, Soc. Nat. 1863 (catalogue untraced); Paris, Exp. Univ. I 1867 (68) and II 1867 (75); Baltimore 1876 (catalogue untraced); New York (I) 1881 (60); New York II 1881 (catalogue untraced); New York I 1894 (252) – 1895 (253); New York 1898–9 (254); Boston 1904 (71); London 1905 (37); Paris 1905 (4); Chicago & Utica 1968 (3); New York & Philadelphia 1971 (12)
LIT: YMSM 1980 (38)

National Gallery of Art. Washington, Harris Whittemore Collection

Whistler painted this full-length life-sized portrait of Joanna Hiffernan in a studio at 18 boulevard Pigalle in Paris during the winter of 1861–2, posing her in a neutral, shallow space against a window covered in a white curtain, with more strong light playing on the figure from the right.

In an age of crinolines, Jo wears a simple white cambric dress. Described by one critic as a 'morning dress' it is not unlike the loose-fitting gowns worn by the Pre-Raphaelite models Elizabeth Siddal and Jane Morris, possibly falling in soft pleats from the shoulder at the back, as in a similar dress seen in photographs of Jane Morris of around 1865.[1] To compound the association with the most avant-garde elements in English painting, Jo grasps a white lily, the ultimate Pre-Raphaelite accessory. The only notes of colour are found in the mass of unbound copper coloured hair falling over her shoulders, and in the blue patterned carpet, covered in a wolf's skin rug.

Even before Whistler submitted the painting along with no.39 to the Royal Academy in 1862, it had created a stir. On 9 April, Jo wrote from London to the American art dealer George Lucas in Paris: 'The White Girl has made a fresh sensation – for and against. Some stupid painters don't understand it at all while Millais for instance thinks its splendid, more like Titian and those of old Seville than anything he has seen – but Jim says for all that, perhaps the old duffers may refuse it altogether.'[2]

They did. On its rejection, Whistler sent it to Matthew Morgan's gallery in Berners Street, London, where it was exhibited under the title 'The Woman in White' alongside the works of other young and not so young Victorian painters including William Powell Frith, Augustus Leopold Egg, Edward Ponyter, and Daniel Maclise. Here it was seen by the critic (and original member of the Pre-Raphaelite brotherhood) Frederic George Stephens. In a generally appreciative review in the *Athenaeum* Stephens criticised the picture on the grounds that 'The face is well done, but it is not that of Mr. Wilkie Collins's *Woman in White*.' In the first of a lifetime of letters to the press, Whistler replied that he had never read Collins's mystery-thriller, a sensational bestseller during 1859–61. The picture, he wrote, 'simply represents a girl dressed in white standing in front of a white curtain'. Yet the controversy (and the publicity) did not displease the painter, who now declared 'open war on the Academy.' The Morgan gallery catalogue was marked 'Rejected at the Academy' and posters advertised 'Whistler's Extraordinary picture *The Woman in White*'.

The following year he submitted the picture to the Paris Salon. Again it was rejected, along with 4,000 other paintings. In response to a chorus of criticism, the Emperor set up the famous Salon des Refusés. 'The White Girl' hung in the Palais d'Industrie, surrounded by 1,200 other works, including those by Jongkind, Cézanne, Pissarro and Manet. Once again it created a scandal, one which rivalled even that of Manet's 'Déjeuner sur l'herbe' in the same exhibition.

In May 1863 Fantin-Latour wrote excitedly to Whistler with the news that Legros, Manet, Bracquemond, Baudelaire and Courbet had all admired his picture. 'Now', he concluded, 'you are famous.'[3] Most critics took the 'White Girl' seriously, although, as in London, not one found it possible to discuss the picture in purely pictorial terms. Jules Antoine Castaganary saw in it the depiction of a young woman on the morning after her bridal night, 'the troubling moment when the young woman questions herself and is astonished at no longer recognizing in herself the virginity of the night before'.[4]

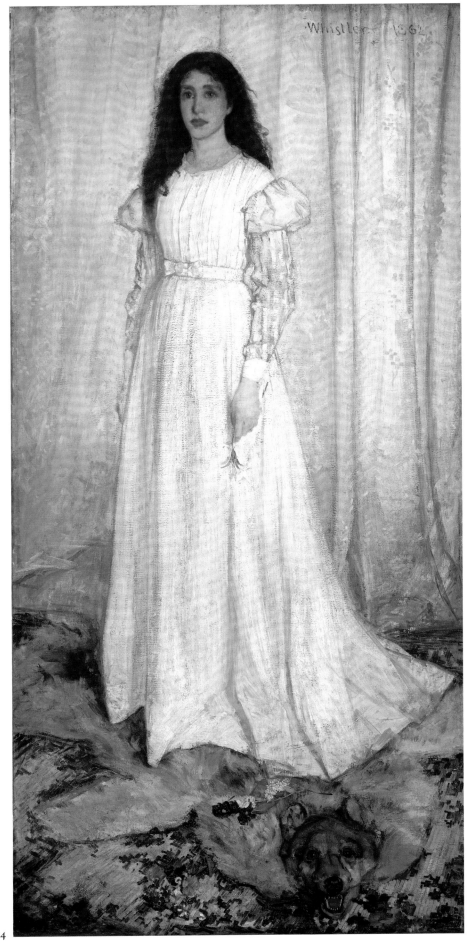

14

Paul Mantz, in the conservative *Gazette des Beaux-Arts*, astutely compared the picture to studies by Jean-Baptiste Oudry of white objects against white backgrounds, and dubbed the portrait a 'Symphonie en blanc'. But his prose then turned purple, as he enthused over this 'strange white apparition ... with her dishevelled hair, her great eyes swimming in ecstasy, her languid pose and that petalless flower in the fingers of her trailing hand'. To Théophile Thoré (Willem Bürger) it was 'a vision' and to Fernand Desnoyers 'the portrait of a spirit, a medium'.[5]

But the reaction that tells us most about the picture is Courbet's. Fantin-Latour reported that the older artist called his picture 'an apparition' — and, added Fantin, 'this annoys him'.[6] In Courbet's eyes, the picture's air of mystery and spiritual intensity constituted a blemish. This response is ironic, since Whistler seems to have considered the 'White Girl' an exercise in Courbet's uncompromising realism. Even Manet is less extreme in his pursuit of visual truth than Whistler is here.[7]

The key to reading the portrait lies in Jo's stance and expression. Whistler intended that his model's face should *lack* expression, that Jo should assume the facial equivalent of the non-colour, white. This explains why her hands fall listlessly by her side, in the words of a contemporary, Ernest Chesneau, 'sans grâce, mais non sans élégance'.[8] Jo's wide staring eyes register nothing; her mouth falls slack because Whistler sought to reduce the importance of her facial expression. Whistler tries to eliminate the possibility of reading an emotional reaction of any sort into the model's countenance.

The picture makes no concessions to a nineteenth-century audience's expectation of narrative. If one compares it to Manet's full-length 'The Street Singer' of virtually the same date (Museum of Fine Arts, Boston) where the viewer is allowed to imagine he is seeing an actual singer standing in a doorway, the radical nature of Whistler's realism becomes clear. Whistler's painting has no subject — or rather, its subject is so blatant that the critics were unable to see it: a model posing in an artist's studio.

Unfortunately for Whistler, the picture fell easily into mid-Victorian conventions for depicting the fallen woman, whether in Holman Hunt's 'Awakening Conscience' 1853 (fig.40), where the redeemed sinner's unbound hair and look of ecstatic transport suggests her affinity to Mary Magdalene, or in Dickens's character of the suspected adulteress Mrs Strong described by David in *David Copperfield* (1850) as having 'such a face as I never saw. It

was so beautiful in its form, it was so ashy pale, it was so fixed in its abstraction, it was so full of a wild, sleep-walking, dreamy horror of I don't know what. The eyes were wide open, and her brown hair fell in two rich clusters on her shoulders, and on her white dress.'[9]

And though there is no character or incident in Collins's *Woman in White* which parallels Whistler's figure, the plot of his other masterpiece, *The Moonstone* revolves around mesmerism and sleepwalking. Nor is it surprising that Whistler's picture should have been interpreted as a portrait of a medium. The craze for both spiritualism and table rapping (in which Jo and Whistler both participated) swept Rossetti's circle in the 1860s.[10] In January 1863 Du Maurier used the 'White Girl' as the primary visual source for his illustration to Collins's 'The Notting Hill Mystery' published in *Once a Week* (fig. 41).

The critical reception accorded to the 'White Girl' on its first exhibition in London and Paris represents the first and most significant instance of the way Whistler's aesthetic intentions were distorted by literary readings. Though it was never exhibited during Whistler's lifetime under the title 'Symphony in White, No.1', the designation of a 'Symphony in White, No.3' shows that Whistler was himself referring to the picture under this title by 1867 (see no.16).

15 Symphony in White, No.2: The Little White Girl 1864

Oil on canvas 76.5 × 51.1 (30⅛ × 20⅛)
Signed 'Whistler'
PROV: Gerald Potter 1865; A.H. Studd 1893; bequeathed to the National Gallery, London 1919 and transferred to the Tate Gallery 1951
EXH: London, RA 1865 (530); London, Int. Exh. 1872 (260); London, Goupil 1892 (33); Munich 1892 (1950a); Glasgow 1893; Antwerp 1894 (2369); Venice 1895 (363); Paris, Exp. Univ. 1900 (76 in US section); Edinburgh 1902 (240); Boston 1904 (28); Paris 1905 (5)
LIT: YMSM 1980 (52)

Tate Gallery, London. Bequeathed by Arthur Studd 1919

This picture was exhibited at the Royal Academy in 1865 as 'The Little White Girl'. By 1867 Whistler had given it the additional title of

'Symphony in White no.II'.[1] The two titles might serve to symbolise Whistler's evolving aesthetic position, and to reflect his gradual disillusion with the earthy Realism he found in Courbet's pictures.

As early as 1855 Baudelaire had complained of Courbet's 'feud with the imagination.'[2] Thoré-Bürger's main reservation about the young Realist painters he saw and praised in the Salon des Refusés in 1863 was that they had 'very little refinement and no taste'. He added that 'the misfortune is that they have scarcely any imagination and … they despise charm.'[3]

After 1863 it is as though Whistler set out to add these ingredients to his pictures. The painting shows Joanna Hiffernan gazing into the mirror over the chimney piece in a room in Whistler's house in Lindsey Row. Gone is the Oriental bric-a-brac of the 'Lange Leizen' (no.22), replaced by carefully selected colour notes in the red and blue of the porcelain on the mantel and in the spray of azalea in the foreground. Jo holds a 'fixed' Japanese fan, of a type made for export to the European market, against her white dress. The restrained and harmonious effect reveals a deeper assimilation of the underlying principles of Japanese art.

The sense of mystery and ambiguity, the suggestion of a story there to be told, which Whistler denied existed in 'The White Girl', he flaunts in 'The Little White Girl'. The wedding ring Jo conspicuously displays on the ring finger of her left hand draws attention to an implied narrative within the picture, even if the spectator is finally denied a Victorian 'subject' of the sort beloved of Royal Academicians.

In April 1865, after it was completed but before the picture left the studio for exhibition at the Royal Academy, the poet Algernon Swinburne composed a verse ballad, 'Before the Mirror' in homage to its beauty.[4] The connection between poem and painting is not the conventional one in Victorian art, in that the one does not illustrate the other. Instead, Swinburne goes to the heart of a work of art by producing a parallel masterpiece which, in its own way, is just as mysterious, just as incomprehensible, as its source of inspiration.

> Come snow, come wind or thunder,
> High up in air,
> I watch my face, and wonder
> At my bright hair;
> Nought else exalts or grieves
> The rose at heart, that heaves
> With love of her own leaves and lips that
> pair.
>
> She knows not love that kissed her
> She knows not where.

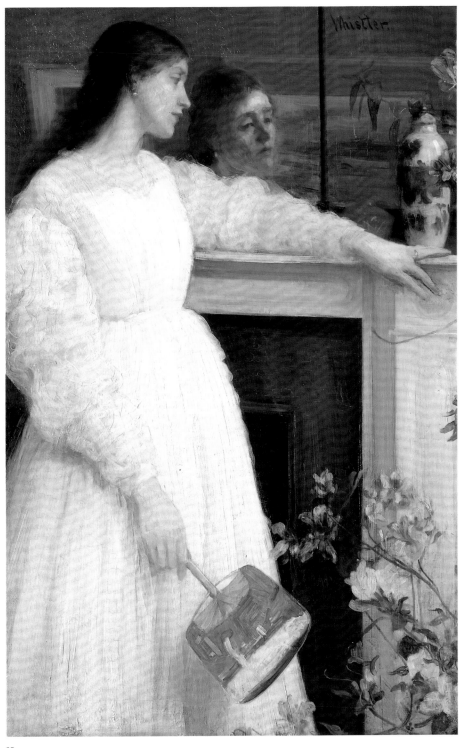

15

Art thou the ghost, my sister,
White sister there,
Am I the ghost, who knows?
My hand, a fallen rose,
Lies snow-white on white snows, and takes
 no care.

'I cannot see what pleasures
Or what pains were;
What pale new loves and treasures
New years will bear;
What beam will fall, what shower,
What grief or joy for dower;
But one thing knows the flower; the flower
 is fair.'

Glad, but not flushed with gladness,
Since joys go by;
Sad, but not bent with sadness,
Since sorrows die;
Deep in the gleaming glass
She sees all past things pass,
And all sweet life that was lie down and
 lie.[5]

Whistler had this poem printed on gold paper, then pasted onto the frame before exhibiting the picture at the Royal Academy.[6] In this way he emphasised the picture's theme of reverie and regret, a theme which allows us to compare it to such high Victorian genre subjects as R.S. Stanhope's 'Thoughts of the Past' 1859 (fig.3 on p.15). Whistler so esteemed the poem that he later described it as 'a rare and graceful tribute from the poet to the painter – a noble recognition of work by the production of a nobler one.'[7]

On both sides of the Channel, links between poetry and the written word were particularly rich in the 1860s. Rossetti's inscription of his own verses on the frame of his 'Lady Lilith' of 1864–8 (Delaware Art Museum, Bancroft Collection) is a well-known example, and at the Salon of 1865 the first five lines of a Baudelairian poem by Zacharie Astruc were inscribed on the label of Manet's 'Olympia'.[8]

Whistler stands at the heart of these artistic and stylistic crosscurrents. Swinburne went so far as to attempt to interest the powerful British critic John Ruskin in Whistler's Frenchified art, and Whistler, in return, introduced Swinburne to Manet[9]: two gestures of cultural cross-pollination which, it must be said, conspicuously failed to bear fruit.

It was not until August 1867 that Whistler finally wrote his famous letter to Fantin-Latour utterly repudiating Courbet's realism and stating his wish to have studied with Ingres, a retrospective of whose work was then being shown in Paris. He had also seen an earlier retrospec-

tive of Ingres's paintings which was at the Exposition Universelle at the time of his arrival in Paris as a young student in November 1855. Whistler's 'Little White Girl' may owe something to Ingres's portrait of the Comtesse d'Haussonville 1845 (Frick Collection, New York), though a more immediate visual source is to be found in an anonymous etching 'Before the Mirror' (fig.42).

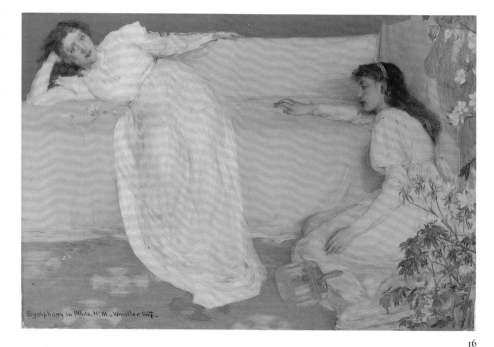

16

16 Symphony in White, No.3 1865–7

Oil on canvas 51.1 × 76.8 (20¼ × 30⅛)
Inscribed, signed and dated 'Symphony in White. No. III. – Whistler. 1867–' (the figure 7 being written over a 5)
PROV: Louis Huth; Edmund Davies 1899; his sale, Christie, London 7 July 1939 (100), bt Barber Institute
EXH: London, RA 1867 (233); London, Society of French Artists 1873 (112); Brussels 1884 (3); London, Goupil 1892 (2); London 1905 (7)
LIT: YMSM 1980 (61); MacDonald 1994 (323)

The Barber Institute of Fine Arts, The University of Birmingham
[Exhibited on London only]

In August 1865 Whistler sent Fantin-Latour a sketch and detailed description of this painting when the artist considered the picture almost finished, with the figure on the right 'tout ce que j'ai fait de plus pur.'[1] Work on the picture was interrupted by Whistler's dash for Valparaiso between February and September 1866. On his return he reworked the painting, notably the figure of the girl seated on the floor, before redating and exhibiting it at the Royal Academy in May 1867.

The picture shows Joanna Hiffernan at the left, wearing the white dress she wore in 'The Little White Girl' (no.15). Seated on the floor is a professional model named Milly Jones, the wife of the actor Stuart Robson. Another exercise in white on white, the potential austerity is relieved by salmon pinks and oranges in the fan, pale purple flowers among the white azaleas, and a sky-blue durrie rug.

Early in 1867 Whistler's brother took 'Symphony in White, No.3' to Paris. Fantin, writing on 12 February of that year, congratulated Whistler on the picture's success. He admired it wholeheartedly, apart from a certain 'vagueness', which, he said, made it look 'like a

dream'. But this was a minor fault. Fantin thought Jo's head the best Whistler had ever done, and added that although Manet had not yet seen the picture, he had been told by the Belgian painter Alfred Stevens how good it was. Tissot, too, was 'like a madman' over it: he had 'jumped for joy'. He also warned Whistler to 'wait for these two gentlemens' imitations.'[2]

Whistler did not have to wait long. Though Manet himself paid Whistler the compliment of imitation in his famous portrait of Berthe Morisot, 'Repose' 1870 (Museum of Art, Rhode Island School of Design), the first artist directly to be inspired by 'Symphony in White, No.3' was Degas. In a sketch of the picture, drawn either from Whistler's sketch in the letter to Fantin or else from the picture itself during the winter of 1867, Degas effortlessly (and, one feels, instinctively) corrected its major fault, the awkward pose assumed by the model on the floor.[3] Degas shifts her weight onto her left arm, which now supports her body, and allows the right arm to swing easily across her lap. Clearly, what had interested Degas was the formal relationship between two women occupying different levels of the same space. When he came to adopt Whistler's composition for his canvas 'Mlle Fiocre in the Ballet "La Source"' 1866–8 (Brooklyn Museum) he altered both poses so fundamentally that it is hard to see Whistler's picture as a direct visual source.

For Whistler's own visual source, one should not rule out Delacroix's 'Women of Algiers in their Apartment' 1834 (fig.4 on p.16) which had been exhibited in Paris in 1864, as the inspiration for the languorous woman seated on the floor. Though one cannot point to it as a for-

17

mal source for any single figure in 'Symphony in White, No.3', as in the 'Six Projects' (see pp.92–4) and 'The Balcony' (see no.24), Whistler was intensely aware of the art of both Delacroix and Ingres and may have been seeking to unite the draughtsmanship of the one with the sensuous painterly qualities of the other.

A more immediate source of inspiration is that of the English painter Albert Moore, whom Whistler met in 1865. In his letter to Fantin of 17 August 1865 he proposed that Moore replace Legros as the third member of the Société des Trois, announcing that the three of them would carry on the 'true tradition of 19th century painting' – a tradition which embraced Delacroix, no less than Ingres. Moore's 'The Marble Bench' (whereabouts unknown), exhibited at the Royal Academy in 1865, showed three girls in white draperies seated or reclining on a white marble bench. An early sketch for 'Symphony in White, No.3' (Munson-Williams-Proctor Institute, Utica; M 323) is also closely related to Albert Moore's 'The Musician' 1867 (Yale Centre for British Art, New Haven).

This was the first of Whistler's pictures to be exhibited under a musical title. The critic of the *Saturday Review*, P.G. Hamerton, who had savaged 'The White Girl' in his review of the Salon des Refusés in 1863, announced that it was 'not precisely a symphony in white' in as much as he could spot notes of yellow, brown, blue, red and green in the composition. Whistler's exasperated retort is justly celebrated: 'does [Hamerton] then … believe that a symphony in F contains no other note, but shall be a continued repetition of F,F,F? … Fool!'[4]

17 The Sleeper c.1863

Chalk on white wove paper laid down
24.9 × 17.6 (9¹³⁄₁₆ × 6¹⁵⁄₁₆)
Signed 'Whistler'
PROV: Whistler's attorney, James Anderson Rose, London; his sale Christie, London 5 May 1891 (112); bt Dowdeswell, London (dealers) B.B. MacGeorge, Glasgow by 1905; his widow, Mrs B.B. McGeorge; Annan & Sons, Glasgow (dealers) 1924; Colnaghi, London (dealers) 1924–5; Martin Birnbaum; Mrs Esther Slater Kerrigan 1927; her sale, Parke Bernet, New York 8–10 Jan. 1942 (32); Scott and Fowles, New York; R.S. Clark 1942
EXH: London 1905 (184); Chicago & Utica 1968 (77)
LIT: MacDonald 1994 (309)

Sterling and Francine Clark Art Institute, Williamstown, Massachusetts

This drawing and no.18 are two similar studies of Joanna Hiffernan. Both are related to the etching 'Weary' (no.19), although they show Jo asleep, rather than resting. This is perhaps the most relaxed of the poses, where Jo's hand rests in her lap. If she was really asleep, then by drawing her, Whistler was taking advantage of the situation to gain several extra hours posing from his model.

In the delicately drawn face, Whistler used the silvery quality of charcoal to the full. The lines lightly criss-cross the surface, going three or four ways across the figure, getting heavier as shapes are defined, and achieving the dense richness of velvet in dark areas. In addition, there is systematic scraping over her arms, in the shadow on the right, and in the spreading mane of her hair, round her head, and across her breast.

The drawing is splendidly rich in texture, profiting from the grain of the heavy weight paper. The paper is now uneven and ragged, and may have been trimmed, cutting off part of the drawing at each side.

18 Sleeping woman c.1863

Chalk and charcoal on cream wove paper
laid down on card 25.4 × 17.6
(10 × 6¹⁵⁄₁₆)
Signed 'Whistler'
PROV: Whistler's attorney, James
Anderson Rose, London; his sale,
Christie, London 5 May 1891 (112), bt
Dowdeswell and Dowdeswell, London
(dealers); B.B. MacGeorge, Glasgow by
1905; Harris Whittemore (1864–1927),
Naugatuck, Conn.; his estate; Parke-
Bernet, New York 19–20 May 1948 (153,
repr.), bt Rosenbach Company,
Philadelphia; L.J. Rosenwald (1891–1971)
of Philadelphia 1948; given to the
National Gallery 1943
EXH: London 1905 (183); London,
Liverpool & Glasgow 1976 (46)
LIT: MacDonald 1994 (310)

*National Gallery of Art, Washington. Rosenwald
Collection*

This is one of two studies related to the etch-
ing 'Weary' (no.19); see also no.17. Although it
is closer to the etching, there are radical differ-
ences in dress and pose. The drawing shows Jo
with a dark jacket open to reveal her white
blouse over a full skirt; in the etching, her dress
has a tight bodice and puffed sleeves. Her head
is bent, and her face appears more youthful and
plump than it does in the etching. Her hands,
barely visible in the etching, are folded.

Both drawings were elaborately worked, with
long lines imitating the sweep of the drypoint
needle, but the luminous quality of the dress
and rippling hair of the drypoint are absent.
Here, the skirt is less heavily worked, and the
crayon skates over the paper. The paper has a
knobbly grain, used to good effect in the soft
parts of the skin.

The hair is drawn with fine, fluent lines, and
then scraped lightly with a knife to make even
finer waves and give a softer effect. The face was
criss-crossed with chalk applied with infinite
delicacy. Whistler worked over the skirt with a
soft black chalk to give additional richness and
texture. Hard fragments in the chalk vary the
softness of the line.

19 Weary 1863

Drypoint printed in black ink on thin,
transparent Japanese paper
Plate: 19.6 × 12.8 (7¾ × 5)
Sheet: 27.3 × 17 (10¾ × 6⅝)
Signed and dated in plate: 'Whistler |
1863'
PROV: Gift of William Loring Andrews
to the Metropolitan Museum of Art,
New York 1883
LIT: Mansfield 1909 (92); Kennedy 1910
(92 11a/111); Lochnan 1984, pp.149–50;
MacDonald 1994 (304–5)

*The Metropolitan Museum of Art, New York.
Gift of William Loring Andrews, 1883*

'Weary' is one of the most famous of Whistler's
etchings and marked the culmination of a peri-
od of productivity in etching and drypoint in
the 1860s. Again it shows Joanna Hiffernan.
Where 'Jo' (K 77) showed her wide awake and
looking directly at the spectator, 'Jo's Bent
Head' (K 73) showed her in profile, looking
down, thoughtfully, and in 'Weary' she was
resting, her glorious red-gold hair spread over
the rounded back of the chair.

At this time Whistler was very closely asso-
ciated with the Pre-Raphaelites, Dante Gabriel
Rossetti, Algernon Swinburne, and Frederick
Sandys. His home at 7 Lindsey Row, where he
had moved in March 1863, was close to Rosset-
ti's in Cheyne Walk in Chelsea. He had every
opportunity to see Rossetti's drawings of Fanny
Cornforth, including a study of Fanny reclining
of c.1862 which is similar in pose and mood to
Whistler's etching of Jo.[1]

He could also have known Rossetti's poem
about a prostitute, 'Jenny', which was written in
1858 and revised over the next decade:

> Why Jenny, as I watch you there
> For all your wealth of golden hair
> Your silk ungirdled and unlaced…[2]

It would be untrue to call Jo's trim and round-
ed bust, as seen in 'Weary', 'ungirdled and
unlaced', but her relaxed pose and the infor-
mality of the scene suggest the closeness of
their artist/model relationship.

In the drypoint, Jo is seen with her hair
spread out in a great aureole around her, as if
she had been asleep. Her fine profile is slightly
raised, as if she is just awakening. With her
beauty, the glossy textures of her dress and hair,
she was voluptuous and tempting, a Danae
newly awakened.

The clarity and richness of this impression
are remarkable. The luminous, slightly shiny

18

19

surface of the Japan paper, reserved for Whistler's finest proofs, complemented the fine, fragile, drypoint lines. It set off the richness of the darker areas with a glowing, golden aura. The flickering lines, and the glow of the paper suggest firelight. The darkness of the room evokes the intimacy of evening.

The strength of the image here is an indication that this is a very early impression, enhanced by Whistler's use of an extremely thin Japanese tissue, the most receptive paper of all to the nuances of drypoint and etching.[3]

'Weary' is one of Whistler's best-known etchings and one of his last works on copper before a hiatus of involvement with this medium, lasting until 1870, interrupted only by the execution in 1867 of one etching, 'Shipping at Liverpool (K 94)'. Whistler's break in his work with the etching needle undoubtedly was in some measure due to the break in his relations with Seymour Haden, to which Jo was a contributing factor.

20

20 Draped figure seated, holding a fan 1865–8

Crayon on off-white laid paper with watermark 'DEDB' (De Erven de Blau)
34.9 × 22.3 (13¾ × 8¾)
Inscribed, possibly by H. Wright of P. & D. Colnaghi & Co., 'Whistler. – Draped figure, seated, holding fan (?Jo?).'
PROV: Bequeathed by Whistler to his sister-in-law, Miss R. Birnie Philip 1903; bequeathed to the University of Glasgow 1958
LIT: MacDonald 1994 (327)

Hunterian Art Gallery, University of Glasgow, Birnie Philip Bequest

These two drawings (nos.20, 21) are closely related, and have the same watermark. In this case, behind the graceful seated woman is another faint figure, a seated woman holding a drooping fan. Long, finely folded robes envelope and conceal the figure.

There are a number of similar studies of women in robes gathered in at the neck, or falling from one shoulder, in semi-classical fashion.[1] The women are doing nothing specific, and in no obvious setting. A certain level of culture – the appreciation of art and music – is implicit. One sketch, now in the Hunterian Art Gallery, shows a woman listening to music, and another suggests a group of women on benches, gathered around to talk or listen – perhaps to music.[2]

No figure composition in oils is known to have resulted from these early sketches, but much of Whistler's work was destroyed by him (see no.47) or was sold at his bankruptcy in 1878, and such drawings as have survived only hint at his activities in the late 1860s.

21 Study of a draped reclining woman 1865–8

Pencil on white laid paper with
watermark of 'DEDB' (De Erven de Blau)
22.8 × 22.2 (9 × 8¾)
PROV: Bequeathed by Whistler to his
sister-in-law Miss R. Birnie Philip 1903;
bequeathed to the University of Glasgow
1958
EXH: London, Liverpool & Glasgow
1976 (47)
LIT: MacDonald 1994 (326)

*Hunterian Art Gallery, University of Glasgow,
Birnie Philip Bequest*

21

In this relaxed figure there are reminiscences of
illustrations Whistler drew in 1862. She echoes
the weary introspection of the woman in 'The
Morning before the Massacre of St
Bartholomew', or of Joanna Douglas in 'The
Trial Sermon' (fig.44).[1] In each picture,
Whistler chose not a moment of action, but of
reflection. The real Joanna Hiffernan posed for
the figure of this other Joanna. She may well
have posed for this equally contemplative draw-
ing, which dates from several years later.

It may have been a preliminary study, con-
nected with the painting 'Symphony in White,
No.3' (no.16) which Whistler was working on
from about 1865. However, in the painting the
models (Joanna Hiffernan and Milly Jones)
wore dresses of the period, with puffed and
gathered sleeves and narrow waistbands. In this
drawing, the costume is almost featureless, sug-
gesting no period or country, except for a hint
of classical antiquity in the way it is gathered
around the neck and at her shoulder.

Whistler was then living in Lindsey Row,
near Dante Gabriel Rossetti, and although his
drawings do not derive directly from Rossetti's
compositions, there are similarities in poses,
costume, and technique. In a series of long
curving lines Whistler sought to describe the
generous roundness of the figure, the shape of
folds falling heavily over the chair. The exag-
gerated curves and relaxed languor of the
woman's body, and the soft, repeated lines
which caress her dress, are reminiscent of Ros-
setti's drawings.

At the Royal Academy in 1865, Whistler
exhibited his most Pre-Raphaelite painting,
'Symphony in White, No.2: The Little White
Girl' (no.15), with two Oriental compositions.
The exhibition marked a turning point in his
work. Also in the Academy was Albert Moore's
painting 'The Marble Seat',[2] showing figures in
classical robes in an unspecific arcadian setting.
Whistler was impressed with Moore's work,

and they became close friends. He was deeply
influenced both by Moore's subject matter and
his technical skill. He introduced Moore to
Japan while Moore directed him towards
Greece and Rome.

In the same exhibition of 1865, among a vari-
ety of religious and classical subjects, Frederic
Leighton exhibited his 'Helen of Troy' (private
collection) and 'David' (fig.43). While the three
statuesque women in recognisably classical
robes in 'Helen of Troy' were in the long term
more directly related to Whistler's figure stud-
ies (see no.27), it was, curiously enough, the
massive David which in pose and costume
found a feminine equivalent in this drawing by
Whistler.[3] Whistler never admitted any debt to
Leighton, but his work, like Moore's, was a
major factor in the new classicism in art.

The neo-classicism of the eighteenth and
early nineteenth century found new impetus
with the systematic excavations at Pompeii
started in 1861. Whistler's friends and patrons,
the Ionides, were among the first to acquire
tanagra statuettes in Greece. Antique settings,
costume and accessories appealed to an educat-
ed public. Classical subjects were ennobled by

the distance of time and place. The ancient
world was seen with the eyes of the nineteenth
century, and used to reflect and illuminate the
contemporary world.

Artists depicted real and imaginary episodes
in antiquity with varying levels of 'authenticity'.
Edward Poynter and Lawrence Alma-Tadema
were arch-exponents of the genre. Leighton was
torn between classicism as subject, and as the
means to escape from the subject. Moore and
Whistler consistently developed towards a new
aestheticism, 'art for art's sake'. Classicism dis-
tanced them from the constraints of specific
subjects, costumes, periods, and even emotions.

In his 'Ten O'Clock' lecture in 1885 (see
no.96) Whistler picked out the greatest
moments in art. To the Greek, he said, the
Goddess 'yielded up the secret of repeated line,
as, with his hand in hers, together they marked
in marble, the measure rhyme of lovely limb and
draperies flowing in unison'.[4]

Repeated line is the hallmark of his drawings
in the 1860s, and drawings such as nos.20 and 21
show his assimilation of the art of antiquity.

Japonisme

Though Whistler would have been able to see a variety of Japanese manufactured goods at the International Exhibition in London in 1862, the 'Japanese Mania' did not begin until towards the middle of the following year. William Michael Rossetti recalled that then 'Mr Whistler ... first called my brother's attention to Japanese art: he possessed two or three woodcut books, some coloured prints, or a screen or two.'[1]

Rossetti goes on to say that Whistler had his 'revelation' in 'the Impressionist Circle' in Paris. There he began to collect blue and white china, fans, silks and bronzes. Like his contemporaries Fantin-Latour, Tissot, Bracquemond and Manet, he bought these articles at La Porte Chinoise at 36 rue Vivienne and at the establishment of E. Desoye in the rue de Rivoli.

As gradually he became aware of the prints of Hokusai and Horishige, his understanding of the principles of Japanese composition enlarged. For approximately ten years, between 1864 and 1874, this increasing sophistication can be traced in his landscapes and figure studies. At the beginning of the period he painted the 'Lange Leizen' (no.22) and 'Caprice in Purple and Gold: The Golden Screen' (fig.6 on p.16; YMSM 60), picturesque compositions in which he used Japanese accessories to create a superficial exoticism in an otherwise conventional Victorian genre scene.

In the 'Six Projects', begun in 1867, he used Japanese parasols and fans to disguise the much more profound influence of classical Greek art (see pp.92–4). Through the art of Japan Whistler sought both to avoid the superficialities of academic neo-classicism, and to re-assert the true classical tradition: the search for balance and the relentless simplification of form. The use of Japanese accessories and compositional devices insured that the toga-clad women in the 'Six Projects' would not be confused with similar figures in the sterile neo-classical machines of painters such as Jean-Léon Gérôme or Lawrence Alma-Tadema.

By the early 1870s (nos.46, 60) Whistler had assimilated the fundamental Japanese principles of simplicity of design and economy of expression into his art. In the 'Ten O'Clock' lecture in 1885 he protests against the thoughtless appropriation of Oriental gewgaws in interior decoration. Feeding this growing comprehension of Japanese decoration was his friendship with British architects like Edward Godwin, Thomas Jeckyll, and William Eden Nesfield. Finally, he was able to unite art and architecture, high art with decoration in the masterpiece that in some ways stands at the heart of his career: the Peacock Room (see p.164–5).

But in looking at Japanese art, Whistler was always selective both in the artists he chose to imitate, and in what he took from each. If he was inspired by Hokusai, for example, he choose only those prints which themselves exhibit an awareness of Western perspective. In Hokusai's woodblock 'People on a Temple Balcony' which might have inspired Whistler's 'The Balcony' (see no.24), the floorboards, balcony railings and roof lines all align with a single vanishing point in Mount Fuji in the distance.[2]

The influence of Japanese art on Whistler's work, though profound, is there-

fore limited. Only in certain landscapes in watercolour of the 1870s does he dispense with conventional illusionistic representation, treating pictorial space as a flat field on which to dispose near abstract forms – much as Toulouse-Lautrec, Bonnard and Gauguin were soon to do.

R.D.

22 Purple and Rose: The Lange Leizen of the Six Marks 1864

Oil on canvas 92 × 61.5 (36¼ × 24¼)
Signed and dated 'Whistler 1864'
PROV: Ernest Gambart (dealer) 1863;
James Leathart, Newcastle 1860s; John G.
Johnson, Philadelphia 1893; bequeathed
to the City of Philadelphia 1917
EXH: London, RA 1864 (593); Newcastle
1887 (777); London, Goupil 1892 (5);
London & New York 1960 (11); Chicago
and Utica 1968 (6); New York and
Philadelphia 1971 (15)
LIT: YMSM 1980 (47)

*Philadelphia Museum of Art. The John G.
Johnson Collection*

'Are you interested in old china? This artistic abode of my son is ornamented by a very rare collection of Japanese and Chinese. He considers the paintings upon them the finest specimens of art, and his companions (artists), who resort here for an evening's relaxation occasionally get enthusiastic as they handle and examine the curious figures portrayed.'[1]

Anna Whistler's letter to a friend in America, written from 7 Lindsey Row in Chelsea on 10 February 1864, chronicles the first flush of Whistler's enthusiasm for collecting Oriental porcelain. Twice in the three months after this letter was written Whistler was in Paris, both times to visit La Porte Chinois at 36 rue Vivienne and the establishment of E. Desoye in the rue de Rivoli, both of which sold Japanese prints, textiles, screens and china.

Many of the bowls and jars from the K'ang Hsi (1662–1722), Yung Cheng (1723–35) and Ch'ieu Lung (1736–95) periods that he bought there found their way into the paintings of this period, and it is through their common interest in collecting blue and white that he cemented a number of important friendships – with Rossetti and Tissot, and with his future patrons Alexander, Leyland, Huth, and Sir Henry Thompson (see nos.62, 63, 68, 83).

In the letter quoted above, Anna mentioned that her son was finishing this picture, the first of his works to draw directly on Chinese and Japanese art. Her description cannot be bettered:

A girl seated, as if intent upon painting a beautiful jar which she rests upon her lap … She sits beside a shelf which is covered with matting, a buff color, upon which several pieces of china and a pretty fan are arranged, as if for purchasers; a Scinde rug carpets the floor … Upon it by her side is a large jar, and all these are facsimiles of those in this room … [and] there is a table covered with a crimson cloth upon which there is a cup (Japanese), scarlet in hue, a sofa covered with buff matting too, but each so distinctly separate, even the shadow of the handle of the fan.[2]

'The Lange Leizen of the Six Marks' refers to the decorative figures that form the maker's marks which appear on rare pieces of blue and white china. 'Lange Leizen' is Dutch slang for 'Long Elizas'. The six Chinese characters around the frame, copied from the bottom of a piece of blue and white porcelain, read (clockwise from the upper right hand-corner): 1. Great; 2. Ch'ing; 3. K'ang; 4. Hsi; 5. Year; 6. Made ('Made during the reign of the Emperor K'ang Hsi of the great Ch'ing (Manchu) Dynasty').[3]

As with 'The White Girl' (no.14) and 'Wapping' (no.33), Whistler subverts a possible reading of the scene as a conventional Victorian genre painting by identifying the figure as a European woman posing in a studio for an artist. He gives her caucasian features and hoop earrings and seats her on what looks like a flimsy wooden European chair, of the sort one might find in an artist's studio. Her Chinese robe has the air of a garment from the dressing-up box, or perhaps the robe a professional model would wear between poses in a life class. The shallow space is entirely Western in character.

As in 'Caprice in Purple and Gold: The Golden Screen' 1864 (fig.6 on p.16; YMSM 60), and 'La Princesse du pays de la porcelaine' 1863–4 (fig.7 on p.16; YMSM 50), Whistler still has not incorporated Japanese principles of colour and design into his pictures. The Orien-

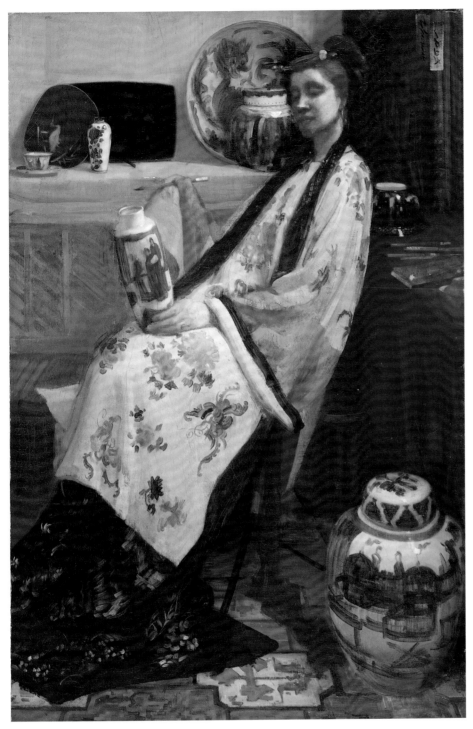

22

tal accessories remain just that: accessories to enliven a composition which is relatively unadventurous, in comparison to 'Harmony in Green and Rose: The Music Room' 1860–1 (fig.2 on p.14), for example.

In May 1863 Whistler was in Amsterdam with Alphonse Legros looking for blue and white china, and also looking at the seventeenth-century Dutch school of genre painters, with their dark interiors, cool even light, and sensuously painted still life details. His own 'At the Piano' (no.11) suggests that he was aware of the paintings of Vermeer, just then being rediscovered in avant-garde artistic circles. The first owner of no.22, the art dealer Ernest Gambart, became a noted patron of the Dutch genre painter Lawrence Alma-Tadema, whose glossy evocations of Greek and Roman life make an interesting contrast to Whistler's more searching painterly technique.[4]

Finally, the subject of the picture, a woman painting a porcelain vase in what is clearly a shop may reflect Whistler's awareness of a great new enterprise recently undertaken by the circle of artists with whom he was friendly. This was the establishment of the firm of Morris, Marshall, Faulkner & Co. in 1861 to specialise in the manufacture of the decorative arts by artists such as William Morris, Burne-Jones, Ford Madox Brown and Rossetti.

When Whistler showed 'The Lange Leizen of the Six Marks' with 'Wapping' at the Royal Academy of 1864, William Michael Rossetti singled out both pictures as 'the most thoroughly satisfying works in the Academy', and — thinking of the deep purple tie to the Chinese robe, the rose colour on the sleeves of the kimono, and the touches of deep magenta and orange — wrote that he considered the 'Lange Leizen' 'the most delightful piece of colour on the walls'.[5] This praise was echoed by other critics, with the exception of Tom Taylor in the *Times* who castigated Whistler for 'slovenliness of execution' and objected to the faulty perspective of the large blue and white jar on the right.[6]

23 Sketch for 'Variations in Flesh Colour and Green: The Balcony'

1864–5

Watercolour and gouache on buff wove paper 62.8 × 50 (24¾ × 19¹¹/₁₆)
PROV: Bequeathed by Whistler to his sister-in-law, Miss R. Birnie Philip; bequeathed to the University of Glasgow 1958
EXH: Berlin 1969 (63); Tokyo 1987–8 (57)
LIT: YMSM 1980 (56); MacDonald 1994 (320)

Hunterian Art Gallery, University of Glasgow, Birnie Philip Bequest

'Variations in Flesh Colour and Green: The Balcony' (fig.45; YMSM 56) was one of several Oriental compositions Whistler painted between 1863–5. This watercolour sketch is almost exactly the same size as the oil. It appears to relate to the state of the painting as it appeared in an early photograph when it was signed and dated 1865.[1] The figures were not changed much in the final version but more blossoms were added. Later, Whistler planned to enlarge the composition, but no large version survives (see no.24).

Among sources for the composition are prints by Torii Kiyonaga (see no.24). The graceful figures in bright robes suggest exotic and Oriental climes. The East is not entirely assimilated, however – rather, it is an accessory and adornment of the West. Whistler's own blue and white china, embroidered robes, Oriental fans and a lute were set against the backdrop of the Thames at Chelsea.

The background is painted in monochrome, with streaky, fluid greys. The distance, lost in mist, is merely suggested. The woman is outlined economically, with a fine brush. Compared to the oils, the colour is limited, yet no less effective for its restraint.

Originally a working drawing, bearing the marks of both erasures and alterations made by the artist, the sheet was later torn and folded, so that in some areas it is difficult to interpret the artist's original intentions.

Whistler produced a series of studies of women standing or sitting on a balcony. The earliest, an incomplete oil, 'Study of Draped Figures' (Hunterian Art Gallery, University of Glasgow; YMSM 58), is probably contemporary with 'Variations in Flesh Colour and Green: The Balcony'. Some drawings show from two to eight figures, and from these he selected individual figures to develop further and incorporate, in their turn, in other compositions.[2]

23

The background was the sea, rather than the Thames.

By 1868 Whistler was working on a series of paintings of 'women with flowers', the 'Six Projects' (see pp.92–4). Two of these, 'Variations in Blue and Green' and 'Symphony in White and Red' (YMSM 84–5) show women on balconies. Robes hint at classical aniquity rather than the Orient, but the figures still bend with the exaggerated curves of Kiyonaga, and both colour and brushwork derive from these versions of 'Variations in Flesh Colour and Green: The Balcony'.

24 Sketch for 'The Balcony' 1867–70

Oil on wood 61 × 48.2 (24 × 19)
PROV: Bequeathed by Whistler to his
sister-in-law, Miss R. Birnie Philip 1903;
bequeathed to the University of Glasgow
1958
EXH: London and New York 1960 (20)
LIT: YMSM 1980 (57); MacDonald 1994
(319–20)

*Hunterian Art Gallery, University of Glasgow,
Birnie Philip Bequest*

This is a variant of a picture that Whistler
worked on over a long period of time and with
which he never seemed quite satisfied ('Varia-
tions in Flesh Colour and Green: The Balcony'
fig.45; YMSM 56). He began it by February 1864,
but continued to tinker with it over the next six

24

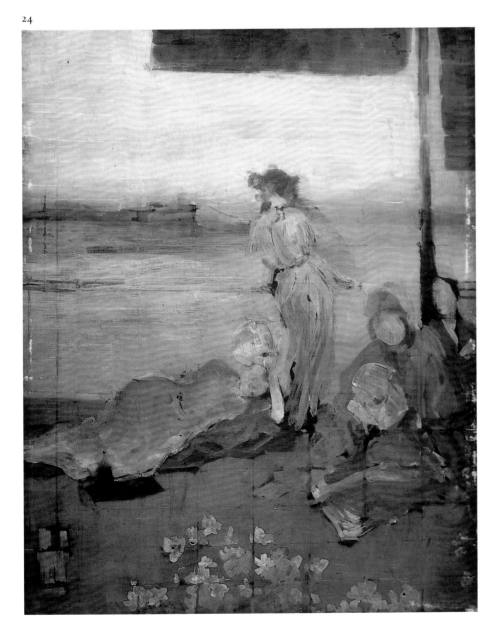

years. Though signed and dated '1865', it was
not exhibited at the Royal Academy until 1870.
A comparison of this sketch with that picture
suggests that it is a loose copy of 'Variations in
Flesh Colour and Green: The Balcony', as it
existed not in 1865 but around 1870. Between
the two dates the main change was the addition
of the blossoms in the foreground. The figures
remained substantially the same.

In January 1867 Whistler wrote to Fantin-
Latour that he planned to enlarge 'la petite
esquisse du balcon' to create a life-sized salon
picture: 'Je vais le faire grand presque comme
nature pour le salon'.[1] This sketch has been
squared in ink for transferring the composition
to a larger panel or canvas, suggesting that it is
the very sketch to which he was referring. As
with 'Whistler in his Studio' (fig.46; YMSM 63),
nothing came of the project.

'Variations in Flesh Colour and Green: The
Balcony' was painted concurrently with the
'Lange Leizen' (no.22) and just as Whistler was
putting the finishing touches on 'Wapping'
(no.33). In a letter to an American friend writ-
ten on 10–11 February 1864, Anna McNeill
Whistler described 'The Balcony' as 'a group in
oriental costume on a balcony, a tea equipage of
old china, they look out upon the river, with a
town in the distance'.[2]

As in the 'Lange Leizen', the exotic costumes
and accessories in 'The Balcony' are superficial
adjuncts to a composition that owes much
more to Ingres and Delacroix than it does to
Hokusai. But unlike in the 'Lange Leizen',
when painting 'The Balcony' Whistler took
certain compositional elements from Japanese
woodcuts. The strong horizontals and verticals
formed by the rolled bamboo blinds, the place-
ment of the seated figure with the lute or
shamisen, all seem to have been lifted from Kiy-
onaga's five sheet composition 'Autumn Moon
on the Sumida' and the same artist's 'The
Fourth Month' from "Twelve Months in the
South" of 1784, both of which Whistler owned
(figs.5, 47b).

Kiyonaga's prints are themselves heavily
influenced by European art, notably in their use
of Western perspective to suggest depth and
distance. The most 'Japanese' detail in the com-
position of 'The Balcony', the sprays of cherry
blossom in the foreground, represent a later
addition to the original 1865 composition, sug-
gesting that Whistler's exposure to Japanese art
was gradual, in stages beginning with the West-
ernised art of Kiyonaga, and progressing to the
less easily assimilated work of Hokusai (fig.47a).

Even at the height of his interest in Japanese
art, Whistler's understanding of the greatest
Japanese artists seems to have been limited.

Whistler uses these flowers not, as Hokusai might, as a sophisticated visual device for contrasting near and far by omitting a measured middle distance, but as a purely decorative accessory. The art of Hokusai was much more important for encouraging Whistler's love of atmospheric effects, subtle nuances of tone, and reiterated visual rhythms than it was for its influence on his depiction of space. Even in his most extreme phase of Japonisme, Whistler was never to use flattened space, vanished horizon lines, and asymmetry with the daring of Gauguin or Toulouse-Lautrec.

Given the importance of Japanese prints for Whistler's developing aesthetic, it would have been easy for him to fabricate a vaguely Japanese-style background view in 'Variations in Flesh Colour and Green: The Balcony'. Instead, he shows the actual view from the balcony of his house in Lindsey Row, looking south towards the smokestacks of Battersea on a misty day. In this way he identifies the four women as models, and the setting as an extension of his own studio. In summer anyone standing on this balcony would have been able to hear the music from the 'Chinese' bandstand at Cremorne Gardens a few hundred yards away.[3]

Between 'Variations in Flesh Colour and Green' and the 'Sketch for "The Balcony"', Whistler had painted both the Valparaiso Nocturnes (nos.43–5) and the 'Six Projects' (pp.92–4). Comparing the two pictures, one sees how Whistler has sought in the sketch to simplify the paint surfaces, using freer, ribbon-like brush strokes of cream, grey and purple in the background to subordinate details and to create a harmonious tonal effect. In order to establish the unity between foreground and background, he is forced to subordinate unnecessary detail such as the models' faces. He is no longer describing, but seeking to create a work of art which is complete in its own right, an *objet d'art* which could be appreciated in purely pictorial terms, for its colour, brush strokes, and composition.

25 Variations in Violet and Green

1871

Oil on canvas 66 × 35.5 (26 × 14)
Signed with butterfly and dated '71'
PROV: Sir Charles McLaren, later Lord Aberconway by 1886, who d. 1934; Paul Mellon, Pittsburg, Pa; Scott & Fowles, New York (dealers); Macbeth Galleries, New York (dealers) 1950; Mrs. C.R. Foulke, Florida 1950; Sotheby, New York 28 May 1987 (3) bt James Maroney, New York (dealer)
EXH: London, Dudley Gallery 1871 (225); London 1905 (81); London & New York 1960 (26)
LIT: YMSM 1980 (104)

James Maroney, New York

According to Anna Whistler, 'Variations in Violet and Green' was painted on the same day in August 1871 as 'Nocturne: Blue and Silver – Chelsea' (no.46). The purple clouds on the horizon indicate a sunset scene, once again overlooking the Thames with ladies in the fashions of 1870 gathered on a green sward in the foreground. The railing curving across the foreground might almost be taken for a Japanese wooden bridge, while the parasol reminds us of Whistler's Japanese tanagra subjects of 1867–70. Indeed, with its sprays of almond blossom and stylised cartouche imprisoning the butterfly signature, the picture represents an extreme moment in Whistler's ten year exploration of Japanese art. In terms of size and format as well as style and subject, it is related to 'Variations in Pink and Grey: Chelsea' (Freer Gallery of Art, Washington, DC; YMSM 105). Both pictures share an aerial viewpoint and a composition which gently leads the eye upward over the blue-grey river, here to a diaphanous sail boat near the high horizon.

The frame, decorated by Whistler, has basket-weave patterns, and is signed with a butterfly and dated '1871'.

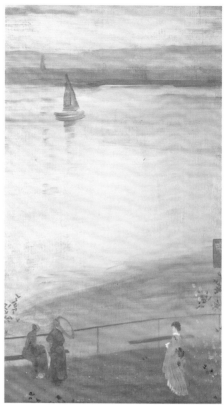

25

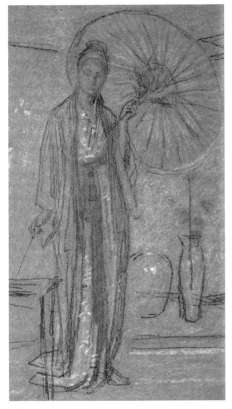

26

26 A Japanese Woman (recto) 1872–3

Girl with Parasol (verso)
Chalk and pastel on brown paper
25 × 12.5 (9¹³⁄₁₆ × 4¹⁵⁄₁₆)
PROV: Hon. John Prince Elton
(1865–1948) by 1904 (132); his widow,
Mrs Elton 1948; her daughter, Mrs
Cross; Coe Kerr Gallery, New York
(dealers) 1987; T. Colville, New Haven
(dealer) 1989; the present owners
EXH: London, Pall Mall 1874 (?15);
Boston 1904 (132); New York 1984 (58,
repr.); Tokyo 1987–8 (46)
LIT: MacDonald 1994 (458)

*Private Collection, New England. Courtesy
Thomas Colville, Inc.*

Sir Henry Cole KCB and his son Alan were
long-term friends of the Whistler family. Sir
Henry was involved in the development of the
Department of Science and Art at South Kens-
ington Museum from 1857 to 1873. He obtained
for Whistler a commission to design two
mosaics to complete the sequence of thirty-five
portraits of artists already installed in arcaded
niches around the upper level of Godfrey Sykes'
South Court in the museum. On 20 March 1872
he specified a figure of 'a Japanese art worker'
for one of the arches.[1] Cole even provided
Whistler with a studio.

The completed figures represented artists,
sculptors and a few ceramic artists, all male.
Some, like the artists who painted them, were,
to say the least, obscure. The artists who car-
ried out the designs ranged from respectable
Academicians to unknown art students. The
commissions were eagerly sought after. Richard
Redgrave, John Phillips, Sir John Tenniel, W.F.
Yeames, G.F. Watts, Lord Leighton, Val Prin-
sep, Edward Poynter and Thomas Armitage
were among those chosen. The first design,
'Bernard Palissy' by Richard Townroe, was
completed in 1864, and after that, between two
and four designs were approved annually until
1871, when, in an attempt to complete the work,
six designs were carried out.

Whistler made at least two drawings which,
if enlarged, could have fulfilled the require-
ments. Unlike all the other designs, they
showed women, but this belated attempt to
redress the balance came to nothing, since
Whistler never enlarged the drawings to the
cartoon size required (104 × 34 ft).

Holman Hunt and W.H. Fisk were consult-
ed, but also failed to produce designs. As a
result, no cartoons were approved in 1872. The
final design, showing Giotto, was completed in
1873, ironically by J.C. Horsley (who was relat-
ed to Whistler through his brother-in-law Sey-
mour Haden, and disliked most uncordially by
Whistler). The mosaics stayed in place until
1949 when they were removed and placed in
storage.

This is one of Whistler's suggestions for
South Kensington, a woman decorating a para-
sol. In a second pastel, she is painting a fan
(fig.48; M 460).[2] The pose of the figure, the
screen and vases in the background, suggest
comparisons with the 'Princesse du pays de la
porcelaine' of 1863–4 (fig.7 on p.17; YMSM 50).[3]
However, they are unrelated, except in so far as
they both derive, at some remove, from
Whistler's study of Oriental prints. The figure
is slightly more Western and more integrated
with her surroundings than was the girl in the
companion drawing. Her parasol fused classi-
cal, Oriental and contemporary modes and
moods.

Whistler drew the face softly, the draperies
tentatively, and the parasol, boldly. There are
signs that he changed his mind as the drawing
progressed. The woman was originally drawn
further to the right. The table-palette was
added over her robe. The screen cuts into both
vases, and the gold background covers the left-
hand vase. This background of scumbled yel-
low gold completes both drawings.

The 'Six Projects'

The 'Six Projects' is the collective name given by the Pennells to the six oil sketches Whistler made for a frieze of figures commissioned by Frederick R. Leyland in 1867.[1] Though the scheme of decoration was never completed, out of the struggle to do so emerged the great stylistic synthesis which Whistler called 'Impressionism' but we would today label 'aestheticism'.

He painted the sketches in the studio of the architect Frederick Jameson at 62 Great Russell Street, London, during 1868.[2] This address is in itself of interest both as the former studio of Edward Burne-Jones (from 1861 to 1864), and because it is almost directly opposite the British Museum. The studies hung successively in Whistler's houses at Lindsey Row, in Tite Street, and in Paris. All are painted on millboard mounted on wood panel, and all are today in the Freer Gallery in Washington, DC.

Four of the six compositions are horizontal in format and show ladies in tanagra-style classical draperies with Japanese fans and parasols at the edge of the sea. Some stroll along the shore ('Symphony in Blue and Pink' and 'Variations in Blue and Green'). Others mount a wooden pier ('Symphony in White and Red') or congregate on a balcony with a glimpse of the sea beyond ('The White Symphony: Three Girls'). The compositions of the two remaining pictures are upright, a 'Venus Rising from the Sea', and a conversation between two figures against what appears to be a garden wall ('Symphony in Green and Violet'). Though individual scenes suggest a possible loose progression from dawn and midday to sunset and dusk, without knowing the room for which the series was painted we are unable to arrange the pictures in sequence.

As he painted, Whistler could visit the British Museum daily, and could study the Elgin marbles, in the course of rearrangement in 1865, and also its collection of polychromed tanagra statues. From the latter he seems to have derived the powder blues and candy pinks of his colour harmonies. In an unusually large number of compositional studies in chalk and pastel, Whistler experimented with the disposition of figures against a horizontal grid composed of a balustrade or railing to create a satisfyingly rhythmic frieze (M 341–50).

It is possible that in the 'Six Projects' Whistler was attempting his own version of Hokusai's 'Oiran and Maids by a Fence' which shows courtesans in elegant kimonos and parasols standing against a wooden railing (fig.49).[3] C.L. Freer was the first to note Whistler's debt in the 'Six Projects' to the Japanese artist Kiyonaga. Two of Kiyonaga's woodcuts have also been suggested as the primary compositional source for Whistler's own 'Variations in Flesh Colour and Green: The Balcony', the visual embryo out of which the 'Six Projects' developed (see no.24 and fig.5 on p.16).

Around September in 1867, while he was enlarging the 'Sketch for "The Balcony"' into what he hoped would be a full-sized Salon painting (no.24), Whistler wrote to Fantin-Latour repudiating the naturalism which until then had been the very foundation of his style:

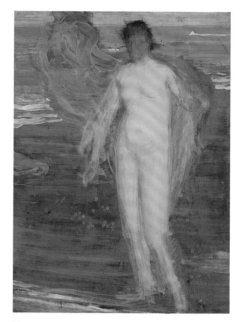

Venus
61.8 × 45.6 (24⅜ × 18)

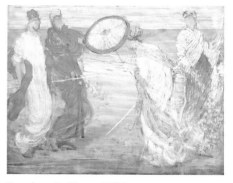

Symphony in Blue and Pink
46.7 × 61.9 (18⅜ × 24¾)

Ah my dear Fantin what a frightful education I've given myself – or rather what a terrible lack of education I feel I have had! … Courbet and his influence was disgusting! … It's that damned Realism which made an *immediate* appeal to my vanity as a painter! and mocking tradition cried out loud, with all the confidence of ignorance, 'Long Live Nature! ! Nature! … Ah! how I wish I had been a pupil of Ingres![4]

Whistler's enthusiasm for the work of Ingres had been ignited by the retrospective of Ingres's work held in Paris during the summer of 1867. The artist friend of Whistler's who had been most influenced by Ingres was Degas, and it is easy to imagine Whistler's frustration with his own tentative, searching style of draughtsmanship when confronted with the vigour of Degas's hand.

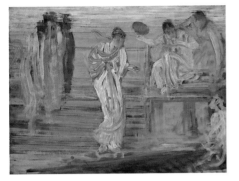

Symphony in White and Red
46.7 × 61.9 (18⅜ × 24¾)

But in turning away from Courbet towards Ingres in the later 1860s, Whistler was also turning his back on the naturalism of avant garde French painting in the years running up to the first Impressionist exhibition of 1874. In the 1860s British art had undergone a classical revival, an important element of which was the prestige accorded by British artists to Ingres's drawings. The influence of Ingres can be traced in the work of Rossetti, Burne-Jones and Frederick Sandys, but most relevant for Whistler's developing aesthetic is that of the English neo-classical painter Albert Moore.

In 1865 Whistler had proposed to Fantin-Latour that Moore take the place of Alphonse Legros in the Société des Trois. Moore was an essentially minor master who restricted his subject matter to toga-draped women standing or reclining in interiors or landscapes. His figures are firmly drawn and painted in clear pastel colours. But though Moore's classicism is of the utmost stylistic importance for the 'Six Projects', in terms of their format and function we must look to the example of another British painter, Edward Burne-Jones.

As a frieze intended for the decoration of an architectural interior, the 'Six Projects' depend on Burne-Jones's frieze of seven canvases illustrating the 'Story of St George' executed between 1865–7. This frieze was inset in a continuous band of decoration around three walls of the dining room at The Hill, the home in Witley, Surrey, of the painter in watercolour Miles Birket Foster. Whistler was in frequent contact with Burne-Jones in the early 1860s through their common acquaintance with Rossetti and members of his circle. Almost as important, the room for which Burne-Jones painted the 'Story of St George' frieze contained Birket Foster's collection of blue and white china, some of it purchased from Rossetti, which was displayed on 'every available shelf and mantel, nook and cranny'.[5]

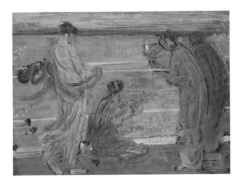

Variations in Blue and Green
46.9 × 61.8 (18½ × 24¾)

Individual panels in the series include 'The King's Daughter' (Musée National d'Art Moderne, Paris) and 'Moritura – The Princess Draws the Lot' (see fig.50). Both show classically draped female figures moving across the foreground plane in a way which is directly relevant for the disposition of the figures in the 'Six Projects'.[6]

In them, Whistler banishes narrative content and works in a range of colours undreamt of by Burne-Jones. To do this, he turned to the theory of *correspondances*, the analogy between painting and music, long familiar from the writings of the crit-

ic Théophile Gautier and novelist Henri Murger, and the central theory of Baude-laire's poetry.[7] The decoration of the original frame designed by Whistler for the enlarged version of 'The White Symphony: Three Girls' (whereabouts unknown: YMSM 88) bears a motif with bars of music from the third of Franz Schubert's 'Moments Musicaux' (Allegro Moderato in F minor), Opus 94.

Whistler would certainly have continued this musical motif on the frames of each of the completed pictures used in the decoration, suggesting that the scheme was inspired by the patron who commissioned the 'Six Projects', Frederick Leyland, who was an accomplished amateur pianist. If so, it may even be possible to suggest a possible location for the series: a music room, either at Leyland's London house, which was then at 23 Queen's Gate in Knightsbridge, or at Speke Hall, his residence outside Liverpool.

The changes in colour and tone from the moody 'Symphony in Green and Vio-let' to the gaiety of 'The White Symphony: Three Girls' may conceivably reflect Whistler's musical sources of inspiration, which would have been clear in the musi-cal notations on the frames, and which the owner could have played as his audience looked up at the series.

Most of the important visual sources for individual figures in the 'Six Projects' can be identified in the work of contemporary British artists. Whistler derived the figure of the woman by the seashore in 'Symphony in Blue and Pink' from Albert Moore's 'Sea Shells' (fig.53), while the composition for the 'White Symphony: Three Girls' is related to Edward Burne-Jones's 'Mirror of Venus' (Gulbenkian Foundation, Lisbon). The confrontation between two draped figures in 'Sympho-ny in Green and Violet' can be compared with a number of Burne-Jones's paintings of the 1860s, notably 'Fair Rosamond and Queen Eleanor' 1861 (private collection, England).

One exception is the figure on the far right of 'Symphony in Blue and Pink'. She seems to be taken from the figure of the serving woman who exits to the right of Delacroix's 'Women of Algiers' (see fig.4 on p16).

Nowhere in his entire oeuvre are the rich blue-green harmonies, pinks, and notes of persimmon, red and salmon pink more vibrant than in the 'Six Projects'. Here, form is actually created through colour so gorgeous that one understands why, in the letter to Fantin-Latour quoted above, Whistler expressed the need to have his colour tamed by drawing: 'My God! Colour – it's truly a vice! Certainly it's probably got the right to be one of the most beautiful of virtues – if directed by a strong hand – well guided by its master, drawing – colour is then a splendid bride with a spouse worthy of her – her lover but also her master.'[8]

And here, finally, lie the roots of Whistler's difficulty with the series. He could not finish the 'Six Projects' because he had been too ambitious, attempting to marry the drawing of Ingres with the colour of Delacroix, and to replace literary sources with musical ones.

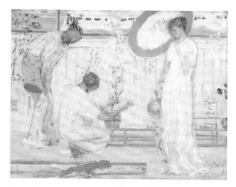

The White Symphony: Three Girls
46.4 × 61.6 (18¼ × 24¼)

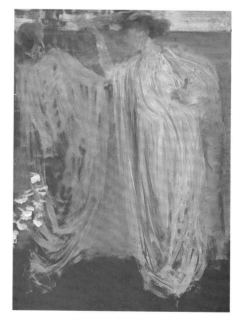

Symphony in White and Green
61.9 × 45.8 (24¾ × 18⅛)

R.D.

27

27 The Dancing Girl 1870–3

Chalk and pastel on brown paper
28.8 × 19.4 (11⅜ × 7⅝)
PROV: Howard Mansfield, New York by
1904; Edwin A. Seasongood, his sale,
Parke Bernet, New York 5–6 Nov. 1951
(303); Closson Galleries, New York
(dealers); Sotheby, New York 29 Nov.
1990 (50) bt by the present owners
EXH: Boston 1904 (129)
LIT: MacDonald 1994 (379)

Mr and Mrs Richard Waitzer

Whistler made numerous studies of women, in
an outdoor setting, on piers, balconies or
beaches. While based on studies from life,
drawings like this were elaborated and schema-
tised later. The artist, at his leisure, selected and
emphasised certain aspects of the work – in this
case, the twisting movement of the dance. His
model is dressed in semi-classical draperies
which flutter around her in an imaginary
breeze. She appears to be or to have been lean-
ing on a railing. The pastel lines have a fine
grainy quality on the fibrous paper.

There are three earlier studies for this pose,
all line drawings in black chalk, with highlights
in white.[1] Only this drawing is coloured with
pastels. The colour is limited to shades of yel-
low and orange which harmonise with the
brown paper. It is used to accentuate the twist-
ing movement of the pose. The addition of
colour suggests that Whistler was satisfied with
the drawing. He may have intended to exhibit it
(it would have harmonised with no.28, which
was exhibited in 1874).

Whistler may also have seen it as a stage in
the development of an oil painting. Encouraged
by the meticulous practise of his friend Albert
Moore, he attempted to follow the traditional
academic method for producing oil paintings.
He started with rough sketches of composi-
tions, moved on to increasingly precise studies
of individual figures and drapery studies, paint-
ed small oil sketches of the complete composi-
tion, transferred the design to a full-scale
cartoon, and finally to the full-scale painting.
However, the method required persistence and
a methodical character. Whistler's enthusiasm
quickly lapsed, and only one full-scale cartoon
has survived.[2]

This pose is exactly like that of the figure on
the left in a figure composition shown in two
pastels, in the Fitzwilliam Museum and
Hunterian Art Gallery (fig.51).[3] These show a
much brighter colour scheme, in shades of blue
and purple. An oil sketch of this composition
appears upside down under 'Nocturne: Blue

and Silver – Cremorne Lights' (no.47). It seems
likely that it was related to the 'Six Projects',
and showed a procession of figures walking by
the sea, rather like 'Symphony in Blue and Pink'
(illustrated on p.92; YMSM 86).[4]

The theme of the 'Six Projects', of women in
classical draperies walking by the sea, painted
without any very specific subject, can be com-
pared to the figures in Frederic Leighton's
'Greek Girls Picking Up Pebbles by the Sea',
exhibited at the Royal Academy in 1871
(fig.52).[5]

Albert Moore's painting 'Sea Shells' which
was exhibited at the Royal Academy in 1874 is
even closer to Whistler, in colour, theme, and
in the manner of conveying movement (fig.53).
Moore drew studies for the figures in 'Shells'
and its pendant, 'Sea Gulls' (whereabouts
unknown) in the studio, using a special fan to
blow the drapery into the air. Whistler saw him
at work, and may indeed have made use of such
a device.

However, he became increasingly concerned
at the resemblance of their paintings. On 19
September 1870 he wrote to Moore:

> while admiring them as you know I do
> everything of yours – more than the
> production of any living man – it struck me
> dimly – perhaps that one of my own
> sketches of girls on the sea-shore was in
> motive not unlike your yellow one – of
> course I don't mean in scheme of colour
> but in general sentiment of movement and
> in the place of the sea, sky and shore, etc.[6]

He suggested that Moore and a mutual friend,
William Eden Nesfield, should look in his stu-
dio at 'the one in blue green and flesh colour of
four girls careering along the seashore, one with
a parasol' and consider if he could legitimately
continue to work on it. The picture concerned
was probably 'Symphony in Blue and Pink'.
The composition now concealed by 'Nocturne:
Blue and Silver – Cremorne Lights' must have
been very similar. The destruction of this com-
position, after so much care had been expended
in studies for individual figures and integrating
the whole composition, suggests that he was
deeply concerned about the development of the
work.

Nesfield told Whistler that he was quite sure
he and Moore could work independently on
the paintings, despite superficial similarities,
'the vulgar fact of there being, shore, sea, and
sky, and a young woman walking in the fore-
ground.'[7] But Whistler was not satisfied. He
never completed the 'Six Projects', and he
destroyed the evidence of at least one of his
compositions.

28 Harmony in Gold and Brown

(recto) 1870–3

Nude Figure (verso)
Chalk and pastel on brown paper
13 × 25.4 (5⅛ × 10)
Signed with butterfly. Inscribed on verso
by Pickford Waller 'Harmony in Gold &
Brown | Pastel by Whistler | Selected
from several Pastels at the White House.
| Whistler gave me my choice from a lot
he had in his Studio & I brought this
away with me. | P.R.W.'
PROV: Pickford R. Waller, London
1878–9; bequeathed to his daughter Sybil
Waller 1930; Christie, London 8 Nov.
1968 (162) bt D'Offay, London (dealer);
I. Spanierman, New York (dealer) 1969;
Sotheby Parke Bernet, New York, 23 May
1974 (41D, repr.) bt in; Gilbert Waters,
Sarasota, Florida; Hope Davis, New
York (dealer) 1991; present owners 1991
EXH: probably London, Pall Mall 1874
(23); London 1905 (175); Berlin 1969 (75);
New York 1984 (52)
LIT: MacDonald 1994 (374)

Mr and Mrs R.M. Thune

Elaborate draperies, hinting at classical antiqui-
ty, distance the artist from contemporary
realism. Whistler ignores the face and concen-
trates on the massive body. He emphasises
shape and movement with curving lines, alter-
nating dark and light strokes of colour. There
are signs that the drawing was worked on over a
period of time. The elaborate stylisation may
cover a much simpler life study. The butterfly
was certainly added later, possibly when the
drawing was bought by the designer and collec-
tor Pickford Waller in 1878.

Colour is blended on the legs and scumbled
over the background with the side of the pastel,
revealing the vertical grain of the paper. The
brown paper blended with the touches of
orange which unify the colour scheme. Colour
transformed a simple figure study into a har-
mony suitable for inclusion in Whistler's first
one-man exhibition in 1874. It is one of the first
drawings by Whistler to have been signed and
exhibited as a work of art in its own right. In
the show were 'some abrupt jottings in lovely
colour for figure compositions of a Japanese
fancy' which could well have included this.[1]

'Harmony in Gold and Brown' is similar to
no.27 both in colour scheme and in its stylised
finish. It is likely that they were exhibited
together in 1874, and possible that no.28 was,
like no.27, a study for an oil painting which has
not survived.

Several of the drawings in the show were
exhibited as 'studies' for compositions and
some for portraits.[2] However, a few, like two
drawings in the Hunterian Art Gallery, Glas-
gow, 'The Dressmaker' and 'Kittens', are inde-
pendent sketches.[3] Whistler showed some
drawings for their own sakes as well as ones
which were related to compositions.

29 Harmony in Flesh Colour and Red 1869

Oil on canvas 38.7 × 35.6 (15¼ × 14)
Signed with butterfly
PROV: J. and W. Rosenheim & Co before
1929; Christie, London 8 April 1929
(105); bt Neasson or Pearson; Arthur
Morrison by 1930; his sale, Sotheby,
London 20 March 1946 (241); bt Roland,
Browse & Delbanco, London (dealers);
John Bryson, Oxford; Durlacher, New
York (dealers) by 1960; Museum of Fine
Arts, Boston 1960
EXH: New York and Philadelphia 1971
(21)
LIT: YMSM 1980 (91); MacDonald 1994
(311)

*Museum of Fine Arts, Boston. Emily L. Ainsley
Fund*

'Harmony in Flesh Colour and Red' belongs in
a sequence of figure studies which includes
'The Balcony' (see nos.23–4), 'Symphony in
White, No.3' (no.16) and the 'Six Projects' (see
pp.92–4). Three women are shown in up-to-
the-minute Victorian fashions in a setting redo-
lent of the dawning Aesthetic Movement. Here
Whistler attempts to combine a Japanese aes-
thetic with classical poses and rhythms, the
grammar of the East with the vocabulary of the
West. In 'The Balcony', he had shown women
in kimonos against a background that was
recognisably that of contemporary industrial
London. Here he reverses the formula by show-
ing European ladies in a vaguely Japanese set-
ting.

Though inspired by prototypes in classical
relief sculpture, the poses and gestures seem
utterly modern. One lady drapes her arm casu-
ally over a railing, while another reaches down
to adjust her high heeled shoe, as though tired
out after an afternoon's shopping. Her gesture
can be compared to those in Degas's studies of
ballet dancers.[1]

Like the 'Six Projects', 'Harmony in Flesh

28

Colour and Red' is unfinished. Both setting and space are ambiguous. At first glance the figures seem to be seated out of doors on a balcony, indicated by the woman with her arm over the balustrade on the left. But the balustrade turns out to be a dado, for on the wall behind her Whistler has sketched in several Japanese fans, indicating an interior setting.

By mentally erasing the figures one is better able to analyse the severe composition, a nearly square format divided into four smaller squares by the horizontal line formed by the dado and the vertical line coinciding with the right leg of the seated middle figure. The balance of solids and voids, horizontal and vertical, round and rectangular creates a lively internal rhythm. At the same time, the daring juxtaposition of the crimson of the dresses with the pink azaleas on the left and deep purple of the striped carpet, low couch and pillow reminds one that Whistler was still very much aware of the vitality of colour and freedom of handling in Delacroix's 'Women of Algiers' (fig.4 on p.16).

A pen and ink study for the picture is in the Munson-Williams Proctor Institute, Utica, NY (M 311). The butterfly signature on the oil, if added by Whistler, must date from the mid-1880s.

29

The Thames

Whistler earned his living in 1862 as an illustrator for the periodical *Once a Week*, living in the same flat as the future *Punch* cartoonist George Du Maurier. His first contact with British artists brought him into a world of caricaturists, illustrators and cartoonists.

When he came to etch the images which would make up the 'Thames Set' (nos.31, 32, 34), his panoramic views over the dilapidated docks of Rotherhithe and Wapping show an awareness of the Parisian views of the master etcher Charles Meryon. The labourers depicted in prints such as 'Longshoremen' (K 45) are subtly different from similar figures in the 'French Set' of etchings. Here Whistler captures the transitory expression on the faces of figures who appear not to know that they are being watched. Such images are remarkably like the drawings of the English illustrator Charles Keene, whom Whistler met after 1859 through their membership in the Junior Etching Club.[1]

Keene's quick, graceful, and closely observed sketches appeared in *Punch*, where he became a sort of British equivalent to the French caricaturist Gavarni. He was a master at catching in pen and ink the absurdities of Londoners at work and play. Whistler comes close to the sense we have in Keene of eavesdropping on a nearby conversation in 'Wapping' (no.33), where the enigmatic trio seem to be seated at a table just across the room. Surely aware of the Baudelarian ideal of the painter as *flâneur*, or detached observer of the urban scene, Whistler's artistic project at this stage in his career was to capture in the high art of the exhibition print and oil painting the ephemeral moment and the unconscious revelation of character characteristic of Keene's caricatures.

According the Pennells, 'Whistler considered Charles Keene the greatest English artist since Hogarth'.[2] But – Pennell adds – 'who was first responsible for the striking similarity in the styles adopted by Whistler and Keene and Millais and Dumaurier ... in the etchings and drawings of the late fifties and early sixties I do not know; and Mr Whistler has told me that he does not.'[3] Notice that no French artist is named in this list.

Yet Whistler shared his admiration for Keene with Degas and Camille Pissarro, (much as Manet admired the draughtsmanship of the *Punch* cartoonist John Leech). All these French artists seem to have been freer than their English counterparts from the traditional prejudice which rigidly separated high art from low, fine art from illustration. Whistler always admired the Hogarthian ability to capture the throb and immediacy of modern life on canvas or etching plate, once making a telling connection between a Victorian follower of Hogarth, the painter of the urban scene William Powell Frith, and the French painter of modern life Edouard Manet. Standing in front of Frith's 'Derby Day' (Tate Gallery, London) he exclaimed 'How did he do it? It's as good as Manet.'[4]

Whistler's painted views of the Thames from the 1860s parallel the development in his figure compositions away from realism and towards idealism. At the beginning to of the period he painted 'Wapping' (no.33) and 'The Thames in Ice'

1860 (fig.54; YMSM 36), in both of which he spells out the gritty reality of the Industrial Revolution's effect on the river at the Pool of London, the city's dockland. Even in 'Chelsea in Ice' of 1864 (private collection; YMSM 53) a lone steamboat puffs down the river opposite Whistler's home in Lindsey Row.

In other views of the Thames between Battersea and Chelsea executed towards the middle and second half of the decade, Whistler depicts row boats, sail boats, barges and lighters, but usually ignores one class of river traffic: the paddle wheeled passenger steam boats which made the Thames a highway for Londoners in the nineteenth century. In their descriptive guide to the Thames of 1859, S.C. and A.M. Hall commented on the 'enormous traffic' which had not existed even twenty years earlier. They point out the 'steam-boat piers which have been such conspicuous objects in our journey from Wandsworth to London, and which the traffic in cheap boats has rendered necessary'.[5]

In Lindsey Row Whistler lived just beside Battersea Bridge Pier and just opposite the City Steam Boat Pier in Battersea. One writer recalled that in the 1860s the passage of a steamer under the narrow wooden spans of Battersea Bridge 'always generated a thrill, for until actually on the spot it looked impossible that the wide-spreading paddle-boxes could ever get through'.[6]

Whistler's fastidiousness did not apply to the landscape on the banks of the river. The Halls' guide to the Thames enthuses over the scenery on the Middlesex (Chelsea) side, even pointing out the charm of Whistler's own 'Lyndsay House … and its old history … full of interest'. But on the Surrey (Battersea) side of the river they saw 'only objects that blot the landscape, however much they may add to the solid wealth of the country … there is but a succession of factories and small cottage houses, which serve to shelter labourers and artizans; unwholesome – looking swamps divide the space with yards and quays, and waggon-sheds, auxiliaries to manufactures of gin, soap, starch, silk, paper, candles, beer, and vitriol'.[7] Another contemporary, writing in the 1850s, called Battersea 'the sink hole of Surrey'.[8]

R.D.

30 Brown and Silver: Old Battersea Bridge 1859–63

Oil on canvas laid down on masonite
63.5 × 76.2 (25 × 30)
Signed 'Whistler 1863'
PROV: Commissioned by Alexander C.
Ionides in 1859; by descent to his son
Alexander ('Aleco') 1892; D.C. Thomson,
London (dealer) 1895; H. Thorburn by
1899; Agnew, London (dealers) 1899;
Edmund Davis 1899; D.C. Thomson,
London (dealer) by 1926; Agnew,
London 1928; Lancelot H. Smith;
Thomas Cochran, New York 1928;
Cornelius N. Bliss, Washington D.C,
who presented it to the Addison Gallery
in 1928
EXH: London, RA 1865 (343); Paris, Exp
Univ. (I) 1867 (70) and (II) 1867 (77);
Paris, Petit 1883 (6); London, Goupil
1892 (31); Edinburgh 1904 (276); London
1905 (17); London & New York 1960 (9)
LIT: YMSM 1980 (33)

*Addison Gallery of American Art, Phillips
Academy, Andover, Massachusetts. Gift of
Cornelius N. Bliss*

30

Though commissioned by the Greek businessman Alexander Constantine Ionides in 1859, this picture is signed and dated 1863. Whistler was certainly capable of working on a canvas over a four year period, but in this case the thickly painted brown and grey pigments, coupled with the atmospheric treatment of the background, suggest a date no earlier than 1862. This supposition is strengthened by a remark of George Du Maurier's who in July of 1862 reported that Whistler was 'painting river pictures for the Greeks'. 'Brown and Silver: Old Battersea Bridge' was exhibited at the Royal Academy in 1865.

Whistler is recorded as living in Chelsea by December 1862, a few months after first meeting Swinburne and Rossetti. The high viewpoint, which Whistler emphasises by having the bargee or waterman in the foreground turn around to look up at the artist, implies that he painted the picture from an upstairs window. The view must be the one from Whistler's own rooms at 7 Lindsey Row.

He looked out onto Battersea Bridge, a wooden construction erected in 1771 to connect Chelsea with Battersea on the Surrey side of the Thames. The intricate wooden pilings under the bridge, seen from below, would become the subject of one of Whistler's most Japanesque Nocturnes (no.54).

Just out of sight to the left of the bridge was a steamboat pier, while in the distance, the sketchily painted factories and smokestack reappear in other Whistler paintings, notably 'The Balcony' (Freer Gallery of Art, Washington, DC; see no.24). Here, the white, two-storied building just to the left of the bridge on the Battersea side is the Swan Tavern; a little further to the left, just after the smokestack, is a factory producing white lead, and still further to the left a timber yard and saw mill.

One detail, however, is unique to his picture. Visible in the distance, past the houses in the right-hand background of the picture, can be seen Joseph Paxton's Crystal Palace, built for the Great Exhibition of 1851. The largest building erected up until that time, the structure had been moved to Sydenham in south London in 1852–4.

This landmark was noticed by Nathaniel Hawthorne in 1863, the same year Whistler completed 'Brown and Silver: Old Battersea Bridge': 'Crossing Battersea Bridge, in the neighbourhood of Chelsea, I remember seeing a distant gleam of the Crystal Palace, glimmering afar in the afternoon sunshine like an imaginary structure, – an air-castle by chance descended upon earth.'[1]

On the bridge itself, horse-drawn carts transport farm produce (possibly from the huge market gardens just behind the timber yard to the left) to the Chelsea shore, where watermen stand by ready to carry goods downstream to London. One barge loaded with barrels has already set off. The cold grey light and sense of mist in the distance suggest that this may be an early morning scene, when one would expect to see countrymen and women bringing their produce to London.

Whistler thus subtly contrasts the timeless activities taking place on the river and the depiction of working men who contribute to the life of the city with the very symbol of modernity in the distance, the Crystal Palace. In the 'Ten O'Clock' lecture Whistler spoke sneeringly of Paxton's masterpiece: 'The sun blares, the wind blows from the east, the sky is bereft of cloud, and without, all is of iron. The windows of the Crystal Palace are seen from all points of London. The holiday-maker rejoices in the glorious day, and the painter turns aside to shut his eyes.'

31 The Lime-burner 1859

Etching and drypoint printed in black
ink on cream laid paper with watermark
of bricked arch in shield surrounded by
stylised foliage
Plate: 25.1 × 17.6 (9⅞ × 6⅞)
Sheet: 27.5 × 19.9 (10⅞ × 7⅞)
Signed in plate: 'Whistler | 1859'
PROV: Gift of Constantine Ionides to
the Victoria & Albert Museum
LIT: Kennedy 1910 (46 I/II)

*Board of Trustees of the Victoria & Albert
Museum, London*

Published in *Sixteen Etchings of Scenes on the
Thames and Other Subjects.*

Soon after his return to London from his stu-
dent years in Paris, in late spring, 1859, Whistler
embarked on his series of etchings document-
ing life along the Thames. Not only was he
engaging a subject in keeping with his Realist

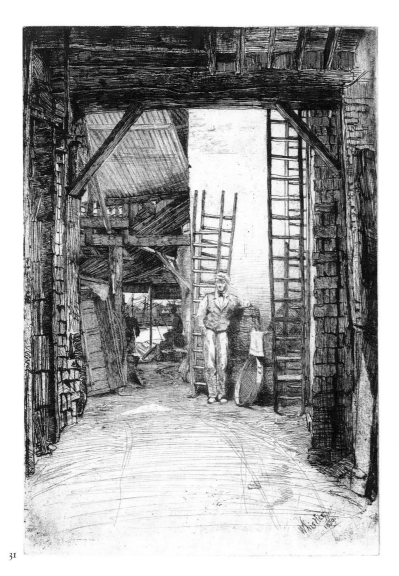

31

propensity at the time, he also was preserving a
record of a London soon to be lost, as Charles
Meryon had done earlier for Paris. For the sum-
mer months he took rooms in Wapping, an area
of London with visual possibilities in keeping
with the working-class subjects he had been
drawn to in Paris.

In many of the Thames etchings, there is the
figure of a workman in the foreground, but
here, the workman is a recognisable individual
– W. Jones, Lime-burner, Thames Street –
according to the title of the print when exhibit-
ed at the Royal Academy in 1869. He is not
merely the representative of his craft, or 'The
Lime-burner', as the print is now known.

Limestone was brought to the wharves along
the river on barges, and transferred to kilns,
where it was burned in preparation for use in
the building trade. A vast amount of lime was
poured straight into the Thames to kill the
stench of what was virtually an open sewer.
Lime was in great demand and the lime-burner
correspondingly prospered.

In a sense, this is as intimate an interior as
'La Marchande de Moutarde' (no.5) of the pre-
vious year, with which it has clear composition-
al affinities. In both, an architectural structure
enframes the central figure, who is surrounded
by the tools of their trade: in the present
instance ladders, a large sieve, a barrel, and a
cart.

Here, however, spaces are far more complex
than in the earlier print. The view through the
courtyard leads out to the Thames, and the ves-
sels and buildings beyond. Blazing daylight has
replaced the indoor luminosity, but the empha-
sis on strong areas of dark and light continues.
Thomas alerted his readers that 'especial notice
should be taken of the disposition of the light,
and breadth of treatment'.[1]

The plates included in *Sixteen Etchings of Scenes
on the Thames and Other Subjects*, which came to be
called the 'Thames Set', were completed by
1861, and impressions were printed by Auguste
Delâtre and Whistler. Publication was deferred
because Whistler and Haden planned a more
grandiose scheme, a set of four dozen etchings
of the Thames from its source to the sea,
inspired perhaps by Hiroshige's 'Fifty-three
Stages along the Tokaido Highway'.[2] However,
between the diverse aims and conflicting per-
sonalities of the two protagonists, the project
came to nothing. The Thames plates were not
formally published until 1871, at which time
Messrs Ellis & Green, King Street, Covent Gar-
den, had the plates steel-faced to help them
withstand the pressure from the press, and they
were printed in editions of one hundred.

The 1871 impressions are cleanly wiped and lack the subtlety of early proofs such as this one. The plates were not destroyed after printing as Whistler had intended, and they later came into the hands of Frederick Goulding who printed them with plate tone on fine papers, more to Whistler's liking.

32 Black Lion Wharf 1859

Etching and drypoint printed in black ink on cream laid paper with 'DE ERVEN DE BLAU' watermark
Plate: 15 × 22.5 (5⅞ × 8⅞)
Sheet: 17.2 × 24.9 (6¹³/₁₆ × 9¹³/₁₆)
Signed in plate: 'Whistler. 1859'
PROV: Gift of Constantine Ionides to the Victoria & Albert Museum
LIT: Mansfield 1909 (42); Kennedy 1910 (42 II/III)

Board of Trustees of the Victoria & Albert Museum, London

Published in *Sixteen Etchings of Scenes on the Thames and Other Subjects*.

Baudelaire in his reviews of the Paris Salon in 1859 urged artists to turn to a new genre, 'the landscape of great cities … the profound and complex charm of a capital city which has grown old and aged in the glories and tribulations of life.'[1]

Whistler was familiar with Wenceslaus Hollar's prints of London river, through Haden, who admired both their literal and technical skill. The low-life of the city, as depicted by Hogarth, was part of his artistic vocabulary. Just as Meryon had recorded the vanishing wharves of the Seine, Whistler might have proposed to record London's vanishing docklands.

The Thames etchings were developed over time: according to the Pennells, he spent three weeks on each plate, carefully suggesting the details of the barges and their cargo, the wood, brick, tile, metal, and other materials he discovered along Black Lion and the other wharfs and waterside buildings, aging and worn, depicted here. For two months, from August to October 1859, he worked down in the decaying and often dangerous city, producing eight etchings.

Black Lion Wharf was on the north side of the Thames, on the upper Pool of London. Whistler would have been on the south side, on one of the wharves west of St Saviour's Dock, or at Horselydown New Stairs.[2]

Whistler drew the lettering in 'Black Lion Wharf' onto his copper plate in reverse so that it would print in the right direction. There is some question whether some of the plates in the 'Thames Set' were reversed. If this plate was reversed, it implies that Whistler had a strong interest in the literal transcription of the scene.

The composition is marked by strong horizontal bands, with a tension established by the shared focus on the young longshoreman sitting with a casual air in the central foreground and the parade of 'warehouses and dwelling-houses' nestling on the far side of the Thames, which Wedmore considered the 'real interest of the picture'.[3]

For the facades, Whistler essentially developed a compendium of etched marks with which he suggested a variety of textures and tones. His interest in Japanese prints was kindled by the time of the 'Thames Set' and is apparent in the flattening of space and concurrent tensions that result.

As in 'Soupe à Trois Sous' (no.2), the figure in the foreground is sympathetically portrayed, and fully characterised, in contrast with the men skulling a boat on the right, who are little more than mannequins, or the workmen beyond, drawn as an afterthought over the boats on which they are at work, or the men on the wharves, ready for casual labour.

Whistler must have liked this print very much: a framed impression of it is suggested on the wall of his famous portrait of his mother (no.60).

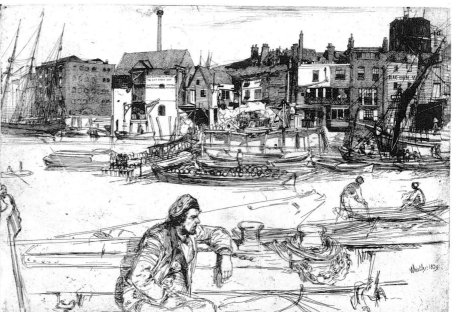

32

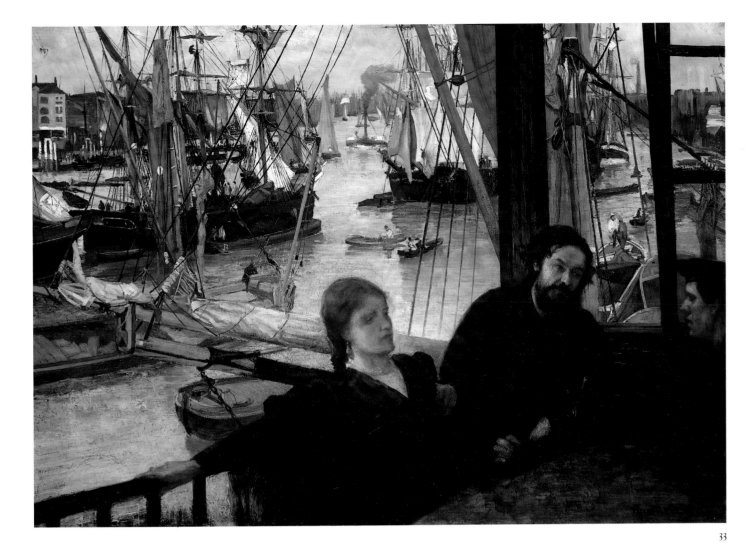

33

33 Wapping 1860–4

Oil on canvas 71.1 × 101.6 (28 × 40)
Signed and dated 'Whistler. 1861'
PROV: Bought from the artist by
Thomas Winans, Baltimore 1864; his
daughter Celeste (Mrs G.M. Hutton),
Baltimore 1878; John Hay Whitney;
presented to the National Gallery in 1982
EXH: London, RA 1864 (585); New York
1866 (360); Paris, Exp. Univ. (I) 1867 (76)
or (II) 1867 (69); Baltimore 1876 (39);
London & New York 1960 (5); New
York & Philadelphia 1971 (10)
LIT: YMSM 1980 (35); MacDonald 1994
(298–9)

*National Gallery of Art, Washington. John Hay
Whitney Collection*

In October 1860 George Du Maurier described
Whistler as 'working hard & in secret down in
Rotherhithe, among a beastly set of cads and
every possible annoyance and misery, doing one
of the greatest chefs d'oeuvres — no difficulty
discourages him.'[1] This *chef d'oeuvre* was 'Wap-
ping', named after the district directly across
the Thames from Rotherhithe, seen in the
background of the picture. Repainted time and
again, it took Whistler four years to complete.

Writing in 1863, the American novelist
Nathaniel Hawthorne described Wapping as 'a
cold and torpid neighbourhood, mean, shabby,
and unpicturesque, both as to its buildings and
inhabitants' where 'everything was on the poor-
est scale, and ... bore an aspect of unre-
deemable decay'. In the background Whistler
shows the wharfs, described by Hawthorne as
'the shabbiest, blackest, and ugliest buildings
that can be imagined, decayed warehouses with
blind windows, and wharves that look
ruinous'.[2] Wapping was filled with ale houses
and gin shops frequented not by sailors but by
petty criminals.[3]

In choosing to paint the London docks,
Whistler was merely seeking out the type of
haunts he had been used to in Paris. Arthur

Severn once described how in his early days in
London Whistler loved to sing 'in *argot* French,
imitations of what he had heard in *low cabarets*
on the Seine'.[4] 'Wapping' was painted in the
English equivalent of such dives, the Angel Inn
on the south side of the Thames near Cherry
Gardens.

The first-floor balcony setting is the same as
in Whistler's etching 'Rotherhithe' of 1860
(no.34) which shows a similar view of teeming
river traffic, spars, masts, sails and rigging. In
the same year, over Christmas, Whistler paint-
ed another view of the river and its shipping
from the Angel, 'The Thames in Ice' (fig.54;
YMSM 36). Whistler frequently complained
both of the slowness of his painting and of the
inadequacy of his training, and yet 'The
Thames in Ice' took him just three days to
finish.

The background in 'Wapping' appears to
have been painted directly and without changes,
the azure blue spars and bright red smokestack
still bright and fresh, suggesting that this area

of the painting gave Whistler little trouble. In the foreground, however, the darkened colours and severe cracking testify to the difficulty Whistler had in painting the figures.

In a letter to Fantin-Latour, probably written late in 1860 or early 1861, Whistler excitedly described the work in an early stage, enclosing a rough sketch (fig.55; M 299). He describes the three figures on the balcony as 'an old man in a white shirt', a 'sailor in a cap and blue shirt, and a 'jolly gal' with 'a superlatively whorish air'. The model for this girl was Joanna Hiffernan.

X-rays reveal that the central figure was originally depicted leaning towards Jo, with his right arm apparently around her shoulder. In his letter to Fantin-Latour Whistler reported that his chief difficulty lay in capturing in the woman's face the expression he was seeking. Having repainted her head three times, he was finally satisfied. Her sassy look now seemed to say to the sailor: 'That's all very well my friend, but I've seen others!' – you know – winking and mocking him'. Clearly the picture was conceived as a narrative scene showing a working-class woman or prostitute parrying the attentions of a potential lover or client. Moreover, in 1861 Whistler remarked of Jo's costume, 'the bust is exposed, one sees the chemise almost entirely'.[5] In 1864 his friend Thomas Armstrong warned him that the Royal Academy would never accept a picture in which so much cleavage was revealed.[6]

Whistler had painted a picture which more than rivalled Courbet for its realistic depiction of the lower depths. In his euphoric letter to Fantin-Latour, he added, 'Shh! Don't speak of it to Courbet!' – as though the subject were too juicy for the older painter to resist stealing. And yet, as it existed in 1860–1 it is doubtful whether such a strong subject could have been exhibited in the Royal Academy. The harrowing realism that passed without comment in an etching such as 'Soupe à Trois Sous' (no.2) was simply unacceptable in an oil painting intended for public exhibition. When Victorian artists like Rossetti and Holman Hunt had shown fallen women in their pictures, these women were seen to regret the error of their ways. Whistler's 1860–1 picture carries no such moral message.

Before 1864 Whistler reworked the three figures completely. By December 1863 he had decided to replace the anonymous old man in the centre with a portrait of his Parisian colleague Alphonse Legros, who had moved to London in August of that year. This figure leans away from Jo, who in turn leans slightly backward, supporting herself with her arm against the balustrade.

Jo's décolletage is far less daring than it had

been when Whistler boasted about it to Fantin in the letter of 1861. Above all, her face, on which the artist had laboured so strenuously to achieve 'expression' in 1860, is now remarkable chiefly for its absence of expression. As a result, the new configuration is as ambiguous as the earlier composition had been explicit. What is the relationship between these three people? Are they arguing? Sitting in sullen silence? Or is Legros the middleman, the pimp, between Jo and the sailor?

The answer is, possibly a mixture of all three. This enigmatic *menage à trois* may owe something to Manet's 'Déjeuner sur l'herbe' (Musée d'Orsay, Paris), which was shown alongside the 'White Girl' in the Salon des Refusés of 1863.[7] But purely human tensions may also have played their part in creating the strange atmosphere in Wapping. In November 1863 Du Maurier reported that 'Jimmy & Legros are going to part company, on account (I believe) of the exceeding hatred with which the latter has managed to inspire the fiery Joe'.[8] Their odd psychological distance from each other in the final version of the painting may well reflect this personal antipathy.

As late as February 1864 Whistler intended to send the picture to the Paris Salon. The decision to show the much altered version at the Royal Academy in 1864 was taken at the last minute, perhaps when Whistler realised that the changes he had made had rendered the picture innocuous.

34 Rotherhithe 1860

Etching and drypoint printed in black ink on cream Japan paper
Plate: 27.5 × 19.9 (11¾ × 7⅞)
Sheet: 31 × 21.4 (12³⁄₁₆ × 8⅜)
Signed in plate: 'Whistler 1860.'
PROV: Gift of Samuel Putnam Avery to New York Public Library
LIT: Mansfield 1909 (66); Kennedy 1910 (66 I–III)

S.P. Avery Collection, The Miriam and Ira D. Wallach Division of Art, Prints and Photographs, The New York Public Library, Astor, Lenox and Tilden Foundations

Published in *A Series of Sixteen Etchings of Scenes on the Thames and Other Subjects.*

'Rotherhithe' is closely related to the horizontal oil, 'Wapping' (no.33), which Whistler began the same year he made the etching,

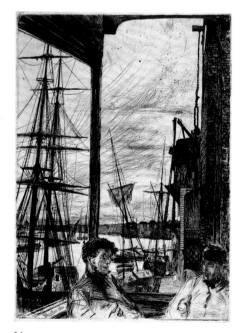

34

although unlike the painting it is vertical in format, lacks the figure of Jo, and looks out onto a different vista. The composition, dominated by the foreground figures, with the corner pillar of the balcony dividing the composition and framing the view of ships and the river beyond, may have been a stage in the development of the oil painting. Whistler described the detail of the background in the painting as being 'like an etching', acknowledging the link between the two interpretations.¹

The etching was exhibited at the Royal Academy in 1862 as 'Rotherhithe', and although formally published as 'Wapping' in 1871, the earlier title has generally been retained. The setting is the balcony of the Angel Inn, Cherry Gardens, in Rotherhithe, on the south bank of the Thames, with Wapping seen across the river. Looking north-west, the dome of St Paul's Cathedral is in the far distance.

The strong grid structure in the foreground of 'Rotherhithe', and overall layering of horizontal bands of land, sea, land, and sky foretell two of the primary structural strategies the artist would use throughout his printed oeuvre. Before they were reworked with the strong diagonals seen here, the cloud formations were configured in horizontal layers.

Only in his earliest etchings did he get involved in such great detail, however, with descriptions of likeness as seen in the two men's faces, using touches of drypoint atop his initial etched structure. By contrast, almost lost among the complexities of the wharfside scene are the figures of several other workmen and fishermen, gestural suggestions of the sort Whistler would come to use frequently. Also of special interest is the darkened wall along the right edge. In its tight clustering of ordered marks it comes closer than other etchings from the 'Thames' or 'French Set' to the surface effects Whistler would explore extensively in the Amsterdam plates three decades later (see no.164).

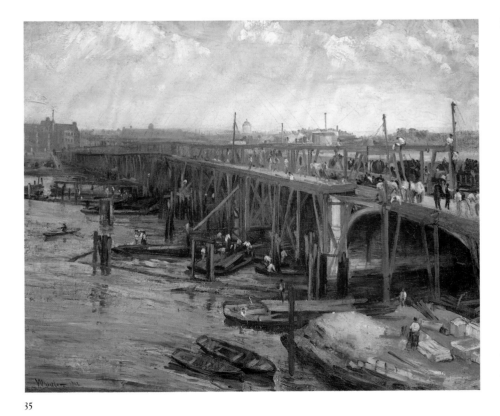

35

35 The Last of Old Westminster

1862

Oil on canvas 61 × 77.5 (24 × 30½)
Signed and dated 'Whistler. 1862'
PROV: G.J. Cavafy 1863; his son Dr John Cavafy; Edward G. Kennedy, Wunderlich & Co. (dealers) 1892; Cottier, New York (dealers) 1892; Alfred Attmore Pope, Farmington, Connecticut 1898; bequeathed to his daughter Mrs J.W. Riddle 1913, who sold it to the Museum of Fine Arts Boston 1939
EXH: Paris, Soc Nat. 1862 (catalogue untraced); London, RA 1863 (352); New York 1898 (282); Boston 1904 (34); London 1905 (35); Paris 1905 (56)
LIT: YMSM 1980 (39)

Museum of Fine Arts, Boston. Abraham Shuman Fund

Whistler recorded progress on the construction of New Westminster Bridge in three works executed between 1859 and 1862. An etching from the 'Thames Set' of 1859 shows in reverse a traditional view of the old bridge, a famous London landmark, seen from the north from across the river with the Houses of Parliament on the left (K 39) while another etching shows the scaffolding from close to (K 72). He painted no.35 over a period of months, probably

between the opening of the new bridge to the public in May 1862 and the final removal of the scaffolding in July of that year.

Work on the construction of New Westminster Bridge began in 1854 and proceeded in three stages. First, a structure one half the width of the completed bridge was built parallel to old Westminster Bridge, upstream. A limited amount of traffic continued to use the old bridge. On the completion of stage one, the new bridge was opened to traffic while old Westminster bridge was demolished. Finally, the second half of the new bridge was built following the lines of the old bridge, thus doubling the width of the completed structure.

Whistler's picture records the final stages of this sequence. In 1897 he referred to the picture as 'The Westminster Bridge',[1] which is more accurate than the title under which it was exhibited at the Royal Academy, 'The Last of Old Westminster'. Despite its title, no trace of old Westminster Bridge, which had long since disappeared, is visible.

One of the bridge's seven spans has had its scaffolding removed, revealing a semi-octagonal granite pillar and cast iron spandrel, the first glimpse of Thomas Page's new structure, designed in the Gothic taste to harmonise with the Houses of Parliament nearby. On the side nearest the viewer at river level, scaffolding is being lowered on to waiting barges. Above, on the bridge itself, the pedestrian pavements have been completed and workmen appear to be erecting lamp standards over each pier. Dozens of masons, labourers, supervisors, and boatmen swarm over, under, and on the side of the bridge. To emphasise the energy and excitement of the scene, Whistler shows carriages, a hansom cab, and a crowd of sightseers looking downstream over the parapet on the far side.

Old Westminster Bridge, built in the 1740s, had been the first new bridge built over the Thames since the Middle Ages. Often painted by such artists as Richard Wilson, Samuel Scott and Antonio Joli, it was a favourite subject of Canaletto, who showed the bridge both under construction and finished. Though Whistler often expressed the highest admiration for Canaletto, this work is much more than simply an artist's homage to an old master.

Had Whistler simply waited a few months, he could have been the first artist to paint the newly completed bridge, carrying on where his eighteenth-century predecessor had left off, and giving his audience a more or less traditional 'view' of one of the sights of London. Instead, he stresses the urgency of his vision by choosing to paint an ephemeral moment in the bridge's history, when the scaffolding has just begun to come down, giving Londoners their first glimpse of the new structure.

Whistler thus announces that he is a painter of the modern urban scene. In 'The Last of Old Westminster' he shows London as a city of the present, a city of new buildings and bridges, a city on the cusp of change.

Whistler painted the bridge from the rooms of Walter Severn in Manchester Mansions, an apartment block on the north bank of the Thames on the site of what is today Old Scotland Yard. From the bow window in the drawing room he could look south across the Thames towards Lambeth, and straight down onto the landing stage for the steamboat which would take him both downstream to Wapping and Rotherhithe and upstream to Chelsea.

Walter Severn's brother Arthur, the artist, saw Whistler at work:

> It was the piles with their rich colour and delightful confusion that took his fancy, not the bridge, which hardly showed. He would look steadily at a pile for some time, then mix up the colour, then holding his brush quite at the end, with no mahlstick, make a downward stroke and the pile was done. I remember once his looking very carefully at a hansom cab that had pulled up for some purpose on the bridge, and in a few strokes he got the look of it perfectly. He was a long time over the picture, sometimes coming only once a week, and we got rather tired of it.'[2]

Severn remembered the time it took Whistler to mix the various tones of grey and white for each pile or workman's shirt. He constantly altered details by painting them over without first scraping down. As a result the paint surface is thickly impastoed and in places cracked.

The river is brushed in freely, with turgid brown paint. During construction the stench from the Thames was so strong that every day six or seven workmen were overcome with nausea and vomiting. The river was not, therefore, a picturesque subject. Before its embankment, the Thames was an open sewer, the carrier of cholera and typhus.

And yet Whistler was conscious that as an artist he had taught Londoners to appreciate the beauty of the Thames. In a letter to Waldo Story written during the autumn of 1887 from Brussels, he remarked on the loveliness of the city he was seeing for the first time, and added that the inhabitants themselves had no idea of its beauty. 'I will have to invent their town for them as I did the Thames for the Londoners!'[3]

36 Battersea Reach c.1863

Oil on canvas 50.8 × 76.2 (20 × 30)
PROV: G.J. Cavafy; Dr John Cavafy; E.G.
Kennedy of Wunderlich, New York
(dealers) 1892; Isaac Cook, Jr, Maine,
1893; John Levy, New York (dealer) by
1918; James Parmelee 1918; his widow 1931,
who presented it to the Corcoran Gallery
of Art 1941
EXH: Chicago & Utica 1968 (9)
LIT: YMSM 1980 (45)

*The Corcoran Gallery of Art, Washington.
Bequest of James Parmelee*

In 1893 Whistler wrote a certificate of authen-
tication for this picture, a view of the Thames
from Chelsea looking upstream from Battersea
Bridge, which is out of sight at the left: 'The
picture called "Battersea Reach" was painted by
me ... when I was living in Lindsey Row,
Chelsea [i.e. after March 1863]. It was a view of
the opposite bank of the river, from out of my
window, on a brilliant autumn evening.'

A year earlier he had mentioned that 'The
Little Thames Picture' had been painted 'in one
go' without the impasto that characterised
other works of this period. He consistently
called the picture an 'afternoon or evening
effect' or 'the little evening on the Battersea
Reach'.

The sketchy use of thin paint is consistent
with this memory of painting *sur le motif* in one
session. The almost transparent figures rushing
by in the foreground at the right give an impres-
sion of ephemeral movement, suggesting that
this is very much a city scene, the river as a place

of work. Their movement is matched by the
sweeping brushstrokes used to indicate a swift
current in the water and scudding clouds over-
head. Their headlong surge out of the picture
towards the left is reinforced by the six diago-
nals formed by the masts of the lighters. But
Whistler maintains the equilibrium by the
hulls of the moored lighters and by the strong
note of the red sail in the lighter mid river. The
warm range of light red and brown colours set
off against the chill grey of the water, evoke a
fine autumnal evening.

37 Battersea Reach from Lindsey Houses 1864–71

Oil on canvas 51.3 × 76.5 (20¼ × 30⅛)
PROV: Bequeathed by Whistler to his
sister-in-law Miss R. Birnie Philip 1903;
bequeathed to the University of Glasgow
1958
EXH: London & New York 1960 (25);
Tokyo 1987–8 (4)
LIT: YMSM 1980 (55)

*Hunterian Art Gallery, University of Glasgow,
Birnie Philip Bequest*

As with 'Grey and Silver: Chelsea Wharf'
(no.38), Whistler worked on 'Battersea Reach
from Lindsey Houses' over a period extending
from about 1864 to 1871. The view across the
Thames to a coal slag on Battersea shore is
roughly the same as in the background of 'Vari-
ations in Flesh Colour and Green: The Bal-
cony' of 1865 (see no.24) and 'Chelsea in Ice'
(Private Collection; YMSM 53) of c.1864. How-
ever, the fashions of the ladies in the fore-
ground are similar to those depicted in
'Variations in Violet and Green' (no.25) of 1871.
Between these two dates Whistler had painted
the 'Six Projects', his attempt to unite the chi-
noiserie of eastern design with the classicism of
Greek tanagra figures (pp.92–4). Here, he
demonstrates that the most banal Western
cityscape can be aestheticised when seen
through fog, just as modern Western fashions
have all the charm of the kimono when accom-
panied by the graceful parasol.

Until well into this century, heavy London
fogs were caused by coal fires and industrial
pollution. At best they were considered an
unhealthy nuisance, at worst, as in Dickens's
Bleak House (1852–3), frankly menacing. The
idea that fogs were occasions for aesthetic con-

36

templation began to be expressed in the 1860s, when, as so often before, foreign visitors to London saw a beauty where it had eluded its residents. The French poet Stéphane Mallarmé, living in London in 1863, wrote to a friend, 'I hate London when there are no fogs: in the mists, it is a town without peer'.[1] In the visual arts, Whistler claimed to have been the first painter to make the fog his special subject.

The sense of objects half seen through a pea soup fog could also be considered a daytime variation on the Nocturne theme, which he began to explore towards 1871. Fog, like darkness, blurred outlines to create a spatial ambivalence through which the eye seeks in vain for points of focus.

37

38 Grey and Silver: Chelsea Wharf

1864–8

Oil on canvas 61 × 46 (24 × 18⅛)
PROV: Gerald Potter, London before 1886, who sold it before Aug. 1895; P.A.B. Widener, Ashbourne, near Philadelphia by 1900; bequeathed to his son J.E. Widener 1915; given to the National Gallery of Art, Washington 1942
EXH: London, Society of French Artists, 1875 (80); London, Goupil 1892 (35); London 1905 (69)
LIT: YMSM 1980 (54)

National Gallery of Art, Washington. Widener Collection

This is another view from the balcony at Lindsey Houses across the Thames towards Battersea – the twin smokestacks and pyramidal coal slag instantly recognisable from 'Grey and Silver: Old Battersea Reach' 1863 (Art Institute of Chicago; YMSM 46) and 'Variations in Flesh Colour and Green: The Balcony' (see no.24) of 1865. Reference to the Stanford Survey Map for 1862 reveals that we are looking towards flour and timber mills as well as chemical and turpentine works. The spire just to the left of centre is that of St Mary's Church, Battersea.

In the foreground, the wall of Chelsea shore creates a strong diagonal against which shadowy figures are shown in movement. The picture may have been started as early as 1864, but

worked on over a period of about four years. The thick layers of paint, which may conceal an earlier composition, and the numerous pentimenti in the masts, rigging and sails suggest several changes of intention. The impressionistic absence of detail, however, might indicate a date after the Valparaiso Nocturnes of 1866 (see nos. 43–5).

It is possible to read the composition both as a traditional view into space, with the foreground giving the viewer a clue as to the distance the eye needs to travel to the background, or as a flat (or nearly flat) pictorial space made up of bands of gray pigment, from the diagonal wall at the bottom of the picture to the dark area (perhaps the muddy river bed exposed at low tide) just below the centre, and the Battersea shore in the distance. Against this flat ground Whistler swiftly summons up the elegant masts, spars, and diaphanous rust coloured sails with light, calligraphic touches of the brush.

A drawing related to this painting is in Leighton House in London (M 396).

38

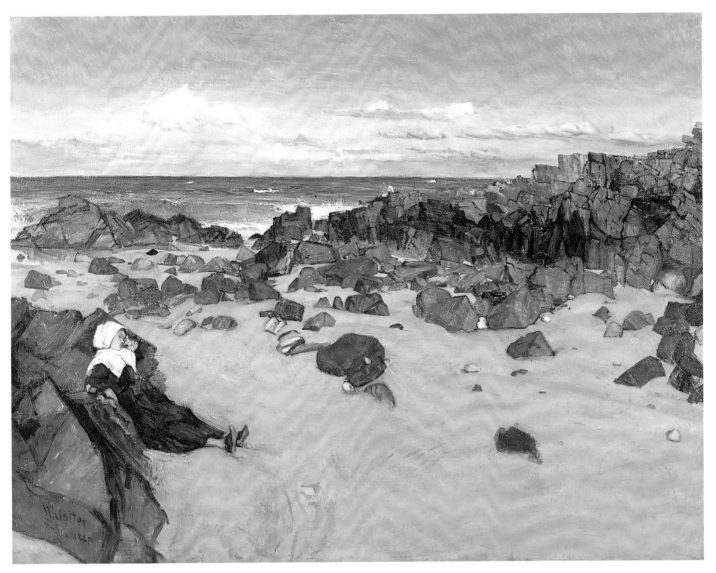

39

39 **The Coast of Brittany** or **Alone with the Tide** 1861

Oil on canvas 87.3 × 115.8 (34⅜ × 45½)
Signed and dated 'Whistler 1861'
PROV: George William Whistler 1863
and by descent; Christie, London 5 May
1906 (103), bt Colnaghi, London
(dealers); William Arnold Healy; his
daughter Susie Healy Camp who
presented it to the Wadsworth
Athenaeum 1925
EXH: Paris, Soc. Nat. 1861 (cat.
untraced); London, RA 1862 (670); New
York 1874 (325); Baltimore 1876; New
York 1878 (76); New York (I) 1881 (204);
possibly New York (II) 1881 (cat.
untraced); Boston 1904 (42); London
1905 (II); London and New York 1960
(6); New York & Philadelphia 1971 (II)
LIT: YMSM 1980 (37)

*Wadsworth Atheneum, Hartford. In memory of
William Arnold Healy, given by his daughter
Susie Healy Camp*

Whistler painted this picture in Brittany (in the
north-east corner of France) in September and
October 1861. A few months later George Du
Maurier reported a conversation with Whistler
on the subject of the 'little Breton girl asleep on
the rock' in which Whistler declared that 'there
is not one part of the picture with which he is
not thoroughly satisfied … and its open air
freshness nothing can stand against'. He waxed
lyrical on the 'Sea line — of the very deepest
blue', and the 'breaking waves with foam at top
& of a transparency which is simply magnifi-
cent'.[1]

'Alone with the Tide', the title under which
the picture was shown at the Royal Academy in
1862, is Whistler's first large-scale landscape in
oil. Its subject, a peasant woman asleep on the

coast of one of the wildest and most desperately poor areas of France, might be regarded as a rural parallel to the low-life urban subjects he had found in the London docklands.

Many of the French artists who worked in Brittany before Whistler were academic painters creating artificial compositions to display exotic Breton costumes and customs. Such subjects achieved wide popularity. In 1859, for example, the Emperor Louis Napoleon commissioned Adolphe Leleux to paint 'Wedding in Brittany' (Musée des Beaux-Arts de Quimper) for 5,000 francs. Closer in spirit to Whistler were the landscapes of Corot, who visited Brittany at least seven times from 1829, and Boudin, a frequent visitor from 1855 onwards.[2] Whistler, a forerunner by thirty years of van Gogh and Gauguin, emphasises the isolation of the area in the single set of footprints in the wet sand leading to the lone figure on the empty beach.

Whistler's growing admiration for Courbet and his intimacy with Alphonse Legros accounts for his choice and treatment of this scene of peasant life. The awkwardly splayed legs of the model, so different from Jo's graceful languor in 'Weary' (no.19) look directly to Courbet's peasant woman in the 'Grain Sifters' 1855 (Musée des Beaux-Arts, Nantes) which Whistler could have seen at Courbet's *Pavillon du Réalisme* at the Exposition Universelle of 1855.[3]

Spencer has emphasised the somewhat surprising parallels between Whistler's seascapes of the early 1860s and those of the British sea painter James Clarke Hook, whom Whistler seems to have regarded with a mixture of admiration and envy. But in 'The Coast of Brittany' it is not only their similarities that are of interest, but the ways in which Whistler's picture flagrantly rejects academic principles of landscape composition in general, and Hook's in particular.

Hook's models look as though they had been posed in a studio, then imposed on a landscape background. By contrast, Whistler makes his lone figure an organic part of the landscape by placing her halfway up the foreground and viewing her from a slightly raised vantage point. This gives his picture a gauche, unposed, Realist appearance, and enhances the effect of being on the spot. But to do this, it was necessary to raise the horizon line and 'flatten' the foreground space. The beach does not recede evenly into depth as in Hook's landscapes, but seems to be tilted upwards as in one of Hook's pure seascapes, such as 'Luff, Boy!' 1859 (Private Collection, North Carolina).[4]

This flattening effect parallels Legros's experiments with perspective distortion in a painting such as his 'Angelus' of 1859 (whereabouts unknown), intended to evoke a primitivism and authenticity very different from popular academic renderings of such scenes. Legros's deliberately naive construction of space in the 'Angelus' so irritated its owner, Seymour Haden, that he repainted it, whereupon Whistler and Legros promptly restored the 'Angelus' to its orginal state.[5] Whistler regaled Fantin-Latour with an account of his subsequent argument with Haden: 'Je parle des idées vulgaires du "repoussoir". Combien c'était bien pour les Academiciens (ce qui veut dire Horsley) [i.e. John C. Horsley RA, a relation of Haden's, and therefore an enemy] et combien c'était absurde dans le vrai maître etc. etc.!!'[6]

An interesting resemblance to Whistler's composition in 'The Coast of Brittany' may be found in Edgar Degas's 'Beach Scene' 1876 in which the two central figures are placed against the flattened foreground in much the same way as here (fig.56).

Whistler at Trouville

Whistler and his mistress Jo spent October and November of 1865 with Gustave Courbet in the fashionable resort of Trouville on the English Channel at Normandy. Courbet had been there since September, living in the Casino in a 'splendid apartment overlooking the sea', painting 'the prettiest women in Trouville' and enjoying the fine weather and sea bathing.[1] He remained until 21 or 22 November, having completed thirty-five canvases, including portraits and seascapes, in three months.

In a letter of 17 November 1865 Courbet noted the presence at Trouville of the thirty-one year old Whistler, 'an Englishman who is my student'.[2] Whistler met Courbet through Fantin-Latour after the older artist had admired 'At the Piano' (no.11) when it was exhibited a Bonvin's studio in 1859. Whistler was not among the students registered at the atelier at 83 Notre-Dame-des-Champs where Courbet taught painting from December 1861 to March 1862, and so cannot be said to have been Courbet's pupil in any formal sense.

The influence of Courbet's gritty Realism is strongest in Whistler's early portraits, 'La Mère Gérard' of 1858–9 (Private Collection; YMSM 26) and the 'Self Portrait' of 1857–8 (Freer Gallery of Art, Washington DC; YMSM 23). In 'The Coast of Brittany' of September – October 1861 (no.39) Whistler pursued the uncompromising naturalism evidenced not only by Courbet's paintings but also in his writings on art. Here is Courbet addressing the art students of Paris in an open letter published in the *Courrier du Dimanche* of 29 December 1861:

> Beauty is in nature and occurs in reality under the most varied aspects. As soon as one finds it, it belongs to art, or rather to the artist who can see it. As soon as beauty is real and visible, it carries its artistic expression within itself. But the artist has no right to amplify that expression. He cannot touch it without running the risk of altering its nature and, consequently, of weakening it.[3]

But Whistler experienced difficulty in becoming a Realist painter in the Courbet mould. Writing to Fantin-Latour from Spain in October 1862, he spoke of his frustration:

> I do not work fast enough! I seem to learn so little! Moreover painting from nature done outside can only be large sketches, It does not work. An end of a floating drape, a wave, a cloud, it is there one minute and then gone for good. You put down the true and pure tone, you catch it in flight as you kill a bird in the air – and then the public asks you for something finished.'[4]

At the time of writing this letter Whistler was painting 'Blue and Silver: Blue Wave, Biarritz' (Hill-Stead Museum, Farmington, Connecticut; YMSM 41). Three years later at Trouville, the impact of Japanese art had already made itself felt in Whistler's views of the Thames and he was beginning to move away from Courbet's heavily impastoed style towards a freer handling of paint. Now, Whistler's palette

lightened, and (to Courbet's disgust) he placed his horizon lines higher than ever. Above all, in using thinner pigment he was able to work more quickly in order to capture those evanescent effects of light and movement which would lead to the Valparaiso 'Nocturnes' of 1866 (nos.43–5).

At Trouville Whistler painted at least five seascapes. One has only to recall the elegant crowd of holiday makers who appear in the work of Eugène Boudin, who was working there by 1863, to realise that Whistler has turned his back on the pretty esplanade lined with wooden hotels and dotted with bathing huts, in favour of more or less empty stretches of beach and sea.

While at Trouville, Courbet painted Jo as 'La Belle Irlandaise' 1865 (National-museum, Stockholm). The following year, while Whistler was in Chile, she posed for one of the two women in Courbet's overtly erotic 'Le Sommeil' 1866 (Petit Palais, Paris). We do not know for certain whether Courbet and Jo actually became lovers, but Whistler certainly parted from his mistress on his return to London in the autumn of 1866, and seems to have had no further communication with Courbet until the French painter wrote to him in 1877 reminiscing about their idyll in Trouville, when 'we went bathing on a frozen beach, and the salad bowls full of shrimp with fresh butter … which allowed us to paint the sky, the sea, and the fish all the way to the horizon. And our payment consisted of dreams and sky.'[5] R.D.

40 Crepuscule in Opal: Trouville

1865

Oil on canvas 35 × 46 (13¾ × 18⅛)
PROV: Frederick Jameson by 1868/9; sold after 1905 to A. Arnold Hannay, London; sold through Scott & Fowles, New York, to Florence Scott Libbey 1923; given to the Toledo Museum of Art 1923
EXH: London, Goupil 1892 (39); London 1905 (140); London & New York 1960 (14); Berlin 1969 (6); Ann Arbor 1978 (40)
LIT: YMSM 1980 (67)

The Toledo Museum of Art; Gift of Florence Scott Libbey

'Crepuscule in Opal: Trouville' is one of the most daringly empty of all Whistler's early landscapes and among the most naturalistic. It shows the sun setting on a deserted and almost featureless beach. The turbulence of the sky and the silver sheen on the water suggest that a storm has passed. The receding tide uncovers the few rocks in the foreground, leaving the wet sand to reflect the yellows and deep pinks in the

40

41

sky. Particularly effective are the dabbed-in breakers in the middle distance, and the frank smear of pigment used to suggest the rock in the lower left foreground.

One could compare the painting with Courbet's 'Low Tide at Trouville' (fig.57) but it is still unclear whether the older artist was influencing Whistler or the other way around. It is unusual among the seascapes painted at Trouville in that its almost lurid colouring may reflect Whistler's close contact in these years with the Pre-Raphaelite circle in London. In particular, through his friendship with Dante Gabriel Rossetti, Whistler may have known William Bell Scott's studies of the deserted Northumberland coast, for example, 'A Seashore at Sunset' (fig.58). Superficially, at least, this is closer in appearance to no.40 than Courbet's more muted seapieces.

41 Harmony in Blue and Silver: Trouville 1865

Oil on canvas 49.5 × 75.5 (19½ × 29¾)
Signed with butterfly in 1892
PROV: Given by Whistler to G.J. Cavafy before 1878; sold to E.G. Kennedy of Wunderlich & Co., New York (dealer) 1892, who returned the picture to Whistler; sold to Mrs J.L. Gardner of Boston 1892; bequeathed to the Isabella Stewart Gardner Museum 1924
EXH: Possibly Paris, Petit 1883 (4); Boston 1898 (90)
LIT: YMSM 1980 (64)

Isabella Stewart Gardner Museum, Boston

In 1886 Whistler listed this painting as 'Courbet – on sea shore –'[1] and later remarked that it was 'The only painting by me of Courbet'.[2] Whistler added the figure (originally further to the left) after the background had dried. The diagonal composition leads the eye from the figure of Courbet through the yacht with the twisting sail to the sail on the horizon.

The lone figure gazing out on the empty sea provides a point of focus against the expanse of sea and sky and also pays homage to Courbet's 'The Seaside at Palavas' of 1854 (fig.59). But here Whistler uses a brush, palette knife, and probably his fingers to sweep his thin pale colours across the canvas from side to side.

To Luke Ionides, Whistler wrote from the Hôtel du Bras d'Or in Trouville on 20 October 1865, 'I am staying here to finish two or three sea pieces which I wish to bring back with me. I believe they will be fine – and worth quite anything of the kind I have ever done. This is a charming place – although now the season is quite over and everyone has left – but the effects of sea and sky are finer than during the milder weather.'[3]

42 The Sea 1865

Oil on canvas 53.3 × 95.9 (21 × 37¾)
PROV: J.H. Whittemore, Naugatuck, Connecticut by 1904; after his death in 1910 owned by Miss G. Whittemore; at her death in 1941 owned by the J.H. Whittemore Co.; H. Whittemore sale, Parke-Bernet, New York 19 May 1948 (89), bt Mrs George A. Martin; bt Graham Gallery, New York 1958; bt Montclair Art Museum 1960
EXH: Boston 1904 (69); Paris 1905 (61); Chicago & Utica 1968 (13); Berlin 1969 (65); Ann Arbor 1978 (47)
LIT: YMSM 1980 (69)

The Montclair Art Museum

The masterpiece of Whistler's Trouville sojourn, and one of the freshest of all Whistler's *plein air* seascapes, this painting combines the immediacy of a sketch with the size and finish of an exhibition picture. Here Whistler shows the English Channel at Trouville in the silvery light of an overcast day, with a yacht riding the swell of the waves at the right. The stiff breeze blows moisture-laden clouds across the horizon, while the breakers toss up flecks of cold foam.

The sky, which is clear at the left, turns cloudy grey at the right. Flecks of deep midnight blue appear here and there within the green tinted waves. Whistler applies the paint with a large square brush, following the curves of the waves without losing contact with the canvas.

42

Valparaiso

Whistler's impetuous flight to Valparaiso in 1866 to assist the Chileans in their war with Spain represented a crisis in his art and life. The previous year he had tried and failed to paint his Realist masterpiece on the subject of the artist in his studio, an ambitious composition measuring ten feet by six which he had hoped would rival Fantin-Latours's 'Homage to Delacroix' (fig.24 on p.42) (see p.17; YMSM 62–3). The failure seems to have contributed to the growing sense of the inadequacy of his technical training, a realisation that in 1867 would lead to Whistler's bitter repudiation of Courbet and the Realist school, but in the short term merely encouraged his precipitous retreat from London.

Though proud of his West Point education, Whistler had not taken part in the American Civil War, as had his younger brother William, a surgeon in the Southern army. Whatever else Whistler was escaping in leaving London at this moment, the journey certainly represented a belated attempt to see military action. Then too, his sympathy for the underdog is consistent with his youthful admiration for Garibaldi and his friendship in Paris with the Irish nationalist John O'Leary.[1] As Courbet's pupil, he would certainly have considered that the Realist style itself was laden with republican, democratic values.

In 1900 Whistler regaled the Pennells with a humorous account of the episode, explaining simply that in 1866 'many of the adventurers the [American Civil] War had made of many Southerners were knocking about London, hunting for something to do, and, I hardly know how, but the something resolved itself into an expedition to go out to help the Chileans … against the Spaniards.'[2] Whistler had gone to fight in a war, not, as he seems to have believed, a revolution. In 1864 the Spanish Pacific Fleet appeared off the west coast of Peru to 'investigate' claims of debt owed to Spaniards by the Peruvian government. When the fleet occupied the Chincha Islands, Chile joined Peru, Bolivia and Ecuador in an alliance against Spain, while the British, American and French governments sent their own fleets to protect the property of its nationals and to provide a strong neutral force between the combatants.

When Whistler set sail with a friend, a Mrs Doty, from Southampton on 2 February 1866, a squadron of six Spanish ships under Brigadier Señor Mendez Nuñez was blockading independent Chile's principle harbour Valparaiso, a town of 80,000 inhabitants. By the time he arrived in the city on 12 March, the situation had deteriorated.[3] On March 27 the Spanish announced their intention to bombard the defenceless city in order to 'destroy every palace, house, or hut within reach of [its] guns'.

Outraged, foreign consuls from virtually every European country protested that they 'would hold the Spanish Admiral responsible in the face of the whole civilized world for this act of devastation and inhumanity'. The American admiral, Commodore John Roberts, then threatened to 'blow the Spanish fleet out of the water', but since no state of war existed between Spain and either America, France or England, their fleets were obliged to withdraw during the attack.[4]

On the evening of 30 March the withdrawal began. On the morning of the following day 'the English and American men-of-war steamed out of the Bay of Valpariso ... [and] stood about three miles from the port, and allowed the seven vessels of the Spanish bucaneering expedition ... to pour in a raking fire of shot, shell, and all manner of projectiles into the defenceless buildings and houses'.[5]

Whistler described his own panicky flight on horseback to the hills with some Chilean officials, and how on their return 'all the little girls of the town turned out and as we rode in called us "Cowards!"'[6] In fact, the Chilean government had given orders that Spanish fire should not be returned, so there was little Whistler could have done apart from helping the fire brigade.

He considered that 'the Spaniards conducted the performance in the most gentlemanly fashion; they just set fire to a few houses.' The whole engagement was over by noon. 'The Spanish fleet [then] sailed again into position, the other fleets sailed in.'

But the effect of the bombardment was actually much more serious than Whistler either realised or remembered. The guns from the ironclad *Numancia* destroyed the fortifications and the port installations and reduced the city to a shambles, 'in one blow wiping out the commercial position gained a quarter-century before' according to one historian.[7] Soon after, Chile and Spain ceased hostilities. Whistler hung around Valparaiso and Santiago through the South American winter, setting sail for England in September 1866. On 17 November George Price Boyce noted in his diary that Whistler had 'only recently returned from Valparaiso ... He has brought back but 2 oil sea-sketches with shipping, both are near Valparaiso, both slight but effective, artistic and true in tone'.[8] The whole adventure had lasted about nine months.

R.D.

43 Nocturne: The Solent 1866

Oil on canvas 50.8 × 94 (20 × 37)
PROV: C.A. Howell, London; possibly his sale Christie, London 13 Nov. 1890 (438); possibly W.T. Spencer, bookseller London by 1910; possibly Mme Frida Strinberg by 1910; Dowdeswell, London (dealer) 1910; Knoedler, New York (dealers); Reinhardt, Chicago (dealer) 1911; William H. Sage, New York; his sale, American Art Association, New York, 15 Nov. 1935 (20), bt Weitzner, New York (dealer); Washington University, St Louis 1936; auction Kende Galleries, New York, 4 May 1945 (148), bt Knoedler; Levy, New York (dealers); Knoedler; Thomas Gilcrease, 1955; sold with his collection to the City of Tulsa, 1955; passed to the Thomas Gilcrease

Institute of American History and Art
LIT: YMSM 1980 (71)

Gilcrease Museum, Tulsa

The picture's early history is unclear. Its title was attached to it only in 1947 on the basis of an entry in Whistler's diary of his journey to Chile (GUL) in which he notes that he sailed on the *RMS Solent* to South America. She was a ship of 1,804 tons built in 1857 for the Royal West Indian Mail Company. But since he both embarked and disembarked at Southampton, the title could also refer to the Solent Strait, the body of water between Southampton and the Isle of Wight.

On the reverse of the canvas is a ruined sketch showing an upright woman dressed in Japanese kimono standing before a chimney piece on which there appears to be a piece of

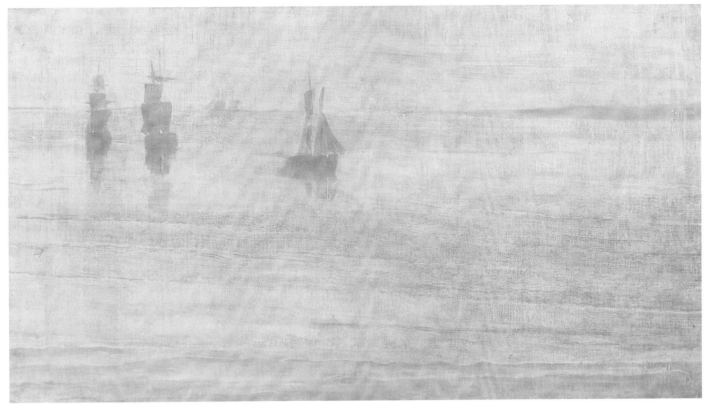

43

porcelain with a spray of blossom on the left (fig.60). This figure might relate to the 'Six Projects', which Whistler began in 1867 (see pp. 92–4), but the pose and costume are also close to the figures in 'Whistler in his Studio' of 1865 (fig.46; YMSM 63).

If, in addition to the unstretched canvases he presumably took out with him on the *Solent*, he also brought this abandoned study which was already on its stretcher, he may well have used it to depict a scene on the outward journey. What is certain is that on his arrival he gave two completed seascapes to a ship's purser to bring back to England. He never saw them again and assumed they had been lost at sea, which explains why this exceptionally important canvas was not exhibited during his lifetime.

This painting represents the first intimation of the Nocturnes of the 1870s. The intense blue tonality and the twilight atmosphere – when watery reflections of the yellow riding lights find an echo in the two lights on the sliver of shoreline – create a mood of perfect tranquillity. Whistler drags a loaded brush in wavy parallel strokes horizontally across the foreground with a 'wristy' motion to create an effect of constant rippling flux.

44 Crepuscule in Flesh Colour and Green: Valparaiso 1866

Oil on canvas 58.4 × 75.9 (23 × 29⅞)
Signed, inscribed and dated 'Whistler. | Valparaiso '66'
PROV: Possibly Christie, London 24 July 1878 (78) bt in by Furber & Price; C.A. Howell before May 1879; his sale Christie, London 15 Nov. 1890 (434), bt W. Graham Robertson, who presented it to the Tate Gallery 1940
EXH: London, French Gallery 1867 (ex cat.); Paris, Exp. Univ. (I) 1867 (71) or possibly (II) 1867 (78); London, Grosvenor Gallery 1879 (56); Paris, Soc. Nat. 1891 (937); London, Goupil 1892 (13); probably Munich 1892 (1950c); possibly Antwerp 1894 (2368); Venice 1899 (59); London 1905 (93); Paris 1905 (59)
LIT: YMSM 1980 (73)

Tate Gallery, London. Presented by W. Graham Robertson 1940

This picture depicts the harbour at Valparaiso bristling with warships, a forest of masts visible in the distance at the right. Judging both by the title and by the violet and purple clouds, the time is sunset. Since three other canvases Whistler painted in Valparaiso depict the prelude or aftermath to hostilities, one might suggest that this too represents a moment close to the events of 31 March.

Reports in the *Times* mention ironclad turreted ships belonging to both the Spanish and American navies, as well as other war steamers whose paddle-wheels were protected with bags of coal. The United States alone had sent one ironclad turreted ship, the monitor *Monadnock*, described as an 'immense colossus of the seas' plus five steamers; Britain was represented by two frigates and a gunboat; France a corvette and gunboat.[1] In the middle distance towards the centre of the composition Whistler shows what look like two steam ships, but these are easy to overlook among the half dozen sailing ships in the foreground, suggesting that Whistler may have been extremely selective about what he represents.

Bearing in mind that he is often more interested in the visual concept than in historical accuracy, it is nevertheless possible to suggest that some sort of manoeuvre has just begun. All the ships in the centre of the picture have swung around towards the open sea; several have just started to unfurl their sails; but two have not. The one flag clearly visible is the French tri-

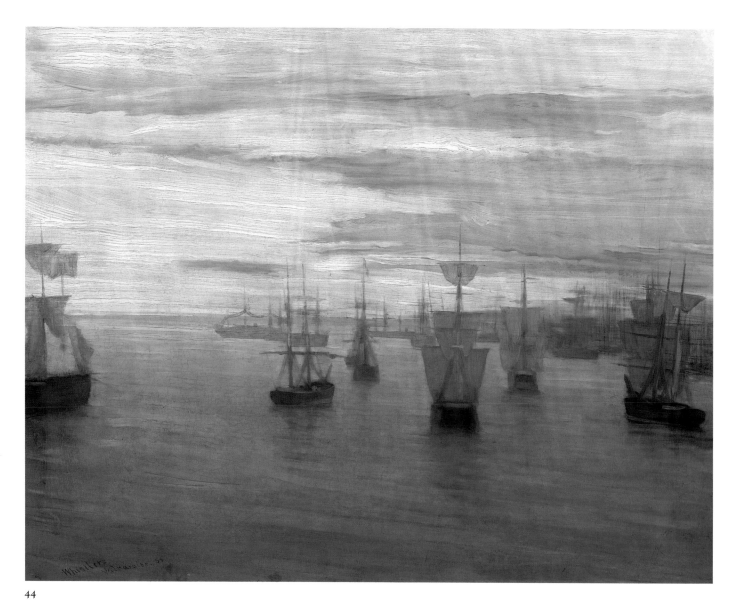

44

colour. It may be that the moment depicted is the evening before the bombardment (therefore on 30 March 1866), as the French fleet prepared to withdraw from the harbour, leaving the town to the mercy of the Spanish.

All those left behind in Valparaiso knew that the defenceless city was about to be shelled. Instead of a calm vista showing ships peacefully anchored in a harbour, Whistler therefore depicts a moment of high drama, a moment which the foreign residents can only have watched in a state of tension, despair or even exhilaration. He never shows the bombardment itself since by his own account he was hightailing it out of town at the time.

There are similarities between Whistler's painting and Manet's marine views of 1864–5, notably his 'Departure from Boulogne Harbour' (fig.61).[2] Yet in spirit the picture is even closer to Manet's depiction of the 'Battle of the Kearsarge and the Alabama' which took place off the coast of Cherbourg in 1864 (Philadelphia Museum of Art).

When exhibited in the French Gallery in 1867 the picture was well reviewed by the critic of the *Athenaeum*, who particularly admired the way Whistler had given 'an aspect of sleepy motion to the vessels, and ... conveyed to the spectator the rolling, seemingly breathing, surface of the sea with a power that is magical.'[3] The English artist Edwin Edwards wrote to Fantin-Latour in January 1867 describing 'Crepuscule in Flesh Colour and Green: Valparaiso':

a very attractive sky, a blue sea which swells both lightly and heavily at the same time the way I imagine it does in the tropics – several boats here and there squeezed around in a kind of circle and their masts half lost in fog and their hulls in the water – and all that without foreground or

without background or both – without chiaroscuro, either all bright or all dark, it's a picture that is very much an ensemble but, even so one could cut it into 3, 4, or 5 pieces and each piece would be a picture ... perhaps it's that Whistler is asking a big question about pictures with their rules for chiaroscuro, receding sides, foregrounds, and backgrounds.[4]

Arthur Jerome Eddy wrote that Whistler completed the picture 'at a single sitting, having prepared his colors in advance'.[5] Note all the pencil work which Whistler added over the creamy paint to suggest the mass of masts and rigging – an unusual blending of techniques, but perfectly effective. The green and blue colours are particularly luminous.

45 **Sketch for 'Nocturne in Blue and Gold: Valparaiso Bay'** 1866

Oil on canvas 76.9 × 50.8 (30¼ × 20)
PROV: Thomas Way 1879; bt from his son T.R. Way by Agnew, London (dealers) 1907; W.B. Paterson, London and Glasgow (dealer), 1907; W.A. Coats, Paisley, who d. 1926; W.B. Paterson; D.C. Thomson, London (dealer) by 1927; E. & A. Milch, New York (dealers) 1927; John Gellatly, Washington, DC 1928; given to the Smithsonian Institution in 1929
LIT: YMSM 1980 (74)

National Museum of American Art, Smithsonian Institution, Washington. Gift of John Gellatly

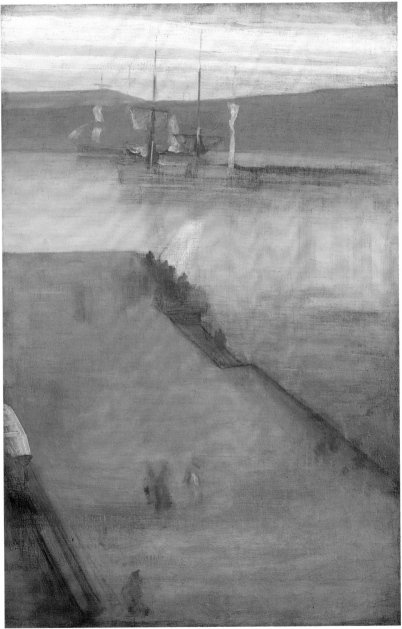

45

This sketch is related to two paintings, 'The Morning after the Revolution, Valparaiso' (Hunterian Art Gallery, Glasgow; YMSM 75) and 'Nocturne in Blue and Gold: Valparaiso Bay' (Freer Gallery of Art, Washington, DC; YMSM 76). A Mr W. McQueen told the Pennells in 1921 that 'his father was in Valparaiso when Whistler was there, that he put Whistler up at his Club, and that it was from the Club windows that the beautiful upright Valparaiso [YMSM 76] was painted'.[1] This club must have been the Naval Circle (the Naval Club) overlooking the port, the site of which later became the Port Governor's quarters.[2] Because the high viewpoint is the same, Whistler must have painted the sketch from the same spot overlooking the port and harbour area which is called Muelle Prat and which according to one historian 'in those days projected itself challengingly into the sea'[3] (fig.62).

It is this pier that gives the work its startling dramatic impact. By abruptly tilting this pier upward towards the horizon, Whistler creates a false picture plane within a conventional pictorial space, without the need for a repoussoir element through which the viewer's eye enters the picture. He is thus able simultaneously to retain naturalistic recession into depth, while creating abstract patterns against a flattened foreground plane.

Certainly it was not his intention to depict an actual moment before, during, or after the bombardment of Valparaiso – since of the two ships in the background he shows one with her fore staysail billowing out and her spanker set, indicating a healthy wind, while the sails of the nearer ship are totally slack.

The Freer picture is a night scene, while the inaptly named 'Morning after the Revolution' is a daytime effect with additional ships in the background and some skiffs to the right of the pier. In the 'Morning after the Revolution' the red, white and blue flags and bunting identify the ships as American, British and French, while among the very few discernable figures on the pier one makes out local people in sombreros and ponchos. In 'Nocturne in Blue and Gold' the mood again changes. It is night, and a mass of shadowy figures seem to be rushing up and down the pier as though in confusion or even panic. Within the context of the picture's title, the shower of yellow and orange sparks might come from a celebrational rocket.

The important thing is that Whistler treated the motif of Valparaiso pier as the focus for a series – of the sort Monet and Pissarro would explore later in the century, and which Whistler himself would exploit in prints.

Nocturnes

As early as October 1862 Whistler had complained to Fantin-Latour about the difficulty of capturing ephemeral effects of light and weather when working *en plein air* (see p.49). Part of the problem was the painting technique he had learned in Paris. This could be employed in paintings executed in the studio, but was much more difficult to use outdoors.

For nine years (1862–71) Whistler wrestled with the dilemma, finally resolving it in the Nocturnes of the early 1870s. At the beginning of the period he simply worked indoors, painting river views from the window of Arthur Severn's flat by Westminster Bridge (no.35) and from his own balcony in Chelsea (nos.30, 36). Even in Valparaiso he painted the pier and harbour from the windows of the Naval Club (no.45). This solution enabled him to retain his painting technique while working *sur le motif*, the two linchpins of his training in Paris (see nos.11, 14).

By 1864, as he began to explore the art of Japan, he began to restrict his palette to subdued colours, to reduce detail, and to concentrate on the careful arrangement of large, simple forms. But when applied to the urban scene, this aestheticising of visual experience in turn created a conflict between style and subject matter. The quest for decorative perfection was hard to reconcile with the teeming reality he actually saw from his London balcony during the day: the dredgers, tugboats and penny steamers that plied up and down the river from morning till night, churning the water into mud. [1]

Rather than abandon his commitment to Realism, Whistler chose to paint the river at quiet times – in conditions of extreme cold, when ice floes reduced the normally bustling river traffic to a single steam boat ('Chelsea in Ice', Private Collection; YMSM 53), in the fog, when the furled brown sails appeared dimly through the mist (nos.37, 38), and finally in his Nocturnes, when the river slept.

With the Greaves brothers as oarsmen, Whistler would start out at twilight and sometimes remain on the river all night, drifting near the lights of Cremorne Gardens (no.47), under Battersea Bridge (no.54), or down to the Houses of Parliament (no.49). Though he was able to sketch on these expeditions, it was not possible to work in oils. Once again, he was confronted with the dilemma of how to capture the beauty he saw out in the dark back in his studio. The key that enabled him to recreate this mysterious and silent world on canvas can be summed up in one word: memory.

Whistler did not himself study with Lecoq de Boisbaudran, the French painter who taught his students to study scenes and objects, fix the forms in their minds, then draw them from memory. But one of his closest friends in his student days in Paris, Alphonse Legros, had been a pupil of Lecoq's, so that Whistler could hardly have failed to be aware of his theories, which in any case echoed those of Whistler's favourite English painter, William Hogarth. Nevertheless, memory seems to have played virtually no part in Whistler's technique before the early 1870s. He began to develop a mnemonic system out of practical necessity, as a means of

creating a vivid mental picture while out on the river which could then be translated into a painting back in the studio.

Several witnesses have left descriptions of the memory technique in action. Thomas Way remembered Whistler leaning on the Embankment wall, looking out over the river, then turning his back on the vista and reciting what he saw in 'a sort of chant': 'The sky is lighter than the water, the houses darkest. There are eight houses, the second is the lowest, the fifth the highest. The tone of all is the same. The first has two lighted windows, one above the other; the second has four.'[2] With his back still to the view, Whistler would then say 'Now, see if I have learned it'. It was up to Way to correct any mistakes in the recitation that followed.[3]

Back in the studio, it was important to commit this mental image to canvas as quickly as possible. With the painstaking technique he had learned in Paris this was hard to do. Whistler therefore turned to a precedent closer to home: the techniques of the English watercolourists, who had long made a speciality of swiftly capturing natural effects on paper with their highly liquid pigments. Though not all of the Nocturnes were necessarily painted quickly (see no.54), during the *Whistler* v. *Ruskin* trial, when Whistler was asked whether his manual labour was rapid, he replied 'Certainly. The proper execution of the idea depends greatly upon the instantaneous work of my hand.'[4] Heightening the similarity to this most British of mediums, when several Nocturnes were shown at the Dudley Gallery in 1875 they were framed under glass, just as watercolours were.[5]

Indeed, it may have been a watercolourist who first stimulated Whistler's interest in painting 'night pieces'. In 1863, Whistler had been a frequent visitor to the flat of the painter George Price Boyce overlooking the Thames at the foot of Hungerford Bridge, even beginning an etching from one of the windows on 6 February of that year. On 2 June, Boyce noted in his diary that he had 'made a study of moonlight effect on river from my balcony.'[6] A number of night scenes in watercolour by Boyce from the early 1860s such as 'Blackfriars Bridge: Moonlight Sketch', 1863 (fig.9 on p.24) are startlingly close to Whistler's Nocturnes of a decade later. The way in which thin pigment is applied as though to stain the absorbent ground is similar in both. How it would have surprised Courbet to hear his disciple Whistler's advice to his disciple Otto Bacher in 1881: 'Paint should not be applied thick. It should be like the breath on the surface of a pane of glass.'[7]

To paint the Nocturnes, Whistler invented a medium of his own, a runny mixture which included copal, turpentine and linseed oil which he called 'sauce'. Having previously sized his canvas or panel and applied a red or grey ground, he washed the surface with his liquid colours, lightening and darkening the tone as he worked.[8] So drippy was the mixture that Whistler had to place the canvas flat on the floor in order to keep the sauce from running off. He worked very quickly, according to Walter Greaves sometimes catching the effect he wanted in an hour and a half, but more often abandoning those canvases in which he could not get the effects he sought.[9] Later, he put the finished canvases out in his garden to dry.

Though not quite the same as Monet's serial paintings of Haystacks and Cathedrals, Whistler's river Nocturnes do form a series of sorts. He confined himself to

painting the factories, bridges, and houses along the shoreline of a relatively short stretch of the Thames between Westminster and Battersea bridges, working from just after sundown, when the river was irradiated with an intense blue, and the lights had just begun to glimmer on the shore and fireworks from Cremorne Gardens crackled over the sky (nos.47, 54), to the darkest hour of the night, when a single light merely served to intensify the surrounding black (no.50).

The designation 'Nocturne' was Frederick Leyland's. In a letter of the early 1870s to Leyland Whistler wrote:

> I can't thank you too much for the name 'Nocturne' as a title for my moonlights! You have no idea what an irritation it proves to the critics and consequent pleasure to me, – besides it is really so charming and does so poetically say all I want to say and *no more* than I wish.[10]

The Nocturnes are at the heart of Whistler's artistic enterprise. The best description of what he was attempting to do in them was given by Whistler himself at the time of *Whistler v. Ruskin*:

> By using the word 'nocturne' I wished to indicate an artistic interest alone, divesting the picture of any outside anecdotal interest which might have been otherwise attached to it. A nocturne is an arrangement of line, form, and colour first. The picture is throughout a problem that I attempt to solve. I make use of any means, any incident or object in nature, that will bring about this symmetrical result.[11]

R.D.

46 Nocturne: Blue and Silver – Chelsea 1871

Oil on wood 50.2 × 60.8 (19¾ × 23⅞)
Signed with butterfly and dated '71'
PROV: W.C. Alexander, London, 1871, who d. 1916; Misses R. and J. Alexander; bequeathed to the National Gallery, London 1972 and transferred to the Tate Gallery
EXH: London, Dudley Gallery 1871 (265); London, Grosvenor Gallery 1879 (192); possibly Paris, Petit 1883 (5); probably Brussels 1884 (2); London, Goupil 1892 (18); London 1905 (31); Paris 1905 (72); London and New York 1960 (26)
LIT: YMSM 1980 (103)

Tate Gallery, London. Bequeathed by Miss Rachel and Miss Jean Alexander

Writing to her sister Kate Palmer on 3 November 1871, Anna Whistler told how, one 'bright afternoon' the previous August when she had been 'too feeble' to sit for her portrait (no.60) her son took her down the river for air. They took a steamer to Westminster to call on some friends. On their return to Lindsey Row in the late afternoon, mother and son found 'the river in a glow of rare transparency an hour before sunset'.[1] Whistler was 'inspired to begin a picture & rushed upstairs to his Studio, carrying an Easel & bushes, soon I was helping by bringing the several tubes of paint he pointed out that he should use and I so fascinated I hung over his magic touches till the bright moon faced us from his window – & I exclaimed Oh Jemie dear it is yet light enough for you to see to make this a moonlight picture of the Thames.'[2]

That Whistler painted two pictures that afternoon and evening – a sunset (no. 25) and a moonlight (no.46) – Anna confirms elsewhere in this letter: 'So now Kate I send you by this Mail Steamer an "Athenaeum" a weekly Paper with a Criticism on these two pictures exhibited now in "The Dudley Gallery" it is so true,

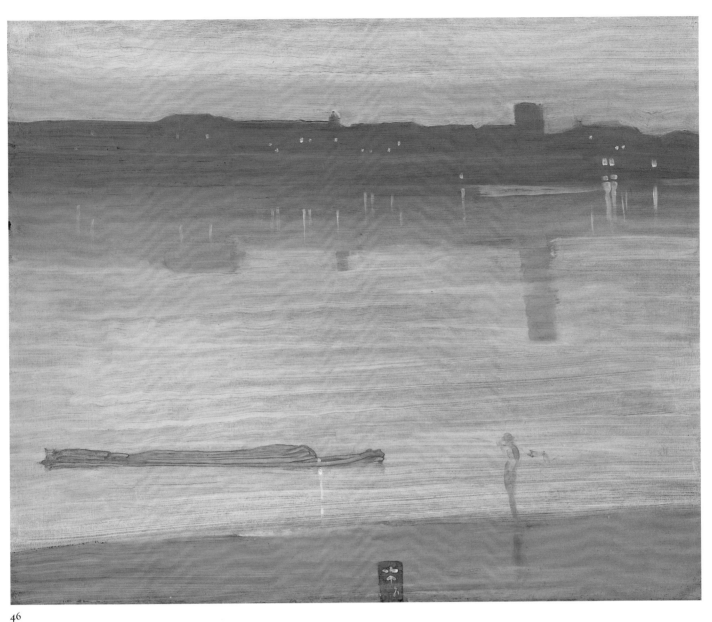

46

The Moonlight is not more lovely than the Sunset tho the Critique gives it only the nod of praise [it is] almost as beautiful tho quite different.'

The first of the Nocturnes, 'Nocturne: Blue and Silver – Chelsea' was painted in Whistler's studio on a thin hardwood panel, with paint of a creamy consistency. Whistler primed the panel with dark grey paint, over which he applied his pigment to create a contrasting sense of luminosity. Since it shows the view from Battersea of the Chelsea shore with the tower of Chelsea Old Church on the right, its details were presumably painted entirely from memory. This is something Whistler might almost be said to emphasise by painting both the low barge and the figure of a mud lark or fisherman in the foreground out of proportion to the rest of the picture.

That autumn the pictures had been shown at the Dudley Gallery. The *Times* on 14 November praised both in terms that would certainly have pleased Whistler:

They are illustrations of the theory ... that painting is so closely akin to music that the colours of the one may and should be used, like the ordered sounds of the other; that painting should not aim at expressing dramatic emotions, depicting incidents of history or recording facts of nature, but should be content with moulding our moods and stirring our imaginations, by subtle combinations of colour, through which all that painting has to say to us can be said, and beyond which painting has no valuable or true speech whatever.

If Whistler shows the river at night, it may

be for more than simply poetic reasons. According to the 'Oarsman's Guide' to the Thames, the heavy river traffic generated by the steamers 'stirs from its oozy bed, in the rear of some friendly obstruction, the sleepy sediment of the tainted Thames.'[3] Except in the dead of night the Thames was a noisy, bustling, smelly highway. At this date a combination of sewage and turbulent waters meant that fish could not survive in the Thames.[4]

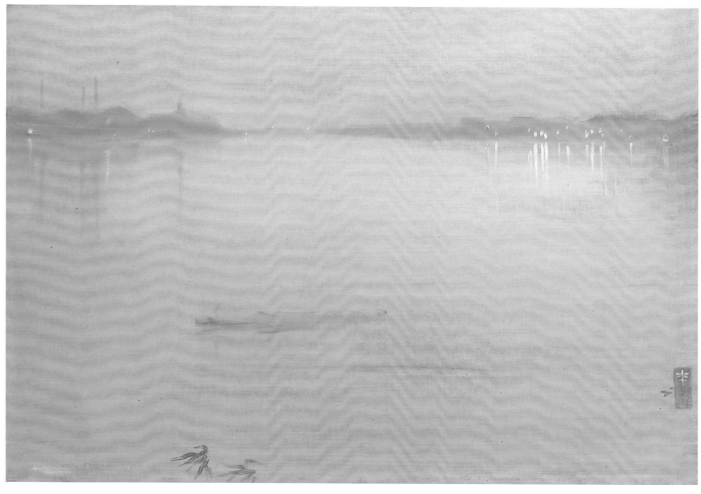

47

47 Nocturne: Blue and Silver — Cremorne Lights 1872

Oil on canvas 50.2 × 74.3 (19¾ × 29¼)
Signed with butterfly and dated '72'
PROV: Gerald Potter, London after 1882;
D.C. Thomson, London (dealer) 1892–4;
A.H. Studd, London 1894; bequeathed
to the National Gallery, London 1919;
transferred to the Tate Gallery 1949
EXH: Possibly Brighton 1875 (98);
London, Grosvenor Gallery 1882 (2);
London, Goupil 1892 (34); Glasgow 1893;
possibly London, Goupil 1898 (25);
Boston 1904 (56); Paris 1905 (69);
London & New York 1960 (27)
LIT: YMSM 1980 (115)

Tate Gallery, London. Bequeathed by Arthur Studd 1919

The viewpoint is from Battersea Bridge looking upriver, with the Battersea shore on the left and the lights of Cremorne Gardens on the right. When it was exhibited in 1882 the critic of the *Athaeneum* (6 May) considered that the time depicted was just before dawn. However the azure blue sky and numerous orange lights from Cremorne Gardens rather suggest an hour on a summer evening when the pleasure grounds were in full swing.

The scene is painted over a composition of four or more robed figures on the seashore, which was probably connected with the 'Six Projects' (see no.27). The destruction of this composition marks the transition from the decorative figure subjects of the 1860s to the Nocturnes and portraits which dominated the 1870s. The canvas has been extended at the right edge on which the butterfly signature appears. Pentimenti are visible in the area around the raft in the foreground.

The canvas was originally commercially primed in white, and the artist presumably rubbed down the figure composition lightly before adding a thin layer of pinkish grey paint to establish the main features of the river scene. The paint is very thin, so that brushstrokes are barely visible. The brush works both up and down, and then right across the canvas, to achieve a smooth surface and smooth transitions of colour. An absolutely smooth surface could not be achieved since the figures underneath had not been totally eliminated. Whistler worked from dark to light in the distance, with the most obvious brush strokes being the two or three outlines along the horizon, defining the roofs, chimney stacks and slag heaps along the Thames. The picture must have been painted quickly, with the lights added last, while the paint was still wet. The soft, luminous colours, and smooth brushwork result in a unified and atmospheric painting.

The frame was decorated by Whistler with a fish-scale pattern.

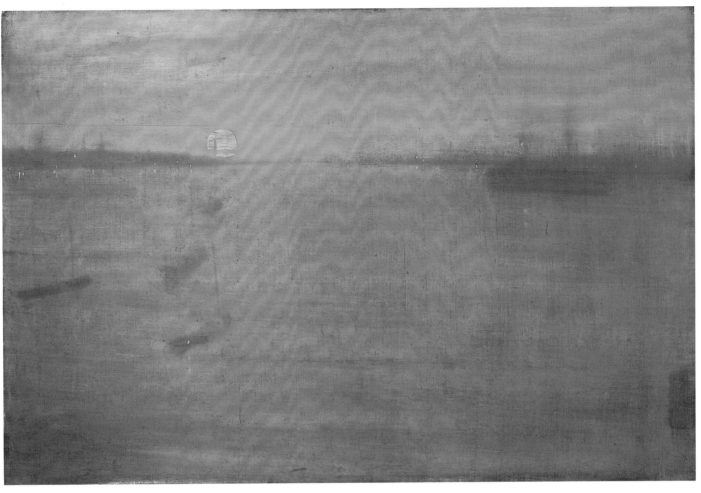

48

48 **Nocturne: Blue and Gold –
Southampton Water** 1872

Oil on canvas 50.5 × 76.3 (19⅞ × 30)
Signed with butterfly and dated '187[2]'
(the last figure indistinct)
PROV: Alfred Chapman, Liverpool 1874;
E.G. Kennedy of Wunderlich, New York
(dealers) 1900; the Art Institute of
Chicago 1900
EXH: London, Dudley Gallery 1872
(187); London, Int. Exh. 1873 (1156);
possibly London, Pall Mall 1874 (10);
London, Grosvenor Gallery 1879 (193);
Paris, Petit 1883 (7); London, Goupil
1892 (20); London, Goupil 1898 (25);
Philadelphia 1901 (106); Boston 1904 (58);
London 1905 (9); Paris 1905 (67)
LIT: YMSM 1980 (117)

Art Institute of Chicago. Charles Stickney Fund

This picture is a view of Southampton Water,
an inlet of the English Channel ten miles long
and nearly two miles wide, about eighty miles
south west of London. Until well into this cen-
tury Southampton was a major port for
transatlantic and European passenger and mer-
chant ships. From here Whistler embarked for
Chile in 1866. His view suggests the busy har-
bour and extensive dockyards in the early hours
of the evening, when the riding lamps on the
ships and the distant lights of the town have
been lit. The full moon is still low in the sky
and the shapes are still indistinctly visible in the
gathering dusk.

This picture, and 'Nocturne: Blue and Sil-
ver' (whereabouts unknown; YMSM 118) were
the first two Nocturnes to be exhibited. After
they were shown at the Dudley Gallery in 1872
Whistler wrote to Frederick Leyland expressing
his thanks for the title 'Nocturne' and report-
ing that 'the pictures at the Dudley are a great
success'.[1]

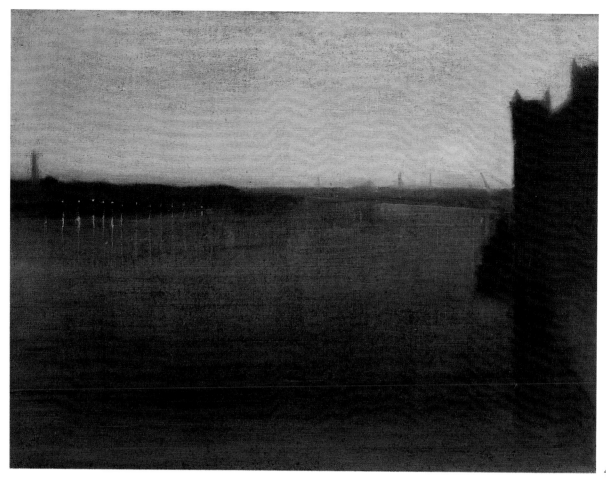

49

49 Nocturne: Grey and Gold – Westminster Bridge 1871–2

Oil on canvas 47 × 62.3 (18½ × 24½)
PROV: Percy Wyndham 1875; Mrs Percy
Wyndham who d. 1920; Adams, London
(dealers) by 1938; Sir William Burrell in
1938; presented to the City of Glasgow
1945
EXH: London, Dudley Gallery 1875 (160);
London, Grosvenor Gallery 1877 (6);
London, Goupil 1892 (19); London 1905
(36)
LIT: YMSM 1980 (145); MacDonald 1994
(569)

Glasgow Museums, The Burrell Collection
[Exhibited in London only]

In 1874 Whistler described this painting to a
prospective buyer as 'a very warm summer night
on the Thames – lovely in colour they say – A
Nocturne in Blue and gold – view of the river
from the Houses of Parliament.'[1] The title
under which it was exhibited in 1892 'Nocturne
from Westminster Bridge' is even more specif-
ic. The dark diagonal at the right is the terrace
of the Houses of Parliament seen from the

bridge, with their shadows reflected darkly in
the blue-black waters. Looking south west
across the river to Lambeth, a string of lights
glimmers along a nondescript stretch of the
river containing light industry and manufactur-
ing, where St Thomas's Hospital stands today.
Along the horizon to the right we see the long
necks of towering wooden winches in use for
the construction of the new embankment at
Millbank or Grosvenor Road (fig.63).

The first owner of 'Nocturne: Grey and
Gold – Westminster Bridge' was Percy Wynd-
ham, a member both of the aristocracy and the
exclusive coterie of aesthetically discriminating
men and women who were known as the
'Souls', patrons, among others of Burne-Jones,
G.F. Watts, Alfred Gilbert, and Auguste Rodin.
Whistler was well aware of the value of such
patronage for his acceptance by the English
public. In a letter to Alan Cole he boasted that
'this vicious art of butterfly flippancy is, in spite
of the honest efforts of Tom Taylor [art critic
of the *Times*] doing its poisonous work and even
attacking the heart of the aristocracy as well as
undermining the working classes!'[2] Wyndham
lent the picture to the prestigious first exhibi-
tion of the Grosvenor Gallery.

Reviewing the Dudley Gallery exhibition of 1875 the *Art Journal* noted that two nocturnes were glazed 'as if they were water-colours'[3] – unconsciously recognizing that by thinning his pigment until it was runny, Whistler was using oil paint like watercolour on thick paper.

The wash sketch for this Nocturne (Private Collection; M 569) shows that Whistler originally painted a barge in front of the terrace to the right. This was painted over in the final version (it is still visible under raking light). The simplification makes the looming mass of the Houses of Parliament at the right more dramatic. Whistler used boats to lead the viewer's eye into the picture in many paintings (e.g. YMSM 140) and in prints (eg. no.114). It is a sign of his increasing artistic confidence to omit it.

50 Nocturne: Grey and Silver 1873–5

Oil on canvas 31.1 × 51.4 (12¼ × 20¼)
PROV: Possibly Luke Ionides 1878; possibly bt back by Whistler in 1892; Théodore Duret, Paris by 1887; auctioned by him, Paris, Petit 19 March 1894 (42); bt by Knoedler, New York (dealers) for an American client; John G. Johnson, Philadelphia by 1904; bequeathed to the City of Philadelphia in 1917; Philadelphia Museum of Art 1933
EXH: Possibly London, Grosvenor Gallery 1878 (56); Pittsburg 1897 (238); Pittsburg 1902–3 (149)
LIT: YMSM 1980 (156)

Philadelphia Museum of Art. The John G. Johnson Collection

When 'Nocturne: Grey and Silver' was shown in Pittsburg in 1897 it was called 'Westminster Palace in Fog'. In fact it shows Battersea shore opposite Lindsey Houses, with Morgan's Folly, a gigantic illuminated clock tower adjacent to Morgan's Crucible Works, shown reflected in the Thames on a moonless night. The tower also appears in the tonally similar 'Nocturne' owned by the White House, Washington, DC (YMSM 153). The single riding lamp suggests that the night is far advanced, when lights from pubs and houses are extinguished.

This is one of Whistler's most simplified Nocturnes, consisting of three bands of grey-black and deep blue. Here Whistler pushes his evocation of darkness to the limit, actually making the details in the picture difficult to see. Peering into the depths of darkness, the eye seeks to focus, and constantly fails.

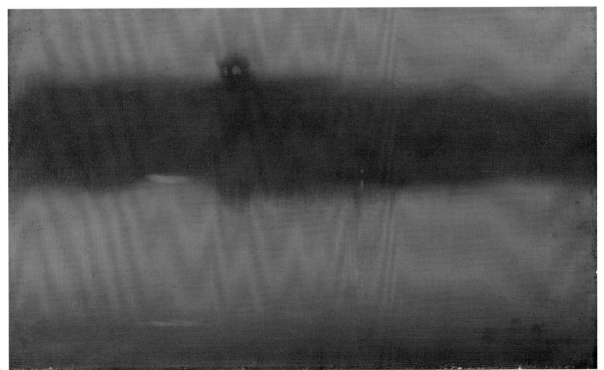

50

51 Nocturne 1875–7

Oil on canvas 55.5 × 39.4 (21⅞ × 15½)
PROV: Bequeathed by Whistler to his
sister-in-law, Miss R. Birnie Philip 1903;
bequeathed to the University of Glasgow
1958
LIT: YMSM 1980 (172)

Hunterian Art Gallery, Universty of Glasgow,
Birnie Philip Bequest

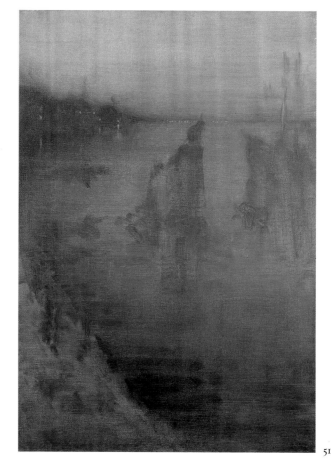

51

The diagonal in the foreground could be the
newly built embankment seen from Whistler's
balcony at Lindsey Houses. If so, we are look-
ing downriver towards Westminster with the
Chelsea shoreline on the left and the lights of
the Albert Bridge in the distance. Alternatively,
the view could be from Battersea Bridge look-
ing upriver, with Battersea on the left, as in the
Tate's 'Cremorne Lights' (no.47). In this case,
the diagonal could be the bridge itself, with
Whistler distorting the perspective. The shapes
in the river represent two Thames barges under
sail, possibly at the Greaves boatyard.

The upright composition recalls that of one
of the earliest Nocturnes, 'Nocturne in Blue
and Gold: Valparaiso Bay' (Freer Gallery of
Art, Washington, DC; YMSM 76) and the
sketch for that painting in this exhibition
(no.45). The lack of precision in the brushwork
might be the result of a change of viewpoint, or
might be a deliberate blurring of shapes.

The frame was painted by Whistler with a
fish-scale pattern and signed with a butterfly.
It was not intended for this painting, and is
unfinished.

52

52 Nocturne in Blue and Silver

1872–8

Oil on canvas 44.4 × 61 (17½ × 24)
Signed with butterfly
PROV: Mrs Flower, widow of Wickham
Flower, by 1905; presented to the
Shakespeare Memorial Gallery, Stratford-
upon-Avon; sold to Agnew, London
(dealers); Knoedler, New York (dealers)
1911; Miss G.B. Whittemore, Naugatuck,
Conn (d.1941); passed to a private
collection, USA
EXH: Possibly London, Grosvenor
Gallery 1878 (53); possibly Paris, Petit
1883 (5); possibly London, Goupil 1898
(25); London 1905 (38)
LIT: YMSM 1988 (151)

Private Collection
[Exhibited in Washington only]

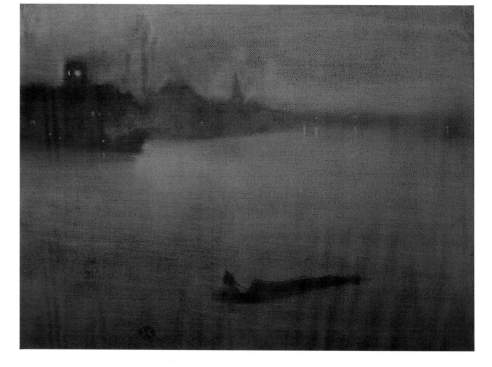

'Nocturne in Blue and Silver' was probably painted soon after 'Nocturne: Blue and Gold – Old Battersea Bridge' (no.54) which Whistler had still not quite finished in 1878. However, the butterfly signature is of the type first used by Whistler about 1883–4. The deep blue tonality, smooth thin paint and black 'staining' effect used to summon up both the barge in the foreground and the silhouetted buildings on the far shoreline are characteristic of Nocturnes painted in the later 1870s.

The view is from Chelsea towards Battersea Reach with the illuminated clock tower of Morgan's Folly at the left. The saturated, deep colour and smooth high finish make this one of Whistler's most mysterious Nocturnes. As the eye gradually adjusts to the darkness, the details of the barge in the foreground can be made out.

53

53 Nocturne: The River at Battersea 1878

Lithotint printed in black on ivory chine collé laid down on wove card
17.1 × 25.9 (6¾ × 10⅛)
Signed in stone with butterfly
PROV: Given by Thomas Way to the British Museum 1905
LIT: Way 1896 (5); Kennedy 1914 (5); MacDonald 1988, pp.38–9

Trustees of the British Museum, London

Published in *Notes*, 1887.

Whistler's lithographs, which number approximately one hundred and seventy, are less well known than his etchings, despite his early role in the revival of interest in the medium at the end of the nineteenth century. The first of the lithographs (discounting a few pieces from his student days), some twenty prints, were made in 1878–9, closely following the break with his patron Frederick R. Leyland (see no.68) and at the height of the legal battles with John Ruskin that led to his bankruptcy (see pp.136–7). Perhaps this new medium provided a welcome and demanding distraction from the problems of daily life.

These first lithographs were accomplished under the tutelage of the printer Thomas Way. His son, Thomas R. Way, entered his father's firm and was closely associated with the later lithographs. In 1896 the younger Way wrote the catalogue of Whistler's lithographs that remains in use today. Unfortunately, disagree-

ments during its publication led to a severing of Whistler's long relationship with the Way family. Way donated this and other proofs and early impressions of the lithographs to the British Museum.[1]

More than half of Whistler's first group of lithographs were lithotints: drawings in wash, often on lithographic stones prepared in advance by Way with a half-tint. To this middle value, Whistler added darker tones and also brought areas of the stone back to lighter tints, by painting them with acid (this process is called 'etching' but has nothing to do with copperplate etching). Sometimes Whistler added crayon work to the washes, and used a sharpened tool to scrape and scratch highlights into his drawings.

Whistler's lithographs, other than lithotints, were drawn with crayon onto transfer paper from which they were offset on stone (see nos.161–3). Not all artists make this distinction between lithograph and lithotint, and many pieces that employ methods similar to Whistler's lithographs are absorbed under the category of lithograph.

As with his etchings, Whistler had proofs pulled as work on the stone progressed, and the lithotints (and lithographs) are known in several states. Some impressions are more beautifully printed than others, revealing all of the tonal gradations of Whistler's transfer drawings. This lovely impression of 'Nocturne: The River at Battersea' presents the final stage of the image.

The lithotint process was perfect for achieving the atmospheric effects of night Whistler sought. Indeed, the liquid qualities of this process undoubtedly contributed to Whistler's achievements with modulated tonal wiping in the Venice etchings that soon followed, the most atmospheric of all being another Nocturne (no.122).

At the time 'Nocturne: The River at Battersea' was drawn only a few proof impressions were pulled. But in 1887, when Whistler's interest in lithography was renewed, six of his early lithographs, including this one printed on blue-grey paper, were issued as a set, *Notes*, by Boussod, Valadon & Co. An edition of one hundred was printed – thirty sets on large paper that were signed by the artist and seventy unsigned sets on smaller sheets. By then, according to Way, the stone for the Nocturne was 'showing signs of deterioration' and was cancelled.[2] The set comprised three Thames subjects, this Nocturne, 'Limehouse', and 'Old Battersea Bridge', two street scenes, 'Gaiety Stage Door' and 'Victoria Club', and a portrait of Maud Franklin, 'Lady Reading' (w 4–5, 10–13).

54 Nocturne: Blue and Gold – Old Battersea Bridge 1872–7

Oil on canvas 68.3 × 51.2 (26⅞ × 20⅛)
Signed with butterfly
PROV: W.P. Graham, 1877; his sale,
Christie, London 3 April 1886 (120); bt
Robert H.C. Harrison, Liverpool; the
National Art Collections Fund who
presented it to the National Gallery,
London 1905; transferred to the Tate
Gallery 1905
EXH: Brighton 1875 (97); London,
Society of French Artists 1876 (147);
London, Grosvenor Gallery 1877 (6A);
Paris, Durand-Ruel 1888 (46); London,
Goupil 1892 (4); London 1905 (12);
London & New York 1960 (35)
LIT: YMSM 1980 (140)

*Tate Gallery, London. Presented by the National
Art Collections Fund 1905*

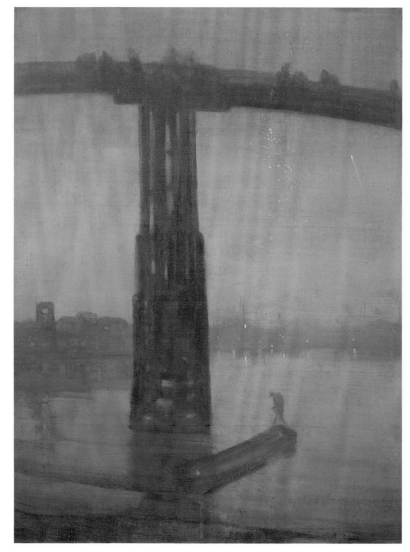

54

When Whistler exhibited this picture at the
Society of French Artists in 1876, he called it
'Nocturne in Blue and Silver No.5'. By 1892 he
had given it its present title. That the colour in
the title changed from silver to gold is of little
importance, since Whistler was somewhat cav-
alier in this respect. What is of interest is that
he considered the Nocturnes to be part of a
numbered series, of which this picture is the
fifth. The first in the series was the first Noc-
turne, the 1871 'Nocturne: Blue and Silver –
Chelsea' (no.46), while the third (YMSM 118) is
untraced. It is not possible to say which Noc-
turnes Whistler considered numbers two and
four. The numbered titles may have been added
by 1876, but it is also possible that they were
added retrospectively, for it is far from certain
that he set out to paint the Nocturnes as a
series in the same sense as Monet did the grain
stacks or Pissarro the Port at Rouen.

The dating of 'Nocturne: Blue and Gold –
Old Battersea Bridge' is problematic. The cen-
tral motif, Battersea Bridge seen from the river
under its arches, is similar to that in 'Blue and
Silver: Screen, with Old Battersea Bridge'
(Hunterian Art Gallery, Glasgow; YMSM 139),
which Whistler was finishing in December
1872. In the distance of both we can see the
lights on the Albert Bridge, which was opened
to the public only in 1873. Even the date of its
first exhibition, 1875, does not clinch the matter,
for as late as July 1877 Whistler told William
Graham, the picture's first owner, that it was
not complete.

Moreover, the intense light blue tonality, sug-
gestive of the early evening rather than the dead
of night, and the dark ground, which Whistler

leaves unpainted to create the dark areas of the
bridge itself, give it an appearance very different
from Nocturnes painted in the early 1870s
(nos.46, 49). A date towards the end of the peri-
od, around 1876–7, might be possible.

'Nocturne: Blue and Gold – Old Battersea
Bridge' has been compared to the great curve of
the wooden bridge in Hiroshige's woodcut of
fireworks on a river by night from the 'History
of Ronino'. Certainly the immense height of
the bridge is Whistler's invention, as a compar-
ison with his own early view of the the structure
in 'Brown and Silver: Old Battersea Bridge
(no.30) shows.

From the time of its exhibition at the first
Grosvenor Gallery exhibition in 1877 no. 54 has
been one of Whistler's most controversial pic-
tures. Reviewing that exhibition, Oscar Wilde
wrote that it was 'worth looking at for about as
long as one looks at a real rocket, that is, for
somewhat less than a quarter of a minute'. It
was one of the exhibits produced during the
Whistler–Ruskin trial (see pp.136–7). Here is

55

the artist's exchange with the counsel for the defendant Sir John Holker:

> Whistler: 'The spectator is supposed to be looking down the river toward London. The picture gives a view of the bridge and, looking through the arch, Chelsea Church in the further distance.'
> Holker: 'Do you say that this is a correct representation of Battersea Bridge?'
> W: 'It was not my intent simply to make a copy of Battersea Bridge. The pier in the centre of the picture may not be like the piers of Battersea Bridge. I did not intend to paint a portrait of the bridge, but only a painting of a moonlight scene. As to what the picture represents, that depends upon who looks at it. To some persons it may represent all that I intended; to others it may represent nothing.'
> H: 'What is that mark on the right of the picture, like a cascade? Is it a firework?'
> W: 'Yes, the cascade of gold colour is a firework …'
> H: 'Are those figures on the top of the bridge intended as people?'
> W: 'They are just what you like.'
> H: 'That is a barge beneath?'
> W: 'Yes, I am very much flattered at your seeing that. The thing is intended simply as a representation of moonlight. My whole scheme was only to bring about a certain harmony of colour.'[1]

Later in the trial, in his testimony on behalf of Ruskin, Edward Burne-Jones gave his opinion of the picture during his examination by Charles Synge Christopher Bowen:

> Burne-Jones: 'It is really very beautiful in colour, but more formless than [the 'Nocturne in Blue and Silver', Fogg Art Museum, Cambridge, Mass.; YMSM 113]. It is bewildering in its form.'
> Bowen: 'And as to composition and detail?'
> B-J: 'It has none whatever.'
> B: 'Mr Whistler has told us that the picture was painted in a day or a day and a half.'
> B-J: 'That seems a reasonable time for it.'
> B: 'Does this picture show any finish as a work of art?'
> B-J: 'No … It shows no finish. I should call it a sketch. I do not think Mr Whistler ever intended it to be regarded as a finished work.'[2]

As late as April 1886 the picture was still capable of incensing a British public determined not to see its beauty. When it was produced at the Graham sale at Christie's in that year it was hissed.[3]

55 The Tall Bridge 1878

Lithotint printed in brown on chine collé laid down on to white wove paper
Sheet: 27.9 × 18.5 (11 × 7¼)
Signed in stone with butterfly
PROV: Gift of Paul F. Walter to the Metropolitan Museum of Art 1984
LIT: Way 1896 (91); Kennedy 1914 (9); MacDonald 1988, pp.21, 38–9; MacDonald 1994 (701)

The Metropolitan Museum of Art, New York. Gift of Paul F. Walter, 1984

Published in *Piccadilly*, no.10, 11 July 1878.

Battersea Bridge was a favoured subject in Whistler's London, and he pictured it frequently in paintings, drawings, etchings, and lithographs. Here, with the bridge looming tall the essential composition is reminiscent of the structure enclosing 'The Lime-burner' (no.31). A horizontal version was done about the same time, 'The Broad Bridge' (w 8). Also apparent is the artist's indebtedness to the spatial ambiguity and broadly conceived designs of Japanese prints.

The bridge, its shadows, and the industrial landscape beyond were drawn on stone with lithographic crayon. Touches of wash vividly enhance the delicate tonalities of the image, not only in the water and sky where they are most visible (and particularly nuanced in this impression), but in the interstices of the wooden piers of the bridge structure itself.

Theodore Watts Dunton asked Whistler to draw four lithographs for publication in his new weekly magazine *Piccadilly*, in 1878. T.R. Way described how Whistler 'forthwith made two studies of Old Battersea Bridge on brown paper, and brought them to the Wellington Street office, and there and then drew them on a fresh stone. "The Long Bridge" and "The Tall Bridge" were at once printed'.[1]

'The Broad Bridge' and 'The Tall Bridge' were drawn on the same stone, and show all the basic features of the two drawings, now both in private collections (M 700–1), except that they are reversed (being drawn directly onto the stone). 'The Broad Bridge' and 'The Toilet' (no.67) were published but *Piccadilly* ceased publication just as 'The Tall Bridge' was underway. All but a few 'hand-pulled proofs' were destroyed, according to Way.

Whistler's first lithographs came out in tiny editions comprising a few proofs (divided between the artist and the printer) and perhaps half a dozen impressions. An attempt to publish a set of lithographs failed through lack of subscribers.[2]

Cremorne

The successor to Ranelagh and Vauxhall, Cremorne Gardens was the last of the great London pleasure gardens. Established in the 1830s, Cremorne had been built at the west end of Chelsea on the river, only a few hundred yards from Whistler's residence in Lindsey Row. It could be reached either by steamboat (from any pier above London Bridge) or, via its King's Road entrance, by foot and hansom cab.[1] Here the Victorian reveller could find restaurants, an hotel, four theatres, (including a circus and marionette theatre), a Stereorama, firework platform, gypsy grotto, maze, and indoor bowling alley.[2]

Just inside the entrance stood an open air gazebo from which the sound of the orchestra playing the polka, the gallop, and the waltz could be heard from mid afternoon onwards. Circling this pagoda-like bandstand was the Grand Platform, a dance floor with room for one thousand dancers, illuminated at night by a ring of gas lamps connected by gaily decorated arches (fig.64).

For nearly fifty years the Gardens flourished by featuring a constantly changing array of novelty attractions including ballets, dramas, concerts, and *tableaux vivants*. On special occasions the Gardens featured tightrope walkers, Hungarian dancers, aquatic spectaculars, clowns, ventriloquists and balloon ascents (daytime and nighttime).[3] Whistler's attraction to Cremorne parallels the years of his most active interest in the theatre and in theatrical subjects (no.64). These increased noticeably after his mother's move to Hastings in 1874.

But by this time, Cremorne was nearing the end of its existence. This is because there were two Cremornes. During the day the Gardens were an entirely respectable resort for the whole family; at night the atmosphere changed. Then it became a 'place where abandoned women paraded, where they met men they had not known before'.[4] In his study of prostitution in 1857 William Acton noted that 'as calico and merry respectability tailed off eastward by penny steamers, the setting sun brought westward Hansoms freighted with demure immorality in silk and fine linen.'[5]

Earlier in the century, when Chelsea had been a sequestered village outside London, this kind of discreet prostitution was tolerated – as was the noise of rapidly driven hansom cabs, the uproar of revellers, and the nightly crackle of the firework display. But as Chelsea became absorbed into the city, and the middle class began to buy houses close to the Gardens, this changed.

From the later 1850s Cremorne began its long period of decline, dragged down by well-publicised legal tussles in 1857 and 1873 over the renewal of its licence for music and dancing. Competition from the dazzling attractions of the Crystal Palace (see no.30), which had opened across the river at Sydenham in 1854, also battered Cremorne's popularity.[6] Whistler sneered at the middle-class propriety of the Crystal Palace, but its very popularity left Cremorne to the demi-monde. In 1877 local residents saw to it that the Gardens' licence was not renewed.

Whistler painted six nocturnal scenes showing Cremorne Gardens. Each deals directly with the issues under debate between the management of the Gardens and

the virtuous gentlemen and women of Chelsea. In no.57 he shows prostitutes parading near the Grand Platform, while both 'The Fire Wheel' (no.56) and 'The Falling Rocket' (no.58) depict the nightly firework display. The noise – and sounds of brass bands, drunken revelry and gusts of laughter – had been a familiar part of Whistler's daily life from the time he moved to Lindsey Row in 1863.

Whistler was among those residents of Chelsea who enjoyed the Gardens and all they stood for. Walter Greaves later recalled: 'What enjoyable evenings those were when we used to sit with Whistler at the windows of the hotel and look down on the wonderful scene below; the whole place ablaze with thousands of lamps, and the crowds of dancers, with their multi-coloured dresses, all moving round the brilliantly lighted bandstand to the strains of the "Derby Gallop" and the noted waltzes of the day.'[7]

In all his depictions of Cremorne, Whistler emphasises the mystery of the Gardens, ignoring the boisterous and rowdy goings on we know were a part of the nightly spectacle. But more than this, he depicts those aspects of Cremorne in which the beauty was ephemeral – the fireworks and the sad parade of prostitutes.

In his painting technique, with thin glazes of paint and flecks of pigment suggesting fairy lights or sparks of fire, it is as though Whistler is trying to preserve the mood of Cremorne by not attempting to describe it too literally. In depicting its melancholy poetry, under threat from middle-class morality, Whistler seems to echo the *Daily Telegraph's* editorial of 6 October 1877 lamenting the passing of the Gardens: 'That the cause of public morality will benefit in the slightest degree by the disappearance of these gardens would be simply too ridiculous to suppose ... Cremorne ... was but a poor, struggling, feeble little show from the beginning.'

R.D.

56 Nocturne: Black and Gold – The Fire Wheel *c.*1872–7

Oil on canvas 54.3 × 76.2 (21⅜ × 30)
PROV: Pawned to Algernon Graves, London (dealer); retrieved by Whistler *c.*1890; Arthur H. Studd, London 1896; bequeathed to the National Gallery, London 1919; transferred to the Tate Gallery in 1949
EXH: London, Grosvenor Gallery 1883 (115); possibly Edinburgh 1886 (1399); Paris, Petit 1887 (212); possibly Brussels 1888 (2); Munich 1888 (2455); New York 1889 (54); Paris, Salon 1890 (2440); London, Goupil 1892 (7); Paris, Soc. Nat. 1892 (ex cat.); Antwerp 1894 (2370); Boston 1904 (66); Paris 1905 (65); London & New York 1960 (34)
LIT: YMSM 1980 (169); MacDonald 1994 (723)

Tate Gallery. Bequeathed by Arthur Studd 1919

Every evening, at either ten or ten thirty, Mr Wells the pyrotechnist put on his Grand Display of Fireworks on the Cremorne fireworks platform (the Grotto). 'Nocturne: Black and Gold – The Fire Wheel' shows the climax of one of these displays, the spectacular Catherine wheel. A crowd of spectators with their backs turned to us, watch the gyration of the wheel at the right, as it throws off a shower of sparks into the night sky. A tiered fountain strung with fairy lights is at the left, with the shadowy shapes of trees at left and right. In 1892 Whistler wrote to the London dealer, D.C. Thomson, 'The two firework pictures are marvellous! – and wonderful proof of the completeness of those works'.[1] In the following year, when Whistler was trying to sell 'The Fire Wheel' to various American dealers and collectors, including Mrs Potter Palmer of Chicago, he made a small watercolour copy of it (Hunterian Art Gallery; M 723) which shows somewhat more detail than is now apparent,

particularly in the area of the fountain. The technique in the oil is complex, with thin washes conveying the blowing smoke and velvety darkness, paint dripped across the surface for the fireworks, and the figures painted with studied brushstrokes.

The long exhibition history reflects the fact that for years 'The Fire Wheel' was deposited as surety for a loan with Henry Graves and Co. The overall darkness of the painting caused problems, and Whistler wrote in 1896 that it was 'in pitiable condition! All the varnish perished – ... No wonder no one could see anything in it – Had it at once cleaned – revarnished – Beautiful again! Sold at once for 1000 gns.'[2]

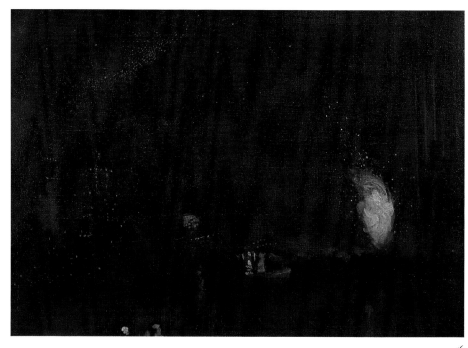

56

57 Cremorne Gardens, No.2 1872–7

Oil on canvas 68.5 × 134.9 (27 × 53⅛)
PROV: Thomas Way, London 1879; his son, T.R. Way before 1896; Agnew, London (dealers) 1903; Alexander Hannay, London after 1905; Percy M. Turner, London (dealer) by 1912; purchased by the Metropolitan Museum of Art 1912
EXH: London 1905 (25); London & New York 1960 (36)
LIT: YMSM 1980 (164)

The Metropolitan Museum of Art, New York. John Stewart Kennedy Fund, 1912

In his *Notes on England*, published in 1870, Hippolyte Taine described an evening visit to Cremorne Gardens. The French visitor saw at once that 'the women were prostitutes but of a higher rank than those in the Strand'. They wore: 'light coloured shawls over white gauze, or tulle dresses, red *mantelets*, new hats. Some of their dresses may have cost as much as £12. But the faces are rather faded and sometimes, in the crowd, they utter shocking screams, shrill as a screech-owl'.[1]

In the controversies which swirled around the Gardens in the 1870s everyone agreed that prostitution existed, but estimates as to how many 'gay women' could be found there of an evening ranged from sixteen to sixty. Also under dispute was what actually happened on the premises. When in 1877 the proprietor of Cremorne, John Baum, sued a Baptist minister for publishing the libel that he ran the Gardens for immoral purposes, witnesses testifying on his behalf described the paths and bowers as well lit and well policed.[2] Against this, a 'check taker' who worked in the Gardens swore at the trial that he had seen men and women make assignations both in the private rooms of the hotel and in the shrubberies.

In the faceless group of a man and four women at the centre of the picture, Whistler uses body language to depict an encounter between four prostitutes and a potential customer. The well-dressed man doffs his cap to two women walking together, as any gentleman might do. But a mid-Victorian book of etiquette for gentleman states that in addition to lifting his hat to a lady 'of course it is understood that ... you must always recognize and part from a lady with a distinct *bow*'.[3] In failing to bow, and in standing with his legs wide apart, this particular gentleman flaunts Victorian convention, which dictated that a man should stand with his feet close together, as though at attention, when bowing to a lady.

Meanwhile, an unescorted women just to his left turns back to eye this fellow, a movement which invites him to turn away from the women he has just approached. A fourth woman with her crimson fan open in a gesture which signifies her availability moves in from the right. Whether these women circle their prey like so

many vultures, or whether the male is simply confronted with a sexual *embarrass de richesse* Whistler leaves it to the viewer to decide.

What is happening at the left and right sides of the picture is also important. Under a shelter at the left, two women huddle together while a slouched male figure crosses his legs and thrusts his hands in his pockets, the epitome of indolent watchfulness. Even at this distance we can guess from his posture that he is not a gentleman, and that the women are leaning against each other as though either sleeping or drunk, a clue as to the wide range of social classes that frequented the Gardens.

By contrast, the Pennells identified the figure seated at a table under a tree at the far right as Whistler himself. Though the figure is given no features which could confirm or refute this suggestion, in a sense it does not matter. Self-portrait or not, the top hat, frock coat, and the elegant way in which he crosses his legs identifies this man as a *flâneur*, Baudelaire's dandy who spends his life as a detached observer of the comedy of life, the urban sophisticate whose pleasure is in the discreet attention he pays to incidents encountered in the cafés and boulevards.

In the depiction of a popular pleasure garden, two contemporary French pictures immediately come to mind. The first is Manet's 'Music in the Tuileries' of 1862 (National Gallery, London), the other Renoir's 'Le Moulin de la Galette' of 1876 (Musée d'Orsay, Paris). But both of these masterpieces show the gardens in the afternoon, crowded with boozy revellers in strong sunlight. In their innocent exuberance they seem a long way from Whistler's mood of subterranean sexual tension.

Whistler's delicate colours range from the soft green of the dress of the woman at the centre, to sulphurous touches of red in the fan and hat of the woman to right of centre. In both theme and treatment, he seems to be looking back to eigtheenth-century painters. Jean-Antoine Watteau is often cited as an inspiration for Whistler's evocation of these ephemeral pleasures, but the subject of an outing to popular pleasure gardens is not unlike that of Jean-Honoré Fragonard's 'La Fête à Saint-Cloud' *c*.1773 (Banque de France, Paris).

Whistler was of course acutely aware of the long British tradition of depicting pleasure gardens, fairs and fetes. William Hogarth's engraving of 'Southwark Fair' (1734) comes to mind as an early example, as do Canaletto's views of Vauxhall Gardens, as in his 'A View of the Temple of Comus &c. in Vauxhall Gardens' of 1751 (fig.65). But closest of all to Whistler's vision of refined flirtation in elegant surroundings is Thomas Gainsborough's feathery evocation of foliage and rustling fabrics in 'The Mall in St James's Park' 1783 (fig.66) which Whistler would certainly have seen when it was exhibited at the Royal Academy in 1876.[4]

57

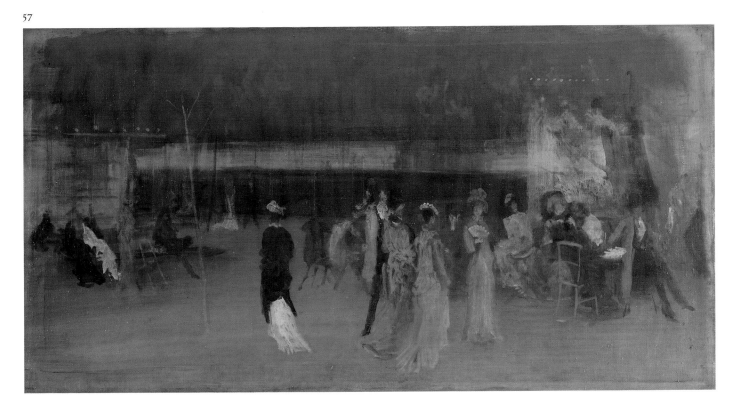

Whistler v. Ruskin

At the first Grosvenor Gallery exhibition in 1877 Whistler exhibited 'Nocturne in Black and Gold: The Falling Rocket', his atmospheric evocation of the lights of Cremorne Gardens at night, its delicately scumbled sky flecked with an impastoed shower of golden fireworks (no.58). John Ruskin's critical attack on this picture and on the artist who painted it appeared in his series of letters to working men, entitled *Fors Clavigera*. His words were as vicious as they were irresponsible: 'I have seen, and heard, much of Cockney impudence before now; but never expected to hear a coxcomb ask two hundred guineas for flinging a pot of paint in the public's face.'

It was over this sentence that Whistler sued Ruskin for libel. But a far more serious libel occurs in the sentence preceding it: 'Sir Coutts Lindsay (owner of the Grosvenor Gallery) ought not to have admitted works into the gallery in which the ill-educated conceit of the artist so nearly approached the aspect of wilful imposture.' As the prosecution asked at the trial, what is the difference between the 'near approach' of wilful imposture, and imposture itself?

Had the review been confined to the relatively small number of readers among whom *Fors Clavigera* circulated, Whistler might well have ignored it. But it was picked up by the national press to be read by a wide British public for whom Ruskin's pronouncements on art amounted to gospel truth.[1] Whistler was telling the truth when he claimed that Ruskin's ridicule had led to a loss of his artistic reputation.

Whistler sued not only to defend his own character, but to correct via the press what he believed to be a popular misconception of the very nature of art. The trial that took place at the Old Law Courts on 25 and 26 November 1878 is still of interest because in it we hear Whistler's own voice raised in exasperated defence of the idea of 'art for art's sake'. That he was forced to manipulate the media in order to do so is a reflection of the failure of a large number of British critics even to attempt to understand his paintings.

Both Whistler and Ruskin used the media to defend their views on art before and during the trial. Whistler used a pre-trial interview in the *World* newspaper as well as his appearance in the witness box as platforms from which to preach to the British public on the nature of art, much as Ruskin had been doing since the 1840s. Testifying for Ruskin were the painters William Powell Frith and Edward Burne-Jones, the one fatuous, the other equivocating. For Whistler there was an eloquent Albert Moore and a brave William Michael Rossetti, who reluctantly forsook an old friendship with Ruskin to defend the painter. Then there were the rats, James Tissot and Joseph Edgar Boehm, who both deserted the Whistlerian sloop, frightened of Ruskin's approaching man-of-war. At least their disappearance made the skirmish that followed an overwhelmingly British engagement.

The whole thing was reported in an atmosphere that we would today call a media circus, and exploited later by Whistler both in his printed pamphlet *Art and Art Critics* and in the 'Ten O'Clock' lecture. But what was it, exactly, that Whistler was defending? To Victorian eyes, his compositions looked empty, his brushstrokes

slapdash, the prominence he gave to the exquisitely placed butterfly signature and his use of painted frames incomprehensible. What was so difficult for the public to grasp was that for Whistler, style and subject were identical.

What one might call the motif, the actual 'view' of Cremorne Gardens, or the Thames, was relatively unimportant; just as in the 'Arrangement in Grey and Black: Portrait of the Painter's Mother' (no.60), it was the arrangement that mattered, not the sitter: 'To me it is interesting as a picture of my Mother; but what can or ought the public to care about the identity of the portrait?'

During the trial, Whistler tried not to refer to his paintings as 'pictures' at all, but as 'arrangements', 'symphonies', 'nocturnes' , 'moonlight effects' or – most revealing of all – as 'a problem that I attempt to solve.'[2] He was doing this in order not to confuse the jury, for whom a 'picture' implied a view, a work of art that gave information about the real world, not a work that could sustain itself through its own artistic devices. In his own words,

> Art should be independent of all clap-trap – should stand alone, and appeal to the artistic sense of eye or ear, without confounding this with emotions entirely foreign to it, as devotion, pity, love, patriotism, and the like.[3]

However ambiguous the outcome of the trial, with its famous verdict of a farthing's damages for the plaintiff, awarded without costs, in the light of art history, Whistler won hands down.

R.D.

58 Nocturne in Black and Gold: The Falling Rocket 1875

Oil on wood 60.3 × 46.6 (23¾ × 18⅜)
PROV: Deposited with Algernon Graves, London (dealer) and by him with Mrs Noseda, by 1881; retrieved by Whistler 1882–90; with Dowdeswell, London (dealers); sold by Whistler to Samuel Untermeyer, New York 1892; his sale Park Bernet, New York 10 May 1940 (29) bt Charles Sessler, Philadelphia (dealer); Knoedler, New York (dealers) 1944; Scott and Fowles, New York (dealers), 1946; Dexter M. Ferry, Jr. for the Detroit Institute of Arts 1946
EXH: London, Dudley Gallery 1875 (170); London, Grosvenor Gallery 1877 (4 in West Gallery); Paris, Petit 1883 (8); New York, 1883 (not numbered in cat.); possibly Edinburgh 1886 (1399); Paris, Petit 1887 (212); New York 1889 (55); Brussels 1890 (840); Paris, Salon 1890 (2440); London, Goupil 1892 (10); Philadelphia 1900 (30); New York 1902 (241); Pittsburg 1902–3 (150); Boston 1904 (64); Paris 1905 (66); London & New York 1960 (33)
LIT: YMSM 1980 (170)

The Detroit Institute of Arts, Gift of Dexter M. Ferry, Jr.

When 'The Falling Rocket' was at the Grosvenor Gallery in 1877 Ruskin described the picture as 'a pot of paint' flung in the public's face. Whistler then sued Ruskin for libel. Under cross-examination by the Attorney-General Sir John Holker, Whistler defended his masterpiece:

> Holker: 'What is the subject of the 'Nocturne in Black and Gold'?'
> Whistler: 'It is a night piece and represents the fireworks at Cremorne Gardens.'
> H: 'Not a view of Cremorne?'
> W: 'If it were called "A View of Cremorne" it would certainly bring about nothing but disappointment on the part of the beholders. (Laughter). It is an artistic arrangement. That is why I call it a 'nocturne.'

A few minutes later came the most famous exchange of the trial.

H: 'Did it take you much time to paint the *Nocturne in Black and Gold*? How soon did you knock it off?'

W: 'Oh, I "knock one off" possibly in a couple of days – (Laughter) – one day to do the work and another to finish it …'

H: 'The labour of two days is that for which you ask two hundred guineas?'

W: 'No. I ask it for the knowledge I have gained in the work of a lifetime.'

(Applause)[1]

With these words Whistler was introducing the novel idea that the value of a work of art did not depend on the amount of time it took to paint it but on the far more intangible concept of the artist's genius.

But Whistler was not the only artist to discuss this particular picture during the trial. Albert Moore testified that in it 'he has painted the air, which very few artists have attempted … As to the picture in black and gold, I think the atmospheric effects are simply marvellous.'[2] On the other hand, to Edward Burne-Jones, the Nocturnes were 'sketches' which did not much resemble night at all. In his statement to the defence counsel he testified that Whistler had

> never yet produced anything but sketches, more or less clever, often stupid, sometimes sheerly insolent, but sketches always … For all artists know that the difficulty of painting lies in the question of completion … The test is finish. In finishing, the chance of failure increases in overwhelming proportion. To complete and not lose the first vigour, that is what all painters have always set before themselves, all without exception.[3]

'Nocturne in Black and Gold: The Falling Rocket' shows the Cremorne fireworks platform (the Grotto) where Mr Wells put on his nightly shows (fig.67).[4] The explosion of orange light in the centre is the climax of the event, in which rockets, flares, and illuminations have been set off at once. Mingled smoke and fire are evoked through a scumbling of blue and black paint. In the foreground appear three ghostly figures ringing the circular ornamental garden in front of the Grotto, while the large area of intensified black running along the left-hand edge of the picture is a tree.

Attention focuses first on the strong sweep of colour at the bottom of the canvas, and is then drawn upward through the black night sky to the shower of orange sparks just above the centre, and finally to the clusters of red, pink, and green dots at the very top. At the right-hand side, a relatively weak cluster of pale red and yellow flecks suggests 'the dying sparks of a spent rocket'. The whole picture, therefore, imitates the path of the rocket from launch, to explosion and dying fall.[5] These effects are achieved not through spattering paint on the canvas, but by carefully painting in each separate fleck of colour.

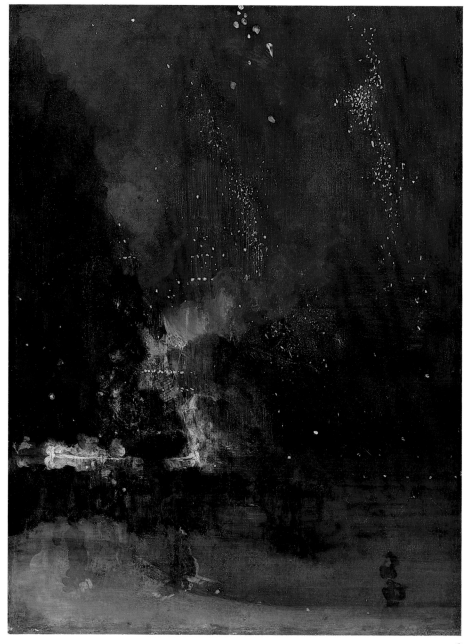

58

59 Nocturne: Blue and Gold –
 St Mark's, Venice 1879–80

Oil on canvas 44.5 × 59.7 (17½ × 23½)
PROV: Boussod, Valadon & Cie., Paris
1891, bt by Gallimard; probably
reacquired by Whistler by 1892; possibly
J.J. Cowan, Edinburgh 1899; with Agnew,
London (dealers) 1903; J.J. Cowan, by
1905; Wallis & Son, London (dealers) by
1912; Miss Gwendoline E. Davies,
Llandinam 1912; bequeathed to the
National Museum of Wales 1952
EXH: London, SBA 1886–7 (331);
London, Goupil 1892 (38); Paris, Soc.
Nat. 1892 (1071); London 1905 (2);
Cardiff 1992 (4)
LIT: YMSM 1980 (213)

National Museum of Wales, Cardiff
[Not exhibited in Washington]

Whistler arrived in Venice in September 1879
(see p.179). Although many of his views of
Venice show obscure areas or unexpected views
of the city, in etchings such as 'Long Venice' he
did not hesitate to depict a panoramic vista
looking towards Santa Maria della Salute such
as Turner might have chosen to paint (K 212).
And in this Nocturne, one of only seven or
eight oil paintings executed there, he shows us
the ultimate tourist attraction, St Mark's itself.[1]

Whistler faces the building head on, from
about half way across the empty Piazza St
Marco, a view made familiar throughout
Europe in thousands of photographs and

watercolours. The difference is that Whistler
paints the basilica so late at night that the lights
from Florian's and Quadri's cafés on either side
of the Piazza have been turned off. All we see is
a cavernous black shadow looming up against
the deep blue of the sky, thin glazes of rich
colour where the only points of focus are in a
glint of golden mosaics and a few sputtering,
smokey flambeaux at the left.

Mysterious and poetic though Whistler's
vision is, 'Nocturne: Blue and Gold – St
Mark's, Venice' is also a calculated response in
the aesthetic debate initiated by Whistler dur-
ing his action for libel against John Ruskin, a
writer whose name was inextricably linked with
that of Venice. The crux of the debate could be
said to concern the issue of realism in art.

Whistler was in Venice at the same time as
the English painter John Wharlton Bunney. At
Ruskin's request Bunney was painting a vast,
stone by stone visual record of the west front of
St Mark's, a project which was to take him six
years to complete (Guild of St George, Reading
University). Bunney's view of the basilica is vir-
tually the same as Whistler's, except that Bun-
ney shows the building during the daytime.
The light is even, the colour subdued, and the
near photographic detail unmodified, as far as
possible, by evidence of the artist's presence.

At this moment, all Europe was outraged by
the scandalous 'restoration' of the mosaics on
the facade of the basilica, an act of official van-
dalism which had caused particular consterna-
tion among Whistler's adversaries, Ruskin and
Edward Burne-Jones, two chief movers in the
'St Mark's Committee' formed in 1879 to stop
the restorations. That Whistler was well aware
of the controversy is shown by a letter from
Ernest G. Brown of the Fine Art Society dated
31 January 1880 in which he tells Whistler that
'the time is just ripe for the Venice etchings'
with the 'row here about St Marks going on'.[2]

Significantly, Whistler includes the scaffold-
ing erected for the restoration, visible just to
the left of centre, an eyesore which Bunney in
his misguided pursuit of visual truth simply
ignores. In the 'Red Rag' Whistler was refer-
ring to Ruskin's disciples when he said: 'The
imitator is a poor kind of creature. If the man
who paints only the tree, or flower, or other sur-
face he sees before him were an artist, the king
of artists would be the photographer.'

Finally, that Whistler painted this Nocturne
in conscious continuation of his quarrel with
Ruskin is suggested by an anecdote recounted
by Booth Pearsall. Standing before the picture
in his Fulham Road studio in the later 1880s,
'Whistler asked me if Ruskin would admit he
could draw architecture'.[3]

59

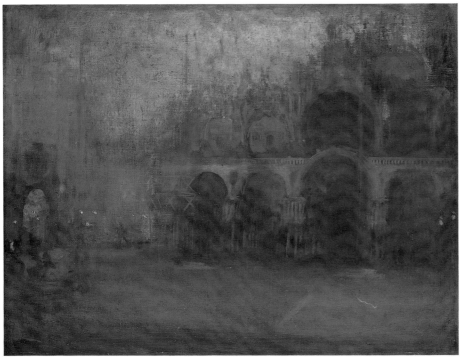

Portraits of the 1870s

Stimulated by a series of three huge exhibitions of British portraits held at the South Kensington Museum from 1866–68 and always aware of the seventeenth century portraiture of Frans Hals and Velázquez, in the 1870s Whistler sought in his art to revitalise the grand tradition of British portraiture (see p.25).

He found a balance between the status of each portrait as an 'arrangement' of form and colour, and its function in giving information about the character of the sitter. The austere beauty of the composition and colour in 'Arrangement in Grey and Black: Portrait of the Painter's Mother' (no. 60) is matched by its powerful grasp of the pious American widow's character. Near the end of his life, during a visit to the Franz Hals museum in Haarlem, Whistler showed how he wished his own portraits to be read. Standing in front of Hals's great group portrait of the Regentesses he said

> 'Look at it - just look - look at the beautiful colour – the flesh – look at the white – that black – look how those ribbons are put in. O what a swell he was – can you see it all - and the character - how he realised it … you see, *she* is a grand person' – pointing to the centre figure – 'she wears a fine collar, and look at her two little black bows – she is the Treasurer' [pointing to another figure] 'She is the Secretary – she keeps the records'.[1]

'Harmony in Grey and Green: Miss Cicely Alexander' (no. 62) took two years to complete. Whistler required over seventy sitting from the six year old child. And although he reduced poor Cicely to an 'Arrangement', in the finished portrait he did not disguise her misery. He took the most sentimentalised Victorian subjects, motherhood and childhood, and created works in which painterly values took precedent over narrative content. By painting the revered historian Thomas Carlyle (no.61), and the most famous actor of the age, Sir Henry Irving (no.64) he showed that even the most eminent Victorians could be treated as 'arrangements' in colour, tone and design.

But Whistler was not consistent. Despite his insistence that a picture 'should have its own merit, and not depend on dramatic or legendary or local interest'[2] in 'Arrangement in Yellow and Grey: Effie Deans' (no.65) he went out of his way to attach a text from Sir Walter Scott to his painting. And although his 'Proposition No.2.' states that 'a picture is finished when all trace of the means used to bring about the end has disappeared',[3] in the same picture he conspicuously allows the thin pigment to run in rivulets down the bottom of the canvas.

All these pictures are painted in a technique very different from the one Whistler has been taught in Paris, and much closer to the British method of 'glazing'. At each session he quickly covered the canvas with a layer of thin translucent paint. But when dissatisfied with one area of the picture, he would scrape the whole canvas bare and start again. This procedure is responsible for the extraordinary freshness of colour and vitality of the picture surface. R.D.

60 Arrangement in Grey and Black: Portrait of the Painter's Mother

1871

Oil on canvas 144.3 × 162.5 (56¾ × 64)
Signed with butterfly
PROV: Pawned to Mrs Noseda; C.A. Howell, & A. Graves 1878–88, and to Richard D'Oyly Carte in 1887–8; bt from the artist by the French State, 30 Nov. 1891 (4,000 francs) for the Musée du Luxembourg; transferred to the Musée du Jeu de Paume 15 July 1922; then to the Musée du Louvre 9 October 1925; then to the Musée d'Orsay 1986
EXH: London, RA 1872 (941); Paris, Durand-Ruel 1873 (cat. untraced); London, Pall Mall 1874 (4); Philadelphia 1881–2 (191); New York 1882 (124); Paris, Salon des Artistes français 1883 (2441); Dublin 1884 (244); Munich 1888 (not in cat.); London, College for Men and Women 1889 (no cat.); Amsterdam 1889 (468); Glasgow 1889 (not numbered in cat.); London, SPP 1891 (224); Paris, Goupil 1891 (no cat.); Paris 1905 (23)
LIT: YMSM 1980 (101)

Musée d'Orsay, Paris

Whistler's mother, Anna Matilda McNeill, was born in Wilmington, North Carolina, on 27 September 1804, daughter of Dr Daniel McNeill of Edinburgh and his second wife, Martha Kingsley. She married Major George Washington Whistler on 3 November 1831. Their first child was the painter, affectionately known as Jemie. After many peregrinations, she settled in London in 1864, retired to Hastings in 1874, and died on 31 January 1881.

In 1873 Whistler wrote to Fanfin-Latour, 'Le portrait de ma mère, je ferai photographier et je t'en enverrai une épreuve'.[1] The portrait was painted between August and October 1871, when she was sixty-seven years old, living with Whistler at 2 Lindsey Row in Chelsea. The grey-walled studio was at the back of the house, on the second floor. Above the black skirting hung framed etchings.

In August 1871, unable to complete 'The Girl in Blue' (later known as 'Annabel Lee', Hunterian Art Gallery, Glasgow; YMSM 79) for William Graham, member of Parliament for Glasgow, because his young model, Maggie, had fallen ill, Whistler asked his mother to pose. He used the smooth back of an old canvas. Before relining, some time between 1883 and 1890, an earlier figure composition was visible on the reverse. Otto Bacher described seeing a child; T.R Way,

a study for the 'Three Girls' (whereabouts unknown; YMSM 89).[2] However, it may have been an atttempt at enlarging 'Harmony in Flesh Colour and Red' c.1869 (Museum of Fine Arts, Boston; YMSM 91).[3]

The spontaneous nature of its origins may explain why Whistler, contrary to his usual practice, applied no size (glue) to the raw canvas before covering it with a thin, water-based grey ground. As a result, the medium seeped into the fabric of the canvas, creating a rich, matt effect. According to Harper Pennington, the canvas was so permeable it was 'stained right through with oil from the face'.[4]

Many writers have noted previous examples of the monumental seated pose – the statue of Agrippina in the Capitol, Canova's portrait of Napoleon's mother at Chatsworth, a tanagra statuette in the Ionides collection (of which Whistler had a photograph) or Caspar Netscher's 'The Lace Maker' (fig.68).[5] In addition, Rembrandt's 'Bathsheba' (Louvre, Paris), though nude, occupies a similar space in relation to the canvas. Contemporary influences may have included an etching of 'Mrs Edwin Edwards' by Charles Keene (fig.69).[6]

Mrs Whistler first posed standing, possibly in the three-quarter pose seen in an etching (K 97) and similar to an outline visible in an X-ray of the painting.[7] After three days, a less tiring, seated, pose was adopted. He then made subtle adjustments to the position of her face and left arm, to the chair and footstool, and moved the curtain to the left. The etching – 'Black Lion Wharf' 1859 (no.9), published with the 'Thames Set' in 1871 – was moved over an inch nearer to the figure to its right. These modifications created a more satisfactory equilibrium in the space round the figure.

The technique has been compared to that of Velázquez and even Frans Hals.[8] A variety of techniques were used, from thick impasto, to the scraping and wiping away of pigment to reveal the canvas. The walls were painted in broad brushstrokes, in shades of grey and cream. Dress and curtain were painted thinly, except for highlights on the curtain. Pink and yellow flesh tones were applied with a small brush. The yellow in the curtain, picked up in the handkerchief and footstool, tells strongly against the prevailing blacks and grey.

Anna Whistler wrote to her sister in November 1871 that during the sittings she offered up a 'mother's unceasing prayer' that her son should succeed in his artistic quest.[9] For years Whistler had difficulty in completing his work, and she did not live to see his eventual success. She was a devout Christian, an Episcopalian in America, and member of the

Church of England, who, in London, worshipped every Sunday at Chelsea Old Church. From its first exhibition in London the portrait was praised for its 'powerful grasp of the Protestant character'.[10] In the portrait, Whistler goes right to the heart of her character, her pious resignation in accepting the trials of her life, which included the death of two children and her husband. Her neat mourning dress, patient pose and resigned expression, clearly describe her position in life, a middle-class widowed lady.

Although immediately appreciated by friends such as D.G. Rossetti and Algernon Swinburne, the 'Portrait of the Painter's Mother' surprised visitors to exhibitions. It was nearly rejected by the Royal Academy in 1872 and was the first work exhibited by Whistler as an 'Arrangement' of colours - grey and black. The *Times* commented, 'An artist who could deal with large masses so grandly might have shown a little less severity, and thrown in a few details of interest without offence'. Whistler, joking, later suggested to Sickert that the addition of 'a glass of sherry and the Bible' would satisfy the public's desire for trivial detail.[11]

After this cool reception, the portrait went unnoticed in Durand Ruel's Paris gallery in

60

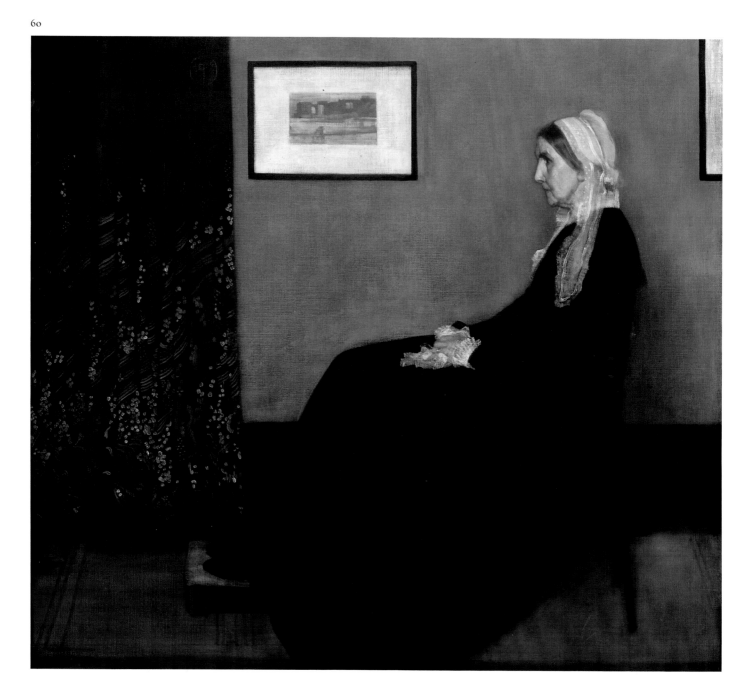

1873, while at the 1883 Salon, opinions were divided. Some were favourable, and in *La Revue Indépendant* in 1884 Huysmans recalled:

> It was disturbing, mysterious, of a different colour from those we are accustomed to seeing. Also the canvas was scarcely covered, its grain almost invisible; the compatibility of the grey and the truly inky black was a joy to the eye, surprised by these unusual harmonies; it was, perhaps, English painting Baudelairised, lunar, real painting.[12]

Whistler claimed he would not sell the portait. His attitude changed in 1891 when he discussed with Stéphane Mallarmé, Théodore Duret, Roger Marx and Gustave Geffroy, ways whereby the painting could be acquired by the Musée du Luxembourg. A subscription or committee did not seem to Whistler to guarantee that the picture would one day hang in the Louvre. A purchase, for a modest price, was finally negotiated, and the 'Portrait of the Painter's Mother' entered the Musée du Luxembourg.[13]

It was not a recent work and, with others by Manet and Fantin-Latour, gave a retrospective aspect to the museum. At a time when Seurat was dying unrecognised, when Gauguin was leaving for Tahiti, this painting must have encouraged Charles Cottet and his friends in the 'Black Gang' whom Léonce Bénédite considered the best artists of the period.

Official sanction was accompanied by banquets and honours. The word masterpiece crept into the panygyrics. The Symbolist poet George Rodenbach wrote that Whistler had become a 'naturalised Parisian':

> As a gift to mark this joyful entry, he sold his masterpiece, Portrait of Whistler's Mother, to the Musée du Luxembourg on very easy terms. What a bold, new line is that of the long body only just glimpsed in the black dress! And what psychological penetration: the very soul tamed by the paintbrush, evoked on the surface of the face! And those chaste whites: that of the lace cap, that of the handkerchief held in the hand as it might be held by a girl making her first communion! Does not old age restore original innocence? And the deep black, flecked with flowerets, of the significant curtain behind which we can feel the woman's whole life still quivering, yet retreating, becoming forgotten! ... And to link these whites and these blacks, there is the overall grey that adheres to the walls, floats like a mist, disseminates its muted tones, unifies its dead ashes, as if it were the outer expression of the ashes of the vanished years in the mother's heart.[14]

Frequently lent to the United States, during the course of the twentieth century this picture has become extremely famous – on a par with the Mona Lisa or Millet's 'Angelus'. It has aften been transformed by greeting cards manufacturers or caricaturists. Ward Kimball places a television set on the left of the painting, to justify the mother's gaze, which is not fixed on the spectator.[15]

Geneviève Lacambre

61 Arrangement in Grey and Black, No.2: Portrait of Thomas Carlyle 1872–3

Oil on canvas 171.1 × 143.5 (67⅜ × 56½)
PROV: Pawned to H. Graves & Co. 1878–91; sold by the artist to the Corporation of Glasgow, 1891
EXH: London, Pall Mall 1874 (6); London, Grosvenor Gallery 1877; Paris, Salon 1884 (2455); Edinburgh 1884 (439); Dublin 1884 (242); Glasgow 1888 (614); London, College for Men and Women 1889 (no cat.); Glasgow 1891 (no cat.); London, New Gallery 1891–2 (264); London, Goupil 1892 (42); Dundee 1895 (402); Glasgow 1896 (14); Aberdeen 1896 (41); Perth 1898 (128); London, Guildhall 1900 (72); Liverpool 1900 (1119); Paisley 1901–2 (151); Wolverhampton 1902 (48); London 1905 (5)
LIT: YMSM 1980 (137); MacDonald 1994 (462, 840)

Glasgow Museum and Art Gallery

As with Whistler's views of the Thames, studies of Cremorne Gardens (nos.56, 57) and certain of the shop fronts (nos.157–9), when he chose to paint the great Victorian historian and social critic Thomas Carlyle he was selecting one of the familiar sights of his own neighbourhood in Chelsea. Carlyle had been the resident genius for forty-seven years, in the words of one author 'to the people of Chelsea a figure as ... seemingly indestructible as Queen Victoria herself'.[1] Living at 2 Lindsey Row, no more than five minutes walk away from Carlyle's house in Cheyne Row, Whistler must have seen Carlyle almost daily, though there is no evidence of personal contact before 1872.

In that year Carlyle visited Whistler's studio

in the company of Mme E. Venturi, the former Emilie Ashurst, author of a short *Life* of the Italian patriot Giuseppe Mazzini, and friend to both men. According to Whistler himself, the 'Arrangement in Grey and Black: Portrait of the Painter's Mother' (no.60) was in the studio, 'and Carlyle saw it and seemed to feel in it a certain fitness of things … He liked the simplicity of it, the old lady sitting with her hands in her lap, and said he would be painted. And he came one morning soon, and he sat down, and I had the canvas ready, and my brushes and palette, and Carlyle said, "And now, mon, fire away!"'[2]

Since Carlyle so admired the 'Mother', Whistler adopted roughly the same profile composition, on a canvas a few inches larger than that on which the portrait of Mrs Whistler is painted, but in an upright format and even more radically pared down, without the curtain or footstool. According to the painter Hugh Cameron, who dropped by Whistler's studio during the sittings, 'It was the funniest thing I ever saw. There was Carlyle sitting motionless, like a Heathen God or Oriental sage, and Whistler hopping about like a sparrow'.[3]

On 29 July 1873 Carlyle was still posing. The poet William Allingham recorded in his diary that Whistler 'had begun by asking two or three sittings but managed to get a great many … If C[arlyle] makes signs of changing his position, W[histler] screams out in an agonized tone, "For God's sake, don't move!" C[arlyle] afterwards said that all W's anxiety seemed to be to get the *coat* painted to ideal perfection; the face went for little.'[4]

Despite this comment, Whistler's portrait of Carlyle is remarkable for the way in which it probes the sitter's character. Though the composition superficially resembles that of the 'Mother', through a few subtle adjustments to the pose (turning the sitter just slightly out of profile towards the viewer, painting the swell of his frock coat where he has failed to adjust it before sitting down) Whistler gently suggests a sense of disorientation, an aura of psychological turbulence that is utterly absent in the portrait of his mother. Above all Whistler's treatment of the philosopher's face is full of sympathy.

Whistler painted Carlyle when his subject was seventy-eight years old and had eight more years to live. According to his biographer James Anthony Froude, the once fierce Carlyle had been overcome with remorse for his treatment of his wife Jane Welsh Carlyle, who had died 1866. Tortured by 'helpless repentance',[5] in his journal of 1867 Carlyle wrote, 'I have no heart or strength of hope or of interest for further work. Since my sad loss I feel lonesome in the earth (Oh, how lonesome!) and solitary among my fellow creatures.'[6] Nor did this mood lift with the passing years. Time hung heavy on his hands, and his life became stagnant. In Froude's apt phrase 'The rocket was burnt out and the stick falling.'[7] At precisely the moment when Whistler was painting him, Carlyle wrote in his journal 'More and more dreary, barren, base, and ugly seem to me all the aspects of this poor diminishing quack world' and the last entry in his journal, dated 6 December 1873, is 'A life without work in it, as mine now is, has less and less worth to me; the poor soul still vividly enough alive, but struggling in vain under the strong imprisonment of the dying or half-dead body.'[8]

As in the portrait of his mother, Whistler's use of the profile against a plain background painted in a limited range of low tones is reminiscent of the folk art of silhouette. But typically, the silhouette of one sitter was accompanied by a pendant showing the sitter's partner. In the 'Mother' the absent spouse is Whistler's own father; here it is Jane Welsh Carlyle. And yet for all its psychological perception, Whistler's portrait was exhibited as an 'Arrangement in Grey and Black', emphasising the formal placement of shapes and colours against a neutral background in a shallow pictorial space. As when he chose to treat his own mother as an 'arrangement', Whistler once again went out of his way to pick a subject wreathed in an aura of reverence, in this case the most famous moral philosopher of the Victorian age, thus demonstrating that through his art the painter can transform even the most eminent personality into a study of shape and texture and colour. It is no accident that the sitter Whistler wished to paint after Carlyle was none other than the former prime minister Benjamin Disraeli, who declined to sit. In Carlyle, Whistler was also tackling one of the most often portrayed of the great Victorians. Ormond lists over eighty portraits of Carlyle, including the life-sized statue in bronze (1874–5) by Whistler's friend Joseph Edgar Boehm erected in Embankment Gardens, Chelsea, in 1881–2.[9]

There are three oil sketches and one oil study for no.61 (YMSM 133–6) as well as one drawing (M 462). An engraving by Richard Josey was published in 1878. The portrait was bought by the City of Glasgow in 1891, the first Whistler to enter a public collection.

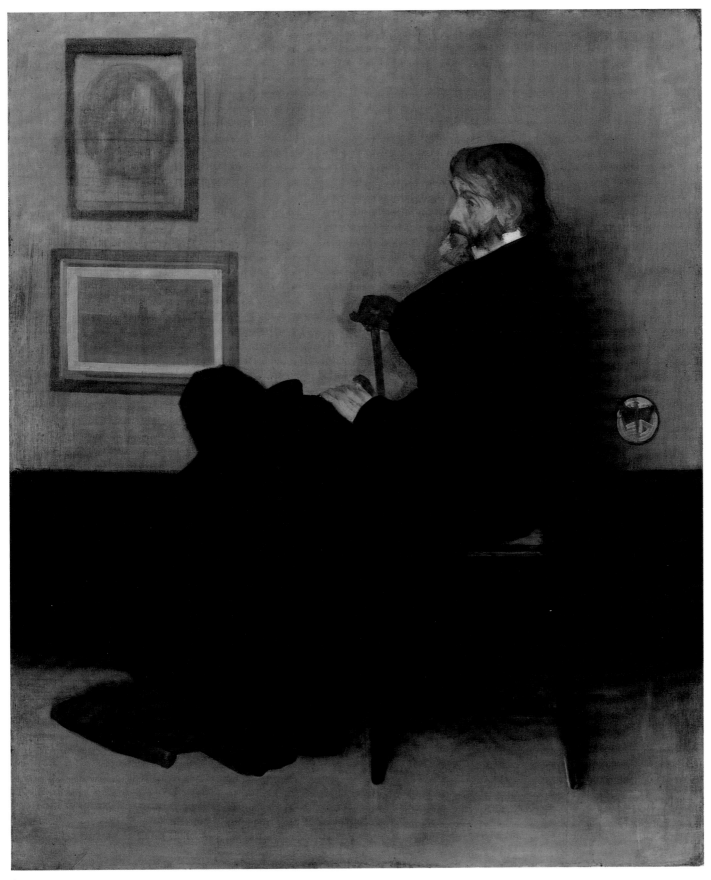

61

62 Harmony in Grey and Green: Miss Cicely Alexander 1872–4

Oil on canvas 190.2 × 97.8 (74⅞ × 38½)
Signed with butterfly
PROV: Commissioned by W.C.
Alexander in 1872; bequeathed to the
National Gallery, London in 1916, with a
life interest to the sitter; passed to the
Tate Gallery on her death in 1932
EXH: London, Pall Mall 1874 (5);
London, Grosvenor Gallery 1881 (113);
Paris, Salon 1884 (2454); Brussels 1884
(4); Munich 1888 (2454); London, SSP
1891 (223); London, Goupil 1892 (23);
London, Guildhall 1894 (136); London,
Grafton 1895 (207); London, Campden
House 1896 (28) (cat. untraced); Dublin
1899 (79); Venice 1899 (ex catalogue);
Paris 1905 (18); London 1905 (32);
London & New York 1960 (31, 113);
Chicago & Utica 1968 (21)
LIT: YMSM 1980 (129); MacDonald 1994
(503–5, 843, 845)

*Tate Gallery, London. Bequeathed by W. C.
Alexander 1932*

Cicely Henrietta Alexander (1866–1930) was
one of the nine children of W.C. Alexander, a
successful banker, specialising in the risky but
lucrative discount market. As a collector of
Oriental art – including lacquer, metalwork
and blue and white china – he inevitably moved
in the orbit of Sir Henry Thompson (see
nos.83–90) through whom he may have met
Whistler. In 1872 the thirty-one year old
Alexander had purchased Whistler's first exhib-
ited Nocturne, 'Nocturne: Blue and Silver –
Chelsea' (no.46). By his own account Alexander
commissioned Cicely's portrait after admiring
'Arrangement in Grey and Black: Portrait of the
Painter's Mother' (no.60), presumably at the
Royal Academy in 1872.[1]

A letter from W.C. Alexander to Whistler
concerning the portrait is dated 21 December
of that year.[2] However, a letter from the artist
to Cicely's mother Mrs Alexander concerning
the sitter's costume, quoted below, is headed
'Tuesday August 26', a date which exists not in
1872, but in 1873. Even if begun earlier, there-
fore, the sittings extended well into 1873, when
Whistler was working on the portrait concur-
rently with 'Arrangement in Grey and Black,
No.2: Portrait of Thomas Carlyle' (no.61).

When the sittings began, Alexander was still
living in Haringay House, Hornsey. In the
autumn of 1873 he moved to Aubrey House,
Campden Hill, Notting Hill Gate.[3] Here
Whistler sketched ideas for the design for the

dining room (see no.80) and planned his por-
trait of Cicely's older sister May (Tate Gallery;
YMSM 127).

In fact, Whistler had intended to paint May
first, but abruptly transferred his interest to
eight year old Cicely, explaining to her father
that 'I should work at the present moment,
with more freshness at this very 'fair arrange-
ment'.[4] Sittings took place at Whistler's studio,
2 Lindsey Houses, Chelsea.

The letter written by the artist to Cicely's
mother Rachel Agnes Alexander on 26 August
[1873] reveals the lengths Whistler was pre-
pared to go in his search for perfection.[5] It also
underlines the artist's continuing commitment
to the Realist aesthetic, his unwillingness to
paint even a shade of white from the imagina-
tion. In it, the painter's mother Anna Whistler
asks Cicely's mother to find a pure white muslin
from which to make the sitter's dress. 'It should
be without blue, as purely white as it can be.'

At this point Whistler takes the pen from
his mother's hand and continues, giving
detailed instructions, including a map, as to
where the fine Indian muslin he prefers can be
purchased. He proceeds to design the dress in
detail: 'The dress might have frills on the skirts
and about it – and a fine little ruffle for the neck
or else lace – also it might be looped up from
time to time with bows of pale yellow ribbon
... the little dress afterwards done up by the
laundress with a little starch to make the frills
and skirts etc stand out – of course not an atom
of blue!'[5] He added a sketch.

Whistler could be so certain about what the
dress was to look like because he had in his
mind's eye a specific style of dress, that worn by
Lola de Valence in Manet's 1862 painting of the
dancer (Musée d'Orsay, Paris).[6] Cicely was in
fact taking dancing lessons during the period
she posed for Whistler, but what might at first
appear to be a balletic pose is actually that of
Manet's 'Lola'.

Having exercised control over every last
detail of Cicely's costume, Whistler also creat-
ed a setting to compliment it. The sisters of
Walter Greaves made the carpet of black and
white tape on which Cicely stood. And stood.
And stood. Whistler required over seventy sit-
tings, each lasting several hours. Often he for-
got lunch, and 'never noticed the tears' when
the child became exhausted. In 1908 Cicely, now
Mrs Bernard Spring Rice, told the Pennells

> I'm afraid I rather considered that I was a
> victim all through the sittings, or rather
> standings, for he never let me change my
> position, and I believe I sometimes used to
> stand for hours at a time. I know I used to

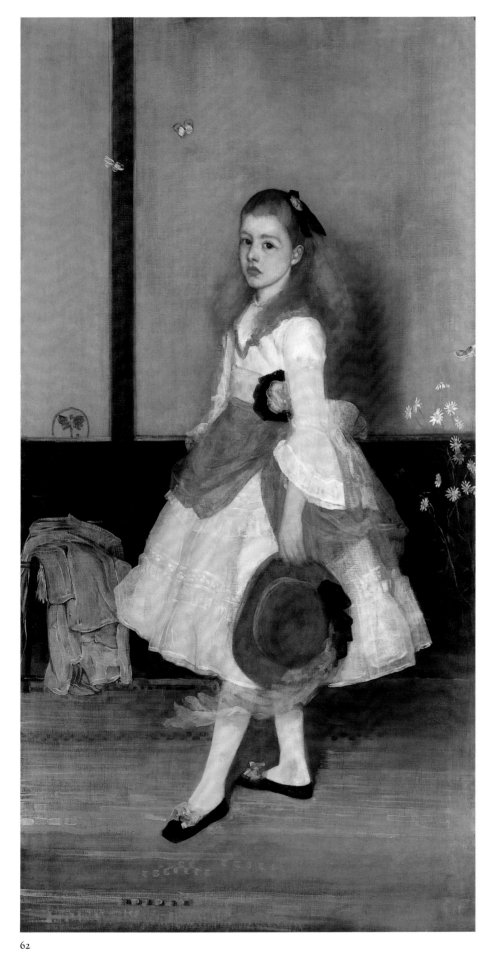

get very tired and cross, and often finished the day in tears … All my memories only show that I was a very grumbling, disagreeable little girl.[7]

Part of the compelling intensity of the picture lies precisely in its undermining of Victorian conventions for depicting little girls as angelic beings, perhaps best seen in John Everett Millais's famous portrait of Miss Edie Ramage, 'Cherry Ripe' of 1879 (Private Collection). For all the prettily feminine details – the flounced muslin dress, butterflies and daisies – it comes as something of a shock when the eye reaches Cicely's angry, pouting face. Whistler faithfully records his sitter's unwillingness to collude in the fiction that she is a carefree little girl, voluntarily standing for her portrait. It would be difficult to cite another example of a portrait in which the sitter all but scowls at the artist.

When the portrait was exhibited for the first time, at the Pall Mall Gallery in 1874, critics attacked the sitter as much as the painting itself, calling it 'a disagreeable presentment of a disagreeable young lady' and 'An arrangement of Silver and bile'.[8] After its exhibition at the Grosvenor Gallery in 1881 the *Magazine of Art* described it as a 'rhapsody in raw child and cobwebs'.[9] Cicely, 'felt quite ashamed when she was pointed out as the original of the portrait and, being recognized, had attention fixed upon her.'[10] Many years later Whistler commented bitterly on the cruelty of these reviews and caricatures in a letter to Mr Alexander of 1899:

> Do you suppose the comic grovelling this year before [the portrait of May Alexander] … wipes away poor little Miss Cissie's tears and her father's blank looks at the coarse ribaldry and vile abuse that was brayed throughout the land when her own beautiful picture was shown? These things are graven in history.[11]

As in the case of 'Arrangement in Grey and Black: Portrait of the Painter's Mother' (no.60) it was the subject as much as its treatment that led French critics to associate the picture with decadence. J.-K. Huysmans, for example, asked his readers to imagine a child, 'une blondine, aristocratique et anémiée, cavalière et douce, une infante anglaise se mouvant dans une atmosphère d'un gris doré par dessous, d'un or effacé de vieux vermeil.'[12] Cicely poses against a grey wall with black dado in a grey toned frock on grey matting. The pale green of the long feather in her hat is picked up in the bows of her black pumps and the transparent grey-green of her broad flounced sash, echoed by the pale green of the butterflies.

[147]

63 Arrangement in Black, No.2: Portrait of Mrs Louis Huth

1872–3

Oil on canvas 190.5 × 99 (75 × 39)
Signed with butterfly
PROV: Louis Huth by 1873, who d. 1905;
by descent to Edward Huth; Lord
Cowdry 1923
EXH: London, Pall Mall 1874 (3);
London, SBA 1884–5 (299); London 1905
(53)
LIT: YMSM 1980 (125); MacDonald 1994
(424–5)

The Viscount Cowdray
[Not exhibited in Washington]

Helen Rose Ogilvy, daughter of a merchant, Thomas Ogilvy, and of Elizabeth (née Wilson), was born on 11 August 1837 at Corrimony, Co. Inverness. She married Louis Huth (1821–1905) in 1855. After Huth's death she married A.B. Howe and died in Oxford in 1924 at the age of eighty-seven.

The youngest son of a rich merchant banker, Huth built a vast and gloomy neo-Gothic pile called Possingworth House, Waldron, Sussex, to the designs of Sir Digby Wyatt in 1866. He served as High Sheriff of Sussex in 1878.

According to his obituary Louis was 'a familiar figure in Christie's rooms', a collector of blue and white china and of paintings by Morland, Constable, Crome and G.F. Watts. More surprisingly, perhaps, in 1872 he purchased Degas's 'Foyer de la danse à l'Opera' 1872 (Musée d'Orsay, Paris). Through the dealer Murray Marks, he became acquainted with his fellow collectors Dante Gabriel Rossetti, Sir Henry Thompson, and Whistler. He was also a member, with Whistler, of the Burlington Club in the 1860s.

In 1865 he bought Whistler's 'Symphony in White, No.3' (no.16), and in 1873 also purchased 'Variations in Pink and Grey: Chelsea' of 1871–2 (Freer Gallery of Art, Washington, DC; YMSM 105). Whistler finished this commissioned portrait of his wife on 31 January 1873. It was therefore painted concurrently with his portrait of Mrs Leyland (fig.74; YMSM 106), in which the sitter is also shown in profile and from the rear.

Mrs Huth wears a heavy dress of black velvet, with a train sweeping across the foreground like a peacock's tail, and a ruff or stand-up collar of lace at her throat to match the lace cuffs falling over her wrists. Her black dress against a black background might be regarded as the female equivalent to the formal evening attire

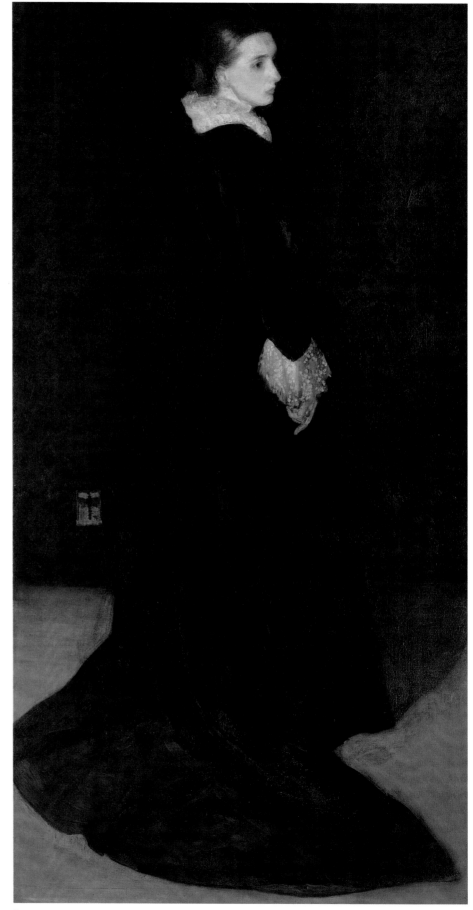

63

worn by Frederick Leyland in his portrait of 1870–1 (Freer Gallery of Art, Washington, DC; YMSM 97).

Mrs Huth wears her hair pulled severely back. Except for a heavy ring she is without jewellery. She is posed against a black shadowy background, as important to the design as the face and figure. As with the 'Arrangement in Black and Grey: Portrait of the Painter's Mother' (no.60), the whole seems to have been painted with the dark tonalities of Frans Hals in mind.

In both pictures, however, Whistler avoids the conspicuous brushwork one associates with Hals. His technique is more simplified, relying on the interplay between layers of paint to create a sense of space and atmosphere. A pastel preparatory sketch in the Ashmolean Museum is squared for transfer (M 455), and traces of pencil still visible at the bottom of the picture indicate where this has been done. This traditional technique argues that at this stage in his career Whistler was not yet confident enough to approach a full-length portrait without first laying in the design on the canvas. But once he had the composition in outline, it is quite possible that, as the Pennells state, he painted the figure 'at once', so that if one part of the portrait went wrong the whole had to be started again. Like Cicely Alexander (no.62) Mrs Huth complained of the long and exhausting hours she was asked to stand for the painter. She is said to have protested to Whistler that Mr Watts had never treated her in that way. 'And still, you know, you come to me!'[1]

In a preparatory crayon drawing in the Art Institute of Chicago (M 454) Whistler has posed the sitter against a curtain enlivened with two lines of dots, perhaps the same curtain used in the 'Portrait of the Painter's Mother'. The suggestion in these drawings is of a picture in a slightly lighter tone, with more colour, and with the velvet of the dress set against the delicate embroidery of the curtain. As seen today, the dark background almost swallows up the figure. Now her elegant profile stands out with startling clarity, shifting the focus from the overall design to the woman.

64 Arrangement in Black, No.3: Sir Henry Irving as Philip II of Spain 1876

Oil on canvas 215.2 × 108.6 (84¾ × 42¾)
PROV: Purchased from the artist by C.A. Howell 1878; A. Graves, London (print sellers); Sir Henry Irving by 1897; Christie, London 16 Dec. 1905 (148), bt Stevens & Brown, London (dealers) on behalf of A. Howard Ritter, Philadelphia; George C. Thomas of Philadelphia by June 1906; sold by Thomas's heirs to C.L. Freer 1909; bt by the Metropolitan Museum of Art, New York 1910
EXH: London, Grosvenor Gallery 1877 (7 in West Gallery); London, College for Men and Women 1889 (no cat.); London, Grafton Galleries 1897 (137); Dublin 1899 (78); London 1905 (27); London & New York 1960 (38)
LIT: YMSM 1980 (187)

The Metropolitan Museum of Art, New York. Rogers Fund, 1910

The theatrical portrait in English art can be traced back to William Hogarth's 'David Garrick as Richard III' 1745 (Walker Art Gallery, Liverpool), and embraces such famous images as Joshua Reynolds's 'Mrs Siddons as the Tragic Muse' 1789 (Dulwich Picture Gallery) Thomas Lawrence's 'John Philip Kemble as Hamlet' 1801 (Tate Gallery, London) and John Singer Sargent's 'Ellen Terry as Lady Macbeth' 1889 (Tate Gallery, London). As a portrait of the most famous actor of his generation in performance, 'Arrangement in Black No.3: Sir Henry Irving as Philip II of Spain' represents Whistler's contribution to the genre.[1]

The great Victorian actor Sir Henry Irving appeared as Philip II in Tennyson's verse play *Queen Mary Tudor* which ran for twenty-three performances at the Lyceum Theatre, London from 13 April to 13 May 1876. Whistler must have painted Irving's portrait during the run since Alan Cole saw it in Whistler's studio on 1 May. Cole noted that Whistler was 'quite & madly enthusiastic about his power of painting such full lengths in two sittings or so.'[2] Irving, on the other hand, told Mortimer Menpes that after twenty sittings Whistler swept the canvas 'bare'.[3] And at the time of the Ruskin trial when William Comer Petheram, counsel to the artist, asked him whether it were a finished portrait, the artist replied 'It is a large impression, a sketch, but it was not intended as a finished picture and was not exhibited for sale.'[4] On re-

examination Whistler repeated that it was 'a mere sketch, unfinished'.[5]

Théodore Duret published a reproduction of the picture in an early stage.[6] It shows the figure before Whistler had covered over the right arm with the cloak, which originally fell back from the shoulder. The chain, garter and shoes were also later additions, suggesting that Whistler worked on the picture again in the mid-1880s. A likely date is the summer of 1885 when he wrote to Irving inviting him to the Society of British Artists to see his portrait of Sarasate 'and let that show you what I meant your portrait to be and then arrange with me for a day or two at my new studio. It is ridiculous that Irving should not be painted – and who else shall paint him!'[7] Certainly when the painters Jacques Emile Blanche and Giovanni Boldini visited Whistler's Tite Street studio in 1885, Irving's portrait was there.[8]

The role of Philip II was not one of Irving's more famous parts – if only because he did not appear on stage until half way through the second act, and then disappeared by the beginning of Act 5. The play centred on the relationship between Queen Mary and her half-sister, the future Elizabeth I. Critics found Irving's bloodless Phillip II 'subtle, the stiff and heartless Spanish grandee to the life'.

Whistler's placement of the figure against a neutral grey background well within the frame surrounded by space could be compared to Velázquez's 'Pablo de Valladolid' c.1635 (Museu del Prado, Madrid). Ironically, the Spanish master had been court painter not to the king Irving portrayed but to his grandson Philip IV. Irving had gone to some trouble to base his costume on Titian's portraits of Philip II and it is this costume of grey tights, short black velvet cloak with its streaks of gold trim that Whistler faithfully records.

Whistler certainly knew Manet's bold portrait of Philibert Rouvière 'L'Acteur Tragique' of 1865 (National Gallery of Art, Washington, DC).[9] We do not know whether he could have seen the same painter's 'Portrait of Faure in the Role of Hamlet' (Museum Folkwang, Essen) which was exhibited at the Salon of 1877, shortly before Whistler painted Irving.[10] In both cases Manet's handling of his figure has a vivid solidity very different from Whistler's much more decorative treatment of Irving. Meier-Graef perceptively remarked that 'Whistler treated Velázquez as Turner had treated Claude, as Reynolds Rembrandt', 'conceal[ing] his Spanish inspiration as discreetly as Manet proclaimed it openly'.[11]

Bernhard Sickert, writing in 1908, criticised the portrait because it failed to suggest 'the

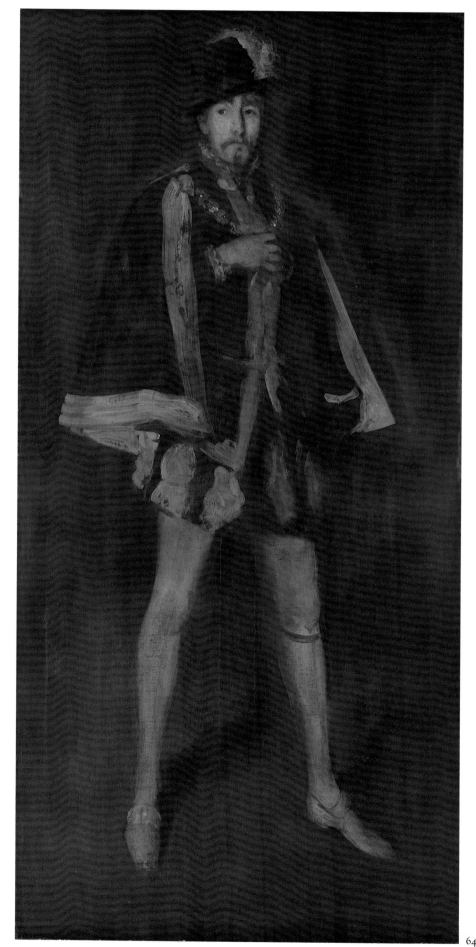

64

character of [Irving's] face, one of the most extraordinary that ever was set on man's shoulders, with its ardent glance of passion and intelligence.'[12] But the opposite view was proffered by Oscar Wilde, writing in 1877, who found the portrait 'so ridiculously like the original that one cannot help almost laughing when one sees it', remarking particularly on the accuracy of the pose Irving 'often adopts preparatory to one of his long wolflike strides across the stage.'[13]

Henry James, reviewing the Grosvenor Gallery for 1877, dismissed Whistler's pictures without particularly mentioning this portrait. Twenty years later, seeing it again at the Grafton Galleries, he made amends. 'To turn from his picture to the rest of the show ... is to drop from the world of distinction, of perception, of beauty and mystery and perpetuity, into – well, a very ordinary place.'[14]

Two etchings show Irving as Philip II (K 170, K 171). Way and Dennis note that the original frame was designed by Whistler.[15]

Finally, in her autobiography the actress Ellen Terry wrote that she had a note written by Whistler to Irving which refers to the picture 'and suggests portraying him in all his characters.'[16] This letter has not been located, but the idea of painting a series of portraits based on the theatre or from literature seems to have appealed to Whistler around this time, as is shown by his 'Arrangement in Yellow and Grey: Effie Deans' (no.65), which illustrates Sir Walter Scott's novel but may also be inspired by a theatrical production.

65 Arrangement in Yellow and Grey: Effie Deans 1876–8

Oil on canvas 194 × 93 (76⅜ × 36⅝)
Signed with butterfly and inscribed '... she sunk her head upon her hand | and remained seemingly | unconscious as a statue | The Heart of Mid-Lothian | Walter Scott'
PROV: Sold through the London print sellers H. Graves & Co to Dowdeswell, London (dealers), 1888; E.J. van Wisselingh (dealer), The Hague 1888; bt Reinhard, Baron van Lynden, The Hague, 1889; his widow, who presented it to the Rijksmuseum 1900
EXH: Edinburgh 1886 (1412); London, Dowdeswell July 1888 (no cat.); Amsterdam 1889 (470); London & New York 1960 (41)
LIT: YMSM 1980 (183); MacDonald in Fine (ed.) 1987, pp.21–3

Rijksmuseum, Amsterdam

'Arrangement in Yellow and Grey: Effie Deans' is a portrait of Whistler's mistress Maud Franklin in the role of Walter Scott's Effie Deans, a character in his novel *The Heart of Mid-Lothian* (1818), set in Edinburgh in 1737. The inscription, which was probably added by Whistler with the butterfly signature at the time of the picture's sale to a Dutch collector in 1889, is a quotation from a passage near the beginning of the novel.

Effie, falsely accused of the murder of her illegitimate baby, has been imprisoned in Edinburgh's Tollbooth prison. Given the chance to escape when a mob attacks the prison, she decides to remain and face death rather than live without her good name. 'She sunk her head upon her hand, and remained, seemingly unconscious as a statue, of the noise and tumult which passed around her.'[1]

In other portraits of Maud around this date Whistler invariably shows her wearing the elegant, figure hugging fashions of the period (YMSM 94, 181). Here the full skirt and plain shawl clearly indicate a poor woman, whether from eighteenth-century Edinburgh or nineteenth-century London. The way in which Maud cradles her head in her hand, isolated in the dark surrounding space, is perfectly consistent with Scott's passage. The question is: did Whistler intend from the first that the picture illustrate a literary text, or did it acquire its status as a literary illustration at some later date?

We do not know. The quotation from Scott's novel is not visible in a photograph of

the picture taken in 1881, which Whistler merely inscribed 'Arrangement in Grey & Yellow'. But when the picture was exhibited in Edinburgh and Amsterdam in 1886 and 1889 the artist called it 'Effie Deans'. At West Point Whistler frequently made drawings inspired by Scott's characters and incidents in the *Waverly* novels. At the beginning of his London career he had worked as an illustrator for *Once a Week*. And yet apart from a single painting entitled 'Ariel', on only one other occasion did Whistler give a literary title to one of his pictures, and then in tribute to a poet and poem he deeply admired: Edgar Allan Poe's 'Annabel Lee' (Hunterian Art Museum, University of Glasgow; YMSM 79).

In the mid-1870s he was an avid theatre-goer, painting Sir Henry Irving in the role of Philip II in Tennyson's *Queen Mary* (no.64). It is therefore worth noting that *Effie and Jeanie Deans*, a play based on *The Heart of Midlothian* by D. George Hamilton was produced at the Albion Theatre in October 1877.[2] In the same year John Everett Millais exhibited his portrait of 'Effie Deans' at the King Street Gallery, London.

In May 1878 Maud became pregnant, giving birth to a girl on 13 February 1879.[3] If the picture were dated 1878, it would explain both the revival of interest in Scott and also the loose costume and weary posture adopted by Maud. It even, in a macabre way, explains the subject, adding an undercurrent of tension which may contribute to the power of the image.

Having said all this, there is no avoiding the conflict between Whistler's often stated insistence on an abstract reading of his work and this picture's status as an illustration. In 'The Red Rag', published in 1878, he wrote about his 'Nocturne Grey and Gold: Chelsea Snow'[4]:

> My 'Harmony in Grey and Gold' is a … snow scene with a single black figure and a lighted tavern. I care nothing for the past, present, or future of the black figure, placed there because the black was wanted at that spot. All that I know is that my combination of grey and gold is the basis of the picture. Now this is precisely what my friends cannot grasp.
>
> They say, 'Why not call it "Trotty Veck" [from Dickens's story *The Chimes*] and sell it for a round harmony of golden guineas?' … I should hold it a vulgar and meretricious trick to excite people about Trotty Veck when, if they really could care for pictorial art at all, they would know that the picture

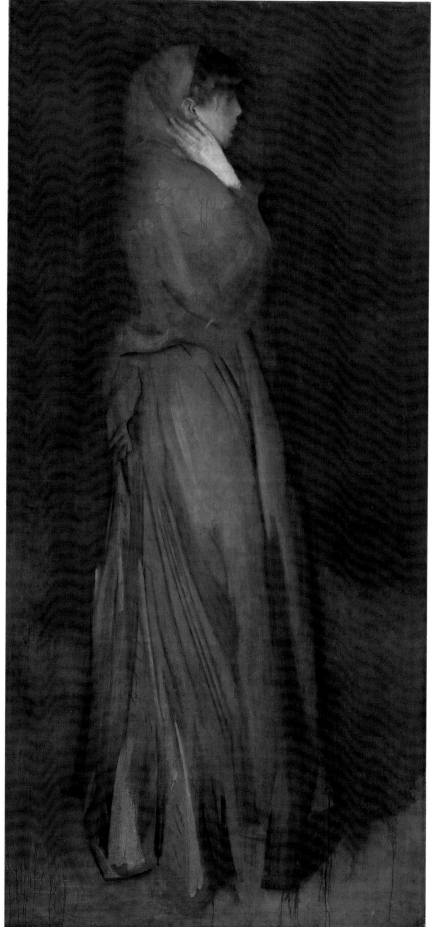

65

should have its own merit, and not depend on dramatic, or legendary, or local interest.

Despite this passage, in this instance Whistler went out of his way to attach a literary text to his painting.

66

66 Sketch of 'Arrangement in Brown and Black: Portrait of Miss Rosa Corder' 1876–8

Pen, brown ink and wash on cream laid paper laid down on paper
14.6 × 8.7 (5¾ × 3⁷⁄₁₆)
PROV: A.S. Cole in 1908; P.J. Sabin in 1914; Colnaghi, London (dealers) May 1914; sold to the British Museum on 7 Dec. 1914
EXH: London, Grosvenor Gallery 1879
LIT: YMSM 1980 (203); MacDonald 1994 (714)

Trustees of the British Museum, London

Rosa Frances Corder (1853–94), daughter of Micah Corder, a lighterman, and Charlotte Hill, was born on 18 May 1853 in Hackney, London. The family fortunes were on the decline. 'I ... have known wealth and poverty and the turning of old friends who lived entirely on my father for years' wrote Rosa to Rossetti in 1876.[1]

One sister, Charlotte, was an actress and also an artist, and a brother, Frederick, was a Fellow and Curator of the Royal College of Music. Rosa studied under the painter Felix Moscheles, and in due course Frederick Sandys gave her lessons in drawing, and Whistler is said to have taught her etching.

Williamson, writing in 1919, suspected her of having been the mistress of Rossetti (whom she met in 1874), Whistler, and C.A. Howell.[2] This was probably an exaggeration. She was indeed the mistress of that remarkable entrepreneur, Charles Augustus Howell (see no.138) and probably bore his child (the same letter to Rossetti commends Howell's conduct as that of 'a good father and brother').[3]

Howell taught her to copy eighteenth-century portraits and erotic drawings by Henry Fuseli.[4] They did not make a very good team. Rosa was right-handed, whereas Fuseli had been left-handed and drew the opposite way.

In his book of satirical drawings, *Rossetti and his Friends*, Max Beerbohm drew Rosa Corder 'nervously perpetuating the touch of a vanished hand' – a watercolour by Rossetti – with Howell keeping watch at the door[5] (fig.73). She copied paintings by other contemporaries – such as Millais's 'Vale of Rest', and by old masters, but whether to order, or for practice, or with intent to deceive, is not clear. She had her own studio, and painted portraits, including ones of Frederick R. Leyland (see no.68) and the print dealer Algernon Graves. Her paintings seem to have been competent but so few have survived that it is difficult to estimate her ability.

It is possible that Rosa Corder, with Howell's encouragement, also faked drawings by Whistler. Howell had an album containing drawings by Whistler of the Leylands, including a study for 'The Blue Girl: Portrait of Miss Elinor Leyland' (see no.78). Someone – and Rosa Corder seems the obvious candidate – produced a composite drawing, combining elements from different sketches in the album.[6] The result was not satisfactory, but with practice, they could deceive even the wary.

Some time after 1873 Howell commissioned Whistler to paint her portrait, 'Arrangement in Brown and Black: Miss Rosa Corder' (fig.72) (YMSM 203). Whistler is said to have got the idea from seeing her in a brown dress passing a black door. She posed in riding dress, to which she was accustomed. At that time, she had a studio and stable in Newmarket, where she painted racehorses. She was an accomplished horsewoman – it was pneumonia brought on by taking more care of her horse than herself that brought about her untimely death.

Riding dress appealed to Whistler (he forced it on Mrs Cassatt against her will, see no.128) and was natural to her. She posed 'standing in a doorway with the darkness of a shuttered room beyond her' and endured forty sittings, lasting sometimes until she fainted, and indeed refused to continue.[7] On 1 September 1878 Whistler wrote begging her to come and pose again: 'I want to thank you for your kind endurance ... the work is complete and an hour or two longer or less will entirely end the matter – I am charmed myself and one of these days you will forgive me.'[8]

The picture was finally exhibited at the Grosvenor Gallery in 1879 to unusual and general acclaim. The *World* on 7 May 1879 praised 'broad grand passages of execution worthy of Velasquez'. The picture has darkened, and these 'grand passages' are more apparent now in the drawing than in the oil, elegant as it is. There are similar sketches in the Art Institute

of Chicago, and in the Lucas Collection in the Baltimore Museum of Art.[9]

This drawing was done for Alan Cole, the son of Sir Henry Cole of the South Kensington museums (see no.26). The Pennells wrote that 'in friends' houses, he would make little sketches of pictures he was working on, and one evening he left with Mr Cole [a sketch of] ... the Rosa Corder'.[10]

The drawing is exceptionally vivid, with the lines of the skirt springing like wire from her waist, accentuated by soft washes. There are some differences between it and the oil. In the sketch, the skirt swirls around to the left, instead of to the right. Her whole figure is seen more from the back, so that the emphasis is on the costume, instead of on her fine profile.

67 The Toilet 1878

Lithotint printed in black and touched with white crayon, on pale grey India paper laid onto white wove card
25.9 × 16.3 (10⅛ × 6⅜)
Sheet: 26.9 × 17.6 (10⅝ × 7)
Signed in stone with butterfly
PROV: Given by Thomas Way to the British Museum 1904
LIT: Way 1896 (6); Kennedy 1914 (6); MacDonald 1988, pp.3–9

Trustees of the British Museum, London

Published in *Piccadilly*, no.9, 4 July 1878.

As in 'Weary' (no.19), there is a sense in 'The Toilet' of a strong personal connection between artist and model. This is reinforced by the title which suggests an activity which only an intimate would be allowed to watch. It is a title Whistler used previously, for a drypoint of 'Jo' (K 93) in 1863, which he apparently abandoned. In both 'Weary' and 'The Toilet' the model is self-absorbed, seemingly unaware she is being watched, to say nothing of being drawn onto copper or stone. It is intriguing that so private a moment was selected for publication in *Piccadilly*, with its wide-spread distribution.

The model for 'The Toilet' is Maud Franklin, who assumed the place in Whistler's household that had been held by Joanna Hiffernan. She was pregnant by the time 'The Toilet' was printed (see no.65, and p.213).

The best impressions of 'The Toilet', like this one, suggest the astonishing range of effects possible when lithotint is combined with work in lithographic crayon. Using the latter medium, Whistler produced the dark granular strokes that frame the figure, add substance to shadows, and articulate ruffles and folds in sleeve and skirt. These contrast with the liquidy fields of tone provided by the lithotint washes. The artist further articulated the edges of forms by scratching lines into the darkness, reintroducing areas of open stone that allow the paper to glow through.

In second state impressions, such as this one, areas of tone throughout have been lightened from the initial drawing. On several, this impression included, Whistler worked directly on the printed sheets, adding touches of white crayon, for example, adding 'grace to the flutter of flounce and frill'.[1] The initial stone for 'The Toilet' also carried the drawing for 'Early Morning' (W 7), intended for publication in *Piccadilly*; but when the journal folded, 'Early Morning' shared the fate of 'The Tall Bridge' (no.55).[2]

67

Frederick R. Leyland

Frederick Richard Leyland (1831–92) was born into a poor Liverpool family, and started work at an early age as apprentice in the offices of the Bibby Line, whose steamers plied the Mediterranean. In 1873 he bought out the family and founded the Leyland shipping line. He extended the business to the North Atlantic, his ships carrying corn from Egypt and cattle from Boston. A far-sighted businessman, he was also President of the National Telephone Company, a director of the South of England Telephone Company and deputy chairman of the Edison Electric Light Company.

M.M.

68

68 Portrait Study of Frederick R. Leyland (recto) 1871–3

Head of a Boy (verso)
Charcoal and chalk on brown paper
28.6 × 18.6 (11⅜ × 7⁵⁄₁₆)
PROV: Howard Mansfield, New York, by 1904; given by Harold K. Hochschild, New York, to Metropolitan Museum of Art, New York 1940
EXH: Boston 1904 (179)
LIT: MacDonald 1994 (425)

The Metropolitan Museum of Art, New York, Gift of Harold K. Hochschild 1940

Leyland was a ruthless and ambitious man, impatient, quarrelsome, and unforgiving: and, on the other hand, hardworking, meticulous, just, a generous patron and friend. Self-educated, he was fluent in several languages, and was a talented musician. He sought to make a position for himself and his family in a better class of society, but the stigma of the *nouveau riche* was attached to him. He would always be a 'provincial shipowner', as Whistler unkindly called him.[1] He was essentially isolated. A biographer wrote: 'he was an individualist; there was nothing sentimental or altruistic about him ... what he really cared about was making money, so that he could buy the things he wanted – his early Italian pictures, his blue and white china, his gilded staircase.'[2]

Leyland's early Renaissance paintings – attributed to Botticelli, Filippo Lippi and Crivelli – hung beside the work of the Pre-Raphaelites – Millais, Ford Madox Brown, Holman Hunt and Burne-Jones. Theodore Child said that it was Leyland's 'dream that he might live the life of an old Venetian merchant in modern London'.[3] Whistler called him 'the Liverpool Medici'.[4] Leyland gave his first commissions to Dante Gabriel Rossetti and Whistler in 1864 and 1867. He commissioned Whistler to paint his family. A magnificent portrait of his wife, a ghostly portrait of one daughter and many drawings of the children resulted (see nos.71–9). His own portrait was started at Speke Hall near Liverpool in August 1870: 'my own martyrdom', he called it.[5] The completed portrait, 'Arrangement in Black: Portrait of F.R. Leyland' (Freer Gallery of Art, Washington, DC; YMSM 97), was exhibited in 1874 at Whistler's one-man exhibition at the Flemish Gallery in Pall Mall, which Leyland is said to have financed.

Leyland was as interested in music as in art. It was he who suggested the term 'Nocturne' to describe Whistler's night paintings, and inspired the musical theme that pervades the 'Six Projects', the Symphonies in colour that were to hang in his music room (see pp.92–4).

Whistler did not share Leyland's love of music, and their friendship was not very deep: it was very much that of patron and painter. This intimate sketch was drawn when their relationship was still friendly, probably when Whistler stayed with the Leylands at Speke Hall. He got on better with the rest of the family, particularly Mrs Leyland and her sister, Elizabeth Dawson. He liked the children, particularly Leyland's son, and was disappointed when their friendship failed to survive his quarrel with Leyland senior (see no.69).

69 Portrait of Frederick R. Leyland

1871–3

Charcoal and white chalk on brown
paper 28.8 × 18.6 (11⅝⁶ × 7⁵⁄₁₆)
PROV: Howard Mansfield, New York by
1904; given by Harold K. Hochschild,
New York, to the Metropolitan Museum
of Art, New York 1940
EXH: Boston 1904 (180); New York 1984
(32)
LIT: MacDonald 1994 (426)

*The Metropolitan Museum of Art, New York,
Gift of Harold K. Hochschild 1940*

This portrait of Frederick Leyland may have
been drawn at the same time as no.68. Here,
Leyland's head is boldly drawn in black and the
paler flesh smudged in with white. The effect is
broad and large in scale. Touches of vivid white
in vertical lines hint at the ruffles of his shirt. At
the time of his bankruptcy, Whistler drew sev-
eral caricatures in which he cruelly mocked the
passion of the '"F.R.L." Frill – of Liverpool'
for such frills.[1]

Their association ended in 1876 when Ley-
land felt Whistler exceeded his commission in
decorating the Peacock Room for the house in
Princes Gate (see pp.164–5). Leyland was a gen-
erous man and Whistler saw him as the source
of inexhaustible funds. He presumed too much
upon a fragile mutual respect and friendship.
Whistler considered Leyland the chief cause of
his bankruptcy in 1878 and was vitriolic in his
criticism.

Whistler began to draw regularly on brown
paper in the late 1860s. In 1870, when he was
staying with the Leylands at Speke Hall, the
printer Auguste Delâtre sent from Paris a par-
cel of Whistler's etchings, wrapped in brown
paper. Whistler wrote back immediately asking
for supplies of this wrapping paper: 'C'est juste
le papier qu'il me faut pour mes dessins. J'en
cherche toujours – mais quoique tous les
marchands ont du papier brun, il est rare d'en
trouver avec ce beau grain –'.[2]

The paper Whistler used varied in quality,
and was often coarse and uneven in surface,
with prominent flecks of fibre and stalk. This
provided a more interesting, irregular texture
on which to work in chalk, than the finer, regu-
lar grain of the coloured papers that were in
more common use.

70 Mrs Leyland Seated *c*.1871

Chalk and pastel on brown paper
28.9 × 18.6 (11⅜ × 7⁵⁄₁₆)
Inscribed in unknown hand '10¾ × 6'
PROV: Possibly F. Keppel, New York, by
1904; bt by the Carnegie Institute, 17
Oct. 1906
EXH: New York 1984 (30), repr.
LIT: YMSM 1980 (106); MacDonald 1994
(429)

*The Carnegie Museum of Art, Pittsburgh;
Andrew Carnegie Fund, 1906*

Frances (1834–1910) was the daughter of
Thomas Dawson of Liverpool, master mariner
and iron moulder. She married Frederick R.
Leyland on 23 March 1855. By the 1870s, the
marriage was in difficulties. Her attachment to
Whistler may not have helped the relationship
of husband and wife.

Whistler ran errands for the ladies with
more devotion than dignity, and squired them
around London when Leyland was away in Liv-
erpool. There were rumours – quite unfound-
ed, according to Mrs Leyland – that they were
going to elope. Yet when he got engaged,
briefly, to her youngest sister Elizabeth, he may
have seen her as a substitute for Frances. It did
not work out. Mrs Leyland said later, she 'was
pretty, but not the wife for him, and it was a
good thing the engagement was broken'.[1]

Whistler started the portrait of Mrs Ley-
land at Speke Hall in November 1871. 'Sym-
phony in Flesh Colour and Pink: Portrait of
Mrs Frances Leyland' was completed by 1874
for exhibition, and hangs now in the Frick Col-
lection in New York (fig.74; YMSM 106).
According to Pennell, the sitter had wanted to
pose in a black velvet dress (see no.75).[2]
Whistler designed an elegant morning dress, a
Pre-Raphaelite concoction of creamy gauzes
studded with rosettes and surrounded by flow-
ers. The final scheme was a three-quarter back
view, a magnificent vision in shades of pink and
russet. Here the rosettes, touched with orange
and light red, appear to have been sewn diago-
nally across the skirt. In the final version they
were strewn generously and asymmetrically
across dress and train, and were lighter in
colour. There are designs for the rosettes in the
Fogg Art Museum, Cambridge, Mass., and the
Fitzwilliam Museum, Cambridge, England
(no.72).

This is one of at least ten working drawings
and one of three which show Mrs Leyland seat-
ed.[3] Here, the dress was tinted and scumbled
with off-white, lemon and orange, the train and
hem in pale orange, the loops of the skirt in

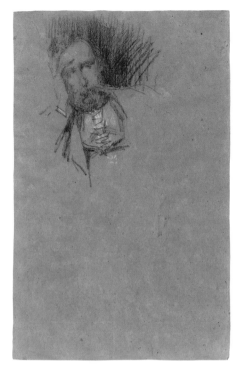

69

70

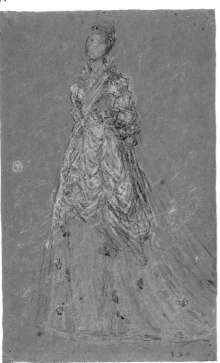

71

pale beige, orange and light red on the flowers. The figure is bending to her right, in a relaxed pose, drawn with confident curves and yet with a certain angularity which indicates that it is quite early in date.

A drawing in the Fitzwilliam Museum (M 428) may also show Mrs Leyland, in a costume similar to that seen in her oil portrait, with ruffles at her neck, and a train. However, she is seated sideways, in a pose more like 'Arrangement in Grey and Black: Portrait of the Painter's Mother' (no.60) – a picture which Mrs Leyland greatly admired and wished her own might emulate.[4] Obviously a seated pose was considered, and would have been less demanding for the sitter, but perhaps it was rejected because it showed off the dress to less advantage.

71 Study for 'Symphony in Flesh Colour and Pink: Mrs F.R. Leyland' 1871–4

Chalk and pastel on brown paper
28.8 × 18.2 (11⁵⁄₁₆ × 7³⁄₁₆)
Signed with butterfly. Inscribed '3.3.0' in unknown hand
PROV: Kennedy, New York (dealers); H.H. Benedict (1944–35) by 1910; Mrs H.H. Benedict sale, Sotheby, London 21 Nov. 1962 (3) bt Weitzner; Agnew, London (dealers) (J2912); J. Hirshchorn 4 Dec. 1962; Christie, New York, 30 May 1986 (183) bt Kennedy, New York (dealers); private collector 1986; Amon Carter Museum 1990
EXH: London, Liverpool & Glasgow 1976 (64); New York 1984 (34) repr.
LIT: YMSM 1980 (106); MacDonald 1994 (433)

Amon Carter Museum, Fort Worth. Purchased with funds provided by the Council of the Amon Carter Museum
[Exhibited in Washington only]

This is one of numerous working drawings for 'Symphony in Flesh Colour and Pink: Portrait of Mrs Frances Leyland' (fig.74; YMSM 106). Mrs Leyland was probably not posing as there are no features to indicate a portrait, although the face is touched with pink. A new model – Maud Franklin, soon to become Whistler's chief model and mistress – posed in the dress when Mrs Leyland was not available.

The butterfly is tiny, on a scale suitable for a large portrait (in the oil it is on the other side). It seems likely that this was one of the drawings which Whistler selected for his first one-man exhibition in 1874.[1] They were elaborate studies, and contained details of the construction of the dress which he designed for Mrs Leyland's portrait, which was itself exhibited in the show for the first time.

In these designs Whistler anticipated the fashion for dresses based on the paintings of Antoine Watteau. It can be assumed he had seen Watteau's work and could have seen etchings, such as the 'Femme de dos' (Bibliothèque Nationale, Paris), or engravings after works like Gersaint's 'Signboard' (Schloss Charlottenburg).[2]

He must have known 'Les Plaisirs du bal' which contains variations in dress and poses which could well have appealed to Whistler (fig.75). There are ruffled collars and gathered sleeves, short cloaks and long trains, over-skirts and under-skirts, in subtle shades of silvery white and flesh pink. The glossy dresses set off dainty heads, hair caught up neatly on top, decorated with ribbons or flowers. Watteau, however, relied on the sheen of the material as sufficient decoration on the dress, where Whistler added rosettes.

In Whistler's final portrait of Mrs Leyland, the costume had some features in common with Watteau (the ruffles of the neck, the long train hanging from her shoulders, the gathered sleeves) and something of a courtly eighteenth-century grace. The colour scheme was akin to Watteau's but it had none of the glittering silkiness of surface, nor did Whistler's woman have Watteau's unabashed coquettishness.

This is an early design for a dress in orange and white chiffon. The design of the dress and the choice of pose developed in parallel. In a sequence of drawings Whistler tried out various methods of gathering in the sleeves, looping up the overskirt, and managing the sweeping train. Whistler simplified the elaborate puffed sleeves and flounced overskirt in the final design. Frontal and back views were tried out, and a pose which showed off Mrs Leyland's profile, and showed the train to advantage, was finally selected.

72 Rosettes 1871–4

Chalk and pastel on brown paper
28.5 × 18.5 (11¼ × 7¼)
Inscribed at top right 'Rosette pour la |
taille –'; at centre right, 'Rosette | pour
la devant de | la robe – | la conserver
bien | *platte.*' and at bottom 'pour
l'aigrette –'
PROV: Dowdeswell and Dowdeswell,
London (dealers); Mrs Knowles, London
by 1903; bequeathed by G.J.F. Knowles to
Fitzwilliam Museum May 1959
EXH: Possibly at London, Marchant 1903
(16); London 1905 (87)
LIT: YMSM 1980 (106); MacDonald 1994
(435)

Syndics of the Fitzwilliam Museum, Cambridge

These rosettes were designed for Mrs Leyland's
dress (see no.71). The large rosettes at the top
were intended to feature at the waist, the central
one was to go on the bodice, and the lower
rosettes were for an *aigrette* or hair ornament.
One of several drawings, 'Study of Mrs Ley-
land' (Freer Gallery of Art, Washington DC; M
430) does show some hair decoration, but in
the final painting, her auburn hair was left
unadorned. The rosettes were drawn in black
chalk before adding various permutations of
shades from white through yellow to orange
and brown to complement the dress.

A second design for the rosettes, in the Fogg
Art Museum, Harvard University, makes it
more apparent that the rosettes were not to be
embroidered or appliqué but were three-dimen-
sional, 'avec un petit bouton brun au milieu' (M
434). The instructions written on these draw-
ings suggest the dress was to be made up in
Paris, but there are no other records to confirm
this.

73 Design for matting (recto) 1873–5

Design for matting (verso)
Chalk and pastel on brown paper
28.4 × 18.7 (11³⁄₁₆ × 7⅜)
Signed with butterfly
PROV: Dowdeswell & Dowdeswell,
London (dealer); Mrs Knowles,
Kensington Gore by 1903; bequeathed by
G.J.F. Knowles to Fitzwilliam Museum
May 1959
EXH: Possibly London, Marchant, 1903
(33); London 1905 (162)
LIT: MacDonald 1994 (494)

Syndics of the Fitzwilliam Museum, Cambridge

This is one of two designs for matting, a sec-
ond being in the Fogg Art Museum in Harvard
University (M 493). They share a similar
restrained colour scheme, and a pattern based
upon natural plant shapes, like a garden. Two
designs for rosettes (see no.72) in the same col-
lections share a similar history. This may be
coincidental but may provide a clue as to their
purpose.

The chequered pattern is reminiscent of the
matting seen in Whistler's portraits of Mrs
Leyland (fig.74; YMSM 106) and of Cicely
Alexander (no.62). Whistler's most faithful
pupil and follower, Walter Greaves, remem-
bered, 'my sisters made the carpet of black and
white tapes which Whistler used when painting
this portrait'.[1]

This design is more elaborate than the car-
pet in Cicely's portrait, but it could have been
intended for another picture, such as the por-
trait of Cicely's sister May (Tate Gallery, Lon-
don; YMSM 127) or to match the colour scheme
of a room. 'Nature contains the elements, in
colour and form, of all pictures, as the key-
board contains the notes of all music' said
Whistler.[2] This matting, with its forms derived
from nature, would have complemented the
seascape theme on the walls in Aubrey House
(see no.80). The colours – beige and orange
alternating with shades of blue and grey – were
less vivid, but would have harmonised with
these same designs.

72

73

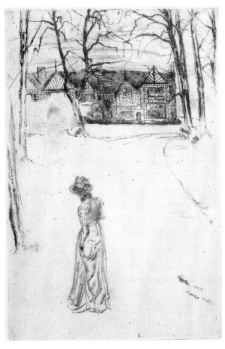

74

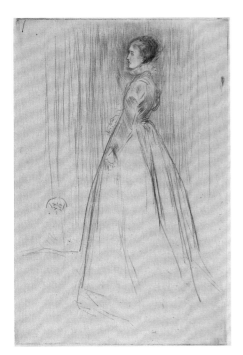

75

74 Speke Hall No.1 1870–4

Etching and drypoint printed in black ink on dark cream laid Japan paper
Plate: 22.5 × 15 (8⅞ × 5⅞)
Sheet: 29.4 × 20.2 (11½ × 7¹¹⁄₁₆)
Signed in plate: 'Whistler 1870– | Speke Hall.'
PROV: Joshua H. Hutchinson; Howard Mansfield; Howard Whittemore
LIT: Mansfield 1909 (95); Kennedy 1910 (96 II/X)

Prints and Photographs Division, Library of Congress, Washington DC

After the hiatus of several years, Whistler became seriously engaged by etching and drypoint again in 1870, presumably with Frederick Leyland's encouragement. From 1869 through 1877, Leyland rented Speke Hall, a tudor manor house outside Liverpool.[1] Whistler was a frequent visitor, working on several portraits of family members. 'Speke Hall No.1' is one of two etched studies Whistler made of Leyland's country home; the other (K 143) is horizontal in format. This plate was probably started in the autumn of 1870. It shows the south front, parts of which date back to the late fifteenth century, and the bay windows, from the early sixteenth century.

The artist reworked the copper plate for this etching again and again, continuing to pull proofs over several years. In this early state, rich drypoint burr appears throughout, offering the most beautiful representation of the details of Speke Hall itself, of the surrounding woods, and of the flowing lines of the woman's dress.

More than ten states of the image are recorded, documenting a variety of changes, the most significant of which were to the foreground figure: shifting her position, removing her entirely, eventually drawing her anew, with different details of attire, and the direction of her head, gazing off in the distance at left, rather than facing the mansion, as here.

In the later states of the etching, Whistler's attention shifted from the figure to the half-timbered building itself. Instead of the window of the Blue Drawing Room, he etched the main entrance porch and bridge over the moat on the north front. This composite view may have been the result of necessity. The etching was not finished until 1878–9, when Whistler was no longer welcome at Speke, and may therefore have been completed using sketches (though none has survived) or photographs.

75 The Velvet Dress 1873

Drypoint printed in black ink on Japan paper
Plate: 23.3 × 15.7 (9⅛ × 6⅜)
Sheet: 30.2 × 20.2 (11⅞ × 7⅞)
Signed in plate with butterfly
PROV: Theodore de Witt; gift of Lessing J. Rosenwald to the National Gallery of Art 1943
LIT: Mansfield 1909 (105); Kennedy 1910 (105 IV/V)

National Gallery of Art, Washington. Rosenwald Collection

The titles of a group of portraits on copper of Frances Leyland call attention to the fabric of her attire, for this and 'The Little Velvet Dress' (K 106), the weight of velvet, elsewhere, the softness of silk (K 107). The sense of tactility that each material suggests provides a distracting subtext for Whistler's involvement with his model, the wife of his great patron, the subject also of numerous drawings and a splendid oil, 'Symphony in Flesh Colour and Pink: Portrait of Mrs. Frances Leyland' (fig.74; YMSM 106).

The three-quarter view, seen from behind, was one Whistler used often at this time. Nevertheless, as in earlier portraits such as 'Bibi Lalouette' (no.7), he focused on facial features. Reflective and introspective in pose and expression, she maintains no obvious contact with the artist. The spectator is drawn into a private moment.

The rest of the figure was treated with great simplicity. It was printed with some light retroussage (dragging ink from the etched lines onto the plate during printing) on the lower lines, which adds lustre to the skirt. The figure contains just a hint of movement, which shows off both figure and dress to perfection.

Ultimately, however, with 'The Velvet Dress', the artist entirely reworked the plate, darkened the dress throughout, and added a hat to Mrs Leyland's attire. A far more formal portrait than the one seen here, the final version is apparently closer to Whistler's original concept.

According to Ralph Thomas, who catalogued an impression similar to the one seen here, the intention of the artist was 'that it shall be further carried out; and the velvet dress, which at present is only an indication, finished'. Thomas also reported that 'The Velvet Dress' and portraits of the Leyland children (K 108–10) 'are in the artist's latest style, and though not less exquisite, graceful, and delicate than any previous ones, still differ totally in manner'.[1]

76 Frederick Leyland Seated *c.*1873

Chalk or charcoal and pastel on brown
paper 33.5 × 24.7 (13¼ × 9¾)
PROV: Mrs Leyland, the sitter's mother,
until her death in 1910; passed by family
descent to the present owner
LIT: YMSM 1980 (108); MacDonald 1994
(508)

Private Collection

F.R. Leyland commissioned portraits of all his
four children. His only son, Frederick Dawson
Leyland, was born on 19 January 1856. At the
time of the portrait he would have been
between fourteen and eighteen years old. The
boy's expression and his whole attitude suggest
he was an uncooperative sitter. According to
Pennell, 'the son, after three sittings, refused to
pose again.'[1]

Sittings apart, it is known, from correspon-
dence between him and Whistler, that they
were good friends, and he invited the artist to
visit him at Harrow in 1872.[2] Although he was
not always on good terms with his father, he
did not take Whistler's part in the dispute with
Leyland.[3]

He was destined to take nominal command
of the Liverpool offices of the Leyland shipping
firm, with two competent managers under him.
Leyland would descend on the office and check
every aspect of their activities and accounts
with meticulous attention to detail.[4] Later, he
went to live in Ireland, but in fact little is known
about him after his father's death.

It has been supposed that the portraits of his
family commissioned by F.R. Leyland were
intended to be in oil, because there are extant
oil portraits of himself, his wife, and one
daughter. However, this drawing and its two
companion portraits (nos.77–8) are unusually
large and highly finished – while there are no
records of related oil portraits. Although
Whistler emphatically denied that Leyland
commissioned or paid for drawings, it is possi-
ble that these three were intended as finished
portraits. On the other hand it is equally possi-
ble that they were given to Mrs Leyland and
were not connected with the commission.

Whistler may have tried to finish this study
after the sitter had departed. The face was
heavily worked. There are fine lines, energetic,
heavy and angular, on the body, with dozens of
pentimenti. The chalk (or charcoal) over the
body has a silvery quality. White was scumbled
across the background. The overall effect of the
cool colour is accentuated by the red kerchief.

77 Portrait of Miss Florence Leyland *c.*1873

Chalk and pastel on brown paper
36.3 × 20.7 (14¼ × 8⅛)
Signed with butterfly
PROV: The sitter's mother, Mrs Frances
Leyland until her death in 1910; her
daughter Elinor (Mrs Speed); by family
descent to the present owner
LIT: MacDonald 1994 (509)

Private Collection

Florence Leyland, born on 2 September 1859,
was the second eldest daughter of F.R. and
Frances Leyland. In 1884 she married
Val (Valentine Cameron) Prinsep, RA
(1838–1904) a painter of portraits and genre
subjects, of good repute and uneven perfor-
mance, who became professor of painting at the
Royal Academy in 1901. They had three sons.
After his death, a memorial service for Prinsep
was held at St Paul's, at which artists of all
ranks and Societies, but particularly the Royal
Academy, were represented. Queen Alexandra
was among those who wrote to express their
grief at her 'terribly sad loss … who will indeed
be missed by all his friends and admirers'.[1]

In an etching and drypoint, 'Florence Ley-
land' (K 110), drawn about 1872, she posed hold-
ing a hoop, and wrote proudly on the copper
plate, 'I am Flo'. A later portrait of her was less
successful. An oil was started when she was
about seventeen, and into long dresses, but the
quarrel with Leyland put an end to sittings, and
Whistler completed it using his mistress Maud
Franklin as a model. It is now in the Portland
Art Museum, Maine (YMSM 107).

Florence was the subject of many beautiful
pastel portraits by Whistler. In nearly all she
posed in frilly dresses, caught in apparently
casual poses.[2] Here she posed more formally, in
a heavy outdoor suit of blue and brown. She
wore glossy leather boots and a sophisticated
hat with brim sweeping down over her fore-
head. She is set against a pale brown dado and
pale blue wall, a subdued harmony, matching
the dress.

Whistler first drew the portrait in black,
then smoothed in the colours, and added
details, including a network of crisp lines, of
subtly varied shades. There are signs of alter-
ations to the figure. Worked up carefully, the
result is a wonderfully solid figure, in colours
warm and harmonious.

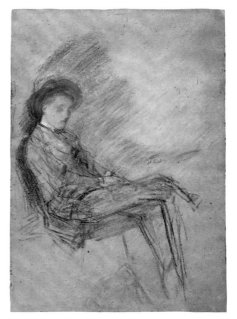

76

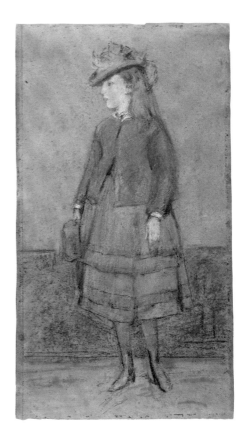

77

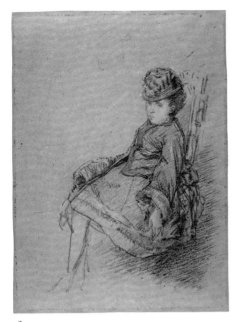

78

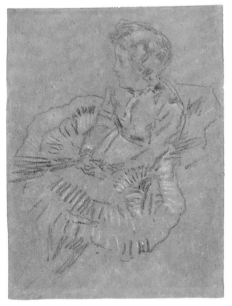

79

78 Elinor Leyland Seated *c.*1873

Chalk and pastel on brown paper
30.5 × 25.3 (12 × 10)
PROV: The sitter's mother, Mrs Frances
Leyland until her death in 1910; the sitter;
by family descent to the present owner
LIT: MacDonald 1994 (510)

Private Collection

Elinor was born in 1861, the youngest of the
children of F.R. and Frances Leyland. She was
Whistler's favourite model. Whistler told her
mother 'really that child is exasperatingly love-
ly'.[1] Giving her age as twenty-six, on 31 Decem-
ber 1889 Elinor married Francis Elmer Speed, a
stockbroker. She died on 22 August 1952 at the
age of ninety-one.

This drawing shows the child dressed up and
holding a muff. Whistler avoids sentimentality
and conveys with charm her droopy and over-
dressed discomfort. Angular touches of white,
with blue on her hat and dress, form a delicate
contrast to the overall warm colour scheme.
About 1873 Whistler drew her both in pastel
and drypoint in an aggressive pose, hands on
hips, and made several drawings emphasising
the perfect oval of her face.[2] These were studies
for a proposed oil portrait, as 'The Blue Girl',
inspired, so T.R. Way said, by Gainsborough's
'Blue Boy'.[3]

One of Whistler's 'pupils', Mortimer Men-
pes, recorded,

The father of a family of three or four girls
told me that each maiden in her turn, as she
reached the desired age, had sat to Whistler
for the same picture – until at last even the
youngest had grown too old and the picture
was finished with a damsel from another
family altogether.[4]

The scheme was continued with other mod-
els (Connie Gilchrist, Maud Waller, Maud
Franklin) but never satisfactorily completed.

79 Elinor Leyland 1873–5

Chalk on brown paper
23.9 × 18.3 (9⅜ × 7³⁄₁₆)
PROV: F.R. Leyland; possibly sold at
Leyland sale, Christie, London 28 May
1892 (3) bt Deprez, London (dealer);
Mrs L. Knowles by 1903; bequeathed by
G.J.F. Knowles to the Fitzwilliam
Museum May 1959
EXH: London, Marchant 1903 (197) and
1904 (9) or 1904 (19); London 1905 (187);
London, Liverpool & Glasgow 1976 (69)
LIT: MacDonald 1994 (514)

Syndics of the Fitzwilliam Museum, Cambridge

On 27 May 1892 Whistler wrote, 'The draw-
ings in the Leyland sale can only be very slight
notes on brown paper left by accident at Speke
Hall – or given carelessly to the children – The
late Mr.Leyland never bought *anything* of mine
of this kind at all'.[1] Whether he bought them,
or not, Leyland acquired several drawings of
the family. Whistler's comment must be con-
sidered in the light of his intense dislike of Ley-
land, whom he held largely responsible for his
bankruptcy.

The girl is undoubtedly Elinor Leyland,
wearing a wide, full-skirted dress. It is a
straightforward and unsentimental drawing,
and not overly dramatic. The scale is large, and
it is drawn with broad strokes of chalk. The
highlighting is very delicate, with light touches
on her face and bolder strokes alternating with
black on her dress. Whistler drew Elinor many
times, sometimes with her sister, but more
often alone, wearing many-layered dresses
which reflect the Leyland obsession with frills.[2]

80 (a) Designs for wall decorations for Aubrey House 1873–4

Charcoal and gouache on brown paper
18.2 × 12.6 (7³⁄₁₆ × 4¹⁵⁄₁₆)
Signed with butterfly. Inscribed 'Dining Room Aubrey House'
PROV: Either bequeathed by Whistler to his sister-in-law, Miss R.B. Philip, or left by Whistler with W.C. Alexander and returned after 1903 to Miss R.B. Philip; bequeathed to the University of Glasgow 1958
EXH: London & New York 1960 (115) repr.; Glasgow 1984 (108); Tokyo 1987–8 (47) repr.
LIT: MacDonald 1994 (489)

Hunterian Art Gallery, University of Glasgow, Birnie Philip Bequest

In 1873 the banker W.C. Alexander bought Aubrey House, on Campden Hill. The house was probably built about 1720 on the site of a spa established after the discovery of mineral springs in 1696. The present house was altered over the years, and the wings were added in the mid-eighteenth century. It was a large and elegant house, and Lady Mary Coke (1726–1811) the author of fascinating *Letters and Journals* (published 1889–96) was the most notable of its owners.

Whistler put forward suggestions for its decoration. He suggested a scheme involving peacock designs for the dining room, which were rejected as too expensive, but was eventually adapted for Frederick R. Leyland (see pp.164–5).[1]

Pen drawings, now in the British Museum, show that Whistler advised on the arrangement of furniture, the placing of dados and panelling, and designed furniture and china cabinets for the rooms, although there is no record that they were ever constructed.[2] Where his designs involved paint rather than construction, however, they were carried out.

In contrast with elaborate Victorian decorations Whistler's scheme of decoration has a startling modernity. The apparent abstraction is deceptive. They can be seen as a simplified view of nature. The beading was picked out in bands of colour, and the walls painted as beach scenes, with horizontal bands of colour, in washes of blue and cream. Spots of white were added to represent shingle, or ripples, in the foreground.

Whistler's delicate coloured decorations for the early nineteenth-century panelling of the 'White Room' were removed in 1913. He is also said to have painted the former drawing room, the 'Red Room'.[3]

80 (a)

80 (b) Designs for wall decorations for Aubrey House 1873–4

Charcoal and gouache on brown paper
15.1 × 10.2 (5¹⁵⁄₁₆ × 4)
Signed with butterfly
PROV: as no.80(a)
EXH: London & New York 1960 (115) repr.; Glasgow 1984 (108); Tokyo 1987–8 (47) repr.
LIT: MacDonald 1994 (490)

Hunterian Art Gallery, University of Glasgow, Birnie Philip Bequest

This drawing shows the various elements – picture rails, dado, and panelling – picked out in co-ordinated colours.

80 (b)

80 (c)

80 (c) Designs for wall decorations for Aubrey House 1873–4

Charcoal and gouache on brown paper
18.3 × 12.9 (7³⁄₁₆ × 5¹⁄₁₆)
Signed twice with butterfly. Inscribed
'Dining Room Aubrey Ho[use]'
(incomplete)
PROV: as no.80(a)
LIT: MacDonald 1994 (491)
EXH: London & New York 1960 (115)
repr.; Glasgow 1984 (108); Tokyo 1987–8
(47) repr.

*Hunterian Art Gallery, University of Glasgow,
Birnie Philip Bequest*

These designs, like nos.80a–d, are beach scenes.
To some extent the colours make use of, and
disguise, the dado and picture rail. The dado
forms the beach, and the picture rail, the line of
the sea at the horizon. The wall between is the
sea, with waves breaking on the beach.

The sheet has been trimmed unevenly, with
part of the design cut off at right.

80 (d)

80 (d) Colour schemes for the decoration of Aubrey House (recto) 1873–4

Head and shoulders of a nude (verso)
recto: charcoal and gouache; verso:
charcoal, on brown paper 14.9 × 24.5
(5⁷⁄₈ × 9⁵⁄₈)
PROV: as no.80(a)
EXH: London & New York 1960 (115);
Glasgow 1984 (108) repr.
LIT: MacDonald 1994 (492)

*Hunterian Art Gallery, University of Glasgow,
Birnie Philip Bequest*

A beach scene, in cream, yellow ochre and
green, the colours of the walls picked up in the
panels. These green designs might have been
for hallways, rather than for rooms.[1]

The Peacock Room

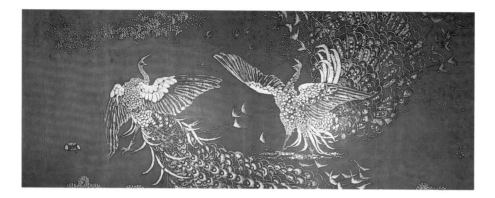

Peacock Room, south wall
Freer Gallery of Art, Washington

Frederick R. Leyland had bought a house at 49 Princes Gate in London in 1867, and commissioned Thomas Jeckyll to adapt the dining room to house his collection of porcelain. Delicate reed-like shelves of carved walnut in the Japanese style were set against hangings of sixteenth-century Spanish leather. In April 1876 Whistler was advising on a colour scheme to complement 'La Princesse du pays de la porcelaine' (fig.7 on p.16; YMSM 50) which hung at one end of the room.[1] Paintings by Burne-Jones were to hang with Whistler's 'The Three Girls' (YMSM 88) at the other end.

Whistler worked on the room while living at 49 Princes Gate through the summer of 1876. By September he had bugun a Peacock scheme which had already been rejected by W.C. Alexander as too expensive (see no.80). The walls and ceilings were painted with peacock feather designs and the closed shutters with 'some lovely peacocks'.[2] He painted the ceiling with a brush fastened to a fishing rod. According to the artist.

> I just painted it as I went on, without design or sketch – it grew as I painted. And towards the end I reached such a point of perfection, putting on every touch with such freedom – that when I came round to the corner where I had started, why, I had to paint part of it over again, or the difference would have been too marked and the harmony in blue and gold developing, you know, I forgot everything in my joy of it.[3]

The panels were completed by the end of October. It was at this stage that Whistler asked Leyland for £2,000 guineas and Leyland refused to pay Whistler more than £1,000, since he had exceeded his commission.[4] Whistler carried on regardless.

Alan Cole found him on 10 November 'quite mad with excitement' over the effect of the gold over the layers of blue paint. The Peacock panel on the south wall appears to have been completed early in December. Whistler enjoyed publicity and leaked details to the press. A report in the *Morning Post* on 8 December left Leyland 'much perturbed'.[5]

On 9 February 1877 Whistler held a press view of the room at which he

"HARMONY IN BLUE AND GOLD.
THE PEACOCK ROOM."

The Peacock is taken as a means of carrying out this arrangement.

A pattern, invented from the Eye of the Peacock; is seen in the ceiling spreading from the lamps. Between them is a pattern devised from the breast feathers.

These two patterns are repeated throughout the room, In the cove, the Eye will be seen running along beneath the small breast-work or throat-feathers.

On the lowest shelf the Eye is again seen, and on the shelf above—these patterns are combined: the Eye, the Breast-feathers, and the Throat.

Beginning again from the blue floor, on the dado is the breast-work, BLUE *on* GOLD, *while above, on the Blue wall, the pattern in reversed,* GOLD *on* BLUE.

Above the breast-work on the dado the Eye is again found, also reversed, that is GOLD *on* BLUE, *as hitherto* BLUE *on* GOLD.

The arrangement is completed by the Blue Peacocks on the Gold shutters, and finally the Gold Peacocks on the Blue wall.

M.M.

distributed his pamphlet *Harmony in Blue and Gold. The Peacock Room* (see quotation left). The *Pall Mall Gazette* on 15 February 1877 praised 'the fantastic freedom of his design'.

Leyland was aware that Whistler had invited fellow-artists and friends and patrons — including the Princess Louise, the Marquis of Westminster, and Prince Teck — to view the room, but having his house opened to press and public without his consent was for Leyland the last straw.

They argued furiously over costs and the terms of the commission. The sum involved was large — about £40,000 at today's prices — and Leyland deliberately insulted Whistler by paying him in pounds, like a tradesman, instead of the guineas expected of a gentleman. Eventually he forbade Whistler to enter his house again.[6]

Whistler may never have seen the room again, though he used various means to gain entrance for friends who wished to see it. He may have been able to visit it after the house was bought by Mrs Whatney (of the brewing family) at the Leyland sale in 1892.

The Peacock Room was bought by C.L. Freer in 1904, dismantled and re-erected in Detroit, which would have delighted the artist. It has found its final home in the Freer Gallery of Art in Washington.

81 Sketches of the Peacock Room

1876

(a) south wall and shutters
(b) roof and wall panelling
(c) pendant and cove
(d) fighting peacocks

Pen and dark brown ink on double sheet of white laid paper, watermark 'Parkins | Royal F[...]' (incomplete)
The drawings were removed from a 131 page, vellum bound, press-cutting book, in Glasgow University Library, each sheet 31.9 × 20.3 (12⁹⁄₁₆ × 8)
Signed with butterfly
PROV: Bequeathed by Whistler to his sister-in-law, Miss R. Birnie Philip 1903; bequeathed to the University of Glasgow 1958
EXH: London and New York 1960 (118); Tokyo 1987–8 (64, repr.)
LIT: YMSM 1980 (178); MacDonald 1994 (582)

Hunterian Art Gallery, University of Glasgow, Birnie Philip Bequest

These drawings approximate most closely to the original proposal for the Peacock room and are probably contemporary with it. Whistler, living in the Leyland's London house, wrote to Mrs Leyland, who was at Speke Hall, 'The dining room's something quite wonderful and I am extremely proud of it. As a decoration it is thoroughly new and most gorgeous and refined. Tell Freddie [F.R. Leyland] that I think it will be a large sum but even then barely pay for the work.'[1]

When the shutters at left and right are folded, at night, the tail feathers expand, like a Japanese fan, to display the birds in full plumage. The sweeping trains of the peacocks on the central shutter swirl in cascades of golden feathers silhouetted against a gold leaf ground.

The shutters were not part of the original commission, and Leyland wrote, on 21 October,

The peacocks you have put on the back of the shutters may possibly be worth (as pictures) the £1200 you charge for them but that position is clearly a most inappropriate one for such an expensive piece of decoration; and you actually were not justified in placing them there without any order from me. I certainly do not require them and I can only suggest that you take them away and let new shutters be put up in their place.[2]

The Peacock Room was bought by Whistler's major American patron, C.L. Freer in 1904. Over the years, the room was 'restored' over-enthusiastically, effectively concealing Whistler's brushstrokes. Much of this over-painting has recently been removed and the delicacy and elegance of the original decoration revealed. It is now in the Freer Gallery of Art in Washington.

81 (a)

82 Cartoon of Rich and Poor Peacocks 1876

Chalk and wash on brown paper, pricked for transfer 181 × 389.2 (71¼ × 153¼)
PROV: Bequeathed by Whistler to his sister-in-law, Miss R. Birnie Philip 1903; bequeathed to the University of Glasgow 1958
EXH: Berlin 1969 (31); Glasgow 1984, p.32; Tokyo 1987–8, (48)
LIT: YMSM 1980 (178); MacDonald 1994 (84)

Hunterian Art Gallery, University of Glasgow, Birnie Philip Bequest

Whistler's cartoon for the south wall of the Peacock Room came to the Hunterian Art Gallery cut, torn, crumpled, and rolled up. Its survival is remarkable. In chalk, with details freely painted in wash, it is by far the largest drawing Whistler produced.

On 29 November 1876 A.S. Cole wrote that the 'Golden Peacocks promise to be superb', presumably meaning this panel. He implied they were completed by 4 December.[1] The print dealer Algernon Graves said that after his disagreement with Leyland, Whistler altered one peacock on the south wall, 'adding feathers so as to suggest a white shirt frill, such as was usually worn by Mr. Leyland, and on the ground some shillings, which the peacock was guarding with his claw'.[2]

Whistler said, '[I] just painted it as I went on, without design or sketch – it grew as I painted'.[3] This is manifestly not true of the panel of the rich and poor peacocks, given the existence of this full-scale cartoon.

The peacock was one of the most popular motifs of the Aesthetic Movement. Whistler

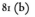

81 (b)

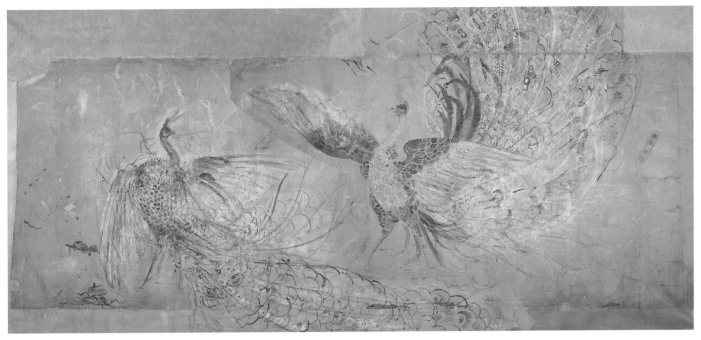

82

saw real peacocks in Rossetti's garden in the 1860s. His friend Albert Moore painted a procession of peacocks on a frieze for Frederick Lehmann's house at 15 Berkeley Square in 1872.[4] The architect E.W. Godwin designed a Peacock wallpaper.[5]

Yet the immediate inspiration for Whistler's peacock designs was evidently Japanese art. The glossy varnish of the room mimics the glossy effects of Japanese lacquer. The primary visual source for the cartoon may be found in Utamaro's woodblock print of 1804 'Utamaro Painting a Ho-o Bird in One of the Green Houses' from the *Annals of the Green Houses*. Individual details may derive from *The Keramic Art of Japan* by George Ashdown Ashley and James Lord Bowes, published in 1875.[6] Bowes was Japanese Consul and Whistler could have seen his collection on a visit to Leyland's house near Liverpool.

It seems likely that Whistler designed and painted the panel after his first quarrel with Leyland, and when he realised that there was no question of Leyland getting the painting, 'The Three Girls' (YMSM 88) originally conceived for the wall at the south end of the room.

The panel was described as representing 'two life-size replicas in gold of peacocks fighting'.[7] Two male peacocks, competing for the attentions of a hen, may symbolise the rivalry of Leyland and Whistler for the affection of Mrs Leyland (see nos.70–1).

E.W. Godwin may have been reflecting Whistler's views (they were friends and collab-orated on decorative schemes) when he wrote that it represented 'less a fight between the gold peacocks, as described in some journals, than a defiance'.[8]

Although there are numerous pentimenti in the cartoon, it does not appear that there was any radical alteration to the design of the rich peacock, as Graves suggested. It was always intended to represent wealth and everything that Leyland stood for. After Leyland excluded him from the house, Whistler drafted a letter to Mrs Leyland, saying 'I refer you to the Cartoon opposite you at dinner, known to all London as l'Art et l'Argent or the Story of the Room'.[9]

Leyland's refusal to pay £1,200 for uncommissioned work was justified but it caused Whistler acute financial embarassment. He held Leyland primarily responsible for his bankruptcy in 1879 but said his only regret was creating such a beautiful room for an unappreciative audience.

The final painting of gold on blue completed the process of stylising every detail into a consistent, elegant decoration. In the process some of the vigour of the original design was lost. The cartoon gives a true representation of Whistler's intentions.

The first stage in preparing the cartoon was a drawing in black and white chalk. This was gone over quickly in grey wash. In a few places pencil lines were used to define details. Then the drawing was pounced with a pin for transfer to canvas.

Traces of rubbing out and reworking are apparent throughout. Originally the tail swept up steeply and curved forward over the head. Brushwork modified the angle and filled in the detail. Many curves of feathers drawn in chalk were not gone over in wash, and the incising of lines was perfunctory, leaving the artist to recreate the design without too much constraint on the canvas.

83 A Catalogue of Blue and White Porcelain Forming the Collection of Sir Henry Thompson, Illustrated by the Autotype Process from Drawings by James Whistler, Esq, and Sir Henry Thompson, Ellis and White, London 1878

Text by Murray Marks; nineteen plates by Whistler (I, III, IV, VI, VIII–X, XII–XIV, XVI–XXI, XXIII–XXVI) and seven by Thompson (II, V, VII, XI, XV, XXII).
Limited edition of 220 copies, bound in cloth with a pattern of hawthorn flowers and thorns embossed in greenish grey on a gold background. Deluxe edition, tooled white on gold leather binding,

with white leather back and corners.
Ordinary edition, boards
26.6 × 19.7 (10 × 7¾)
Deluxe edition, boards
29.2 × 22.9 (11 × 9)
The paper is watermarked 'J.Whatman | 1877'
LIT: MacDonald 1978, pp.291–5;
MacDonald 1994 (592–645)

Paul G. and Elaine S. Marks

'Purple and Rose: The Lange Leizen of the Six Marks' (no.22) was, Whistler told Fantin-Latour on 3 February 1864 'rempli de superbes porcelaines tirés de ma collection'.[1] The collection of porcelain he had built up over fifteen years (some 300 pieces) was sold at his bankruptcy sale on 7 May 1879 and cannot be traced.[2] After his marriage in 1888 to Beatrice Godwin, the widow of E.W. Godwin, he and his wife amassed a second collection, of attractive pieces for everyday use – probably not of the quality of the first – which is now in the Hunterian Art Gallery in Glasgow.

Whistler shared this enthusiasm for collecting Oriental art with Rossetti, who in turn passed it to Sir Henry Thompson (1820–94), surgeon, astronomer and artist. The dealers Murray Marks (1840–1918) and George Durlacher had a shop at 395 Oxford Street which was from 1875 a focus for Oriental enthusiasts, including Whistler, Rossetti and Sir Henry Thompson, Louis Huth (see no.63), and Miles Birkett Foster (see p.93).

Murray Marks helped Thompson both to buy porcelain and to catalogue his collection. At Marks's suggestion, in 1876 Thompson asked Whistler to illustrate a catalogue, for which Marks wrote the preface and catalogue entries.

According to Marks's biographer, G.C. Williamson,

Whistler prepared for Marks half a dozen sketches, showing the way he thought the book should be illustrated. None of these sketches were actually used in the book itself, in fact, they do not represent actual pieces, but were sketched by Whistler, from his own memory of what the porcelain was like, and with adaptations from certain pieces which were at that time in his own collection.[3]

By October 1876 Whistler was working on the project. On 29 December 1876 Whistler told Marks, 'Your drawings I think you will find much more valuable than you expected'. Three weeks later Thompson was still advising

Marks on the selection of porcelain for reproduction.[4] The whole job took at least four months. Thompson's porcelain (339 pieces), the catalogue, and the drawings for the catalogue, were finally exhibited in Marks's shop: the private view was held on 30 April 1878.

Most of the porcelain is probably from the K'ang hsi era (1662–1722) during the Ch'ing dynasty (1644–1911), although there was at least one piece from the Ming dynasty (1368–1644) (see no.90).

Whistler drew thirty-eight pieces of porcelain, making preliminary studies for nearly all of them. Twenty-nine of the studies are in the Munson-Williams-Proctor Institute, Utica, NY while the final drawings are in several collections, including the Freer Gallery, Washington DC, and Glasgow Art Gallery.[5] Whistler varied his style to suit each piece, working sometimes in line but usually in wash. Nearly all the illustrations were done in monochrome, although some had touches of colour. His copies were not as slavish as Thompson's but more expressive. The essence of the design was captured, without too much emphasis on detail. He understood the brushwork and copied it intelligently. His solution is essentially painterly.

This was not by any means Whistler's first work in watercolour. In the Military Academy at West Point he received instruction in the medium. Technically proficient, he made copies after Turner, Duffield Harding, and George Cattermole, among others, as well as expressive original studies.[6]

He used watercolour occasionally thereafter, but mostly for corrections to prints. Painting porcelain, he regained his early expertise. In effect, by copying brushstrokes, he got inside the skin of the original artists. Not only was he supremely competent, but he had at his command a variety of brushstrokes which he would use with freedom in the 1880s.

84 Square Canister with square neck, and saucer-shaped Dish

1876–8

Pen, black ink and wash on white wove paper laid down on card
23.2 × 20 (9⅛ × 7⅞)
Signed with butterfly
PROV: Murray Marks; probably sold, Christie, London, 7 Feb. 1879 (534) bt

84

85

Pickford Waller; bequeathed to his daughter Sybil Waller in 1930; Christie, London, 12 Nov. 1965 (32A) bt Weitzner, London (dealer); Knoedler's, New York (dealers); Munson-Williams-Proctor Institute 19 May 1969
EXH: Six drawings (whether preparatory or final drawings is not known) were exh. London 1905 (156–61)
LIT: Thompson 1878, cat.no.202 or 113, final design repr. pl.XVII MacDonald 1994 (630)

Munson-Williams-Proctor Institute, Museum of Art, Utica, New York

This preliminary sketch shows all the features of the final design, which is in the Freer Gallery of Art in Washington, DC, except that the reflections and shadows were largely eliminated.[1]

Only the roughest indication was given of the patterns on the porcelain (a dignatory or statesman holding audience with musicians in the foreground), painted with long angular strokes of a broad brush. As a watercolour sketch it is bold and effective and forms a useful foundation for the more careful delineation of patterns in the final version.

The dish was one of two similar pieces in the Thompson collection. It was 33 cm (13 in) in diameter, decorated, as Marks wrote, with 'sharply drawn flowers and leaves painted in white enamel, which form a raised pattern on a ground of bright powder blue'. Whistler's hard-edged style imitates the 'sharply drawn' pattern.[2]

The original jar, 31.7 cm (12½ in) high, was presented by Sir Henry Thompson to the Fitzwilliam Museum in Cambridge in 1920 (fig.78).[3] It is of the K'ang hsi Period (1662–1722), a dramatic piece, with panels showing figures in an interior with a tiled floor, and riders in a landscape. The neck is painted delicately with flowers and foliage and the lid with abstract patterns. When translating these patterns into pen, Whistler concentrated on conveying the general effect of contrasting areas of pattern, but not on literal detail.

The final version retained the spontaneity of the earlier sketches but made no attempt to clarify the decorations. The painterly qualities of the first sketches were somewhat at variance with the requirements of the subject and the limitations of the catalogue.

85 Cylindrical Vase with thick neck
1876–8

Pencil, pen, black ink and wash heightened with white on cream paper, laid down on card 21.7 × 16.8 (8½ × 6⅝)
Signed with butterfly
PROV: Murray Marks; probably sold Christie, London 7 Feb. 1879 (534) bt Pickford Waller; bequeathed to his daughter Sybil Waller in 1930; Christie, London 12 Nov. 1965 (32A) bt Weitzner, London (dealer); Knoedler, New York (dealers); Munson-Williams-Proctor Institute, 19 May 1969
EXH: Possibly London 1905 (156–61) (see no.84)
LIT: Thompson 1878, cat.no.130, final design repr. pl.XIII; MacDonald 1978, pp.291–5; MacDonald 1994 (620)

Munson-Williams-Proctor Institute, Museum of Art, Utica, New York

This is one of two preliminary designs for the drawing of a fine Rouleau vase, 45.6 cm (18 in) tall, decorated with prunus blossom, which probably dated from the eighteenth century.[1] This form of decoration was known in England (through Rossetti) as the 'Hawthorn' pattern.

Sir Henry Thompson's illustrations of similar blossom are meticulous, but show the stems and blossom in more detail.[2] He found it necessary to go over the background several times with small, fussy, brushstrokes, thus losing much of the impact of the natural shapes.

In Whistler's first design, shown here, there is a dark area all round the vase, consisting of several grey washes painted unevenly on top of each other, with the butterfly superimposed prominently in white paint. Conspicuous guiding lines show that Whistler mapped out the perspective and the bounds of the patterns before painting the designs freehand. The blossoms on the vase were drawn with pencil before the dark ground was painted around the flowers.

In the second study the vase and butterfly were again set on a dark background. It was the only study where Whistler felt the need for colour – and used blue crayon and to indicate the rich glazes of the magnificent vase.

In the final version Whistler turned the vase anti-clockwise, and eliminated both the dark background, and any trace of colour (Freer Gallery of Art, Washington DC; M 622). The pattern was drawn neatly in light-coloured ink and the ground painted freely with black wash. A judicious use of outline, and layers of glossy ink washes prevent the vase appearing flat.

[169]

The lack of colour which clearly bothered Whistler in the preliminary designs was achieved by suggestion in the final painting, perhaps the most attractive of the Thompson plates.

86 Double Gourd Vase and Saucer-shaped Dish 1876–8

Pen, black ink, and wash over pencil on cream paper 21.6 × 16.5 (8½ × 6½)
Signed with butterfly
PROV: Murray Marks; probably sold, Christie, London 7 Feb. 1879 (527–33), bt Pickford Waller; probably sold, R.T. Waller collection, Christie, London 6 Jan. 1894 (50) bt [Deprez]; possibly sold by Deprez and Gutekunst, London (dealers) to F. Keppel, New York (dealer) 1894–8; James Graham & Sons, New York (dealers) 1969; private collection, New Jersey 1972; Knoedler, New York (dealer) 1984; the present owners 1985
EXH: New York 1984 (50)
LIT: Thompson 1878, cat.nos.26 and 31, repr. pl.IX; MacDonald 1978, pp.291–5; MacDonald 1994 (613)

Paul G. and Elaine S. Marks

Whistler here showed one of three vases ornamented with arabesques and flowers on a blue ground, 25.4 cm (10 in) high. The preliminary design for the vase is in the Munson-Williams-Proctor Institute, roughly sketched in pencil to give a general impression of the distribution of the figures (lange leizen) in the panel (M 612). There is no extant study for the dish, with its pattern of aster flowers.

In this final design, the underlying pencil drawing used to transfer the design is visible on the vase and dish. Both pieces have a nearly continuous painted outline, except at the bottom right of the vase where a white outline has been left clear to avoid any confusion between the adjacent patterns.

The details were precisely rendered with both pen and brush, set off by broad washes of shadow. The arabesques and radiating flower patterns on the dish were painted with fine, sinuous brush-strokes which express the painterly qualities of the original.

87 Oviform Vase 1876–8

Pen, black ink and wash on off-white paper, laid down on card 14.7 × 10.9 (5¾ × 4⁵⁄₁₆)
Signed with butterfly
PROV: Murray Marks; probably his sale, Christie, London 7 Feb. 1879 (534) bt Pickford Waller; bequeathed to his daughter, Sybil Waller 1930; Christie, London, 12 Nov. 1965 (32A) bt Weitzner, London (dealer); Knoedler, New York (dealer); Munson-Williams-Proctor Institute 1969
EXH: Possibly London 1905 (156–161) (see no.84)
LIT: Thompson 1878, cat.no.6, final design repr. pl.I; MacDonald 1994 (595)

Munson-Williams-Proctor Institute, Museum of Art, Utica, New York

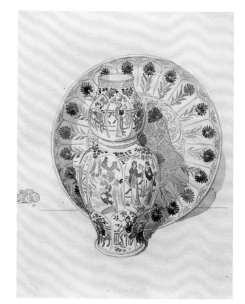

86

This was one of two similar vases in Thompson's collection. According to Marks's description in the Thompson catalogue, it showed 'a mandarin, attended by three warriors' on one side, and 'an official seated at a table writing with two attendants behind him' on the other, and was 27.9 cm (11 in) high. The reproduction was only 11.3 cm (4⁷⁄₁₆ in) high, a substantial reduction calling for much simplification.

The preliminary drawings in the Munson-Williams-Proctor Institute vary in precision, freedom, detail and expressiveness. They were the means by which Whistler learnt to vary his brushwork to suit each piece of porcelain and each pattern or figure. If necessary he made two or three attempts before embarking on the final illustration. Whistler did not work entirely freehand, but ruled and measured the outlines for accuracy, and sketched out the designs in pencil before painting them. There are traces of a central perpendicular guiding line in pencil on the final design, which is in Glasgow Art Gallery, and on many other the drawings.[1]

In this case, there are numerous alterations to the left side and foot of the vase. The neck and cover of the vase are seen from lower down and the butterfly is lower and nearer to the vase than in the final design. In this sketch, Whistler used shadows to indicate the roundness and solidity of the vase, but in the final design, he relied on linear perspective.

The final design in some details kept close to the preliminary sketch, but the costume of the warriors was clarified when it came on the market in 1893. Whistler said 'if he had them now that he would not sell them for less than one hundred dollars each' and signed them again, 'for the pleasure of having seen them again.'[2]

87

88

88 Globular Bottle with long thin neck, Cylindrical-shaped Pot with flat cover surmounted by a knob, and Shallow Bowl 1876–8

Pencil, pen, brown ink and wash on white paper 20.6 × 17 (8⅛ × 6¹¹/₁₆)
Signed with butterfly
PROV: Murray Marks; probably sold Christie, London, 7 Feb. 1879 (527–33), bt. Pickford Waller; bequeathed to his daughter Sybil Waller in 1930; Christie, London, 14 Nov. 1966 (94, repr.) bt Knoedler, New York (dealers) for the present owner
LIT: Thomson 1878, cat.nos. 244, 245, and 255, repr. pl.XXIV; MacDonald 1994 (644)

Shirley Latter Kaufmann

In January 1877 Sir Henry Thompson suggested to Marks that Whistler should paint the '"tiger Lily" jar and cover' and a 'set of 2 pots & 2 bottles' which may be two of these pieces.[1]

The preliminary design for the complete illustration, in the Munson-Williams-Proctor Institute, shows the bottle further to the left, and facing the opposite way from in the final design, and the cylindrical pot turned slightly more to the left (clockwise).[2]

The bottle vase was one of a pair in Thompson's collection, 17.8 cm (7 in) high, with the mark of a leaf, and arabesques in the medallions on a transparent wavy blue ground. The cylinder jar was 17.8 cm high, with the mark of a leaf and fillet, ornamented with scroll leaves and a circular ornament containing arabesques. The bowl, with a border of hawthorn, around a carp leaping, was 25.4 cm (10 in) in diameter.

At one stage, possibly before Whistler started on these illustrations, it seems that someone – probably Marks – had urged Whistler to design plates himself. Some rough designs came into the hands of W.C. Alexander – perhaps they were intended to fill the china cabinets at Aubrey House (see no.80) – and are now in the British Museum.[3] One of the plates incorporates 'Nocturne: Blue and Gold – Old Battersea Bridge' (no.54) and one has a design with a fish and a border of prunus blossom, similar to Thompson's bowl.

In the process of planning the illustrations, Whistler made a pen drawing of six pieces of porcelain, including one similar to this bowl, showing the way he thought of carrying out the designs.[4]

It is apparent that Whistler particularly liked the fish designs, which involved both wave and scale patterns. They were to be influential in the design and brushwork of his decoration of the Peacock Room, which was begun by September 1876, and overlapped with the ongoing illustrations for Thompson (see pp.164–165).

89

89 Treble-gourd Vase with long neck, and Bowl with scalloped edge 1876–8

Pencil, pen, brown ink, and wash on white paper 20.6 × 17 (8⅛ × 6¹¹/₁₆)
Signed with butterfly
PROV: Murray Marks; probably sold Christie, London, 7 Feb. 1879 (527–33), bt Pickford Waller; bequeathed to his daughter, Sybil Waller 1930; sold Christie, London 14 Nov. 1966 (93) bt Knoedler, New York (dealer), for the present owner
LIT: Thomson 1878, cat.nos.219 and 286, repr. pl.XXI; MacDonald 1994 (640)

Shirley Latter Kaufman

Thompson owned three such bottles, this one 24.8 cm (9¾ in) high, decorated with arabesques, ornamental bands and the 'sacred eye' symbol on a blue ground on the lower gourds, and inscriptions in the four panels on the upper gourd. The bowl was one of a pair, 20.3 cm (8 in) in diameter, ornamented with a floral pattern possibly gardenias.

In the preliminary study in the Munson-Williams-Proctor Institute the design was roughly drawn (M 639). There were numerous alterations to the outline and patterns of the vase and bowl and the patterns were only partially completed. The final design was drawn with precise pen lines, the decisiveness of the drawing complementing the clarity of the design.

Comparing this striking and simple composition with an illustration by Thompson (pl. V) it is clear that while Thompson was extremely knowledgeable, he was less capable as an illustrator. His work is over-precise and detailed, and he failed to co-ordinate the disparate elements of scale, shape and pattern. Whistler's painting of arabesques and asters on the bowl, painted freehand, is far more successful in conveying the character of the originals. The composition of his still-life is stunningly effective.

90 Globular-shaped Bottle with long neck, and a deep dish 1876–8

Pencil, pen, brown ink and wash on white paper 20.6 × 17 (8⅛ × 6¹¹⁄₁₆)
Signed with butterfly
PROV: Murray Marks; probably sold, Christie, London, 7 Feb. 1879 (527–33), bt Pickford Waller; bequeathed to his daughter Sybil Waller 1930; sold Christie, London 14 Nov. 1966 (98) bt Knoedler, New York (dealers) for the present owner
LIT: Thomson 1878, cat.nos. 249 and 201, repr. pl.XVI; MacDonald 1994 (628)

Shirley Latter Kaufman

The bottle, decorated with a leaping salmon, was 25.4 cm (10 in) high. The dish, 31.6 cm (12½ in) diameter, was one of a pair depicting warriors, described by Marks as having the mark 6 and a double ring. It appears to be earlier than most of the collection, dating from the Ming dynasty (1368–1644).

As usual, the preliminary design for no.90 is in the Munson-Williams-Proctor Institute (M 627). It was signed with a butterfly just to the right of the centre, inside the dish, where in the final design there is a warrior waving a banner.

The final design captures the essential quality of the different patterns and scenes depicted on the porcelain. The warriors and horsemen in the panels were summarised with increasing brevity, until the lowest one became little more than an abstract arrangement of brushstrokes. The pattern of waves and the fish on the bottle were first drawn freely with a fine pen, and completed in washes of great sensitivity to the variations of tone and texture. The result is essentially a watercolour rather than a decorative illustration.

91 Trellis (recto) 1881

Trellis (verso)
Pen, off-black ink and watercolour on white wove paper 17.8 × 25.4 (7 × 10)
Signed with butterfly. Inscribed 'The trellis work must in this arrangement | be pale *primrose* color – anything at all | of an *orange* tendency would make the whole *hot* – The doors and roofing will give the orange –'
PROV: Bequeathed by Whistler to his sister-in-law, Miss R. Birnie Philip 1903; bequeathed to the University of Glasgow 1958
EXH: Berlin 1969 (123)
LIT: MacDonald 1994 (848)

Hunterian Art Gallery, University of Glasgow, Birnie Philip Bequest

90

A major patron of Whistler in the 1880s was Janey Sevilla, daughter of James Callander of Ardkinglass and Craigforth, and ward of the 8th Duke of Argyll. In 1869 she married the Duke's second son, Archibald Campbell, who died in 1913. She herself died in July 1923. Lady Archie posed to Whistler for several portraits, including 'Arrangement in Black: La Dame au brodequin jaune' (no.130).

In 1881 Whistler wrote from Yorkshire 'in the blank condition of mind brought about by continued contemplation of landscape' to Lady Archie, saying that on his return he would call 'to ask if you could at all understand those drawings I sent you for the trellis work of the cottage'.[1] In May 1881 she sent Whistler 'a thousand thanks for the trellis designs' which were then being erected and painted at Coombe Hill Farm, and exasperating both her husband and the decorators. She told Whistler that her husband wrote 'about 6 furious missives a day consequent on the revelations made to him by the exasperated decorators of Coombe Farm. The [last thing he has] on his mind is the Antwerp blue wh. I said must be used for the outside trellis. On every page he alludes to "Jimmies needless trellis." So until this is set right i.e. (put up on the wall I hope) don't go to see him, or you will have to buy the 100 sets of armour!

I have quite come to the conclusion that the fairy effect would be more complete wth the peacock [colours] as you first suggested.'[2]

As designed by Whistler, the colour was not peacock blue and green, but bright lemon yellow with yellowy orange around the upper windows. The light red butterfly sets off the scene, matching both chimney and roof. For contrast, Whistler showed it scattered with purple flowers.

91

When Whistler and his wife Beatrice came to decorate their own garden at 110 rue du Bac in Paris in the 1890s, they filled it with trellises, some of which were painted blue, and which are seen in lithographs (W 140–1) and a watercolour by Beatrice, now in the Hunterian Art Gallery, Glasgow.

92

92 Design for Lady Archibald Campbell's Parasol 1881–2

Pencil and watercolour on off-white wove paper 29.3 × 23.2 (11⁹⁄16 × 9⅛)
Signed with two butterflies. Inscribed in unknown hand – possibly by Lady A. Campbell: 'I will send you the size in a drawing | but you ought to carve it from a natural | flower: I suppose it will be carved in box | wood [or] very strong wood? The wood I should | wish to | be painted | in the natural | colors of the flower | [by Mr.] Whistler | room enough | for the hand to grasp | between the flowers | head *wth* hole | for screw. | Smaller bud | on left side of stick to | recline on the parasol.'
PROV: Bequeathed by Whistler to his sister-in-law, Miss R. Birnie Philip 1903: bequeathed to the University of Glasgow 1958
EXH: Berlin 1969 (124)
LIT: MacDonald 1994 (849)

Hunterian Art Gallery, University of Glasgow, Birnie Philip Bequest

Lady Archibald Campbell was deeply involved in the theatre, both in acting and writing. Whistler sketched her as 'Orlando' in the first of a series of pastoral plays, *As You Like It*, in 1884 (Hunterian Art Gallery; YMSM 317) with costumes designed by E.W. Godwin. The setting was Coombe wood, near the Campbell's residence at Coombe Hill Farm at Norbiton, Kingston on Thames (see no.91). Godwin, his wife Beatrice (later Mrs Whistler, see no.194), Constance (Mrs Oscar) Wilde, and Whistler himself were involved to varying degrees in the productions.

Whistler and Oscar Wilde were neighbours in Tite Street, and met in 1881, about the time this parasol was designed. Wilde was the most enthusiastic aesthete of his generation, combining the taste of the Pre-Raphaelites with elements of Whistler's and William Morris's principles of design. His publicising of the Aesthetic Movement was at first appreciated by Whistler, an ardent self-publicist himself. The gently mocking cartoons of George Du Maurier in *Punch*, and the extravagence of Gilbert and Sullivan's *Patience* helped to make the movement widely accepted.

Indeed, it became too common for Whistler, who by 1885 was attacking it, in his 'Ten O'Clock' lecture: 'Art is upon the Town! – to be chucked under the chin by the passing gallant – to be enticed within the gates of the householder – to be coaxed into company, as a proof of culture and refinement.'[1]

This parasol could have been intended for use in private theatricals, or for fancy dress. It consisted of six pale green leaves enclosing seven darker leaves around a central flower. The flowers were drawn basically as circles with petals or leaves indicated by semi-circles within them. Washes of pale green and cream hint at the subtle colours required.

It would have been a bit impractical for everyday use. It was essentially a private commission and designed for use upon a unique occasion. Whistler had no intention of putting it into production. It was designed for individual impact and (with its prominent butterfly) to be instantly recognisable as Whistler's work.

93 Velarium 1887–8

Pencil, pen, brown ink and watercolour
on off-white wove paper 25.3 × 17.7
(9¹⁵⁄₁₆ × 6¹⁵⁄₁₆)
Signed with butterfly and 'J. McNeill.
Whistler'
Inscribed on verso in unknown hand
'Patent No 6223/26/4/88'
PROV: Private collection, Britain 1953;
Nordness Gallery, New York (dealers)
1962–6; Sotheby, London, 19 Feb. 1974
(49) bt The Fine Art Society, London
(dealers); University of Glasgow 1974
LIT: MacDonald 1994 (1122)

Hunterian Art Gallery, University of Glasgow

Sixty years after its foundation in 1823, the Society of British Artists (SBA) was in deep financial trouble, and in need of new blood. In November 1884 Whistler was elected a member. The pictures he exhibited with the Society – the portraits of the famous violinist Pablo de Sarasate (Carnegie Institute, Pittsburgh; YMSM 315) and of Mrs Huth (no.63) – were received with acclaim. He was elected to the committee, and in June 1886, made President. He took office in December and set out autocratically to reform the society. In 1887, on his own initiative, he presented Queen Victoria with a congratulatory address on the occasion of her Golden Jubilee, celebrating the fiftieth anniversary of her ascension to the throne and won for the Society the title of Royal Society of British Artists (RBA). It was his most generally popular achievement. Meanwhile, he redecorated the galleries (see no.95). The velarium was his first major innovation.

Whistler told the Pennells: 'Picture galleries lighted at the top are very good for the spectators but not for the pictures, for the falling light is reflected up from the floor on to the pictures so that they cannot be properly seen.'[1]

This drawing was intended for submission to the Patent Office when Whistler applied for a patent 'for means of suspending velarium panoply or other canopied draperies from ceilings, roofs or otherwise.' The Patent was dated 26 April 1888 but it was later abandoned.[2] Whistler first sketched the design in pencil, and the velarium was tinted cream, with a brownish shadow, and the butterfly, slightly orange.

The velarium as described by Pennell was 'a translucent screen, the edges of which are allowed to hang down, placed some two or three feet below the skylight of the gallery. The light therefore falls upon the pictures alone, and everything under the velarium is in shadow.'[3] It was used for the first time in the exhibition of the RBA in May 1886. The piece of cloth hung from ten points, and the drawing gave details of hooks and eyes, and supports (strings). The critic of the *St James Gazette* begged leave to 'doubt whether an awning looped up with promiscuous strings is in place in this symmetrical room'.[4]

The fullest description was given in *Truth*:

A kind of awning was suspended under the skylight, in order to exclude the glare of white light, which would not have been harmonious with the scheme of colour. This drapery was made of some soft material, which matched, as nearly as possible, brown paper, and was suspended in pretty folds by means of brass hooks, hung by cords to the skylight.[5]

At this time the walls of the gallery were of a sepia shade of brown, and the ceiling pale brown and gold. The scheme was flattering to the spectators but *Truth* omitted to mention what effect it had on the pictures.

When Whistler was forced to resign from the RBA in 1888, he took his velarium with him. It was the one innovation of which his Society had approved, so they ordered a new one. Whistler reminded them that he had taken out a patent on the velarium – and indeed he had, but so recently as to suggest that he did it merely to foil the RBA.

Indeed, a label still on the picture in 1961 read: 'This drawing of a Velarium was executed | by J.McNiel [*sic*] Whistler, Esq. in the presence | of his Wife and Alexr. Jno.Jaylor, for the | purpose of taking out a Patent for construction | owing to his controversy with the | Royal Society of British Artists.'[6]

Ayerst Ingram, an active member of the RBA, commented ironically that it was 'a patent taken out by the Greeks and Romans'.[7] Whistler failed to stop the RBA from putting up another one.

It was used again, quite sucessfully, in the Knightsbridge galleries of the International Society of Sculptors, Painters and Gravers in 1899, where, as President, Whistler enjoyed greater support from an efficient committee, which included Joseph Pennell, Albert Ludovici and John Lavery: and the result was a beautiful and unified exhibition.

93

94

95

94 Interior of the gallery of the British Artists 1886–7

Pen and dark brown ink over pencil on
cream laid paper laid down 20 × 15.8
(7⅞ × 6¼)
Signed with butterfly
PROV: G.R. Halkett by 1921; Ashmolean
Museum 1943
EXH: London & New York 1960 (124,
repr.)
LIT: MacDonald 1994 (1125)

The Visitors of the Ashmolean Museum, Oxford
[Not exhibited in London]

This shows the velarium to be erected in the
Suffolk Street galleries of the Society of British
Artists (see no.93). Whistler made a prelimi-
nary pencil drawing, then worked over it rough-
ly in pen, scrawling lines right through the
spectators. Figures were scraped out and
altered. These alterations suggest that this was
not a private note but was intended to demon-
strate Whistler's plans.

The velarium hung above a double line of
small pictures. Whistler pruned the exhibitions
drastically, so that works were no longer hung
from floor to ceiling. Inferior work was ruth-
lessly excluded. The results were revolutionary.
The *St James Gazette* described the effect:

> Instead of 800 pictures, the rooms contain
> but 500. Of these a considerable proportion
> are of Mr Whistler's school; and the gallery
> has been redecorated to suit these, under
> the direction of the President. The dull red
> of the walls has given way to a Whistlerian
> yellow; yellow festoons swing on the frieze
> above, and an awning hangs beneath the
> skylight.[1]

Members who found their work rejected,
and those over whom Whistler rode
roughshod, objected. Whistler proposed his
friends Mortimer Menpes (see no.140) and
William Stott of Oldham for membership of
the SBA: he invited foreigners, Alfred Stevens
and Claude Monet, to exhibit. He tried – and
failed – to exclude new members opposed to
his views.

Meetings became increasingly unpleasant.
Menpes, sensing the inevitable, resigned on 12
May 1888, earning the epitaph, 'the early rat'
that leaves the sinking ship.[2] At the annual gen-
eral meeting on 4 June, 'they brought up the
maimed, the halt, the lame, and the blind – lit-
erally – like in Hogarth's election.'[3] Whistler

was defeated, Wyke Bayliss became President,
and twenty-five of Whistler's friends and 'fol-
lowers' resigned, including Sidney Starr,
Theodore Roussell, Charles Keene, Alfred
Stevens, Waldo Storey, Albert Ludovici Jr, and
Jacomb Hood. As Whistler said, 'the "Artists"
have come out, and the "British" remain – and
peace and sweet obscurity are restored to
Suffolk Street!'[4]

95 Interior of the British Artists exhibition 1886–7

Pencil on cream laid paper, watermark of
a plumed helmet on a shield, between
crossed axes, over 's&h' on a scroll
20.1 × 12.6 (7¹⁵⁄₁₆ × 4¹⁵⁄₁₆)
PROV: Whistler's son, Charles J.W.
Hanson; Sir Robert Witt; bequeathed to
the Courtauld Institute 1952
EXH: London & New York 1960 (125)
LIT: MacDonald 1994 (1123)

Courtauld Institute Galleries, London
(Witt Collection)
[Exhibited in London only]

Whistler took office as President of the SBA in
December 1886. In that winter, under his super-
vision, their galleries in Suffolk Street were
redecorated. This summary sketch outlines the
galleries, the doors masked by looped up cur-
tains, hung alternately on the left and right.
The velarium masks the ceiling (see no.93). A
comfortable ottoman stands in the centre of
the gallery. The figures craning inwards to look
at the paintings add a personal touch to the
design. There are several more drawings of the
planned decoration, in New York Public
Library, and in the National Gallery of Art in
Washington – which show Whistler's work in
situ.[1]

With staggering insensitivity, Whistler sent
to this winter exhibition of the SBA in Decem-
ber 1886 both his portrait of the newly widowed
Beatrice Godwin, 'Harmony in Red: Lamp-
light' (fig.30; YMSM 253) and one of his former
mistress, Maud Franklin, 'Harmony in Black,
No.10' (whereabouts unknown; YMSM 357).
The two women were known to be deadly
rivals. Maud had fought a losing battle for
Whistler's affection while he fought a losing
battle to reform the SBA.

96 Mr Whistler's 'Ten O'Clock'

1888

19 × 14.6 (7½ × 5¾)
Privately published by Chatto and
Windus, 1885, in an edition of 25 copies,
28 pages, brown paper covers designed by
Whistler, printed by Thomas Way.
There were numerous subsequent
editions. The definitive edition was
published by Chatto and Windus,
London, 1888, 29 pages, brown paper
cover, printed by Spottiswoode and
Company, New-Street Square, London

Paul G. and Elaine S. Marks

The lecture was first delivered at the Prince's
Hall in London on 20 February 1885, and
repeated at Cambridge on 24 March and
Oxford on 30 April. The choice of venues sug-
gests that Whistler was attempting both a pop-
ular and scholarly statement of his position in
art.

The time for the lecture was dictated by the
habits of London society. It gave everyone time
to dine before going out for the evening. Given
Whistler's reputation as wit and dandy, the
audience expected entertainment. At first he
was nervous but as the lecture progressed he
gained in confidence and caught the imagina-
tion of the audience. Those who came to scoff
went away convinced.[1]

The artist was completely serious. The lec-
ture had been written and rewritten, and prac-
tised on friends and 'followers'. Drafts of the
text are written in Sickert's handwriting as well
as Whistler's.[2]

The subjects included the artist's place in
history and contemporary society, the artist's
relationship to nature and inspiration, and the
current movements in art and aesthetics.

The audience included Whistler's fashion-
able patrons, friends, family, critics, writers and
fellow artists:

> Mr Whistler's 'Ten O'clock' attracted, as,
> of course, everybody knew it would, most
> of the beauty and talent that one is accus-
> tomed to see on 'first nights' at the most
> fashionable theatres. The worst feature of
> the business was that more than half the
> audience could not hear what the lecturer
> was talking about, and probably more than
> half of the half that did hear didn't under-
> stand … Mr Whistler was very eloquent
> and sweeping in his assertions. Oscar Wilde
> declared that he looked like 'a miniature
> Mephistopheles mocking the majority,' an

alliterative sentence which must have given
the apostle of sweetness and light many an
anxious hour to elaborate.[3]

In his review, Oscar Wilde praised
Whistler's eloquence but winced at the attack
on his own concepts of taste, beauty and dress.
'An Artist is not an isolated fact … he … can
no more be born of a nation that is devoid of
any sense of beauty than a fig can grow from a
thorn', and, Wilde added, 'The poet is the
supreme artist, for he is the master of colour
and form, and the real musician besides, and is
lord over all life and all arts'.[4]

One of the most critical – and unpleasant –
reviews of the lecture came from the art critic
Theodore Child, smarting from Whistler's
attack on critics, who thought the artist should
give people pleasure and the critic's place was to
help the artist communicate with his public.[5]

However, the attack that hurt Whistler most
came from his old friend, Algernon Swinburne
(see no.15) in a review of the 1888 edition of the
lecture.[6] Swinburne intended to praise
Whistler's art, and held that, despite what
Whistler had said, his art did appeal both to
the intellect and the emotions. Whistler pub-
lished the review in *The Gentle Art of Making Ene-
mies*, commenting on small points made by
Swinburne, and generally objecting to the sub-
stance and tone of the review. Although Swin-
burne meant no offence, Whistler's indignation
is understandable, 'I have lost a confrère; but,
then, I have gained an acquaintance', he wrote
bitterly.[7]

The lecture was translated into French by
Stéphane Mallarmé in 1888. His translation is
sensitive to nuances of meaning and brilliantly
effective. By then, Mallarmé was much more in
tune with Whistler's views than Swinburne.
Artist and poet had just met, and their collab-
oration on this project formed the basis for
both friendship and collaboration (see no.186).

MR. WHISTLER'S

"TEN O'CLOCK."

96

97

98

97 The Gentle Art of Making Enemies London 1890

Ordinary ed.: boards 20.8 × 15.8
(8³⁄₁₆ × 6¼); pp. 20.5 × 15.8 (8¹⁄₁₆ × 6¼)
Deluxe ed. (250 copies): boards
25.8 × 18.8 (10³⁄₁₆ × 7⅜); pp. 25 × 18.7
(9¹³⁄₁₆ × 7⅜)
1st ed., 1890, 292 sides (with 112
butterflies up to p.287): 2nd ed., 1892,
340 sides (added a further 7 butterflies)
LIT: MacDonald 1994 (1238–70)

Paul G. and Elaine S. Marks

J. McClure Hamilton told the Pennells that Sheridan Ford, a journalist of somewhat shady reputation, discussed with Whistler the idea of publishing Whistler's letters to the press as *The Gentle Art of Making Enemies*. It is not clear where the idea originated. Ford started to collect the letters, but Whistler decided to pay Ford off and edit the book himself when he realised the value of such a collection in terms of publicity. Hamilton advised Ford to return the cheque and complete the book, avoiding any material which might have copyright problems. Ford went ahead and published a slim, shoddy volume, but Whistler pursued him with legal injunctions through several countries, and effectively stopped its distribution.

Whistler turned to the publisher William Heinemann to bring out his own edition. Their collaboration was completely satisfactory, and was the start of a lasting friendship.

The book contains reprints of Whistler's brown paper pamphlets, such as 'Art and Art Critics' and the 'Ten O'Clock' lecture, catalogues, and his witty literary assaults on art critics and former friends.

Whistler concerned himself with every detail. The Pennells recorded: 'He chose the type, he spaced the text, he placed the Butterflies, each of which he designed especially to convey a special meaning. They danced, laughed, mocked, stung, defied, triumphed, drooped wings over the farthing damages, spread them to fly across the Channel, and expressed every word and almost every thought.'[1] Many butterflies were, as Pennell said, individually designed for particular situations. Whistler gave the wings, bodies, and antennae recognisably anthropmorphic characteristics.

Duret wrote: 'Lorsqu'il s'agit de pamphlets, d'épigrammes ou de morceaux d'attaue, le gentil papillon des champs s'est ainsi transformé en bête de combat, se convulsant dans des poses agressives et laissant voir une longue queue terminée par un dard menaçant.'[2]

Whistler put what might be considered an inordinate amount of energy into the design of the book and the production of butterflies. The result is elegant and amusing. William Heinemann retained the blocks of the individual butterflies. At the request of Whistler's lawyer, William Webb, he sent him a hand-pulled set of some ninety-seven of the butterflies and explained,

> Of course they will come out infinitely clearer when printed on a press. These are only pulled by hand, and it is almost impossible to get them quite right unless sufficient pressure is used. And if one uses too much, as on one of them, they get so black, but every line and dot is preserved in absolute facsimile.[3]

These proofs make it clear that a separate block was made for each butterfly, and by far the majority were from different designs.

98 Eden versus Whistler: The Baronet & The Butterfly. A Valentine with a Verdict

Paris 1899

Boards covered in brown paper, spine in yellow ochre cloth, title and butterfly inlaid in gold, 112 pp. (of which the first twenty-eight and last six sides are unpaginated) cream laid paper:
boards 20.9 × 18 (8 × 7¹⁄₁₆);
pages 20.3 × 18 (8 × 7¹⁄₁₆)
LIT: MacDonald 1994 (1547–79)

Paul G. and Elaine S. Marks

Sir William Eden (1849–1915) commissioned a portrait of his wife Sybil (1867–1945) in 1894. Whistler, dissatisfied with the amount (100 guineas) and manner (an informal 'valentine') of payment, retained and altered the portrait as well as keeping the cheque. Eden filed a suit in the Civil Tribunal of the Seine. Finally, in December 1897, the Court of Appeals let Whistler retain the portrait but return the money. The portrait, altered, and rubbed down, is now in the University of Glasgow (YMSM 408). As usual, Whistler expected the uncritical support of his friends and when Sickert was seen to associate with Sir William Eden, it marked the real end of their association.

Whistler was perfectly satisfied with the result of the appeal. By his stand, the Code Napoléon had been altered, to specify an

artist's right to decide the fate of his works. He planned to publish an account of the affair, a compilation of letters, newspaper reports and legal documents, with William Heinemann, who had published *The Gentle Art of Making Enemies* (see no.97). There was some problem with publishing in London, and, with Heinemann's tacit agreement, Louis-Henry May in Paris took over the publication.

A first proof was run off, illustrated with butterflies originally drawn for *The Gentle Art of Making Enemies*. These butterflies were mostly replaced by new ones. In a second proof, there are at least two versions of some of the designs. They were slightly reduced in size in the final publication.[1]

For the text, Whistler designed fifteen butterflies, and drew a club on a cushion, and a frog, for the dedication. He described the problem of finding a frog as model:

> I was to apply for one to the Zoological Gardens, Wimbush was to find one, but in the meanwhile Teddy Godwin brought one and made a drawing of it. But the thing died. You know, they say I starved it. They had put it in a paper box. Well, it must have caught a fly or two. And I thought toads lived in amber or something for hundreds of years. Perhaps it was because I hadn't the amber.[2]

The Baronet and the Butterfly was comparatively sparing of butterflies. Many marginal annotations, which in *The Gentle Art of Making Enemies* would have warranted a butterfly, did not get one. Some of the butterflies were very badly reproduced. There were publication problems, and it was not an entirely satisfactory venture. However, Whistler did not admit of criticism and publicly expressed himself delighted with the results.

99 Butterfly Design for 'L'Envoie'

1898

Pencil, pen and dark brown ink on off-white wove paper laid down
19.7 × 15.2 (7¾ × 6)
recto: inscribed 'For l'Envoie | Butterfly about same size as present trial | one – *quite* as small – perhaps a *little* smaller' and, in unknown hand, '4¾ to 1½ [arrow] 1', 'top', '(5)';

verso: inscribed in unknown hand 'black [bing] PP | 2nd margin | Lay only [&] show [&] mgin | [2] and 10 | [Devonald/Deverald] | R'
PROV: Christie, London 17 Oct. 1980 (1), bt D'Offay, London (dealer); Christie, London 6 Nov. 1981 (2), bt the present owners
EXH: New York 1984 (7)
LIT: MacDonald 1994 (1576)

Anita and Julius L. Zelman Collection

Whistler's first dated butterfly was drawn in 1869, on the cartoon 'Venus' (Freer Gallery of Art, Washington DC; M 357). It was, at first, a monogram of the letters 'JW', but it soon developed new characteristics: veins on the wings lasted until about 1882; and the antennae and body came and went, and the wings became more rounded. A sting in the tail was added occasionally, where appropriate (usually in letters to the press) after 1878.

The butterfly, carefully placed, and forming a part of the colour scheme, was a vital decorative addition to his work. He took it fairly seriously. After disposing of him as their President, the RBA disposed of a signboard on which he had painted a lion lying down with a butterfly. 'You say they *only* painted out my butterfly', he said indignantly, 'It is as if you were condoling with a man who had been robbed and stripped, and said to him, "Never mind. It is well it is no worse … Why, you might have had your throat cut."'[1]

He capitalised on the additional notoriety his butterfly provided. By the time of the publication of *The Gentle Art of Making Enemies* in 1890 it was recognised by press and public alike as Whistler's mocking trademark. This butterfly was drawn for publication by William Heinemann in *The Baronet and the Butterfly* (no.98). It was the last butterfly in the book, marking Whistler's last words on the subject, 'As a man wipeth a dish – wiping it and turning it upside down!' It was reproduced exactly but reduced in scale. A preliminary version of this design, drawn somewhat more loosely, is in the Harry Ransom Humanities Research Centre at the University of Texas, Austin (M 1575).

By 1899 Whistler's butterfly bore little relationship to his original monogram. An anthropomorphic form cavorted across the pages with malicious glee. It bore a certain resemblance to Whistler himself, with his distinctive white lock standing up from curly hair.

99

Venice

In November 1878 Whistler was awarded a farthing's damages in his libel case against John Ruskin. The costs of the case, his own extravagence, and a vengeful creditor in the person of his former patron Frederick Leyland, forced Whistler into bankruptcy in May 1879. At the age of forty-five, he found himself homeless and almost penniless. Outwardly, Whistler kept his spirits up. When a friend met him on a London street in August 1879 he thought 'he was very spry indeed and announced himself to be in full work.'[1]

The work was a commission from the London art dealers, the Fine Art Society, for a set of a dozen etchings of Venice to be completed within three months for publication before Christmas. In September 1879, Whistler arrived in Venice. Here he was to remain for fourteen months, bringing home a body of work which contained some of the most innovative things he had ever done, including about fifty etchings, one hundred pastels, and seven or eight paintings.

Once in Venice, installed in lodgings with Maud Franklin, first near the Frari and later on the Riva degli Schiavoni, Whistler complained to his sister about the injustice of his having to live 'in a sort of Opera Comique country when the audience is absent and the season is over'.[2] That winter was particularly cold and Whistler soon became ill 'because I rashly thought I might hasten matters by standing in the snow with a[n etching] plate in my hand and an icicle on the end of my nose.'[3]

Like any painter or writer coming to Venice in the second half of the nineteenth century, Whistler was fully aware of Ruskin's glorious prose evocations of the city and of J.M.W. Turner's visions of luminous palaces suspended between sky and water. Their Venice was a city of past glories, a decaying maritime empire from which nineteenth-century Britain could take warning. Venice is a city of facades, and Ruskin and Turner concentrated exclusively on its public face, the watery tourist trail along the Grand Canal.

By contrast, Whistler's vision of Venice was essentially new. He was the first major artist to stray off the Grand Canal along the stagnant backwater canals, the first to penetrate the secret cortiles and high bare salons of impoverished palazzos. He set out to depict the lagoon on hot moonless nights, when the only light gleams from riding lamps swaying on the prows of silent gondolas. 'I have learned to know a Venice in Venice,' he wrote, 'that the others seem never to have perceived.'[4]

Whistler shows us not only the poetic and mysterious Venice, but a teeming, living city, a city we simply do not recognise in the work of Turner or Ruskin. In masterly prints such as 'The Rialto' (no.100) or 'The Riva' (K 192), he shows Venice humming with every variety of human life and activity, reminding us that the first important critic to write sympathetically about Whistler's art had been Baudelaire, and that Whistler never ceased to model himself on Baudelaire's painter of modern life. The artists whom he took for his models were not Turner or Richard Parkes Bonington, but Canaletto and Guardi.

R.D.

100 The Rialto 1879–80

Etching and drypoint printed in black
ink on dark cream laid paper
Plate: 29.7 × 20 (11¾ × 7⅞)
Sheet: trimmed to platemark
Signed with butterfly and 'imp' in pencil
on tab
PROV: Bernard Buchanan MacGeorge,
Glasgow; Metropolitan Museum of Art,
New York 1917
LIT: Mansfield 1909 (208); Kennedy
1910 (211 I); MacDonald 1994 (733)

*The Metropolitan Museum of Art. Harris
Brisbane Dick Fund, 1917*

Published in *A Set of Twenty-six Etchings.*

Undoubtedly thrilled both to be out of London and finally engaged by a project that had been on his mind for some years, Whistler let the artistic process run its course and remained in Venice for fourteen months instead of three and completed some fifty etchings instead of twelve. Whistler's correspondence with the Fine Arts Society's officers, Brown and Marcus Huish, documents his activity and repeated requests for money and supplies.[1]

Before leaving London Whistler bought some two dozen copper plates in several sizes from Hughes and Kimber, on which to etch the dozen plates of the set for the Fine Art Society. 'The Rialto' was done on one of these plates – as indeed were 'The Balcony' (no.103) and 'The Doorway' (no.104) which were a similar size. It is therefore likely that these plates were etched fairly early during Whistler's year in Venice.

However, in the end 'The Rialto' was not selected for the 'First Venice Set'. A variety of sizes, subjects and treatment was required for each set. It may be that having selected the immediately recogniseable view of St Mark's square, 'The Piazzetta' (K 189), for the first set, Whistler felt it necessary to reserve this, the second best-known site, for a second set.

In December 1880, one year late, *Venice: Twelve Etchings* (the 'First Venice Set') went on view at the Fine Art Society. Further exhibitions took place in the following few years. In 1886, despite the fact that the proposed editions of one hundred of the 'First Venice Set' were yet to be completed, the firm of Dowdeswell's published *A Set of Twenty-six Etchings* (the 'Second Venice Set'). It was to consist of twenty-one Venice plates, including 'The Rialto', and five other subjects, in editions of thirty (plus twelve additional prints of each of fifteen subjects, this among them). The printing of this group was completed quickly, by July 1887, with the plates turned over to Dowdeswell's as the printing ended.

For the most part, Whistler departed from the tradition of Canaletto, Turner, and others captivated by this picturesque city before him. He sought out sites along the back streets and quieter waterways. 'The Rialto' is among the exceptions to this rule.

As he had done throughout his career, Whistler carried grounded plates and an etching needle with him as he wandered the city, drawing on copper directly on site. It shows the approach to the Rialto Bridge with the tower of San Giovanni Elemosinario, possibly seen from a window overlooking the Campo San Bartolomeo. Crowds of people throng the street – a count reveals more than seventy-five figures.

This etching is one of the few Venice subjects for which a related drawing exists, though it was not drawn from the same vantage point but from the opposite side of the river. It was sketched on the paper in which the copper plate was wrapped, and is now in the Hunterian Art Gallery, Glasgow (M 733). Perhaps it was done first, to help Whistler to work out a suitable viewpoint and composition. The second and final state reveals only minor changes from what is seen here, such as the removal of foul bite (unwanted accidental marks that occur during the etching process) especially in the foreground at the right, and a few of the faint foreground figures.

Early impressions, like this one, not only have extraordinary clarity of line but also show light striations, mainly vertical, the traces of lines Whistler had partially removed even before the first proofs were taken. A light overall film of ink marks most impressions. The use of black ink, as well as the style of the butterfly signature, marks this as one of the earliest impressions, printed in Venice, with the special sharpness those proofs have. Whistler complained that printing in Venice was 'very primitive and difficult and on another pilgrimage of this kind I should certainly bring out my own press-'[2] Later, in the summer, he borrowed Otto Bacher's press at the Casa Jankowitz.[3]

The copper plates for the 'Second Venice Set' were cancelled and prints from the cancelled plates exhibited when the set was published, to prove that the edition was limited. The plates are now housed at the Art Institute of Chicago.

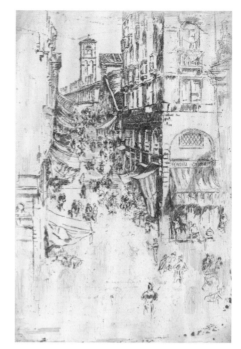

100

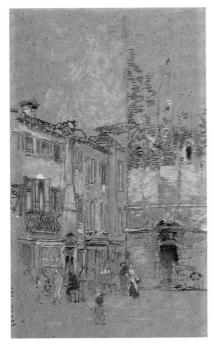

101

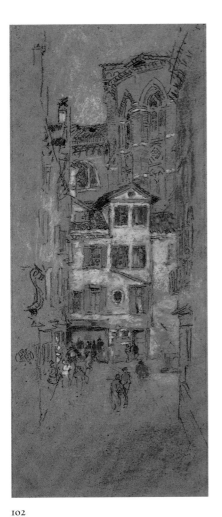

102

101 Campanile Santa Margherita

1879–80

Chalk and pastel on brown paper
29.9 × 18.1 (11¾ × 7⅛)
Signed with butterfly
Inscribed 'N:39 – 11½ × 6½'
PROV: J.P. Heseltine by 1886; Colnaghi,
London (dealers) 1926; Kennedy, New
York (dealers) 1926; Macbeth, New
York (dealers), 1928; Thomas Cochran
1928; anonymous gift to Addison
Gallery of American Art 1928
EXH: London, FAS 1881 (2); London
1905 (78); Paris 1905 (164)
LIT: MacDonald 1994 (773)

*Addison Gallery of American Art, Phillips
Academy, Andover, Massachusetts. Gift of
anonymous donor*

Campo Santa Margherita lies north of the Zat-
tere, beyond Santa Maria del Carmine, and not
far from where Whistler stayed on the Rio di
San Barnaba, early on in his year in Venice. It is
off the tourist route, a sheltered square with a
busy market and several cafés. This drawing
probably dates from the winter of 1879–80.

In the square is the simple Scuola dei Varo-
tari, where the confraternity of the tanners once
met, and at the far end is the seventeenth-cen-
tury Scuola di Santa Maria dei Carmini.
Whistler must have sat by the well at the north
end of the campo to draw the old bell tower.
He would continue past the tower to reach San
Rocco and the Frari.

As with his pastel of the Frari (no.102)
Whistler took at least nine separate sessions to
complete the pastel to his satisfaction. He drew
the tower with firm, confident strokes, and
crisp detail. Subtle shades of bone, beige and
grey were rubbed into the walls. A dozen vivid
colours sparkle on the shutters and the figures.
The paper is the usual paper Whistler used in
Venice (see no.102). The composition is simple,
concentrating on conveying the basic structure
of the tower – a square block of weathered brick
and stone, with a grotesque stone head above
the door as the only ornamental feature.

The architect E.W. Godwin attended
Whistler's exhibition of Venetian pastels in
1881. He wrote a review of the show, deriving it
from notes jotted down in a catalogue, which is
now in Glasgow University Library.[1] He is,
with T.R. Way, the main source for first-hand
information on the pastels, and their reception
in London. Godwin described this pastel,
somewhat unenthusiastically, as showing 'a
somewhat looser handling', but he was not
alone in his criticism. The *Queen* thought it one

of several pastels giving 'very elementary ideas
of the subjects represented'.[2]

Although the work was exhibited in 1881, the
butterfly looks like a later addition, perhaps
added at Heseltine's request, a couple of years
later. J.P. Heseltine, the first owner, was a friend
of Whistler and a Trustee of the National
Gallery, and had three Venice pastels.

102 Under the Frari 1879–80

Chalk and pastel on brown paper
29.8 × 13 (11¾ × 5⅛)
Signed with butterfly
Inscribed 'No.35 11½ × 4¾'
PROV: Whistler's cousin, Ross Winans,
Baltimore; Albert Rouillier, Chicago
(dealer); Marshall Field, Chicago by
1915; Mrs Diego Suarez (formerly Mrs
E. Marshall Field); Woolworth, New
York (dealer); Knoedler, New York
(dealers) 1962; present owner 1964
EXH: London, FAS 1881 (17); New York
(11), 1914 (1); New York 1938 (5); Paris
1938 (?179); New London 1949 (52);
Greensburg 1963 (233)
LIT: MacDonald 1994 (771)

Shirley Latter Kaufmann
[Exhibited in Washington only]

The massive church of the Frari, with its fine
bell-towers, was started in 1330. It is the main
Franciscan church in Venice, the interior dom-
inated by Titian's magnificent altarpiece 'The
Assumption of the Virgin'.

Whistler and Maud Franklin stayed near the
Frari for some time during the winter of
1879–80. It was an exceptionally cold winter,
and Whistler found it easier to work in pastel
than to hold an icy copper plate. Even then, he
could work only for a short time, before warm-
ing up in the cafés around the Frari. Nine pin-
holes at the top corners, where the paper was
pinned to a board, show that Whistler spent
many days – when the light was right – per-
fecting the drawing.

Whistler did not come to Venice to draw
pastels, and although he may have brought a
variety of paper, he must have bought more
there when etching proved difficult. Most of
the Venetian pastels, including several done in
the first winter, are on the sort of paper seen
here, auburn brown in colour, with a distinctive
fine vertical grain (see nos.101, 109–12), which
he did not use before or after.

This paper provides the base colour and substance of the buildings, slightly varied with touches of beige and browns and set off by the bright colours of the shutters. Attention focuses on the figures in the square and in the shadowed Sottoportico San Rocco beyond.

Looking each way from virtually the same viewpoint on the bridge of Calle del Scalater, Whistler drew two views, this one of the church of the Frari from the south-west, and one looking the opposite direction, down the canal, past the white marble columns of the early sixteenth-century church of San Rocco.

Over the years, this pastel of the Frari has sometimes been confused with the pastel of San Rocco, which is now in Boston Public Library. The mistake in titles may have occurred as long ago as their first exhibition in 1881.[1] It is possible that by the time Whistler got home he had forgotten which was which. However, the views are unmistakable, unchanged in over a century.

In his 'Ten O'Clock' lecture in 1885, Whistler defined Art as 'a goddess of dainty thought – reticent of habit … selfishly occupied with her own perfection … seeking and finding the beautiful in all conditions and in all times … As did Tintoret and Paul Veronese, among the Venetians, while not halting to change the brocaded silks for the classic draperies of Athens.'[2]

Surrounded by the decaying splendour of Venetian palaces, and the colourful costumes of sailors and bead-stringers, Whistler found no need for 'the classic draperies of Athens'. But when he returned home, lacking these stimuli, he clad his models in semi-classical draperies. The only pastel of a street scene he attempted, several years later, was not a success.[3] London required different models, different methods.

The Metropolitan Museum of Art. Bequest of Susan Dwight Bliss, 1967

Published in *A Set of Twenty-six Etchings.*

The building has been identified as 66 Calle Vinanti, north of the Campo Santa Margherita (see no.101) between San Pantalon and the Frari (see no.102).[1]

'The Balcony' shows how Whistler summarised minute aspects of Venetian architecture with brevity, rather than with the extensive detail employed two decades earlier along the Thames. The atmospheric effects he achieved were heightened by his propensity for the vignette form, clustering the densest area of marks at the centre of the sheet with the weight and emphasis dissipated toward the edges. According to Mortimer Menpes, Whistler's 'secret' of drawing was to start at the central point of interest and move outward simultane-

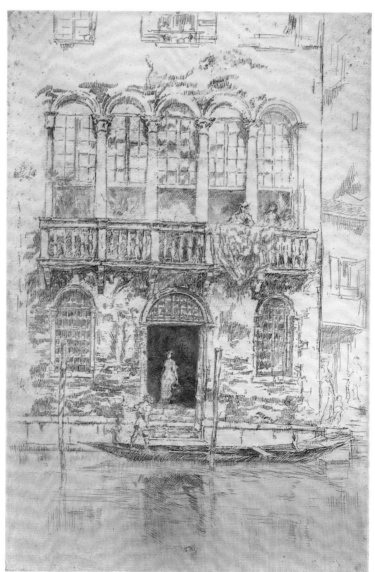

103

103 The Balcony 1879–80

Etching and drypoint printed in dark brown ink on cream laid paper
Plate: 29.7 × 19.9 (11¾ × 7¹⁵⁄₁₆)
Sheet: trimmed to platemark
Signed on plate with butterfly
Signed with butterfly and 'imp' in pencil on tab
PROV: Bequest of Susan Dwight Bliss to Metropolitan Museum of Art 1967
LIT: Mansfield 1909 (204); Kennedy 1910 (207 IX)

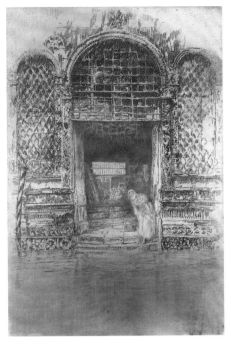

104

ously toward all edges; any stopping point would then allow for a complete image.[2]

This did not stop him reworking the central area in practically every state of this particular etching. The whole of the scene was roughed out in the first state, but the figures were not resolved. In six subsequent states these were repeatedly burnished out and reworked. The first three states were completed in Venice, but the figures were radically altered years later in London. He redrew the woman in the doorway, and sketched the gondolier in various attitudes. It was only in the eighth state that the woman in the door with her large water-jug, and the two women at the end of the balcony became clear.

No matter how brief he was, Whistler always provided notes to be especially savoured. One of them here is the cocky wide-brimmed hat on the man leaning his elbows on the flowing cloth draped over the balcony. It is tempting to read a signal between that hat and the one carried by the gondolier below. The interraction between the figures is vital to the composition. The grandeur of the Renaissance palace forms a fitting setting for a group which has something of the courtly grace of Van Dyck's nobility.

Whistler showed that he was at last satisfied by printing later impressions with the subtle vertical wiping of a thin surface of ink on the water which distinguishes – and transforms – impressions published for the 'Second Venice Set'. The vertical orientation of the plate tone in this impression reinforces the connection between the figures.

Like Rembrandt, Whistler sought special antique papers for his etchings, often using end-papers and fly-leaves torn from books. Such sheets became increasingly expensive, and while working on the Venice editions which called for large quantities of paper, Whistler took up the practice of trimming his sheets to the plate-mark. His reasons were noted in a group of ten 'Propositions' published with the 'Second Venice Set'. The cost of paper was not among them, of course, but he did slyly comment on the absurdity of valuing prints for the size of the margins rather than the quality of the image. The rectangular format of the plate was interrupted by the tab of paper Whistler retained at the bottom to carry his butterfly signature and the letters 'imp' that indicated he had printed the impression, or supervised its printing.

This impression dates from 1886–7 and was printed for inclusion in the 'Second Venice Set', or as one of the extra twelve impressions made of this subject.

104 The Doorway 1879–80

Etching and drypoint printed in dark brown ink on laid paper with watermark: Strasbourg lily, and 'FJ' or 'FB' monogram
Plate: 29.2 × 20 (11⁹/₁₆ × 7¹⁵/₁₆)
Sheet: trimmed to platemark
Signed on plate with butterfly
Signed with butterfly and 'imp' in pencil on tab
PROV: Metropolitan Museum of Art 1917
LIT: Bacher 1908, pp.193–4, doorway repr. p.195; Mansfield 1909 (185); Kennedy 1910 (188 VI/VII)

The Metropolitan Museum of Art. Harris Brisbane Dick Fund, 1917

Published in *Venice: Twelve Etchings*.

Just near to the Campo San Bartolommeo, where Whistler etched 'The Rialto' (no.100) he also etched this Renaissance doorway in the Palazzo Gussoni from a gondola in the Rio de la Pava.[1] The theme was one he continued to explore in the later etchings of Venice, in for instance 'The Dyer' (K 219).

Whistler's Venetian views are of two sorts, the vistas, and the enclosures, the latter exemplified by compositions like 'The Doorway'. With the darkened interior, Whistler offered a place marked by mystery, a contrast to the decorative elegance of architectural details: the graceful repeated motifs derived from flowers and vines; the diamond-shaped window panes flanking square panes; nature juxtaposed with geometry. The extravagance of detail marks this as a building with a very different earlier life, a symbol of Venice's faded elegance.

The palace facade frames a plebeian workshop, a chair-maker's shop, with working women at the door onto the canal. A young girl, dipping a cloth into the canal, in the first states of the etching, was changed in the third state into an older woman, with a somewhat tired and careworn figure looming out of the shadows behind her. In this, the sixth state, the younger woman is looking down at her reflection in the water, and the figure behind has been softened and falls back into the shadows. These figures were replaced in the seventh state by younger figures, which were not fully worked out and remained pale and insubstantial. The woman on the steps in her various incarnations functions as a link between canal-side and inside spaces.

The darkened interior is quite complicated, sheltering not only the shadowy woman behind

the figure on the steps, but at least two more figures at the far side of the room. Crates and chairs are stacked one on another, and planks lean against a side wall. Chairs are suspended from the ceiling. Suggestions of a column and alcoves enhance the interior architecture, and the horizontal window at the back of the enclosure, another layer of light, suggests another place beyond.

The area of tone along the bottom third of the plate differs from impression to impression, but in general, the water mirrors the darkness seen through the doorway. Here it is quite richly inked, rubbed in swirls, as well as up and down, masking considerable line-work throughout the water.

'The etchings themselves are far more delicate in execution, more beautiful in subject, and more important in interest than any of the old set' Whistler assured Marcus Huish of the Fine Art Society in January 1880.[2] This etching was selected for the 'First Venice Set' issued by the Fine Art Society in 1881.

The set as published comprised several canal subjects, this grand Renaissance 'Doorway', 'The Two Doorways' (K 193), and one of Whistler's largest prints, 'The Palaces' (K 187) on the Grand Canal. In three prints, figures provided the main interest, 'The Beggars' (K 194), gondoliers in 'The Traghetto' (K 191) and bead-stringers in 'The Mast' (K 195). The main tourist centre figured in 'The Piazzetta' (K 189) of St Marks, along 'The Riva' (K 192) to 'The Little Mast' (K 185). To set the scene, there were two distant views, 'The Little Venice' (K 183), and 'The Little Lagoon' (no.114). Finally, there was a technically innovative print, the 'Nocturne' (no.122). The set was divided between landscape and vertical format, with a variety of techniques and subjects.

Printing of the 'First Venice Set', with assistance most notably from Mortimer Menpes and Walter Sickert, engaged Whistler until his death, at which time a few of the editions, including that of 'The Doorway', remained incomplete. The London printer Frederick Goulding finished them posthumously at the request of Whistler's sister-in-law Rosalind Birnie Philip. The butterfly signature on this impression dates from 1887, suggesting that date for the printing, which was in fact concurrent with the printing of the 'Second Venice Set'.

When *Venice: Twelve Etchings* was exhibited in December 1880, critical reception was harsh. The *World* called them 'of unimportant dimensions, and of the slightest workmanship', which Whistler politely but firmly disputed: 'an etch-

ing does not depend, for its importance, upon its size.'[3]

Whistler hoarded the press-cuttings and a few years later, in publishing a catalogue to accompany the exhibition of fifty-one *Venice Etchings* at the Fine Art Society in 1883, he wryly annotated his titles with a judicious selection of the earlier critical comments.[4] Although the *Daily News* on 2 December 1880 had singled out 'The Doorway' for praise, Whistler selected a less favourable comment for use in the catalogue: 'We think that London fogs and the muddy old Thames supply Mr Whistler's needle with subjects more congenial than do the Venetian palaces and lagoons.'[5]

105 The Palace in Rags (recto)

1879–80

Houses by a canal, with bridges (verso)
Chalk and pastel on brown paper
28 × 16.5 (11 × 6)
PROV: Whistler's cousin, Ross Winans, Baltimore; Albert Rouillier, Chicago (dealer); Marshall Field, Chicago by 1915; his widow (later Mrs Diego Suarez); Knoedler, New York (dealers) 1960; Norman B. Woolworth; Agnew, London (dealers); R. Light, Santa Barbara (dealer) 1974; the present owners 1974
EXH: London, FAS 1881 (33); London & New York 1960 (80); London, Liverpool & Glasgow 1976 (99, repr.); New York 1984 (88)
LIT: MacDonald 1994 (770); Grieve and MacDonald 1994

Private Collection

Whistler and Maud are said to have taken rooms in the dilapidated Palazzo Rezzonico, where many artists had their studios. Sargent stayed there a year later, and his 'Venetian Interior' of *c*.1882 (fig.79) shows the same room – although Whistler's pastel suggests more pictures hung on the walls. Even the drapes at the window appear the same – and perhaps the same old lady is sitting by the window.

This drawing shows Whistler's constant interest in windows as a frame, with figures lit by the light of the window and also silhouetted against it. The spatial problems were resolved with a delicate use of colour. When it was

exhibited in 1881, the *Daily Telegraph* noted 'a fine bit of gloom, with a poetic gleam of central light'.[1]

A flight of steps leads to a long chamber barely furnished but hung with pictures. Women in black sit by a tall window, beside a man drawn with meticulous detail. The figures are black and brown with minute flecks of complementary colours, green and blue, pink and orange. Deep colours frame the view, where the roofs are bright in the sun. The window and figures are vignetted, framed around the edge with bold strokes of black and brown.

105

106 Nocturne: Furnace 1879–80

Etching and drypoint printed in dark brown ink on Japanese paper
Plate: 16.8 × 23 (6¾ × 9¹⁄₁₆)
Sheet: trimmed to platemark
Signed on plate with butterfly
Signed with butterfly and 'imp' in pencil on tab
PROV: Bequeathed by Whistler to his sister-in-law, Miss R. Birnie Philip 1903; bequeathed to the University of Glasgow 1958
LIT: Mansfield 1909 (210); Kennedy 1910 (213 VI/VII)

Hunterian Art Gallery, University of Glasgow, Birnie Philip Bequest

Published in *A Set of Twenty-six Etchings.*

This was etched on a copper plate which was bought by Whistler from a craftsman in Venice (the 'pebbled' back distinguishes these from the smooth machine-finished Hughes & Kimber plates). This suggests that it was done when Whistler had completed the two dozen plates he had brought from London. He was by then, presumably, thinking about not only what appealed to him as subjects, but what would complement those already etched. Similar copper plates were used for the 'Fishing Boat' (no.116) and another furnace subject, 'Glass-Furnace, Murano' (K 217). The two furnaces, like the Nocturnes, relied on atmospheric effects rather than decorative detail or human interest.

Peering through doorways on Venice's backwaters Whistler 'learned to know a Venice in Venice that the others never seem to have perceived', he wrote to Marcus Huish. He further let him know that he was 'frozen – and have

been for months – and you can't hold a needle with numbed fingers, and beautiful work cannot be finished in bodily agony – also I am starving – or shall be soon'.[1] Even knowing Whistler's propensity for colourful speech, and that he was mercilessly imposing on a group of young American admirers, there undoubtedly was some truth in his description of the circumstances under which he was making this extraordinary body of work.

'Nocturne: Furnace' unites several of Whistler's favoured themes. His first night scene, 'Street at Saverne' (K 19) in the 'French Set', dates from as far back as 1858. From the early 1870s, the title 'nocturne' had been part of his vocabulary, at the suggestion of Frederick Leyland. His first print of a blacksmith shop was 'The Forge' of 1861 (K 68). The subject continued to attract him long after he had completed this beautiful Venetian version, in the Lyme Regis lithographs of 1895 (see no.192).

Other Whistlerian staples are the compositional structure, with both doorway and window framing the central visual events; and the dramatic effects staged by light. This is not the intimacy of lamplight as seen in 'The Music Room' (no.10), but the glow of a blazing furnace. In addition, the strongly defined shapes and concurrent sense of geometry anticipate the 'Square House, Amsterdam' (no.165). Yet in the clearest impressions such as this, such tiny touches as the features of the person peering through the window may be discerned.

This was among the subjects in the 'Second Venice Set' of which an extra twelve impressions were printed.

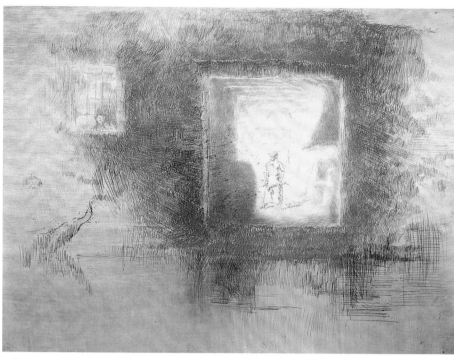

106

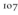

107

107 San Biagio 1879–80

Etching and drypoint printed in dark brown ink on wove paper
Plate: 20.9 × 30.1 (11⁷⁄₁₆ × 12)
Sheet: trimmed to platemark
Signed on plate with butterfly
Signed with butterfly and 'imp' in pencil on tab
PROV: Bequeathed by Whistler to his sister-in-law, Miss R. Birnie Philip 1903; bequeathed to the University of Glasgow 1958
LIT: Mansfield 1909 (194); Kennedy 1910 (K197 VII/IX)

Hunterian Art Gallery, University of Glasgow, Birnie Philip Bequest

Published in *A Set of Twenty-six Etchings.*

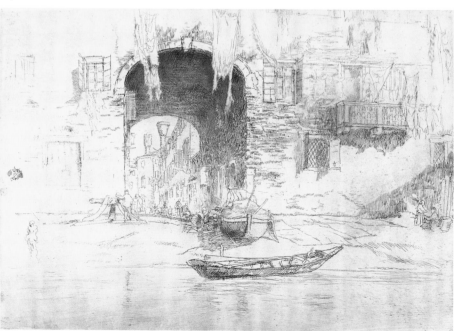

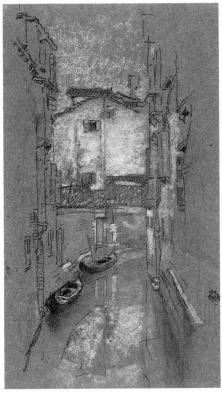

108

San Biagio is at the eastern end of the Riva degli Schiavoni. The artists kept their boats pulled up on the sloping shore near the ancient archway, just east of the Casa Jankowitz (the foreshore was built up in Mussolini's time). Whistler must have worked from a gondola, offshore.[1]

Recalling 'La Marchande de Moutarde' (no.5) makes clear that scenes through doorways were one of Whistler's passions from the start. As apparent from the previous three etchings (nos.104–6), in Venice he expanded the theme, constructing complex facades that blanket the surface of the sheet.

'San Biagio' is particularly lovely. Extensive detail on the wall at the right of the archway – the narrow ancient bricks and crumbling plaster, the window panes and shutters, the gracefully curved columns of the balcony, laundry hanging out to dry, the stark shapes of shadowed areas – are in contrast to the open suggestive character of the wall at the left. The scene beyond the darkened passageway, with the sharply diagonal view of buildings along the street, is another of Whistler's favourite themes, and one that also goes back to the 'French Set', in for example, 'Street at Saverne' (K 19).

'San Biagio' was etched on a copper plate with what Getscher describes as a 'flaked' back, which would have been bought in Venice, probably in the summer of 1880.[2] Both versions of 'The Traghetto' (K 190–1) were on these 'flaked' plates. Most of these copper plates are now in the University of Glasgow, and the backs of the plates, as well as revealing their origins, bear the marks of the hammering and reworking that was involved in making alterations.

In this impression of the seventh state of 'San Biagio' recorded by Kennedy, the image is fully set down, having been through a variety of changes in architectural details, and the number and position of the figures. A warm orangey plate tone suffuses the scene with an evening glow, and gives substance to the delicate network of lines. In subsequent states the artist enhanced areas of shading. Most of the Venice etchings that Kennedy recorded in large numbers of states in fact went through several more than the cataloguer accounted for. Indeed, it seems that as edition printing progressed, the artist was apt to draw an additional stroke or two after almost every impression of some plates.

This was among the 'Second Venice Set' subjects of which twelve impressions over the edition of thirty were printed.

108 Canal, San Cassiano 1879–80

Chalk and pastel on brown paper
29.2 × 17.1 (11½ × 6¾)
Signed with butterfly
Inscribed 'Ponte Raspi = | o Sansoni – San Cassiano'
PROV: Whistler's cousin, Ross Winans, Baltimore; Marshall Field, Chicago by 1915; his widow (later Mrs Diego Suarez), New York by 1949; F. Woolworth, New York (dealer), by 1962; Knoedler, New York (dealers), 1962; bt Westmoreland County Museum of Art 1963
EXH: London, FAS 1881 (20); New York (11) 1914 (4); New York 1938 (1, repr.); exh. Paris 1938 (182); New London 1949 (50); New York 1983 (8); San Francisco 1984 (94, repr.)
LIT: MacDonald 1994 (778); Grieve and MacDonald 1994

Westmoreland Museum of Art, Greensburg, Pennsylvania, William A. Coulter Fund

The title 'Canal, San Canciano' given in 1881 is misleading which is surprising since it is correctly identified in the inscription. San Canciano is north-east of the Ponte di Rialto. This pastel, however, represents a small canal to the west of the Grand Canal near San Cassiano.

Whistler evolved a new method of drawing in Venice. He first outlined the bare bones of the composition with fine black chalk. In this case, the scene was vignetted, the curve of the canal leading in on the left, and a 'butterfly' in sharp perspective moving in on the right. The recession ceased abruptly at the building in the middle distance, its walls parallel to the picture frame.

The drawing could not have been left without colour, for the black lines are lacking in emphasis. To this skeletal framework of widely spaced lines Whistler added five colours, white, brick-red, light blue, turquoise, and a deep green. E.W. Godwin in 1881 noted the 'Delicate colour'.[1]

In the spring of 1880, Whistler wrote home to his mother:

after the wet, the colours upon the walls and their reflections in the canals are more gorgeous than ever – ... and with the sun shining on the polished marble, mingled with the rich toned bricks and plaster, this amazing city of palaces becomes really a fairyland created one would think especially for the painter. [2]

[187]

The effective use of detail and colour suggests that 'Canal, San Cassiano' dates from early in 1880, when Whistler finally came to terms with the quality of Venetian light.

109 Courtyard on Canal; Grey and Red 1879–80

Chalk and pastel on brown paper
30.1 × 20.2 (11⅞ × 7¹⁵⁄₁₆)
Signed with butterfly
PROV: Walter Greaves; W. Marchant, London (dealer); R.A. Canfield of Providence, R.I. by 1905; Knoedler, New York (dealers) 1914; Harris Whittemore, Naugatuck, Conn. 1914; J.H. Whittemore Company, Naugatuck; Whittemore sale, New York, Parke Bernet, 19 May 1948 (62, repr.) bt Knoedler, jointly with C. Carstairs, New York (dealer); J. Lionberger Davis, St Louis 1948; given to the City Art Museum of St Louis 1957
EXH: London, FAS 1881 (11); London, Marchant 1903 (191) and 1904 (25) or 1903 (170) and 1904 (21); Paris 1905 (166); Chicago & Utica 1968 (55, repr.)
LIT: MacDonald 1994 (790)

The Saint Louis Art Museum: Museum Purchase
[Exhibited in Washington only]

The composition is split firmly down the middle by the passageway. The windows and the doorway, parallel to the picture frame, form a 'T' shape, similar to that seen in his painting, 'Nocturne: Blue and Gold – Old Battersea Bridge' (no.54).

The basic compositional device is one of balance. The dark passageway frames the light canal, a door frames bright figures. The women at the well and the slight tilt of the cobbled courtyard provide a diagonal lead-in and offset the basic symmetry of the composition. The alternation of areas of colour and detail, and the emphasis on perspective, is reminiscent of the work of Pieter de Hooch, in for instance, 'The Courtyard of a House in Delft' (National Gallery, London) which Whistler admired, and of which he owned a photograph.[1] Even the colour is similar – the red bricks of Holland here become the rosy red of dilapidated plaster. The shutters are in complementary shades of blue and green, and through the passage is a glimpse of water and a mooring pole in vivid

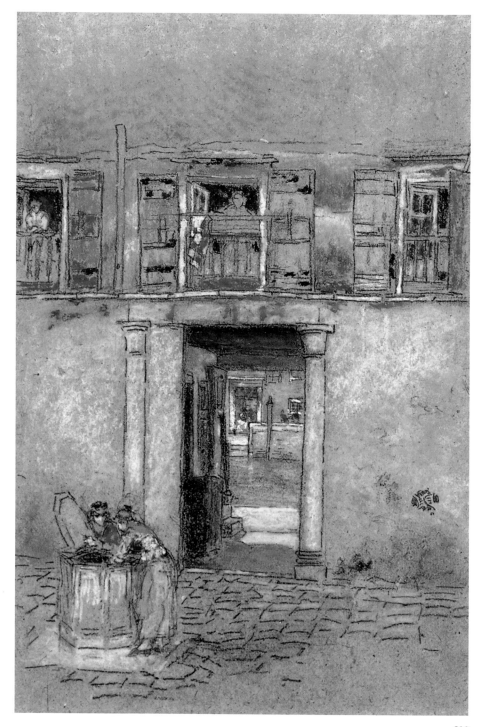

109

blue. It took at least a dozen sessions to complete this colourful and detailed drawing.

There are signs of alterations. The figure on the right was originally higher. There are traces of another drawing underneath at right, and above the dark brown butterfly, and another butterfly seems to have been crossed out to left of the final one. It was quite usual for Whistler to rub out one drawing and start another on top.

110 **Venetian Courtyard** 1879–80

Chalk and pastel on brown paper
30.2 × 20.3 (11⅞ × 8)
PROV: Weyhe, New York (dealers) 1990;
bought by the present owners 1990
LIT: MacDonald 1994 (793); Grieve and
MacDonald 1994

Dr and Mrs John E. Larkin, Jr

110

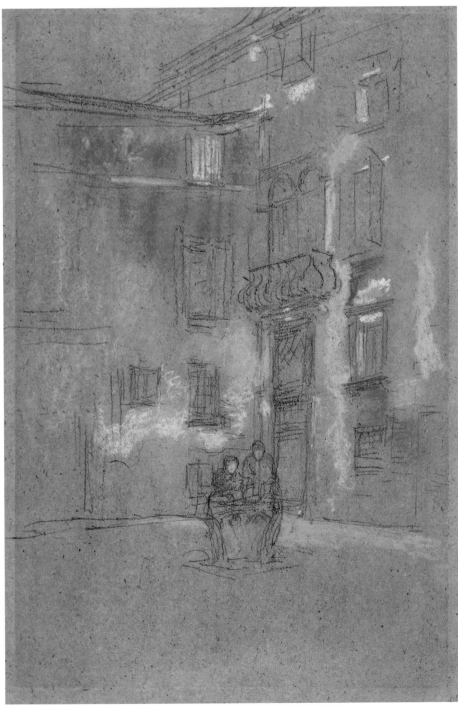

This was drawn in a little courtyard – the Corte Bollani – in Castello, barely a stone's throw from the Riva degli Schiavoni, halfway along the route between the Casa Jankowitz and San Marco.[1]

It is less delicate in technique, and more brilliant in colour, than Whistler's earlier work in Venice. A combination of glowing orange, light red, and sienna, with touches of lighter shades, bone and beige, was used. Some of the colours were softened and rubbed into the brown paper, some drawn with firm or squiggly strokes of pure colour. Whistler conveyed with utter conviction the textures of crumbling stone and plaster, and layers of terracotta washes over the ancient walls.

The artist wrote home to his sister-in-law Nelly Whistler in the autumn of 1880, 'The pastels you know Nellie I verily believe will be irresistable to buyers – ... I assure you the people – painter fellows – here, who have seen them are quite startled at their brilliancy'.[2]

And indeed, the 'painter fellows' of the Casa Jankowitz – who included J.W. Alexander, Otto Bacher and Harper Pennington (see no.123) – were impressed. A story is told by the Pennells of the artist 'Wolkoff, or Roussof as he is known in Bond Street' trying to imitate Whistler's pastels, without success.[3] The American, Jerome Elwell, however, produced a series of pastels of Venice which have often been mistaken for Whistler's, though they are, in fact, rather pale in colour and weak in outline.[4]

Back in America in 1882, the pastel groundswell led to the formation of the Society of American Painters in Pastel under the nominal leadership of Robert Blum. Their first exhibition was held in 1884. Whistler's austere influence was seen in the pastels of American Impressionists like John Henry Twachtman and J. Alden Weir, and in those of Thomas Dewing and Dight William Tryon. But there was an alternative school, derived partly from the work of the Italian artist, Giuseppe de Nittis. By 1889, when Whistler's Venice pastels were shown at Wunderlich's in New York, his style had been superseded by the flashier, broader technique of William Merritt Chase and Robert Blum.[5]

111 Corte del Paradiso 1879–80

Chalk and pastel on brown paper
29.9 × 14.7 (11¾ × 5¾)
Signed with butterfly. Inscribed 'No 38.
5⅝ × 11½' and 'Corte del Paradiso'
PROV: Cyril Flower, Lord Battersea, by
1886; John H. Wrenn, Chicago; Harold
Brent Wrenn 1911; John Henry Wrenn
1938; his widow Mrs J.H. Wrenn 1981;
Parke Bernet, New York, 2 Dec. 1982
(10, repr.); the present owners
EXH: London, FAS 1881 (52); London,
Marchant 1903 (173) and 1904 (24);
London 1905 (61)
LIT: MacDonald 1994 (784)

*The Warner Collection of Gulf States Paper
Corporation, Tuscaloosa, Alabama, USA*

The Corte del Paradiso lies off the Ruga Ciuffa
just east of a busy market square, the Campo
Santa Maria Formosa. The tiny, sheltered
courtyard has remained unchanged to this day.
It is not far from the Riva degli Schiavoni, and
yet quite off the tourist track. It was a working-
class area, busy with small shops and markets,
but the Corte del Paradiso was an oasis of calm
where Whistler could work undisturbed.

The format of this work is dramatic, very
narrow – twice as high as broad – and suited to
the narrow and claustrophobic courtyard.
Instead of vignetting the scene, Whistler cut
the paper down to contain only the essentials.
The measurements written on the picture were
instructions by Whistler to the framemaker,
done at the time of the 1881 exhibition. Many of
the pastels are so inscribed (see nos.101–2, 112,
118), although not all that were framed could
get into the show. Balances between vertical and
horizontal formats, as well as a variety of sub-
jects, were chosen for the show.

Now, the picture has a late Whistler frame,
dating from after 1890, which suggests it may
have been returned to the artist, perhaps for
exhibition, in the 1890s.

112 The Zattere; Harmony in blue and brown 1879–80

Chalk and pastel on brown paper
27.9 × 19.4 (11 × 7⅝)
Inscribed 'N9 11 × 7½'
PROV: Ross Winans, Whistler's cousin,
Baltimore; A. Rouillier, Chicago
(dealer); Marshall Field, Chicago by
1915; his widow, Mrs Diego Suarez by
1938; F.W. Woolworth, New York
(dealer); Knoedler, New York (dealers)
1962; private collector, Boston 1963;
Knoedler 1985; the present owner, 1985
EXH: London, FAS 1881 (4) New York
1984 (81) (repr. as 82)
LIT: MacDonald 1994 (774)

*Terra Foundation for the Arts, Daniel J. Terra
Collection*
[Exhibited in London only]

Along the south of the city, beside the Canale
della Giudecca, runs the Fondamenta delle Zat-
tere. It was a busy waterfront, where sail and
steam ships could unload, and the broad quays
were crowded. Whistler would have been sit-
ting near the Chiesa dei Jesuiti or the bridge
over the Rio di San Gervasio e Protasio looking
west.

In 1881 E.W. Godwin justifiably named this
as the masterpiece of Whistler's exhibition of
Venetian pastels at the Fine Art Society: 'the
brown paper, with just a touch, represents in
value the quay from the base of the drawing to
a considerable distance upwards, then a group
of boats, then the blue water to the left, and
blue sky above. Note the important emphasis
of the two white dots on the boat and the pre-
ciousness of the blue created by the base of the
brown.'[1]

Privately, Godwin noted 'very pretty | note
also the important emphasis of white | deli-
cious value of blue used – preciously as opals'.[2]

Pan, less flattering, complained of the lack of
foreground, 'surely the hand that drew the dis-
tant ships … could have filled up the ugly
brown triangle of untouched surface that is left
to make a foreground for itself' but admitted
that Whistler would have suggested that any-
one wanting that level of finish 'had better buy
a print of Mr. Frith's "Derby Day"' instead.[3]

Unlike etching, pastel is not naturally a
medium for precision. Etching requires the fine
point of a needle, pastel employs a broad, soft,
chalk. The precision of this pastel took a long
time to achieve, at least ten sessions. To differ-
entiate shapes and colours as Whistler does
here requires exquisite judgement and 'the
knowledge of a lifetime'.

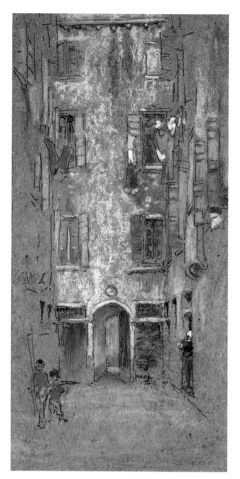

111

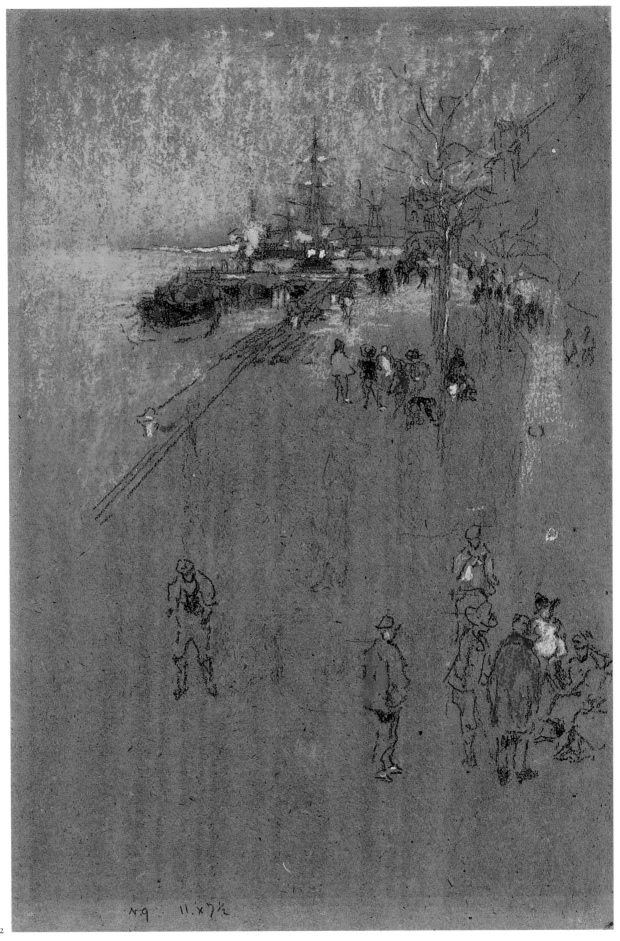

112

113 The Church of San Giorgio Maggiore 1879–80

Chalk and pastel on brown paper
19.6 × 29.6 ($7^{11}/_{16}$ × $11^{5}/_{8}$)
Signed with butterfly
PROV: Revd George F. Weld, Boston;
Doll & Richards, Boston (dealers);
Anna Sears Amory, Boston; Arthur H.
Hahlo, New York (dealer); bequeathed
by James Parmelee to the Corcoran
Museum of Art 1941
EXH: Exh. cat., New York 1947 (35);
London & New York 1960 (84); San
Francisco & Cleveland 1984 (92)
LIT: MacDonald 1994 (805)

*The Corcoran Gallery of Art, Bequest of James
Parmelee*
[Exhibited in Washington only]

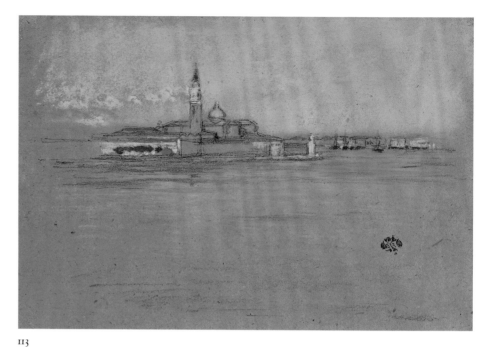

113

San Giorgio Maggiore stands on an island
south of Venice, dominating the view south
from the Riva degli Schiavoni. It takes its name
from the Benedictine monastery founded in the
tenth century, although the monastery was sup-
pressed in the nineteenth century and turned
into a barracks. The church, designed by Palla-
dio, was begun in 1566, and completed after his
death, in 1610. It has a mathematical harmony
which must have appealed to Whistler.

This was drawn from the Riva degli Schi-
avoni, a little west of the Casa Jankowitz, where
Whistler was living in the summer of 1880 (he
was back in London in November). Five
months later, in March 1881, Henry James
arrived and took rooms on the Riva. He
described San Giorgio:

> Straight across, before my windows, rose
> the great pink mass of San Giorgio Mag-
> giore, which, for an ugly Palladian church,
> has a success beyond all reason. It is a suc-
> cess of position, of colour, of the immense,
> detached campanile, tipped with a tall gold
> angel. I know not whether it is because San
> Giorgio is so grandly conspicuous, and
> because it has a great deal of worn, faded-
> looking brickwork, but for many persons
> the whole place has a kind of suffusion of
> rosiness.[1]

Whistler's pastel might almost illustrate this
passage.

114

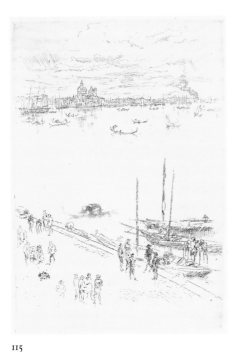

115

114 The Little Lagoon 1879–80

Etching and drypoint printed in dark
brown ink on laid paper
Plate: 22.5 × 15.1 (8¾ × 6⅛)
Sheet: trimmed to platemark
Signed on plate with butterfly
Signed with butterfly and 'imp' in pencil
on tab
Inscribed on verso, with 'oo', possibly by
Whistler, as a mark of approval
PROV: Purchased from Colnaghi
London (dealers) 1972
LIT: Mansfield 1909 (183); Kennedy 1910
(186 II/II)

Hunterian Art Gallery, University of Glasgow

Published in *Venice: Twelve Etchings*.

This was probably etched during Whistler's
first few months in Venice, and is on one of the
smallest size of copper plates bought from
Hughes & Kimber in London.

It is one of Whistler's most delicate Venet-
ian etchings, with only the briefest touches of
linework defining the gondoliers, the quiet
waters barely interrupted by shadows, the dis-
tant buildings, and clouds hanging low in the
sky. It relies largely on the variety of the etched
line. It confirms Frederick Wedmore's convic-
tion that 'Whistler has occupied himself
increasingly, and … with high triumph, not
with how to imitate … and transcribe, but with
how to imply and suggest'.[1]

Impressions of the subject are not enhanced
by dramatic areas of tone, but generally are
marked by an overall misty quality that high-
lights the dark linear touches. Whistler drew on
the copper plate with an extraordinarily light
hand in precisely the right places, structuring a
great distance in space. A sense of stillness per-
vades the scene: Whistler locked in a moment,
as if with a camera, or looking backward in
time, emulating Rembrandt's sparely drawn
etching, 'The Goldweigher's Field'.

In later impressions the wear on the plate
had taken a toll; and when printed in lighter
coloured ink, the drawn forms lack emphasis
and the space is less clearly structured than
here.

Whistler and, after 1888, his wife often sig-
nified impressions they particularly liked with
tiny 'o' or 'oo' annotations. This impression
was given such approval.

115 Upright Venice 1879–80

Etching and drypoint printed in dark
brown ink on laid paper
Plate: 25.1 × 17.8 (9⅞ × 7)
Sheet: trimmed to platemark
Signed on plate with butterfly
Signed with butterfly and 'imp' in pencil
on tab
PROV: Purchased from Colnaghi,
London (dealers) 1968
LIT: Mansfield 1909 (202); Kennedy 1910
(205 II/II)

Hunterian Art Gallery, University of Glasgow

Published in *A Set of Twenty-six Etchings*

This plate appears to have been started during
the winter of 1879–80. In composition it is like
Whistler's pastel, 'The Brown Morning – Win-
ter' (Private Collection; M 746), which shares
the same high horizon and vertical format. The
view is taken from the far eastern end of the
Riva degli Schiavoni. In the first state, Whistler
etched only the top third of the plate, contain-
ing the distant view west towards Santa Maria
della Salute, and the Grand Canal. A few gon-
doliers provided a suggestion of the waterway
activity on the Grand Canal, and the sky
offered clues to the atmospheric conditions of
the day, so important to Whistler's renditions
of Venice. It was a quiet scene, not very differ-
ent in its mood of serenity from 'The Little
Lagoon' (no.114). After setting the print aside,
possibly considering it finished, Whistler
returned to it several months later.[1]

In the summer of 1880 when he completed
this etching, Whistler was increasingly con-
cerned with 'finish'. He felt the pressure of the
commission to complete a set of etchings. This
was probably completed, looking from an
upper floor in the Casa Jankowitz at the eastern
end of the Riva where Whistler and Maud
stayed for a while in a room adjacent to one
rented by the American Otto Bacher, painter
and etcher, one of those associated with the
'Duveneck boys' (see no.123). Whistler took
advantage of Otto Bacher's printing press, to
pull proofs of his etchings, including this one.

This second state impression shows the
completed scene. Several boatmen have been
added, and groups of figures punctuate the
Riva in the foreground. Whistler suggested a
sense of comradeship and interaction without
any distinguishable facial expression. One of
his great achievements is this ability to impart a
rich narrative without ever falling into an illus-
trative mode.

The even wiping of ink across the plate gives

a glowing, sunny look to the scene. Most impressions of 'Upright Venice' carry a light overall surface tone that allows the focus to remain on the linework. Two subsequent states of the print are altered by slight modifications, for example to reflections of the gondolas. The printing of this plate was accomplished apace, by January 1887, including the twelve extra impressions.

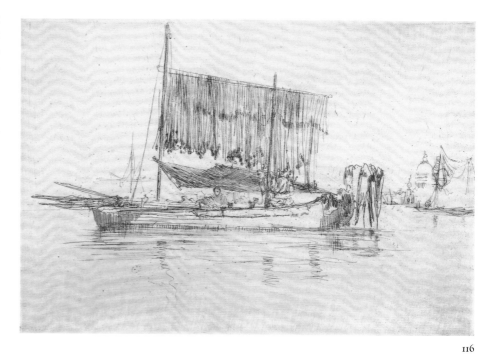

116

116 Fishing-Boat 1879–80

Etching and drypoint printed in dark brown ink on laid paper, a sheet from a book with binding holes along the right edge, with watermark 'C Taylor'
Plate: 15.5 × 23.2 (6¼ × 9⅛)
Sheet: 19.4 × 23.8 (7¾ × 9⅜), irregularly trimmed
Signed with butterfly and 'imp' in pencil
PROV: Metropolitan Museum of Art 1917
LIT: Mansfield 1909 (205); Kennedy 1910 (208 III/V)

The Metropolitan Museum of Art. Harris Brisbane Dick Fund, 1917

Published in *A Set of Twenty-six Etchings.*

In 1886 Frederick Wedmore wrote of the Venetian etchings that 'some of us thought at first they were not satisfactory because they did not record the Venice which the cultivated tourist, with his guidebooks and his volumes of Ruskin goes out to see ... For him, the lines of the steamboat, the lines of the fishing tackle, the shadow under the squalid archway, the wayward vine of the garden, had been as fascinating, as engaging, as worthy of chronicle as the domes of St. Marks ... His subject was what he saw, or what he decided to see, and not something that he had heard about.'[1]

Among his Venetian etchings this is Whistler's only study of a single vessel, close up. It is a portrait of a fishing boat, nets hung up to dry. It was probably etched in the summer of 1880, when working from a gondola out on the lagoons had distinct advantages over the steamy heat of the city. While hardly described in meticulous detail, the boat is nevertheless reminiscent of the carefully wrought sailing vessels and barges that played a central role in the Thames prints.

The plate is known in five states, but most of the work added and deleted was on the figure seated in the boat, and on the awning that shades him. The short drypoint strokes that modulated the hanging net in the second state

wore down immediately and are barely visible on this third state impression. Thus there is a greater sense of openness here, of air flowing through the nets. The barest of differences in tone between the surfaces of sky and water are indicated with extreme subtlety.

'Fishing-Boat' apparently was among the earliest editions to be completed. The plate was turned over to Dowdeswells before the end of 1886 and, with others from the set, is in the collection of the Art Institute of Chicago.

117

117 Fishing Boats 1879–80

Chalk, charcoal and pastel on brown paper laid down on board
29.6 × 20.2 (11⅝ × 7¹⁵⁄₁₆)
Signed with butterfly
PROV: Louis Huth by 1886; his widow, later Mrs A.B. How; sold after her death, Christie, London 24 April 1925 (98) bt D.C. Thomson, London (dealer); Carroll Carstairs, New York (dealer); bequeathed by Mary Hanna to Cincinnati Art Museum 1956
EXH: London, FAS 1881 (47); London, Grosvenor 1888 (4, 85, 88 or 89); Cincinnati 1965 (4)
LIT: MacDonald 1994 (819)

Cincinnati Art Museum. Bequest of Mary Hanna
[Exhibited in Washington only]

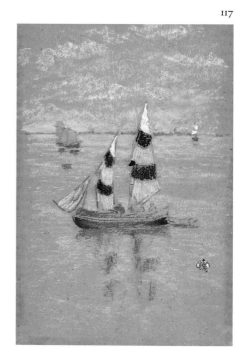

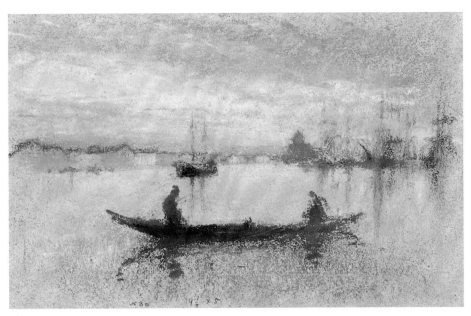

118

D.C. Thomson said that this was 'a Drawing very much liked by Whistler himself'.[1]

In 1881 E.W. Godwin called it 'a most powerful mosaic of black and gold'.[2] The *Observer* praised the drawing of the water despite 'the characteristic ugliness of the black and yellow sails'.[3]

Although dominated by the dramatic white, yellow and black striped sail in the foreground, it represents several fishing boats, spread in a great triangle across the lagoon. The frame may have been the original and matched the yellow gold of the sail and its reflection. In a cartoon which appeared in *Punch* (and which was framed and hung by Whistler in his exhibition in 1881) the nearest sails were turned into a series of sinister Pierrots.[4]

The pastel required at least four sessions to complete. Since Whistler could hardly expect to draw the same boats several days running, he possibly completed the pastel in the studio.

The figures and boat were drawn with soft, disjointed outlines, while a finer line described the distant boat on the left. The sails were filled in with the point of the pastel. Pale blue and grey, drawn with the side of the pastel, and slightly rubbed, suggest the sky and oily sea, and were drawn carefully around the sails so that they stand out boldly on the brown paper. The butterfly is crisper than the rest of the drawing and may have been added later.

This appears to have been one of the few Venice pastels exhibited in London after the first exhibition at the Fine Art Society and was exhibited at the Grosvenor Gallery in 1888. However, the critic of *Nature* wrote 'the effect of a great number of pastels together is wearisome', thus dismissing the whole medium.[5]

118 The Giudecca; note in flesh colour 1879–80

Chalk and pastel on grey wove paper
15.2 × 24.1 (6 × 9½)
Inscribed 'N30 9⅛ × 5'
PROV: Given to the sculptor Sir Joseph Edgar Boehm, London; Macbeth, New York (dealers); Christie, London 27 March 1909 (85) bt Bates; Colnaghi, London (dealers) 1909; Burton Mansfield, New Haven, Conn. 1909; after his death, sold at auction, New York, American Art Association, 7 April 1933 (14) bt J.A. Kalman; George Dupont Pratt, Glen Cove, L.I.; given to Amherst College 1933
EXH: London, FAS 1881 (13); Pittsburgh 1911 (70); New York 1947 (38); Amherst 1956 (54); London & New York 1960 (81); Chicago & Utica 1968 (57)
LIT: MacDonald 1994 (817)

Mead Art Museum, Amherst College, Gift of George D. Pratt, Class of 1893

The broad Canale della Giudecca runs between Venice and the Isola della Giudecca, to the south of the city. The Giudecca is a string of eight islands. The major building on it is the late Renaissance masterpiece, the church of the Redentore.

Otto Bacher, who was one of the 'Duveneck boys' (see no.123), wrote that Whistler 'would load his gondola, which was virtually his studio, with materials, and the old gondolier would take him to his various sketching points.' This pastel was probably drawn from the gondola – a slightly unstable seat. Bacher recorded that 'His gondolier, Cavaldoro, a very handsome sort of man, was hired by Whistler by the month … If he did not ride, he would follow his master, carrying the paraphernalia under his arm'.[1]

The deep blue-grey and brown juxtaposed on the gondola and its reflection produced a more three-dimensional effect than black alone. On the water, faint touches of lemon alternating with strokes of a light red and orange, have a remarkable luminosity. Lemon and orange, blue and grey, smoothed together in the sky, provide a crepuscular glow. The buildings were outlined in black and brown coloured with the white and the flesh colour of the title.

This is one of a group of pastels drawn on grey paper,[2] and although it is not absolutely certain whether this was at the beginning or end of the trip, their bright colours and looser handling suggest that they date from the autumn, shortly before Whistler left Venice in November 1880.

[195]

A few months later, in 1881 Whistler exhibited fifty-three pastels at the Fine Art Society in New Bond Street. E.W. Godwin – who had some influence on Whistler's theories of design – described the effect of the gallery as decorated to Whistler's orders:

First a low skirting of yellow gold, and then a high dado of dull yellow green cloth, then a moulding of green gold, and then a frieze and ceiling of pale reddish brown. The frames are arranged 'on the line', but here and there one is placed above another. Most of the frames and mounts are of rich yellow gold, but a dozen out of the fifty-three are of green gold, dotted about with a view to decoration, and eminently successful in attaining it.[3]

This pastel had place of honour on the south wall of the gallery.[4]

The critic of the *Athenaeum* wrote, 'It is difficult to resist the charm of the silvery and flesh-tones in … *The Giudecca*, which comprises a gondola floating on a calm and exquisitely graded water.'[5]

The *Daily Telegraph* appreciated 'The decorative plan of placing the slender, curved black hull across the picture, on a straight line, is consummately successful in its avoidance of stiffness'.[6] That gondola dramatically dominates the scene. By its size and colour (although not by any change in the level of detail) it defines the surrounding space.

The sculptor Sir Joseph Edgar Boehm was a friend of Whistler for many years and made a bust of the artist in 1872. Whistler appears to have given this pastel to Boehm, and wrote on the back 'To Boehm – whose Art is exquisite and whose sympathy is sufficient'. Boehm, deeply appreciative of 'the ever joy-giving picture' called it 'the bella Venetia!'[7]

119

Santa Maria della Salute is one of five churches built in Venice to celebrate the end of the plague of 1630–1. It is a beautiful white octagonal building, designed by Baldassare Longhena and completed in 1687, which dominates the waterfront of Venice.

The view was probably taken from Whistler's room on the top floor of the Casa Jankowitz, although it could have been drawn from the Riva degli Schiavoni itself. On many evenings Whistler drew and etched the domes of the church, looking out along the Riva into the sun, setting red and yellow through the smoke and dust of the town.[1]

Sometimes he drew with precision, but his later works exaggerated the effects produced by the mists of evening upon its Baroque magnificence. Shapes became increasingly attenuated and distorted. This view of Santa Maria della Salute is like that in the etching 'Nocturne: Salute' (K 226). In both, the actual outlines of the church are unclear in the gathering darkness. However, where the etching is a mirage expressed completely in vertical lines, the pastel is a muted harmony of pink, yellow and dove grey, spread boldly across the sky and in shimmering waves across the water.

119 Sunset: Venice 1879–80

Chalk and pastel on beige paper
12.1 × 24.8 (4¾ × 9¾)
PROV: Thomas Way 1903; possibly
W.H.H. Jessop; Miss K. Jessop by 1973;
Sotheby, London, 14 March 1973 (4) bt
Williams, London (dealer); Spanierman,
New York (dealer), by 1974; Sotheby
Parke Bernet, New York, 23 May 1974
(41G, repr.), bt the present owner
EXH: New York 1984 (84) repr.
LIT: MacDonald 1994 (813)

Private Collection

120 The Riva – Sunset; red and gold
1879–80

Chalk and pastel on brown paper
14 × 26.7 (5½ × 10½)
Signed with butterfly
PROV: Robert Woods Bliss, Dunbarton
Oaks, Washington, DC; William Rolfe,
Jr.; Christie, London, 22 June 1962 (4)

bt Rogers; Mortimer Brandt, New York (dealer), 1962–3; Sotheby Parke Bernet, New York 20 June 1966 (13) bt Agnew, London (dealers); Yale University Art Gallery 11 Oct. 1966
EXH: London, FAS 1881 (6); New Haven 1977 (130, repr.); Claremont 1978 (33, repr.); Ann Arbor 1978 [39]
LIT: MacDonald 1994 (807)

Yale University Art Gallery. Mary Gertrude Abbey Fund
[Exhibited in Washington only]

This is a view of the Giudecca, with the church of the Redentore on the left and Santa Maria della Salute on the right. It was probably drawn from the Riva degli Schiavoni (see no.121), but

120

could have been drawn from a gondola out in the sheltered waterway.

The artist wrote home to his sister-in-law, Nelly Whistler, in the autumn of 1880, 'the pastels … are, and remain even in my present depression, lovely! … complete beauties, and something so new in Art that every body's mouth will I feel pretty soon water'.[1]

In the exhibition of 1881, this pastel was among the most admired and bore the relatively high price of sixty guineas. The *Athenaeum* thought it 'brilliant and effective'[2] and Wedmore cited it as 'One of the most successful examples of a power to reject everything that is superfluous'.[3] The *Observer* commented: 'It is a somewhat lurid but magnificent sunset, and the little waves of the lagoon are glowing, though somewhat sullenly, with red and blue and orange fires. Nothing could be more dexterous than the way in which the dimpled sea is rendered by a few broad lines.'[4]

J.E. Millais was among the visitors to the exhibition, and wrote directly to Whistler to compliment him: 'I was so charmed with your Venice work that I cannot resist writing you a line to say so. They gave me real pleasure. The gradations, tenderness, and lovely tints of sunset, & sea quite delighted me.'[5]

In this sunset scene, the dark brown paper provided the substance of the buildings and the troughs of the waves, and contrasted with the sultry colours of sky and sea.[6] A touch of bright red in the water at left gives an impression of the sun going down, while blue and grey on the buildings accentuated the contrasts which occur just at sunset.

121

121 Nocturne: ships and gondolas, Venice 1879–80

Chalk and pastel on brown paper laid down on card 20 × 29.9 (7⅞ × 11¾)
PROV: Bequeathed by Whistler to his sister-in-law, Miss R. Birnie Philip 1903; bequeathed to the University of Glasgow 1958
EXH: Berlin 1969 (82); London, Liverpool & Glasgow 1976 (86); Glasgow 1984 (113, repr.)
LIT: MacDonald 1994 (801)

Hunterian Art Gallery, University of Glasgow, Birnie Philip Bequest

The Riva degli Schiavoni is the broad and busy quay on the north side of the Canale di San

Marco, running westward from the Molo, in front of the Doge's Palace, to the Ria dell'Arco, and continuing, under different names (Riva Ca' di Dio, Riva San Biagio, Riva dei Setti Martiri) in a sweeping curve around St Mark's basin to the public gardens. From the Riva, gondolas set off through the back canals and across the lagoon. It was a favourite area for Whistler after he moved into the Casa Jankowitz, at the Campo San Biagio, towards the western end of the Riva.

When G.A. Storey ARA was in Venice in 1880 he met Henry Woods and Whistler at Florian's in the Piazza San Marco. 'It was moonlight, and the waters shone like silver, the black gondolas looking intensely dark against them. Whistler was in ecstasies of delight – and made three strokes in his notebook. "I've got it!" he exclaimed – "That's it – that reminds me of the whole scene".'[1]

This is the only record of Whistler using a notebook in Venice – though the dozen sketchbooks in the Hunterian Art Gallery show that he habitually carried one with him. However, Harper Pennington, who arrived in Venice in the autumn of 1880 (see no.123) describes Whistler memorising a view at night: 'He would stand for, maybe, half an hour without speaking or moving, getting the tints and forms by heart and fixing them in mind for the morrow's work.'[2]

This pastel could have been memorised, or started on the spot and touched up later. Two similar pastels drawn from the Riva degli Schiavoni, but looking out towards San Giorgio, are now in the Freer Gallery of Art, Washington, DC.[3] In these, the pointed prows of the gondolas form the foreground, and the sky and water smoothed and scumbled across the paper leave bare the looming towers of San Giorgio.

Here, it is the half-seen masts of the ships that tower above a misty lagoon. The view, across the lagoon from the Riva degli Schiavoni, takes in the domes of Santa Maria della Salute and the grand canal on the right. Colour is used with great restraint – only blue, turquoise and grey, rubbed in. These misty colours suggest infinite space.

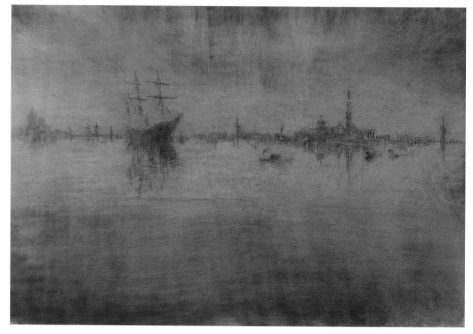

122

122 Nocturne 1879–80

Etching and drypoint printed in dark brown ink on off-white laid paper with watermark: 'FELLOWS | 1804'
Plate: 19.8 × 29.4 ($7^{13}/_{16}$ × $11^1/_2$)
Sheet: trimmed to platemark
Signed in pencil with butterfly and 'imp' on tab
PROV: Gift of Lessing J. Rosenwald to the National Gallery of Art 1943
LIT: Mansfield 1909 (181); Kennedy 1910 (184 IV/V)

National Gallery of Art, Washington. Rosenwald Collection

Published in *Venice: Twelve Etchings*.

The view is from the Riva degli Schiavoni, close to the Casa Jankovitz. In reverse of the site as seen, the dome of Santa Maria della Salute is at left and San Giorgio Maggiore at right. It may have been etched on site or using pastels drawn from the Riva, as was 'Nocturne: San Giorgio' (Freer Gallery of Art, Washington DC; M 803).

Just as Whistler seems to have added a stroke or two after almost every impression of some plates, his use of plate tone also varied from impression to impression.

A spare drawing, almost entirely composed of parallel vertical lines suggesting distant boats and buildings, the gestural and tonal cues provided by Whistler's surface wiping have turned each impression virtually into a monoprint. It is a radical departure from traditional etching.

In each impression distinctive qualities of light and allusions to weather are suggested. In this densely inked impression, the linear work is powerfully overshadowed by the rich layer of colour overall. Whistler first wiped the plate horizontally, paler in the centre and shading out to the darker edges, and then with radiating lines conveyed the last glow of the sun in the darkening sky. One can imagine Whistler at work, wiping the plate with great abandon, shifting the motion of his hand as he developed the sky, with its deep reflections in the gently moving water.

The sequence of the Venetian plates is difficult to work out because the subjects and treatment are so varied. It seems possible that some of Whistler's most innovative works are in fact among the earliest, while those that are most detailed and 'finished' date from later, when he felt the need to satisfy the Fine Art Society's requirements.

'Nocturne' and 'Nocturne': Palaces' (K 202) are particularly radical, with light and at times random hatching unified by the wiping of surface ink across the plate. They must have been conceived from the first as being inked and wiped in this way.

Bacher commented that his monoprints or 'Bachertypes' influenced Whistler in his wiping of plates.[1] This might suggest that this Nocturne was etched in the late summer of 1880, when Whistler was staying at the Casa Jankowitz and borrowing Otto Bacher's printing press to print his copper plates.

However, Whistler's use of surface ink was a fairly logical extension of his earlier printing experiments. Auguste Delâtre would have shown Whistler how to manipulate plates in printing both by leaving areas of surface ink, and by retroussage (the slight dragging of ink on the plate during printing so that each line has an extra richness). Whistler, while appreciating the richness of line in early prints from any plate, had reservations about the use of retroussage to imitate that quality. He experimented in the manipulation of the acid in etching, to gain variety in the strength and shape of the line, and in the use of surface ink.

He also, as a matter of course, made off-prints from etchings (printing a print either onto paper or even onto another plate, to get a reverse image), to help when making alterations to the plate. He had, in the 1870s, worked in ink and watercolour on prints before carrying out amendments on the copper-plate. In some cases, as in a portrait of Miss Alexander (K 139) in the Freer Gallery of Art, the result was more a watercolour, than a print.[2] All these manipulations prepared the way for the printing of 'Nocturne'.

Whistler may have known Degas's mono-types, and may have met Vicomte Napoléon Lepic who was a friend of Degas, and influenced his print-making. Lepic published a pamphlet in 1876, *Comment je devins graveur à l'eau-forte* (Paris) explaining his methods.[3] Furthermore, his work was collected by Whistler's friend George Lucas, and could have been known to Whistler through him.

Whistler's manipulation of 'Nocturne' was so extreme that a contemporary critic wrote:

> 'Nocturne' … can hardly be called, as it stands, an etching; the bones as it were of the picture have been etched, which bones consist of some shipping and distant objects, and then over the whole plate ink has apparently been smeared. We have seen a great many representations of Venetian skies, but never saw one before consisting of brown smoke with clots of ink in diagonal lines.[4]

123 Harper Pennington 1880–2

Chalk and pastel on brown paper
21.4 × 13.8 (8⁷⁄₁₆ × 5⁷⁄₁₆)
Signed with butterfly
PROV: Given by L.J. Rosenwald to the National Gallery of Art, Washington 1943
LIT: MacDonald 1994 (835)

National Gallery of Art, Washington. Rosenwald Collection
[Exhibited in Washington only]

Harper Pennington was born in Baltimore in 1855. He came from a prominent Maryland family, his mother being a descendant of Charles Carroll of Carrollton, a signatory of the Declaration of Independence.

He spent two frustrating years 'drawing charcoal studies of the nude' under Gérome at the Ecole des Beaux Arts. 'What a lot of trouble I might have saved you if I had met you sooner!' said Whistler in 1880.[1] Pennington's first exposure to Whistler's work was in 1876 when he visited the Academy Charity Exhibition in Baltimore at which 'Symphony in White, No.1: The White Girl' (no.14) was exhibited. 'The shock of wonder and of joy with which Whistler's pictures burst upon me was — indescribable'.[2]

In 1880 he went to Munich and was advised to join Frank Duveneck's winter art class in

Florence. In the autumn he arrived in Venice and was introduced to Whistler at the Café Florian. He joined a group of young American artists, the 'Duveneck boys', Otto Bacher, J.W. Alexander and Rolshoven. Whistler enjoyed their admiration. 'The superlatives of youngsters were, I dare say, gratifying', commented Pennington, who became immediately an ardent pupil: 'His extreme patience with us beginners was exemplary, while he gave his counsel and advice as delicately as possible, for fear of seeming to encroach upon the prerogatives of our titular master, Duveneck, who was, himself, an eager listener always.'[3]

It is not quite clear when Whistler made this portrait: probably while still in Venice, when he was habitually working in pastel. It shows Pennington as a dapper figure, the hard outlines conveying, appropriately, a youthful smartness. The grey cut-away jacket with its narrow lapels, the slim dark grey trousers flaring modestly at the ankle, the wing-collared shirt, and the round felt hat with its narrow brim, were in the current European fashion, and of a style popular among the young Venetians. Whistler's butterfly matched Pennington's startling orange tie. Perhaps the drawing celebrated the acquisition of the suit: perhaps it was a demonstration of method – and certainly, Pennington came to use pastel regularly in later years.

Whistler invited the young man to return with him to London but he wanted more time in Italy, to travel and paint. For Katherine de Kay Bronson – the queen of American expatriate society in Venice, a friend and patron of Whistler – Pennington painted a more than competent portrait of the poet Robert Browning.[4] Two or three years later (the records are contradictory) Pennington renewed his acquaintance with Whistler in London.

Pennington took a studio in the King's Road, and visited Whistler in Tite Street, which was always full of admirers – Frank Miles and Oscar Wilde, Waldo and Julian Story, Walter Sickert. Pennington described him as 'more than kind ... he took me about to picture shows and pointed out the good and the bad'. In the National Gallery 'Whistler went at once to almost smell the Canalettos'.[5]

In 1885 Pennington drew Whistler giving his 'Ten O'Clock' lecture, and not long after, Whistler made a pen sketch showing him as a much more portly and respectable figure than he appears in this pastel.[6] He was, with Whistler, a member of the Beefsteak Club, a private dining club in Leicester Square. He

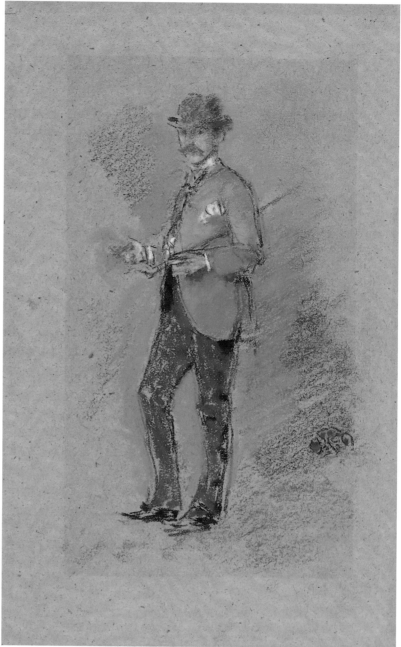

123

acquired a select clientele, which included Edward, Prince of Wales.

He developed a monogram very like Whistler's butterfly, which was, he said 'a simple evolution, – not a conscious imitation'.[7]

He was homosexual, and his straightforward pastels of young boys form an interesting comparison to Whistler's pastels of young girls. Eventually he returned to the States and settled in Baltimore, where he died in 1920 at the age of sixty-five.

Portraits of the 1880s

According to Théodore Duret[1] during the 1880s it took courage to have one's portrait painted by Whistler (no.127). The respectable clients of the 1870s – Leylands, Huths, and Alexanders – largely disappeared after the Ruskin trial, the publicity over Whistler's row with Frederick Leyland, and his subsequent bankruptcy. In their place came the *demi-monde* – the adventuresses Lady Meux (no.124) and Lily Langtry (destroyed; YMSM 227) and the notorious divorcée Lady Colin Campbell (destroyed; YMSM 354). In one case he painted a pint-sized denizen of the Victorian underworld (no.129). Clients with unimpeachable social credentials tended to be close friends like Lady Archibald Campbell (no.130), or else Americans (no.128).

Precisely because so many of these portraits were of sitters with no status to lose, Whistler had a freedom to experiment with costume, pose and gesture that he might not have had with a more conservative clientele. He never forgot his ostracism by the British establishment. After the triumphant success of his 1892 Goupil Gallery exhibition, when he was inundated with requests for portraits, he complained to the Pennells 'why wouldn't they be painted years ago, when I wanted to paint them?'[2]

M.M.

124 Arrangement in Black No.5:
Lady Meux 1881

Oil on canvas 194.2 × 130.2 (76½ × 51¼)
PROV: Commissioned by Henry Meux 1881; in 1900 bequeathed to Lady Meux, who d. 1910; by family descent to Ian Gilmour; Hirschl and Adler, New York (dealers) by 1967; bt Honolulu Academy of Arts 1967
EXH: Paris, Salon 1882 (2687); London, College for Men and Women 1889 (no cat.); London, Grafton Galleries 1893 (46); London & New York 1960 (44) Chicago & Utica 1968 (31, 85)
LIT: YMSM 1980 (228); MacDonald 1994 (850–1)

Honolulu Academy of Art. Purchased with donations from the community and Robert Allerton Fund, 1967

The first full-length portrait commissioned from Whistler after his return from Venice in 1881, 'Arrangement in Black No.5: Lady Meux' is one of three portraits ordered by Mr Henry Meux, who succeeded his father as third baronet in 1883. The sitter was 'so well satisfied' with this portrait that she immediately posed for a second, 'Harmony in Pink and Grey: Portrait of Lady Meux', now in the Frick Collection in New York (fig.81; YMSM 229).[1] A third portrait of the same sitter in furs was begun but destroyed by the artist (fig.82; YMSM 230). According to T.R. Way a fourth portrait in riding habit was discussed but not begun,[2] suggesting perhaps Lady Meux's desire to be immortalised in every new outfit.

Mrs Julian Hawthorne recalled the memorable sight of Whistler at work on this portrait. Mrs Meux stood on a dias some twenty feet from the artist, who 'held in his left hand a sheaf of brushes, with monstrous long handles; in his right the brush he was at the moment using. His movements were those of a duellist fencing actively and cautiously with the small sword.'[3]

Mrs Meux is dressed to kill in a low-cut figure-hugging black velvet evening gown, its mermaid tail fanning onto the floor behind her. The enveloping black is relieved by the full-length white sable stole. She is ablaze with diamonds, including a tiara and necklace, with a bracelet worn over long black gloves.

The Frick portrait could not be more different. It shows Lady Meux in a day dress and is painted in a light palette of soft pinks and greys. In the unfinished portrait she was

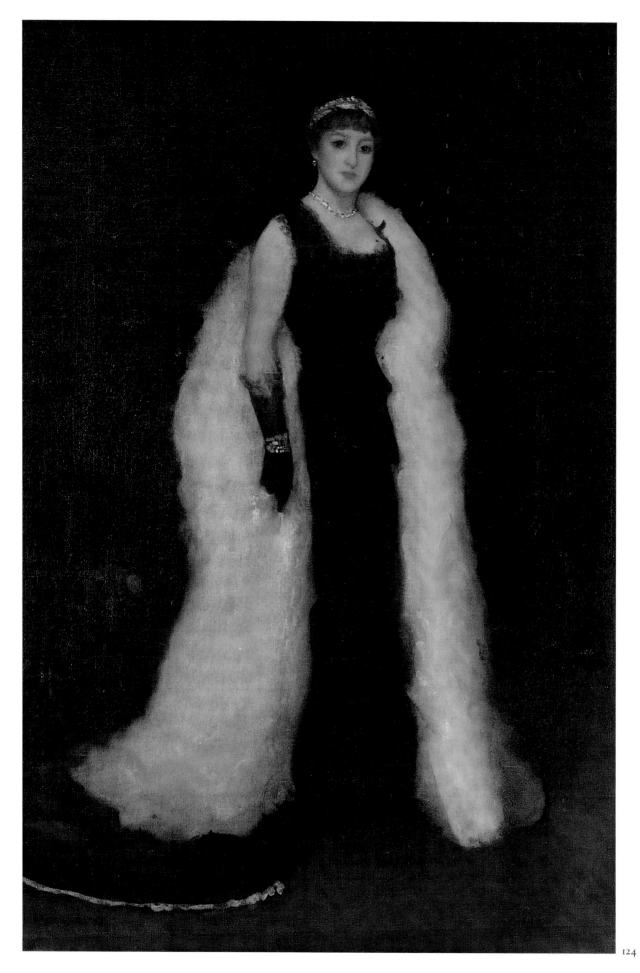

124

swathed in outdoor furs and a muff in tones of crimson and brown. A caricature by C.H.F. Brookfield, reproduced in the *Graphic* of 25 March 1911, shows Whistler at work on all three portraits simultaneously (fig.83).

The cartoon suggests that he approached the triple commission as though painting a single work of art. It is even possible that he intended the portraits to hang in the same room, where the poses, costumes, and nuances of colour and tone would work harmoniously together. Bearing in mind that a fourth portrait was contemplated, we might suggest that Whistler intended to treat the portraits as a series, a modern-day equivalent to eighteenth-century paintings on the theme of the times of day or the four seasons. At the Grosvenor Gallery's second annual exhibition in 1878, James Tissot, whom Whistler had known since 1857, had exhibited just such a series, individual portraits of pretty women in different costumes shown at different times of the year, with titles such as 'July' and 'October' (fig.84).[4]

Valerie Susie Langdon had married Henry Meux in haste and in secret on 27 October 1878. Henry was the scion of a wealthy family of brewers. The beer which bears their name is pronounced 'Mewks', though his family insisted that their name should be enunciated in the French way, as in 'Mews'.

Mews or Mewks, Henry's relations were far from pleased to learn of his alliance. Rumours circulated in London that he had met the future Lady Meux at the bar of the Horseshoe Tavern at the gates of the family brewery in Tottenham Court Road. Though Valerie always claimed to have been an actress, to an embarrassingly large number of young men about town she was known to have worked under the name of Val Reece at the Casino de Venise in Holborn, a dance-hall well known as the haunt of prostitutes.[5]

And to cap all this, Henry's mother, a daughter of Lord Bruce and granddaughter of the Marquess of Ailesbury, was indignant to learn from the scurrilous magazine *Truth* that her new daughter-in-law had cohabited for a time with a certain corporal Reece. 'I never for an instant thought it possible [Henry] should be mad enough to *marry* any lady of that class', she wrote. To Henry's grandmother the Dowager Marchioness of Ailesbury, Valerie wrote in her own defence, 'I can very honestly say that my sins were committed before marriage and not after', not perhaps realising that in the strict moral code of Victorian society, a lady was not supposed to admit to having committed any sins at all. But by then it was too late. 'Being impressed with the necessity of presenting his wife with jewels worthy of her birth and station' Henry had bought Val £10,000 worth of diamonds – jewels she is wearing in Whistler's portrait of her.

But neither jewels, nor residences both in fashionable Park Lane and at her husband's seat Theobald's Park in Hertfordshire, nor her collection of Egyptian antiquities, nor even Henry's succession to the title in 1883 gained Val the respectability she sought. She was received neither by her husband's aristocratic family, nor by polite Victorian society. In her will she exacted revenge, excluding the Brudenell-Bruce family 'by reason of the omission on their part and on the part of members of their respective families to properly receive me as the wife of my late husband'.

It was traditional in English society for a woman to have her portrait painted soon after making a great marriage. But when Mrs Meux made her way to 13 Tite Street in 1881, introduced to Whistler through Charles Brookfield, it was precisely because she was already an outcast in Victorian society that she had the courage, or rather recklessness, to choose to be painted by so notorious an artist. In this portrait she and Whistler collaborate together in the creation of an image of a 'grand dame'.

Though not delivered to Sir Henry until 1889, 'Arrangement in Black: Portrait of Lady Meux' was sent to the Salon of 1882. In a letter to Henri Rouart on 2 May Degas described it as 'Un Whistler étonnant, raffiné à l'excés, mais d'une trempe!'.[6]

It is somehow appropriate that the Prince and Princess of Wales visited Whistler's studio to see the portrait. If the future Edward VII admired Lady Meux's buxom figure and the vulgar exuberance with which she displays her newly acquired wealth, she was a figure who belonged not to the stuffy age of his mother Queen Victoria, but to the much freer society of Edwardian England.

125 Arrangement in Black – No.3

1881

Pencil, pen and brown ink on off-white
laid paper 17.7 × 11.2 (6¹⁵⁄₁₆ × 4⅜)
Signed with two butterflies
Inscribed 'Arrangement in Black – No.3.'
PROV: E.G. Kennedy, New York
(dealer) by 1891; Sessler, Philadelphia
(dealer) by 1928; L.J. Rosenwald of
Philadelphia, on 25 June 1928; given to
the National Gallery of Art,
Washington 1943
LIT: YMSM 1980 (228); MacDonald
1994 (851)

*National Gallery of Art, Washington. Rosenwald
Collection*

Whistler's correspondence with Lady Meux
suggests a close and even intimate relationship.
'You and I', she wrote, 'always get on well
together I suppose we are both a little eccentric
and *not* loved by *all* the world.'[1]

The paintings portray a voluptuous and
fashionable woman, the satin sheen of her
dresses caressed with the brush, her sensual fea-
tures set off by pastel colours. Whistler called
his 'Arrangement in Black', his 'beautiful Black
Lady',[2] while Théodore Duret, who saw him at
work on it, saw in the effect, 'quelque chose de
mystérieux et de fantastique.'[3]

Whistler made sketches of all three paint-
ings.[4] They are bright, with jagged lines, and
concentrate on the dress and composition, rather
than the face. Lady Meux was probably not pre-
sent at all. They are preliminary sketches intend-
ed to plan the pose and convey the total effect of
the portraits, but there is no way to distinguish
them from sketches done after the portrait when
it was more or less completed.

'Arrangement in Black, No.5: Lady Meux'
(no.124) was completed by October 1881. This
drawing almost certainly dates from 1881. The
rough frame sketched round the drawing shows
that it was a plan for, or drawing of, the paint-
ing, rather then a separate drawing of Lady
Meux.

The drawing was done with considerable
force, in an angular, jerky style. The back-
ground is pale, the dress, which Whistler
worked over more than once, dark brown.
Fussy, fine lines of shading run down the soft
swelling robe. The pen butterfly, almost con-
cealed by the scrawled shadows, is contempo-
rary with the drawing – the pencil one was
added ten years later, in 1891, when the Ameri-
can dealer, E.G. Kennedy brought the drawing,
'Arrangement in Black, No.3' to Paris for
Whistler to see.

126 Harmony in Crimson and Brown

1881

Pen and brown ink on cream laid paper
16.7 × 9.7 (6⁹⁄₁₆ × 3¹³⁄₁₆)
Signed with two butterflies. Inscribed
'Harmony in Crimson and Brown–'
PROV: E.G. Kennedy, New York
(dealer) by 1891; Kennedy, New York
(dealers) Feb. 1951; bt present owners
1961
LIT: YMSM 1980 (230); MacDonald 1994
(853)

Joseph and Roth Solman, USA

The third portrait of Lady Meux, clad in win-
ter sables, had a turbulent history. In October
1881 it was on exhibition in Whistler's studio,
clearly unfinished, and Mrs Hawthorne wrote
that it was 'treated in a subdued tone of brown
and brownish-red ... the figure is enveloped in
a long brown fur cloak reaching nearly to the
feet' (fig.82).[1]

The drawing may date from this time. The
figure, face brightly lit, emerges from the shad-
ows, heavily worked with glossy ink. The pen
lines are broad and passionate. Fine, agitated
lines create an appropriate furry effect.

The discomfort of posing in furs must have
been severe. Since the furs were packed away for
the summer, the opportunity for sittings was
limited. In December 1884, when Whistler
made a second sketch of the painting within its
frame, it looked almost completed. Slightly
more detail of the head and hat were noted than
in the earlier drawing. Menpes wrote that 'The
pen-holder and the finger were freely used as a
brush in the execution of the drawing.'[2] Sittings
dragged on and on. In 1886 Whistler was furi-
ous because Lady Meux sent her maid to pose
'in borrowed furs'.[3]

Harper Pennington (see no.123) witnessed
one of the last sittings. Whistler was nervous
and impatient and she lost her temper: 'See here
Jimmy Whistler!' she said, 'You keep a civil
tongue in that head of yours or I will have in
some one to *finish* those portraits you have made
of me!'[4] Lady Meux finally gave up in 1889 and
had her furs remodelled, and the oil remained
unfinished and was presumably destroyed.

A couple of years later, in 1891, the New
York dealer, E.G. Kennedy, brought eleven
drawings, including two of 'Lady Meux' (see
no.125) to Paris for Whistler to see.[5] It was
probably then that Whistler signed them again,
with tiny pencil butterflies.

Lady Meux had not entirely done with
Whistler. In 1892, when he was in Paris, she
wrote saying that she thought of being painted

125

126

in a new dress, something quite different: 'If you *ever* paint me again I should like you to paint me in something *dreamy* I look best in soft colours.'[6] There is the faintest suggestion of reproach in the letter: after all, two out of the three portraits of Lady Meux showed her in black and brown, and only one in those 'soft colours'! But perhaps he had had enough of her whims, or Sir Henry had had enough of Whistler, for nothing came of it.

127 Arrangement in Flesh Colour and Black: Portrait of Théodore Duret 1883–4

Oil on canvas 193.4 × 90.8 (76⅛ × 35¾)
Signed with butterfly
PROV: Bt from Whistler by Duret c.1885; sold to the Metropolitan Museum of Art, New York 1913
EXH: Paris, Salon 1885 (2460); London 1905 (10)
LIT: MacDonald and Newton 1987, pp.150–4; YMSM 1980 (252)

The Metropolitan Museum of Art. Wolfe Fund, Catherine Lorillard Wolfe Collection, 1913

The son of the wealthy owner of a brandy business from the town of Cognac in the province of Charente, Théodore Duret published his first book of art criticism in 1867. By the time his *Histoire des peintres impressionnistes* appeared 1878, he had become an eloquent supporter of Degas, Manet and the Impressionists. He was also a collector, traveller, (crooked) art dealer,[1] and boulevardier, christened by his friend Manet 'the last of the dandies'.[2]

Manet met Duret in a restaurant in Madrid in 1865, soon after the scandal caused by the exhibition of 'Olympia' at the Salon. He introduced the critic to Whistler in November 1880.[3] In March 1881 Duret published a perceptive review of Whistler's art in the *Gazette des Beaux-Arts* which led to a renewed interest in Whistler's work in Paris.[4]

In 1883, over dinner in London, the conversation turned to a portrait then on exhibition showing the president of some official body wearing his red robes of office. Whistler and Duret agreed that the convention was absurd. This was hardly an original observation. In his review of the Salon of 1846 Baudelaire had asked painters to accept modern costume, 'Great colourists know how to get an effect of colour with a black suit, a white neck-cloth, and a gray background'.[5]

Duret and Whistler enlarged on the subject. 'Now evening dress', Duret wrote, 'was the suit in which gentlemen in England passed a portion of their life; they wore it at dinner, in society, at the theatre, at a ball, and yet nobody was ever painted in it. Was it then so ungraceful, and did it offer such difficulties of execution that painters must systematically avoid it.'[6]

In fact Whistler had painted Frederick Leyland in evening dress a decade before (YMSM 97), and Duret himself had posed as one of the gentlemen in evening dress and top hats in Manet's 'Masked Ball at the Opera' of 1873–4 (National Gallery of Art, Washington, DC). Perhaps remembering that very picture, Whistler asked the critic to bring a pink domino, a loose evening cloak, to his first sitting. Dominos often included a mask to conceal the upper part of the face and were worn by both ladies and gentlemen at masked balls.

Whistler asked his friend to stand in front of a grey hanging to relieve the uninflected black of the evening suit. The domino, falling over Duret's left leg 'allowed [Whistler] to destroy the ugly parallelism of the two sides of the body and to diversify the contours'.[7] But it did more than this. The pink domino is itself a gorgeous decorative adjunct, shot through as it is with orange and lilac. Its colour is if possible intensified by the presence of the crimson fan, painted in one long sweep as though the artist had not lifted his brush from the canvas.

When writing their biography of Whistler, the Pennells record how, on a visit to Duret's Paris apartment, the critic took a sheet of white paper, cut a hole in it, and placed it against the background, 'to prove that the grey, when surrounded by white, is pure and cold, without a touch of rose, and that Whistler got his effect by his knowledge of the relation of colours and his mastery of the tones he wished to obtain'.[8] The title 'Arrangement en couleur chair et noir', however, is not Whistler's, but was given to the picture by Duret in 1904.

But to concentrate on these technical and formal problems is to overlook the strong narrative dimension of the portrait. In asking Duret to pose holding a fan and what we may presume from its colour to be a lady's cloak, and in instructing him to remove his top hat as though in deference to a lady, Whistler renders his sitter passive, a slightly ridiculous figure at the mercy of the woman for whom he is waiting. We may compare the isolated and slightly overweight Duret to Jean-Antoine Watteau's depiction of a

character from the Commedia dell'Arte, the bovine clown Gilles, alone on stage in his famous 'Le Grand Gilles' 1717–19 (Musée du Louvre, Paris).

As with the portrait of Lady Archibald Campbell, which Whistler was painting simultaneously with Duret (no.130), the pose implies the presence – or, perhaps, better, the absence – of a companion. One might contrast Lady Archibald's commanding hauteur with Duret's impotent passivity, and suggest that in the portrait of Duret, Whistler implies the triumph of the female, a subject Tissot was to explore in his series of full-length oils 'Les Femmes de Paris' which he began in 1883.

Whistler was certainly aware of Manet's vigorous but relatively small-scale portrait of Duret wearing an elegantly informal grey suit, painted in 1868 (Musée du Petit Palais, Paris).

Indeed, Whistler and Manet had enjoyed a stimulating creative rivalry, each occasionally exploring ideas first developed by the other.

In his portrait, Manet crammed his figure into the canvas, the tip of Duret's shoe touching its lower edge, his hat close to the top. Manet's delightful still life in the lower foreground is known to have been an afterthought, to add colour to a nearly monochrome canvas, and correct the balance of a composition in which the sitter would otherwise seem isolated in the empty space to his left and right.

On the other hand, in Whistler's picture the standing figure is placed well back within the surrounding space. His broad treatment of the sitter's costume and elimination of extraneous details were conceived from the beginning in terms of a complete and unified decorative effect. As well as paying homage to Manet, who died in the year this painting was begun, Whistler's picture is also a subtle criticism of a particular portrait.

Duret's growing collection, which eventually included no less than eight paintings by Degas, six by Manet, two Courbets, three Cézannes and works by Morisot, Corot, Pissarro, Renoir and Sisley as well as Whistler's own 'Nocturne: Grey and Silver' (no.50) may well have been another factor in Whistler's wish to paint the critic in 1883. As in the case of the Cassatt family (see nos.128, 129) Whistler was acutely sensitive to any opportunity to place one of his pictures in such distinguished company.

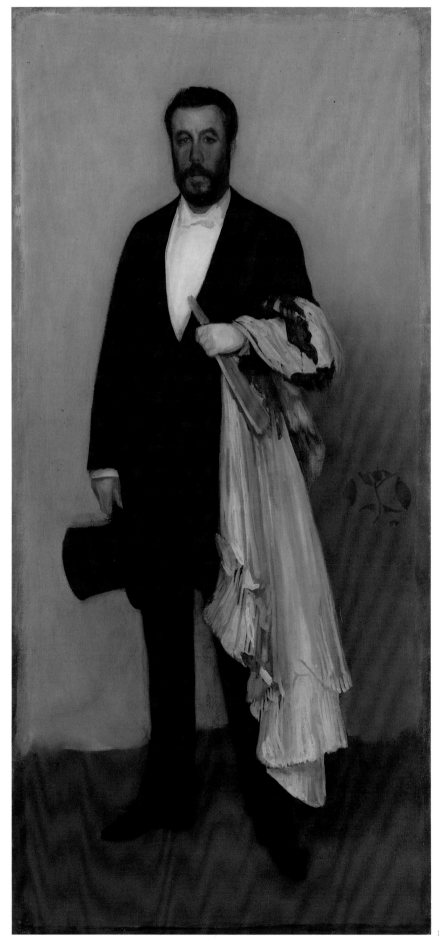

127

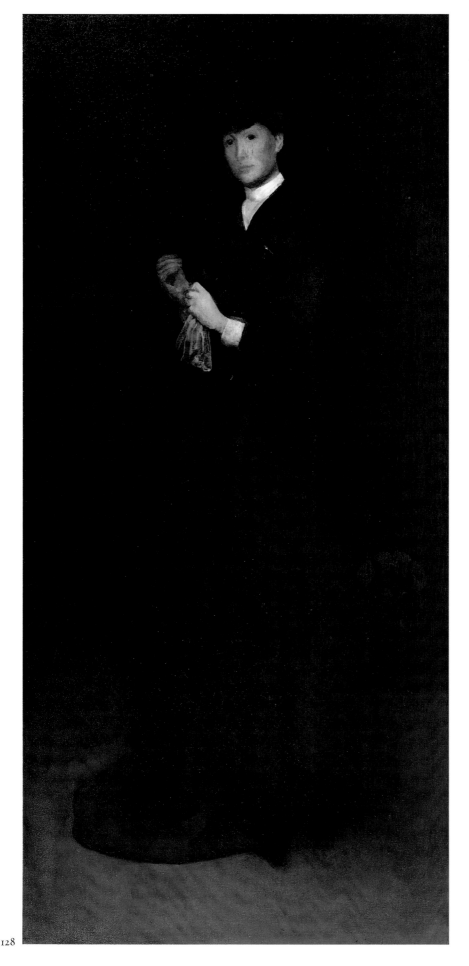

128

128 Arrangement in Black, No.8: Portrait of Mrs Cassatt 1883–5

Oil on canvas 191.1 × 90.8 (75¼ × 35¾)
Signed with butterfly
PROV: Commissioned by the sitter's husband, Alexander J. Cassatt 1883; by descent; Hirshl & Adler, New York (dealers) 1989; purchased by the present owners 1989
EXH: London, SBA 1885–6 (362); New York (II) 1894 (355); Boston 1904 (45)
LIT: YMSM 1980 (250)

Mr and Mrs Donald L. Bryant, Jr

The Philadelphians Alexander J. Cassatt and his wife Lois were at the end of a long European tour when they arrived in London on 2 April 1883. The following day they went to Whistler's studio at 13 Tite Street, Chelsea, to commission this portrait of Mrs Cassatt, the first Whistler to enter their collection, which otherwise consisted of French Impressionist paintings.

The guiding spirit behind their acquisitions was Alexander's sister, the painter Mary Cassatt, follower and close friend of Degas. On her advice, Alexander acquired eight Monets, four Renoirs, three Manets, two pictures by Degas, one Morisot and at least four Pissarros. When these pictures were shown in New York at Durand-Ruel's in 1886 along with those from the Erwin Davis and Havemeyer collections, they helped to initiate the American interest in Impressionism.[2]

Ironically, Mary Cassatt had recommended that her sister-in-law be painted by Renoir, but after visiting the artist in his studio, neither Mr nor Mrs Cassatt liked the pictures they saw there, and instead approached Whistler.[2] For his part, Whistler seems to have been well aware of the importance for establishing an American reputation of placing one of his full-length portraits in such a collection. When he was packing the portrait to send to Mr Cassatt in Philadelphia, he included in the case a second example of his work, 'The Chelsea Girl' (no.129) as a gift for his patron.

Though he experienced the usual delays in completing the picture and handing it over to his patrons, Whistler was careful not to quarrel with this particular couple. Alexander and Lois Cassatt represented a breed hitherto rare in Whistler's personal experience – genuine American aristocrats. Alexander Cassatt, with residences in both Rittenhouse Square in Philadelphia and in the suburb of Haverford, Pennsylvania, was president of the mammoth

Pennsylvania Railroad, a man of immense wealth and social prestige. Mrs Cassatt was born Lois Buchanan, niece of James Buchanan, the fifteenth President of the United States.

Daily morning and afternoon sittings took place in Whistler's studio during most of April 1883. Whistler was painting against the clock since the Cassatts sailed at the end of the month. After their return to America on 28 April, Whistler continued to work on the portrait, exhibiting it at the Society of British Artists in 1885–6. He finally despatched it to Philadelphia only in 1886 or 1887, but told Mary Cassatt he considered the picture unfinished.

On 14 October 1883 Mary Cassatt discussed the portrait in a letter to her brother. 'I thought it a fine picture, the figure especially beautifully drawn. I don't think it by any means a striking likeness, the head inferior to the rest, the face has no animation but that I believe he does on purpose. He does not talk to his sitters, but sacrifices the head to the ensemble.' She noted however, that 'he would have liked a few more sittings [and] that he felt as if he was working against time … After all, I don't think you could have done better, it is a work of art and as young [John Singer] Sargent said to Mother, this afternoon, it is a good thing to have a portrait by Whistler in the family'.[3]

At first Lois Cassatt commented that the picture 'looked too much like her to be pleasant'.[4] Later the sitter remembered that once 'from something I said Whistler took it that I did not consider it a likeness, nor do I, but he replied, "After all it's a Whistler."'[5] In 1887 the artist replied to a letter to his patron, 'I know it is not a striking likeness – I do not delude myself in the least – and when I come over I will paint you another … with pleasure – Anything in this world rather than that Mrs Cassatt should be obliged to put on her hat & costume and stand in a particular light in order that she may faintly resemble her unfortunate picture.'[6]

Before he began work on the portrait, Whistler had visited Mrs Cassatt in her hotel to chose her outfit. According to her, 'He spent more than one hour in deciding which dress I should wear in the portrait & finally after trying on five he decided in favor of the riding habit, much to my disappointment. I had thought I would like a nicer style of painting than that.'[7] Her son, a schoolboy in Switzerland, told his father that 'Mama is mad at having her picture painted in Riding Habit'.[8] Though he was too polite to say so, it is entirely possible that when Whistler ruffled through the dresses in the American lady's wardrobe, he found nothing that satisfied his artistic eye.

Nevertheless the choice was not inappropriate. Mrs Cassatt was officially in mourning for another sister-in-law, Lydia Cassatt, who had been interred at Marly, outside Paris, on 6 January 1883. Even more important, Alexander Cassatt's leisure was devoted to his great avocation, horses and horsemanship, a passion which his wife shared.

Whistler had first shown a woman in a black riding habit in the 1860–1 painting, 'Harmony in Green and Rose: The Music Room' (fig.2 on p.14; YMSM 34). He returned to the theme in his 'Portrait of Miss Leyland' of c.1871 which is almost identical in pose to no.128 (whereabouts unknown; YMSM 109). He painted a variation on the theme in 'Miss May Alexander' of c.1875 where the sitter wears a riding habit of fawn colour, with gloves and a large picture hat (Tate Gallery; YMSM 127). He painted Rosa Corder, an accomplished horsewoman, in riding dress in 1878 (see no.66). In the 1880s he planned but did not begin a portrait of Lady Meux in a riding habit (see no.124).

Whistler's interest in depicting women in riding costume has many counterparts in French and English art. Both Courbet and Manet had been drawn to the subject of the Amazon, or horsewoman. Whistler may not have known Frederic Leighton's early masterpiece 'May Sartoris' c.1860 in her black riding habit, then in a private collection, but he was certainly familiar with British sporting pictures, and particularly those of Francis Grant, many of which show elegant ladies in hunting costume.

In his influential essay 'The Painter of Modern Life' Baudelaire praised the beauty of the 'amazons', the fashionable ladies who rode in the Bois de Boulogne. Hippolyte Taine, in his *Notes sur l'Angleterre*, published between 1860 and 1870, was severe on British women's lamentable want of taste in dress. An exception was the horsewomen he saw in the park wearing 'riding habit[s], black, close fitting to the torso, simple and without ornament, denoting boldness, agility, strength, physical well-being'.[9] From Manet Whistler may have noted the motif of the woman drawing on her gloves in 'The Balcony' 1868–9 (Musée d'Orsay, Paris) and used it in his portrait of Mrs Cassatt. A similar motif has a notable precedent in Carolus Duran's 'La Dame au gant' 1869 (Musée d'Orsay, Paris).

The frame, which is original, was designed by Whistler.

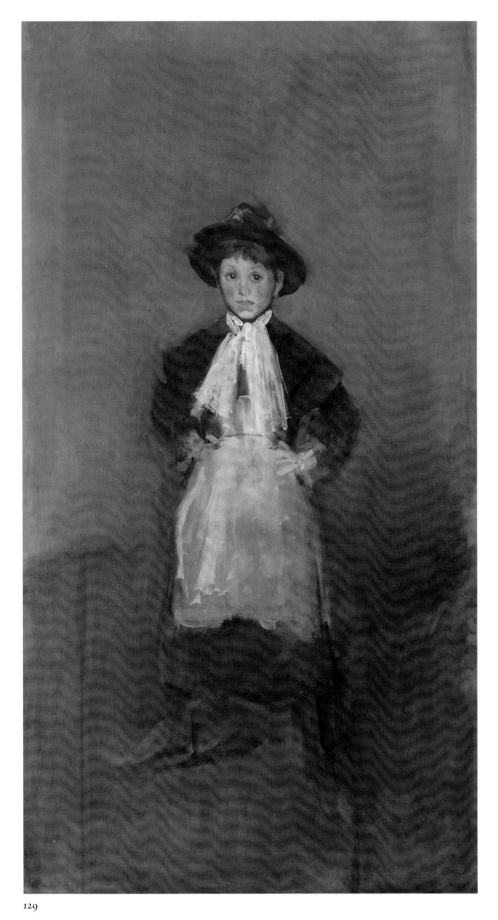

129

129 The Chelsea Girl 1884

Oil on canvas 165 × 89 (65 × 35)
PROV: Given by the artist to Alexander
J. Cassatt 1886; after his death in 1906 by
descent to M and Mrs W. Potter Wear
and thence to the present owner
EXH: Chicago 1893 (744); Philadelphia
1893-4 (26); Boston 1904 (48); London
& New York 1960 (51); Chicago & Utica
1968 (36)
LIT: YMSM 1980 (314)

Private Collection

In 1893 Whistler wrote to the organisers of the
Columbian Exhibition at Chicago describing 'The
Chelsea Girl' as 'the sketch of *one afternoon* – or
rather the first statement or the beginning of a
painting – I am not *excusing* it mind – for of
course it is a damn fine thing'. But it was not,
he wrote, 'a *representative* finished picture!' by
which America could judge him at his best.[1]

Yet it is precisely as 'the first statement of the
beginning of a painting' that it has been partic-
ularly valued. It shows the degree of finish
Whistler could attain after a first swift laying in
of pigment. According to Whistler's pupil
Walter Sickert, the large full-length portraits
against plain backgrounds 'were not begun,
continued and ended. They were a series of
superimpositions of the same operation, based
on a hope that the quality of each new opera-
tion might be an improvement on that of the
last.'[2]

Sitter after sitter tells us that Whistler rapid-
ly brought his portraits to what in their eyes
appeared to be a state of perfection, only to
return next morning to see the previous day's
work wiped out. Sickert estimated that 'per-
haps thirty percent' of the perpendicular six-
foot canvases were allowed to remain in
existence, and that of the survivors, 'it is prob-
able that the slighter and less well-known will
in time rank as the finest.'[3] In this category he
included 'The Chelsea Girl'.

On 29 June 1884 the *Whitehall Review* reported
that Whistler was painting 'a veritable daughter
of the people, with all the defiance of an
offspring of the *proletaire* in her attitude'. Sickert
said that the sitter was a 'coster child'. She is
dressed in the costume of the London commu-
nity of costermongers, who made their living
selling fruit and vegetables from street barrows.

Around her neck she wears a large yellow
handkerchief or scarf known as a 'kingsman',
without which no self-respecting coster man or
woman would be seen on the streets. The coster
girl 'wore the heavy, cotton print dress typical
of working-class women, cut short enough to

show her stout laced boots. If she was lucky she had a bright-coloured shawl or two.'[4] This particular girl wears a flesh-coloured apron, black shawl, and crushed man's hat.

In choosing a coster child as model Whistler selected one of the picturesque sights of Victorian London, a sight inextricably associated with the city he learned to know as a boy through the study of Hogarth's engravings. Coster children were sent out into the streets early in their lives. They quickly became tough and street smart. Utterly uneducated, they were notorious for the carrying power of their voices, quick repartee, and distinctive brand of humour. One child of about twelve interviewed by Henry Mayhew for *London Labour and the London Poor* said she was 'up to the business as clever as a man of thirty' and could 'chaff down a peeler [policeman] … uncommon severe'.[5]

In mid-Victorian London costermongers had a reputation for unrelenting hostility to the police, living precarious lives on the fringes of the criminal world. By the 1880s, however, their reputation for delinquency was beginning to fade, though they still retained their characteristic slang, dress, and mannerisms. Whistler paints this barrow girl on the scale reserved for ladies of society.

The spread-legged pose, with hands placed jauntily on the hips, is one Whistler first used in the early 1870s in a drypoint of Elinor Leyland (K 109) and pen and ink sketches for his portrait of Grace Alexander, which was never carried out (British Museum; M 506–7). Sir Joshua Reynolds and William Holman Hunt reserved the pose specifically for portraits of boys, in ironic quotation of Holbein's portrait of Henry VIII.

Finally, in choosing a child model, Whistler invited comparison with certain of the most famous works of Velázquez, notably 'Baltasar Carlos as a Hunter' (Museo del Prado, Madrid). In the way the physical space surrounds the subject, 'The Chelsea Girl' could be compared too to Velázquez's 'Pablo de Valladolid' (Museo del Prado) (see also no.205).

According to Whistler's follower, Sidney Starr, the artist impulsively sent this picture as a present to Alexander Cassatt by way of apology for having kept him waiting for the delivery of the portrait of his wife (no.128).[6] In doing so, however, Whistler was undoubtedly aware that the picture would hang in one of the finest early collections of Impressionist paintings in America, which the artist Mary Cassatt was then helping her brother to form.[7]

The frame is decorated with a peacock feather motif and may originally have framed another picture.

130 Arrangement in Black: La Dame au brodequin jaune – Portrait of Lady Archibald Campbell 1882–3

Oil on canvas 218.4 × 110.5 (86 × 43½)
PROV: Bt from Whistler by Alexander Reid, Glasgow (dealer) 1892; purchased for the Wilstach Collection, Philadelphia 1895; passed to the Philadelphia Museum of Art
EXH: London, Grosvenor Gallery 1884 (192); Paris, Salon 1885 (2459); Munich 1888 (2453); Paris, Exp. Univ. 1889 (165); London, Goupil 1892 (41); Chicago 1893 (758); Philadelphia 1893–4 (35); London & New York 1960 (45); Chicago & Utica 1968 (33)
LIT: YMSM 1980 (242)

Philadelphia Museum of Art. W. P. Wilstach Collection

As with his portraits of Lady Meux (no.124) Whistler painted Lady Archibald Campbell three times in three different costumes and poses. He destroyed the first canvas, which showed the sitter, a cultivated aristocrat and enthusiastic amateur actress, in black velvet court dress (YMSM 240). The second portrait, in which she was depicted descending a staircase – in the sitter's words, 'giving the impression of movement' – the artist also abandoned and eventually destroyed (YMSM 241). Work on the second canvas was interrupted by Lady Archibald's departure from London. 'When I returned', she later recalled, 'he asked to make a study of me in a dress in which I called upon him … As far as I remember it was painted in a very few sittings.'[1] This is the third.

It would have been difficult for any model to hold a pose for very long in which she balances all her weight on her right leg. The motif of the beautiful woman turning in mid-stride to glance over her shoulder is reminiscent of Thomas Lawrence's full-length portrait of 'Elizabeth Farren' 1790 (Metropolitan Museum of Art, New York). Such a formal source was particularly appropriate because Miss Farren had been a glamorous actress who married a great aristocrat, the Earl of Derby. Whistler could have seen Lawrence's youthful masterpiece both at the Manchester *Art Treasures* exhibition of 1857 and at the South Kensington *National Portraits* exhibition of 1867.

At the second Grosvenor Gallery exhibition in 1878 James Tissot had exhibited both a small oil study and an etching called 'October' (fig.84).[2] Both works show Tissot's mistress in a chic outdoor costume, raising her skirts provocatively as she casts a coy look at the spectator.

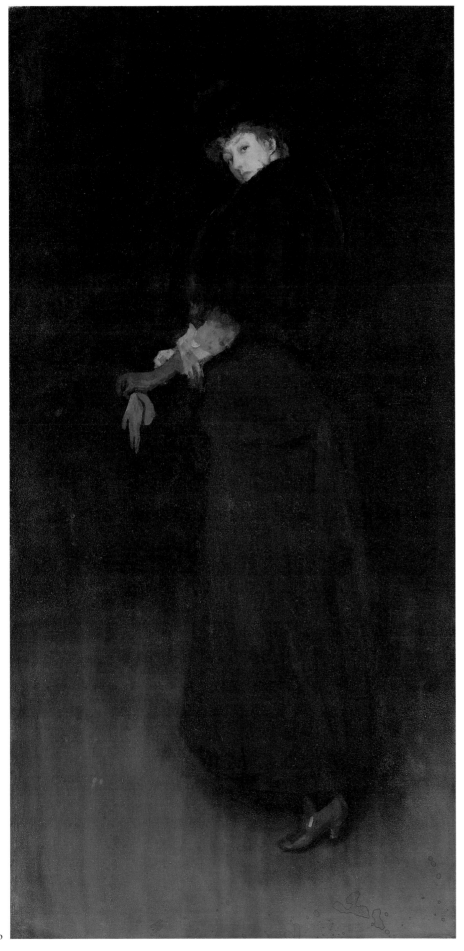

130

Between 1883 and 1885 Tissot would paint a series of large, full-length oil portraits collectively entitled 'Les Femmes de Paris' in which there are echoes of Whistler's portraits of beautiful women from different levels of society in the 1870s and 1880s. That there was competition between the two artists is certain. In a letter to his sister-in-law written from Venice in which he described his new pastels, Whistler added, 'Tissot I daresay will try his hand at once.'[3]

But despite these formal sources, the pose seems to have been misunderstood. According to Graham Robertson, 'the Campbell family rejected it with the delicate remark that it represented a street walker encouraging a shy follower with a backward glance.'[4] The picture was originally exhibited in London, Paris and Munich as the 'Portrait of Lady Archibald Campbell'. Before it won a gold medal at the Exposition Universelle in Paris in 1889, Whistler had changed the title, explaining to Lady Archibald that he had withdrawn 'the name from the work, and the picture ceasing to be a portrait, went forth as the "Brodequin Jaune" under which title only was it known at [the] Exposition Universelle'.[5]

The Campbell family's attitude may in part have been coloured by their experience of one of the most notorious of all Victorian sex scandals, the suit for divorce brought by Lady Colin Campbell against Lord Archibald's younger brother. Their divorce held London spellbound in 1886, involving as it did Lord Colin's accusation of his wife's adultery with no less than three co-respondents. Whistler was also a close friend of Lady Colin's. At the time of the trial she posed for him in a gown by Worth in a picture that is now lost (YMSM 354). And although it is inconceivable that Whistler would have painted a woman such as Lady Archibald in a compromising pose, the portrait is full of ambiguities which make the Campbell family's nervous apprehension perfectly comprehensible.

For a Victorian lady to raise her skirts and deliberately to expose her ankles was distinctly unladylike. In an era where gaudy costumes were worn by both respectable women and the higher class of West End prostitute, the latter relied not on costume but on bold glances and inviting gestures to attract her clients. According to Ronald Pearsall, 'the more expensive street walkers worked to a system. In the winter when it was cold they would congregate in Burlington Arcade ... and when their coy signals were responded to, would glide into prearranged shops to sort out details'.[6]

The picture's subtitle, 'The Yellow Buskin'

also carries a charged sexual connotation. A buskin is a thick-soled half boot, often buttoned, which became fashionable in the 1880s. Colours in shoes had been introduced as early as 1862, but yellow was a colour beginning to be associated with sexual daring. The buskin emphasised a lady's foot and ankle while at the same time concealing it, creating a new erogenous zone in the female body. While apparently innocent, a boot such as the one Lady Archibald displays 'might have been specifically designed for the erotically over-excitable'. Ladies boots became a constant source of sexual innuendo in late Victorian music-hall songs.[7]

It would also be possible to read erotic innuendo into the superbly painted yellow glove in the sitter's right hand. It is as though she intended to drop it in order to tempt a gentleman to pursue her, as is the case in Max Klinger's series of etchings 'The Glove'.[8] However, Whistler was so steeped in the art of Frans Hals, Velázquez and even Titian that the glove is more correctly seen as a tribute to several of the most ravishing passages in their work.

Finally, Lady Archibald's arched eyebrows and bold look was interpreted as a 'come hither' glance. In fact, the look may be more challenging than flirtatious. It is even possible to associate it with an actual incident in which Lady Archibald, under pressure from friends, had come to Whistler's studio one day in a state of some agitation to demand changes in his portrait of her. Duret, who tells the story, strongly implies that the point at issue was the pose itself.[9] When Whistler refused to repaint the portrait, Lady Archibald stormed out of Whistler's studio and into a waiting hansom cab, returning only when Théodore Duret begged her not to deprive the world of a masterpiece.[10]

Whistler, we may imagine, tried to capture the look of inquiry and challenge she shot him just as she was leaving, a look, moreover, which as an excellent actress, she was able to reproduce. In Duret's description of the picture, he hints that disdain is the emotion we are meant to read in Lady Archibald's expression, describing her in the picture as 'grande et svelte, détourné la tête pour donner un dernier regard avant de s'éloigner, type fierté d'élégance.'[11]

The 'Yellow Buskin' is another in Whistler's series of 'Arrangements in Black', which includes 'Lady Meux' (no.124) and 'Mrs Cassatt' (no.128). The brown-black of the fur hat and stole just about registers against the jet black of the upper background, a background which gives way to a lighter black in the lower half of the picture. Lady Archibald remembered Whistler calling her attention to his method of 'placing the subject well within the frame, and explaining that a portrait must be more than a portrait, must be of value decoratively.'[12] When Degas saw the picture at the Exposition Universelle in 1889, what he admired was the way Whistler achieved a sense of endless depth in his black background, telling Walter Sickert 'Elle rentre dans le cave Watteau.'[13]

Whistler became friends with Lord and Lady Archibald at the time of the first Grosvenor Gallery exhibition in 1877.[14] The turbulent marriage of Lord Archibald, a younger son of the Duke of Argyll, to the 'adorable, bewitching yet infuriating' Janey Sevilla Callander, was at any rate more exciting than his work at Coutts Bank.[15] 'The epitome of aestheticism', Janey stood at the centre of a coterie of cultured society figures, including Sir Coutts and Lady Lindsay, Percy and Madeleine Wyndham (see no.49) and Princess Louise, daughter of Queen Victoria, the wife of Lord Archibald's elder brother the Marquess of Lorne. Through his friendships within this circle Whistler could eventually count among his acquaintance the Prince and Princess of Wales.

In 1886 Lady Archibald published an essay on her philosophy of decoration, which centred largely on the effects achieved by Whistler in the Peacock Room, and in which she expounded her own theory of the synaesthetic connection between colour and music.[16]

When Lord Lorne died childless, Lady Archibald's son Niall Diarmid succeeded his uncle as Duke of Argyll.

Maud

Mary Franklin was born 9 January 1857 at Bicester near Oxford, the daughter of Charles Franklin, a cabinet maker and upholsterer, and Mary Clifton. In later years she studied painting under Whistler and exhibited under her mother's name, as Clifton Lin.[1]

She probably first posed for Whistler in place of Mrs Leyland (see no.71) before 1874. She was also the original model for what became a portrait of Florence Leyland (Portland Art Museum; YMSM 107), after Whistler's quarrel with Leyland in 1876–7.

Certainly by 1877 she was installed as Whistler's model and mistress. She was then twenty; Whistler was more than twice her age. Whistler told George Lucas in 1879 'she is very charming and … you will be delighted with her'.[2] The American artist John White Alexander described her as 'not pretty, with prominent teeth, a real British type'.[3]

As a model, she was both sensitive and expressive. She posed for some of his finest paintings (see no.65), for drawings, pastels and watercolours (see nos.131–5) and for etchings and lithographs (no.67).[4] She posed also, both clothed and nude, for Whistler's followers, including Mortimer Menpes and Stott of Oldham (see pp.51–2). Maud had at least two daughters, Maud Mary Whistler Franklin, born 13 February 1879, and Ione, born on 15 October, possibly in 1877, or in 1881 after the trip to Venice. Both were brought up by foster parents, but the young Maud died at an early age. Maud's health suffered, and a number of watercolours in the 1880s show her in bed (nos.132–4).

When Beatrice Godwin and Whistler decided to marry, Maud departed for Paris where she was aided by George Lucas (see no.132). Eventually she married a wealthy New Yorker, and they had a son, John Franklin Little. After her husband's death, she was married again, to another New Yorker, R.H.S. Abbott, and lived in a villa near Cannes until her death about 1941.

M.M.

131 The Yellow Room 1883–4

Watercolour, on white paper laid down
on card 24.1 × 15.8 (9½ × 6¼)
Signed with butterfly
PROV: A.A. Hannay, London by 1896;
Goupils, London (dealers); Scott and
Fowles, New York (dealers) about 1932;
Miss Ellen Henderson; C.C. Henderson,
New Orleans by 1959; private collection;
loaned to St Petersburg Museum of
Fine Arts 1992
EXH: Possibly Dowdeswell, London,
1884 (21); London, Guildhall 1896 (108);
possibly Paris 1905 (ex. cat.); London &
New York 1960 (91): New Orleans 1968
(31)
LIT: MacDonald 1994 (881)

*Museum of Fine Arts, St Petersburg, Florida.
Annonymous Loan*

Maud Franklin, in violet dress, sits in
Whistler's house at 13 Tite Street, which
Whistler leased on 22 March 1881. They were
still redecorating when they moved in two
months later. They lived there for four years,
finally moving into the Vale, also in Chelsea, in
1885.

On 26 August 1881 Alan Cole noted in his
diary that Whistler had talked of 'his new yel-
low room'.[1] The house was decorated, accord-
ing to Pennell, with 'a scheme of yellow'. C.A.
Howell (see no.138) said that 'one felt in it as if
standing inside an egg'.[2]

His sister-in-law, Nelly Whistler, admired it
and asked Whistler to help her achieve a simi-
lar effect. Without his constant supervision,
Nelly had disastrous results. He sent further
instructions:

If the first coat had been as I directed grey
brown – This too crude and glaring
condition of the yellow would not have
occurred –

It is just because of the horrid white
ground – Also why on earth should the
workmen think for themselves that after all
two coats of the yellow upon white would
do just as well as *one* coat of yellow on grey!
– This was so ordered by me because in my
experience the result would have been fair
and at the same time soft and sweet – ...

See that the man gets a tube of 'Ivory
black' from any colorman's and a tube of
'raw Sienna'. Let him put first about a
saltspoon full of the Ivory black into his
pot of yellow paint, 'mix well – and stir' –

this will lower the moral tone of that
yellow! – ... if ... it even looks a little
green – all the better–

Then mix and stir in say half the tube of
raw Sienna – and I should think you would
bring things back to their natural harmony
... and don't be shocked if the *first little daub*
of this new mixture looks dirty on the
bright yellow coat already on the wall ...
remember that when the second coat is all
over the wall you will *only see the second coat!* –
You can't make any mistake – it is not like
the distemper business, because here you
see exactly what you are about in the pot! –
Que Dieu vous garde! –'[3]

There are pots on the mantelpiece, a fan
above the mirror, and a parasol in the grate –
which suggests the watercolour was painted in
the summer – probably in the summer of 1883.
The scene is intimate, and Maud's pose, strik-
ingly casual.

Whistler's American pupil, Harper Penning-
ton (see no.123) described the 'Sunday break-
fasts' at which Whistler entertained his friends
and patrons in the season,

His famous Sunday luncheons were always
late in being served, outrageously delayed
without apparent cause. It was no uncom-
mon thing for us to wait an hour, or even
two, for the eggs, fish, cutlets, and a sweet
dish, of which the meal consisted. A bottle
of very ordinary white wine was our only
drink. The whole thing was, in fact, an
'arrangement' – just a color scheme in yel-
lows to match his 'blue-and-white' old
porcelain and his blue-and-yellow dining
room.[4]

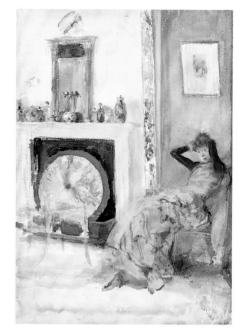

131

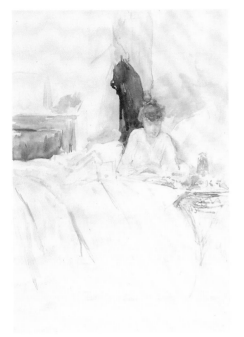

132

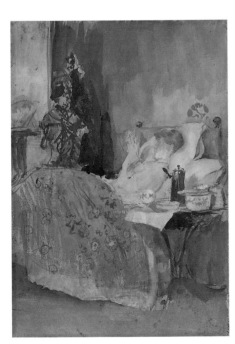

133

132 Maud reading in bed 1883–4

Watercolour on white wove paper
25.1 × 17.5 (9⅞ × 6⅞)
Inscribed on verso by G.A. Lucas, 'This
Aquarelle painted by Whistler from his
model Maud was presented to me by
him. G.A.Lucas. Paris, France.'
PROV: George A. Lucas, Paris; Henry
Walters 3 Aug. 1908; Walters Art Gallery
1937
EXH: New London 1949 (37); London
& New York 1960 (88); New York 1984
(23)
LIT: MacDonald 1994 (899)

Walters Art Gallery, Baltimore, Maryland

George Aloysius Lucas (1824–1909), like
Whistler, failed to graduate from West Point.
After a brief career working with Whistler's
half-brother, George, as a civil engineer on the
railroads, Lucas left Baltimore for Paris, where
he established a flourishing business as an art
dealer and helped exhibit and sell the pictures
of Whistler and his friends.[1]

Over the years, Lucas gave Maud shelter
when she was ill and Whistler too poor or
unwilling to support her. He was fond of
Maud, and treated her generously.

This is one of a series of studies of Maud in
bed, ill or convalescent (nos.132–4). There is a
black coat – a man's coat presumably – hanging
up. A fan on the mantelpiece is painted with a
splash of pink. Maud's pale orangey dress
matches the pattern of the china on her bedside
table. The intimacy of the scene is emphasised
by the untidiness of the room.

Lucas showed the watercolour to E.R. Pen-
nell, saying 'this for the lover of Whistler is
perfect'.[2] Both as an example of Whistler's
work, and as a memento of their friendship, it
had only pleasant associations for him.

Harper Pennington, who frequented
Whistler's studio at this time, said: 'That
Whistler was tender hearted is certain … He
was not in the least cruel. His models constant-
ly spoke to me of the considerate treatment
they received at his hands, of his perfect polite-
ness and thoughtfulness'.[3] He was less thought-
ful when his model was also his mistress. In
March 1886 Lucas recorded Whistler's audacity
in visiting Paris with both Maud Franklin and
Beatrice Godwin.[4] When it became clear, in
October of the same year, that Whistler would
abandon Maud in favour of Beatrice, Lucas was
disgusted with his callous behaviour and
refused to have anything further to do with
him.

Maud moved to Paris, and saw Lucas fre-
quently, 'to relate her separation griefs etc.'[5]
Perhaps they had an affair – Whistler seems to
have thought so – but in any case, for several
years, until she married, Lucas gave her much-
needed support and comfort.

133 Maud reading in bed 1883–4

Pencil, pen, brown ink and watercolour
on tan card 25.1 × 17.5 (9⅞ × 6⅞)
Signed with butterfly
PROV: Possibly the Whistler family,
Baltimore; F. Keppel, New York
(dealer); Mrs John P. Elton, Westbury
by 1949; given by Mr and Mrs Arthur E.
Allen, Jr, to Dartmouth College 1971
EXH: New London 1949 (34);
Dartmouth 1975 (7), pp.17–8 repr.;
New York 1984 (24)
LIT: MacDonald 1994 (902)

*Hood Museum of Art, Dartmouth College,
Hanover, N.H. Gift of Mr and Mrs Arthur E.
Allen, Jr, Class of 1932*

This watercolour of Maud is painted on the
cardboard backing of a block which originally
contained thirty-two sheets of paper. Five
watercolours of Maud Franklin in bed, includ-
ing 'Pink Note – The Novelette' and 'Resting
in Bed' (Freer Gallery of Art, Washington, DC;
M 899–903) are similar in size and were almost
certainly taken from this sketchbook (see
nos.132, 134). 'Resting in Bed' (M 901), the least
finished of these, is the most explicit, showing
Maud as a *demi-mondaine*, with the accessories of
a rumpled bed, a top hat, and a novel. The
other watercolours are more ambivalent, and
although they obviously show the same setting,
Whistler modified the overt licentiousness of
the subject.

This drawing, being on card, was inevitably
painted thickly, and Whistler used gouache so
that the colour would not sink into the coarse
card without trace. Pink and grey flowers on the
pale blue bedcover, a yellow splash on the fan,
and a yellow plate, pink and purple robes hang-
ing behind Maud, brighten the composition.

134 Convalescent or Petit Déjeuner; note in opal 1883–4

Watercolour on white paper 26 × 18.1
(10¼ × 7⅛)
Signed with butterfly
PROV: Dr Isaac Lennox Browne 1884;
Dr John McIntyre, Glasgow by 1888;
auction, Glasgow, McLellan Galleries
1929 (date and lot number unknown);
Reid & Lefevre, Glasgow, and Knoedler,
New York (dealers), 1929; Daniel H.
Carstairs, Germantown, Pa. 1929;
Knoedler; Ronald Tree, New York 1933;
bequeathed to the present owner 1976
EXH: London, Dowdeswell, 1884 (13) as
'Petit Déjeuner; note in opal'; Glasgow
1888 (538) as 'Convalescent'; Glasgow
1901 (1071); London, Whitechapel
Gallery 1903 (214, repr.); London 1905
(48, repr.); London & New York 1960
(89); New York 1984 (26)
LIT: MacDonald 1994 (903)

Private Collection

In the early 1880s Maud Franklin suffered ill health, possibly as the result of pregnancies, and she may have been really ill at the time this series was painted (see nos.132–3).

The first owners of this watercolour were, like Whistler's brother William, specialists in diseases of the throat. They may have given it the title by which it has become known, 'Convalescent', but it is worth noting that the title, though appropriate, was not Whistler's.

This is the most quiet and harmonious of the five studies. At Whistler's first exhibition at Dowdeswell's in 1884, it was described as 'the ghost of a warm-coloured blonde reads a pale blue book in bed, breakfast waiting on the table at her side'.[1] She is indeed somewhat wraith-like, lost in wash on wash of pale whitish blue, right over her and her pillows. The precision of the final touches on her face, and on the porcelain, brings the scene into focus.

The *Standard* commented '"Petit Déjeuner" indicates a lady who has breakfasted in bed, and is reading a novel. A fine frowsiness is delicately conveyed to the sense of the spectator.'[2] The suggestion of the *demi-mondaine*, also seen in no.133, is obliquely suggested.

The 1884 reviews were mildly favourable. The *Artist* thought it 'one of the most graceful and refined drawings in the room. The face and hand are beautifully drawn, full of feeling, and are coloured with that fine sense the artist possesses in such a marked degree'.[3]

There is a subtlety about the diagonal composition – which leads from the table across

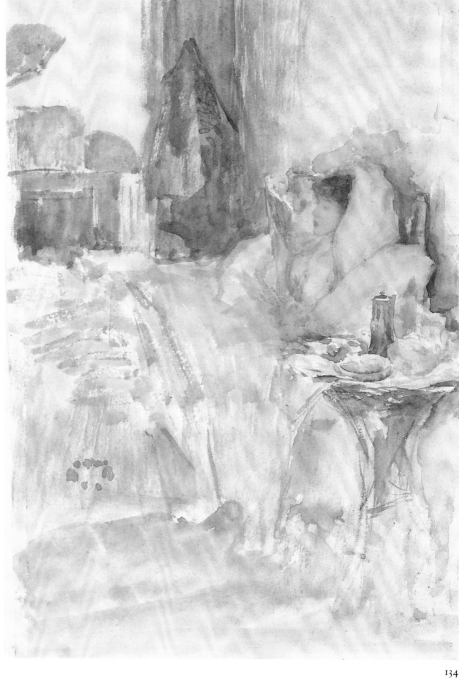

134

Maud to the coat and fireplace. Background, table, butterfly and pot are a harmony of quiet greys, monochromatic except for a few soft dabs of pale colour on the plates and book.

The broad brushstrokes skate over the smooth surface, clearly defining the man's coat hanging up by the bed. A drier brush outlines the curved legs of the table. Bold alternating strokes of yellow and blue-toned greys cross the bed. Sharper, painterly strokes flick back and forth over the table, conveying the sparkle of the breakfast dishes. The brush provides a vari-

ety of textures which animate the surface. There are signs of pentimenti, and her arm was obviously reworked. Whistler took unusual pains with this watercolour and the result is delightful.

135 Note in Red: The Siesta 1883–4

Oil on panel 21.6 × 30.5 (8½ × 12)
Signed with butterfly
PROV: D.C. Thomson, Goupil Gallery, London (dealer) 1891; Sir George A. Drummond, Montreal 1891; his sale, Christie, London 27 June 1919 (166), bt A. Reid, Glasgow (dealer); E.R. Workman, London; Knoedler, New York (dealers) 1924; Stevenson & Scott, New York (dealers) 1924; Scott & Fowles, New York (dealers) 1926; Hunt Henderson, New Orleans; by family descent until 1980; a private collector; Daniel J. Terra
EXH: London, Dowdeswell 1884 (17); Dublin 1884 (236); Munich 1888 (58); New York 1889 (26); Boston 1904 (84); London 1905 (142)
LIT: YMSM 1980 (254)

Daniel J. Terra Collection

This single-ended sofa, with its undulating back, is seen in three of Whistler's paintings, all of which were painted in 1884. In 'Arrangement in Pink, Red and Purple' (no.136), the scattered items of clothing suggest a dressing-room, and the young girl appears ripe for seduction. The sofa is not intended for sitting, but lounging or lying.

In a watercolour, 'Milly Finch' (fig.85; M 907) the theme is developed. Milly lies back on the sofa holding a wide open fan, one hand to her lips, in universally recognisable gestures of invitation and arousal. Behind her, paralleling Manet's 'Olympia' (Musée d'Orsay, Paris) is a second woman – a shadowy figure, but not an attendant – doing her hair. The charged atmosphere suggests a brothel (rather than a theatrical dressing room). Milly's slim and silky dress is more explicitly seductive than nudity (recalling Goya's 'Clothed Maja'). The colour scheme is almost identical, with a dress in lilac, against the embroidered red-covered sofa.

135

However, in 'Note in Red: The Siesta', the mood is ambivalent. The figure is Maud Franklin, and she is resting, turned away from the artist. She had in fact been ill, and over the next two years, her relationship with Whistler became increasingly strained. Milly Finch may have been her first rival, and Beatrice Godwin (see no.150) certainly succeeded her in Whistler's affections. These undercurrents – her illness, and her disaffection – may underly her pose.

However, the voluptuous colour and brush-work suggest something more. The colour is vivid, dominated by the strong red of the sofa, and the brushwork is vigorous and uninhibited. The relationship may have been disintegrating but the painting has remarkable strength and unity.

136 Arrangement in Pink, Red and Purple 1883–4

Oil on panel 30.5 × 22.8 (12 × 9)
Signed with butterfly
PROV: J.E. Blanche, Dieppe 1885; J. Emery; Alphonse Kann, Paris (dealer) by 1919; Agnew, London (dealers) 1919; James P. Labey, New York (dealer) 1919; Cincinnati Art Museum, 1920
EXH: London & New York 1960 (48); Chicago & Utica 1968 (32); Ann Arbor 1978 (79)
LIT: YMSM 1980 (324)

Cincinnati Art Museum. John J. Emery Endowment

The painter Jacques-Emile Blanche bought the picture from Whistler in Dieppe in 1885, call-ing it a *'Scherzo, arrangement in pink, red & purple, a few spots of colour'*.[1] On this basis it has been assumed that the picture was painted when Whistler first visited Dieppe in 1885.[2] However, the subject stands in front of the same red sofa that appears in 'Note in Red: The Siesta' (no.135) which was first exhibited in 1884. In terms of style and colour range, the two pic-tures are closely related, suggesting that they were painted around the same time, 1883–4. The same studio prop reappears in 'Red and Pink: La Petite Mephisto' c.1884 (Freer Gallery of Art, Washington, DC; YMSM 255).

Blanche identified the sitter as his young friend Olga Alberta (1872–1931), daughter of

the Duchess of Caracciolo (fig.86). In 1899 Olga married Adolph de Meyer (1868–1946) the society photographer, created Baron de Meyer by the King of Saxony at the request of Edward VII in 1902.[3] Olga's mother Blanche had been a daughter of a French diplomat of Portuguese extraction and an American moth-er. Married by arrangement to the Neapolitan Duke of Carracciolo, soon after the wedding Blanche had fled to England, reappearing in society several years later in the possession of a small child and a villa at Dieppe. The aptly named Villa Mystery was known to have been purchased for her by Edward Albert, Prince of Wales.

Dieppe was the ideal place for this particu-lar child to be raised, being outside England, but just across the Channel so that the godfa-ther after whom she was named, the future King of England, could visit incognito by yacht. In the summer Dieppe became a cross-roads of international high society, ready to overlook but not to forget the dubious social position occupied by the Duchess. 'My dear friend', Henry James told Jacques-Emile Blanche, 'Your Dieppe is a reduced Florence, every type of character for a novelist seems to gather there'.[4]

Here the 'dear little child', who spent her days collecting crabs and mussels near her mother's villa, precociously watched the com-ings and goings of her mother's numerous lovers. Her appearance and personality fasci-nated the artists, aristocrats and bohemians who gathered round her mother. 'Although she was reserved', writes Blanche, 'she was full of fun; we understood her silent moods and her melancholy when we stopped amusing her or did not ask her to dances at the Casino. She felt she was a prisoner, without friends of her age or her rank.'[5]

This is because respectable families refused to allow their children to associate with Olga. In response, she made friends with the artists who circled round her mother, and who in the morally dubious atmosphere of the Villa Mys-tery, had begun to size up the auburn-haired beauty as a future sexual conquest. The critic George Moore put it crudely: 'You're all after the girl, a fine Melisande for the stage, with her beautiful hair down to her heels. She's paintable, I admit, but as to one's daily use, I should rather have the mother than the child. Too slender for me … You know my tastes.'[6]

In Blanche's words, 'It would have needed a Henry James or Marcel Proust to analyze the psychological substratum, the infinite shades and subtleties, in Olga as a young girl when she came into contact with people'.[7] In fact, Olga's

136

situation did inspire James to write one of his greatest novels of childhood, later remarking that the 'enchanting Olga learnt more at Dieppe than my *Maisie* knew.'[8] Charles Haas, on whom Proust was to base the character of Charles Swann in *A la Recherche du temps perdu*, was a close friend of the Duchess, and Proust is said to have used Olga in his account of Swann's love affairs.

All this background is of importance because it was Whistler's interest that launched Olga among fashionable painters. Degas considered both mother and daughter 'ladies whose grand air ... reminded him of thoroughbred horses'[9] and Sickert, Helleu and Boldini all drew her, attracted to the elongated grace of her figure, her delicate profile and almond-shaped eyes. But only Whistler's portrait suggests the ambiguity of her position in life, the aristocrat who was not recognised by society, the virgin who was yet sexually aware, the innocent child whose mother was prepared to sell her to the highest bidder.

Whistler shows the twelve or thirteen year old *en fleur*. Olga raises her demure, ankle-length frock to show one scarlet stocking. Though her throat is swathed in a scarf, that too is scarlet. Her tall, straight, angular body is contrasted to the voluptuous curves of the ornate Victorian sofa against which she stands. This studio prop is seen in other paintings by Whistler where the models recline luxuriantly, a piece of furniture on which a seduction might well take place. Scattered on it we note a jumble of diaphanous clothing, lending a further erotic charge to the picture of supposed innocence.

In short, Whistler shows Olga as a sexually precocious adolescent, still demure, but aware of her attractions.

Whistler applies the thinned oil paint over a grey ground as through he were working in watercolour, creating 'puddling' effects of paint in the background. In a bold colour contrast he sets Olga's pink-lilac dress against a crimson sofa, itself placed against a deep blue curtain.

137 Black and Red or Study in Black and Gold (Madge O'Donoghue) 1883–4

Watercolour on white laid paper, laid down on card 22.8 × 15.9 (9 × 6¼)
Signed with butterfly
PROV: E.J. Poole, London 1884; A.A. Hannay, London by 1896; Scott and Fowles, New York (dealers) in 1926; possibly sold by W. Macbeth, New York (dealers), to Babcock Galleries, in 1944; Mr and Mrs C.C. Henderson, New Orleans by 1959; Knoedler, New York (dealers); Paul Mellon, 21 Dec. 1970; given to the National Gallery 1991
EXH: London, Dowdeswell 1884 (15); possibly exh. Munich 1888 (30); exh. London, Guildhall 1896 (101); Paris 1905 (87); London & New York 1960 (90);
LIT: MacDonald 1994 (936)

National Gallery of Art, Washington. Gift of Mr and Mrs Paul Mellon, in Honour of the Fiftieth Anniversary of the National Gallery of Art

A draft of the catalogue for Whistler's exhibition at Dowdeswell's in 1884 lists 'Black and feather – Madge' at the relatively high price of £100.[1] In the 1905 *Memorial Exhibition* catalogue the sitter was named as 'Madge O'Donoghue'. The name suggests she was Irish, and from her appearance she was an attractive and fashionably dressed young woman – possibly an actress, possibly a professional model – but nothing else is known about her. The *Morning Post* described it as 'a charming study of a girl whose dress is arranged in those two hues'.[2]

The *Artist* compared this watercolour with the finest of Whistler's figure studies (no.134), saying it struck 'as strong a note as "Petit Déjeuner" strikes a sweet one … a girl, dressed in dull violet and Indian Red, seated on a slim yellow chair, holding her hat on her lap; the head is exquisitely modelled and the hair simply but wonderfully told, sits gracefully on the lady-like figure – a few bold, vigorous touches give us her black felt hat and feather, and the folds of her dress.'[3] The art critic Frederick Wedmore was impressed, 'how much dignity in the attitude, in the pose of the head, of the lady who sits up straight in her small straight chair and hangs one arm behind it!'[4]

Menpes wrote that 'In watercolours, Whistler always used Chinese white with every tone, to give body to the pigment'.[5]

Here, the subtly varied layers of pale pink and flesh-colour, of grey and blue, were strengthened with white body-colour. Sensuous brushstrokes caress the surface, conveying the shot-silk shimmer of fine material. The spark of pink on her left hand and the feather in her hat, and on her sensitive profile, glint brightly. The face is luminous, and the figure glows against the black background.

The black coat or cloak flung over her legs (rather like the coat over Carlyle's knees in no.61) adds to the rich darkness of the surface.

137

'Notes' – 'Harmonies' – 'Nocturnes'

When Whistler returned from Venice in 1880, he was determined to make his mark on the London art world. After exhibiting the Venetian prints and pastels at the Fine Art Society, he began immediately to work for a series of one-man exhibitions of an entirely new sort: showing small works in different media together in a harmonious setting reminiscent of an aesthetic drawing room.

Whistler designed the decoration for his first exhibition in Dowdeswell gallery at 133 New Bond Street in 1884 and called it an *Arrangement in Fleshcolour and Grey*.[1] *Queen* described the decor:

> The walls are of a warm flesh colour, the ceiling toned to correspond, the carpet is grey, the mantelpiece is draped with grey velvet edged with flesh-colour cord, and at the corner of the mantel valance a Japanese butterfly of flesh-coloured velvet and a darker shade of grey is appliqué … In front of the grey velvet curtains, which close up the fireplace, stands a large crater of flesh-colour earthenware, containing a large plant of marguerite daisies. Altogether the effect is very refined, harmonious and pleasant … the tints of the frames are subordinated to the pictures.[2]

Even the attendant was dressed to match.

The Private View, which took place on 17 May 1884, was so fashionable a crush that no one actually looked at the pictures. However, the press coverage was extensive and at times enthusiastic (see nos.134, 137, 139). The exhibition was an artistic but not a financial success, and many of the pictures left over were sold, at about £10 a time, to a London lawyer, H.S. Theobald, who spent the next ten years lending them to Whistler for exhibitions in Europe and America.

Nevertheless Dowdeswell's undertook a second exhibition in 1886. It was an *Arrangement in Brown and Gold*. Again Whistler persuaded them to redecorate the gallery to match the gilt frames and harmonise with the colours of his paintings.

He was insistent that what the papers called his 'Arrangement in Brown Paper and Gold' should not be spoilt by any cheeseparing on Dowdeswell's part, 'coming upon the public without the usual *complete perfection of finish* which is the great characteristic of the Whistler shows'. Dowdeswell said that the show was an 'absolute loss' to him. Whistler replied, 'I had flattered myself that I managed to produce effective shows, as far as the decoration … goes, at a minimum expenditure' but he could not be blamed for the general state of the economy.[3]

In the first show, Whistler exhibited thirty-eight oils (eg. no.134), twenty-six watercolours (including nos.134, 137, 139–40) and three pastels. His watercolours were seen for the first time, and their striking colour and straightforward technique made an immediate impact. Watercolours dominated the second exhibition in 1886: forty-eight (see nos.144–8) out of a total of seventy-five works. Only twelve were oils, and there were eight pastels and seven drawings.

At Wunderlich's in New York in 1889, the final exhibition of *'Notes'* – *'Harmonies'* – *'Nocturnes'*, as it was then called, comprised sixty-two works: thirty watercolours,

fifteen pastels and a few drawings (including several unsold after the two Dowdeswell shows, such as nos.144–7). The twelve oils exhibited included two much larger works, 'Nocturne in Black and Gold – The Falling Rocket' and 'Nocturne in Black and Gold – The Fire Wheel' (nos.58, 56) added because Whistler wanted to sell them. This was Whistler's second and last one-man show in New York, and important for its influence not only on other artists, but on exhibition design.

Sales were negligible, but the works which went to important American collectors such as Charles L. Freer, Harris Whittemore, Howard Mansfield (see no.150) and Havemeyer, were of exquisite quality and in the case of Freer formed the basis for a unique collection.

M.M.

138 Selsey Bill 1881

Watercolour on white paper
20.3 × 29.3 (8 × 11½)
Signed with butterfly
PROV: B.B. MacGeorge, Glasgow by 1905; possibly owned in 1921 by Mrs Knowles, London; auction, Morrison M'Chlery, Glasgow, 16 May 1958 (lot no. unknown); bought from a New York dealer by the present owner
EXH: London 1905 (129)
LIT: MacDonald 1994 (863)

Private Collection

Selsey Bill is on the south coast of England, east of the Isle of Wight, and directly south of Chichester. Washed by the long Atlantic rollers, it juts out into the English Channel. It is a bleak and windy spot, battered by the prevailing westerly winds.

Whistler is only known to have visited Selsey when staying with Charles Augustus Howell, that fast-talking, chain-smoking entrepreneur extraordinary. Howell was probably born in Oporto on 10 March 1840, the son of Alfred William Howell, a Lisbon merchant who occasionally gave drawing lessons, and Dona Enriqueta Amelia de Souza de Rosa Coelho.[1]

In England in 1856 he met D.G. and W.M. Rossetti, and settled in London about 1864 as secretary to Ruskin, to Swinburne, and finally to D.G. Rossetti.

Howell helped Whistler in his tangled affairs, to pawn, sell and engrave his pictures, print and sell etchings, and negotiate with clients and dealers. He even bought paintings from Whistler (see no.66). He was charming, persuasive and unscrupulous, desribed by Whistler as 'the genius, the superb liar, the Gil-Blas, Robinson-Crusoe hero out of his proper time, the creature of top-boots and plumes – splendidly flamboyant.'[2]

Yet in the end, Howell made little profit from Whistler and was one of the chief creditors at his bankruptcy.

In London, Howell lived at Chaldon House in Fulham, near old Putney bridge. He died on 24 April 1890, aged only fifty, apparently abandoned by his friends, and in sordid circumstances.

However, in his heyday, he had bought a row of fishermen's cottages at Selsey called 'Old

138

Denner', and converted them into one house, where he 'passed as a great personage ... and there he gave out-of-door treats to hundreds of children ... at somebody else's expense.'[3]

Whistler's painting probably shows 'Old Denner'. He sensitively leaves areas of white paper bare to convey the sparkle of beach, sea and sky. The house was skilfully painted, its warm grey and pink walls and dark roof standing out boldly against the sky.

139 Nocturne in grey and gold – Piccadilly 1881–3

Watercolour on white wove paper
22.2 × 29.2 (8¾ × 11½)
PROV: Jonathon Hogg, Dublin 1884; bequeathed to the National Gallery of Ireland 1930
EXH: London, Dowdeswell 1884 (9); Dublin 1884 (251); Dublin 1888 (11); Dublin 1899 (82a); London, Liverpool & Glasgow 1976 (28)
LIT: MacDonald 1994 (862)

The National Gallery of Ireland

139

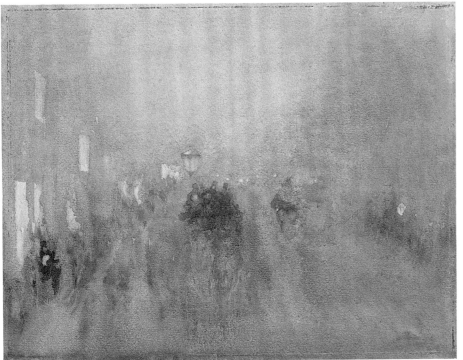

'I am bored to death after a certain time away from Piccadilly!' wrote Whistler in Venice to his sister-in-law Nelly in 1880, 'I pine for Pall Mall and I long for a hansom!' His nostalgia extended to the pea-soup fogs of London, 'for I am their painter!'[1]

He may have felt less enthusiastic on his return, plunged immediately into the thick November fogs. Sometimes it was so dark that the gas lamps had to be lit in the middle of the day.[2]

The 'Smoke Committee' agitated for the introduction of smokeless coal,

as an immediate means at hand of abating the nuisance to which Londoners had become more and more subject ... the peculiar noxious character of London fogs was owing to the atmosphere being charged with particles of carbon which escaped combustion in domestic and other fires. It was the immense quantity of these fires which caused the injury. [3]

There were over three and a half million people in London in 1880. It was the biggest and dirtiest city in the world. The fog, sometimes lasting for days on end, caused and aggravated severe chest infections, killing hundreds each winter. Yet curiously enough these fogs, a unique London phenomenon, became something of a tourist attraction, after Whistler had painted them.

Whistler himself looked – and found – suggestions of Venice in the fog: 'And when the evening mist clothes the riverside with poetry, as with a veil ... and the tall chimneys become campanili, and the warehouses are palaces in the night ... fairy-land is before us'.[4]

Oscar Wilde held Whistler, among others, responsible for the growing awareness of fogs, if not for the fog itself.

At present, people see fogs, not because there are fogs, but because poets and painters have taught them the mysterious loveliness of such effects. There may have been fogs for centuries in London. I dare say there were. But no one saw them, and so we do not know anything about them. They did not exist until Art invented them. Now it must be admitted, fogs are carried to excess.[5]

Piccadilly itself was a nightmare of noise and dirt. Stage-coaches for the country and omnibuses for Kensington passed the shops, great and small (Swan and Edgars, Fortnum and Masons), the booksellers (Hatchards and Quaritch), the clubs and pubs, passed Burlington House, home of the Royal Academy and

the Royal Society, and passed the Egyptian Hall.

This picture represents the effects of night and fog – the ultimate diffusion of light and form. The critics recognised 'the gas illumined, smoky atmosphere of Piccadilly, Hansom cabs, and hurrying figures in the roar and activity of this great London thoroughfare'.[6] 'One faintly makes out the passengers on top of an omnibus, and very yellow light streaming from windows', wrote another, 'The horses are "understood"'.[7]

The *Kensington News* called it 'one of the most enchanting little atmospheric gems one could well desire to possess'.[8] *Society* commented on 'that artless art which portrays Piccadilly with a blur of grey and a dot of gold'.[9]

It was equally well received in Dublin in 1888, where the *Irish Times* thought it 'quite characteristic and astounding almost'.[10] Whistler agreed to let the organiser of the Dublin exhibition, Logan Pearsall Smith, reduce the prices of watercolours from £50 to £40 and from £20 to £15 at his discretion. Pearsall arranged the sale to Jonathon Hogg, and Whistler, to Hogg's amazement, sent him a receipt.[11]

In 1899 Whistler's apprentice Miss Inez Bates saw it and another watercolour (no.140) in Hogg's house in Dublin, and told Whistler. He, having apparently forgotten that anything had been sold to an Irish collection, replied, 'I know nothing of them! That is, I neither trace them by their names – nor by the fact of their being in Ireland!' However, she described them to him and he was reassured.[12]

Whistler used in this watercolour a 'sauce' technique comparable to that used in his oils of Cremorne and the Thames. Taking the lightest tone, the windows, he applied an overall wash of cream and let it dry. Then he outlined the windows, and some of the lights and left them untouched, applying darker washes of grey to the rest of the sheet. Working quickly, he built up the darkest areas with further colour as the wash dried. The result was smooth and wonderfully atmospheric.

When it was dry, the faces in the omnibus, the distant spots of light and the brighter lamps in the street and on the cabs were painted in precisely, using spots of white body-colour with yellow, pink or blue on top, glowing in contrast to the grey washes surrounding them.

140 Sunrise; gold and grey 1884

Watercolour on white wove paper
17.5 × 12.6 (6⅞ × 4¹⁵⁄₁₆)
Signed with butterfly
PROV: Jonathon Hogg, Dublin 1884;
bequeathed to National Gallery of
Ireland 1930
EXH: London, Dowdeswell 1884 (47) or
(55); Dublin 1884 (231);
LIT: MacDonald 1994 (917)

The National Gallery of Ireland

St Ives is a Cornish village, centre of the fishing industry, and a picturesque subject long popular with artists. Whistler went there with his followers, Mortimer Menpes and Walter Sickert, late in 1883. At first he was not impressed:

Well – for dulness, this place is simply amazing! – nothing but Nature about – and Nature is but a poor creature after all – as I have often told you – poor company certainly – and, artistically, often offensive – ... The work I am doing may make this exile worthwhile – I have such inspirations too![1]

However, they worked steadily on small paintings of the harbour, full of fishing boats, and seascapes on the beach and along the steep cliffs overlooking the sea.[2] At the end of January Whistler was writing, 'The country you know never lasts me long and if it had not been for the Sea I should have been back before now – However I shall bring a few "little things."'[3]

He experimented freely, both in colour and technique. His watercolours were particularly light and bold in colour. This is an extremely stylised watercolour, Oriental in conception, with fishing boats like Arab dhows setting out across an oily sea. It was painted dramatically in pale washes. Layers of clouds drip freely into each other, and swirling mists create extraordinary shapes around the fences, houses under the cliff, and the butterfly. According to Logan Pearsall Smith, who organised Whistler's exhibit in Dublin in 1884, it represents 'a bit at the end of Barnoon Terrace, St Ives, Cornwall'.[4]

Menpes was Australian born, and came to England in 1875. He studied art at the South Kensington schools but left to help Whistler print his Venetian etchings. He described Whistler in St Ives as a good companion as well as a hard task-master,

The boats, the sea, the fishermen – all fascinated him ... He rose at cock crow, and seemed to be always full of the most untir-

140

142

Painted in tones of grey and black accented by the note of yellow in the row boat in the foreground, 'A Freshening Breeze' depicts a harbour scene, possibly that of St Ives in Cornwall or Southend-on-Sea in Essex, on an overcast day. The little fishing boat near the centre crests a swell as a tall masted boat turns towards the open sea, and a similar vessel docks alongside a pier in the upper right-hand corner. Sewage pipes form a prominent motif along the shore line. A watercolour in the Freer Gallery of Art entitled 'The Anchorage' appears to show the same scene (M 887).

As in many of Whistler's views (e.g. nos.45, 112), the harbour is seen from a slightly raised viewpoint, perhaps looking down from a bluff or hotel window. The shadowy stain indicating a lone figure walking on the strand in the foreground adds a decorative note against the flattened pictorial space.

ing energy. By the time the first glimpse of dawn had shown itself in the sky, he would be up and dressed and pacing very impatiently along the corridor ... 'Have you got my panels prepared?' – 'Did you mix that grey tone and put in the tube?' – 'Menpes, have you brought any of those note-books with Dutch paper in them?'[5]

As for Sickert, he had met Whistler in 1879 and left the Slade school to become his pupil in 1882. At times he worked in Whistler's studio, or Whistler worked in his. They even worked from the same models, including Théodore Duret (no.127), and painted together in St Ives and Dieppe.

However, Sickert quickly grew independent of Whistler, and was able to view his master with both affection and at times devastating clarity of judgment. He probably understood Whistler's aims and achievements more than any other artist, and was able to develop from them his own powerful vision.

141

141 A Freshening Breeze 1883

Oil on panel 23.5 × 13.2 (9¼ × 5⅜)
Signed with butterfly
PROV: John G. Ure, Glasgow by 1905; Christie, London 29 April 1911 (22); Marchant, London (dealers); private collection; Daniel J. Terra
EXH: London 1905 (101)
LIT: YMSM 1980 (275)

Terra Foundation for the Arts, Daniel J. Terra Collection

142 Grey and Green: A River 1883–4

Oil on panel 14.5 × 25 (5¾ × 9⅞)
Signed with butterfly
PROV: Otto Goldschmidt 1885–91; his widow, Mme B.M. Goldschmidt by 1913; Knoedler, New York (dealers) 1913; Miss H.E. Gwell, San Francisco 1926; Maxwell Galleries, San Francisco (dealers) by 1972; Ira Spaniermann, New York (dealer) 1972; New York, Sotheby Park Bernet 23 May 1974 (41A), bt in; Davis & Long, New York (dealers), 1978; Dr John E. Larkin, Jr 1979; the present owner 1984
EXH: Claremont, Sacramento & Stanford 1978 (59); Ann Arbor 1978 (52) New York 1984 (114)
LIT: YMSM 1980 (295)

Private Collection

'Grey and Green: A River' is a view of the harbour at Dordrecht, the Netherlands, painted either in the summer of 1883 or on a second visit early in 1884.[1] Whistler also executed a number of watercolours on these visits (see M 968–76) and several etchings (K 242–4).

Whistler paints with thinned pigment onto a ground of soft grey, working *sur le motif*, and completing the picture in one session, just as he would a watercolour. The grey–green tonality is relieved with touches of red in the distant houses, while the moored boats are indicated with the point of a tiny brush.

143 Off the Dutch coast 1883–4

Watercolour on off-white wove paper
14.6 × 25 (5¾ × 9¹³⁄₁₆)
PROV: Bequeathed by Whistler to his
sister-in-law, Miss R. Birnie Philip 1903;
bequeathed to the University of
Glasgow 1958
EXH: Ann Arbor 1978 [28]; Tokyo
1987–8 (59, repr.)
LIT: MacDonald 1994 (940)

*Hunterian Art Gallery, University of Glasgow,
Birnie Philip Bequest*

It is likely that this was exhibited in one of
Whistler's one-man exhibitions of the 1880s, as
was no.148, but so many titles suggest seascapes
that it is difficult to identify.

In this small watercolour Whistler conveyed
the effect of the low coastline, the complexity
of the buffeting, criss-crossing waves, the depth
of colour of the deep seas under chilly northern
skies. The horizon is slightly curved, as though
seen through a modified fish-eye lens. This
accentuates the low, sea-level viewpoint, as if
Whistler was showing the curvature of the
earth.

It appears to have been painted out at sea,
from a small boat, and the surface is spattered
with spray and sea-mist. The spray blends with
the complex criss-crossing and interlocking
brushstrokes. The serried ranks of receding
waves show how observant Whistler was of the
patterns of nature. The view is slightly
vignetted, which may be because Whistler had
to hold the board at the top and bottom very
firmly to prevent it going overboard. The fad-
ing off at the edges makes the central area seem
more vivid.

The sky and distant land, with the silhouette
of a windmill showing that it is indeed 'Off the
Dutch Coast', were painted in shades of grey.
Layer upon layer of cobalt blue, very dilute,
build up to rich colours where the washes cross,
but sometimes, where the brushstroke
impinged on another stroke not yet dry, the
colours ran and dissipated, giving a softer edge.
Whistler dragged his brush lightly across the
irregular texture of the paper to leave a speck-
led trail of white spots which effectively conveys
the sparkle of spray.

144 Green and pearl – La plage, Dieppe 1884–5

Watercolour on off-white paper laid
down on card 12 × 21 (4¾ × 8¼)
Signed with butterfly
Inscribed on verso 'No 29' (crossed out)
and 'No 20Y' in unknown hand
PROV: Bequeathed by Whistler to his
sister-in-law, Miss R. Birnie Philip 1903;
Colnaghi, London (dealers) 1943; Mrs
F.L. Evans, Oxfordshire 1943; Christie,
London, 19 May 1972 (37, repr.) as
'Beach Scene', bt J. Baskett, London
(dealer), for Paul Mellon; given to the
National Gallery of Art 1991.
EXH: London, Dowdeswell 1886 (29);
possibly Munich 1888 (28); New York
1889 (20); Birmingham 1952 (214);
London & New York 1960 (95)
LIT: MacDonald 1994 (1025)

*National Gallery of Art, Wahington. Gift of Mr
and Mrs Paul Mellon, in Honour of the Fiftieth
Anniversary of the National Gallery of Art*

The 'Etablissement des Bains' was situated by
the casino in Dieppe. On a fine day, the chang-
ing rooms, tents and bathing machines, were
bustling with activity. The crowds strolled or
sat and watched the passing scene which was, as
Baedeker advised, 'amusing'.

In 1886 this work was exhibited as 'Green
and pearl – La Plage, Dieppe', in 1889 as 'Grey
and Gold – The Beach – Trouville'. The same
pictures, despite the changes in title, travelled
from one exhibition to another in the 1880s:
from Dowdeswell's in London to the Galerie
Georges Petit in Paris, to Munich and New
York. In 1887 Whistler selected a preponder-
ance of French subjects, pictures of Dieppe,
Honfleur and Paris, for exhibition in Paris.
Unfortunately the Dieppe paintings, 'Bleu et
argent', 'Argent et violet', 'Vert et violet', and
'Vert et argent' (cat.nos.177, 179, 186, 207) are
difficult to identify.[1]

In New York in 1889, a critic picked out this
picture:

the differentiation of small spots into types
and almost personal traits is carried further,
and, it seems, to the very limit of sugges-
tiveness. The pose of a chair, the crossing
of a foot, have a personal aim so distinctive
that it is almost ludicrous when associated
with these hasty blots and dashes of color.[2]

It shows Whistler's ability to express with
the point of a brush the idiosyncratic and dis-
tinctive characteristics of a person or an object.
These linear marks can be read as clearly as

143

144

145

writing. Many of the details, the ship, the figures and chairs, are a deep purplish-brown and grey or black, but there is lots of colour too, blue and pink, orange and lemon, scattered across the pale sands.

145 Blue and opal – The Photographer *c.1885*

Watercolour on white paper laid down on card 12.4 × 21.4 (4⅞ × 8⁷⁄₁₆)
Inscribed on verso in unknown hand '44Y' and other dealer's numbers
PROV: Howard Mansfield, New York 1889; Harlow McDonald & Co., New York (dealers); Mrs Cornelis J. Sullivan, New York (dealer) by 1934–5; E.A. Seasongood 1935; New York, Parke Bernet 5–6 Nov 1951 (304); private collector; Macbeth, New York (dealers), 1951; Prof. C.H. Morgan, Amherst 1952; Macbeth 1956; Hirschl and Adler, New York (dealers) 1957; the present owner 1959
EXH: London, Dowdeswell 1886 (25); New York 1889 (44) ; Boston 1904 (87); New York 1942 (70)
LIT: MacDonald 1994 (1037)

Private Collection

This was probably painted at Dieppe in the autumn of 1885. The colour scheme resembles that of other watercolours painted in Dieppe and it shares their restraint and economy.

The subject shows Whistler's interest in recording figures not just as spots of colour or compositional aids, but as participating in activities. Dieppe provided plenty of opportunities to paint people at work and play.

Photography was extremely popular by the mid-1880s. High winds, sea and sand permitting, seaside photographers were increasingly common, although the promenade, rather than the beach, was the more usual venue. This picture is both a record of a passing moment and a tribute by one art to another.

Whistler grew up in the age of photography. When he was first in London, Seymour Haden's partner, James Traer, was particularly interested in optics (see no.11). Whistler himself used photography to record and promote his work. As early as 1869 he sent photographs of pictures to prospective clients.[1] In 1873 and several times in later years, the contents of his studio were photographed, providing a record

of paintings which were later altered, like nos.65–5, or destroyed.[2] In 1892 he sold albums of photographs after his 1892 retrospective exhibition, bringing to their production an attention to detail which exhausted D.C.Thomson and the Goupil Gallery.[3]

He used photographs occasionally as a working tool, in planning alterations to his work.[4] Photographers like his friend James Hedderley, who recorded the buildings and waterfront of a disappearing Chelsea, provided him with records to which he could refer in making etchings.[5] Photographs of work by artists he particularly admired (e.g. Velázquez, Pieter de Hooch and Tintoretto) were used as sources for compositions (see nos.177, 205).

He posed enthusiastically both for studio portraits and snapshots out doors, promoting his own complex self-image as dandy, friend, and worker. Tantalisingly, he is known to have discussed the possibilities of photography with friends, including Degas, in the early 1890s.[6] The one thing he does not seem to have done, was to take photographs himself.

146 Variations in violet and grey – Market Place, Dieppe 1885

Watercolour on white paper
21 × 12.1 (8¼ × 4¾)
Signed with butterfly
PROV: Deprez, London (dealer) 1891;
O. Gutekunst; D.C. Thomson, London (dealer) 1893; Harlow, MacDonald & Co., New York (dealers); Knoedler, New York 1928 (dealers); Daniel H. Carstairs, Germantown, Pa. 1928; Knoedler, jointly with Reid and Lefevre 1929; Wadsworth Lewis, New York 1930; his sale, Sotheby Parke Bernet, New York, 2 April 1943 (397, repr.) bt Carstairs, New York (dealer); Mrs Polly Brooks Howe; the present owners
EXH: London, Dowdeswell 1886 (11); Paris, Petit 1887 (179); Munich 1888 (26); New York 1889 (19)
LIT: MacDonald 1994 (1024)

Private Collection

This watercolour was probably painted when Whistler stayed with Sickert and his wife at the Maison Goude, 21 rue de Sygogne, Dieppe, in September 1885.

Whistler also painted a watercolour, the 'Flower Market: Dieppe', which is now in the

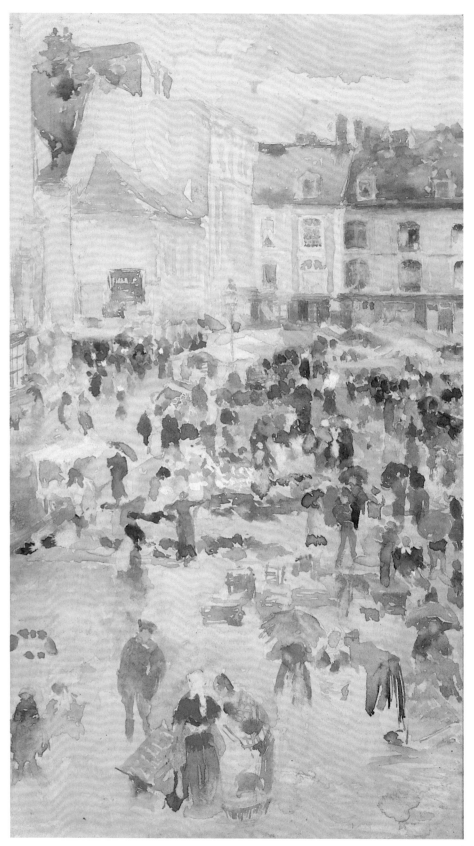

146

147

Freer Gallery of Art.[1] Although the figures are on a larger scale it is clear that the two works date from about the same time. This, however, is by far the more elaborate and important of the two, switching from a horizontal format and a focus on individuals to a vertical format and a distant crowd. It was exhibited in Paris in 1887, and was seen there by Camille Pissarro, who was impressed by Whistler's work: 'Whistler has some very fine bits of sketches in paint, forty-two!! ... His little sketches show fine draftsmanship', and again, 'Whistler is very artistic; he is a showman, but nevertheless an artist'.[2]

This was one of the most complex of Whistler's watercolours, and would have appealed to Pissarro both in subject and colour: he explored the subject further, in a series of watercolours and drawings, culminating in 1894–5 with a coloured etching, 'Marché de Gisors (rue Cappeville)' (Louvre, Paris).[3] Like Whistler, Pissarro switched from a horizontal to a vertical format, looking down on the crowds, and both giving a general impression of the scene while focusing on some individuals.

Two years later, in 1889, Whistler's watercolour caused considerable comment in New York. The *Evening Sun* described it as:

a confused mass of blotches, single strokes of the brush, spots but little more than microscopic, and these resolve into the busy industries of a market, huckstering groups, types distinguished by the outline, and which could by no means be confounded with another mass of blotches.[4]

One critic noted, 'a market place in Dieppe, with a crowd of most living little figures' and another wrote, 'the masses are well managed, and at the same time the effect of motion is preserved.'[5]

The foreground figures each have a striking individuality. Pointed, narrow brushstrokes were used to suggest the gathered skirts of the women, chairs, boxes and baskets. The jerky brushstrokes change in a moment to the evocative shapes of figures – people standing, bending, choosing, and paying. The scene is vignetted, and the carpet of detail fades towards the edge, where there are several unfinished figures and houses.

147 Grey and pearl – Bank Holiday Banners 1883–4

Watercolour on off-white paper, tipped down 21.5 × 12.2 (8⁷/₁₆ × 4¹³/₁₆)
Signed with butterfly. Inscribed on verso in unknown hand 'No 35 Y.'
PROV: Mrs Knowles, Kensington Gore, London by 8 July 1903; bequeathed to the Fitzwilliam Museum by G.J.F. Knowles 1959
EXH: London, Dowdeswell 1886 (15); New York 1889 (35); London, Marchant 1903 (36); London 1905 (85)
LIT: MacDonald 1994 (954)

Syndics of the Fitzwilliam Museum, Cambridge
[Not exhibited in London]

It has been suggested that the tricolour flag might indicate a beach on the Continent – Dieppe perhaps, or Scheveningen. Whistler was certainly in Holland in the summers of 1883 and 1885. However, bank holidays are a peculiarly English institution and it is more likely to be an English resort. Assuming it could not have been painted in the winter, the remaining bank holidays of 1884 were Good Friday and Easter Monday (11 and 14 April), Whit Monday on 2 June, and the first Monday in August, which was the 4th.

Whistler used the paper as a base colour which registered through transparent washes of watercolour. Areas were left bare, setting off pure areas of colour. For the sky, the brush was drawn right across the paper, stroke after stroke, in wavy lines, in pale grey tones tending towards cream and green at the horizon. Occasionally one stroke drips down into the next. Drops of grey, cream and turquoise brighten the grey sea. The beach was done mostly in one broad wash of beige.

Spiky brushwork with the finest of pointed brushes defined details along the horizon, the dresses of individual figures, and the masts and rigging of ships. The fidgety strokes are full of nervous life.

The picture is subdued in tone, despite the colours – touches of coral and pink, grey and purple and brown, with cobalt and red on the flags, and dresses in red. White body colour rendered the greys and pinks opaque so that they would register over darker colours.

There are at least four copies or variants of this watercolour by an unknown hand, in the style of H.B. Brabazon.[1] It is not known if they were done by one of Whistler's pupils, working beside him, as Menpes and Sickert had done in St Ives (see no.140) or if they are fakes, copied from a colour reproduction of no.147.[2]

148

148 Arrangement in blue and silver – The Great Sea *c.*1885

Watercolour on white paper laid down on card 17.6 × 25.3 (6^{15}/$_{16}$ × 9^{15}/$_{16}$)
PROV: Edward W. Hooper (1839–1901), Boston, July 1886; bequeathed to his daughter Mabel (Mrs Bancel Lafarge, 1875–1944), Mount Carmel, Ct. 1901; bequeathed to her son, L. Bancel Lafarge, Mount Carmel, Ct. 1944; given to his wife and children 1962; Knoedler, New York (dealers) 1985; the present owner 1985
EXH: London, Dowdeswell 1886 (58); Boston 1904 (143); New York 1984 (133) repr.
LIT: MacDonald 1994 (1043)

Private Collection

In 1862 Whistler painted 'Blue and Silver: Blue Wave, Biarritz' (Hill-Stead Museum, Farmington, Connecticut; YMSM 41). When he started, he intended to include a group of figures, waving and pointing out to sea, which would have provided a 'subject' and focus in the picture. He eliminated the figures and ended up with a picture of waves pounding on a rocky shore, the sort of seascape he saw as a challenge to the English marine painters, J.C. Hook and Henry Moore (see no.39).

He was by no means the first to paint such subjectless seascapes. British marine painters tended to paint ships, battles, wrecks, and coastal scenes, but there was also a tradition of painting studies of the sea alone – there are dozens of studies by Turner, for example. Whistler himself, in his youth, had copied Robert Carrick's chromolithograph of one of Turner's great seascapes, 'Rockets and Blue Lights (Close at Hand) to Warn Steam-Boats of Shoal Water' (Sterling and Francine Clark Art Institute).[1]

To some extent this picture follows in the technical traditions of British watercolour painting, but in exhibiting subjectless seascapes, Whistler placed himself outside that tradition.

However, a more immediate stimulus in the 1880s was the work of the Impressionists, and specifically Monet. His method of painting the sea, in the Belle Ile subjects in particular, was familiar to Whistler. Indeed, in 1887 when Whistler was President of the Royal Society of British Artists, Monet exhibited recent seascapes of Belle Ile and Dieppe at his invitation. Monet warned Whistler that the Society might object to the inclusion of a foreigner.[2] He was quite right, and Whistler was voted out of office, though it was not entirely the fault of Monet's paintings (see pp.50–3).

Throughout his life, Whistler continued to

paint seascapes of extreme simplicity, using them as an opportunity to experiment with technique. In some – his watercolours of St Ives for instance (see no.140) – he flooded the surface with water and dropped spots of colour into it, accepting and developing the accidental effects which resulted. This painting of stormy seas is more controlled.

It can be related to nos.143 and 153, which show predominantly sea and sky and were painted out at sea. If Whistler was painting from a rocking boat, he would have to work faster than usual, resulting in a satisfying unity of colour and technique. The tiny ship beating across the horizon helps to give a sense of scale.

The surface of the picture is complex. It is a study in brushwork and colour. Whistler varied his technique to suit the subject. Here, he used pure watercolour, painting the paler washes first, and leaving areas of white paper clear, or barely covered with thin washes of paint. He used a heavy paper with a knobbly texture, conveying the sparkle of light and foam, and the rich colours of deep seas, with wide strokes of a big brush.

149 A Red Note: Fête on the Sands, Ostend 1887

Oil on panel 13.7 × 23.5 (5½ × 9¼)
Signed with butterfly
PROV: E.W. Hooper, Boston 1891; his daughter Ellen Hooper Potter, who d. 1974; bequeathed to her daughter Mary (Mrs John B. Swann); private collection; Daniel J. Terra

149

EXH: London, RBA 1887–8 (277); Paris, Durand-Ruel 1888 (43); New York 1889 (40); Brussels 1890 (842); Boston 1904 (2); Ann Arbor 1978 (58)
LIT: YMSM 1980 (366)

Terra Foundation for the Arts, Daniel J. Terra Collection

The Belgian seaport of Ostend is a popular resort on the North Sea, developed as a spa by Leopold II, King of the Belgians. A regular steamer service to Dover meant that Whistler would have stopped here often on his way to Paris. Whistler painted the picture in the autumn of 1887, during a visit to Holland and Belgium with his brother and sister-in-law. The newspaper *La Saison d'Ostende* noted the arrival on 13 September of that year of a 'Whistlev [sic], Rent. Londes [sic]', staying at the Hotel Continental, travelling alone. The term 'rent' ('rentier') means that Whistler had listed his profession as 'independent means' rather than 'artist'.

On that same day, King Leopold returned to Ostende from Dover and was met by his wife Queen Clementine D'Orleans of Saxe Coburg, who had travelled up from Brussels.[1] Whistler's picture presumably shows the welcoming party waving the King's ship into harbour, with cheering crowds and flags. The seething mass of spectators seems to turn its back on the viewer to look out towards the open sea, possibly towards the battle ship which is visible at the right. At the far left the black, yellow, and red Belgian flag undulates in the wind. Also on the left we can make out a flag with a light blue ground and fleur-de-lys. The presence of this second flag is somewhat enigmatic, since there is no fleur-de-lys in Belgian heraldry. It is possible that this flag may symbolise Queen Clementine's Orleaniste descent. On the right the unmistakable Red Ensign is being displayed – the British naval flag which was flown only from merchant ships at this date. Its presence is easily accounted for, since King Leopold had been in England for the celebrations marking the Golden Jubilee celebrating Queen Victoria's fifty years on the throne.

After its exhibition at the Royal Society of British Artists' winter exhibition 1887–8, the *Manchester Courier* described the picture as a fête 'at night',[2] but in fact it is a daytime scene, in overcast weather, the bright red of the British flag providing the only strong note of colour against the prevailing grey. It is one of Whistler's most 'Impressionistic' later landscapes, an atmospheric evocation of a milling crowd assembled at the edge of the sea.

150 Green and Blue – The Fields – Loches 1888

Watercolour on white linen
12.2 × 20.6 (4¾ × 8⅛)
Signed with butterfly
Inscribed verso: 'Green and Blue' and signed with butterfly; inscribed by Howard Mansfield 'Made by Whistler in the Touraine in 1888 when he and his wife were there on their wedding journey–'; inscribed in unknown hand 'H.M. bought this on the last day of the 1st Exhibition of Whistler Watercolors in New York held at H. Wunderlich and Company. H.M. has wished for it all along and an unexpected fee enabled him to acquire it.'
PROV: Howard Mansfield, New York 1889; H. Harlow and Company · (dealers), New York; Mrs C.J. Sullivan by 1934; Macbeth, New York (dealers); Edwin A. Seasongood, by 1935; Parke Bernet New York 5–6 Nov. 1951 (305) bt Knoedler, New York (dealers); Hammer Galleries, New York (dealers), 1956; Charles Lock, New York (dealer) by 1960; given by Mr and Mrs Louis V. Keeler to Cornell University 1960
EXH: New York 1889 (3); Boston 1904 (92); Chicago 1968 (67); Claremont 1978 (63) repr. p.61; Ann Arbor 1978 (24).
LIT: MacDonald 1994 (1183)

Herbert F. Johnson Museum of Art, Cornell University; Gift of Mr and Mrs Louis V. Keeler

Beatrice Philip (1857–96), daughter of the sculptor John Birnie Philip (1824–75), married the architect E.W. Godwin in 1876. She was an artist, and designed decorative panels for furniture, and jewellery. After his death, she and Whistler were married, on 14 August 1888. She worked with Whistler on life-drawing in the studio, and under his tutelage, painted small portraits of considerable charm.

On their honeymoon, they went first to Boulogne and Paris. At the shop of E. Mary et fils in the rue Chaptal they bought materials for the trip – prepared linen-covered blocks that Whistler wanted to try out. These felt like fine canvas, and provided a regular grain and texture which Whistler used for delicate and sparkling effects.

They travelled down the Eure and Loire to Tours and Loches. They spent most of the month of October in Loches, a small town on the river Indre south-east of Tours. Whistler wrote back to his son, Charles J.W. Hanson: 'I don't want the people to know that I am here. I

150

also don't want their attention to be drawn to my long stay in any one place, so you might suggest that I had been travelling about making visits in the neighbourhood of Paris and Bordeaux.'[1]

It is not clear why Whistler was lying low – whether he was avoiding business or personal complications – or just determined to be alone with his wife. For both of them, it was a working honeymoon. In Loches, Whistler made a set of etchings (K 382–92) and taught Beatrice to etch. They both worked on an etching of the view from Agnes Sorrel's Walk, similar to Whistler's etching of that name (K 385) where the green fields and low wooded hills of Touraine are seen just beyond the town.

'Green and Blue – The Fields – Loches' is a view of these same gentle hills. There are many shades of green in fields and shadows, and trees, some touched with the reds of autumn. Long streaks of green wash take up two thirds of the picture space. Each brushstroke is individually descriptive of some detail – fence, cows, or the bright red butterfly.

They finally returned home in November, and Whistler's watercolours were packed up to go to Wunderlich's in New York, for the third exhibition of *'Notes'– 'Harmonies' – 'Nocturnes'* in 1889. 'Green and Blue – The Fields – Loches' shared in the mildly favourable notices:

Looked at from this artists' standpoint, regarded as impressions of certain color-effects, every one of these pictures is good, and most of them are excellent ... the beautiful color-effects he so frequently produces are quite marvellous – 'stunning' – is perhaps the most appropriate word.[2]

Late Townscapes and Seascapes

In the years after his wife's death, in 1896, Whistler wandered restlessly from town to town, from sea to sea, searching for 'new interests' in subjects which had always fascinated him: the sea, and shop fronts.

The dealer Edward G. Kennedy went with Whistler to Honfleur immediately after his wife's death. Psychologically he needed to work but could not settle down to it. He told his sister-in-law, 'I have not been able to manage anything … However, if fine tomorrow, I may bring away a bit of the sea'.[1] And in Calais, later in the year, 'I began a little shop here – but it was a queer hard day today & I have done no good'.[2]

The Birnie Philip sisters protected him from day-to-day problems. Staying with them at Dieppe he was able to work on his favourite subjects – sea, shops, and babies. On his last major journey, in search of better health, in 1900–1, his young brother-in-law Ronald Philip travelled out to Ajaccio with him and the publisher William Heinemann joined him later (see no.173).

Whistler rarely strayed far from his hotel. The mere mechanics of carrying panels and paints and brushes – even with the help of faithful friends – made long expeditions difficult. He strolled the streets of Chelsea or Dieppe, Domburg or Ajaccio looking for subjects – shop-fronts, if the weather was suitable – or the girls he asked to model in the studio. Joseph Pennell went to Dieppe with him in July 1897 and immediately he was off 'hunting for a little shop front he remembered'.[3]

Whereas his portraits still took dozens of painful sittings, and were often left unfinished, these smaller pictures could be completed in two or three sittings. Health, and weather permitting, the little pictures show Whistler in total control.

Fluent brushstrokes described the essence of a scene – a doorway and a window full of goods, people passing by and children at the doors, or a few people scattered along an empty beach, and waves white on the shore. Strong colours contrast with delicate detail. Whistler was pushing further the boundaries of the apparently limited subject. Increasingly isolated and abstract shapes mark the late shop fronts. A few brushstrokes sweeping from side to side of the sheet suggest the broad sands and seas of the northern coasts. These late M.M. works are marked by risks taken, and justified.

151 The Bathing Posts, Brittany 1893

Oil on panel 16.6 × 24.3 (6½ × 9½)
PROV: Bequeathed by Whistler to his sister-in-law, Miss R. Birnie Philip, 1903; bequeathed to the University of Glasgow 1958
EXH: London & New York 1960 (56)
LIT: YMSM (409)

Hunterian Art Gallery, University of Glasgow, Birnie Philip Bequest

From July to mid-September 1893 Whistler and his wife toured Brittany, an area of France Whistler had not visited since 1861, when he had painted 'The Coast of Brittany' (no.39). By the 1880s this once remote province had been discovered by artists, including Gauguin, who arrived in 1886, and those artists associated with the school of Pont-Aven, including Emile Bernard, Paul Serusier and Maurice Denis. All were attracted to the picturesque costumes and customs of the local inhabitants. In his oils, Whistler concentrated on the landscape around him.

From his point of view the visit was not a success for the unusual reason that fine weather robbed him of the misty light and moody atmosphere he found so essential for painting. To his dealer D.C. Thompson he wrote from Brittany,

> I have had enough of the country – Beautiful it might all have been perhaps if it had not been for the devilish fine weather! – I suppose it is six weeks since it has rained – and all the tourists in the world must have been enchanted with the brazen sky and tin sea – nothing for the painter – nothing! – at least not for this one – [1]

Nevertheless, he produced seven oils on this trip (YMSM 409–15), among them several of his finest seascapes, including nos.152–3. For although as he told Joseph Pennell 'the sea [was] for gold-fish in a bowl', he returned again and again to paint the sail boats riding on the gentle swells, on occasion painting the open sea from a boat (no.153 and YMSM 412).[2] In no.151, he stands on the shore at Belle Ile,[3] close to the bathing posts indicating a spot by a beach presumably crowded with tourists and bathers.

151

152 Marine: Blue and Grey 1893

Oil on panel 14 × 22.2 (5½ × 8¾)
Signed with butterfly
PROV: Goupil, London (dealers) by 1898; J. Montgomery Sears, Boston 1898 until at least 1934; Macbeth Galleries, New York (dealers) by 1943; Millicent Abigail Rogers 1943, who married A. Peralta Ramos; bequeathed to her son Arturo Peralta Ramos, Jr. 1953
EXH: Boston 1904 (16)
LIT: YMSM 1980 (410)

Private Collection

Perhaps because he had become tired of the sun's relentless glare during his tour through Brittany in the summer of 1893, Whistler works here either in the evening or on a moonless night looking out over the dark sea. Long ribbons of deep blue pigment scumbled with a lighter grey-blue indicate long rollers rumbling onto the shore, with the jagged silhouette of a black breakwater in the foreground. The smoother application of paint on the horizon suggests a night mist over the sea.

152

153

153 Violet and Silver: A Deep Sea

1893

Oil on canvas 50.2 × 73.3 (19¾ × 28⅞)
Signed with butterfly
PROV: John A. Lynch, Chicago 1894
(d.1938); his widow Mrs Clara Margaret
Lynch; given by her to the Art Institute
of Chicago 1955
EXH: London, Grafton Galleries 1894
(56); Paris, Soc. Nat. 1894 (1181); Boston
1904 (533); Chicago & Utica 1968 (40);
Ann Arbor 1978 (41)
LIT: YMSM 1980 (411)

*Art Institute of Chicago. Gift of Clara Margaret
Lynch in memory of John A. Lynch*

Painted in Brittany during the hot summer of
1893, 'Violet and Silver: A Deep Sea' was one of
three marines which, according to the Chicago
collector Arthur Jerome Eddy, Whistler exe-
cuted 'off-shore while the boatman steadied his
boat.'[1] Another, of the same size and technique,
is in the Hill-Stead Museum, Farmington,
Connecticut (YMSM 412).

Whistler had not painted a marine on this scale since the late 1860s, and never did so again. He was pleased with the result, telling the dealer E.G. Kennedy that 'they are, as all the world are agreed the finest things of the kind I have painted'.[2]

Indeed they are. There is a boldness and confidence in the handling of the paint very different from the delicacy of most of Whistler's work in oil at this date. The thickly painted white caps seem to ride the cobalt blue sea, while the white of the clouds is broadly brushed over the lighter aquamarine of the sky. Large areas of the canvas are left raw, as though to emphasise that the picture was painted on the spot, not in the studio.

154 Beach scene with a breakwater

1899–1900

Watercolour on cream Japan paper laid down on card 21.3 × 12.6 (8⁷⁄₁₆ × 4¹⁵⁄₁₆)
Signed with butterfly
PROV: Bequeathed by Whistler to his sister-in-law, Miss R. Birnie Philip 1903; Colnaghi, London (dealers), 1943; F.F. Madan, Oxford 1943; bequeathed to the Ashmolean Museum 1962
EXH: Berlin 1969 (222)
LIT: MacDonald 1994 (1592)

The Visitors of the Ashmolean Museum, Oxford
[Not exhibited in London]

The scene has not been identified. The technique, with its sophisticated use of Japan paper, is similar to that seen in watercolours of Pourville and Belle Ile and suggests that it may be contemporary with them.[1] On the other hand, the boldness of the brushwork might point to an earlier date.

Whistler had experimented in the early 1890s with the techniques of colour separation necessary for colour lithography. Some of his work, particularly in pastel, but sometimes, as here in watercolour, grew out of his experience of juxtaposing and clarifying separate lines and colour in print-making. Hence it is probably no coincidence that the seated figure by the fence has the simplified and almost abstract quality of a colour print by Edouard Vuillard.

The colour is subdued, with grey dominating. The sea was painted in three shades of muted green with successive, separate brushstrokes. The strokes, consciously beautiful have

the inevitability and descriptive power of Japanese art.

The dark clouds above the horizon were painted with care, leaving the vestige of a line at the horizon. Wiggly strokes across the sky, suggest scurrying clouds. Some of the clouds and waves are paper left bare, but occasionally Whistler reinforced them with white bodycolour which differs in quality from the lustrous paper. Bare paper was left round the lively figures, which were painted with tiny brushstrokes in pink, grey and black.

The composition is striking, with the fence and breakwater framing the figures. Curiously, all the figures on the right cast grey shadows to the left – while the other figures cast no shadows – suggesting that Whistler worked on this picture on more than one occasion, when the light had changed.

155 Sunday at Domburg 1900

Watercolour on cream wove Japan paper 14.7 × 24.8 (5¾ × 9¾)
Signed with butterfly
PROV: Bequeathed by Whistler to his sister-in-law, Miss R. Birnie Philip 1903; gift to E.F.J. Deprez, London (dealer), 1905; sale, Christie, London, 8 June 1916 (38), bt. Colnaghi, London (dealers), and Knoedler, New York (dealers); Steven C. Clark, New York 1916; Knoedler 1917; Edward D. Bettens 1917; gift to Fogg Art Museum 1917
EXH: Chicago & Utica 1968 (69); Berlin 1969 (107); Claremont 1978 (83)
LIT: MacDonald 1994 (1613)

Fogg Art Museum, Harvard University Art Museums, Gift of Edward D. Bettens to the Louise E. Bettens Fund

Domburg is on an island off the Dutch coast, near Middleburg and Flushing (see no.172). It is a small village, with good sea-bathing, and pleasant coutryside. Whistler set off for a few days there with an old friend, the American artist Jerome Elwell, on 10 August 1900. It was popular with Dutch artists – Jan van Toorop, Piet Mondrian, F.H. Nibbrig and J. van Heemskerk – until the First World War. It was almost certainly Toorop, who had known Whistler for at least twenty years, who recommended Domburg and directed Whistler to the Pension Duinoord on the Herenstraat.[1]

154

On 17 August 1900 Whistler told the Pennells, 'he found Domburg a wonderful little place, just beginning to be known but not yet exploited, and he recommends a visit before it is ruined. He feels all the better for it, he says, and he looks it.'[2]

He showed the Pennells a watercolour 'of Domburg nestling among the dunes'. When she was working on the Whistler biography in 1906, Elizabeth Pennell visited Domburg and found it still unspoilt, 'two or three long streets lined with trees ... low red-roofed cottages, a small group of hotels, high dunes protecting the village. The sky forever cloud swept, the red roofs above the green, the lines of dunes are in Whistler's watercolours.'[3]

Whistler's picture shows the Hervormde Kerk beyond the sheltering dunes. The beach at left consists of five broad strokes across the paper – tinted with a cream that emphasises the silky, luminous quality of Japan paper. Washes were painted with the side of the brush.

When describing the details of the landscape, the brushstrokes are slender and wavering, with a nervous indecision which adds to their vitality. Many of the brush lines are blurred and details blotted on the absorbent paper. The light brushstrokes, and the delicate tinting of colour – the turquoise of sky, the pink of the umbrella and red of the roofs – are what distinguish Whistler's late watercolours.

This is in a deep Whistler reeded frame typical of the late 1890s.

Whistler returned again and again to the Netherlands, he said, because it was so tidy:

> That's just why I like it – no great full-blown, shapeless trees, and the trunks of the trees painted white, and the cows wear quilts, and it is all arranged and charming. And look at the skies! – They talk about the skies of Italy – the skies of Italy are not blue, they are black. You do not see blue skies except in Holland and here [in England], or other countries, where you get great white clouds, and the spaces between are blue! And in Holland there is atmosphere, and that means mystery.[4]

155

156

156 The Shop – an exterior 1883–5

Watercolour and pencil on white wove paper 19.4 × 28.3 (7⅝ × 11⅛)
Signed with butterfly
PROV: Mrs Frances M. French by 1904; Hollis French by 1934; sold by Knoedler, New York (dealers) Jan. 1946 to Grand Central Galleries, New York; bought by IBM by 1951
EXH: Boston 1904 (139)
LIT: MacDonald 1994 (949)

Collection IBM Corporation, Armonk, New York

The shop was an assymmetric wooden construction. Where it was painted is not known – possibly the south coast of England. It was certainly painted on the spot. This is (for

Whistler) an unusually large and vivid water-colour.

The basic details were outlined in brown wash, and then built up in beige and white. Much of the picture was painted with big soft brushstrokes with a round ended brush 3 mm (⅛ in) wide on heavy paper. Many areas were left unpainted and the background was unfinished, but from Whistler's point of view it was complete, in that it conveyed what he intended, and so he signed it.

The paned windows, shining with reflections, reveal colours within and without. The artist included, as he so often did, a woman with her baby at the window, and lively children at play. Using the brush like a pen, nearly at right angles to the paper (as in Japanese brush-writing) he painted calligraphic details of the cart and hens and people passing by in bright clothes.

Whistler painted many shop-fronts in the 1880s, nearly always, as here, with figures, unposed, going about their daily business. Some of the early ones – of St Ives for instance – are assymetrical (like this one), and rather dark (unlike this). Later, he often moved in closer to the subject (see no.158), so that the shop-front itself filled the entire picture space. This is anticipated here, where the cursory edges form a decorative frame for the rectangle of the shop under its narrow awning which is the area of greatest detail.

157

157 A Chelsea street 1883–6

Watercolour on white paper 12.6 × 21.7 (4¹⁵⁄₁₆ × 8⁹⁄₁₆)
PROV: Bequeathed by Whistler to his sister-in-law, Miss R. Birnie Philip 1903; Colnaghi, London (dealers) 1943; Mrs T.G. Winter 1943; Colnaghi's 1944; D.F. Springels 1944; bequeathed to Mrs Springels; Sotheby London, 30 June 1986 (90, repr.); bt the present owner
LIT: MacDonald 1994 (953)

Yale Center for British Art, New Haven, Paul Mellon Collection
[Not exhibited in Paris]

The title 'A Chelsea street with a donkey on the right' was inscribed on a label on the verso by Harold Wright of Colnaghi's, possibly with information from Rosalind Birnie Philip; but the 'Chelsea' was crossed out and amended to

read, incorrectly, 'Paris', by an unidentified writer, 'JBS'.

Whistler lived in Chelsea for nearly forty years. After a brief sojourn in Venice he returned in 1881, first to 13 Tite Street, for three years, then to 454A Fulham Road, to the 'Pink Palace', the Vale, Chelsea in 1885, and was back in Tite Street, at the Tower House, in 1888. It was popular with artists, and Sargent lived right across the street. Whistler found subjects for prints and paintings in the local people and streets.

The shop represented was probably either the tobacconist, James Nicholas, at 34 Church Street in Chelsea, or another tobacconist and newsagent, James William Nicholas, who was at 88 Cheyne Walk in 1881 and had moved to 75 Cheyne Walk by 1893.[1]

Although this watercolour cannot be identified conclusively with works exhibited in 1884 or 1886, it could possibly have been 'Old Shop, Chelsea: pink and grey' or 'The Little Grocery, Chelsea; grey and red'.[2] The frame is the original: the sort Whistler used in the 1880s, with narrow bands of reeding.

The fine brushstrokes suggesting people walking along the pavement are so flickering and broken as to be almost abstract. The children in the foreground were unfinished and the shops behind the horse and cart barely touched in.

Lights and reflections in doors and windows were a favourite subject of Whistler's, treated here with a build up of small strokes running into each other. The spiky brushwork around the two upper windows on the right, and on the horse and cart, are typical of Whistler's vivid treatment of peripheral detail, in marked contrast to the layers of washes elsewhere.

158

seems to offset the void of the cellar windows at the lower left. The overall green tonality is relieved by a bright red cloth hanging on the door by the two children. The thin paint is applied over a light grey ground and dragged in places until Whistler's brush is dry.

It is not possible to say whether Carlyle's sweetstuff shop was in Chelsea or Soho. Indeed, the title given to the picture by the *Echo* is not necessarily Whistler's own.

The new smaller scale of the shop-front series was to have an enormous impact on French artists of the 1890s, particularly those associated with the group known as the Nabis. Edouard Vuillard and especially Pierre Bonnard were to treat their pictures as formal arrangements much as Whistler had done. Each carried out his researches into colour and composition in small-scale canvases where he could better control his subject, and which the eye could take in all at once, rather than piecemeal.

158 Carlyle's sweetstuff shop 1885–9

Oil on panel 12.7 × 21.5 (5 × 8½)
Signed with butterfly
PROV: W. O'Leary, Detroit (dealer);
John L. Robertson, Scranton, Pa
1925–35; bequeathed to his wife;
bequeathed to their daughter Jean (Mrs
Robert W. Maloney, Jr) by 1972;
Hirschl & Adler, New York (dealers);
Agnew, London (dealers); Anthony
D'Offay, London (dealer) 1979; Hazlitt,
Gooden & Fox, London (dealers); Dr
John E. Larkin 1979; Daniel J. Terra
EXH: London, College for Men and
Women 1889 (no cat.); Ann Arbor 1978
(36)
LIT: YMSM 1980 (375)

Terra Foundation for the Arts, Daniel J. Terra Collection

When it was exhibited in London in 1889, the *Echo* identified this as 'Carlyle's sweetstuff shop … just a bit of wall, an old village shop window, with oranges and sweets, a door and two children's figures'.

We can compare it with earlier shop-front subjects, 'Blue and Orange: Sweet Shop' and 'An Orange Note: Sweet Shop' both painted in St Ives during the winter of 1884 (YMSM 263, 264). Here Whistler stands slightly closer to the building, thus emphasising the abstract design, the natural 'arrangement' of squares and rectangles. The large rectangular window on the left, for example, balances the area on the right comprised of window and green shutter. Again, the deep black-green square in the lower right

159 Maunder's Fish Shop, Chelsea

1890

Lithograph printed in black on chine collé laid down on white wove card
19 × 17.1 (7½ × 6¾)
Signed in stone with butterfly
PROV: Given by Thomas Way to the
British Museum 1905
LIT: Way 1896 (28); Kennedy 1914 (28);
MacDonald 1988, pp.40–1

Trustees of the British Museum

Published in the *Whirlwind*, vol.2, no.26, 27 December 1890, p.198.

Mrs Elizabeth Maunder's long-established fish shop at 72 Cheyne Walk was demolished in 1900, but a photographic record survives in the National Monuments Record Office (fig.87).

Many of Whistler's lithographs of the 1890s explore picturesque shop-fronts, similar to those seen in etchings of the previous decade (and others that were being done essentially concurrently with the lithographs). 'Maunder's Fish Shop' is a case in point: in 1887 the artist had made the incredibly spare, tiny 'Little Maunders' (fig.88; K 279), measuring approximately three by two inches. It focuses on the peaked roof of the building, an element which is outside Whistler's vignetted frame of reference here. A drawing of the same Maunder's

159

Fish Shop (private collection; N 1587) has some similarities of technique, such as the radiating lines of shading.

When Whistler returned to lithography in 1887 he usually drew on specially prepared transfer papers, rather than on the heavy and cumbersome lithographic limestone. The drawings were then offset (transferred) to stone by the printers, with no loss in detail or quality of line. As necessary, Whistler sent transfer drawings from Paris, or Lyme Regis, to Thomas Way and Son in London for application to stone and then printing. This process enabled him to work in lithography wherever he happened to be, with equal spontaneity as his work in etching, pastel, watercolour. Thomas R. Way has described a sketch pad Whistler designed, of transfer sheets he could carry with him.[1]

Transfer lithography has the added advantage of a double reversal, from transfer paper to stone, and then from stone to printing paper. The print, therefore, reads in the same direction as the transfer drawing.

In general the transfer lithographs, including 'Maunder's Fish Shop', are marked by an overall textural quality that varies from subject to subject. This reflects either the character of the transfer paper, or that of the drawing board or other surface such as a book that Whistler placed beneath his sheet as he worked. In this instance, a medium grain *papier viennois* was used; but later he became familiar with the smoother *papier végétal* (see no.161).

In this case, the drawing was sent to Way in October or November 1890 and was transferred to several stones for printing in the *Whirlwind*, in time for Christmas 1890. The lithograph was then machine printed by Thomas R. Way and given away as a supplement to the unconventional and ardently pro-Jacobite paper, which was co-edited by the Hon. Stuart Erskine and Herbert Vivian. They praised Whistler's work in general, and in November they published a sonnet by Stéphane Mallarmé in tribute to Whistler.

Apart from publication in the *Whirlwind*, an edition of approximately twenty-eight impressions was printed by T.R.Way, and, after Whistler's death, thirty-three were printed by Frederick Goulding, with the approval of Whistler's sister-in-law, Rosalind Birnie Philip. The stone was not destroyed, and is now in the Hunterian Art Gallery.

160

160 A Brittany shop with shuttered windows 1893

Watercolour on off-white paper laid down on card 12.8 × 21.7 (5 × 8⁹⁄₁₆)
Inscribed on verso by Harold Wright of Colnaghi, 'In Brittany' and in unknown hand 'Women, Children at a Shop Door'
PROV: Bequeathed by Whistler to his sister-in-law Miss R. Birnie Philip 1903; Colnaghi, London (dealers) 1943; Villiers David, London, 1943; Christie, New York, 6 Dec. 1985 (185A, repr.), bt Knoedler, New York (dealers); Daniel J.Terra 1986
LIT: MacDonald 1994 (1351)

Terra Foundation for the Arts, Daniel J. Terra Collection

In the summer of 1893 Whistler was in Brittany with his wife (see nos.151–3). For two months they travelled, first inland, through Vitré to Lannion, and on to the côtes-du-nord. They were in Perros-Guirec by the middle of August, and by 6 September staying at the Hôtel Gricquel in 'this far away little town' of Paimpol.[1]

Although Whistler painted seascapes (see no.151), much of the time – in the little sketchbooks in which Whistler (and his wife) recorded the passing scene, and in two other watercolours, 'Breton Women Knitting' (Hunterian Art Gallery) and 'Peasant Women Standing under a Tree' (private collection) – he concentrated on the local people and costume.[2]

At Vitré Whistler drew lithographs of the canal (no.161) and market (W 39) and at Paimpol, 'The Clockmaker's House' (W 42). He also

made two of his most complex colour lithographs, 'The Red House, Lannion', and 'The Yellow House, Paimpol' (w 100–1). These are studies of house fronts, filling the entire sheet, with small figures shopping and gossiping, animating the scene.

Here, Whistler painted the doors and windows of the ground floor and figures passing by, to the exclusion of all else. They are totally isolated. Only the edges of the paper define the space. The theme was one to which he continually returned (see nos.171–2). Expressive brushwork and clear colours – with black and red dominating the colour scheme – distinguish this watercolour.

The technique shows Whistler's increasing freedom. There are four or five layers of colour in the window. White body colour is mixed in to the tints of pink and green in the window on the left, and the goods painted with fine, spiky brushwork. The precision of these little pots and bottles is delightful, contrasting as it does with the free washes elsewhere, with colours running into one another. The background is lightly washed with beige and grey, with quite a lot of paper left bare. The figures were left unfinished, and indeed the shutters are painted over the figures on the left.

161

161 The Market-Place, Vitré 1893

Lithograph printed in black on dark cream laid paper laid on paper
19.8 × 15.9 (7⅞ × 6¼)
Sheet: 27 × 22 (10⅝ × 8⅝)
Signed in stone with butterfly
PROV: Given by Thomas Way to the British Museum 1905
LIT: Way 1896 (40); Kennedy 1914 (40); MacDonald 1988, pp.40–1

Trustees of the British Museum, London

The Whistlers travelled from Paris to Brittany in the summer of 1893, stopping in Vitré, Lannion, and Paimpol (see nos.151–3). Whistler sent several transfer drawings back to London for printing by the Ways. 'I am very much interested in the lithograph business again' he wrote to Thomas R. Way.[1]

He sent three drawings from Vitré on 12 September 1893.[2] The results satisfied him. 'They are most delicate and *beautifully* printed' he said, but he only ordered four or five proofs of each, rather to Way's disgust.[3] In the end,

only a dozen impressions were made in Whistler's lifetime, although Goulding pulled a full edition of fifty-six in May 1904 before the stone was destroyed.[4]

This market scene is reminiscent of the Venetian etching, 'The Rialto' (no.100). As there, people move among the awnings – here more than two dozen figures, walking, talking, looking, and handling the merchandise. Whistler conveys the liveliness of these interactions by means of the pulsating patches of light and dark that organise the picture's structure. There is considerable range in the tones here, from the most delicate of greys to touches of black.

Whistler told Way, 'the work is beginning to have the mystery in execution of a painting', suggesting that it was the subtlety of lithography that appealed to him, as compared to the precision possible in etching.[5]

162 La Fruitière de la rue de Grenelle 1894

Lithograph on cream Japan paper
21.7 × 15.5 (8½ × 6⅛)
Sheet: 30 × 22 (11¾ × 8⅝)
Signed in stone with butterfly
PROV: Gift of Thomas Way to the British Museum 1905
LIT: Way 1896 (70); Kennedy 1914 (70); MacDonald 1988, pp.44–5

Trustees of the British Museum, London

Settled in Paris at 110 rue du Bac, with a studio nearby at 186 rue Notre-Dame-Des-Champs, Whistler continued to mine the geometry of architectural facades. The rue de Grenelle crossed the rue du Bac close to Whistler's home. Most of his lithographs were drawn in this neighbourhood, which he had known for thirty years.

By picking out architectural details meticulously, Whistler responded to the unique elegance of Paris. Particularly compelling are the highly articulated objects seen in the shop windows, jewel-like still lifes, and details of plants on the balcony above. Whistler also incorporated, as he so often did, a mother embracing her baby – and one of those distinctive mongrels that are peppered throughout his oeuvre.

Whistler's transfer lithographs have no rival in their delicate and economical use of the medium. He achieved a wide variety of effects by considerable experimentation with different

grades of papers and lithographic crayons. Here, at the height of his efforts in this medium, he was working on the smooth *papier végétal*, a thin, highly sensitive French paper that permitted a surface beneath it to be rubbed through, a method we today call *frottage*. The transfer and printing of *papier végétal* differed somewhat from the grained papers with which the Ways were familiar. In fact, Whistler in Paris had to instruct his printers in London in the particular requirements of this subtle drawing.

By using it, Whistler achieved an incredibly subtle contrast of values and textures, as for example in the figure seated in the shop who is articulated by tonal details of her pose. Somewhat of a departure is the descriptive strength of the leaves of the plant, upper left, and the baroque architectural oval adjacent to them.

By contrast, Whistler's butterfly signature almost gets lost at the right, appearing as an element of pattern or shadow on the awning. Whistler's interest in design and balance plays an important role in his placement of his butterfly signature.

Whistler sent this drawing on transfer paper from Paris over to Way in London on 23 September 1894, and proofs were returned to him within a couple of days. There is a real sense of collaboration between the Ways and Whistler and they shared his pleasure in the 'sweet quality' of this lithograph, which was, Whistler said, 'more beautiful in quality as a *lithograph* than what we obtained before!'[1] He was delighted with its simplicity and immediately ordered a full edition of thirty prints.

The master printer, Frederick Goulding printed a further edition of thirty-one prints after Whistler's death, before the stone was destroyed so that no more prints could be taken.[2]

163 Late Piquet 1894

Lithograph printed in black on green laid paper 18 × 15 (7⅛ × 6)
Sheet: 18.1 × 15.2 (7⅛ × 6)
PROV: Bequeathed by Whistler to his sister-in-law, Miss R. Birnie Philip 1903; bequeathed to the University of Glasgow 1958
LIT: Way 1896 (57); Kennedy 1914 (57); MacDonald 1988, pp.42–3

Hunterian Art Gallery, University of Glasgow, Birnie Philip Bequest

The date: August 1894, when the Whistlers were living at 110 rue du Bac.[1] The scene: a late-night café in Paris. The game: Piquet, an ancient and elaborate card game for two persons, popular at the time throughout Europe. It is, curiously, the origin of the phrase 'carte blanche' – a bonus score to the player who has no face cards.

With the exception of a few of the Thames etchings (see, e.g. no.2), Whistler's interior views, those in which the artist/viewer is inside with the sitters, depict friends and family, or models at rest. In Whistler's prints, it is rare for a genre scene such as this composition to be set within an architectural space, rather than in a garden or park, or on a terrace, although there are several similar drawings of café scenes.[2]

The hat hanging on the clothes stand is an example of Whistler's ability to grasp an object and set it down with both immediacy and absolute refinement. Drawn with great economy, the woman seated at the left of the players, with her lean features, her hair twisted up and topped by a tiny hat with a cockade or flower on top, is the epitome of the bar-girl. Despite the lack of detail in the drawing of her features, we grasp her gaze, bent flirtatiously on the activity at the next table.

The drawing is marked by the transfer paper's overall granular texture. Little gradation is apparent in the line quality itself. Strokes were set down swiftly, to grasp facial expressions and poses before the sitters shifted their positions, unaware they were serving as Whistler's models.

'Late Piquet' fulfils Whistler's aspirations for his lithographs, as recorded in his correspondence with Thomas R. Way. Describing a print of which he was particularly proud, the artist wrote: 'The work is simplicity itself – most direct – and with no fumbling and retouching'.[3]

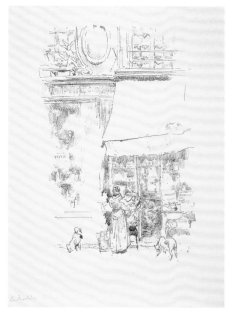

162

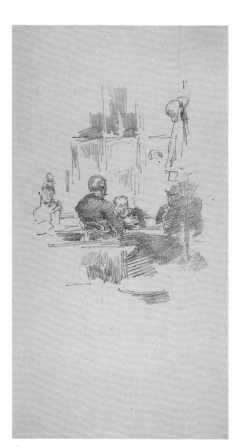

163

Amsterdam

Whistler travelled to Amsterdam several times over the years, making his first etching of the city in 1863. In the autumn of 1889, he travelled with Beatrice to the city for a few months, spurred by the inclusion of his work in the third exhibition of the Etching Club of Holland at the Hague.[1] While there he completed more than a dozen etchings. He wrote to Marcus Huish of the Fine Art Society:

> I find myself doing far finer work [than] any [that] I have hitherto produced – & the subjects appeal to me most sympathetically – which is all important … I will produce new plates, of various sizes – The beauty and importance of these plates you can only estimate from your knowledge of my care for my reputation – and from your experience of myself in the Venice transaction – Meanwhile I may say that what I have already begun is of far finer quality than all that has gone before – combining a minuteness of detail, always referred to with sadness by the critics who hark back to the Thames etchings … with greater freedom and more beauty of execution than even the Venice set or the last Renaissance lot can pretend to.[2]

The etchings were never issued as a 'set', despite these efforts to interest the Fine Art Society in a publishing project, offering them ten plates and thirty proofs of each. The cost was to be 2,000 guineas, including the editions which Whistler, himself, would print. He was justifiably proud of his accomplishments in the city of Rembrandt. Each print was to be sold for no less than ten guineas because 'the quality will be of that "preciousness" that will class the proofs among those for which I habitually ask 12 or more'.[3]

The price was too high. Although Huish asked Whistler to reconsider, no agreement was reached, and an exhibition of the Amsterdam etchings scheduled for mid-1890 was cancelled. As a result, the Amsterdam plates were printed in smaller editions than earlier series, such as the Venetian etchings and are less well known. They are, however, the magnificent culmination of Whistler's etching career.

M.M.

164 Steps, Amsterdam 1889

Etching and drypoint printed in dark brown ink on crisp Oriental tissue, attached to off-white card mount by the artist
Plate: 24.1 × 16.2 (9½ × 6⅜)
Sheet: trimmed to platemark
Signed in plate with butterfly
Signed with butterfly and 'imp' in pencil on tab
Mount signed and inscribed: 'To | George Henschel–', and butterfly
PROV: George Henschel; gift of Lessing J. Rosenwald to National Gallery of Art Washington 1943
LIT: Mansfield 1909 (402); Kennedy 1910 (403 II III/IV)

National Gallery of Art, Washington. Rosenwald Collection

'Steps, Amsterdam' depicted a site along the Rozen Gracht.[1] It functions almost as a transitional piece. More tightly organised, and with more fully developed figural details than the Venetian scenes, its surfaces are less intensely articulated and layered than those of other Amsterdam plates, notably 'Embroidered Curtain' (no.166).

Laundry hanging overhead is one of the signs of everyday life which are the hallmarks of Whistler's etchings. Another detail of great beauty here is the garden of hanging pots and flower boxes that enlivens the first-floor window at the right, sandwiched between the laundry and the graceful suggestion of a chair.

The total effect is quite light and delicate. The door was rubbed down a little to soften the quality of the lines. The finest and faintest lines, barely breathed onto the copper, print clearly on the fine Japan paper.

On the whole the Amsterdam etchings were printed with less reliance on plate tone than were the Venetian etchings (see nos.103–4). Whistler's careful articulation of reflections in canals is nowhere more sensitive and specific than here, in this glowing impression. With the leanest of tonal layers subtly unifying the linework, every mark may be individually read. Even the reflected figures hold together with great clarity.

Among the most satisfying aspects of 'Steps, Amsterdam' is Whistler's depiction of children, catching intuitively their expressive gestures and attitudes. Staring out of a ground-floor doorway at right, into a window at left, or playing in the street, they are portrayed with the same affection (albeit in quite a different manner) Whistler showed in early portraits of children

such as 'Bibi Lalouette' and 'Annie Haden' (nos.7, 12). Also drawn with considerable grace are the two dogs that diagonally bracket the cobblestone pavement.

165 Square House, Amsterdam 1889

Etching and drypoint printed in dark brown ink on cream laid paper
Plate: 23.2 × 17.6 (9⅛ × 6⅞)
Sheet: trimmed to platemark
Signed on plate with butterfly
Signed in pencil with butterfly and 'imp' on tab
PROV: Gift of Lessing J. Rosenwald to the National Gallery of Art, Washington 1943
LIT: Mansfield 1909 (403); Kennedy 1910 (404 I/II)

National Gallery of Art, Washington. Rosenwald Collection

Whistler's titles for the Amsterdam etchings suggest with precision what particular detail attracted him to a scene, as in 'Steps, Amsterdam' (no.164) and 'Embroidered Curtain' (no.166). In the 'Square House', Amsterdam the geometry of the structure sparked his imagination. He highlighted it with a dramatic disposition of light and dark, emphasising shape over all else.

The woman in the doorway, her figure curved like an hourglass, interacts with the figure on the balcony above, forming a central point of human interest. There is the suggestion of another person on the left, not quite realised, like someone who has moved in a photograph. The figures are more subtly suggested than those in 'Steps, Amsterdam', and appear less solidly constructed than their reflections. Whistler's wonderful grasp of descriptive detail is visible in so seemingly insignificant an element as the empty segment of clothesline at the top of the plate.

The marks with which Whistler developed the buildings' surfaces, while retaining individual clarity, mesh to form an overall texture and tone; and in this sense they are radically removed from the mark-making style Whistler used for structures along the Thames thirty years earlier, as exemplified in 'Black Lion Wharf' (no.32).

'Square House, Amsterdam' was essentially complete in this first state. Touches of shading throughout were the only additions, and

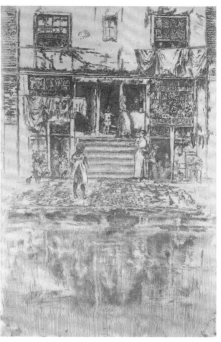

164

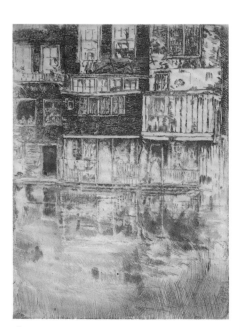

165

Whistler also removed some of the foul-biting round the edge, which resulted from the acid eating through the etching ground to produce an unwanted dark edge.

166 Embroidered Curtain 1889

Etching and drypoint printed in brown ink on paper
Plate: 23.8 × 15.9 (9⅜ × 6¼)
Sheet: trimmed to platemark
Signed on plate with butterfly
Signed in pencil with butterfly and 'imp.' on tab
PROV: Bequeathed by Ethel Wrenn to the Art Institute of Chicago
LIT: Mansfield 1909 (411); Kennedy 1910 (410 III/VII)

Art Institute of Chicago. Bequest of Ethel Wrenn to the John H. Wrenn Memorial Collection

Whistler's Amsterdam etchings are the finest in his etched oeuvre. In 1890, surveying his etching career, Whistler divided the prints into three periods. Ignoring the 'French Set' in favour of those made along the Thames, he described the early group as displaying 'the crude and hard detail of the beginner … all is sacrificed to exactitude of outline.' Of his second phase, the Venice prints, he noted that his 'enemies' called it 'inchoate,' whereas he thought of this style as "Impressionism." With the Amsterdam etchings, however, he 'endeavored to combine stages one and two. You have the elaboration of the first stage and the quality of the second.'[1]

Nowhere is this elaboration more fully seen than in 'Embroidered Curtain', which was published by Mansfield as 'The Lace Curtain'. It depicted a late seventeenth-century building at 52–4 Palmgracht in the Jordaan district, which no longer exists.[2]

Whistler here developed the facade format undertaken in Venice, and explored in dozens of London shop scenes in the intervening decade. He developed an extraordinary range of intricately manipulated networks of marks that differentiate the curtain of the title, the panes of glass, brick walls, cobblestones, iron railings, and the ever-present, ephemeral reflections in water.

Given the importance of the subject in his prints from the very start, Whistler must have found the reversals intrinsic in printmaking particularly sympathetic to mirror reflections in water.

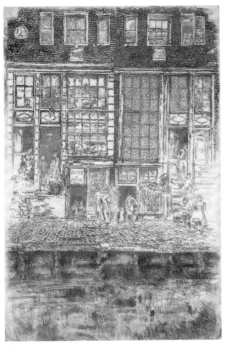

166

167 Nocturne: Dance House 1889

Etching and drypoint printed in dark brown ink on very thin wove paper
Plate: 27 × 16.6 (10⅝ × 6½)
Sheet trimmed to platemark
Signed in pencil with butterfly and 'imp' on tab
PROV: Bequeathed by Whistler to his sister-in-law, Miss R. Birnie Philip 1903; bequeathed to the University of Glasgow 1958
LIT: Mansfield 1909 (407); Kennedy 1910 (409 II/II)

Hunterian Art Gallery, University of Glasgow, Birnie Philip Bequest

Whistler devoted so much time to etching over the course of his career, because he found in it particular qualities not otherwise available to him. From such early prints as 'Reading by Lamplight' and 'The Music Room' (nos.9, 10), through the various depictions of furnaces (see nos.106, 192), to etched Nocturnes such as this, the power of light to form an image was central to his explorations on copper. Whether using black ink or brown, the atmospheric darkness established mood and structure, creating the mystery that is the essence of his art.

In the Venetian Nocturnes, Whistler depended on tonal wiping for his rich, dark effects (see no.122). By contrast, for 'Nocturne: Dance House', he developed tones by layering networks of lines. Etching and drypoint are capable of far richer surfaces than lithography, the print medium with which he was more thoroughly engaged at this period of his life; and in prints such as this, he developed the density and weight specific to the process. Light emanating from the windows, and from a street light whose radiance enhances the overall reflected glow in the canal, emphasises the mystery embedded in the darkness.

In 'Nocturne: Dance House' he developed most fully the tonal structures he had admired – 'ce merveille sa ronde de nuit'[1] – in Rembrandt etchings such as 'The Star of the Kings' (B. Holl 113) and 'The Adoration of the Shepherds' (fig.89), and his attention to his master's lessons is vividly apparent.[2]

In the early 1880s Whistler had painted a glorious group of watercolour Nocturnes in Amsterdam.[3] During this 1889 trip, he completed two nocturne etchings, 'Nocturne: Dance House' and 'Little Nocturne, Amsterdam' (K 414). The latter was worked overall with patches of diagonal parallel lines juxtposed with loosely rendered cross-hatching that together

suggest a darkened atmosphere. 'Nocturne: Dance House' is by far the more dramatic of the two Amsterdam night pieces, and may be seen as the culmination of Whistler's career as an etcher.[4]

168 Sunflowers, rue des Beaux-Arts

1892–3

Etching and drypoint printed in black on cream laid paper with incomplete watermark, possibly the top of a scroll or shield
Plate: 21.8 × 27.9 (8⁹⁄₁₆ × 11)
Sheet: 23.4 × 34.9 (9³⁄₁₆ × 13¾)
Signed on plate with butterfly
Inscribed on verso, 'Nathaniel Sparkes | Imp'
PROV: Acquired by the National Gallery of Art 1992
LIT: Mansfield 1909 (417); Kennedy 1910 (422 I/II)

National Gallery of Art, Washington. Ailsa Mellon Bruce Fund

In 1887 while printing the editions of the 'Second Venice Set' Whistler had etched about a hundred swiftly drawn etchings, half of them shop-fronts. At the same time he renewed his interest in lithography, and it was this medium which dominated his work in Paris in the early 1890s. He continued, however, to make a few etchings, responding to shopfronts near his home in the rue du Bac. The plates were printed in very small editions, and all of them, including 'Sunflowers, rue des Beaux Arts', are little known.

With almost a half-century of experience both in surveying the passing scene and wielding the etching or drypoint needle, Whistler's hand was brilliantly assured when he embarked on the group. Backing away from the layering of a wide range of descriptive marks which distinguishes the Amsterdam etchings, he returned to a more open and atmospheric hatching technique, similar in handling to the Venice etchings. He also returned to the use of black ink, which he had for the most part eschewed both in the Venetian and Amsterdam prints.

The rue des Beaux Arts leads directly to the Ecole des Beaux Arts. At No.8, Fantin-Latour had his studio. In 1876, when he married Victoria Dubourg, they moved into the apartment above the studio. Although Fantin and Whistler never returned to the closeness of stu-

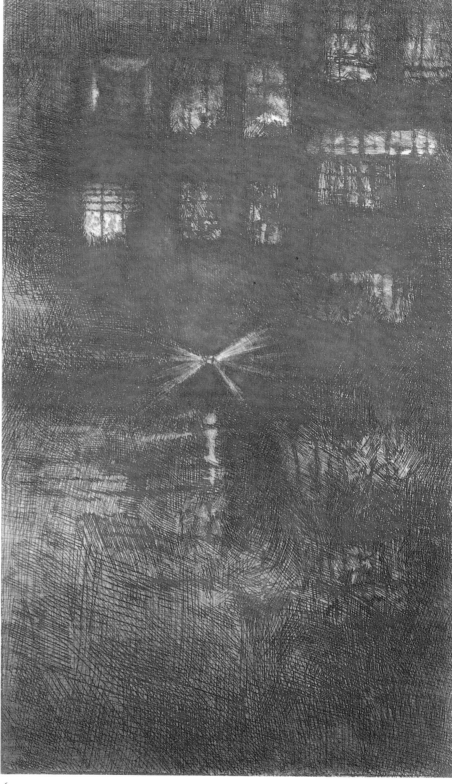

167

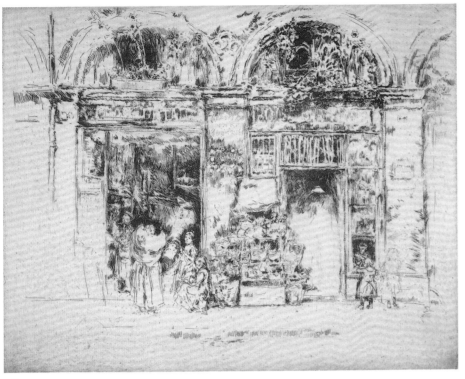

168

dent days, they remained in friendly contact. Indeed, in the 1890s they compared print-making techniques. In 1892, Fantin introduced Whistler to new varieties of transfer paper, which inspired a new burst of creativity. Even the subjects – women engaged in unspecific activities in the studio – and the themes – of music and dance – brought them closer together.

Whistler was obviously aware that the rue des Beaux Arts was associated with the centre of art studies in Paris, as well as being the home of a friend. The baroque opulence of the flower shop, exaggerated by his light, jagged lines, may be a response to these artistic stimuli.

In this shop-front, 'Sunflowers, rue des Beaux-Arts', shadows continue to be Whistler's subject. Indeed, what he appears to have been doing here is focusing on the shadows rather than the objects, just as he had given more emphasis to reflections than to figures along Amsterdam's canals. This approach translates here into a yet greater distillation, perhaps Whistler's response to sunlight obliterating details. A flickering light is pervasive. The sunflowers of the title may symbolise the sun itself.

Yet an anecdotal element remains, in the detailed character of a few of the faces, and in the back view of a child, gazing at what appears to be a poster depicting a man at the right.

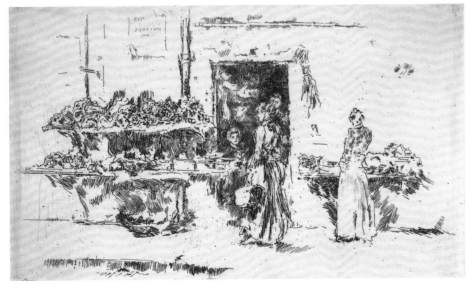

169

169 Fruit Shop, Paris 1893

Etching and drypoint in black on off-white laid paper with watermark of a figure in a railed garden
Plate: 12.7 × 21.7 (5 × 8½)
Sheet: trimmed to platemark
Signed in plate with butterfly
Signed with butterfly and 'imp.' on tab
Verso signed and inscribed '2nd proof' and butterfly
PROV: Howard Mansfield; Harris G. Whittemore; Paul F. Walter; bt the Metropolitan Museum of Art, The Elisha Whittelsey Fund 1991
LIT: Mansfield 1909 (427); Kennedy 1910 (424 only state)

The Metropolitan Museum of Art, New York. The Elisha Whittelsey Collection, The Elisha Whittelsey Fund, 1991

Whistler's etchings of the 1890s, like 'Fruit Shop, Paris', differ from those of earlier decades not only in that they build on all he had learned

in the etching medium, but build as well on his work in lithography.

Three characteristics of lithography seem central. First, Whistler's use of the lithographic crayon, a broader marking tool than the etching needle, has altered the character of his line and seems to have placed an even greater emphasis on the study of shadows. He often delineated figures and objects by drawing the shadows around them. While he was always interested in shadows, these late works called for a somewhat greater abstract complexity than the compositions developed around darkened doorways. Secondly, Whistler's line seems to have taken on a softer, more curving character, perhaps responding to the softness of the crayon medium. Thirdly, the lithographs as a group have a greater sense of intimacy: they are drawings of models posing, drawn close-up; portraits of family and friends. Even those that depict shop-fronts seem to be viewed from a tighter vantage point than was generally used in the etchings.

The impact of these three qualities may be seen in 'Fruit Shop, Paris', in which the scale of the figures is larger, and their relationship to the viewer closer, than in the earlier shop-front etchings. Also, shadows consistently define the forms; and this is emphasised by the strength and clarity of the etched line. It is further enhanced by Whistler's return to black ink, after the warm browns that were essential to the Amsterdam prints. And the lines that carefully describe the vegetables and fruits, while relatively short, have a curvacious flow that is new in Whistler's etchings.

Yet the essential elements remain, particularly in the figures, where Whistler seems to be suggesting the range of possibilities in the directness, intensity, and fullness of these personal encounters.

170 The Blue Butterfly c.1897

Pen and black ink on off-white laid paper with watermark of crown and 'Regia' (incomplete) 9.8 × 15.3 (3⅞ × 6) Signed with a butterfly. Inscribed 'THE BLUE BUTTERFLY | MR WHISTLER'S WORK'
PROV: Bequeathed by Whistler to his sister-in-law, Miss R. Birnie Philip 1903; bequeathed to the University of Glasgow 1958
EXH: Berlin 1969 (132); Tokyo 1987–8 (74, repr.)

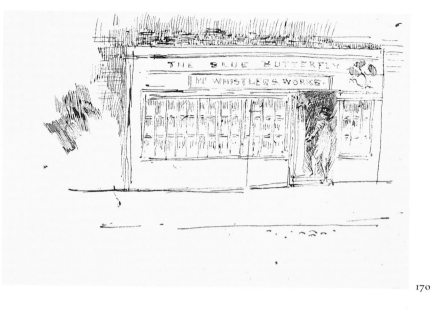

170

LIT: MacDonald 1994 (1473–4)

Hunterian Art Gallery, University of Glasgow, Birnie Philip Bequest

This is drawn on the back of the draft of a letter from Whistler to Mrs Boyt written shortly before the death of his wife Beatrice, and refers to her ill health. She died on 10 May 1896 (see no.195).

In 1896 Whistler was planning to set up the 'Company of the Butterfly'. By putting his affairs on a commercial basis he hoped to avoid the day to day involvement with clients that came between him and his work. He took the lease of a shop at 2 Hinde Street, Manchester Square, London, on 2 April 1897.

The drawing shows a projected shop-front – slightly deceptive, because the rooms were actually on the first floor. Whistler also designed a special letterhead, with a butterfly on a half-mourning background.[1]

The Pennells described the rooms: 'They were charming, a delicate tint on the walls, the floor covered with matting, white muslin curtains at the windows. A few prints were hung. One or two small pictures stood on easels.'[2]

The shop operated until 1901 but was not all Whistler had hoped. Mrs Christine Anderson, who ran it, was inefficient and obstructive. Whistler was continually 'astonished' at her attitude to clients but unfortunately never got around to firing her for incompetence.[3] The shop was closed half the time, and when it was open, depressingly quiet. The Pennells never saw anyone there.

Whistler used the premises to store pictures.[4] C.L. Freer, the most persistent of collectors, did manage to buy a few works there,[5] but

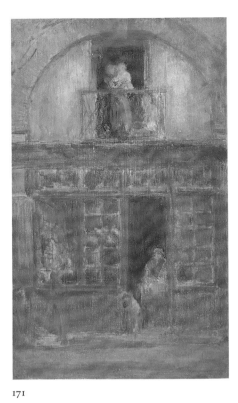

171

on the whole clients still preferred to come direct to Whistler and discover treasures in his studio.

This drawing, however, is not just a design for a shop-front over which Whistler had no control. It is the sort of shop which always interested him (see nos.158–9). Similar multi-paned windows are seen in Whistler's etchings of Amsterdam (see no.166). The repeated vertical lines of the windows give unity to the picture surface. Disappearing into the delicately cross-hatched shadows of the doorway, the figure of a woman in the doorway resembles Whistler's 'The dancer' (no.183).

171 A Shop with a Balcony c.1899

Oil on panel 22.3 × 13.7 (8¾ × 5⅜)
PROV: Bequeathed by Whistler to his sister-in-law, Miss R. Birnie Philip 1903; bequeathed to the University of Glasgow 1958
EXH: London & New York 1960 (58);
LIT: YMSM 1980 (526)

Hunterian Art Gallery, University of Glasgow, Birnie Philip Bequest

A comparison with the balconied building shown in 'La Blanchisseuse, Dieppe' of 1899 (Hunterian Art Gallery; YMSM 527) suggests no.171 was painted in France around the same date. The architecture is drawn in pencil over the grey primed panel, then painted with pigments thinned to the consistency of water-colour.

172

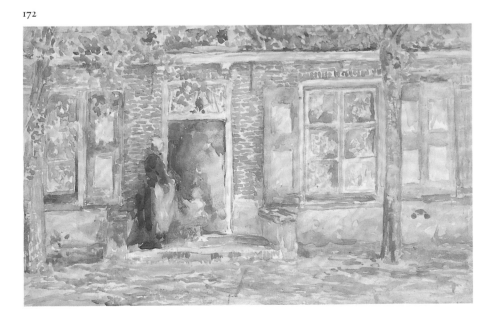

172 A house at Flushing 1899–1900

Watercolour on cream paper laid down on board 14.5 × 24.5 (5¹¹⁄₁₆ × 9⅝)
Signed with butterfly. Inscribed on verso by Harold Wright of Colnaghi, 'At Flushing | after 1896'
PROV: Bequeathed by Whistler to his sister-in-law, Miss R. Birnie Philip 1903; bequeathed to the University of Glasgow 1958; I. Spanierman, New York (dealer) May 1968; the present owners
EXH: London & New York 1960 (101); New York 1984 (115) repr.
LIT: MacDonald 1994 (1590)

Roy and Cecily Langdale Davis

Flushing was a town of some 11,000 inhabitants, a busy seaport situated on the island of Walcheren, at the mouth of the Schelde, Holland. From Victoria Station in London, a train journey of one and a quarter hours would have brought Whistler to Fairhaven, and the steamer took eight hours to cross to Flushing. It was one of the most popular crossings, and one certainly used by Whistler, since it was within easy reach of both Brussels and Amsterdam.

He was drawn to Holland all his life – first by his enthusiasm for the etchings of Rembrandt, and then, by the paintings of Hals, Vermeer and Pieter de Hooch. When he first exhibited his own etchings in Holland, in 1863, they were awarded a gold medal. He maintained contact with Dutch etchers (through the Nederladsche Etsclub) and with painters, particularly those, like James Maris, Josef Israels, H.W. Mesdag and Jan van Toorop, whose work was in sympathy with his.

Whistler went to Amsterdam on 10 August 1899, staying at the Bible Hotel, and complained to his sister-in-law on 20 August, 'I bring away with me nothing!!'.[1] He could, however, have painted this little house on his way home – or perhaps when he visited the village of Domburg, a few miles up the coast, in 1900 (see no.155).

This watercolour is remarkable for its high finish, and the harmonious colour scheme of green and brown. The variety of colour and texture, weathered bricks, bright foliage, and little figures, are intricately worked overall. The little figures have the intimate realism characteristic of the work of Israels, although the light colour and broken brushstrokes are reminiscent of Impressionism.

173 The Open Door *c.*1901

Pen, brown ink, crayon and watercolour
on brown paper 21.6 × 12.9 (8½ × 5⁵⁄₁₆)
PROV: Possible bequeathed by Whistler
to his sister–in–law, Miss R. Birnie
Philip 1903; Henry Tozer; possibly
Sotheby, London 14 Dec. 1960 (210), bt
Betts; Charles Locke, New York by
1960; given by Mr and Mrs Louis V.
Keeler to Cornell University 1960
EXH: Chicago & Utica 1968 (63);
Claremont 1978 (67) repr. p.64; New
York 1984 (99)
LIT: MacDonald 1994 (1696)

Herbert F. Johnson Museum of Art, Cornell
University; Gift of Mr and Mrs Louis V. Keeler

173

In 1900 Whistler had not been well. He was
'lowered in tone: probably the result of living in
the midst of English pictures'.[1] It was advisable
to spend the winter in a milder climate abroad.
His step-brother, Ronald Philip, accompanied
him, first to Tangier, which he found 'too East-
ern' and Algiers, 'too cheap!'.[2] North Africa
proved wet and cold. He returned, ill, to Mar-
seilles, and stayed there for two weeks.

Eventually, in January 1901, they went on to
Ajaccio in Corsica, where Whistler spent three
months, staying at the Hotel Schweizerhof, in a
genial Germanic atmosphere. Ronald Philip
returned home, but William Heinemann then
arrived, and stayed a couple of weeks. The
helpful curator of the local museum lent him a
studio, but Whistler found being under obser-
vation himself distasteful, and in any case, he
was really depressed, and unfit to work on
large-scale works. 'I suppose I must just hang
on here and close my eyes', he wrote home to
Rosalind Birnie Philip, 'for there are beautiful
things in uncanny corners.'[3]

He concentrated instead on etching and
sketching. Two sketchbooks full of studies of
the people and streets and ports of North
Africa and Corsica show that he was unable to
stop working.[4] He realised his compulsion to
work was self-defeating: 'For years I have had
no play! … for years I have made for myself my
own treadmill … and the marvel is that I lived
to be free in this other Island – and to learn, in
my exile, that again "Nothing matters!"'[5]

He returned finally at the beginning of May,
and, much refreshed, launched with enthusiasm
into a summer of work.

In some ways the two watercolours he made
on brown paper on Corsica, this and 'The Gos-
sips, Ajaccio' (Albright-Knox Art Gallery, New
York; M 1675) hark back to his work – and are
reminiscent of his earlier pastels of Venice,
done over twenty years earlier (see nos.109–11).

However, where there he had summarised
the textures of crumbling plaster and stone in
pastel, here he worked in a mixture of pen and
watercolour. Some of the lines were drawn with
a brush and some with pen. The colours – red,
blue and cream, mixed with white – were bold-
ly brushed across the surface.

The hens were marvellously scribbled with
pen dots and dashes. The sinister figure in the
doorway is curiously lost in shadows, washes
obscuring the precision of the penwork. There
are pentimenti around the figures. The baby
and mother's head, the turquoise dress and
blues on the door, and the beige band above the
lintel, are painted brightly in body-colour.

Scale

Some of the difficulties Whistler had in the 1860s, when he first worked on a small scale, intending to enlarge his studies to life-size for the Salon (see nos.24, 27) may have been caused by his seeing that these small studies were satisfactory in themselves.

Even in the late 1890s, when Whistler was working on 'Purple and Gold: Phryne the Superb! – Builder of Temples' (Freer Gallery of Art, Washington, DC; YMSM 490) he had at first intended to enlarge it, but in the end felt this to be unnecessary: 'Would she be more superb – more truly the Builder of temples – had I painted her what is called life-size by the foolish critics who always bring out their foot rule? Is it a question of feet and inches when you look at her?'[1]

By 1880 Whistler had formulated views on consistency in art, which he maintained thereafter. He fought the prejudice against small prints and pictures, which was spread by dealers and galleries. The 'exhibition picture' upon which the reputation and livelihood of an artist relied, was expected to be big, and to dominate the gallery.

Whistler's pictures were painted 'low in tone' (since, as he said, people are so in nature), and small in scale. They were planned to harmonise with each other and to be suitable for private rooms. When planning his own exhibitions in the 1880s he consistently selected small works.

In etching, he held out against the large plates so popular in Victorian times,: which were supposed to provide the measure of the artist's 'skill'. He stated in his first 'Proposition' (one of his statements of art):

I. That in Art, it is criminal to go beyond the means used in its exercise.
II. That the space to be covered should always be in proper relation to the means used for covering it.
III. That in etching, the means used, or instrument employed, being the smallest possible point, the space to be covered should be small in proportion.[2]

Economically this was unsatisfactory: people were not prepared to pay for the small print or painting what they would for a large one. Sir William Eden was a case in point. He refused to pay 500 guineas for a life-size head of his wife, and settled on a miniature full-length panel (Hunterian Art Gallery, Glasgow: YMSM 408). Eden, according to Whistler, thought, 'A man is a d-d fool who gives more for a thing he can get for a smaller price', especially when 'the picture was only twelve inches long by six inches high – and the face only as big as a sixpence'.[3]

Whistler eventually rubbed out his portrait of Lady Eden and repainted it rather than accept the hundred guineas which Eden offered for it (see no.98).

Small-scale portraits, such as those of Ethel Philip (no.189) and Charles Edward Holloway (no.188) were conscious assertions of the importance of small works. Their very intimacy encouraged close study, and the entry into a private world of colour, meaning, and harmony.

M.M.

174 Dancing girl 1885–90

Watercolour over pencil on off-white
wove paper 29.7 × 22.4 (11¹¹⁄₁₆ × 8¹³⁄₁₆)
Signed with butterfly. Inscribed on verso
by Harold Wright 'J.McNeill Whistler
| Model draping (The model probably
| one of the Pettigrews) | (ex
Collection of Miss R. Birnie Philip) |
the Artist's Executrix & Sister-in-law. |
(Done during the Cheyne Walk period)
| 1896 or later.'
PROV: Bequeathed by Whistler to his
sister-in-law, Miss R. Birnie Philip 1903;
Colnaghi, London (dealers, 1957); Cecil
Higgins Museum 1958
EXH: Berlin 1969 (104)
LIT: MacDonald 1994 (1068)

*Trustees of the Cecil Higgins Art Gallery,
Bedford*
[Not exhibited in Washington]

Whistler's sister-in-law, the normally reliable
Rosalind Birnie Philip, suggested that this
model was 'one of the Pettigrews'. It is possible
that in this case she was wrong. The Pettigrew
sisters were professional models who posed for
Whistler about 1890 (see no.176) but this
watercolour probably dates from earlier. Hetty
Pettigrew's hair was chestnut, Lily's was red.
This 'dancing girl' looks dark-skinned, with
brown curly hair, and earrings, coming over as a
vivid personality, possibly Italian.

It is possible that this – or a watercolour very
like it – was the 'Caprice in Red' sent to the
winter exhibition of the Society of British
Artisits in December 1885.[1]

A critic commented that there was 'nothing
capricious, unless it be the price. It is a perfect-
ly well ordered study of flesh colour and red –
an energetic model, springing, as it were – or, as
it is, from the unfolded and widely extended
drapery.'[2] The 'Caprice' offended some critics
who said 'the muslin surroundings leave the
model more "naked and ashamed" than actual
nudity'.[3]

Nos.566 and 568 in the same show were two
pastels, 'Harmony in Opal and Violet' (where-
abouts unknown; M 1075) and 'Note in Violet
and Green' (Freer Gallery of Art, Washington
DC; M 1074). They also had a certain eroticism,
although, as the art critic Frederick Wedmore
tactfully put it: 'they are very well chosen, and
very well placed models, lightly draped and
drawn with a delicate vision of what it is most
graceful to include and most wise to omit.'[4]

Whether slightly draped or manifestly
naked, these studies of women were a challenge

to the puritanical. John Calcott Horsley RA
was a painter of historical genre subjects, whose
dislike of nude paintings earned him the nick-
name 'Clothes Horsley'. Shortly before the
SBA exhibition, in a lecture to a church con-
gress, he deplored the effect of nude models on
both artist and model:

If those who talk and write so glibly as to
the desirability of artists devoting them-
selves to the representation of the naked
human form, only knew a tithe of the
degradation enacted before the model is
sufficiently hardened to her shameful call-
ing, they would forever hold their tongues
and pens in supporting the practice. Is not
clothedness a distinct type and feature of
our Christian faith? All art representations
of nakedness are out of harmony with it.[5]

Whistler added a note to one of the pastels,
'Horsley soit qui mal y pense' and asserted that
'the unseemliness of senility' needed no further
comment.[6] His relationship to Horsley
(who was Seymour Haden's brother-in-law)
undoubtedly added spice to the situation.

In this watercolour, it is not so much the
explicit painting of the nude figure, with the
transparent drapes enhancing and not in any
way concealing the body, which is remarkable,
but the warmth of her expression, which sug-
gests a strong interraction between model and
painter.

It is also unusual in its proportions. The
sheet is slightly larger than usual and the figure
is small in relation to it. The background is
bare, hardly suggesting even the studio or cur-
tains against which his models usually posed.
The dancer stands as if on a stage, movement
implicit in her stance.

Whistler first made an elaborate drawing of
the subject in pencil, and then, perhaps finding
the medium inadequate, worked over it in
watercolour, painting with verve and precision.
The shape of the brush was used with painter-
ly freedom, and the watercolour shimmers with
rich, glowing shades of russet and brown.

175 A dancing woman in a pink robe, seen from the back 1888–90

Charcoal and gouache on brown paper
laid down on card 28 × 18.2 (11 × 7³⁄16)
Signed with butterfly
PROV: Bequeathed by Whistler to his
sister-in-law, Miss R. Birnie Philip 1903;
bequeathed to the University of
Glasgow 1958
EXH: Glasgow 1984 (148); Tokyo 1987–8
(56, repr.)
LIT: MacDonald 1994 (1214)

*Hunterian Art Gallery, University of Glasgow,
Birnie Philip Bequest*

175

Whistler was still in contact with the Ionides
and familiar with their collection of tanagra
statuettes – indeed, a few years later, in 1894, he
tried to help them to sell it.[1] His studies of
women moving gently around the studio may
derive from his reawakened interest in tanagra
statuettes. The costume, with the robe girded
under her breasts, suggests the antique. In a
similar study in the Hunterian Art Gallery,
'The Rose Drapery', the colour – a rich Pom-
peian red – accentuates the classical associa-
tion.[2]

A note by Rosalind Birnie Philip identified
the model as 'Eva', presumably meaning the
elder of the two sisters, Eva and Gladys Car-
rington.[3] Eva was a lively and athletic model
who posed for several 'dancing girls' about 1898
(see no.183). Whether she was already posing
for Whistler some ten years earlier, when
Whistler's first 'dancing girls' were painted, is
questionable.

There are several of these studies in the Uni-
versity of Glasgow, all sketched in charcoal on
fibrous brown paper, and worked over freely in
watercolour. Bold brushstrokes of pink and
white body-colour suggest a transparent robe.
The colour scheme is limited to shades of blue
and pink. The colour turned muddy grey when
the brush touched charcoal.

Whistler habitually destroyed drawings and
reused paper (as he reused canvases). In this
case there appears to be a standing draped fig-
ure underneath the drawing. There are signs of
earlier drawings under his pastels so often as to
suggest he liked the resulting complexity of the
surface. The traces of earlier ideas and shapes
added a certain urgency and vitality to the
work, and were evidence of the process of artis-
tic creation.

This particular drawing was left 'unfinished'
in that her legs and right arm were not drawn in
fully, and her robes originally clung to her body
and draped onto the floor. This carelessness for

the traditional concept of 'finish' was at appar-
ent variance with his 'Proposition: – No.2', one
of his short statements on art, which was pub-
lished with the catalogue of 'Notes' – 'Harmonies'
– 'Nocturnes' in 1884:

A Picture is finished when all traces of the
means used to bring about the end has dis-
appeared. To say of a picture, as is often
said in its praise, that it shows great and
earnest labour, is to say that it is incom-
plete and unfit for view.[4]

However, Whistler was well aware that a uni-
fied concept and harmonious design was more
effective than a meticulously tidy and uniform-
ly detailed picture.

176 Mother and Child *c.*1890

Pastel on brown paper laid down on
board 27.9 × 18.1 (11 × 7⅛)
PROV: Marchant, of Boussod, Valadon
& Cie, Paris & London (dealer); Behg,
Paris; John H. Wrenn by 1904; by family
descent to a lady; Sotheby Parke Bernet,
New York 2 Dec. 1982 (14, repr.)
bought by the present owner
EXH: Boston 1904 (115); New York 1984
(45) repr.
LIT: MacDonald 1994 (1282)

Sally Engelhard Pingree

William Pettigrew, a cork cutter, married Harriet Davis in 1853 and they had thirteen children over the next twenty-one years. The mother brought three of the girls — Hetty, Lily and Rose — to London where they became popular as professional artists' models. The sisters posed first for Millais's 'An Idyll' of 1745 (Lady Lever Art Gallery, Port Sunlight) exhibited at the Royal Academy in 1884. They went on to pose for Edward Poynter, Onslow Ford, Frederick Leighton, William Holman Hunt, Val Prinsep, John Gilbert, Walter Sickert, John Singer Sargent, John William Godward, Philip Wilson Steer, Theodore Roussel and Whistler.

Hetty Pettigrew was the oldest. According to Rose, she had 'soft straight hair, like a burnished chestnut, glorious skin and big hazel eyes'.[1] She posed for a series of pastels by Whistler, who 'admired her and was very amused by her cleverly cruel sayings'.[2] Hetty became a sculptress, and exhibited for several years. Lily had 'curly red hair, violet eyes, a beautiful mouth, classic nose, and beautifully shaped face, long neck, well set, and a most exquisite figure; in fact, she was perfection!'[3]

This pastel probably shows Rose Amy Pettigrew, who was born on 25 February 1870. Her memoirs, written *c.*1947, provide the main source of information on the Pettigrews. Rose eventually fell in love with Wilson Steer, having modelled for the 'Sofa' (Municipal Art Gallery, Pieter-maritzburg) which was exhibited at the New English Art Club in 1889, but the romance came to nothing. Rose married Harry Waldo Warner in 1896.

Rose first posed for Whistler about 1885 when Maud Franklin was still 'Mrs Whistler'. She did not approve of the real Mrs Whistler — Beatrice — although, she said, Beatrice wished they could adopt her (Beatrice and James had no children together, although they had children by previous partners). 'I was generally posing for Whistler's charming little pastels, so used to lunch with them, to my great delight', said Rose of her visits to Tite Street.[4] The pastels are intricate in design and beautiful in colour and seem to have given particular pleasure to Whistler and his wife.

The early portraits show Rose with shoulder-length hair and bushy fringe, but she often put it up. By 1892–3 she had longer hair. She wrote:

> I was the ordinary little one, with bushels of very bright gold hair, a nose, which started straight but changed its mind, by turning up at the tip, a rose-leaf complexion, and a cupid's bow mouth ... I had an extremely pretty figure, and although not

nearly so handsome or beautiful as my sisters, was easy on the eye. We all had extremely beautiful hands.[5]

By 1891 Rose was Whistler's most important model, posing five days a week – for graphics, drawings and paintings, frequently as a 'mother' with her 'baby'. Whistler called the pastels of Rose and family, the 'Rosie series'. In the spring of 1891 he wrote to his wife about the importance of his recent pastels, 'the beautiful Rosies and Nellies' and begged her to take good care of 'drawers full of Rosies'.[6] Nellie has not been identified but could be another model, or a child in some of the pastels.

The identity of the baby is uncertain. The Pennells mention a child of under three who posed for the pastels, and while her mother rested, Whistler watched the child. '"Really," he said, "you are a beautiful little thing!" She looked up at him, "Yes, I is, Whistler," she said.'[7]

The Pettigrew sisters' older brother Alfred and his wife Jane had a little girl, Harriet Lilian, in 1885. Another baby, Ethel Jenny, was born in 1893. She remembers being taken to visit Rose and could therefore have been 'Baby Pettigrew'.[8]

Several pastels show the same pair, who, despite the title of this pastel, are probably Rose Pettigrew and her niece. Rose was used to children and happy with the baby.

Drawn with restrained, caressing lines, the figures were neatly touched with colour. Deep blues and purples were rubbed and scumbled across the transparent robe. Glowing creamy flesh tones drawn with the round end of the pastel highlight relaxed limbs. The paper is a dark greyish brown with golden flecks of stalk, combining with the coloured pastels to rich effect.

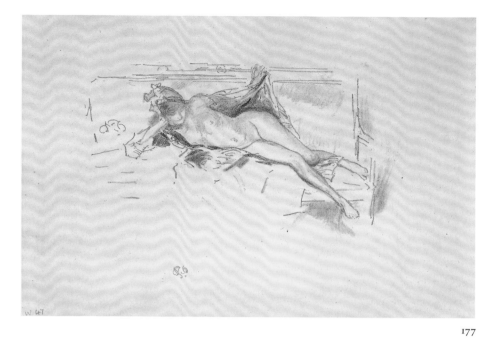

177

177 The Nude Model Reclining 1893

Lithograph on laid paper with watermark of rampant lion between banded shield
11.4 × 22 (4½ × 8¾)
Sheet: 20 × 30.9 (7⅞ × 12¼)
Signed in stone with butterfly
Signed in pencil with butterfly
PROV: Bequeathed by Whistler to his sister-in-law, Miss R. Birnie Philip 1903; bequeathed to the University of Glasgow 1958; Paul F. Walter 1985; gift of Paul F. Walter to the Metropolitan Museum of Art 1985.
LIT: Way 1896 (47): Kennedy 1914 (47); MacDonald 1988, pp.42–3

The Metropolitan Museum of Art, New York. Gift of Paul F. Walter, 1985

Young models like this figured frequently in Whistler's pastels and graphic work in the early 1890s. Here, against the elegant lines of the Empire sofa in Whistler's studio, lifting her embroidered robe, she appears slight, her hips narrow, her breast barely developed. The pose is derived from a Tintoretto 'Venus', of which Whistler owned a photograph, and it is a pose he used in several variations (see no.178). The model could not have held it for long, so the artist had to work quickly. The brevity of this glimpse of the naked body is emphasised by the conciseness of the technique.

Beatrice Whistler was often beside the artist in the studio at work. She encouraged him to draw these lithographs and pastels of young girls, and girls with babies, which dominated

his work in the early 1890s, and sometimes drew from these models herself.[1]

There is a marvelous range of line and tone, here, and although printed, the marks retain the freshness of direct crayon drawing. About the time he was working on 'The Nude Model Reclining' Whistler wrote to Way, 'I really believe I am making at last something altogether peculiar – don't you? I am getting now a richness with it – a certain velvety daintiness – unlike anything I have ever seen.'[2]

One new characteristic in Whistler's lithographs by this time was his use of a stump to develop tones by rubbing, possibly an offshoot of his efforts at drawing them here. The delicate surfaces thus achieved extended Whistler's lithographic process, but they were particularly difficult to print. Thomas R. Way's experiments with the method, however, enabled him to develop the necessary skills to rise to Whistler's challenge.

Whistler sent this drawing on transfer paper from Paris to Way in London in November 1893. When he saw the proofs he ordered an edition of twelve. However, a few days later, he decided that minor alterations were needed, which he marked on a proof and returned to Way. After Way had made the corrections on the stone, a further dozen impressions were pulled. Whistler's perfectionism and Way's professionalism achieved a deceptive appearance of simplicity.[3]

178 Mother and child reclining on a couch 1890–6

Watercolour on buff Japan paper laid down on card 18.1 × 26.8 (7⅛ × 10%₆)
PROV: Bequeathed by Whistler to his sister-in-law, Miss R. Birnie Philip 1903; Colnaghi, London (dealers), 27 March 1943; National Art Collections Fund 13 May 1943; given to the Victoria and Albert Museum
EXH: Paris 1961 (11); Berlin 1969 (101), repr. p.63
LIT: MacDonald 1994 (1297)

Board of Trustees of the Victoria & Albert Museum, London

Whistler explored the mother and child subject at some length, but exhibited few of his pictures, so that they were known to only a few, to artists in his own circle, like Theodore Roussel, who also employed the Pettigrews (particularly Hetty) as model.[1]

Whistler made several lithographs of a young woman with a baby on a sofa (w 102, 134–5) which were drawn in 1890 and printed (at Beatrice Whistler's insistence) in 1895.[2] He drew decorative and colourful pastels of the Pettigrew sisters with the baby intertwined on the sofa.[3]

Finally, he painted four 'mother and child' subjects on Japan paper.[4] Stylistically, they could date from later than the pastels of similar subjects (see no.176). However, Rosalind Birnie Philip identified the models as the Pettigrew sisters, and lacking any other evidence, it must be assumed that Whistler continued to work with these, his favourite models.

This watercolour was worked up carefully, to avoid spoiling the fragile paper. The sofa was outlined in brown and the figure in grey. The brushstrokes have a voluptuous fullness. The colours were separated so that they would not run. Glowing washes of beige, pink and lilac complement the paper, set off by touches of bright coral-red on the coverlet, and a sea blue-green ribbon. The greatest precision and the finest point was reserved for her pink lips and the curve of her closed eyelids.

178

179 Blue and Violet – Iris 1890–4

Pastel on brown paper
27.4 × 17.7 (10¾ × 6¹⁵⁄₁₆)
Signed with butterfly. Inscribed on label
attached to back board 'Blue and Violet
– Iris', signed with butterfly
PROV: R.A. Canfield, Providence, 8 May
1903; Knoedler, New York (dealers)
1914; sold to George F. Baker, New
York, 1914; Edith Kane Baker, Locust
Valley, N.Y.; Parke Bernet, New York 28
Oct. 1977 (259, repr.) bt. Hirschl and
Adler, New York (dealers); Agnew,
London (dealers); the present owners
EXH: Boston 1904 (125); Paris 1905 (145);
Buffalo 1911 (25, repr.); New York 1984
(46)
LIT: MacDonald 1994 (1278)

Private Collection

About 1890, Whistler, encouraged by his wife, drew numerous studies of a young woman with a child, exploring their tender relationship. The drawings are fine in colour, straightforward in drawing, and unsentimental. Titles like 'Iris', 'Pearl' and 'Shell' distance them from the constraints of 'subject' and emphasise their neutrality. Whistler had written in 1878 'the picture should have its own merit, and not depend upon dramatic, or legendary, or local interest'.[1]

In the 'Ten O'Clock' lecture in 1885 he described the relationship between the artist and nature: 'He looks at her flower, not with the enlarging lens, that he may gather facts for the botanist, but with the light of one who sees in her choice selection of brilliant tones and delicate tints, suggestions of future harmonies.'[2]

The French poet Stéphane Mallarmé translated the 'Ten O'Clock' lecture in 1888, and discussed Whistler's ideas with him. He made Whistler more aware of the possible layers of meaning in both subjects and colours – and the inter-relationship of visual and literal elements. Titles like 'Rose' and 'Pink' were the names of flowers, and were descriptive of colour, and the unfolding flowers and buds symbolised the young women with babies.

In this case, the iris had additional symbolical associations, both with Iris, messenger of the Gods, and with irridescence – as in the rainbow colours of pastels. The violet of the title is found in her cap. Her robe is turquoise blue, with contrasting orange ribbons, intense against the smooth dark paper. Whistler used three pinks, and worked with both the stump end of the pastel, and rubbing (both with fingerss and a pointed roll of paper), for the flesh

tones. There are signs of minor alterations, and her arm originally rested on the railing, while her foot or robe were further to the right.

Both Whistler and his wife had made life-studies from the nude before their marriage. It seems unlikely that it was a misplaced prudishness which stopped them drawing from the nude now that they were together. More likely it was an increased interest in colour which made Whistler clothe his models in these thin gauzes, and his involvement with Symbolism which stopped him from making these costumes specific as to date or origin.

In 1903, two months before Whistler's death the collector Richard Canfield (see no.202) visited his studio and bought this pastel for £178 10s. od.[3]

179

180 Design for a Mosaic 1888–91

Pastel on brown paper
28 × 17.5 (11 × 6⅞)
Signed with butterfly
PROV: J.H. Hutchinson; his widow;
possibly sold, Christie, London, 27 Feb.
1892 as 'An Arrangement in Lemon and
Turquoise', bt Robertson; W. Graham
Robertson by 1905; Christie, London 22
July 1949 (135) bt Leger, London
(dealer); Mrs J.L. Neame, Jersey,
Channel Islands; Hon. Mrs David
Fellowes; Sotheby, London, 14 July 1965
(54); private collector 1965; by family
descent to the present owner
EXH: London 1905 (40); London &
New York 1960 (116)
LIT: MacDonald 1994 (1226)

Private Collection
[Not exhibited in Washington]

Both nos.180 and 181 belonged to the collector J.H. Hutchinson, and it is not clear which one was referred to on 24 February 1892 when the London dealer D.C. Thomson asked Whistler the value of Hutchinson's pastel 'Study in Lemon and Turquoise', so that he could bid at auction to keep prices up. Whistler replied, 'The Pastel I remember is very rich and brilliant – ought certainly to be pushed | – You should sell it for £130 – or £150'.[1]

There is a long tradition that this pastel relates to the commission for a mosaic for South Kensington Museum in 1872 (see no.26). In 1905 the *Morning Post* mentioned this 'most brilliant and luminous drawing', as a design

180

'approved and accepted' for a lunette at South Kensington Museum, and regretted that the project had come to nothing.[2] The Pennells called the pastel 'The Gold Girl' and said that Whistler had intended to enlarge it as a cartoon.[3]

The pose – but not the costume – has some similarities to the painting, 'Tanagra' (Randolph Macon Woman's College, Lynchburg, Va; YMSM 92), and the related drawing and cartoon of 1869 (fig.90; M 358).[4] These could have been developed in the 1870s in connection with the South Kensington project. If so, the whole emphasis was altered by the addition of the parasol and the elaborate robes.

The two drawings of 'Japanese art workers' (see no.26) which appear to be Whistler's direct response to his commission for South Kensington museum date from around 1872, but this pastel as it stands could not possibly date from that early. It has a bright blue butterfly against a trefoil (drawn perhaps round a sixpenny piece) which is an integral part of the design and dates from about 1888. The trefoil was the symbol for Whistler's wife, Beatrice, whom he called his 'Luck'. Furthermore, the pastel is in a flat, beaded yellow-gold Whistler frame, dating from the late 1880s, which complements the golds of the drawing.

However, it could have been drawn over an earlier study. The chalk lines vary in colour and some – where a harder chalk has been used – may date from an earlier composition.

Even if the original figure dates from earlier, the detail and colouring date from the 1880s. Over the background there is a scumble of pale lemon, drawn with the side of the pastel and lightly rubbed in, so that the paper's horizontal grain is apparent. The figure was outlined in black and flesh tones, filled in with touches of colour. The face was detailed, the flesh colours rubbed in, and white highlights added.

Since there are some minor signs of reworking, and it was common enough for Whistler to totally rework earlier pastels, it remains possible that it was originally drawn in 1869, and completely redrawn and signed two decades later. As Whistler said, 'Very often on such occasions, seeing again after absence the picture with a fresh eye I put on a new touch or two upon them by which they gain'.[5] The problem remains unresolved, an interesting sidelight on a fascinating picture.

In the pastel as it now appears, specifically Oriental accessories were added. The magnificent robe was used in two other pastels, 'The Arabian' and 'The Fortune Teller' 1888–90 (Hunterian Art Gallery, Glasgow; M 1225, 1227) apparently for its exotic association, rather than

[259]

for specifically Oriental subjects. Two other pastels of the period, no.181 and 'A Masked Woman' (Hunterian Art Gallery, Glasgow), also feature elaborate embroidered robes.[6] These robes inspired some of the finest of Whistler's figure studies, including this superb pastel.

181 The Japanese Dress 1888–90

Pencil, chalk and pastel on brown paper laid down on card
26.6 × 17.9 (10½ × 7 1/16)
Signed with butterfly. Inscribed '2 Lindsey Houses–Chelsea'
PROV: Dowdeswell, London (dealers); J.H. Hutchinson; his widow; H. Mansfield 1891; A. Reid, Glasgow (dealer) by 1913; Colnaghi, London (dealers) 1913; B.H. Hahlo & Co., New York (dealers) 1913; Harlow, McDonald & Co., New York (dealers); Mrs C.J. Sullivan, New York by 1934; E.A. Seasongood, 1935: Seasongood sale, Parke Bernet, New York 5 Nov. 1951 (301, repr.); given by George W. Davison to Wesleyan University 1952
EXH: Boston 1904 (116);
LIT: MacDonald 1994 (1227)

Davison Art Center. Wesleyan University. Gift of George W. Davison (B A Wesleyan 1892), 1952
[Exhibited in Washington only]

In 1890 the collector J.H. Hutchinson was buying pastels from Whistler and having pastels from his collection touched up (see no.180). On 10 February 1890 Whistler wrote to Dowdeswell, London dealers, 'I want to show you another beautiful pastel for Mr Hutchinson'.[1]

After Hutchinson's death, this pastel was owned by Howard Mansfield, a great collector and author of a catalogue of Whistler's etchings. In 1901 Whistler wished to borrow this pastel for exhibition, but the dealer E.G. Kennedy reported Mansfield as saying, 'the only figure piece he has is but a sketch.'[2] Whistler replied: 'the pastel figure he has I dont consider a "sketch" if he does – It is a very brilliant drawing and of beautiful colour – Gold – & blue & violet – in short a sparkling business altogether – indeed I think he has two'.[3]

As with no.180, tradition suggests that this pastel was started in the 1870s, and that it was

181

exhibited by the London dealer, Deschamps, at the French Gallery. If so it must have been thoroughly reworked. The parasol and the background could easily have been done earlier, and there are numerous signs of alterations, but the figure as it now appears is of the 1890s.

With its combination of Oriental motifs, a graceful figure, richly clad, and a high degree of finish, it is very like no.180. The elaborately patterned robe is probably that seen in 'The Arabian', a portrait of Hetty Pettigrew, which confirms a date around 1890s (Hunterian Art Gallery, Glasgow; M 1225).[4]

The figure was drawn with black chalk, the lines varying in strength and precision, standing solid against the hazy, scumbled background. Her face was drawn softly, the parasol, more roughly. Then all the intricate detail of the pattern was filled in with precision, illuminating the glittering, many-faceted surface. The recurrence of certain colours – the pink and orange on the parasol and on her coat, the steely blues and dark greens of the embroidery – unifies the composition.

182 Loie Fuller dancing 1892

Pen and black ink on off-white wove paper 20.9 × 31.9 (8¼ × 12⁹⁄₁₆)
PROV: Bequeathed by Whistler to his sister-in-law, Miss R. Birnie Philip, 1903; bequeathed to the University of Glasgow 1958
EXH: Berlin 1969 (99); New York & Philadelphia 1971 (43) repr. pl.64
LIT: MacDonald 1994 (1346)

Hunterian Art Gallery, University of Glasgow, Birnie Philip Bequest

Loie Fuller (Marie-Louise Fuller, 1862–1928) was a singer from Illinois who made her debut as a dancer at the Folies Bergère on 5 November 1892. In one of her dance routines, 'Le Papillon', she swirled diaphonous draperies around her body, barely moving her body at all. Complex lighting enhanced the dramatic effects.

Whistler must have attended one of the first performances, for within a month, Isabella S. Gardner, the great Boston socialite and collector, wrote asking him to show her 'the whirling tracings of Loie Fuller that you pencilled'.[1]

He had always been fascinated by the theatre. Nightly at the Gaiety Theatre in the late 1870s he drew Nellie Farren and Connie Gilchrist and the other stars of burlesque in fantastic roles and costumes.[2] Actors and actresses posed for their portraits (see no.64). In 1892, Loie Fuller's performance had the additional attraction of featuring his own symbol, the butterfly.

Loie Fuller inspired many other artists. Among these, Henri de Toulouse-Lautrec made a lithograph of Loie, in which he printed a series of impressions in subtly varied semi-metallic colours to simulate the light and movement of her dance.[3] Later, Pierre Roche's statuette of c.1897 (Musée des Arts Décoratifs, Paris) translated her movements into the swirling forms of Art Nouveau.[4]

Whistler continued to study the effects of veils to convey movement with models in his studio (see no.183) and developed from these swirling arabesques a less stylised method of rendering movement.

182

183 The dancer *c.*1900

Pen and black ink on tan paper laid
down on card 15 × 10.8 (5⅞ × 4¼)
Signed with butterfly
PROV: Bequeathed by Whistler to his
sister-in-law, Miss R. Birnie Philip 1903;
bequeathed to the University of
Glasgow 1958
EXH: London & New York 1960 (128,
repr. pl.20); Paris 1961 (13); Berlin 1969
(100)
LIT: MacDonald 1994 (1627)

*Hunterian Art Gallery, University of Glasgow,
Birnie Philip Bequest*

The figure was at different times thought to be
either Connie Gilchrist or Loie Fuller (see
no.182).[1] It is more likely to be the 'long-legged
dancing blue girl' Eva Carrington in Whistler's
studio.[2]

In 1898, the twelve year old Edith Burkitt,
daughter of Whistler's housekeeper, saw
Whistler at work at 8 Fitzroy Street:

Whistler was making nude paintings at this
time of a girl, Eva Carrington – or they
might have been pastels. He discovered her
also in one of the 'alleys'. She was quite
brazen and when I went into the studio he
had an understanding that his maid Marie
should take her out of his studio to the
kitchen – 'while Miss Edith is here'.[3]

This is one of a series of drawings in ink and
charcoal, which could date from the late 1890s,
or from after Whistler's return from Corsica in
1901.[4]

M. Menpes wrote that Whistler asked his
models to move around the studio and asked
them to stop when he saw a pose he liked.[5] This
drawing is the product of such a method.

Whistler may have been influenced in his
studio practice by his friend, the sculptor
Auguste Rodin, who, like Whistler, drew fig-
ures in movement. Rodin's eye never left the fig-
ure while his hand drew by instinct. He
attempted, he told Camille Mauclair in 1898, 'a
drawing of movement in air'.[6]

Whistler was concerned with the technical
problems of representing movement on paper.
He held the image of a movement in his mind
long enough to convey it with pen or chalk. He
could later rework it at his leisure, accentuating
the shape and roundness of the body and the
movement of drapery, without consulting the
model continually – hence the numerous penti-
menti in this study. The original image was
refined by the addition and/or removal of lines,
and, in the case of pastels, of colour.

The costume is one invented by Whistler
and shown on numerous studies of dancing
models in his studio (see no.175). This dancing
girl in clinging, billowing draperies, swirling
around in the shadows of the studio, is the
finest of the series.

184 Gants de Suède 1890

Lithograph on cream paper with
countermark crowned GR with
pronounce cross (the counter to Pro
Patria FI) 21.5 × 10.1 (8½ × 4)
Sheet 33.1 × 20.7 (13 × 8⅛)
Signed in stone with butterfly
Stamp 'RBP' (Lugt 406)
PROV: Bequeathed by Whistler to his
sister-in-law, Miss R. Birnie Philip 1903;
bequeathed to the University of
Glasgow 1958
LIT: Way 1896 (26); Kennedy 1914 (26);
MacDonald 1988, pp.40–1

*Hunterian Art Gallery, University of Glasgow,
Birnie Philip Bequest*

Published in *Studio*, III, no.13, April 1894,
repr.p.20.

Ethel Birnie Philip (1861–1920) was four years
younger than her sister Beatrice, Whistler's
wife. Ethel and her mother joined the
Whistlers in Paris where Ethel served as the
artist's secretary for a time. She eventually mar-
ried the writer, Charles Whibley. This regal
portrait is one of two Whistler did of Ethel at
about the same time. In the other, entitled 'The
Winged Hat' (fig.91; w 25), his elegant sister-in-
law was wearing the same distinctive *chapeau*.

'Gants de Suède' reveals Whistler at his most
assured, drawing with sweeping strokes. There
is no hesitancy and no revision. The barest of
marks define Ethel's features – the shape of her
lips, the direction of her gaze, strands of hair
peeking from beneath the hat's wide brim – yet
they are clearly visible even from some distance.
The crisp stripes on her puffed sleeves and
bodice are in clear contrast to the parallel linear
marks that create shadows.

Whistler, intrigued by the *Studio*'s use of
artists' lithographs, authorised Way to look
into having his work included, which the print-
er did. Appreciating its general appeal, in
December 1893 Whistler agreed to sell 'Gants
de Suède' to Gleeson White for publication in
the *Studio*, for £10.[1] Thus 'Gants de Suède' is a
comparatively well known and popular print.

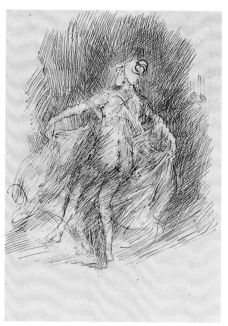

183

184

Way must have transferred the drawing to more than one stone, for he hand-printed eight impressions in 1894, and a further twenty at the time of the Fine Art Society exhibition in 1896. It was among the lithographic stones bequeathed to Rosalind Birnie Philip, Beatrice's youngest sister, and Whistler's ward and executrix, in 1903. She commissioned the firm of Frederick Goulding to reprint (and in a few instances print for the first time) the stones she had inherited. This was among them. In February 1904 he printed an edition of forty.[2]

The presence of the rectangular Birnie Philip stamp (Lugt 406) on the verso of this impression is evidence that this was one of the original lifetime impressions. Some, but not all, of those that were printed posthumously are marked by a round Birnie Philip stamp (Lugt 405).

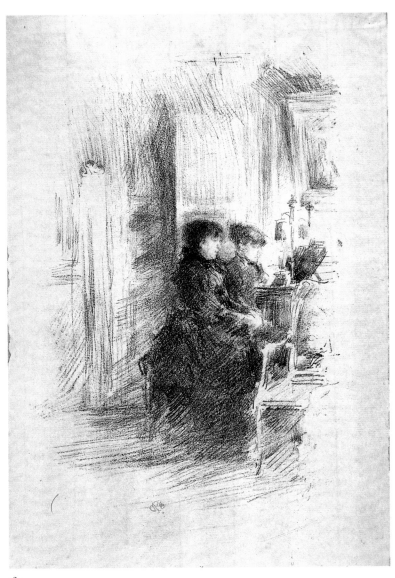

185

185 The Duet 1894

Lithograph printed in black on cream laid paper 24.3 × 16 (9⅝ × 6⅜)
Sheet: 27.4 × 19.9 (10¾ × 7⅞)
Signed in stone with butterfly
Signed in pencil with butterfly
Stamp 'RBP' (Lugt 406)
PROV: Bequeathed by Whistler to his sister-in-law, Miss R. Birnie Philip 1903; bequeathed to the University of Glasgow 1958
LIT: Way 1896 (64); Kennedy 1914 (64); MacDonald 1988, pp.44–5

Hunterian Art Gallery, University of Glasgow, Birnie Philip Bequest

Returning to the intimate setting of a family music room seen in early paintings and etchings (see nos.10–11), in 'The Duet' Whistler depicted his wife Beatrice and her sister Ethel at the piano in the Whistlers' Parisian home on the rue du Bac. It is one of Whistler's most elaborate interiors in lithography, with the structure of the room, pictures on the wall, the chair between the viewer and the pianists, fully suggested (in Whistlerian terms). The expressive faces of the women, clearly readable, though drawn with the lightest of touch, offer a record of the peaceful pleasures of home which were important to Whistler at this time. They were soon to be interrupted, however, by Beatrice's illness which would send them back to London.

Whistler was dissatisfied with 'The Duet' when the Ways sent proofs in August 1894. He wrote to them that: 'The Duet won't do – I know all about the Rembrandt effect – but the hands are unworthy.' Way, for once, disagreed, but Whistler insisted, 'I shall do another of the same subject. Meanwhile don't show it.[1] He did, in fact, make a second version, 'The Duet, No.11' (w 65), and – registering Way's disapproval – had it printed in Paris.[2] In it the figures are placed at a greater distance from the viewer and the setting is generally less fully defined than here.

Apparently finding it less satisfactory, Whistler retouched his initial drawing successfully in the following year, after which he allowed a sizeable edition of thirty-nine to be printed by Way. Whistler had set the limit of any edition at one hundred but few editions approached these numbers.[3]

The most *intimiste* of Whistler's lithographs, this print anticipates the work of Edouard Vuillard and Pierre Bonnard in the later 1890s.

Symbolism and Decadence

Towards the end of his life Whistler was lionised by Symbolist and Decadent artists and poets. In 1889, Joris Karl Huysmans, author of the decadent novel *A rebours*, wrote that 'dans ses harmonies de nuances, passe presque la frontière de la peinture: il entre dans le pays de lettres, et s'avance sur les rêves mélancholiques où les pâle fleurs de M. Verlaine poussent.'[1] At first it might seem odd that a painter who was essentially a Realist and who went to great lengths to repudiate any literary dimension to his art, should be taken up by those whose work explored a world of fantasies, dreams and emotions.

Yet as early as 1865 the poet Swinburne had been inspired by Whistler's 'Symphony in White No.2' to write a Symbolist poem, which Whistler proudly attached to the frame of the painting (no.15). When sending Whistler those verses Swinburne wrote that they were inspired by the enigmatic quality of the white maiden gazing at her own reflection in the mirror: 'I know it was entirely & only suggested to me by the picture, where I found at once the metaphor of the rose & the notion of sad & glad mystery in the face languidly contemplative of its own phantom & all other things seen by their phantoms.'[2]

After 1888 Whistler was a regular visitor to the French Symbolist poet Mallarmé's famous Tuesday night gatherings of poets, critics, and painters (see no.186). In their eyes, Whistler evoked the mysterious essence of his subjects without describing them in detail, in Mallarmé's famous phrase, 'not the object, but the effect it produces.' Mallarmé, who translated the 'Ten O'Clock' lecture into French in 1888, paid tribute to Whistler's 'unique and solitary genius'[3] and compared him to the American poet who in his eyes outshone all others, Edgar Allen Poe.[4]

Whistler, like Mallarmé, achieves a poetic resonance in his pictures by imposing a certain distance between himself and his subject. By refusing to describe in detail, he does not manipulate his viewers' response, allowing him to project his own emotions onto each image. Whereas most conventional critics had seen Whistler's art as empty, Symbolists saw it as a reaction to a modern world which offered too *much* visual information.[5]

In the mid-1860s, in his use of musical terminology for the titles of his paintings, Whistler had been highly influenced by the Baudelarian theory of *Correspondances* between the arts. At the turn of the century the process reversed itself when composers in the Symbolist circle in Paris were inspired by Whistler's paintings. In the last letter Theodore Duret wrote to Whistler, he asked whether his friend had heard of Debussy's Nocturnes which 'are derived from Whistler's terminology'.[6]

One clue as to how the Decadent movement viewed Whistler is given in the critic Richard Le Gallienne's essay, 'What Is Decadence in Literature?' The answer is that it is the 'expression of isolated observations', such as the 'picturesque effect of a beggar's rags, like Gautier', or 'one's mother [considered] merely prismatically, like Mr. Whistler'. Le Gallienne concluded that 'at the bottom, decadence is merely limited thinking, often insane thinking'.[7]

R.D.

186

186 Stéphane Mallarmé No.1 1894

Lithograph on appliqué Japan paper
9.5 × 7 (3¾ × 2¾)
Sheet: 13.2 × 10.6 (5¼ × 6¼)
Signed in stone with butterfly
Stamp 'RBP' (Lugt 406)
PROV: Bequeathed by Whistler to his
sister-in-law, Miss R. Birnie Philip 1903;
bequeathed to the University of
Glasgow 1958
LIT: Way 1896 (66); Kennedy 1914 (66);
MacDonald 1988, pp.44–5

*Hunterian Art Gallery, University of Glasgow,
Birnie Philip Bequest*

Whistler's printed oeuvre is punctuated with intimate portraits of friends and family, artists and writers, from early drypoints like that of the sculptor Charles Drouet (no.8), to a series of lithographs of the mid-1890s that introduce us to the artist's biographers, the graphic artist Joseph Pennell and his wife, Elizabeth Robins (W 103–5, 111); the painter Walter Sickert (W 79); and the printer of Whistler's lithographs, Thomas Way (W 107–8). It is not surprising, then, that he was invited to contribute a frontispiece portrait to the first edition of Stéphane Mallarmé's *Vers et prose*, (1894).

Whistler and Mallarmé (1842–98) had many shared beliefs, not the least of which was in the importance of nature as inspiration for art. Nature, however, was not to be literally transcribed: it was not the object, Mallarmé said, but the effect it produced, that was important. They apparently met about the time Mallarmé translated Whistler's 'Ten O'Clock' lecture into French for publication in *La Revue Indépendante* in May 1888. Whistler was pleased with the translation, and the two men formed a close friendship, which was consolidated when the Whistlers moved to Paris in 1892, and lasted until Mallarmé's death in 1898.[1]

Mallarmé occasionally sent letters to his friends with the addresses written as quatrains, as for example,

Leur rire avec la même gamme
Jaillira si tu te rendis
Chez Monsieur Whistler et Madame
Rue antique du Bac cent-dix.

In 1892 Whistler tried to get these 'Récréations Postales', 'the work of the most dainty of French Poets – Mallarmé', published by his own publisher, William Heinemann, and designed a cover in the form of an envelope, but the project fell through.[2]

Mallarmé was involved in one way or another with most of Whistler's concerns in France.

In particular, he was active in persuading the French government to purchase the portrait of Whistler's mother (no.60) for the Musée du Luxembourg, and obtain honours for him.[3]

Mallarmé, at the centre of a group of artists and writers which spread its influence throughout Paris and France, was the leader of the Symbolist movement. Whistler attended Mallarmé's famous 'mardis' (Tuesdays), the Symbolists' Salon, at 89 rue de Rome, and visited his country house at Valvins, Seine-et-Marne. They conducted a fascinating correspondence which included the discussion of events in their own lives, mutual friends, their artistic undertakings, battles with adversaries, and so forth.[4] Mallarmé wrote to Beatrice as well, sending her poems during her fatal illness.

After the death of his wife, Whistler wrote to Mallarmé:

Je suis enfin toujours seul – seul comme a du l'être Edgar Poe, a qui vous m'avez trouve d'une certaine resemblance – Mais en vous quittant, il me semble dire Adieu à un autre moi! – seul dans votre Art comme je le suis dans le mien – et en vous serrant la main ce soir, j'ai eprouve le besoin de vous dire combien je suis sensible à toutes les intimités de pensée que vous m'avez témoigne.[5]

There was no sense of competition and they both appreciated the subtleties and insights in each other's work.

The Pennells provided an account of Whistler at work on the portrait of Mallarmé in the studio, working on thin transfer tissue: 'I remember he put the paper down on a roughish book cover. He liked the grain the cover gave him, for it was not mechanical, and, when the grain seemed to repeat itself, he would shift the drawing, and thus get a new surface'.[6]

The French writer Henri de Regnier recorded Mallarmé's account of posing for Whistler at 110 rue du Bac:

lorsqu'il posait pour l'admirable portrait en lithographie que fit de lui Whistler, ce dernier l'avait placé debout devant la cheminée du salon. On était em hiver et le feu y était si ardent que Mallarmé finissait par en sentir la cuisson, mais, chaque fois qu'il faisait mine de s'éloigner du foyer, Whistler, tout en travaillant, lui faisait signe impérieusement de ne pas bouger, si bien que, la séance terminée, Mallarmé s'aperçut, en rentrant chez lui, qu'il portait aux mollets de véritables brûlures. Quand, plus tard, il le dit à Whistler, Whistler éclata de son rire le plus diaboliquement satanique, ce

rire qu'il me semble entendre encore résonner au fond de mon souvenir, comme j'y entends la douce voix, mystérieusement précise, du poète, ami des peintres.'[7]

Whistler's textured zigzag stroke, drawn on a varied diagonal, sometimes layered with shifts in direction, almost miraculously suggests space and volume. Subtle tonalities develop from variations in the pressure of the artist's hand. Only in the writer's facial features are we offered Whistler's extraordinary gifts in capturing details of likeness. It was indeed a sympathetic portrait of the poet, much admired by their friends. Rodin, asked to do a posthumous memorial to Mallarmé, planned to incorporate Whistler's lithograph, 'si précis, si entier, si compris', saying he could not possibly do better.[8]

Apparently there were several sittings. Whistler first drew a portrait of Mallarmé on transfer paper in October 1893, but Lemercier failed to transfer it to stone for printing successfully. Various versions of the lithographic portrait were drawn and then destroyed. A second portrait (W 150) is even more ephemeral in feel, and is known in very few impressions. By 2 November 1893 Belfond was printing the portrait shown here.[9] It was also printed in a small edition of independent lithographs, this among them.

Vers et prose was extremely successful, and as a result, the portrait was published with *Vers et Prose* in editions of over one thousand a time for each of the first three editions. Further editions were pulled, until by 1935 (the 23rd edition) the image was getting rather faint! However, the first editions, like this one, are as subtle as the poet himself. Whistler distrusted his Paris printers despite the success of this print and was glad to return to the Ways who, he said, understood his 'fastidious and difficult' character.[10]

187 Rose et Gris: Geneviève Mallarmé 1897

Oil on panel 20.6 × 12.2 (8⅛ × 4¾)
PROV: Given by the artist to Geneviève Mallarmé; Edmond Bonniot, widower of Geneviève Mallarmé; Louise Bonniot, his second wife, d. 1970; bequeathed to present owner
LIT: YMSM 1980 (485)

Private Collection
[Exhibited in Paris only]

Whistler went to Valvins, Stéphane Mallarmé's country house, on 20 October 1897, and in a single sitting painted this little portrait of his daughter Geneviève.

It was perhaps on this occasion – we know that he was also planning to paint a portrait of Mallarmé (see no.186) – that he left at Valvins the little paintbox that is now in the Bibliothèque Jacques Doucet (Mallarmé–Mondor collection). He took the picture back to Paris and ordered a frame with reeded moulding alternating with flat tints, which gave increased breadth to this refined sketch. It was soon ready, as is shown by the letter Whistler wrote on 23 October 1897: 'The little picture of the princess in her rose and grey boudoir is already in its frame'.

Mallarmé's only daughter was then nearly thirty-three. Françoise Geneviève Stéphanie Mallarmé was born on 19 November 1864 in Tournon, where Mallarmé and his young wife Maria Christina Gerhardt had arrived the previous year when Mallarmé took up the post of English teacher at the lycée. Geneviève Mallarmé (Madame Edmond Bonniot) died in 1919.

Geneviève Lacambre

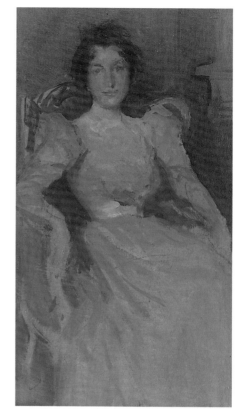

187

188 Rose and Brown: The Philosopher 1896–7

Oil on wood 21.5 × 13.5 (8¾ × 5⅛)
Signed with a butterfly
PROV: Georges Petit, Paris (dealer), Comtesse de Béarn 31 Dec 1899; by descent to the present owner
EXH: London, Goupil, Holloway exhibition, 1897 (no cat.); Paris, Soc. Nat. 1897 (1258); London, SPP 1897 (11); London, ISSPG 1898 (181); London 1905 (96); Paris 1905 (30)
LIT: YMSM 1980 (472)

Private Collection

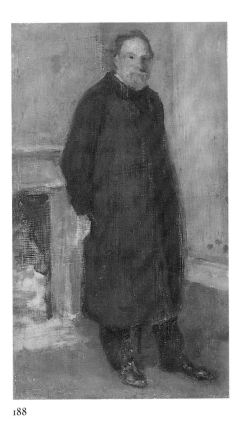

188

189

From about 1884, Whistler began to experiment in the genre of the small-format portrait which was done rapidly, perhaps in only two sittings, such as the portrait of George A. Lucas he painted on 22 and 23 August 1886.[1] He may have been influenced by the format of Manet's image of Théodore Duret, which measured only 43 × 35 cm (13 × 13¾ in).[2] The fact that these little portraits are near-monochrome makes it reasonable to see them as a reaction to the spread of photography, competing with it in format but magnifying the work by a large frame.

Whistler painted 'The Philosopher' in London during the winter of 1896–7 and, if Ludovici[3] is to be believed, he demanded a great many sittings from the model, the watercolourist Charles Edward Holloway. This landscape painter, who was born in 1838, was a Chelsea neighbour. He had travelled to Venice in 1875 and 1895 and Whistler had probably made his acquaintance in the 1880s. Whistler was a good friend to him during the last months of his life, the period when this portrait was painted, just before he died on 5 March 1897. 'Rose and Brown: The Philosopher' was included in the posthumous exhibition of Holloway's work.

Pennell writes that as Whistler was so occupied with Holloway's illness and funeral, he had no time to send his works to Paris.[4] However, the catalogue of the 1897 Salon, which opened on 24 April, includes three of his titles, one of which is 'Rose and Brown: The Philosopher'. They probably arrived late: in the April 1897 issue of *L'Artiste*, the critic Raymond Bouyer notes: 'I could see neither Puvis de Chavannes nor James M.N. Whistler … The three entries by the symphonist of northern harmonies appear in the catalogue but are not yet in the show.'[5] The works must have arrived in Paris, though, and Whistler too: on 21 May he was able to announce that the portrait of Holloway was leaving for London. The regularity with which Whistler sent this work to exhibitions shows that he was entirely satisfied with it.

Geneviève Lacambre

189 Miss Ethel Philip Reading *c.*1894

Oil on panel 21.2 × 12.7 (8⅜ × 5)
PROV: Bequeathed by Whistler to his sister-in-law, Miss R. Birnie Philip 1903; bequeathed to the University of Glasgow 1958
EXH: London & New York 1960 (60)
LIT: YMSM 1980 (417)

Hunterian Art Gallery, University of Glasgow, Birnie Philip Bequest

According to a label on the back of the painting (which is based on information given by Rosalind Birnie Philip) this depicts Whistler's sister-in-law Ethel Birnie Philip (1861–1920) in the sitting room of the artist's house at 110 rue du Bac in Paris around 1894. Ethel was the third of the seven surviving children of the sculptor John Birnie Philip (1824–1875) and Francis Black. The eldest sibling, Constance (1854–1929) married the painter Cecil Gordon Lawson, while the second, Beatrice (1857–1896), first married the architect and designer Edward Godwin and then, in 1888, Whistler (see nos.194–5). After Beatrice's death, Whistler formally applied to have the youngest sister Rosalind Birnie Philip (1873–1958) made his ward, and at his death bequeathed his entire estate to her.

It would be hard to overestimate the security and happiness Whistler's marriage into the Birnie Philip family brought him, and this is clearly reflected in a work such as no.189. Here the scene is as intimate and peaceful as those in Whistler's depictions of domestic harmony at Deborah Haden's house in Sloane Street in the late 1850s (see nos.9–11). For his wife and in-laws Whistler had affectionate nicknames. Beatrice he called 'Trixie', 'Chinkie' or 'Luck', Rosalind became 'the Major' (with Whistler signing himself the 'General'). He was particularly close to Ethel, whom he called 'Bunnie' and who before her marriage acted as his secretary and model, and who helped Rosalind to nurse him in his last illness.

In the summer of 1895 Ethel married the journalist, editor, translator and essayist Charles Whibley (1859–1930), otherwise 'Wobbles', from the garden of 110 rue du Bac. Ethel's marriage drew her deeper into Whistler's world. Whibley had worked as a correspondent on the *Scots Observer*, publishing one of the first articles in English on Degas (31 October 1891). In the later 1890s he became Paris correspondent for the *Pall Mall Gazette*.

Whibley was part of the select circle of Symbolist poets, artists and intellectuals who surrounded the poet Stéphane Mallarmé. Indeed,

the poet and journalist were close enough friends for Mallarmé to have sent Whibley his collection of poems, *Divagations*, in 1897.[1] For Whibley's own volume of collected essays *A Book of Scoundrels*, which was also published in 1897, Whistler designed the elegant cover.

Here, the intimate domestic scene painted on a small scale, the use of a palette of soft pinks and greys reminds one of the early work of the Nabis, and particularly of Vuillard and Bonnard.

190 The Little Rose of Lyme Regis

1895

Oil on canvas 50.8 × 31.1 (20 × 12¼)
PROV: E.G. Kennedy, Wunderlich, New York (dealers) 1896, who sold it to the Museum of Fine Arts, Boston in the same year
EXH: Boston 1905 (26); Paris 1905 (42)
LIT: YMSM 1980 (449)

Museum of Fine Arts, Boston. William Wilkins Warren Fund

Rosalind Birnie Philip identified the sitter as Rosie Randall (1887–1958), daughter of the Mayor of Lyme Regis, Dorset. Whistler went to Lyme Regis with his wife on 15 September 1895, but Beatrice Whistler soon returned to London, leaving her husband to distract himself through work from his frantic worry over his wife's illness. In October he wrote to Trixie that his persistence had brought lasting benefits to his art, and of his touching belief that this would in some unspecified way help her to get well.[1] He returned to London at the end of November.

Little Rosie Randall is posed full face, wearing a red pinafore over a black dress against a brown background. Her steady gaze does not hide her vulnerability or the slight nervousness suggested by her clasped hands. The portrait is thinly painted with a great deal of oil in the pigment giving it a smooth surface finish. Though often seen as pendants, nos.191 and 192 are in fact independent pictures.

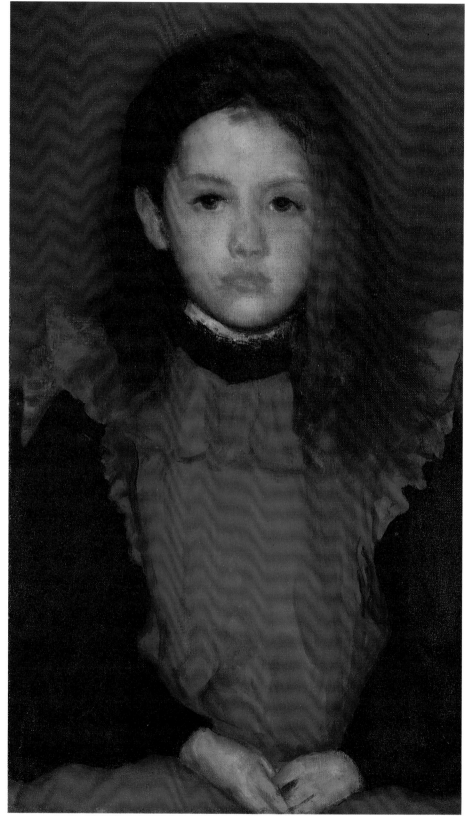

190

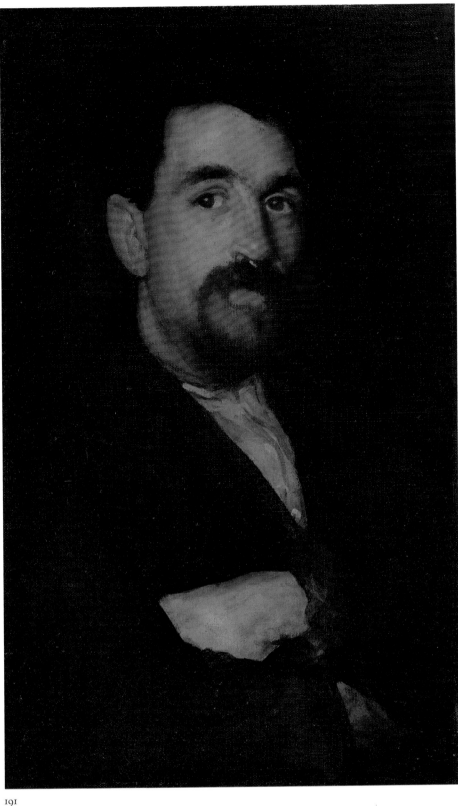

191

191 **The Master Smith of Lyme Regis** 1895–6

Oil on canvas 50.8 × 31.1 (20 × 12¼)
Signed with butterfly
PROV: E.G. Kennedy, Wunderlich, New
York (dealers) 1896; bt Museum of Fine
Arts, Boston in the same year
EXH: Buffalo 1901 (99); Boston 1904
(36); London 1905 (24); Paris 1905 (27)
LIT: YMSM 1980 (450)

*Museum of Fine Arts, Boston. William Wilkins
Warren Fund*

Throughout his career Whistler had painted,
etched and drawn forges and furnaces. From a
practical point of view, a forge provided a warm
light studio; from a human point of view, com-
pany and activity. Here he paints the black-
smith Samuel Edward Govier (1855–1934) who
worked at the forge depicted both in litho-
graphs (see no.192) and in a small panel paint-
ing 'The Forge at Lyme Regis' (Hunterian Art
Gallery, Glasgow; YMSM 442) (figs.92–3).

Painted on a red ground, the dark tonal
range and sense of the head emerging from the
background reveals the lifelong importance of
Velázquez's portraits to Whistler's art.

Whistler painted at least nine pictures in
Lyme Regis. He wrote to his wife on 7 Novem-
ber, 'This work may & doubtless will bear evi-
dence to the innermost of the agonies we have
gone through – Scars! – deep scars –'.[1] But
nos.190–2 are startling precisely because they
reflect so little of Whistler's underlying emo-
tional turmoil, unlike the heartbreaking pathos
of no.194.

The sitter here was the same handsome
blacksmith who appears in several lithographs
(no.192). Whistler also painted his daughter
Ada (whereabouts unknown; YMSM 446).

192 The Blacksmith 1895

Lithograph printed in black on cream
wove paper 21 × 15 (8¼ × 6)
Sheet: 21.5 × 16.6 (8½ × 6½)
Signed in stone with butterfly
Signed in pencil with butterfly
Stamp 'RBP' (Lugt 406)
PROV: Bequeathed by Whistler to his
sister-in-law, Miss R.Birnie Philip 1903;
bequeathed to the University of
Glasgow 1958
LIT: Way 1896 (90 II); Kennedy 1914 (90
II); MacDonald 1988, pp.46–7

Hunterian Art Gallery, University of Glasgow,
Birnie Philip Bequest

'The Blacksmith' was started during the artist's
stay at Lyme Regis in 1895. They stayed at the
Royal Lion Hotel, in a room with a bay win-
dow overlooking the main street. It was Octo-
ber, too cold to paint by the sea, or along the
cliffs. It was a steep walk down the hill to the
sheltered harbour. It was no place for a sick
woman, and she returned to London before her
husband.

Meanwhile, Whistler drew one lithograph
after another from the window – the quiet
street on Sunday, the shops across the way, the
celebrations on Guy Fawkes night. A short
stroll round the corner was the local forge,
where a roaring furnace provided a glow of
warmth and light. The smithy was a family
concern and Samuel Govier, a good-looking
man, willingly posed for a portrait as 'The
Master Smith' (no.191), and for several litho-
graphs.

Unfortunately the lithographs did not take
well on the thin, textureless transfer paper
Whistler was using, and Way felt that they had
not transferred properly to the stone for print-
ing. Whistler was disappointed, but had ten
impressions of 'The Blacksmith' printed. He
then suggested transferring the image to a sec-
ond stone, so that he could rework it. He pro-
duced a second state, of which Way printed
four impressions. The lithograph was complet-
ed in London, with T.R. Way posing in Govi-
er's place.[1] Whistler was satisfied with this third
state, and had fifteen impressions pulled. Few
lithographs caused Whistler so much trouble,
few are so complex and rich in detail.[2]

'Lithography *reveals* the artist in his true
strength as draughtsman and colourist – for the
line comes *straight from his pencil* – and the tone *has*
no further fullness than he himself, in his knowl-
edge, gave it', wrote Whistler.[3]

This lithograph highlights Whistler's draw-
ing at its most lively, in a clearly delineated
image of the smithy at work. The bright glow
of the furnace which drew Whistler repeatedly
to such workshops casts mysterious shadows,
producing a dramatic black and white pattern-
ing which is a natural foil for Whistler's graph-
ic propensity.

192

193 The Thames 1896

Lithotint printed in black on appliqué
Japan paper 26.5 × 18.7 (10½ × 7⅜)
Sheet: 26.5 × 18.7 (10⁷⁄₁₆ × 7⅜)
Signed in stone with butterfly
PROV: Bequeathed by Whistler to his
sister-in-law, Miss R. Birnie Philip 1903;
bequeathed to the University of
Glasgow 1958
LIT: Way 1896 (125); Kennedy 1914 (125);
MacDonald 1988, pp.48–9

Hunterian Art Gallery, University of Glasgow,
Birnie Philip Bequest

From January to March 1896, the Whistlers
lived on the top floor of the Savoy Hotel, where
Beatrice lay in a room overlooking the Thames.
When she felt well enough, she painted the
view (Hunterian Art Gallery, Glasgow). The
artist, ever at her side, but never one to rest qui-
etly, made a half-dozen lithographs of views
from the hotel windows. Most of them were
offset from transfer paper, but with 'The
Thames' Whistler returned to the lithotint
technique he had used so successfully for his
early essays on stone (w 7, 9; nos.53, 55). A site
on the South Bank, from Waterloo to Hunger-
ford Bridge, it is seen here in reverse.

As he had with his earlier lithotints,
Whistler took the image through several stages,
and in this case, early impressions printed by
Way are marked by a far more delicately
nuanced surface than later ones. Remarkably
beautiful is the vast range of modulations of
tone with which Whistler constructed the
riverside architecture in the distance, and the
suggestions of foliage just opening as spring
arrived along the Thames.

Writing to E.G. Kennedy, Whistler
described the print as 'a largish wash drawing of
the river – promises to be very beautiful and
from your late lectures to me very startling, as
it will cost probably something like ten guineas
a proof!'[1]

Unfortunately Whistler quarrelled with his

193

lithographic printers, the Ways, in 1896. Ostensibly the quarrel erupted over Way's catalogue of Whistler's lithographs, but at the time Whistler was under the unbearable tension surrounding the illness and death of his wife. The split could not be healed and meant the end of Whistler's work in lithography. Although few impressions of 'The Thames' had been printed (six of the first, ten of the second and twelve of the third state) and the stone was in perfect condition, Whistler refused to let Way print any more after their quarrel.

The subject, however, was extremely popular, and it was left to Frederick Goulding, after Whistler's death, to print an edition of eighty-one impressions, using Birnie Philip's impressions as guides, and a final edition of forty in May 1904, matched with a third state impression owned by C.L. Freer.[2] Way wrote generously that Goulding, 'is to be congratulated on having succeeeded as well as he did with so difficult a task'.[3]

194 The Siesta 1896

Lithograph printed in black on paper
13.6 × 21 (5⅜ × 8¼)
LIT: Way 1896 (122); Kennedy 1914 (122); MacDonald 1988, pp.48–9

Paul F. Walter

In 'The Siesta' and 'By the Balcony' (no.195) Whistler portrayed his ailing wife Beatrice, lying in bed in the Savoy Hotel. The title 'The Siesta', modifies the gravity of her situation, suggesting she is only at rest rather than dying. It is a particularly poignant image. The artist riveted his attention on his wife's loving gaze, as she watched him working in the medium she had encouraged him to pursue during the years of their marriage.

This portrait of her is one of the most finely honed of all those the artist completed in this medium. His total control of crayon and transfer paper, and of the stump which he prob-

194

ably used for tonalities in the darkness of her hair, is everywhere apparent. He achieved not only a penetrating likeness, but seemed also to capture evidence of something far more deep – their mutual empathy, the fruits of their years together. Surely Trixie's presence transformed Whistler's life by offering him personal stability, as well as a relationship – marriage – sanctioned by polite society.

Way said that 'Fortunately there was not the slightest flaw in transferring to stone, and the first print satisfied him entirely … And he had some twenty proofs printed at once'.[1] In fact thirty-one impressions were printed at the time and none later. The quality of these impressions may in part be the result of this immediate transfer, and the comparatively small edition.

Beatrice was the daughter of John Birnie Philip, a Scottish sculptor, and was herself an artist and designer (see no.150). A collection of her work (drawings, etchings, oils and jewellery) is in the Hunterian Art Gallery in Glasgow. In 1876 she married E.W. Godwin, the architect who was to design Whistler's White House. The couple were friends of Whistler's. When Godwin died in 1886, Whistler soon abandoned Maud Franklin in favour of Beatrice, and in August 1888, they were married. They moved to Cheyne Walk that autumn and later set up a home in Paris, at 110 rue du Bac.

In 1894, Beatrice became ill, and at the end of the year they closed up their Paris home and returned to London where cancer was diagnosed. From that time they lived a peripatetic existence, moving from place to place, living in hotels much of the time.

195 By the Balcony 1896

Lithograph printed in black on wove paper 21.3 × 14 (8½ × 5½)
Sheet: 28.4 × 21.9 (11⁷⁄16 × 8⅝)
Signed on stone with butterfly
PROV: given by Lessing J. Rosenwald to the National Gallery of Art, Washington in 1946
LIT: Way 1896 (124); Kennedy 1914 (124); MacDonald 1988, pp.48–9

National Gallery of Art, Washington. Rosenwald Collection

If Whistler seems to have captured his love for Beatrice and the richness of their life together in 'The Siesta' (no.194), in 'By the Balcony' he seems to be acknowledging her illness, to be imagining life without her. It is startling to see in Whistler's lithographs an area so stark and dark as the triangle-like shape that surrounds Trixie's head as she faces, not her husband, but the city outside. Later that winter the couple moved to a cottage on Hampstead Heath, where Beatrice died on 10 May.

A sense of solidity is invested in Beatrice's covered figure and the bed on which she rests, providing weight and substance to the present moment, something to grasp and hold on to, as the failing woman grasps the frame of the open window. By contrast, the future, the distance, the world outside, are barely indicated, and we, too, as viewers with the artist, feel the momentous presence of death in the room.

In 'By The Balcony' Whistler worked to the edge in all four directions, incorporating broad open areas and architectural details; juxtaposing descriptive linework with atmospheric areas of tone.

One of the rarest of Whistler's prints, Way records only six impressions of this lithograph. Neither Whistler nor Beatrice's sister Rosalind Birnie Philip could bear to have the stone reprinted and it was destroyed in 1903 after Whistler's death.

Much of Whistler's art addresses life's ephemeral nature. His lithographs are among his most daring works in this respect. In the etchings, the ink layer provides a physical substance, no matter how sparingly the line is used. The lithographs, however, seem on the edge of disappearing. They allude to fragility, to the importance of the moment; they speak about beauty, about loss.

'By the Balcony' – structured to conflate the inner world and the outer world, to portray the love of both a person and a place – seems poignantly to summarise the themes of Whistler's art.

195

Portraits of the 1890s

Each summer Whistler divided his time between painting seascapes and town-scapes in the open air, and drawing from models or painting portraits in his studio. With health failing, in the winter he was increasingly restricted to the studio.

Surrounding him were his full-length portraits of the Philip sisters (nos.196–8). Occasionally he worked on them again, rubbing down and repainting. Despite years of tinkering, portaits of Ethel Philip such as 'Red and Black: The Fan' (no.197) are dramatic in design, harmonious in colour, and precise in their judgment of character.

As the deterioration of paintings executed in the 1870s and 1880s became increasingly apparent, Whistler continued to experiment with new painting techniques in the last decade of his life. He concluded that he had been mistaken in believing that the swift application of thinned pigment was a virtue in art: 'the one *great* truth that has impressed me is that time *is* an element in the making of pictures!! & *haste* is their undoing'.[1]

For a brief period in 1895, in Lyme Regis, Whistler declared himself satisfied with the level of finish achieved in portraits like 'Little Rose' and the 'Master Smith' (nos.190–1). These reflect his continuing debt to Velázquez and his rediscovery of an artist whom he had admired since childhood: Hogarth. Particularly in his late portraits of children (nos.200–1) he tended to adopt the head and shoulders format which Hogarth had used, for example, in 'The Shrimp Girl' (fig.11 on p.26).

On the other hand, he had great difficulty in completing commissioned portraits to his own satisfaction. Wealthy American collectors such as Isabella Stewart Gardner and George Vanderbilt (see no.199) flocked to his studio, but not all received their portraits before Whistler's death in 1903. The most successful sitters were those patrons who had become friends, such as Richard Canfield (no.202).

Despite some failures, Whistler's constant reworking is triumphantly vindicated in late works such as 'Mother of Pearl and Silver: The Andalusian' (no.196) and in the series of introspective self-portraits, which he painted with increasing intensity until the end of his life (nos.203–6). To the world he continued to present the face of the 'master'. In private, he wrote to his wife in almost biblical terms of his hope that a lifetime of struggle would reap lasting benefits:

> *Do* you think all this suffering & this persistence *can* be for nothing? … And then one can walk upright – and outrun the fleetest! And failure will be no more. And the past will be forgiven – and time will be as nothing! And then it will be revealed that those who have never stumbled, have been lying down – and shall be trodden on in the ditch![2]

R.D. and M.M.

196

196 Mother of Pearl and Silver: The Andalusian 1888–1900

Oil on canvas 191.5 × 89.8 (75⅜ × 35⅜)
Signed with butterfly
PROV: Wunderlich, New York (dealers)
1900; J. Harris Whittemore, Naugatuck
1900; Gertrude Whittemore, (d. 1941);
presented to the National Gallery of
Art in 1943 by Harris Whittemore and
his sister Mrs C.H. Upson
EXH: Paris, Exp. Univ. 1900 (103);
Philadelphia 1902 (49); Boston 1904
(46); Paris 1905 (25)
LIT: YMSM 1980 (378)

National Gallery of Art, Washington. Harris Whittemore Collection

The model for this portrait was Whistler's sis-
ter-in-law Ethel Philip, his favourite model in
the 1890s (see nos.184, 189, 197–8) and the sub-
ject of at least five oil paintings as well as many
studies on paper,[1] etching (K 441) and lithogra-
phy (nos.184–5). Here she wears her hair in a
tight topknot such as one sees worn by many of
the models of Toulouse-Lautrec, and stands in
the pose assumed by Frances Leyland in 'Sym-
phony in Flesh Colour and Pink' of 1871–4
(fig.74; YMSM 106).

Though the dealer E.G. Kennedy claimed to
have seen Whistler at work on the picture as
early as 1888, the style of dress indicates a date
closer to 1894–95 when leg-of-mutton sleeves
were in fashion. The title refers to the silk
evening dress, whose bolero jacket of transpar-
ent silk gauze or fine net is inspired by tradi-
tional Andalusian costume. On 3 December
1892 the French sculptor Charles Drouet wrote
to Whistler asking for the return of 'le costume
Espagnol' if the painter had no further use for
it.[2] Clearly, however, the garment Whistler
depicts in no.196 has far more to do with
Parisian high fashion than with Spanish nation-
al dress.

On 14 June, 1900 Théodore Duret wrote to
Whistler asking whether the artist had seen the
exhibition of Lalique jewellery and couturier
dresses in Paris.[3] Whistler's interest in women's
fashion was as acute in the 1890s as it had been
in the 1870s when he had designed the dresses
of both Mrs Leyland and Cecily Alexander (see
nos.70–2, 62). The very fact that Whistler had
felt it necessary to design those garments
implies his dissatisfaction with women's fash-
ions at that date in Britain.

The situation was slightly different in 1886
when he painted Lady Colin Campbell in a
white satin frock, 'one of Worth's creations,

made on purpose for the portrait.'[4] In the early 1890s Whistler was living in Paris. This was the heyday of the Houses of Worth, Redfern, and Dracoll and particularly of the great couturier Mme Cheruit, whom Whistler may well have known, since she was the mistress of his friend, the painter and etcher Paul Helleu. That Whistler took a more than casual interest in high fashion is corroborated by a box full of costume plates and journals among his papers at the Glasgow University Library. The style of dress in 'The Andalusian' and in another portrait of Ethel entitled 'Rose et or: La Tulipe' 1892–6 (Hunterian Art Gallery, Glasgow, YMSM 418) might for example be compared to the 'Robe de drap pelure d'oignon garnie de guipure crème' the creation of Mme Pelletier-Vidal, 19 rue de la Paix, of 1894.

The titles 'L'Andalusian' and 'La Tulipe' are worth considering. Unlike those of two other portraits of Ethel, 'The Felt Hat' (no.198) and 'The Fan' (no.197), neither is merely descriptive. At this date, couture dresses were given names, so that wealthy customers might ask to see the 'Tulip' or the 'Andalusian' models. A lady might ask her own dressmaker to copy the 'Andalusian' or the 'Tulip' from the coloured fashion magazines of the 1890s. It is possible that the titles refer not to a Spanish woman or a flower, but to the model of dress worn by Ethel.

From her correspondence with Whistler it is obvious that Ethel Whibley took a lively interest in clothes. Whistler frequently asks her to bring over to Paris pieces of fabric, and often comments in passing on women's dress. Since Ethel, who was not a wealthy woman, is always turned out in the height of Parisian fashion in contemporary photographs, it is possible that she made the dresses (or had them made), based on illustrations in fashion periodicals.

'L'Andalusian', then, is not a portrait of a person, but of a dress. To underscore the point, Ethel wears no jewellery, but allows the dress to stand on its own, exactly as one would expect a fashion model or mannequin to do.

In 1896 Whistler referred to no.196 as 'that Spanish lady', suggesting that its soft blacks and greys were chosen from the beginning for their association with the Spanish master Velázquez. In 1900 he called it the 'Andalouse'. In 1900 it was exhibited at the Exposition Universelle in Paris under its present title. One might add that it is well known that Picasso admired Whistler, but hard to pinpoint any works he would have seen apart from reproductions. He could, however, have seen this portrait on his first visit to Paris to see the Exposition Universelle of 1900, when the title would undoubtedly have attracted the interest of the nineteen year old Andalusian-born painter.

197 Red and Black: The Fan 1891–4

Oil on canvas 187.4 × 89.8 (73¾ × 35⅜)
Signed with butterfly
PROV: Bequeathed by Whistler to his siter-in-law, Miss R. Birnie Philip 1903; bequeathed to the University of Glasgow 1958
EXH: London, RSPP 1903 (4)
LIT: YMSM 1980 (388)

Hunterian Art Gallery, University of Glasgow, Birnie Philip Bequest

Whistler referred to this full-length portrait of Ethel Philip (later Mrs Charles Whibley, see nos.189, 196, 198) as 'the Red lady' in a letter to his wife in 1891. In a letter to the sitter ('Bunnie') dated 26 July 1897 Whistler mentioned that their mutual friend Isabella Stewart Gardner was in Paris, 'And of all things in the world what do you think she especially is craving for? The Red Bunnie: not only because of its beauty as a picture but because of all the associations.'[1]

Whistler could not sell the picture to Mrs Gardner because he had already reserved it for another American collector – Alfred Pope of Cleveland – but on Whistler's death it was still in his studio. When it was exhibited as 'Rouge et Noir – L'Eventail' in London in 1903, it was described as 'unfinished'.

In fact Whistler was unwilling to part with the portraits of his wife and her sisters. This is one of his most accomplished late tonal harmonies, all the more daring for the way in which the crimson of the sitter's dress is subtly modulated by setting it against a russet orange-brown background, while the greatest possible visual drama is created through the black feather boa snaking down from Ethel's raven hair past her elbow-length gloves and fan, towards one daintily slippered foot. A bright red bow or aigrette in her hair might almost form the butterfly signature which is otherwise absent from the composition. In this painting one can see more clearly what Whistler disguises in other portraits of Ethel: that she was a tall, big-boned woman, not thin, but of a commanding presence.

197

198 Harmony in Brown: The Felt Hat 1890s

Oil on canvas 191.3 × 89.9 (75¼ × 35⅜)
Possibly signed with butterfly
PROV: Bequeathed by Whistler to his
sister-in-law, Miss R. Birnie Philip 1903;
bequeathed to the University of
Glasgow 1958
LIT: YMSM 1980 (395)

*Hunterian Art Gallery, University of Glasgow,
Birnie Philip Bequest*

This is the fifth portrait of Whistler's sister-in-law Ethel Philip (see nos.189, 196, 197), begun by 1891. In November 1901 Whistler wrote to another sister-in-law, Rosalind Philip, to say that he had rediscovered this portrait of Ethel, which he thought worth completing. The picture remained, however, unfinished, and was not exhibited during Whistler's lifetime.

Whistler had made a lithograph of the same sitter in 1890 entitled 'Gants de suède' (no.184) in which the costume and pose are similar to those seen here. In the lithograph Ethel wears an outdoor dress and is drawing off one long, elbow-length suede glove. In the painting, it has been suggested that the unfinished area around the hands might be intended for a fan, or even for an exhibition catalogue which Ethel refers to as she looks up at a picture in an exhibition. But it is also possible that, as in the print, she is pulling off her gloves.

We must be very careful about attributing to an unfinished picture qualities Whistler never intended it to have. Nevertheless, the way in which the elongated figure seems to emerge, wraith-like, from the shadowy background the absence of details and textures and above all the tendency to flatten form against a spatially ambiguous background: all put one in mind of the Symbolist art nouveau paintings of Gustav Klimt. It is therefore worth noting that on 13 December 1897 Klimt wrote to Whistler inviting him to accept honorary membership in the Society of Austrian Artists Secession.[1]

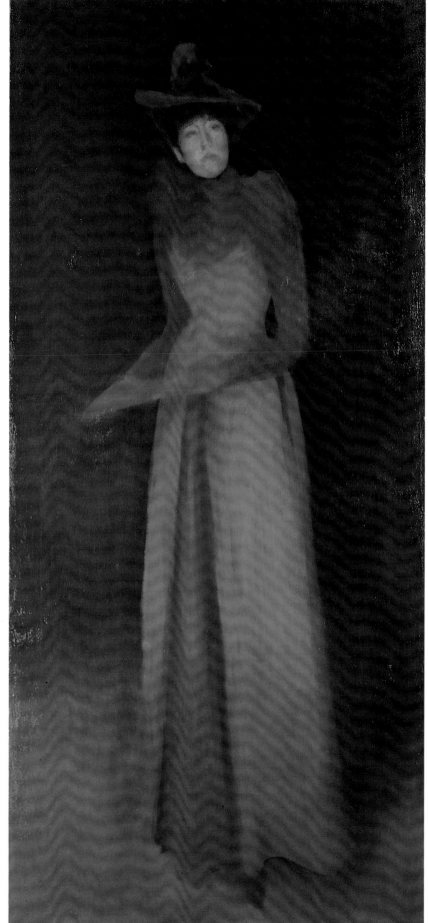

198

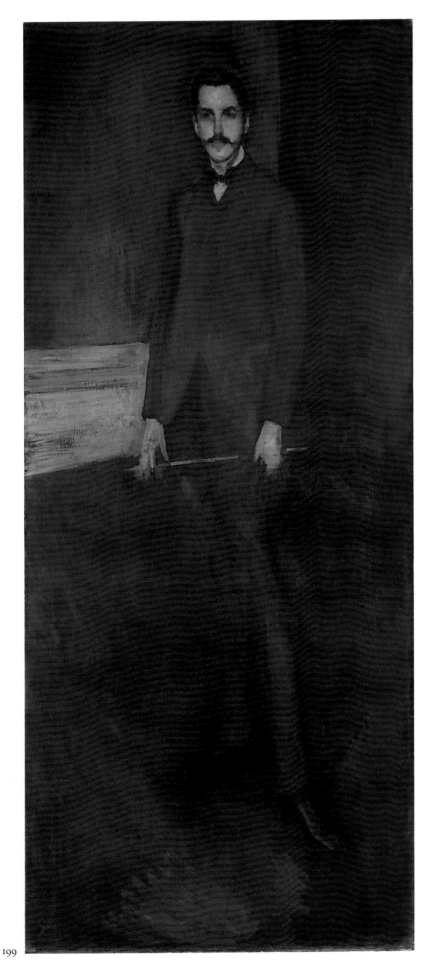

199

199 Portrait of George W. Vanderbilt 1897–1903

Oil on canvas 208.6 × 91.1 (82⅛ × 35⅞)
PROV: George W. Vanderbilt, who d.
1914; his widow Mrs Edith Stuyvesant
Gerry, who gave it to the National
Gallery of Art, Washington 1959
EXH: Paris 1905 (22)
LIT: YMSM 1980 (481); MacDonald 1994
(1505)

*National Gallery of Art, Washington, DC. Gift
of Edith Stuyvesant Gerry*
[Exhibited in Washington only]

George Washington Vanderbilt was twenty-six
when his father died, leaving him six million
dollars and his magnificent house and furnish-
ings at 640 Fifth Avenue in New York City.
The youngest of eight children, he was
described by his niece Consuelo Vanderbilt
Balsan as 'quite different from my other uncles
and aunts. With his dark hair and eyes, he
might have been a Spaniard. He had a narrow
sensitive face, and artistic and literary tastes.'[1]

But if he was the sole intellectual in Ameri-
ca's wealthiest family, he nevertheless inherited
the family penchant for building on a gargantu-
an scale. Today he is remembered both for Bilt-
more House, the immense château he built on
125,000 acres of wilderness near Asheville in
North Carolina, and for the programmes of
agriculture and forestry he initiated there.

Designed by Richard Morris Hunt, Bilt-
more had 250 rooms spread over four acres.
These Vanderbilt furnished with rare tapes-
tries, rugs, bronzes, prints, and with his collec-
tion of twenty-three thousand books. The park
was laid out by Frederick Law Olmsted. Such a
palace needed a châtelaine, and Vanderbilt
acquired one when he married Edith
Stuyvesant Dresser in Paris in 1898. But even
she could do little about the discomfort of Bilt-
more. Henry James, who made the mistake of
visiting in February 1905, complained of the
'fantastic immensities of scale' in the 'colossal
heartbreaking house.'[2]

Such a house also needed a portrait of the
owner. It was for this that the thirty-five year
old Vanderbilt approached Whistler in Lon-
don in May 1897, possibly through their mutu-
al friend Jonathan Sturges, to whom Whistler
sent his regards in his initial reply: 'I think I
may frankly say that I could not ask for a more
sympathetic subject than yourself and therefore
am greatly pleased at the prospect of painting
your portrait!'[3] The portrait was begun in June
in London.[4] By December of that year
Whistler had brought the picture to a point so

near completion that he needed only to 'put the very last little dainty polish upon it.'[5] And in the same month Vanderbilt offered to pay him the considerable sum of 1,000 guineas immediately, and the same again when he took possession of the portrait.[6]

But as so often before, the artist remained unsatisfied. More than a year later Whistler complained to a friend of 'Vanderbilt and completions of portraits "while you wait!" – maddening!'[7] The painting was in his studio at the time of his death in 1903, and exhibited at his memorial exhibition in Paris as 'unfinished'. Whistler also painted Vanderbilt's wife and infant daughter (YMSM 515, 549).

In their correspondence, which covers the years 1897–1903, Vanderbilt emerges as a cultured, cultivated man, who addressed Whistler as 'Cher Maître'.[8] One letter, inviting Whistler to dinner with Sturges and Henry James, is signed 'yours devotedly'.[9]

The Pennells report that 'probably not one of his other portraits of men interested Whistler so much; certainly not one was finer than the picture when we saw it in the London studio.' And yet when they saw it again in Paris in 1905 they declared it a 'wreck'.[10] Once again, it is difficult to know how far to trust the Pennells' judgement. They may have been bothered by the fact that the oil paint is applied in a variety of techniques from scumbling in the light colours, to thin washes of dark grey and black pigment. Almost everywhere Whistler leaves the black priming clearly evident through the overlying paint layers.[11] In many areas Whistler has rubbed the paint, but this was his normal painting technique. This lends the picture its indistinct quality, a ghostly effect not unlike that found in certain portraits by Reynolds. Recent conservation has further confirmed the painting's inherent strengths and qualities.

Vanderbilt is shown wearing clothes suitable for riding in town. According to an etiquette book published in 1871, if a gentleman wished to ride in the park, he should wear clothes 'similar to that in which you walk, though what is called a jacket is more convenient than a frock coat. Do not ride in patent leather boots. Carry a simple cane or whip, with a silver head. In the country, cords and boots may be adopted, but never in town.'[12]

Vanderbilt's dignified riding costume contrasts to the fantastic get-up worn by Lord Ribblesdale in John Singer Sargent's famous portrait of 1902 (National Gallery, London). Sargent certainly knew Whistler's depiction of the shy and introverted American aristocrat, and may even have had the Whistler in mind in choosing Ribblesdale's very similar pose. Then too, in what may be a private homage to Whistler, Sargent's portrait contains what looks very like a butterfly logo painted onto the wall behind the sitter.

Of all Whistler's male full-length portraits – a distinguished series that includes the Leyland, Duret (no.127), Sarasate, and Montesquiou – this is the most austere. A study in black on black, the figure is unrelieved by a cloak or expanse of white shirt front. We are left with a sense of a lonely and sensitive man, the kind of cultivated aristocrat whom poets and painters of the Symbolist movement particularly admired. A photograph of Vanderbilt reveals that Whistler caught the dark soulful eyes of a man who might have stepped out of the pages of Poe or d'Annunzio (fig.95). A comparison with John Singer Sargent's portrait of the same sitter shows how much more acutely Whistler responded to these qualities than Sargent in his much beefier and far more conventional portrait.

200 Little Juniper Bud – Lizzie Willis 1896–7

Oil on canvas 51.6 × 31.4 (20¼ × 12⅜)
PROV: Bequeathed by Whistler to his sister-in-law, Miss R. Birnie Philip 1903; bequeathed to the University of Glasgow in 1958
EXH: London & New York 1960 (66); Berlin 1969 (47)
LIT: YMSM 1980 (475); MacDonald 1994 (1501)

Hunterian Art Gallery, University of Glasgow, Birnie Philip Bequest

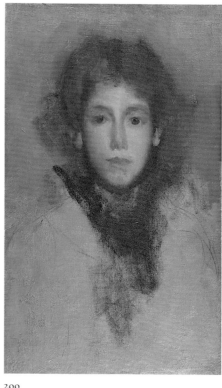
200

The finest of Whistler's late studies of young children, 'Little Juniper Bud – Lizzie Willis' is one of three portraits of the eight year old daughter of the housekeeper at the studio he took at 8 Fitzroy Street in March 1896. Whistler himself described the canvas as 'barely begun', with the outline of the figure sketched in crayon over a grey primed canvas, and only the touchingly vulnerable face brought near completion.

The title refers to the juniper plant which gives gin its flavour. Whistler called another portrait of Lizzie 'The Gin Girl' (Private Collection; YMSM 477), explaining that 'The father

& mother were both dissipated'.[1] Lizzie herself occasionally indulged.[2] Describing Queen Victoria's Jubilee celebrations in a letter to his sister-in-law Rosalind Birnie Philip on 24 July 1897, Whistler noted that special permission had been granted to 'keep open the Public houses until three o'clock in the morning – the Queen knows her people! – and by that hour, I suppose, there wasn't one of her subjects who wasn't superbly drunk in the land! Miss Loomis & children – and doubtless little Lizzie among them – in the midst of the Willis family!'[3] In the same month the Willis's were dismissed, presumably for drunkenness.

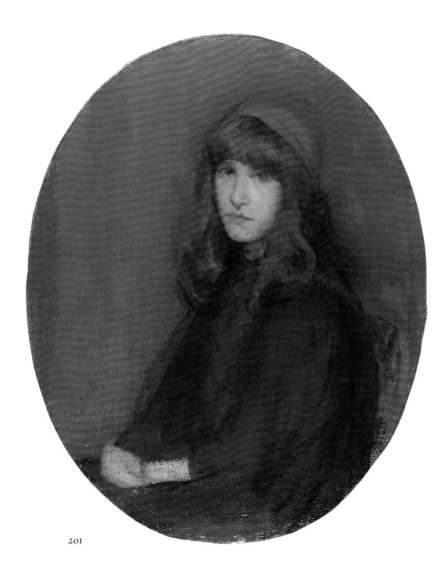

201

201 Lillie: An Oval after 1896

Oil on canvas 60.5 × 48.8 (23¾ × 19¼)
PROV: Bequeathed by Whistler to his sister-in-law, Miss R. Birnie Philip 1903; bequeathed to the University of Glasgow 1958
EXH: Edinburgh 1904 (78); Paris 1905 (38); London & New York 1960 (65); London, Colnaghi 1973 (112)
LIT: YMSM 1980 (465)

Hunterian Art Gallery, University of Glasgow, Birnie Philip Bequest

In the later 1890s Whistler was in the habit of taking a cab through the poorer London streets searching for 'subjects suitable to his art'. In practice this meant little girls from the slums, ragamuffins whose innocent faces and tattered clothing appealed to his sense of the picturesque. One might almost describe these subjects as the human equivalent to the dilapidated facades and shop-fronts he found in Chelsea and Dieppe.

Whistler arranged for the child's mother to bring Lillie Pamington to his studio, but when she arrived he was appalled to find her hair 'frizzed and curled in a way that he considered frightful'. He insisted that he paint her as he had first seen her.[1] This is one of ten portraits he eventually painted of her. She took to the life of a model happily, and posed also for Whistler's follower, Theodore Roussell.

202 Portrait of Richard A. Canfield or His Reverence 1902–3

Oil on canvas 49.6 × 29.5 (19½ × 11⅝)
PROV: Richard A. Canfield 1903
(d. 1914); his son, Howland D. Canfield;
Knoedler, New York (dealers) 1920;
Cincinnati Art Museum 1922; Parke-
Bernet, New York 18 Oct. 1945 (30), bt
L.M. Philip; New York, Parke-Bernet 28
April 1961 (65), bt by present owner
LIT: YMSM 1980 (547)

Private Collection, USA

On the night of 1 December 1902 New York police smashed their way into a four-storey brownstone house at 5 East 44th Street, finally closing the most notorious gambling house in the city. Situated next door to Delmonico's restaurant and catering to a wealthy and influential clientele, the operation was owned by Richard A. Canfield, gambler, aesthete, and one of Whistler's most sympathetic later patrons.[1]

Born in 1855, as a collector Canfield possessed knowledge and discrimination. He developed a taste for reading in his cell in a Rhode Island jail, where he had served six months in 1885 for violating the gaming laws. On his release he opened a gambling casino on West 26th Street in New York. His profits, and those from his clubs in Newport, Rhode Island, and Saratoga Springs in New York State, made him a millionaire. In 1899 he moved his New York operation to the corner of 44th Street and Fifth Avenue. Here he installed his collections of early American and Chippendale furniture, tapestries, chinese porcelain, and Barye bronzes.

Although tolerated, gambling was still illegal in the United States. But the raid in 1902 was effected through the use of a perjured warrant, and Canfield fought back through the courts. Since he himself had not been arrested, he was free to leave the country, and on 24 December sailed for England, settling into Claridges Hotel for the next four and a half months.

Three years earlier, in 1899, Charles Freer had introduced this colourful character to Whistler. At once Canfield began to collect Whistler's work, commissioning this portrait by 1901. Whistler had started work on the portrait by April 1902,[2] although most of the sittings took place the following year, during Canfield's long sojourn in London.

He visited Whistler every day through that winter and spring of 1903 until his departure for New York on 16 May. Whistler, who was ill and frail, would sometimes work three hours on the head and shoulders portrait, sometimes

not at all. The finished canvas is Whistler's last completed painting.

Despite the disapproval of his future biographers Elizabeth and Joseph Pennell, who considered it a scandal that Whistler should know such an 'odious' character, the artist himself saw nothing wrong with the friendship. Not only did Canfield amuse him and pay the prices Whistler asked, but Whistler respected the gambler's opinions on art, telling the Pennells that he was 'the only man who never made a mistake in the studio'.[3] And besides, he enjoyed Canfield's cocktails.

So strongly did Whistler feel about the issue that he fell out with another old friend, the dealer E.G. Kennedy, over the friendship. Just as Whistler had painted Cremorne Gardens at the very moment when the moral crusaders of Chelsea were attempting to close it down, so he instinctively saw that Canfield's worth had nothing to do with his louche, but finally harmless, occupation. We can gauge something of the charm that attracted him to the client he nicknamed 'His Reverence' in the following anecdote, recounted by Canfield in a later interview.

On May 14 or 15 1903 Whistler told his sitter,

> You are going home tomorrow, to my home as well as yours, and you won't be coming back till the autumn. I've just been thinking that maybe you had better take the picture along with you. His Reverence will do very well as he is, and may be there won't be any work in me when you come back. I believe I would rather think of you as having this [portrait] in your collection, for I've a notion it's the best work I've done.[4]

Canfield, knowing that Whistler was talking of his approaching death, refused the portrait lest he seem to confirm Whistler's fears. The canvas was therefore sent to him after Whistler's death two months later.

In May 1903, Joseph Pennell reported that this was one of Whistler's 'finest portraits'. When the Pennells saw the picture in Paris in 1905, however, they described it as 'ruined' (as, without justification, they did a number of Whistler's other pictures, see nos.22, 199). In fact, it has a freshness that one often finds in those portraits that Whistler did not have time to overwork. The paint is applied so thinly that the canvas is visible in places, but the picture is in good condition.

It is also an exceptionally good likeness, even down to the characteristic furrowing of the brows which we can see in photographs of the sitter. Canfield stood five feet eight inches tall,

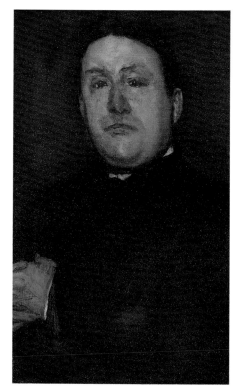

202

and at this time his two hundred pound weight forced him to wear a corset. His face has been described as 'fat and florid' with searching dark eyes, and he had a deep voice. He was a heavy drinker. Canfield amassed the most important collection of Whistler's work in America after Freer.[5] A few months before his death in 1914 he sold this collection – etchings, lithographs, drawings and seven paintings – to Knoedler's in New York (e.g. no.179).[6]

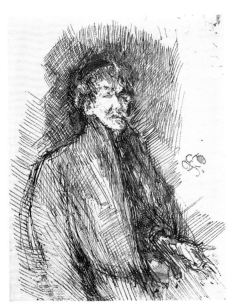

203

203 Portrait of Whistler 1898–1900

Pen and brown ink on cream laid paper
11.2 × 8.8 (4⁷/₁₆ × 3⁷/₁₆)
Signed with butterfly. Inscribed on verso with part of a signed letter:
'…[Whi]stler's acknowledgements | … [Dai]ly Mail – | … [p]aralised with gratitude | … [a]t the delicacy and kind | … you chew the food you | … Readers – Of course you | Pray receive my compliments | J. McNeill Whistler' and, in unknown hands, calculations, and numbers
PROV: Whistler's model, Carmen Rossi, Paris; sale, Hôtel Drouot, Paris 25 Nov. 1903 (6, repr.) bt Marchant, London (dealer); Joseph Pennell; given by E.R. & J. Pennell to the Library of Congress 1917
EXH: London, Marchant 1903 (183); London 1905 (181); London & New York 1960 (129); New York 1984 (5, repr.)
LIT: MacDonald 1994 (1533)

Prints and Photographs Division, Library of Congress, Washington DC

About 1896 Whistler commenced work on a self-portrait, 'Gold and Brown' (no.204). In 1898 he sent it to the first exhibition of the International Society of Sculptors, Painters, and Gravers, the exhibiting body of which Joseph Pennell was a founder member and Whistler the first President.

Whistler could have copied 'Gold and Brown' for reproduction in 1898 – which might account for the vivid detail of the drawing – but in the event it was photographed for the catalogue.[1] However, certain differences suggest that it showed the painting at a different stage (in the painting the coat is unbuttoned, his right hand is in a waistcoat pocket, and there is

no overcoat over his shoulders). Indeed, it may well have been a drawing from life, done at some time during the evolution of the portrait, which he continued to work on after 1898.

In the drawing, a tangle of vigorous cross-hatching, reinforced by monochrome washes, blends the figure with its background. Whistler washed and scraped out an area down the right side of the face, and over the cheek on the left, and redrew it. This suggests he was unusually concerned with recording either the precise details of his appearance or of the painting at that time.

It is a brilliant sketch; less introspective than the oil, and having a grandeur totally belying its size.

The drawing was in Whistler's studio in Paris when he was working on the self-portrait in the late 1890s. It was in 1898 (when the portrait was exhibited, but not completed) that the Académie Carmen was opened in the Passage Stanislaus in Paris, ostensibly under the control of Carmen Rossi, but with the active support of Whistler. He and the American sculptor, Frederick MacMonnies, undertook to teach there, and students flocked to attend. Unfortunately Whistler's attendances grew less frequent and ceased entirely in 1901.

Meanwhile, Carmen, a Neapolitan, who had been Whistler's model in Paris for many years, posing for both lithographs and oil paintings (YMSM 441, 505–7) was suspected of stealing both oils and drawings from Whistler's studio.[2] He was fond of her, and extremely tolerant, refusing to take action against her although he tried to do so against the dealers involved.

She said that 'Whistler gave her the paintings … instead of money, in payment of bills he owed her'.[3] However, the sale of her collection, including this drawing, took place immediately after Whistler's death, which tends to confirm suspicions.

The drawing passed soon after to Whistler's biographers, Elizabeth and Joseph Pennell, who formed one of the most important collections of Whistler manuscripts, literature, prints and drawing (Library of Congress). This drawing was one of their most prized possessions.

204 Gold and Brown 1896–8

Oil on canvas 62.4 × 46.5 (24½ × 18¼)
Signed with butterfly
PROV: G.W. Vanderbilt by 1900;
bequeathed in 1914 to his widow, later
Mrs Edith Stuyvesant Gerry; given to
the National Gallery of Art,
Washington 1959
EXH: London, ISSPG, 1898 (179);
Boston 1904(2); Paris 1905 (29); London
& New York 1960 (129)
LIT: YMSM 1980 (462); MacDonald
1994 (1533)

*National Gallery of Art, Washington. Gift of
Edith Stuyvesant Gerry*

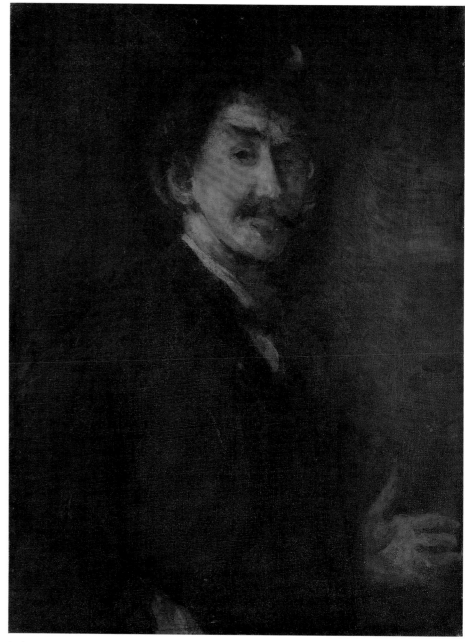

204

According to Whistler's sister-in-law Rosalind
Birnie Philip, 'Gold and Brown' was the portrait
'Whistler wanted to be remembered by'.[1] Cer-
tainly it is the finest of the three half-length
self-portraits begun in Whistler's Fitzroy Street
studio around 1896.[2]

In 1892 he had refused to allow a much ear-
lier self-portrait, 'Arrangement in Grey: Portrait
of the Painter' 1872 to be exhibited in the retro-
spective of his work held at Goupil in London
(fig.95; YMSM 122). That work pays direct
homage to the famous self-portraits of Rem-
brandt and Sir Joshua Reynolds, but is flawed
because the artist appears to hold his brushes in
a right hand attached to a left arm.

The late series may represent his attempt to
'correct' the earlier portrait. Certainly this por-
trait's dark tonality and searching self-scrutiny
puts one in mind of Rembrandt, though here
the artist carries neither brush nor palette.

When painting the portrait, Whistler
intended it for the exhibition at the Interna-
tional Society of Sculptors, Painters and
Gravers which was held at the Skating Rink,
Knightsbridge in May 1898.[3] Not only was
Whistler President of the Society, but he knew
that the Italian portraitist Giovanni Boldini's
bravura full-length portrait of him, painted in
1897, would be in the exhibition (fig.96).

Boldini's slick but undeniably vivacious per-
formance could be seen as the face Whistler
presented to the public. In contrast his own
view of himself shows us a more mellow figure,
an artist of substance and gravity, but not with-
out hints of the peacock of old, with his quiff
of white hair and monocle. A smile is beginning
to play on his lips and his eyes glint with satir-
ic humour. Suitably for the President of an
international society, the American-born,
French-trained and English-based artist wears
the red ribbon of the Legion d'Honneur, which
he had been given in 1892.

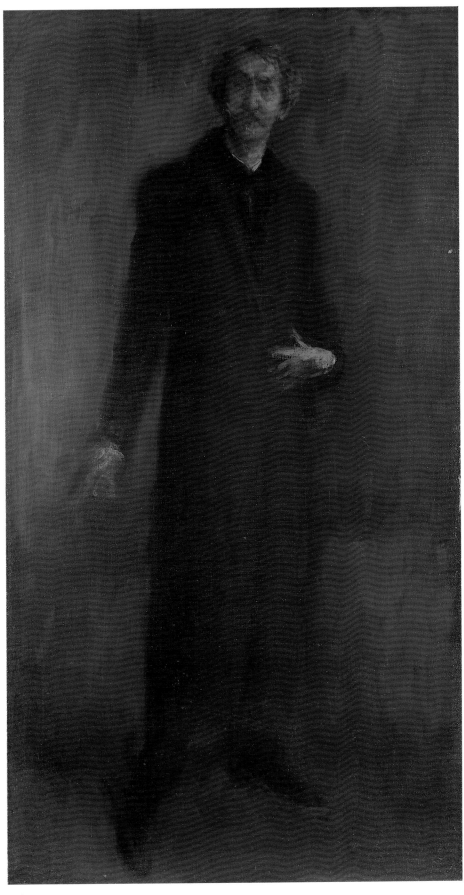

205

205 Brown and Gold 1895–1900

Oil on canvas 95.8 × 51.5 (37¾ × 20¼)
PROV: Bequeathed by Whistler to his
sister-in-law, Miss R. Birnie Philip in
1903; bequeathed to the University of
Glasgow 1958
EXH: Paris, Exp. Univ., 1900 (108 in
American Section)
LIT: YMSM 1980 (440)

*Hunterian Art Gallery, University of Glasgow,
Birnie Philip Bequest*

In June 1895 work on 'Brown and Gold' was so
far advanced that Whistler believed he would
finish it in a week. Work was interrupted by the
illness of his wife Beatrice, who died on 10 May
1896. Whistler was still apparently working on
the picture late in 1899, finally exhibiting it only
in 1900. As a self-portrait it therefore records
the most harrowing years of the artist's life. To
the painter Frederick Sandys, he wrote on 2
April 1896 that he was 'unable to do work' as,
frantic with worry, he moved with his wife
'from place to place and from doctor to med-
ical imposter'.[1] When all else failed he turned
to prayer.[2]

In the summer following Beatrice's death
Whistler was distraught. He wrote to his sister-
in-law Rosalind, 'Oh dear me – what is to
become of me! – I do nothing but think of my
beautiful Trixie!!'[3] And again, from Honfleur, 'I
still put out my hand to take the [hand] that I
may never again hold and again I know that I
journey by myself. I have lost her by the way,
and all haste and all eagerness are vain and
nothing shall come of it.'[4] Over the next few
years he complained of chronic fatigue, accom-
panied by (or caused by) depression. '*What* am I
to do. What am I to do', he wrote to William
Heinemann in 1899, 'I find myself continually
calling out in the solitude of my own sad com-
pany! The days are filled with dragging work
for the joy would seem to have gone out of that
– and the nights are not filled with sleep.'[5] Mal-
larmé compared Whistler in these years to
Edgar Alan Poe 'who was also alone'.[6]

Miss Birnie Philip, responding to a claim by
E.A. Gallatin that Whistler repainted this por-
trait after its exhibition in 1900, wrote that the
picture had been rubbed down at that date but
not repainted. It may well be that Whistler
continued to work on it after 1900 but it is
clearly not rubbed down to the canvas.

The pose is that of Velázquez's 'Pablo de
Valladolid' in the Prado, though the face, paint-
ed with brushwork of quivering, nervous inten-
sity, unsparingly records the ravages of worry
and anxiety.

Figure Illustrations

Figures 1–36 are illustrated in the essays, on pp.13–55

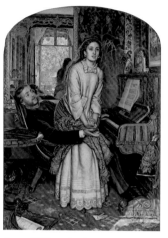

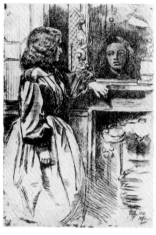

fig.37 Whistler 'La Marchande de Moutarde' 1858 Pencil on paper *The Freer Gallery of Art, Smithsonian Institution, Washington, DC*

fig.40 William Holman Hunt 'The Awakening Conscience' 1853 Oil on canvas *Tate Gallery, London Presented by Sir Colin and Lady Anderson through the Friends of the Tate Gallery 1976*

fig.42 Anon. (formerly attributed to John Everett Millais) 'Before the Mirror' 1861 Etching *Victoria & Albert Museum, London*

fig.43 Frederic, Lord Leighton 'David' exh. 1865 Oil *Cleveland Musuem of Art*

fig.38 Whistler 'La Marchande de Poterie à Cologne' 1858 Pencil on paper *Freer Gallery of Art, Smithsonian Institution, Washington, DC*

fig.41 George Du Maurier 'The Notting Hill Mystery', *Once a Week*, vol.8, 10 January 1863, *The British Library, London*

fig.39 Henri Fantin-Latour 'Two Sisters' 1859 Oil on canvas *St Louis Art Museum*

fig.44 Joanna in 'The Trial Sermon', *Good Words* 1862

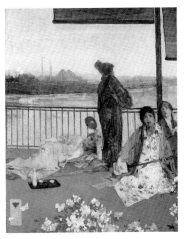

fig.45 Whistler 'Variations in Flesh Colour and Green: The Balcony' 1864–5 *Freer Gallery of Art, Smithsonian Institution, Washington, DC*

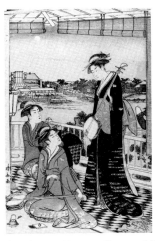

fig.47b Torii Kiyonaga 'Autumn Moon on the Sumida' *British Museum, London*

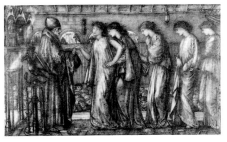

fig.50 Edward Burne-Jones 'Moritura: The Princess Draws the Lot' 1865–7 Pencil *British Museum, London*

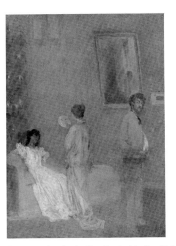

fig.46 Whistler 'Whistler in his Studio' 1865–6 Oil on paper mounted on mahogany panel *The Art Institute of Chicago. Friends of American Art Collection*

fig.48 Whistler 'Japanese Lady Decorating a Fan' c.1872 Pastel on tan paper *Cleveland Museum of Art*

fig.51 Whistler 'Four Women on a Terrace by the Sea' 1870–3 Chalk and pastel on paper *Hunterian Art Gallery, Glasgow University, Birnie Philip Gift 1935*

fig.52 Frederic, Lord Leighton 'Greek Girls Picking Up Pebbles by the Sea' before 1871 Oil on canvas *Private Collection, Mexico*

fig.47a Hokusai 'People on a Temple Balcony', c.1834 Woodblock *Rijksmuseum Voor Volkenkunde, Leiden*

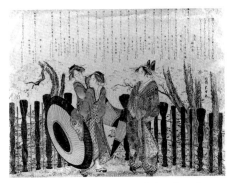

fig.49 Hokusai 'Oiran and Maids by a Fence' c.1796–7 Woodblock, double long surimono *Musée National des Arts Asiatiques-Guimet, Paris. Ex-Hayashi Tadamasa Collection*

fig.53 Albert Moore 'Sea Shells' exh. 1874 Oil on canvas *The Board of Trustees of the National Museums & Galleries on Merseyside (Walker Art Gallery)*

fig.54 Whistler 'The Thames in Ice' 1860
Oil on canvas *Freer Gallery of Art, Smithsonian
Institution, Washington*

fig.57 Gustave Courbet 'Low Tide at Trouville'
mid-1860s Oil on canvas *Board of Trustees of the
National Museums and Galleries on Merseyside
(Walker Art Gallery, Liverpool)*

fig.60 Whistler 'Sketch of an Upright Woman' on
reverse of 'Nocturne: The Solent' Oil on canvas
1866 *The Thomas Gilcrease Institute of American History
and Art, Tulsa, Oklahoma, USA*

fig.55 Whistler, Sketch of 'Wapping' (no.33) in
letter to Henri Fantin-Latour 1860 Pen on paper
Library of Congress, Manuscript Division, Pennell Collection

fig.58 William Bell Scott 'A Seashore at Sunset'
Oil on canvas *Private Collection. Courtesy The Fine
Art Society, London*

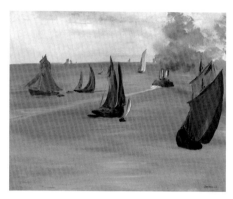

fig.61 Edouard Manet 'Departure from Boulogne
Harbour' 1864–5 Oil on canvas *The Art Institute of
Chicago. Mr and Mrs Potter Palmer Collection*

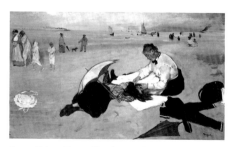

fig.56 Edgar Degas 'Beach Scene' 1876
Oil on paper, mounted on canvas *The Trustees,
The National Gallery, London*

fig.59 Gustave Courbet 'The Seaside at Palavas'
1854 Oil on canvas *Musée Fabre, Montpellier*

fig.62 Naval club overlooking Valparaiso Harbour
(undated) *British Library*

fig.63 Progress of the Southern Embankment of the Thames at Lambeth, Photo: *Hulton Picture Company*

fig.64 'Cremorne Gardens: The Crystal Platform' from the *Illustrated London News*, 1857 *Guildhall Library, Corporation of London*

fig.65 Johann Sebastian Muller after Antonio Canaletto 'A View of the Temple Comus in Vauxhall Gardens' Engraving *British Museum, London*

fig.66 Thomas Gainsborough 'The Mall in St James's Park' 1783 Oil on canvas *The Frick Collection, New York*

fig.67 Cremorne Gardens, fireworks platform (The Grotto) *c.*1870 *Photo: Royal Commission on Historical Monuments (England), National Monuments Record, London*

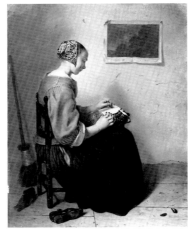

fig.68 Caspar Netscher 'The Lace Maker' 1664 Oil on canvas *The Trustees of the Wallace Collection, London*

fig.69 Charles Keene 'Mrs Edwin Edwards' 1860s Etching *British Museum, London*

fig.70 Edouard Manet 'The Tragic Actor (Rouvière in the Role of Hamlet)' 1866 Oil on canvas *Gift of Edith Stuyvesant Gerry, Board of Trustees, National Gallery of Art, Washington*

fig.71 Edouard Manet 'Portrait of Faure as Hamlet' 1877 Oil on canvas *Museum Folkwang, Essen*

fig.72 Whistler 'Arrangement in Brown and Black: Miss Rosa Corder' 1875–8 Oil on canvas *The Frick Collection, New York*

fig.73 Sir Max Beerbohm 'Mr – and Miss – Nervously Perpetuating the Touch of a Vanished Hand' 1917 (From *Rossetti and His Friends*) Pencil and watercolour on paper *Tate Gallery, London*

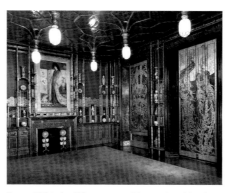

fig.76 Whistler 'Harmony in Blue and Gold: The Peacock Room' 1876–7 Oil colour and gold on leather and wood (view from north-east corner) *Freer Gallery of Art, Smithsonian Institution, Washington*

fig.79 John Singer Sargent 'Venetian Interior' *c*.1880–2 Oil on canvas *The Carnegie Museum of Art*

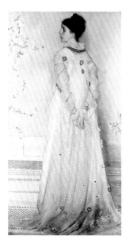

fig.74 Whistler 'Symphony in Flesh Colour and Pink: Portrait of Mrs Frances Leyland' 1871–4 Oil on canvas *The Frick Collection, New York*

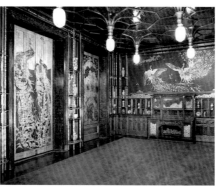

fig.77 Whistler 'Harmony in Blue and Gold: The Peacock Room' (view from south-east corner) *Freer Gallery of Art, Smithsonian Institution, Washington*

fig.80 Rembrandt van Rijn 'Landscape with a View toward Haarlem (Goldweighers Field)' 1651 Etching and drypoint *Rosenwald Collection, Board of Trustees, National Gallery of Art, Washington*

fig.75 Antoine Watteau 'Les Plaisirs du Bal' *c*.1715–17 Oil on canvas *The Governors of Dulwich Picture Gallery*

fig.78 Oriental canister, K'ang hsi period (1662–1722) *Fitzwilliam Museum, Cambridge*

fig.81 Whistler 'Harmony in Pink and Grey: Portrait of Lady Meux' 1881 Oil on canvas *The Frick Collection, New York*

fig.82 Whistler 'Harmony in Crimson and Brown' Oil on canvas *Probably destroyed Photo: Glasgow University Library, Whistler Collection*

fig.85 Whistler 'Milly Finch' 1883–4 Watercolour on paper *Freer Gallery of Art, Smithsonian Institution, Washington*

fig.88 Whistler 'Little Maunder's' 1887 Etching (K 279) *Hunterian Art Gallery, Glasgow University*

fig.83 C.H.F. Brookfield, Caricature of Whistler painting the three portraits of Lady Meux at once *Rosenbach Co, Philadelphia*

fig.86 Olga de Meyer, *c.*1880s *Photo: Baron de Meyer. Courtesy of George Eastman House, Louise Dahl Wolfe Collection*

fig.89 Rembrandt van Rijn 'The Adoration of the Shepherds: A Night Piece', *c.*1652 Etching, drypoint and burin on Japan paper *Rosenwald Collection, Board of Trustees, National Gallery of Art, Washington*

fig.84 James J. Tissot 'October' 1877 Oil on canvas *Collection of Montreal Museum of Fine Arts. Gift of Lord Strathcona and Family*

fig.87 Photograph of Maunder's Fish Shop *Chelsea Library, Royal Borough of Kensington & Chelsea*

fig.90 Whistler 'Venus' 1867 Chalk on brown paper *Freer Gallery of Art, Smithsonian Institution, Washington*

fig.91 Whistler 'Winged Hat' 1890 Lithograph
(w 25) *Hunterian Art Gallery, Glasgow University*

fig.94 George Vanderbilt, 1914 Photograph
Bittmore Estate, Asheville, North Carolina

fig.92 The Smithy, Lyme Regis 1890s Photograph
The Lyme Regis Philpot Museum

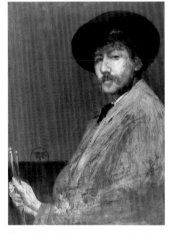

fig.95 Whistler 'Arrangement in Grey: Portrait of
the Painter' 1872 *The Detroit Institute of Arts, Bequest of
Henry Glover Stevens in memory of Ellen P. Stevens and
Mary M. Stevens*

fig.93 Samuel Govier 1890s Photograph
The Lyme Regis Philpot Museum

fig.96 Giovanni Boldini 'Portrait of James McNeill
Whistler' 1897 Oil on canvas *The Brooklyn Museum.
Donor A. Augustus Healy*

Notes

James McNeill Whistler

I am grateful to Margaret MacDonald, whose editing immeasurably improved a first draft of this essay.

1 Frank Anderson Trapp, 'The Universal Exhibition of 1855', *Burlington Magazine*, vol.107, no.747, June 1965, pp.300–5.
2 Pennell 1908, II, p.234.
3 Virginia Dodier, 'Haden, Photography and Salmon Fishing', *Print Quarterly*, vol.3, no.1, March 1986, pp.34–50.
4 Lochnan 1984, pp.95–6.
5 Robin Spencer, 'Whistler's Early Relations with Britain and the Significance of Industry and Commerce for his Art: Part I', *Burlington Magazine*, vol.136, April 1994, pp.212–24.
6 Antonin Proust, 'Edouard Manet: Souvenirs', *La Revue Blanche*, Feb.–May 1897, p.170.
7 Preface to the catalogue of the exposition held at the *Pavillon du Réalisme* at the Exposition Universelle of 1855. Gustave Courbet, *Courbet raconté par lui-même et pars ses amis, ses écrits, ses contemporains sa postérité*, Geneva 1950, II, p.60.
8 Ionides 1925, p.11: 'It was [Whistler] who started the love for Chinese and Japanese things, which was taken up by Rossetti and others.'
9 Rossetti to Mrs Gabriele Rossetti, 12 Nov. 1864, in Oswald Doughty and J.R. Wahl, *Letters of Dante Gabriel Rossetti*, Oxford 1965, II, p.527.
10 Fantin-Latour to Whistler, April 1863, GUL F9.
11 See YMSM 1980 (63), pp.36–7.
12 Jack Lindsay, *Gustave Courbet: His Life and Art*, Bath 1973, p.142.
13 J.McN. Whistler, 'The Red Rag', published in *World*, 22 May 1878, reprinted in Whistler 1890, pp.126–8.
14 Whistler to Fantin-Latour, ?Sept. 1867 (LC PC), published in Spencer 1989, pp.82–4.
15 Sarah Walden, 'Portrait of an Enigma' unpublished ms., 1990.
16 Bacher 1908, p.103.
17 Ira M. Horwitz, 'Whistler's Frames', *Art Journal*, vol.39, no.2, Winter 1979–80, pp.124–31.
18 See Albert Ludovici, *An Artist's Life in London and Paris 1870–1925*, 1926, p.78.
19 David Park Curry, 'Total Control: Whistler at an Exhibition', in Fine (ed.) 1987, pp.67–82.
20 Pennell 1921, p.299.
21 Menpes 1904, pp.120–1.
22 Bacher 1908, p.156 and Ludovici, op.cit., 1926, pp.74–9.
23 Sickert 1947, p.38.
24 John Stokes, *In the Nineties*, New York and London 1989, p.xxi.
25 Ibid., p.146.
26 Oscar Wilde, 'The Decay of Lying', *De Profundis and other Writings*, London 1973, pp.78–9.
27 See 'Arrangement in Black, No.8: Portrait of Mrs Cassatt' (no.128), and Graham Robertson's complaint that Whistler's portraits of Rosa Corder (no.66) and Robert de Montesquiou (Frick Collection, New York) do not look like the sitters. Kerrison Preston (ed.), *Letters from Graham Robertson*, 1953, pp.95, 367–8.

28 Pennell 1908, I, p.231.
29 Lochnan 1984, pp.198–205.
30 Duret 1917, p.73.
31 See P.G. Konody, *The Painter of Victorian Life: A Study of Constantin Guys* with an introduction and a translation of Baudelaire's 'Peintre de la vie moderne' (ed. C. Geoffrey Holme), 1930. The passages on which Whistler draws are found on p.23 and p.57.
32 Stokes, op. cit., p.51.
33 GUL D130–2.
34 D.C. Thomson to Whistler, 19 March 1892, GUL T50.
35 Pennell 1908, II, p.124.

Whistler and British Art

1 J. Comyns Carr, *Some Eminent Victorians Personal Recollections in the World of Art and Letters*, 1908, p.142.
2 Pennell 1908, I, p.159.
3 See, for example, Allen Staley, exh. cat., New York & Philadelphia 1971, pp.11–22.
4 For a brief summary of this debate in nineteenth-century French art see Lionello Venturi, *History of Art Criticism*, New York 1964, pp.243–5.
5 Whistler was adept at copying the watercolours of English artists including Turner. See Macdonald 1994 (176).
6 Virginia Surtees (ed.), *The Diaries of George Price Boyce*, 1980, p.38 (2 June 1863).
7 Reviewing the Dudley Gallery exhibition of 1876 the *Art Journal* noted that two Nocturnes were glazed 'as if they were water-colours' (see no.49).
8 Sickert 1947, p.15.
9 *Catalogue of the Second Special Exhibition of National Portraits Commencing with the Reign of William and Mary and Ending with the Year MDCCC*, exh. cat., South Kensington Museum 1867 and *Catalogue of the Third and Concluding Exhibition of National Portraits Commencing with the Fortieth Year of the Reign of George the Third and Ending with the Year MDCCCLXVII*, exh. cat., South Kensington Museum 1868.
10 Sickert 1947, p.22.
11 Ibid., p.26.
12 Ibid., p.22.
13 Ibid., p.15.
14 William T. Whitely, *Thomas Gainsborough*, London and New York 1915, p.247.
15 Menpes 1905, p.72. Menpes was to write the first critical and factual biography of Gainsborough.
16 Bacher 1908, p.31.
17 Sickert 1947, p.22.
18 Pat Rogers (ed.), *Joshua Reynolds, Discourses*, 1992, p.305.
19 Way 1912, p.28. Whistler saw 'The Blue Boy' not at the South Kensington exhibition but at the Royal Academy in 1870.
20 Ozias Humphrey quoted by Whitely, *op. cit.*, p.391.
21 Pennell 1908, II, p.275.
22 Way 1912, p.28.
23 Pennell 1908, I, p.177.

24 In his dual career as painter and print maker Whistler patterned himself on Hogarth, and it is arguable that Whistler's zest for pamphleteering and public debate ultimately derives from Hogarth's pugnacious example. Certainly Whistler shares his love of London with Hogarth.
25 For example, D.G. Rossetti, Frederick Augustus Sandys, Ford Madox Brown, Albert Moore, and William Holman Hunt. Compare their attitude to Whistler's, who actually wrote to the Royal Academy in the later 1860s telling them that he had been expecting to be elected for several years! ([n.d.] GUL R154).
26 Whistler did not exhibit in Paris between 1873 and 1882.
27 Whistler was much closer to Morris in the 1860s than has sometimes been realised. Compare his 'La Princesse du pays de la porcelaine' (fig.7) to Morris's 'La Belle Iseult' 1858 (Tate Gallery, London).
28 Charles Harvey and Jon Press, *William Morris Design and Enterprise in Victorian Britain*, Manchester and New York 1991, p.55.
29 Ibid., pp.97–105.
30 Pennell 1908, I, pp.192–3.

Whistler and America

1 See no.202.
2 *Henry James Letters*, ed. Leon Edel, Cambridge, Mass., 1975, II, p.167. James added that 'he paints abominably.' He and Whistler were never close.
3 Letter to Mrs William Whistler, 6 March 1900, GUL W732.
4 Baltimoreans, who did not know otherwise, proudly accepted him as a native son. During the Ruskin trial, under examination and presumably under oath, he said he was born in St Petersburg. Linda Merrill, *A Pot of Paint: Aesthetics on Trial in Whistler v. Ruskin*, Washington 1992, p.141.
5 Letter to Lady Seymour Haden, [n.d.], Freer Gallery of Art, Washington, DC.
6 [Sept.] 1896, GUL S55.
7 'In looks and character he is as little as possible like a New-Englander, but perhaps like his fellow townsman, Edgar Allan Poe, he may have been born by chance in a New-England state', *New York Times*, 17 June 1883. Despite their shortcomings as cadets at West Point, both Poe and Whistler are honoured by memorials there. The Poe Memorial is adjacent to the Whistler Memorial designed by Augustus Saint-Gaudens.
8 *The Swinburne Letters*, ed. Cecil Y. Lang, New Haven 1959, I, p.290.
9 Barbier 1964, p.257.
10 'My Note Book', *Art Amateur*, vol.15, Nov. 1886, p.112.
11 'Mr. Whistler as a Witness,' *Critic*, vol.27, 22 May 1897, p.361.
12 'Whistler: The Head of the Impressionists,' *Art Review*, vol.1, 1886, p.1.

13 'Whistler as an Etcher,' *Art Amateur*, vol.1, Oct. 1879, p.89.

14 *New York World*, 9 Feb. 1888.

15 *New York Times*, 6 April 1879.

16 *New York Times*, 22 March 1885.

17 Arthur Symonds, *Studies in Seven Arts*, New York 1906, p.124.

18 'The Fine Arts: The Society of American Artists', *Critic*, vol.2, 22 April 1882, p.119.

19 E.S. Crawford, in Eddy 1903, p.279.

20 [?Dec. 1899], typescript, pp.531–2, LC PC.

21 Jan. 1899, typescript, p.92, LC PC.

22 [n.d.], typescript, cont.13, p.1162, LC PC.

23 Louisine Havemeyer, *Sixteen to Sixty: Memoirs of a Collector*, New York 1961, p. 208.

24 William C. Brownell, 'The Paris Exposition: Notes and Impressions', *Scribner's Monthly*, vol.7, Jan. 1890, p.34. 'Much more so than Sargent', Brownell added.

25 Rennell Rodd, in Pennell 1908, I, p.192. 'The most courteous and vivacious of men, he is only a dogmatist on one subject – he insists on his guests eating buckwheat cakes', *Boston Transcript*, 7 June 1878. Henry James describes his breakfasts as 'elegant and pleasant'. He had tomatoes and buckwheat cakes. Edel, op. cit., II, p.167. See Margaret MacDonald, *Whistler's Mother's Cookbook*, London 1979.

26 Otto Bacher, *With Whistler in Venice*, New York 1908, p.24.

27 Feb. 1898, typescript, p.852, LC PC.

28 Pennell 1908, II, p.175.

29 Pennell 1908, I, p.109.

30 Pennell 1908, II, p.142.

31 Pennell 1908, II, p.177.

32 Rollo Brown, *Lonely Americans*, New York 1929, pp.55–6.

33 Pennell 1908, II, p.222.

34 Pennell 1921, p.236.

35 Pennell 1908, II, p.71.

36 Pennell 1908, I, p.189.

37 Letter to Alan Cole, [?1873], p.464, LC PC.

38 *Boston Transcript*, 2 May 1885. In 1902, George W. Smalley wrote: 'We are entitled to be judged by our best, and there will be no dispute that the two Americans who, as artists, stand above all others are Mr. Whistler and Mr. Sargent.' 'American Artists Abroad', *Munsey's Magazine*, vol.27, April 1902, p.45.

39 John W. McCoubrey, *American Art 1700–1960: Sources and Documents*, Englewood Cliffs 1965, pp.110, 112.

40 Lloyd Goodrich, *Winslow Homer*, New York 1945, p.6. For Whistler's American work, see Nancy Dorfman Pressly, 'Whistler in America: An Album of Early Drawings,' *Metropolitan Museum Journal*, vol.5, 1972, pp.125–54.

41 George Smalley, 'American Artists Abroad', *Munsey's Magazine*, vol.27, April 1902, p.45.

42 *New York Commercial Advertiser*, 22 Nov. 1866.

43 *New York Times*, 8 April 1877.

44 'The Old Cabinet', *Scribner's Monthly*, vol.15, April 1878, p.888.

45 Spencer 1989, p.109.

46 *New York Evening Post*, 8 March 1876.

47 E.V. Lucas, *Edwin Austin Abbey, Royal Academician: The Record of his Life and Work*, New York and London 1921, I, p.79.

48 'Whistler in Painting and Etching', *Scribner's Monthly*, vol.18, Aug. 1879, pp.490, 491.

49 *Baltimore Bulletin*, 27 Nov. 1875.

50 *New York Evening Post*, 20 April 1878.

51 *Louisville Courier-Journal*, in *American Architect and Building News*, vol.4, 14 Dec. 1878, p.199.

52 *New York Tribune*, 15 Jan. 1878.

53 *New York Express*, 9 April 1879.

54 'Wapping' (no.33) was in the Artists' Fund Society exhibition in 1866, and at the Düsseldorf Gallery with the Samuel P. Avery Collection in 1873. 'The Coast of Brittany' (no.39) was shown at the National Academy of Design in 1874, and at the Society of American Artists in 1878.

55 *Philadelphia Public Ledger*, 8 Nov. 1881.

56 'The Philadelphia Exhibitions', *Independent*, 24 Nov. 1881, p.6.

57 *New York Evening Post*, 21 March 1879.

58 'The American Artists Exhibition', *Art Amateur*, vol.6, May 1882, p.114.

59 *New York Evening Post*, 2 Nov. 1883.

60 Ibid.

61 Clarence Cook, 'Two Picture Exhibitions', *Art Amateur*, vol.10, Jan. 1884, p.28.

62 'The New York Water-Color Exhibition, *Art Amateur*, vol.10, 14 March 1884), p.84.

63 *New York Times*, 23 May 1884.

64 'Fine Arts: The Society of American Artists', *Independent*, 12 June 1884, p.744.

65 He put it differently a few years later: 'I find art so absolutely irritating in its effect on the people that I really hesitate before exasperating another nation.' 'James Abbott McNeill Whistler', *American Architect and Building News*, vol.22, Nov. 1887, p.259.

66 *Philadelphia Press*, 30 March 1884.

67 Letter to E.G. Kennedy, 7 April 1895, typescript, E.G. Kennedy Correspondance, no.88, LC PC.

68 'I shall come to America when the duty on works of art is abolished', he told Royal Cortissoz: *Art and Common Sense*, New York 1913, p.212.

69 Letter to E.G. Kennedy, 4 Feb. 1894, typescript, Library of Congress, E.G. Kennedy Correspondance, no.76, LC PC.

70 Pennell 1908, II, 242.

71 Arthur Warren, *London Days: A Book of Reminiscences*, Boston 1920, p.168.

72 Pennell 1921, p.154.

73 Don Seitz, *Whistler Stories*, New York and London 1913, p.128.

74 Warren, op. cit., p.168.

75 *Boston Evening Transcript*, 9 March 1889.

76 'Chicago Letter', *Critic*, vol.19, 27 May 1893, p.351.

77 Mary Cassatt to Alexander Cassatt, Paris, 14 Oct. 1883, in *Cassatt and her Circle: Selected Letters*, ed. Nancy Mowll Mathews, New York 1984, p.172.

78 'I wish you to have a fine collection of Whistler!! perhaps the collection': Letter to Freer, 29 July 1899, typescript, GUL F449.

79 Isabella Stewart Gardner suggested to Sargent the rather ludicrous possibility of putting the dismantled Peacock Room in Bates Hall. John Singer Sargent to Whistler, 1 Nov. 1897, GUL S34.

80 'The Art Motive in Photography', *Photography in Print*, ed. Vicki Goldberg, Albuquerque 1988, p.281.

81 'The present generation of painters', John C. Van Dyke wrote in 1919, in words that could as easily apply to photographers, 'thinks [Whistler's] *Ten O'Clock* the law and gospel of art': *American Painting*, New York 1919, p.151.

82 Lloyd Goodrich, *Thomas Eakins*, Cambridge, Mass. 1982, II, p.15.

83 Ibid.

84 Clarence White's response to the Sarasate's acquisition was his unmistakable Whistlerian photograph, 'The Violinist', of 1897.

Whistler and France

1 Anon. (an exhibitor), 'Le Salon de 1888', *La Revue Indépendante*, vol.7, no.20, June 1888, p.440: 'When we pay a hasty visit to these galleries, we only stop in front of the two frames of marvelous etchings by the American, Whistler'.

2 Charles Morice, 'Deux morts: Whistler, Pissarro', *Mercure de France*, vol.50, 1904, pp.72–84.

3 Ibid., p.84.

4 Despite Delannoy's pleas to the administration on 13 April 1861 (Louvre Archives, quoted in *Impressionnisme, les origines 1859–1869*, Paris 1994, p.302).

5 Charles Baudelaire, *Oeuvres complètes*, Paris 1987, II, pp.735, 740. In both versions of the article, which appeared in April and then September 1862 and was reprinted in *L'Art Romantique*, the comment on Whistler remains the same.

6 Charles Baudelaire, *Correspondance*, Paris 1973, II, p.326.

7 Henry Houssaye, 'Le Salon de 1882', *Revue des Deux Mondes*, 15 June 1882.

8 Ernest Chesneau, *Les Nations rivales dans l'art*, Paris 1868, p.161.

9 Ernest Chesneau, *L'Art et les artistes modernes en France et en Angleterre*, Paris 1864, pp.196, 190 (a reprint of an article in the *Constitutionnel* of 1863).

10 Unpublished passage from the third *carnet* in the possession of the Bibliothèque nationale and quoted in Henri Loyrette, *Degas*, Paris 1991, p.227 and p.759 n.95.

11 Quoted, for instance, in Emile Zola, *Le Bon Combat, de Courbet aux Impressionnistes*, Paris 1974, p.273.

12 Castagnary, *Salons 1857–1870*, Paris 1892, I, p.179.

13 This exhibition was held from 26 April until 24 May 1891. Whistler's entry was described as: '965. Sketches (three sheets) (Beurdeley collection)'.

14 Louis-Edmond Duranty, 'Ceux qui seront les peintres', *Almanach parisien pour 1867*, Paris 1867, p.13, quoted in *Fantin-Latour*, exh. cat., Paris, Ottawa & San Francisco 1982, p.173.

15 When this painting was acquired for the Luxembourg in 1892, Whistler was upset that they had not instead chosen 'Homage to Delacroix', in which he appears. Cf. Robin Spencer, ''Whistler, Manet and the Tradition of the Avant-Garde', *Studies in the History of Art*, vol.19, Washington 1987, pp.61, 64 n.62.

16 Cf. Robin Spencer, loc. cit., pp.56–7.

17 Cf. Henri Loyrette, *Degas*, Paris 1991, p.222, who quotes a letter from Manet to Degas on the subject, written on 29 July 1868, on which Degas had noted Whistler's address.

18 Cf. *Impressionnisme, les origines 1859–1869*, exh. cat., Grand-Palais, Paris 1994, especially p.313, for Degas.

19 Cf. *Degas*, exh. cat., Paris, Ottawa & New York 1988–9, nos.92–3 and p.298, and Théodore Reff, 'Le Papillon et le vieux boeuf', in exh. cat., New York & Philadelphia 1971.

20 Daniel Wildenstein, *Claude Monet, biographie et catalogue raisonné, Peintures*, Lausanne and Paris 1974, I, no.262.

21 Cf. YMSM 1980 (138).

22 Ernest Chesneau, 'Le Japonisme dans les arts', *Musée Universel*, vol.2, 1873, pp.214–7.

23 Ibid., p.216.

24 Cf. YMSM 1980 (138); letter in the possession of the Walters Art Gallery, Baltimore.

25 Chesneau, loc. cit., p.216.

26 Cf. the reissue of this text in the catalogue of *The New Painting – Impressionism 1874–86*, Washington and San Francisco 1986, p.480.

27 Robin Spencer, 'Whistler, Manet and the

Tradition of the Avant-Garde', *Studies in the History of Art*, vol.19, Washington 1987, p.57, fig.14.

28 Spencer 1989, p.108. My grateful thanks to Robin Spencer for having sent me the French text of this letter, and for all his help in the research on the Durand-Ruel exhibition.

29 Letter from Duret to Pissarro, Fondation Custodia Paris, quoted by Shigemi Inaga, 'Théodore Duret (1838–1927)', unpublished thesis, University of Paris VII 1988, p.78.

30 Janine Bailly-Herzberg, *Correspondance de Camille Pissarro, 1865–1885*, Paris 1980, I, p.160.

31 Paul Leroi, 'Le Salon de 1882', *L'Art*, 1882, vol.3, p.139.

32 Guillaume Dubufe and Roger Ballu, 'Dialogue sur le Salon de 1883', *Nouvelle Revue*, 1 June 1883, p.211.

33 Article in *La France*, 24 May 1886, published in Octave Mirbeau, *Combats esthétiques*, I, 1877–1892, Paris 1993, pp.280–1. In a letter in the possession of the Musée Rodin, and published in *Quand Rodin exposait*, exh. cat., Musée Rodin, 1992, pp.222–3, Whistler thanks Rodin 'for the trouble you took to secure Mr Mons Mirbeau's article in La France'.

34 J.-K. Huysmans, 'Salon officiel de 1884', *La Revue Indépendante*, vol.1, 1884, pp.107, 111.

35 G. Dargenty, 'Chronique des expositions – Exposition Internationale de Peinture et de Sculpture – Galerie Georges Petit', *Courrier de l'Art*, 27 May 1887, p.163.

36 J.-K. Huysmans, Chronique d'art – Le Salon de l'Exposition Internationale de la rue de Sèze', *La Revue Indépendante*, June 1887, p.854.

37 Léonce Bénédite, *Exposition Universelle de 1900: Rapport du jury international*, I, pt.2: *Beaux-Arts*, Paris 1904, pp.653–4.

38 Cf. exh. cat., New York & Philadelphia 1971.

39 Cf. Pascal Forthuny, 'Notes sur James Whistler', *Gazette des Beaux-Arts*, Nov. 1903, pp.386–7.

40 Edouard Rod, 'Les Salons de 1891', *La Plume*, 1891, p.101.

41 Charles Morice, 'Salons de la Nationale et des Français', *Mercure de France*, vol.50, 1904, pp.696–7.

42 Charles Morice, 'Deux morts: Whistler, Pissarro', *Mercure de France*, vol.50, 1904, p.83.

43 See pp.53–5. Cf. Joy Newton and Margaret MacDonald, 'Rodin: The Whistler Monument', *Gazette des Beaux-Arts*, vol.92, Dec. 1978, pp.221–32; Newton and MacDonald 1984, pp.116–23.

44 Rodin's large plaster cast of 'The Muse of Whistler', lent by the Musée Rodin to the Musée d'Orsay, Paris, has been on show at the Musée d'Orsay since it opened in 1986.

45 Quoted by François Monod, 'Les Premiers ouvrages de Whistler', *Art et Décoration*, vol.17, 1905, p.192.

Whistler for President!

I am very grateful to the University Court of the University of Glasgow, holders of Whistler's copyright, for permission to quote from his letters, to the RBA for granting access to their records, and to the Tate Gallery Archive for access to the papers of the ISSPG and John Lavery.

1 Interview in *Pall Mall Gazette*, 11 June 1888, reprinted in Whistler 1890, p.206.

2 Seconded by Ayerst Ingram; half-yearly general meeting, SBA minutes: Wyke Bayliss, seconded by Horace Cauty, suggested the suspension of ballot procedures.

3 2 Jan. 1885, SBA minutes.

4 Draft, 19 June 1888, GUL LB7, p.9.

5 Menpes 1904, p.110.

6 To Mrs W. Whistler, [n.d.], [June/Dec.1886], GUL w75.

7 *Pall Mall Gazette*, 11 June and 6 July 1888, reprinted in Whistler 1890, pp.207, 211–20.

8 D'Oyly Carte to Whistler, 20 Dec.1886, GUL D139.

9 Menpes 1904, p.106.

10 *Magazine of Art*, 1887, p.275.

11 'A British Artist' to *Daily News*, and Whistler's reply, 24 and 26 Nov. 1886; interview with *Pall Mall Gazette*, 11 June 1888; reprinted in Whistler 1890, pp.188–90, 207.

12 RBA minutes, 6 June 1887.

13 A motion to officially limit the size of works in some categories was defeated, 25 March 1887, SBA minutes.

14 Proposal to Stop President Inviting Works for Exhibition, withdrawn, 3 Jan. 1887, SBA minutes.

15 'Coast of Belle Ile, Brittany'; 'Meadow of Limetz'; 'Village of Bennecourt'; 'Cliffs near Dieppe'; GUL M356.

16 *Spectator*, 10 Dec.1887; see also *St James's Gazette*, 30 Nov. 1887.

17 1 May and 20 Nov. 1885, 9 April 1886, 25 March and 4 July 1887, SBA minutes.

18 1 Dec. 1885, 26 March 1888, RBA minutes.

19 12 May 1888, RBA minutes; Menpes 1904, pp.111–2.

20 Exh. SBA 1887–8; *Home and Colonial Mail*, 2 Dec. 1887.

21 Anon, 'Current Art', *Magazine of Art*, 1888, p.110, repr. p.109.

22 Letter to *Court and Society Review*, 29 July 1886.

23 *Manchester Examiner*, 2 Dec. 1887.

24 *St James Gazette*, 30 Nov. 1887.

25 Letter to the *Times*, published 9 Dec. 1886 in *Pall Mall Gazette*, republished in Whistler 1890, pp.202–3.

26 [1885–7] GUL S74.

27 Wendy Baron, *Sickert*, London 1973, nos.19, 40.

28 Lecture on 7 Oct. 1885 partially quoted in Whistler 1890, p.193; Anon, 'The Society of British Artists,' *Magazine of Art*, 1886, pp.162–3; see MacDonald 1994 (1074).

29 1 Nov. 1886, SBA minutes.

30 *Judy*, 8 Dec. 1886, p.267.

31 Franklin as 'Clifton Lin', exh. SBA 1884–5 to 1887–8; Beatrice Godwin as 'Rix Birnie' 1885–6 to 1887–8: see Margaret F. MacDonald, 'Maud Franklin', in Fine (ed.) 1987, pp.24, 26.

32 Menpes 1904, p.23.

33 Anon., 'Current Art', *Magazine of Art*, 1887, p.111.

34 Descriptions in *St James's Gazette*, 1 Dec. 1886; RBA minutes, 1 Nov. 1887; Menpes 1904, p.107; Pennell 1908, I, p.64; Ludovici 1926, p.78.

35 Whistler was not present at the meeting, 9 April 1888, RBA minutes.

36 Whistler on 9 Aug. 1900, quoted by Pennell 1908, II, pp.65–7; meeting, 10 Aug. 1887, RBA minutes.

37 Whistler to Mitchell, 17 May 1887, GUL H227; Matthews to Whistler, 20 July 1887, GUL G200; drafts of design in LC PC and GUL V64; photos in GUL and LC PC; MacDonald 1994 (1130–2).

38 Whistler, 9 Aug. 1900, quoted by Pennell 1908, II, pp.6–7: the meeting was on 10 Aug. 1887, RBA minutes.

39 First lion used in Dec. 1886; 'royal' lion designs, GUL R185–8: MacDonald 1994 (1121, 1133–6).

40 Letter in Humanities Research Centre, University of Austin, Texas; Menpes 1904, p.109.

41 Whistler to SBA, 30 March 1889, and interview with *Pall Mall Gazette*, 3 April 1889, et seq., reprinted in Whistler 1890, pp.218–28.

42 Album now in Hunterian Art Gallery, University of Glasgow.

43 1 Nov. 1887, proposed Whistler, seconded Roussel; and again on 7 May 1888, RBA minutes.

44 GUL R217, and Whistler's reply, 6 May 1888, GUL R218: meeting, 7 May 1888, RBA minutes.

45 [n.d.] [c.7 May 1888], GUL LB7, p.2.

46 *Pall Mall Gazette*, 11 June 1888, quoted in Whistler 1890, p.208.

47 Draft by Whistler, GUL X15: lists of resignations, GUL LB7 p.38; 12 Nov. 1888, GUL R220; 25 June 1888, RBA annual general meeting.

48 Lavery to Whistler, 4 May 1898, Tate Gallery Archives 72-45/305.

49 Typescript account by Lavery of the ISSPG, Tate Gallery Archives 72-45/325.

50 Ludovici to Whistler, 16 and 19 April 1898; F. Howard to Whistler, [n.d.]; Whistler to F. Howard, 10 April 1898, GUL II.38–9, 30; see Newton and MacDonald 1984, pp.113–23.

51 Whistler to Lavery, 26 June 1899, Tate Gallery Archives 7-45/280.

52 Whistler to Lavery and Committee, 21 March 1899, and typescript by Lavery; Tate Gallery Archives 72-45/267, 325.

53 LC PC, MacDonald 1994 (1537–8).

54 Whistler to J. Lavery and Committee of ISSPG, [13] May 1898, Tate Gallery Archives 72-45/262.

55 Horace Page to Lavery, 9 Jan. 1898, Whistler to Lavery, 19 and 20 July 1899, Lavery to W. Webb, honorary solicitor, 24 Aug. 1899 and reply, 31 Aug. 1899, Tate Gallery Archives 72-45/35–7, 200, 280–1.

56 Typescript by Lavery, Tate Gallery Archives 72-45/325.

57 Newton and MacDonald 1984, p.116.

58 Exh. cat., London, ISSPG 1898 (16, repr.).

59 P. Fragiacomo to Lavery, 31 Jan. 1899, Tate Gallery Archives 72-45/195.

60 Klimt to Whistler, 13 Dec. 1897, GUL S150.

61 Letter from Whistler, published in *Daily Chronicle*, 15 May 1902, and Rodin to Pennell, Pennell 1908, II, p.278–9; Newton and MacDonald 1984, p.119.

62 Ludovici to Whistler, 11 May 1898, GUL I49.

63 Whistler to Lavery and Committee of ISSPG, 5 Feb. 1899, Tate Gallery Archives.

64 e.g. 'La Plage, St Malo', ISSPG 1901 (118), repr.

65 Whistler to Ludovici, [May 1898], LC PC, MacDonald 1994 (1539–40); *Art Journal* 1898, p.249, repr. Newton and MacDonald 1984, p.116.

66 Pennell 1908, II, p.262.

Catalogue

Early Prints and the 'French Set'

1 The standard catalogue of Whistler's etchings is Edward G. Kennedy, *The Etched Work of Whistler, Illustrated by Reproductions in Collotype of the Different States of the Plates*, New York 1910. It was reprinted by De Capo Press, New York, in 1974; and Alan Wofsy Fine Arts, San Francisco, in 1978. The most comprehensive study of Whistler's work in this medium is Katharine A. Lochnan's *The Etchings of James McNeill Whistler*, New Haven and London 1984.
2 Wedmore 1886 (20).

no.1

1 Thomas Armstrong, *A Memoir*, London 1912, pp.179, 186, 190.
2 See Beatrice Farwell, *The Charged Image: French Lithographic Caricature 1816–48*, Santa Barbara Museum of Art 1989 (191, repr.)
3 *Le Diable à Paris*, 1845; see Lochnan 1984, p.32, repr.

no.2

1 Ralph Thomas, *A Catalogue of the Etchings and Drypoints of James Abbott MacNeil Whistler*, 1874 (25). Thomas's catalogue was published the year of Whistler's first one-man show at 48 Pall Mall, which included fifty etchings.
2 Duret 1904, p.12. Trans: 'A cheap restaurant frequented by the poor and the wretch. The young man called Martin who ran it (on the left of the etching) became famous fighting in the militia in Paris during the battle of June 1848. He had been decorated for bravery and newspapers had spread his name. But after a series of unfortunate affairs he had lost all standing and was reduced to running this dive.'
3 Thomas, op.cit. (25).

no.3

1 Eloise according to Pennell and Mansfield; Héloïse according to *Whistlers and Further Family*, exh. cat., Glasgow University Library, Glasgow 1980 (15); Pennell 1908, I, pp.56–7.

no.4

1 See M.F. MacDonald, 'Venus and other Pagan Goddesses', in exh. cat., Glasgow 1984 (15–17).
2 Lochnan 1984, pp.107–8.
3 Wedmore 1886 (56).

no.5

1 Thomas 1874 (11).
2 MacDonald 1994 (272–3, repr.).
3 Lochnan 1984, pp.42, 46–7, repr. p.54, pl.54.
4 Wedmore 1886 (16).

no.6

1 Inscription on 1st state, Mansfield 1909 (17).
2 Lochnan 1984, pp.36–8.
3 See Ruth Fine, *Drawing Near: Whistler Etchings from the Zelman Collection*, exh. cat., Los Angeles County Museum of Art 1984, p.35, no.3.
4 Wedmore 1886 (8).

no.7

1 Lalouette to Whistler, 8 Aug. 1860, GUL L12; see Pennell 1908, I, p.55.

no.8

1 Pennell 1908, I, p.70.
2 Lochnan 1984, pp.104–5.
3 Unidentified press-cutting, [1874], GUL pcl, p.67.
4 Wedmore 1886 (53).

no.9

1 Lochnan 1984, pp.60–4, repr.

no.11

1 *William Holman Hunt: Pre-Raphaelitism and the Pre-Raphaelite Brotherhood*, London 1905, II, p.360; DuMaurier 1951, p.4; Pennell 1908, I, p.83.
2 DuMaurier 1951, p.4.
3 The Victorian craze for the stereoscope peaked in the 1850s when the London Stereoscope Company sold 250,000 of these devices in three months and adopted as its slogan 'No home without a stereoscope'. See Richard D. Altick, *The Shows of London*, Cambridge, Mass. and London 1978, p.233.
4 Pennell 1908, I, p.83.
5 W. Bürger to Edouard Manet, May 1867, GUL B212.
6 Degas, quoted in a letter from Paul Poujaud to Marcel Guerin, 11 July 1936 in Edgar Germain Hilaire Degas, *Letters*, ed. Marcel Guerin and trans. from the French by M. Kay, Oxford 1947, p.236.
7 Gordon Fleming, *The Young Whistler*, London 1978, p.43.
8 Entry for 12 July 1844, GUL W345, p.34
9 Anna Whistler wrote to Joseph Harrison, 7 July 1849, concerning the detention of the piano in Hull Customs House waiting for import taxation to be paid, LC PC.
10 YMSM 1980 (28).

no.12

1 She appears in two major paintings as well: 'At the Piano', 1858–9 (no.11); and 'The Music Room', 1860 (Freer Gallery of Art; YMSM 34).
2 Lochnan 1984, pp.107, 112.
3 Wedmore 1886 (57).

Jo

1 Pennell 1921, p.161.
2 Pennell 1921, pp.118: Pennell 1908, I, pp.94–5.
3 Du Maurier 1951, p.105.
4 K 92–3; YMSM 1980 (40, 44, 52, 60–3); *Once a Week*, vol.7, 16 Aug. 1862, repr. p.210; MacDonald 1994 (301–2, 304–6, 341–3).
5 Du Maurier to T. Armstrong, [Feb.1864], Du Maurier 1951, p.227; Whistler to Fantin-Latour, [1864], LC PC.
6 Anna Whistler to J. and W. Whistler, 22 Jan. 1866, GUL W521.
7 Du Maurier to T. Armstrong, [Nov. 1863], Du Maurier 1951, p.219.
8 [n.d.], [before July 1861], LC PC.
9 Pennell 1921, pp.162–3.
10 Whistler to Hanson, 2 May 1880, GUL H55.
11 Letter in Bibliothèque nationale, Paris, Estampes, Box v, quoted in *Gustave Courbet 1819–1877*, exh. cat., Royal Academy, London 1978 (87).
12 Ibid., (87); Pennell 1921, p.162.
13 Louisine W. Havemeyer, *Sixteen to Sixty: Memoirs of a Collector*, privately printed for the family of Mrs H.O. Havemeyer, New York 1961, p.212.

no.13

1 Wedmore 1886 (64).

no.14

1 Stella Mary Newton, *Health, Art & Reason, Dress Reformers of the 19th Century*, London 1974, p.32, fig.8.
2 John A. Mahey (ed.), 'The Letters of James McNeill Whistler to George Lucas', *Art Bulletin*, vol.49, Sept. 1967, pp.247–57.
3 [15] May 1863, GUL F12.
4 Jules Castaganary, *Salons 1857–1870*, Paris 1892, I, p.179.
5 For a discussion of the critical reaction to the picture see Denys Sutton, *Nocturne: The Art of James McNeill Whistler*, London 1963, pp.36 et seq.
6 [15] May 1863, GUL F12.
7 Charles Stuckey, 'What's Wrong with this Picture?', *Art in America*, no.69, Sept. 1981,

pp.96–107.
8 Ernest Chesneau, *L'Art et les Artistes Modernes en France et en Angleterre*, Paris 1864, p.190.
9 Charles Dickens, *The Personal History of David Copperfield*, ed. Trevor Blount, London 1979, p.304.
10 Luke Ionides, *Memories*, Paris 1925, p.49.

no.15

1 The exhibition of no.16 at the Royal Academy of 1867 under the title 'Symphony in White No.III' implies that Whistler had renamed 'The Little White Girl' 'Symphony in White, No.II'.
2 George Heard Hamilton, *Manet and his Critics*, New Haven and London 1954, p.31.
3 Ibid., p.49.
4 Swinburne to Whistler, 2 April 1865, GUL S265.
5 Swinburne, *Poems and Ballads*, London 1866.
6 Stanzas 4 and 6 appeared in the RA catalogue.
7 Letter to *Morning Post*, 6 Aug. 1902; Pennell 1908, II, p.280.
8 Hamilton, op. cit., p.68.
9 Cecil Y. Young (ed.), *The Swinburne Letters*, New Haven and London 1959, III, p.42, letter 629.

no.16

1 16 Aug. 1865, LC PC; MacDonald 1994 (323).
2 12 Feb. 1867, GUL F14.
3 Edgar Degas, Notebook 20 (Paris, 1864–7) Musée du Louvre, Paris, Cabinet des Dessins, RF 5634 ter. See Theodore Reff, *The Notebooks of Edgar Degas*, I, Oxford 1976, p.107.
4 Whistler 1890, pp.44–5, dated June 1867 (a draft of the text in Glasgow University Library was probably written in 1878).

no.19

1 S 291; collection Sir R. Brinsley Ford.
2 *New York Sunday Sun*, 22 March 1903, quoted in Lochnan 1984, pp.149–50.
3 The circle at the lower right is a collector's mark, stamped on the verso of the sheet; its clarity offers an idea of the thinness of the paper.

no.20

1 Hunterian Art Gallery, University of Glasgow; MacDonald 1994 (325–8).
2 MacDonald 1994 (328, 350).

no.21

1 Walter Thornbury, 'The Morning before the Massacre of St. Bartholomew. August 1572', *Once a Week*, vol.7, 16 Aug. 1862, pp.210–11, wood engraving repr. p.210; anon. ['N.C.'], 'The Trial Sermon', *Good Words for 1862*, ed. Norman MacLeod, London 1862, p.585, wood engraving repr. p.649.
2 Alfred L. Baldry, *Albert Moore: His Life and Work*, London 1894, repr. opp. p.28.
3 Ernest Rhys, *Frederick, Lord Leighton*, London 1898, repr. opp. p.18.
4 First published in London 1885; republished in Whistler 1890, pp.131–59 (see p.158).

Japonisme

1 William Michael Rossetti, *Some Reminiscences*, London 1906, I, p.276.
2 Matthi Forrer, *Hokusai: Prints and Drawings*, exh. cat., Royal Academy of Arts, London 1991, no.22.

no.22

1 K. Abbott (ed.), A. McN.Whistler, 'The Lady of the Portrait, Letters of Whistler's Mother', *Atlantic Monthly*, vol.136, 1925, pp.323–4.
2 Ibid.
3 Ira Horowitz, 'Whistler's Frames', *Art Journal*, Winter 1979–80, p.124.
4 As, for example, 'The Greek Potters' 1871, repr. p.337 of Vern G. Swanson, *The Biography and Catalogue Raisonné of the Paintings of Sir Lawrence Alma-Tadema*,

London 1990.
5 William Michael Rossetti, *Fine Art, Chiefly Contemporary*, 1867, p.274.
6 Quoted in Gordon Fleming, *James Abbott McNeill Whistler: A Life*, New York 1991, p.107.

no.23
1 Photograph in Lucas Collection, Baltimore Museum of Art.
2 Munson-Williams-Proctor Institute, New York; Hunterian Art Gallery, University of Glasgow and National Gallery of Art, Washington; MacDonald 1994 (341–6, 348–9).

no.24
1 LC PC quoted in Benedict, I, 1905, p.148.
2 Mrs Anna Whistler to Mr Gamble, GUL W516.
3 D.P. Curry in exh.cat., Washington 1984, p.79.

no.26
1 Cole's letter includes a sketch of the arches which may be by Whistler, GUL S163; MacDonald 1994 (457).
2 'Japanese Lady Decorating a Fan', MacDonald 1994 (459).
3 *J.A. McNeill Whistler*, exh. cat., Lyman Allyn Museum of Art, New London, Conn., 1949 (44) as a study for the 'Princesse du pays de la porcelaine'.

The 'Six Projects'
1 See the discussion in YMSM 1980 (88). Note, too, Rossetti 1903, p.320.
2 He was at work on the series by July 1868 according to W.M. Rossetti.
3 Matthi Forrer, *Hokusai*, exh. cat., Royal Academy of Arts, London 1991, no.85.
4 LC PC; quoted in full in Spencer 1989, pp.82–4.
5 Jan Reynolds, *Birket Foster*, London 1984, p.104. A photograph showing a corner of the dining room is reproduced p.98.
6 Martin Harrison and Bill Waters, *Burne-Jones*, London 1973, ill. p.90.
7 Joanna Richardson, *Baudelaire*, London 1994, p.333.
8 Whistler to Fantin-Latour, Sept. 1867, LC PC. Quoted in Spencer, op.cit., p.83.

no.27
1 Fitzwilliam Museum, Cambridge, and Freer Art Gallery, Washington, DC; MacDonald 1994 (377–8).
2 'Venus', dated 1869, Freer Gallery of Art, Washington, DC; MacDonald 1994 (357).
3 MacDonald 1994 (384–5).
4 YMSM 1980 (86); it was a little larger (50.2 x 74.9 cm as against the Symphony's 46.7 x 61.9 cm) and on canvas instead of panel.
5 Auction, Sotheby, London, 30 March 1994 (191).
6 GUL M436.
7 19 Sept. 1870, GUL N20.

no.28
1 Sidney Colvin, 'Exhibition of Mr. Whistler's Pictures', *Academy*, vol.5, 13 June 1874, pp.672–3.
2 e.g. exh. cat., London, Pall Mall 1874 (5, 7, 13, 16–20, 23); see MacDonald 1994 (557–63).
3 MacDonald 1994 (531, 554).

no.29
1 For example, 'Dancer Adjusting her Slipper' (pencil, 1873, The Metropolitan Museum of Art, New York), reproduced in *Degas*, exh. cat., Paris, Ottawa & New York 1988–9, no.135.

The Thames
1 *Twenty-one Etchings by Charles S. Keene: Printed by F. Goulding*, Introduction and Notes by M.H. Spielmann, London 1903, p.5.
2 Pennell 1908, I, p.231.

3 Joseph Pennell, *The Work of Charles Keene*, London 1897, pp.25–6.
4 Pennell 1921, p.78.
5 S.C. and A.M. Hall, *The Book of the Thames, from its Rise to its Fall*, London 1859, p.411.
6 Alfred Rosling Bennett, *London and Londoners in the Eighteen-Fifties and Sixties*, London 1924, p.123.
7 Hall, op.cit., pp.395, 398.
8 Sherwood Ramsey, *Historic Battersea: Topographical Biographical*, London 1913, p.21.

no.30
1 Nathaniel Hawthorne, *Our Old Home: A Series of English Sketches*, Boston 1863, p.299.

no.31
1 Thomas 1874 (38)
2 Katherine Lochnan, '"The Thames from its Source to the Sea": An Unpublished Portfolio by Whistler and Haden', in Fine (ed.) 1987, pp.29–45.

no.32
1 Baudelaire, *Salons*, Paris 1859.
2 Lochnan 1984, pp.79–80, 83.
3 Wedmore 1886 (40).

no.33
1 Du Maurier 1951, p.16.
2 Nathaniel Hawthorne, *Our Old Home: A Series of English Sketches*, Boston 1863, p.284.
3 Ibid., p.292.
4 Pennell 1908, I, pp.79–80.
5 Letter to Fantin-Latour, LC PC.
6 T. Armstrong to Pennell, 8 Sept. 1907, LC PC.
7 See Robin Spencer, 'Whistler's Subject Matter: "Wapping" 1860–1864', *Gazette des Beaux-Arts*, vol.100, Oct. 1982, p.138.
8 Du Maurier 1951, pp.218–9.

no.34
1 Whistler to Fantin-Latour, [n.d.], [1859], LC PC; Lochnan 1984, p.119.

no.35
1 Whistler to Kennedy, 10 June 1892, NYPL I 16.
2 Pennell 1908, I, p.101.
3 GUL S254.

no.37
1 Mallarmé to Henri Cazalkis, 24 July 1863. Stéphane Mallarmé, *Selected Letters of Stéphane Mallarmé*, ed. and trans. Rosemary Lloyd, Chicago and London 1988, p.23.
2 GUL W680.

no.39
1 Du Maurier 1951, p.105.
2 Sarah Richardson, *Painting in Brittany: Gauguin & his Friends*, exh. cat., Laing Art Gallery, Newcastle Upon Tyne 1992.
3 Sarah Faunce and Linda Nochlin, *Courbet Reconsidered*, exh. cat., Brooklyn Museum 1988, passim.
4 See Robin Spencer, 'Whistler's Subject Matter: "Wapping" 1860–64', *Gazette des Beaux-Arts*, vol.100, Oct. 1982, p.138, fig.9.
5 Pennell 1921, pp.79–80.
6 5 Jan. – 3 Feb. 1864, LC PC.

Whistler at Trouville
1 Courbet to Urbain Cuenot, Trouville, 16 Sept. 1865. See Gustave Courbet, *Letters of Gustave Courbet*, ed. and trans. Petra ten-Doesschate Chu, Chicago 1992, letter 65-15, p.267.
2 Courbet to his family, Trouville, 17 Nov. 1865, op.cit., letter 65-16, p.269.
3 Ibid., letter 61-16, p.204.
4 LC PC.
5 Courbet to Whistler, 14 Feb. 1877, op.cit., letter 77-9, p.601 (GUL C196).

no.41
1 [n.d.] GUL W784, quoted in YMSM 1980 (64).
2 Whistler to D.C. Thomson, April 1895, LC PC.
3 LC PC, quoted in YMSM 1980 (64).

Valparaiso
1 Ionides 1925, p.8. Ronald Anderson, 'Whistler: An Irish Rebel and Ireland Implications of an Undocumented Friendship', *Apollo*, vol.123, 1986, pp.254–8.
2 Pennell 1921, p.42.
3 Whistler's diary, GUL NB9; see MacDonald 1994 (340).
4 *Times*, 14 May 1866 and 15 May 1866.
5 Ibid. See also William Columbus Davis, *The Last Conquistadores: The Spanish Intervention in Peru and Chile 1863–1866*, Athens, Georgia 1950, p.302.
6 Pennell 1921, p.42.
7 Frederick M. Nunn, *The Military in Chilean History: Essays on Civil and Military Relations, 1810–1973*, Albuquerque 1976, p.59.
8 Virginia Surtees (ed.), *The Diaries of George Price Boyce*, Norwich 1980, p.45.

no.44
1 William Columbus Davis, *The Last Conquistadores: The Spanish Intervention in Peru and Chile 1863–1866*, Athens, Georgia 1950, p.295.
2 Robin Spencer, 'Whistler, Manet, and the Tradition of the Avant-Garde' in Fine (ed.) 1987, p.55.
3 'The Winter Exhibition at the French Gallery', *Athenaeum*, no.2045, 5 Jan. 1867, pp.22–3.
4 Spencer, op. cit., p.62 n.32.
5 Arthur J. Eddy, *Recollections & Impressions of James A. McNeill Whistler*, Philadelphia 1903, p.23.

no.45
1 Pennell 1921, p.48.
2 Alfonso Calderon (ed.), *Memorial De Valpariso En los 450 años de su Descubrimiento*, Valparaiso 1986, p.335.
3 Ibid., p.354.

Nocturnes
1 LC PC.
2 Pennell 1921, p.115.
3 Way 1912, p.67.
4 Merrill 1992, p.152.
5 'The Dudley Gallery Winter Exhibition', *Art Journal*, n.s., vol.15, 1876, pp.45–6.
6 Virginia Surtees (ed.), *The Diaries of George Price Boyce*, Norwich 1980, p.38.
7 Bacher 1908, p.31.
8 Pennell 1908, I, p.164–5.
9 Pennell 1921, pp.115–16.
10 Whistler to Leyland, [n.d.], Chelsea, LC PC.
11 Merrill 1992, p.144.

no.46
1 Anna Whistler to Julia and Kate Palmer, 3 Nov. 1871, LC PC.
2 Ibid.
3 Quoted in S.C. and A.M. Hall, *The Book of the Thames, from its Rise to its Fall*, London 1859, p.418.
4 Ibid.

no.48
1 LC PC.

no.49
1 [n.d], LC PC.
2 LC PC.
3 'The Dudley Gallery Winter Exhibition', *Art Journal*, n.s., vol.15, 1876, pp.45–6.

no.53
1 Thomas R. Way, *Mr. Whistler's Lithographs* was first published in 1896, updated by Way in 1905, and reissued in 1914 by E.G. Kennedy. It remains the

standard reference, despite Mervyn Levy's updated but confusing Whistler's *Lithographs: A Catalogue Raisonné* (London 1975). A revised catalogue raisonné by Nesta Spink is forthcoming from the Art Institute of Chicago. See also Susan Hobbs, *Lithographs of James McNeill Whistler from the Collection of Steven Louis Block, with catalogue by Nesta R. Spink*, exh. cat., Smithsonian Institution Traveling Exhibition Service, Washington 1982; and MacDonald 1988, pp.20–55.
2 Way 1912, p.87.

no.54
1 Merrill 1992, pp.150–1.
2 Ibid., p.173.
3 Pennell 1908, II, p.59.

no.55
1 Way 1912, p.19.
2 Whistler temporarily abandoned lithography after his bankruptcy in 1879, when he obtained a commission for a set of drawings of Venice (see p.179) did not return to it until 1887, when the second 'Venice Set' had been completed.

Cremorne
1 The site is now the area around Lot's Road power station.
2 Map of Chelsea and Battersea, 1865, Guildhall Library Department of Manuscripts.
3 'Cremorne Gardens Chelsea 1831–78', scrapbook, 3 vols., Chelsea Public Library.
4 *Daily Telegraph*, 11 Oct. 1873 and 6 Oct. 1877. Both clippings are in the Cremorne scrapbook, Chelsea Public Library.
5 William Acton, *Prostitution Considered in its Moral, Social and Sanitary Aspects*, London 1857 (2nd, revised, ed. 1870), p.17.
6 Richard D. Altick, *The Shows of London*, Cambridge, Mass. and London 1978, pp.483–5.
7 Tom Pocock, *Chelsea Reach: The Brutal Friendship of Whistler and Walter Greaves*, London 1970, p.64.

no.56
1 2 May 1892, LC PC.
2 28 March 1896, NYPL II 84.

no.57
1 Hippolyte Taine, *Notes on England*, trans. with an introduction by Edward Hyams, London 1957, pp.36–7.
2 *Daily Telegraph*, 11 May 1877 (clipping, 'Cremorne Gardens Scrapbook', II, Chelsea Public Library).
3 [Anon.], *Etiquette for Gentlemen being a Manual of Minor Social Ethics and Customary Observances*, London 1857, p.22.
4 John Hayes, *The Landscape Paintings of Thomas Gainsborough: A Critical Text and Catalogue Raisonné*, London 1982, II, cat.148, pp.516–20.

Ruskin v. Whistler
1 His Honour Judge Parry, 'Whistler versus Ruskin', *Cornhill Magazine*, n.s., vol.50, Jan. 1921, p.24.
2 Merrill 1992, p.144.
3 'The Red Rag', *World*, 22 May 1878.

no.58
1 Merrill 1992, pp.145–8.
2 Ibid., p.158.
3 Ibid., p.296.
4 D.P. Curry in exh. cat., Washington 1984, p.86.
5 Ibid.

no.59
1 Hugh Honour and John Fleming, *The Venetian Hours of Henry James, Whistler and Sargent*, London 1991, p.48; Richard Dorment, 'Venice out of Season', *New York Review of Books*, 24 Oct. 1991, pp.10–11.

2 GUL F38.
3 Pennell 1908, II, p.28.

Portraits on the 1870s
1 Pennell 1908, II, p.285
2 'The Red Rag', 1878, republished in Whistler 1890, p.127.
3 Whistler 1890, p.115.

no.60
1 Trans: 'I will have a portrait of my mother photographed and I will send you a proof'; undated letter in LC PC, originally dated 1867 by John Sandberg, 'Japonisme and Whistler', *Burlington Magazine*, Nov. 1964, p.507. Robin Spencer, who is preparing Fantin-Latour's letters for publication, shows that it dates from 1871. We are grateful to him for pointing this out.
2 The painting of her portrait is described by Anna Whistler to Kate Palmer, 3–4 Nov. 1871, LC PC; see Margaret F. MacDonald, 'Whistler: The Painting of the "Mother"' *Gazette des Beaux-Arts*, Feb. 1975, pp.73–86.
3 It measures 38.7 x 35.5 cm, a ratio of approximately 1 to 1.1, similar to the proportions of 'Arrangement in Grey and Black: Portrait of the Painter's Mother'.
4 Sarah Walden, 'Portrait of an Enigma', unpublished ms., 1990; Sarah Walden, 'Rethinking Whistler's Mother: Restoration Reveals Severets of an American Icon', *Architectural Digest* (San Francisco), 3 Sept. 1991, pp.42, 44, 50 repr. p.44.
5 John Ingamells, *The Wallace Collection Catalogue of Pictures: IV Dutch and Flemish*, London 1922, cat.no.P237, pp.244–7. Netscher's painting could have been known to Whistler through the etching by P. de Marc. We are grateful to Eric Denker for pointing out this source.
6 Liana De Girolami Cheney and Paul G. Marks (eds.), *The Whistler Papers*, Lowell, Mass., fig.8, p.99. See also Legros's 'Angelus' (whereabouts unknown).
7 The X-ray shows a figure horizontally towards the bottom of the canvas, with the head at bottom left, near the curtain.
8 Anon., 'Le Modernisme de Frans Hals', *L'Art Moderne* (Brussels), 23 Sept. 1883, p.302 and 30 Sept. 1883, pp.311–12.
9 Anna Whistler to Kate Palmer, 3–4 Nov. 1871, LC PC.
10 *Academy*, 15 May 1872.
11 Press-cutting book, GUL PC1, p.9.
12 J.-K. Huysman. 'Le Salon officiel de 1884', *La Revue Indépendante*, 1884, vol.1, p.1.
13 Margaret F. MacDonald and Joy Newton, 'The Selling of Whistler's "Mother"', *American Legion of Honor Magazine*, vol.49, no.2, 1978, pp.97–120.
14 Georges Rodenbach, 'Quelques peintres – M. James M.N. Whistler', *Le Figaro*, 29 Oct. 1894.
15 Ward Kimball, *Art Afterpieces*, Los Angeles 1980, repr.

no.61
1 Tom Pocock, *Chelsea Reach*, London 1970, pp.31–2.
2 Pennell 1921, p.174.
3 Quoted by David Alec Wilson and David Wilson MacArthur, *Carlyle in Old Age: 1865–1881*, London 1934, p.296.
4 H. Allingham and D. Radford, *William Allingham, A Diary*, London 1907, p.226. According to the Pennells, Carlyle finally rebelled and refused to return. The father of Phil Morris sat for the coat (Pennell 1921, p.104).
5 James Anthony Froude, *Thomas Carlyle: A History of his Life in London 1834–1881*, London 1884, II, pp.323.

6 Ibid., pp.334–5.
7 Ibid., p.418.
8 Ibid., pp.419, 424.
9 Richard Ormond, *Early Victorian Portraits, National Portrait Gallery*, London 1973, I, pp.85–95.

no.62
1 Elisabeth Luther Cary, *The Works of James McNeill Whistler*, New York, 1913, p.188. Cary quotes Alexander as writing that the portrait was painted in Chelsea in 1874. Alexander must have been thinking of the date when the portrait was first exhibited.
2 GUL A137.
3 Florence M. Gladstone, *Aubrey House Kensington 1698–1920*, London 1922.
4 Whistler to W.C. Alexander, [n.d.], [1872–3] (BM 1958-2-8-21).
5 Whistler to Mrs Alexander, 26 Aug. [1873], BM.
6 *Manet 1832–1883*, exh. cat., Galleries Nationales du Grand Palais, Paris, and Metropolitan Museum of Art, New York 1983, cat.nos.50, 53.
7 Pennell 1908, I, pp.173–4.
8 Both quoted by Reginald Colby, 'Whistler and "Miss Cissie"', *Quarterly Review*, vol.298, July 1960, p.315.
9 Quoted by Sidney Starr, 'Personal Recollections of Whistler', *Atlantic Monthly*, vol.101, April 1908, p.532.
10 Théodore Duret, *Whistler*, trans. Frank Rutter, London and Philadelphia 1917, p.102.
11 GUL A170.
12 J.-K. Huysmans, *Certains*, Paris 1889 (1904 ed., pp.68–9).

no.63
1 Pennell 1908, I, p.179.

no.64
1 Reynolds's 'Mrs Siddons' and Hogarth's 'Garrick as Richard III' were both exhibited at the Third Exhibition of National Portraits, held at the South Kensington Museum, 13 April 1868.
2 Alan Cole, diary extracts, 1 May 1876, LC PC, copy in GUL LB6, p.244, partly quoted by Pennell 1908, I, pp.199–200 who dates it 5 May. See YMSM 1980 (187).
3 Menpes 1904, p.76.
4 Merrill 1992, p.143.
5 Ibid., p.152.
6 Duret 1904, repr. p.63.
7 Laurence Irving, *Henry Irving: The Actor and His World*, London 1951, p.274.
8 Jacques Emile Blanche, 'James MacNeill [*sic*] Whistler', *Renaissance Latine*, June 1905, p.318.
9 Denis Rouart and Daniel Wildenstein, *Edouard Manet: Catalogue raisonné*, Paris 1975, I, cat.106, p.104.
10 Ibid., cats.256, 257, pp.208–9.
11 Julius Meier-Graefe, *Modern Art: Being a Contribution to a New System of Aesthetics*, trans. F. Simmonds and G.W. Chrystal, London 1908, II, pp.222–3.
12 Bernhard Sickert, *Whistler*, London and New York 1908, pp.22–3.
13 Oscar Wilde, 'The Grosvenor Gallery 1877', reprinted in *Miscellanies*, London 1908, p.18.
14 Originally published as 'London' in *Harper's Weekly*, 26 June 1897, reprinted in John L. Sweeney (ed.), *The Painter's Eye, Notes and Essays on the Pictorial Arts by Henry James*, London 1956, pp.258–9.
15 T.R. Way and G.R. Dennis, *The Art of James McNeill Whistler: An Appreciation*, London 1903, p.48.
16 Ellen Terry, *The Story of My Life*, London 1908, p.123.

no.65
1 Effie's son later joined a bandit gang and was nicknamed the 'Whistler'. We are grateful to Joyce Stoner for this reference.

2 Donald Mullin, *Victorian Plays: A Record of Significant Production on the London Stage 1837–1901*, New York, Connecticut, London 1987, p.94. The production was popular enough to be revived at the Marylebone Theatre in August 1879.
3 Margaret F. MacDonald, 'Maud Franklin', in Fine (ed.) 1987, p.23.
4 Whistler 1890, p.126.

no.66
1 Letter to D.G. Rossetti, 24 March 1876, quoted in Helen Rossetti Angeli, *Pre-Raphaelite Twilight*, London 1954.
2 Williamson 1919, p.133.
3 Angeli 1954, op.cit., p.237.
4 Mark Jones (ed.), *Fake? The Art of Deception*, exh. cat., British Museum, London 1990 (239).
5 Ibid., repr. watercolour by Beerbohm, Tate Gallery (A01039).
6 Whereabouts unknown, photograph in LC PC; Howell's Album is in GUL LB11–12; see MacDonald 1994 (711, 713, 717).
7 W. Graham Robertson, *Time Was*, London 1931, pp.188–91, 194–5.
8 Humanities Research Center, Austin, Texas.
9 MacDonald 1994 (713, 715).
10 Pennell 1908, I, p.202.

no.67
1 Wedmore 1886, p.14–15.
2 Way 1912, pp.17–8, 20. According to Way, hundreds of impressions of 'The Toilet' were printed for *Piccadilly*. These impressions are a pale ghost of the early proofs, lacking most of the richness and contrast seen here. If untrimmed, they are marked with Thomas Way's imprint, the words 'Supplement to Piccadilly' and a date of 'July 11, 1878'.

no.68
1 Whistler in *World*, 31 Dec. 1884, reprinted in Whistler 1890, p.174.
2 Clement Jones C.B., *Pioneer Shipowners*, Liverpool 1934, II, 1938, p.124.
3 Quoted by Williamson 1919, p.84 (see M. Susan Duval, MA thesis, 'A Reconstruction of F.R. Leyland's Collection: An Aspect of Northern British Patronage', Courtauld Institute of Art, London, 1982).
4 Quoted by Pennell 1908, I, p.156.
5 Leyland to Whistler, GUL L101.

no.69
1 Glasgow University Library, and Ashmolean Museum, Oxford; MacDonald 1994 (718–19).
2 Institut Néerlandais, Paris, Delâtre 1972, A779. Trans: 'This is exactly the paper I need for my drawings. I am always looking for some – and although all the retailers have brown paper of some sort, it is rare to find some with such a good grain'.

no.70
1 Pennell 1921, p.101.
2 Pennell 1908, I, pp.185, 177–9.
3 MacDonald 1994 (428–38).
4 Anna Whistler to Kate Palmer, 3 Nov. 1871, LC PC.

no.71
1 Other drawings, now in the Freer Gallery of Art, Washington, DC, may also have been exhibited in 1874; MacDonald 1994 (430–1).
2 E. de Goncourt, *Catalogue raisonné de l'oeuvre peint, dessiné et gravé d'Antoine Watteau*, Paris 1875, II, repr p.73, and III, no.47; *Watteau*, exh. cat., National Gallery of Art, Washington 1984, p.234, repr.; exh.cat., Washington 1984, introduction by D.P. Curry, p.46.

no.73
1 Quoted by W. Marchant, in *Walter Greaves*, exh.cat., Goupil Gallery, London 1911, p.3.
2 'Ten O'Clock' lecture, first published 1885, republished in Whistler 1890, p.142.

no.74
1 See exh. cat., London, Liverpool & Glasgow 1976 (30–2).

no.75
1 Thomas 1874 (76).

no.76
1 Pennell 1908, II, repr. opp. p.128; Pennell 1921, pp.101, 103.
2 17 Nov. 1872, GUL L136.
3 F.D. Leyland to Whistler, 3 April and 17 July 1877, GUL L140–1.
4 Clement Jones, C.B., Pioneer *Shipowners*, Liverpool 1934, II, 1938, p.124.

no.77
1 *Times*, 17 Nov. 1904, p.10.
2 e.g. in Hunterian Art Gallery, University of Glasgow, Freer Gallery of Art, Washington, DC, and Boston Museum of Fine Arts; MacDonald 1994 (523–30).

no.78
1 [n.d.], [1870–5], PC LC.
2 K 109; drawings in Munson-Williams-Proctor Institute, New York; Freer Gallery of Art, Washington, DC; and British Museum, London; MacDonald 1994 (516–21).
3 Way 1912, p.30; YMSM 1980 (111); MacDonald 1994 (50, 709, 717, 844).
4 Menpes 1904, p.75.

no.79
1 Whistler to Thomas Way, GUL LB5, p.3.
2 Freer Gallery of Art, Washington, DC; Hunterian Art Gallery, University of Glasgow; and Fitzwilliam Museum, Cambridge; MacDonald 1994 (510, 512–5).

no.80a
1 YMSM 1980 (178).
2 British Museum; MacDonald 1994 (488).
3 Florence M. Gladstone, *Aubrey House, Kensington 1698–1920*, London 1922, pp.5, 33, 54, repr. 'White Room'.

no.80d
1 Susan Weber, 'Whistler as Collector, Interior Colorist and Decorator', unpublished MHPA thesis, Cooper Hewitt Museum, New York 1987, p.35.

The Peacock Room
1 Mrs F.R. Leyland to Whistler [n.d.], LC PC.
2 Whistler to Alan Cole, 3 Sept. 1876, LC PC.
3 *Academy*, 2 Sept. 1876; Pennell 1908, I, pp.204–5.
4 21, 30 Oct., GUL L106, 110.
5 A.S. Cole, quoted by Pennell 1908, I, p.205.
6 6 July 1877, GUL L117.

no.81
1 [n.d.], [Sept.–Oct. 1876], LC PC.
2 LC PC, quoted in Spencer 1989, p.120.

no.82
1 A.S. Cole, quoted by Pennell 1908, I, pp.20–5.
2 Graves, Algernon, 'James Abbott McNeill Whistler', *Printseller and Print Collector*, I, Aug. 1903, pp.341–3.
3 Pennell 1908, I, p.204.
4 Cartoons in Victoria and Albert Museum, D255-1905 to D267-1905, *Albert Moore and his Contemporaries*, exh. cat., Laing Art Gallery, Newcastle upon Tyne, 1972 (41–5).

5 Elizabeth Aslin, *E.W. Godwin: Furniture and Interior Decoration*, London 1986 (77); the Peacock wallpaper was produced by Jeffrey & Co. in 1873 and illustrated in 'Art Furniture', William Watt, 1877; design in Victoria & Albert Museum, London, E513-1963.
6 See pl.XII; Robin Spencer, *The Aesthetic Movement*, London 1972, pp.70–4.
7 Anon., 'Mr J.A. McNeill Whistler's Decorative Work, the Peacock Room', *Queen*, 17 Feb. 1877, p.124.
8 Edward W. Godwin, 'Notes on Mr Whistler's Peacock Room', *Architect*, 24 Feb. 1877, pp.117–8.
9 [July 1877], GUL L133.

no.83
1 Letter in LC PC.
2 Sale catalogue, Sotheby, London 12 Feb. 1880, lots 1–56.
3 Williamson 1919, p.43, repr. opp. p.44; sketch sold after Marks' death, at Christie, London, 5 July 1918 (27) but has since disappeared; MacDonald 1994 (592).
4 Williamson 1919, *op.cit.*, Original letter in copy in Victoria and Albert Museum, Library Reserve Collection (Q4, 5, acc.no. L1768-1939), opp. p.36.
5 MacDonald 1994 (594, 596, 599, 601, 603, 605, 609–11, 615, 617, 619, 622, 624, 628, 631, 633–4, 638, 640–2, 644, 647, 649).
6 MacDonald 1994 (142–3, 173–6).

no.84
1 MacDonald 1994 (631). We are grateful to Jan Stuart and Linda Merrill, Freer Gallery of Art, Washington, for their help in describing the porcelain.
2 Another drawing in the Munson-Williams-Proctor Institute shows the dish alone; MacDonald 1994 (629).
3 M.F. MacDonald, 'Whistler's Designs for a Catalogue of Blue and White Porcelain', *Connoisseur*, vol.198, Aug. 1978, pp.291–5, canister repr. p.292, pl.3.

no.85
1 Munson-Williams-Proctor Institute; MacDonald 1994 (620–1).
2 Thompson 1878, pl.XI, cat.no.282, and pl.XV, cat.no.330.

no.87
1 MacDonald 1994 (596).
2 J.H. Jordan to C.L. Freer, 1 May 1893, Archives, Freer Gallery of Art, Washington, DC.

no.88
1 Cat.nos.244 and 255 in the Thompson catalogue: Williamson 1919, original letter opp. p.36 in copy in Victoria and Albert Museum.
2 MacDonald 1994 (443).
3 *Designs for Plates*, British Museum, 1958-2-8-16; MacDonald 1994 (591).
4 Whereabouts unknown; Pennell 1908, I, repr. opp. p.216; MacDonald 1994 (592).

no.91
1 [n.d.], Fales Library, Elmer Holmes Bobst Library, New York University.
2 [n.d.], GUL C14; see Lady Archibald Campbell, *Rainbow Music: or, The Philosophy of Harmony in Colour Grouping*, London 1886.

no.91
1 Published London 1885, republished in Whistler 1890, p.135.

no.93
1 Pennell 1921, p.305.
2 Patent Office, 405-8721: Patent No.6223.
3 Pennell 1921, p.305.

4 *Truth*, 6 May 1886.

5 *St James Gazette*, 1 Dec. 1886; GUL pc7 pp.19, 22.

6 Photocopy, GUL.

7 Pennell 1908, II, p.69.

no.94

1 1 Dec. 1886.

2 RBA minutes, 4 June, 2 July, 1 Aug., 1 Oct. 1888; Whistler 1890, p.210; see also Menpes 1904, p.111.

3 Interview in *Pall Mall Gazette*, 11 June 1888, republished in Whistler 1890, p.208.

4 Ibid., p.210.

no.95

1 New York Public Library, gift of V.A. Blacque; National Gallery of Art, Washington 1943-3-8814-5; MacDonald 1994 (1126–8).

no.96

1 *World*, 25 Feb. 1885, p.17.

2 GUL w768–80.

3 *Orange Blossoms*, 26 Feb. 1885, GUL pc6 p.7.

4 'Mr. Whistler's Ten O'Clock', *Pall Mall Gazette*, 21 Feb. 1885, pp.1–2; republished in Whistler 1890, p.161.

5 *New York Sun*, 5 Dec. 1885.

6 *Fortnightly Review*, 1 June 1888.

7 Whistler 1890, p.262; Swinburne in the *World*, 3 June 1888; republished in Whistler 1890, p.262.

no.97

1 Pennell 1908, II, p.106, see also pp.100–13.

2 Duret 1904, pp.116–7. 'In the case of the pamplets, epigrams, attacks, the gentle butterfly of the fields is turned into a beast of prey, convulsing itself in aggressive attitudes and disclosing a long tail terminated by a threatening sting': trans. Frank Rutter, 3rd ed., 1917, p.81.

3 10 Sept. 1903, letter and proofs in collection of Paul G. and Elaine S. Marks; MacDonald 1994 (1238–70, proofs repr. p.449).

no.98

1 Proofs in GUL 211/1–3.

2 Whistler, recorded on 25 Sept. 1898, Pennell 1921, p.19.

no.99

1 *Pall Mall Gazette*, 3 April 1889; Whistler 1890, pp.219–20.

Venice

1 Dante Gabriel Rossetti to Walter Theodore Watts-Dunton, 29 Aug. 1879. Dante Gabriel Rossetti, *Collected Letters*, ed. O Doughty and J.R. Wahl, Exford 1967, IV, p.1663.

2 Whistler to Deborah Haden, 1 Jan. 1880. The George A. Lucas Collection of the Maryland Institute College of Art, on indefinite loan to the Baltimore Museum of Art. Quoted in Lochnan 1984, p.183.

3 Whistler to Marcus Huish, [n.d.] [Jan. 1880], GUL LB3/8.

4 Whistler to Marcus B. Huish, [n.d.] [Jan. 1880], GUL LB3/8.

no.100

1 For a detailed study of the Venice etchings, see Robert H. Getscher, 'Whistler and Venice', Case Western Reserve University, PhD, 1970 (University Microfilms, 1971).

2 Whistler to Ernest Brown [n.d.], [1880], GUL LB9, p.1.

3 Bacher 1908, pp.113–4.

no.101

1 GUL EC 1881.1: Whistler kept a clipping of Godwin's review, 'Mr Whistler's "Venice Pastels"', *British Architect*, 4 Feb. 1881, GUL pc4, pp.37–8.

2 *Queen*, 12 Feb. 1881, GUL pc15, p.41.

no.102

1 Way 1912, repr. opp. p.52: either Way confused the numbering in the show in 1881, or Whistler titled the two pastels incorrectly; see MacDonald 1994 (772).

2 Published in 1885, republished in Whistler 1890, pp.136–7.

3 'Chelsea Fruit Shop' 1886–8, Fogg Museum of Art, Harvard University; MacDonald 1994 (1117).

no.103

1 Grieve and MacDonald 1994: I am indebted to Dr Alastair Grieve of the University of East Anglia for permission to publish this information ahead of our forthcoming book.

2 Menpes 1904, pp.22–3.

no.104

1 Site identified by Grieve and MacDonald 1994; see also Bacher 1908, pp.193–5.

2 [n.d.], [Jan.1880], GUL LB3/8, quoted by Lochnan 1984, pp.183–4.

3 *World*, 8 and 29 Dec. 1880, reprinted in Whistler 1890, pp.50–1.

4 Whistler's press-cuttings are in GUL pc5 and 15. Major reviews were listed by Getscher and Marks 1986, pp.279–80 and Getscher 1991. See Ruth Fine 'James Abbott McNeill Whistler: Venice. Second Series. Manuscript and Proofs of the Catalogue Dated 17 February 1883', in *Visions of a Collector: The Lessing J. Rosenwald Collection in the Library of Congress Rare Book and Special Collections Division*, Washington 1991, pp.15–18.

5 Quoted in *Etchings and Drypoints, Venice, Second Series*, exh. cat., Fine Art Society, London 1883 (14) 'Long Lagoon'; reprinted in Whistler 1890, p.96. The show opened on 17 Feb. 1883.

no.105

1 *Daily Telegraph*, 5 Feb. 1881, GUL pc4, pp.47–8.

no.106

1 GUL LB3/8, quoted in exh.cat., London, Liverpool & Glasgow 1976 (86) and Lochnan 1984, pp.183–4.

no.107

1 Grieve and MacDonald 1994.

2 Robert H. Getscher, 'Whistler and Venice', Case Western Reserve University, PhD, 1970 (University Microfilms, 1971).

no.108

1 E.W. Godwin, 'Mr Whistler's 'Venice Pastels'', *British Architect*, 4 Feb. 1881.

2 [n.d.] [1880], GUL w559.

no.109

1 For a discussion of de Hooch's influence on Whistler's etchings, see Lochnan 1984, p.42.

no.110

1 I am indebted to Dr Alastair Grieve for identifying this site.

2 Whistler to Mrs W. Whistler, [n.d.], GUL w683.

3 Pennell 1908, I, p.269. Alexandre Nicolaievitch Roussoff or Volkoff-Muromzoff (1844–1928) settled in Venice, and first exhibited at the Royal Academy in 1880.

4 e.g. 'Venetian Scene', in *American Artists Abroad*, exh.cat., Nassau County Museum of Art 1985, pl.28; and 'Etude de Venice', in *Recent Acquisitions: Important American Paintings*, exh. cat., Bernard Danenberg Galleries, Inc., New York 1969 (32): both exhibited as by Whistler.

5 See Theodore E. Stebbins, *American Master Drawings and Watercolours*, exh. cat., Whitney Museum of American Art, New York 1976, pp.224–7.

no.112

1 E.W. Godwin, 'Mr Whistler's "Venice Pastels"', *British Architect*, 4 Feb. 1881.

2 GUL EC 1881.1.

3 *Pan*, 5 Feb. 1881.

no.113

1 *Portraits of Place*, Boston 1885, p.15; Margaretta Lovell, *Venice: The American View*, exh. cat., California Palace of the Legion of Honor, San Francisco, Cleveland Museum of Art, 1984 (94).

no.114

1 Wedmore 1886, p.13.

no.115

1 Bacher 1908, p.270.

no.116

1 Wedmore 1886, pp.10–11.

no.117

1 D.C. Thomson, *Barbizon House*, London 1927, no.13, repr.

2 E.W. Godwin, 'Mr Whistler's "Venice Pastels"', *British Architect*, 4 Feb. 1881.

3 *Observer*, 6 Feb. 1881, GUL pc4, p.45.

4 Anon., 'Mr.Whistler's Venice; or, Pastels by Pastelthwaite', *Punch*, vol.80, 12 Feb. 1881, p.69, repr. as 'Awfully Cowld!'.

5 See *Daily Telegraph*, 10 Oct. 1888, GUL pc10, p.35; *Nature*, 9 Jan. 1889, GUL pc10, p.63.

no.118

1 Bacher 1903, pp.74, 97.

2 MacDonald 1994 (816–8, 820).

3 E.W. Godwin, 'Mr Whistler's "Venice Pastels"', *British Architect*, 4 Feb. 1881.

4 *Daily Telegraph*, 5 Feb. 1881, GUL pc4, p.48.

5 *Athenaeum* 1881, p.206, GUL pc15, pp.27, 47.

6 *Daily Telegraph*, 5 Feb. 1881; GUL pc4, p.48.

7 Paper originally on back of frame.

no.119

1 Pastels in the Frick Collection, New York; Fogg Art Museum, Harvard University; Fogg Museum of Art, Harvard University; Freer Gallery of Art, Washington, DC; Hunterian Art Gallery, University of Glasgow; and private collections; MacDonald 1994 (808–12, 814–5); etchings, K 205, 212, 215, 220, 226, 228, 231.

no.120

1 Whistler to Mrs W. Whistler, [n.d.], GUL w684.

2 Anon., 'Mr Whistler's Pastels', *Athenaeum*, no.2780, 5 Feb. 1881, p.206, GUL pc15, pp.27, 47.

3 Frederick Wedmore, 'Fine Art: Mr Whistler's Pastels', *Academy*, vol.19, no.459, 19 Feb. 1881, p.142.

4 *Observer*, 6 Feb. 1881, GUL pc4, p.45.

5 17 Feb. 1881, GUL M348.

6 See exh. cat., *Venice: The American View*, California Palace of the Legion of Honor, San Francisco, Cleveland Museum of Art 1984 (91).

no.121

1 Gladys Storey, *All Sorts of People*, London 1929, p.81.

2 'James Abbott McNeill Whistler', typescript sent to Joseph Pennell, LC PC, vol.297, p.7.

3 'Venice', and 'Nocturne – San Giorgio', MacDonald 1994 (802–3).

no.122

1 Bacher 1908, p.117.

2 Exh.cat., Washington 1984, repr. pl.95.

3 Robert H. Getscher, 'Whistler and Venice', Case Western Reserve University, PhD, 1970 (University Microfilms, 1971).

4 *British Architect*, 10 Dec. 1880, GUL pc4, p.19.

no.123

1 H. Pennington, 'James Abbott McNeill Whistler', typescript sent to Joseph Pennell, LC PC., vol.297, p.9.

2 H. Pennington, 'The Whistler I Knew', *Metropolitan Magazine*, vol.31, no.6, March 1910, p.770.

3 H. Pennington, 'James Abbott McNeill Whistler', op. cit., p.6.

4 Collection Countess Rucellai, repr. Christopher Wood, *Dictionary of Victorian Painters*, 2nd ed., 1978.

5 Pennell 1908, II, p.21.

6 A.E. Gallatin, 'Notes on an Exhibition of Whistleriana', *American Magazine of Art*, vol.10, no.6, April 1919, pp.201–6; Pennell 1921, repr. opp. p.203 as 'Sketch of Harper Pennington'; MacDonald 1994 (1100).

7 2 March 1907, PC LC, PW 297, 3846; Pennell 1921, repr. opp. p.202.

Portraits of the 1880s

1 Duret 1904, p.94.

2 Pennell 1908, II, p.126.

no.124

1 Pennell 1908, I, p.301.

2 Way 1912, p.65.

3 Mrs Julian Hawthorne, 'A Champion of Art', *Independent*, vol.52, 2 Nov. 1899, pp.2957–8.

4 Michael Wentworth, *James Tissot*, Oxford 1984, pls.130, 132.

5 P.E. Rooke (ed.), 'Theobalds through the Centuries' and P. Phillips, 'The Meux Succession: The Rise and Demise of a Dynasty', unpublished typescript in the Wiltshire Library and Museum Service, Trowbridge, Wiltshire.

6 'An astonishing Whistler, excessively subtle but of such quality!' Quoted by M. Guerin, *Lettres de Degas*, Paris 1945, p.62.

no.125

1 15 Jan. 1892, GUL M341; correspondence in GUL M340 etc., and LC PC.

2 Pennell 1908, I, p.301.

3 Duret 1904, p.94.

4 Another drawing of 'Arrangement in Black' is in the Art Institute of Chicago, and one of 'Harmony in Pink and Grey' in the Wesleyan Art Center, Middletown, Ct; MacDonald 1994 (850, 852).

no.126

1 'Mr Whistler's New Portraits', *Harper's Bazaar*, 15 Oct. 1881, p.658.

2 Menpes 1904, repr. opp. p.xx; MacDonald 1994 (993): the photograph of the oil, in Glasgow University Library, probably dates from this time.

3 Lady Meux to Whistler, and her reply, 29 July 1886, GUL M338; Whistler to Sir Henry Meux's solicitor, E. Upton, 11 July 1889, GUL U26–8.

4 Pennell 1908, I, p.302.

5 9 June 1891, GUL W1180; MacDonald 1994 (851–2).

6 15 Jan. 1892, GUL M341.

no.127

1 Gary Tinterow, 'The Havemeyer Pictures' *A Splendid Legacy: The Havemeyer Collection*, Metropolitan Museum of Art, New York 1993, p.14.

2 *Manet 1832–1883*, exh. cat., Galleries Nationales du Grand Palais, Paris and the Metropolitan Museum of Art, New York 1983, p.289.

3 Edouard Manet to Théodore Duret, 22 Nov. [1880], GUL M257.

4 Théodore Duret, 'James Whistler', *Gazette des Beaux Arts*, vol.23, April 1881, pp.365–9.

5 George Heard Hamilton, *Manet and His Critics*, New Haven and London 1954, p.29.

6 Duret 1904, trans. Frank Rutter, London and Philadelphia 1917, p.69.

7 Ibid., p.70.

8 Pennell 1908, I, p.308.

no.128

1 Suzanne G. Lindsay, *Mary Cassatt and Philadelphia*, exh. cat., Philadelphia Museum of Art 1985, pp.14–15.

2 Mary Cassatt to Lois Cassatt, 29 Dec. 1884, Frederick A. Sweet, *Miss Mary Cassatt: Impressionist from Pennsylvania*, Oklahoma 1966, p.93.

3 Mary Cassatt to A.J.C. Cassatt, 14 Oct. 1883, quoted by permission of the estate of Mrs John B. Thayer.

4 Transcript of Lois Cassatt diary entry, 11 April 1883, quoted by permission of the estate of Mrs John B. Thayer.

5 Lois Cassatt to E.R. and J. Pennell, 10 June 1919, LC PC.

6 Whistler to Alexander Cassatt, draft (1887), Hunterian Art Gallery, Glasgow, Sketchbook g, pp.23–4, quoted in YMSM 1980 (250).

7 Lois Cassatt diary, op. cit., entry 4 April 1883.

8 Edward Buchanan Cassatt to Alexander J. Cassatt, 7 April 1883, quoted by permission of the estate of Mrs John B. Thayer.

9 Hippolyte Taine, *Taine's 'Notes on England'*, trans. with an introduction by Edward Hyams, London 1957, p.56.

no.129

1 Whistler to Kennedy, 21 Sept. 1893, NYPL E.G. Kennedy papers I 43, in YMSM 1980 (314).

2 *Daily Telegraph*, 25 April 1925 (Sickert 1947, p.37).

3 Sickert 1947, p.38.

4 Kellow Chesney, *The Victorian Underworld*, London 1972, p.52.

5 Ibid., p.54.

6 Starr 1908, p.534.

7 Suzanne G. Lindsay, *Mary Cassatt and Philadelphia*, exh.cat., Philadelphia Museum of Art 1985, pp.12–15.

no.130

1 Pennell 1908, I, p.305.

2 Michael Wentworth, *James Tissot*, Oxford 1984, pl.130.

3 [n.d.] [1880], GUL W684.

4 Letter, 9 Feb. 1937, quoted in Kerrison Preston (ed.), *Letters of W. Graham Robertson*, London 1953.

5 E. Whistler to Lady Archibald, Sept. 1895, GUL C21.

6 Ronald Pearsall, *The Worm in the Bud: The World of Victorian Sexuality*, London 1971, p.324.

7 Ibid., pp.426–7.

8 Hans Wolfgang Singer, *Max Klinger: Etchings, Engravings and Lithographs*, (113–22).

9 Duret 1904, pp.95–9.

10 Pennell 1908, I, p.306.

11 Théodore Duret, 'Whistler et son oeuvre' in *Les Lettres et les Arts*, 1 Feb. 1888, I, p.219, quoted in Macdonald and Newton 1987, p.154 n.1. Trans: 'Tall and svelte, she turned her head to throw a final look before leaving, the personification of haughty elegance.'

12 Pennell 1908, I, p.305.

13 Walter Sickert, 'Degas', *Burlington Magazine*, vol.31, Nov. 1917, p.186.

14 François Crucy, 'James McNeill Whistler', *L'Art et les Artistes*, vol.1, April 1905, p.43, thought Lady Meux introduced Whistler to Lady Archibald but on the grounds of Lady Meux's social status before her marriage this is highly unlikely. Whistler is recorded as dining with Lady Archibald at the opening of the Grosvenor Gallery in 1877.

15 Jehanne Wake, *Princess Louise, Queen Victoria's Unconventional Daughter*, London 1988, p.205.

16 Lady Archibald Campbell (Janey Sevilla Campbell)

Rainbow-Music; or The Philosophy of Harmony in Colour Grouping, London 1886.

Maud

1 M.F. MacDonald 'Maud Franklin', in Fine (ed.) 1987, pp.13–28; see also *Whistlers and Further Family*, exh. cat., Glasgow University Library, Glasgow 1980 (14–15).

2 Pennell 1921, pp.164–5.

3 13 Sept. 1879, letter in Baltimore Museum of Art, published in Mahey 1967, p.255.

4 YMSM 1980 (94, 106–7, 112, 131–2, 181–3, 185–6, 192–4, 223, 236, 254, 353, 357–8); MacDonald 1994 (454, 470, 497, 548, 655, 689–94, 697, 780, 846, 867, 881–2, 896–903, 905, 926–8, 1016, 1101, 1102, 1190, 1611); Kennedy 1910 (114–5, 133); Kennedy 1914 (1–3, 6, 13, 131).

no.131

1 Transcript in LC PC.

2 Quoted by Pennell 1908, I, p.300.

3 16 Dec. 1881, GUL W689; letter reproduced in full by Nigel Thorp, *Whistler on Art*, London 1994, no.27.

4 'The Whistler I Knew', *Metropolitan Magazine*, vol.31, no.6, March 1910, p.772.

no.132

1 Lillian Randall, ed., *George A. Lucas: An American Art Agent in Paris, 1857–1909*, Princeton 1979, II, pp.31, 35, 38; MacDonald 1994 (176).

2 Pennell 1921, pp.163–4.

3 H. Pennington, 'James Abbott McNeill Whistler', typescript sent to Joseph Pennell, LC PC.

4 Randall op.cit., I, p.27; II, p.625.

5 Ibid., I, p.27.

no.134

1 Unidentified press-cutting, GUL pc6, p.9.

2 *Standard*, 1 Jan. 1884, GUL pc7, p.13.

3 *Artist*, 1 June 1884, GUL pc6, p.54; pc7, p.11.

no.136

1 Jacques-Emile Blanche, *Portraits of a Lifetime*, New York 1938, I, p.56.

2 YMSM 1980 (324).

3 Philippe Jullian, *De Meyer*, ed. Robert Brandau, New York 1976, p.19.

4 Blanche, op. cit., p.52.

5 Ibid.

6 Ibid., p.53.

7 Ibid., p.55.

8 Ibid., p.52.

9 Jullian, op. cit., p.20.

no.137

1 Rosenwald collection, Rare Books and Manuscripts Division, LC.

2 GUL pc6, p.54.

3 Anon. ('An Enthusiast'), 'Mr Whistler and his Art', *Artist*, vol.5, 1 June 1884, pp.199–210.

4 F. Wedmore, 'Mr Whistler's Arrangement in Flesh Colour and Gray', *Academy*, 24 May 1884, p.374, GUL pc6, p.56.

5 Menpes 1904, p.73.

'Notes' – 'Harmonies' – 'Nocturnes'

1 Designs for butterfly on valance (Fine Art Society), and private view card (whereabouts unknown); MacDonald 1994 (958–9).

2 31 May 1884, GUL pc7, p.5.

3 Whistler to Dowdeswell, [n.d.], 27 July [1886], Rosenwald Collection, Rare Books Division, LC; see MacDonald 1994 (1103).

no.138

1 According to W.M. Rossetti, quoted by Williamson 1919, p.112.

2 Quoted by Pennell 1921, p.58.

3 Williamson, op. cit., pp.149, 151; Helen Rossetti
Angeli, *Pre-Raphaelite Twilight*, London 1934, p.224.

no.139

1 To Mrs W. Whistler, [n.d.] [1880], GUL w680.
2 Letter of W.R. Coles, 'National Health Society',
Times, 18 Dec. 1880, p.11.
3 Smoke Committee Meeting, *Times*, 25 Oct. 1880,
p.6.
4 'Ten O'Clock Lecture', London 1885, reprinted
Whistler 1890, p.144.
5 *The Decay of Lying*, 1889.
6 *Daily Express*, 1 Dec. 1885, GUL pc3, p.116.
7 *Standard*, 2 Jan. 1884, GUL pc7, p.16.
8 29 May 1884, GUL pc6, p.13.
9 22 May 1884, GUL pc6, p.52.
10 22 Aug. 1888, GUL pc10, p.21.
11 LC PC; Pearsall, quoted by Pennell.
12 GUL A23.

no.140

1 To Mrs W. Whistler, [n.d.], GUL w698.
2 YMSM 1980 (262–88); MacDonald 1994 (915–21).
3 To E.W. Godwin, 30 Jan. 1884, GUL G120.
4 L.P. Smith to Pennell, 14 Oct. 1907, LC PC Box 296,
no.3433.
5 Menpes 1904, pp.135–6.

no.144

1 YMSM 1980 (325–35); MacDonald 1994 (1024, 1035,
1039–40).
2 *Fun*, 1 March 1889.

no.145

1 'Venus', Freer Gallery of Art, Washington, DC;
MacDonald 1994 (357).
2 Sets of photographs are in the Baltimore Museum
of Art; S.P. Avery Collection, New York Public
Library; GUL and LC PC.
3 e.g. Whistler to D.C. Thomson, 11 May 1892 and 5
May 1893, LC PC and replies 13 May 1892 and 9 May
1893, GUL T83, 122.
4 A photograph of no.145 was worked on in
watercolour, GUL (YMSM 1980 (38)).
5 Nigel Thorp, 'Studies in Black and White:
Whistler's Photographs in Glasgow University
Library', in Fine (ed.) 1887, pp.96–7.
6 Degas to Whistler, [n.d.], [1890s] GUL D21,
published in M.F. MacDonald and J. Newton (eds.),
'Letters from the Whistler Collection (University of
Glasgow) Correspondence with French Painters',
Gazette des Beaux-Arts, Dec. 1986, p.209.

no.146

1 Exh. cat., Washington 1984, p.194, repr. pl.122;
MacDonald 1994 (1026).
2 14 and 15 May 1887; J. Rewald, *Camille Pissarro: Letters
to Lucien Pissarro*, London 1943, pp.108, 110.
3 Leymarie and Melot, p.112; see *Camille Pissarro*, exh.
cat., Hayward Gallery, London, Grand Palais, Paris,
Museum of Fine Arts, Boston 1981, nos.186–9.
4 16 March 1889, GUL pc10, p.85.
5 *Sun*, 10 March 1889; *Home Journal*, 15 March 1889, GUL
pc10, p.87.

no.147

1 One sold, Sotheby, New York, Parke Bernet, 11 April
1973 (37): another, exh., London 1960 (96); and two
in private collections (Mellon).
2 William Scott, 'Reminiscences of Whistler: Some
Recollections of Venice', *Studio*, vol.30, no.128, Nov.
1903, repr. opp. p.97.

no.148

1 M. Butlin and E. Joll, *The Paintings of J.M.W. Turner*,
New Haven and London 1977 (387); copy in private
collection, MacDonald 1994 (176).

2 GUL M356, published in M.F. MacDonald and J.
Newton (eds.), 'Letters from the Whistler
Collection (University of Glasgow) Correspondence
with French Painters', *Gazette des Beaux-Arts*, Dec.
1986, p.206.

no.149

1 *Echo d'Ostende*, 15 Sept. 1887.
2 *Manchester Courier*, 30 Nov. 1887.

no.150

1 Whistler to Charles J.W. Hanson, [n.d.] [Oct.–Nov.
1888], LC PC.
2 *Epoch*, 8 March 1889; see also *Evening Sun*, 16 March
1889.

Late Townscapes and Seascapes

1 Whistler to R. Birnie Philip, 18 July 1896, GUL P306.
2 16 Sept. 1896, GUL P313.
3 Pennell 1908, II, p.195.

no.151

1 [n.d.] [July 1893], LC PC.
2 Pennell 1908, II, p.148.
3 The location is inscribed on a label on the back of
no.151 and probably comes from information
provided by R. Birnie Philip.

no.153

1 Eddy 1903, pp.274–5.
2 13 July 1893 (E.G. Kennedy papers, NYPL I, 50).

no.154

1 e.g. 'Opal and Gold – Pourville Evening' (private
collection), 'Grey and Gold – Belle Isle' and 'Blue
and Silver – Belle Isle,' Hunterian Art Gallery,
University of Glasgow; MacDonald 1994 (1591,
1595–7).

no.155

1 The pension was run by M.M. Elout-Rose, mother-
in-law of Mies Elout Drabbe, a friend of Toorop:
see F. Heijbroek, 'Holland van het water: de
bezoeken van James Abbott McNeill Whistler aan
Nederland', *Bulletin Rijksmuseum*, vol.36, no.3, 1988,
p.251.
2 Pennell 1921, pp.179, 191–2.
3 Ibid.
4 Ibid., p.251.

no.157

1 The better-known wine-merchants, George
Nicholas and Son, were then at 3 Abchurch Lane,
further from Whistler's usual haunts.
2 Exh.cat., London, Dowdeswell 1884 (8 and 63);
MacDonald 1994 (951–2).

no.159

1 Way 1912, pp.88–9. See also Smale 1984, pp.72–83.

no.160

1 Whistler to the secretary of a committee, GUL N22.
2 MacDonald 1994 (1364–5).

no.161

1 Whistler to T.R. Way, 12 Sept. 1893, Freer Gallery
Archives 96.
2 R.B. Philip listed the location as Paimpol, not Vitré
(GUL LB6); MacDonald 1988, p.40.
3 Whistler to T.R. Way, 20 Sept. 1893, Freer Gallery
Archives 98; MacDonald 1988, p.40.
4 Whistler to T.R. Way, Freer Gallery Archives 96;
Way to Whistler, 23 Dec. 1893, GUL w106;
MacDonald 1988, pp.40–1.
5 Whistler to T.R. Way, 23 Nov. 1893, Freer Gallery
Archives 107.

no.162

1 Whistler to T.R. Way, 17 Sept. 1894, Freer Gallery
Archives 141, 158; see Smale 1984, p.75. The

Way–Whistler correspondence is in GUL, LC PC and
the Freer Gallery of Art, Washington, DC: it has
been edited by Nicholas Smale, for inclusion in the
forthcoming catalogue raisonné of Whistler's
lithographs by Nesta Spink, to be published for the
Art Institute of Chicago.
2 MacDonald 1988, pp.44–5.

no.163

1 Way to Whistler, 11 Aug. 1894, GUL w112; Way
pulled an edition of twenty-five, and Goulding, in
1903, a further forty-five; MacDonald 1988, pp.42–3.
2 e.g. 'Beefsteak Club', Hunterian Art Gallery;
MacDonald 1994 (1158).
3 Whistler to Way, 17 Sept. 1894 (LC PC), as quoted
in Smale 1984, p.74.

Amsterdam

1 See Heijbroek 1988, pp.225–56; English summary by
Patricia Wardle, pp.273–75.
2 Whistler to Marcus Huish, GUL F13/95; quoted in
exh.cat., London, Liverpool & Glasgow 1976, p.48;
and Lochnan 1984, pp.251.
3 Whistler to Marcus Huish, GUL F 164.

no.164

1 See Heijbroek 1988, pp.225–56.

no.166

1 *Pall Mall Gazette*, 4 March 1890; GUL, pc6, p.62.
2 Heijbroek 1988, p.274.

no.167

1 Whistler, writing from Amsterdam, to Fantin-
Latour, [1863], LC PC, quoted in exh.cat., London,
Liverpool & Glasgow 1976 (107).
2 See Lochnan 1984, pp.251–2.
3 Freer Gallery of Art, Washington, DC and British
Museum, London; MacDonald 1994 (877; 943–7).
4 Betsy G. Fryberger in exh. cat., Stanford 1978 (66).

no.170

1 Design in LC PC, printed sheet in GUL; MacDonald
1994 (1474).
2 Pennell 1908, II, pp.199–200.
3 R. Birnie Philip to Mrs Anderson, 25 Jan. 1899,
Columbia University, New York.
4 List of stored work, by R. Birnie Philip, 1901, GUL
NB3 pp.5–6; MacDonald 1994 (728, 932, 1624–5).
5 Freer Gallery of Art, Washington, DC; MacDonald
1994 (883, 1511). I am grateful to Martin Hopkinson
for showing me his article on the Company of the
Butterfly, to be published in the *Burlington Magazine* in
Oct. 1994.

no.172

1 To R. Birnie Philip, GUL P390.

no.173

1 Pennell 1921, pp.202, 205, Pennell 1908, II, p.263.
2 Margaret F. MacInnes, 'Whistler's Last Years.
Spring 1901 – Algiers and Corsica, *Gazette des Beaux
Arts*, 6th ser., vol.73, May–June 1969, p.324.
3 30 Jan. 1901, GUL P428.
4 Hunterian Art Gallery, University of Glasgow,
MacDonald 1994 (1643, 1666, 1693).
5 To R. Birnie Philip, 6 Apr.1901, GUL P443.

Scale

1 Pennell 1908, II, pp.205–6.
2 Whistler 1890, p.76.
3 Whistler wanted the Grafton gallery to frame the
quotation after Eden beside 'Rose and Silver:
Portrait of Mrs. Whibley' (exh. London, SPP 1896
(19)) but A. Stuart Wortley wrote on 10 Nov. 1896
that he thought the picture alone would make its
point (GUL w1124).

no.174

1 Whereabouts unknown, MacDonald 1994 (1067).
2 Unidentified press-cutting, [Dec. 1885], GUL PC3, p.1.
3 *Bazaar and Mart*, [Dec. 1885], GUL PC6, p.39.
4 'The Society of British Artists', *Academy*, vol.28, 19 Dec. 1885, p.417, GUL PC6, p.39.
5 Quoted by Pennell 1908, II, pp.57–8.
6 *Pall Mall Gazette*, 10 Dec. 1885, reprinted in Whistler 1890, p.195.

no.175

1 Album of photographs of the Ionides collection of tanagra statuettes, Hunterian Art Gallery, University of Glasgow; see MacDonald 1994 (1419).
2 MacDonald 1994 (1213).
3 'Draped full length (Eva)' or 'Dancing figure (white draperies red cap', in Whistler's studio at 8 Fitzroy Street in London on 16 Feb. 1901, GUL NB3, pp.11–12.
4 Published as the preface for the catalogue of *'Notes'–'Harmonies'–'Nocturnes'* in 1884, reprinted in Whistler 1890, p.115.

no.176

1 Bruce Laughton, *Philip Wilson Steer*, Oxford 1971, pp.113–4, 116–7.
2 G.P. Jacomb Hood, *With Brush and Pencil*, London 1925, p.45; e.g. 'The Arabian', Hunterian Art Gallery, University of Glasgow, MacDonald 1994 (1273); YMSM 1980 (435).
3 Laughton op.cit, pp.113–4; YMSM 1980 (434).
4 Laughton, op.cit., p.117.
5 Ibid., p.114.
6 [n.d.], [April and 14 June 1891], GUL W584, 586.
7 Pennell 1908, II, p.205.
8 Family details kindly provided by Mrs B.M. Pettigrew: see exh.cat., Glasgow 1984, p.50.

no.177

1 Drawings in Beatrice Whistler's Collection, Hunterian Art Gallery, Glasgow.
2 Whistler to Way, 21 Nov. 1893 GUL LB 5/30), quoted in Smale 1984, p.79.
3 Whistler to Way, 23 and 28 Nov. 1893, [Jan.1894], Freer Gallery Archives 107, 111, 117; Way to Whistler, 18 Nov. 1893, 4 Dec 1893, 12 Feb. 1894, GUL W115, 103, 109; MacDonald 1988, pp.42–3.

no.178

1 e.g. 'Portrait of Miss Hetty Pettigrew', Margaret D. Hausberg, *The Prints of Theodore Roussel: a catalogue raisonné*, New York 1991 (80), pp.106–8.
2 In addition there are two untransferred lithographs reworked in pen, 'A woman and a baby asleep on a sofa', and 'Mother and child reclining', Hunterian Art Gallery, University of Glasgow, MacDonald 1994 (1304–5).
3 'Mother and Child – The Pearl', and 'The Shell' (Freer Art Gallery, Washington, DC) and 'Violet and Gold' (Hunterian Art Gallery, University of Glasgow), MacDonald 1994 (1290–3).
4 Two in the Hunterian Art Gallery, one collection unknown, MacDonald 1994 (1298–1301).

no.179

1 GUL NBI, p.108.
2 'The Red Rag', *World*, 22 May 1878.

no.180

1 GUL T32; 27 Feb. 1892, LC PC.
2 *Morning Post*, 23 Feb. 1905.
3 Pennell 1908, I, pp.150–1, repr. opp. p.150.
4 'Rose and Silver', Hunterian Art Gallery, University of Glasgow; 'Venus', Freer Gallery of Art, Washington, DC, MacDonald 1994 (357–8).
5 To M'Corkindale, [n.d.] [1892], private collection (copies, Glasgow University Library).
6 MacDonald 1994 (1225, 1227).

no.181

1 10 and 27 Feb. 1890, Rosenwald Collection, Rare Books Division, LC.; inscription on old backing.
2 Note, E.G. Kennedy papers, NYPL.
3 17 April 1901, E.G. Kennedy papers, NYPL III 146.
4 MacDonald 1994 (1273–4).

no.182

1 [Nov./Dec.1892], GUL G7. BP II G/3.
2 MacDonald 1994 (663–72, 709–12).
3 Loys Delteil, *Le Peintre-graveur illustré, X–XI; H. de Toulouse Lautrec*, Paris 1920 (39); Jean Adhémar, *Les Lithographiès et pointes sèches de Toulouse Lautrec*, Paris 1905 (8).
4 *Toulouse Lautrec*, exh.cat., Hayward Gallery, London, Grand Palais, Paris 1991, pp.304–9.

no.183

1 e.g. London & New York 1960 (128, repr. pl.20) as 'Two Studies of Loie Fuller Dancing'.
2 Whistler to R. Birnie Philip, 27 Jan. [1901], GUL P427.
3 Edith Shaw and M.F. MacInnes 'Four Years with Whistler', *Apollo*, vol.87, March 1968, pp.198–201.
4 Cleveland Art Museum and Hunterian Art Gallery, University of Glasgow, MacDonald 1994 (1624, 1626–31).
5 Menpes 1904, p.72.
6 Kirk Varnedoe, 'Rodin's Drawings', *Rodin Rediscovered*, National Gallery of Art, Washington 1981, pp.179–83.

no.184

1 Whistler to T.R. Way, 24 Dec. 1893, 11 Jan.1894, Freer Archives 116, 118; MacDonald 1988, pp.26, 40–1.
2 Details of the editions are given in MacDonald 1988, pp.40–1.

no.185

1 Whistler to Way, 18 Sept. 1894, Freer Gallery Archives 138; MacDonald 1988, pp.23, 44–5.
2 The history of the lithographs is problematical, and will undoubtedly be clarified with publication of Nesta Spink's catalogue raisonné. Way thought the second version of 'The Duet' (w 65) was printed by Belfond, but Miss R. Birnie Philip claimed it was Lemercier; MacDonald 1988, p.31.
3 Finally Goulding printed an edition of twelve: see MacDonald 1988, pp.28, 30.

Symbolism and Decadence

1 Quoted in Jonathan Mayne, 'The Literature of James McNeill Whistler', *Burlington Magazine*, vol.107, June 1965, p.324.
2 Swinburne to Whistler, 2 April 1865, GUL S265.
3 25 Oct. 1897, GUL M237.
4 Whistler to Mallarmé, 1–12 Jan. 1897, GUL M234, published in Carl Barbier, *Mallarmé–Whistler Correspondance*, Paris 1964; the Barbier Collection is now in Glasgow University Library.
5 John Stokes, *In the Nineties*, New York, London, etc., 1989, p.14.
6 Duret to Whistler, 30 June 1903, GUL D208.
7 The review first appeared in *Century Guild Hobby Horse*, Jan. 1892, and was reprinted in Le Gallienne's *Retrospective Reviews: A Literary Log*, London and New York 1896, pp.24–5.

no.186

1 See M.F. MacDonald, *Whistler and Mallarmé*, exh. cat., Hunterian Museum, University of Glasgow 1973.
2 Whistler to Heinemann, 23 June 1892, LC PC; designs in Glasgow University Library and Hunterian Art Gallery; see MacDonald 1994 (203).
3 M.F. MacDonald and J. Newton, 'The Selling of

Whistler's Mother', *The American Society Legion of Honor Magazine*, vol.49, no.2, 1978, pp.97–120.
4 Barbier, op. cit.
5 Whistler to Mallarmé, [n.d.] [Oct.1896], GUL AM M/38, published in Barbier, op.cit., p.257, no.CXLV. Trans: 'I am now always alone – as lonely as Edgar Poe must have been, to whom you found I had a certain resemblance. But leaving you seems like saying Farewell to a second self – alone in your Art as I am in mine and in shaking your hand tonight, I felt the need to tell you how sensible I am of the intimacies of thought you shared with me.'
6 Pennell 1908, II, pp.134–5.
7 Henri de Regnier, *Nos Rencontres*, Paris 1931, p.213. Trans: 'when he posed for the wonderful lithograph portrait that Whistler made of him, the latter had placed him standing in front of the living room fireplace. It was winter and the fire was blazing so intensely that Mallarmé ended up feeling the baking heat, but each time he tried to move away from the hearth, Whistler, while still working, imperiously signalled him not to budge, so that at the end of the session, Mallarmé realised on his way home that he had real burns on his calves. When he later told Whistler, Whistler burst out laughing in the most diabolically satanic way, a laugh that I can still hear resonating deep in my memory just as I can also still hear the gentle, mysteriously precise voice of the poet, friend of the painters.'
8 Memoir dated 19 Nov. 1898, André Fontainas, *De Stéphane Mallarmé à Paul Valéry: Notes d'un témoin 1894–1922*, Paris 1928.
9 MacDonald 1988, pp.44–5.
10 Whistler to T.R. Way, 12 Nov. 1893, Freer Gallery Archives 105.

no.188

1 Walters Art Gallery, Baltimore; YMSM 1980 (355).
2 Given by Duret to the Musée du Petit Palais, Paris in 1908.
3 Albert Ludovici, *An Artist's Life in London and Paris 1870–1925*, London 1926, pp.93–4, 99.
4 Pennell 1908, II, p.187.
5 Raymond Bouyer, 'Les Artistes aux Salons de 1897', *L'Artiste*, April 1897, p.259.

no.189

1 Charles Whibley to Mallarmé, 1 Feb. 1897, GUL W295.

no.190

1 Whistler to Beatrice Whistler, 29 Oct. 1895, GUL W625.

no.191

1 Whistler to Beatrice Whistler, 7 Nov. 1895, GUL W627.

no.192

1 Way 1912, p.117.
2 Whistler to T.R. Way, 10, 18–9 Oct. 1895, Freer Gallery Archives 156, 159, GUL W121; MacDonald 1988, pp.46–7.
3 Whistler to M. Huish, [n.d.] [1895] GUL LB3/36; MacDonald 1988, p.24.

no.193

1 Whistler to Kennedy, endorsed 3 April 1896, NYPL, quoted by Susan Hobbs in *Lithographs of James McNeill Whistler from the Collection of Steven Louis Block*, exh. cat., Smithsonian Institution Traveling Exhibition Service, Washington 1982, p.31.
2 MacDonald 1988, pp.35, 48.
3 Way 1905, pp.6–7; see also Lochnan 1984, p.132 and MacDonald 1988, p.34.

no.194
1 Way 1912, p.126.

Portraits of the 1890s
1 Whistler to Beatrice Whistler, 11 Nov. 1895, GUL w630.
2 Whistler to Beatrice Whistler, Oct. 1895, GUL w625.

no.196
1 MacDonald 1994 (1059–61, 1191, 1326, 1411–15, 1423, 1457).
2 C.L. Drouet to Whistler, 31 Dec. 1892, GUL 164.
3 T. Duret to Whistler, 14 June 1900, GUL D199.
4 A. Ludovici, *An Artist's Life in London and Paris*, London 1926, p.88.

no.197
1 GUL P352.

no.198
1 Gustave Klimt, Society of Austrian Artists, to Whistler, 13 Dec. 1897, GUL S150.

no.199
1 Consuelo Vanderbilt Balsan, *The Glitter and the Gold*, Maidstone, Kent 1973, p.3 (1st ed. 1953).
2 Leon Edel (ed.), *Henry James Letters, vol.IV, 1895–1916*, Cambridge and London 1984, pp.344, 346.
3 Whistler to Vanderbilt, 20 May 1897, Vanderbilt Archive, Biltmore House, Asheville, North Carolina.
4 Whistler to R. Birnie Philip, 14 June 1897, GUL P347.
5 Whistler to Vanderbilt, [Dec. 1897], GUL V5.
6 Vanderbilt to Whistler, 31 Dec. 1897, GUL V6.
7 Whistler to Heinemann, [Feb. 1899], LC PC.
8 Vanderbilt to Whistler, 9 March 1899, GUL V10.
9 10 April 1902, GUL V16.
10 Pennell 1908, II, p.203.
11 National Gallery of Art, Washington, Painting Conservation Department 'Examination Report and Treatment Proposal', 13 July 1993.
12 [Anon.], *Modern Etiquette in Private and Public, Including Society at Large: Courtship and Marriage – Ball-Room, etc.*, London 1871, p.41.

no.200
1 [n.d.] Diaries, Bk 12, Freer Gallery of Art, Washington, DC (quoted in YMSM 1980 (477)).
2 Drawing of 'Lizzie Willis', 16 Jan. 1897, is inscribed by Whistler, quoting Lizzie, 'I was drunk once!!', GUL P338.
3 GUL P351.

no.201
1 Edith Shaw and Margaret F. MacInnes, 'Four Years with Whistler', *Apollo*, vol.87, March 1968, pp.198–201.

no.202
1 See Alexander Gardiner, *Canfield, The True Story of the Greatest Gambler*, New York 1930, and Canfield's obituary in the *New York Times*, 12 Dec. 1914.
2 Canfield apparently forgot these earlier sittings, later stating that he first sat for no.202 on New Year's Day 1903. See Gardiner, op. cit., p.234.
3 Pennell 1908, II, p.292.
4 Gardiner, op. cit., p.235.
5 Ibid., p.157.
6 'Symphony in Grey and Green: The Ocean' (YMSM 1980 (72)), 'Arrangement in Brown and Black: Portrait of Miss Rosa Corder' (YMSM 1980 (203)), and 'Arrangement in Black and Gold: Count Robert de Montesquiou-Fezensac' (YMSM 1980 (398)) are today in the Frick Collection, New York.

no.203
1 This drawing has also been mistakenly called a study for 'Brown and Gold' (no.205): see Pennell 1908, II, repr. opp. p.202; Pennell 1921, pp.40, 243–4, repr. opp. p.40.
2 MacDonald 1994 (1072).
3 Pennell 1921, pp.243–4.

no.204
1 Holker Abbott, Copley Society of Boston, to Joseph Pennell, 31 March 1904, LC PC.
2 The other two are in the Hunterian Art Gallery, University of Glasgow (YMSM 460, 461).
3 R. Birnie Philip to E.G. Kennedy, 8 May 1898, NYPL II III.

no.205
1 2 April 1896, LC PC.
2 Whistler to Beatrice, 3 Nov. 1895, GUL w626.
3 Whistler to R. Birnie Philip, 30 Sept. 1896, GUL P319.
4 1896, GUL w308.
5 Whistler to William Heinemann, LC PC.
6 1–12 Jan. 1897, GUL M234.

Chronology

MARGARET F. MACDONALD

Whistler as a child, *c.*1844
Glasgow University Library

Miniature of George Washington Whistler
*Library of Congress, Prints and Photographs
Division, Pennell Collection*

1834

11 July: James Abbott Whistler born in Lowell, Massachusetts, third son of Major George Washington Whistler, civil engineer, and eldest son of his second wife, Anna Matilda McNeill.

1837

The Whistler family moved to Stonington, Connecticut.

1840

Family moved again, to Springfield, when Major Whistler was appointed chief engineer on the Western Railroad of Massachusetts.

1842

Major Whistler went to Russia as civil engineer on the railroad from St Petersburg to Moscow.

1843

28 September: Mrs Whistler arrived in St Petersburg with her sons James and William and step-daughter Deborah.

1844

James had private tuition from an advanced art student, Alexander Ossipovich Koritskii.

1845

14 April: Started to attend drawing lessons at the Imperial Academy of Fine Arts in St Petersburg.

1847

February: While convalescing from rheumatic fever James was given a volume of Hogarth's engravings. Ever afterwards he maintained that Hogarth was the greatest English artist.

Summer: Mrs Whistler took Deborah and the boys to England.

16 October: James was groomsman at the wedding in Preston of Deborah and Francis Seymour Haden, a surgeon who became a notable etcher.

1 November: Back in St Petersburg.

1848

6 July: After another attack of rheumatic fever James left St Petersburg for London, and spent a term at school near Bristol.

1849

January: Stayed with the Hadens in London. Sir William Boxall took James to see the Raphael cartoons at Hampton Court.

7 April: Major Whistler died. Mrs Whistler and William left St Petersburg and moved to London.

August: Family went to live in America, at Pomfret, Connecticut. The boys went to school at Christ Church Hall for two years.

1851

1 July: James entered the United States Military Academy at West Point as a cadet-at-large. He added to his name his mother's maiden name of McNeill.

1852

Whistler's earliest published work, the title-page of the music sheet *Song of the Graduates*, appeared.

1854

16 June: Discharged from West Point for deficiency in chemistry, though top of his class in drawing under Robert W. Weir. Worked as an apprentice for a few months at Ross Winans's locomotive works in Baltimore, where his half-brother George was partner and superintendent.

7 November: Appointed to a post in the drawing division of the US Coast and Geodetic Survey, Washington, DC. Etched maps and topographical plans.

1855

February: Resigned from the Coast Survey where his attendance had become infrequent.

April: Painted one of his first oil portraits, of his patron Thomas Winans in Baltimore.

29 July: Obtained a visa for France where he had decided to study art.

September: Left New York for England and stayed with the Hadens for a month in London.

2 November: Arrived at Le Havre, France. Registered for morning classes at the Ecole Impériale et Spéciale de Dessin in Paris on 9 November and for evening classes on 20 November.

1856

17 June: Entered Charles Gleyre's studio and met Henri Martin, Henri Oulevey, George Du Maurier, Edward Poynter and L.M. Lamont. Met Aleco Ionides and later Ionides's brother Luke, who were among his earliest patrons. The American art agent George Lucas gave him financial support.

1857

Worked on copies in the Musée du Louvre.

11 September: Went with Martin to the *Art Treasures Exhibition* in Manchester which included fourteen paintings by or attributed to Velázquez.

1858

June: Worked on copies in the Musée du Luxembourg and on portraits.

14 August: Obtained a visa for Germany, and set off on an etching tour of northern France, Luxembourg and the Rhineland with an artist friend, Ernest Delannoy. They went to Nancy, Saverne and Strasbourg, and returned by Heidelberg and Cologne.

7 October: Returned to France and began printing the 'French Set' etchings at Auguste Delâtre's in Paris (nos.1, 3, 5–6). Met Henri Fantin-Latour in the Louvre. He took Whistler to the Café Molière, the meeting place of a circle which included Alphonse Legros, Carolus-Duran and Zacharie Astruc. Whistler showed them the 'French Set'. Fantin brought him into contact with Gustave Courbet and his followers at the Brasserie Andler. The Société des Trois – Fantin, Whistler and Legros – was formed. He also met Félix Bracquemond.

6 November: Left Paris for London where he began his first important painting, 'At the Piano' (no.11). The 'French Set' of etchings was published in London from Haden's house.

1859

12 January: Returned to Paris via Dieppe.

April: Two etchings accepted for the Salon, but 'At the Piano' was rejected and exhibited in François Bonvin's studio in the rue St-Jacques where it was seen and praised by Courbet.

6 May: Moved to London, staying with the Hadens and in rooms in Wapping near London Docks. Began the 'Thames Set' etchings. Went with Fantin to the Royal Academy, where two of Whistler's etchings were exhibited.

6 October: Returned via Dieppe to Paris.

1860

May: 'At the Piano' was the first painting exhibited by Whistler at the Royal Academy. Du Maurier shared a studio at 70 Newman Street with Whistler.

October: Painting 'Wapping' (no.33), which included the figure of Joanna Hiffernan, the red-haired Irish girl who became his mistress and principal model.

Christmas: Painted 'The Thames in Ice' (fig.54; YMSM 36) in three days.

Whistler as a boy, before 1850 *from E.R. and J. Pennell, The Life of James McNeill Whistler, London 1908*

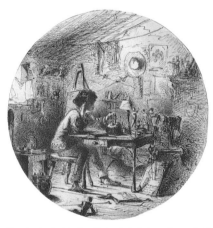

'An Artist in his Studio' *c*.1856 Ink and pencil *Freer Gallery of Art, Smithsonian Institution, Washington, DC*

'Portrait of Whistler with Hat' 1857–8 *Freer Gallery of Art, Smithsonian Institution, Washington, DC*

Edward J. Poynter, 'Portrait of James McNeill Whistler' 1858 Pencil *Freer Gallery of Art, Smithsonian Institution, Washington, DC*

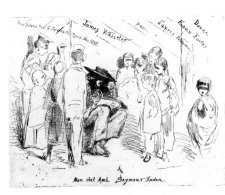

Title-page to the 'French Set' 1858 Etching *Hunterian Art Gallery, University of Glasgow, J.W. Revillon Bequest*

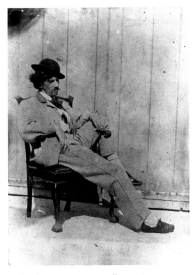

Whistler, *c.*1860 *Freer Gallery of Art, Smithsonian Institution, Washington, DC*

1861

May: 'La Mére Gèrard' (YMSM 26) and three etchings exhibited at the Royal Academy. Stayed several times with Mr and Mrs Edwin Edwards and introduced them to Fantin-Latour, who visited Whistler in the summer.

July: Ill with rheumatic fever in London.

July–August: Probably met Edouard Manet for the first time in Paris.

31 August: Left Paris for three months in Brittany on doctor's advice and painted his first major seascape, 'The Coast of Brittany' (no.39).

Winter: In Paris, painting 'The White Girl', later called 'Symphony in White, No.1: The White Girl' (no.14) at 18 boulevard Pigalle.

1862

January: Thames etchings exhibited at Martinet's gallery in Paris and praised by Baudelaire.

February: Visited London for four days, returned to Paris, and was back in London by 7 April.

May: 'The White Girl' rejected but 'The Coast of Brittany' (no.39), 'The Thames in Ice' and one etching, 'Rotherhithe' (no.34), accepted and well received at the Royal Academy.

21 June: *Once a Week* published the first of several illustrations.

1 July: *Athenaeum* published his first letter to the press, about 'The White Girl' then on show at Morgan's Gallery, Berners Street.

28 July: Met D.G. Rossetti and Algernon Swinburne.

October–December: Intended to go with Jo Hiffernan to see the work of Velázquez in Madrid, but stopped at Guéthary in the Basses-Pyrenées and painted 'The Blue Wave, Biarritz' (YMSM 41).

Late December: Living at 7A Queen's Road West, Chelsea, for three months.

1863

March: Moved to 7 Lindsey Row in Chelsea, near Rossetti. Met other members of the Pre-Raphaelite circle; the Greaves brothers, Chelsea boat-builders who began to work as his pupils; and probably the architect Edward W. Godwin. Made drawings and drypoint, 'Weary' (no.19), showing Jo asleep.

Spring: Visited Paris with Swinburne and introduced him to Manet.

April: 'The White Girl', rejected by the Salon, was one of the most controversial pictures at the Salon des Refusés in Paris.

May: 'The Last of Old Westminster' (no.35) exhibited at the Royal Academy. Whistler's etchings exhibited at The Hague won a gold medal. Visited Amsterdam with Alphonse Legros.

18 June: In Paris to see the Salon des Refusés.

Winter: Whistler's mother came to London from America to live with him.

December: Concentrated on Oriental subject pictures incorporating his own china, fans and other accessories, including 'La Princesse du pays de la porcelaine' (YMSM 50).

1864

February: Worked on 'Variations in Flesh-colour and Green: The Balcony' (YMSM 56) at Lindsey Row (see nos.23–4). In the spring he crossed to Paris several times to pose with Manet, Baudelaire and others for Fantin's 'Homage to Delacroix'.

May: 'Wapping' (no.33) and 'The Lange Leizen' (no.22) exhibited at the Royal Academy.

Winter: Mrs Whistler went to Torquay for her health. Jo sat for 'Symphony in White, No.2: The Little White Girl' (no.15) and 'The Golden Screen' (YMSM 60).

1865

April: His brother, Dr William Whistler, who had been in the Confederate army, came to live in London.

In Paris Whistler posed in a Chinese robe for Fantin's 'Le Toast! (Hommage à la Vérité)', exhibited at the Salon with Whistler's 'La Princesse du pays de la porcelaine'.

May: 'The Little White Girl' and 'Old Battersea Bridge' (no.30) exhibited at the Royal Academy with two Oriental compositions. Whistler met Albert Moore and they became close friends. Later in the year Moore replaced Legros as the third member of their Société des Trois. Whistler drew classically draped figures like Moore's (see nos.27–8).

16 August: Working on 'Symphony in White, No.3' (no.16).

September: With his brother escorted his mother to Coblenz and retraced the route of his holiday on the Rhine of 1858.

October–November: Joined Jo and Courbet at Trouville. Whistler painted several seascapes (nos.40–2) and Courbet painted Jo as 'La Belle Irlandaise'.

1866

January: Made a will in Jo's favour and gave her powers to manage his affairs while he went to South America, where the Chileans were engaged in a war against Spain.

12 March: Arrived in Valparaiso where he kept a journal of naval and military developments but avoided involvement. Painted a number of seascapes (YMSM 71–6; nos.44–5) including his first night scenes.

September: Sailed for England. After his return it would seem he parted amicably from Jo.

1867

February: Moved to 2 Lindsey Row (96 Cheyne Walk) where he lived for the next eleven years.

23 April: Whistler accused Seymour Haden of disrespect towards Haden's late partner, Dr Traer, and knocked Haden through a plate-glass window in Paris. Haden and Whistler never spoke to each other again and it was some time before Whistler could communicate with Deborah. Also quarrelled with Legros.

May: Exhibited three paintings at the Royal Academy (YMSM 46, 61, 65), including 'Symphony in White, No.3', the first picture with a musical title to be exhibited by Whistler (no.16); two at the Salon (no.11; YMSM 36); and four at the Exposition Universelle in Paris (nos.14, 30, 33, 44), including 'Crepuscule in Flesh Colour and Green: Valparaiso' (no.44).

August: Wrote to Fantin-Latour rejecting Courbet's Realism, and wishing he could have studied under Ingres. Made numerous studies of classically draped figures including the 'Six Projects' (YMSM 82–7; see p.92–4).

1868

February–March: Milly Jones was sitting to Whistler, possibly for the completion of 'Symphony in White, No.3', in Frederick Jameson's house at 62 Great Russell Street.

23 July: W.M. Rossetti saw the 'Six Projects'.

December: Attempting to paint a large picture, 'The Three Girls' (YMSM 88), in Jameson's house.

1869

Spring: Returned to 2 Lindsey Row.

6 May: Perfecting drawing and cartoon of 'Venus' (M 356–7).

The Liverpool shipowner, F.R. Leyland, had been Whistler's patron for several years and commissioned him to paint all his family (YMSM 95–7, 106–11; see nos.68–79).

Autumn: First of many visits to Leyland's home at Speke Hall.

1870

Working on figure compositions with flower themes, such as 'Morning Glories' (M 409–11), as well as the 'Six Projects'.

May: Exhibited 'The Balcony' at the Royal Academy (YMSM 56; see nos.23–4).

10 June: Birth of Charles James Whistler Hanson child of Whistler and Louisa Hanson, a parlourmaid.

1871

Spring: Published *Sixteen Etchings of Scenes on the Thames* and began to paint a succession of Thames Nocturnes, first called 'Moonlights' (no.46).

Attended Victor Barthe's life-classes with the Greaves brothers.

Summer: Painted the portrait of his mother, 'Arrangement in Grey and Black' (no.60).

November: Began the portrait of Mrs Leyland at Speke Hall (YMSM 106; see no.71).

Winter: Began to exhibit work in small London dealers' exhibitions, including Durand-Ruel's gallery, the Society of French Artists, and took great interest in the framing and presentation of his work.

1872

February: At Speke Hall became engaged, briefly, to Mrs Leyland's sister Elizabeth Dawson.

20 March: Commissioned to design two mosaics for South Kensington Museum, which were never executed (see no.26).

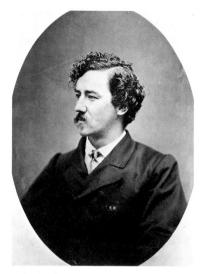

Whistler facing right: inscribed to Rossetti, mid-1860s *Library of Congress, Prints and Photographs Division, Pennell Collection*

The drawing-room at 7 Lindsey Row, 1860s: *Library of Congress, Prints and Photographs Division, Pennell Collection*

Anna Matilda McNeill Whistler, *c*.1865 *Whistler Collection, Glasgow University Library*

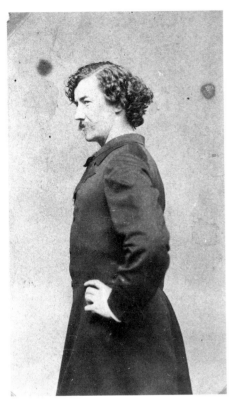

Whistler, c.1864 *Whistler Collection, Glasgow University Library*

Maud Franklin, late 1870s *Library of Congress, Prints and Photographs Division, Pennell Collection*

May: 'Arrangement in Grey and Black: Portrait of the Painter's Mother' (no.60) admitted to the Royal Academy after Sir William Boxall threatened to resign if it was rejected. It was the last picture shown by Whistler at the RA. Admired by Thomas Carlyle who agreed to pose for Whistler (see no.61).

November: In the exhibition at the Dudley Gallery in London Whistler used the word 'nocturne' for the first time to describe his pictures (YMSM 117–18). 'Grey Note', his first exhibited watercolour, was shown at the British Institution (M 472).

Mrs Louis Huth admired the portrait of Mrs Leyland and commissioned a portrait (see no.63).

1873

January: Exhibited his self-portrait (YMSM 122) and pictures of the Thames at Durand-Ruel's in Paris. Worked on decorative schemes for W.C. Alexander at Aubrey House (no.80).

Began to give dinner parties and initiated his midday 'Sunday breakfasts'.

July: Painting the portrait of Thomas Carlyle (no.61).

Winter: Finished the portrait of F.R. Leyland in evening dress (YMSM 97; see no.68). Maud Franklin, who had taken Jo's place as Whistler's mistress and chief model, stood for the final drapery studies in the portrait of Mrs Leyland, 'Symphony in Flesh Colour and Pink' (YMSM 106; see no.71).

1874

June: Held his first one-man exhibition, in the Flemish Gallery, Pall Mall, where, among thirteen oils, thirty-six drawings (nos.26, 28), fifty etchings and one painted screen (YMSM 139), portraits of Carlyle (no.61), Mrs Huth (no.63), Miss Cicely Alexander (no.62) and Mr and Mrs Leyland (YMSM 97, 106) were first exhibited.

1875

8 August: Mrs Whistler on doctor's advice went to live in Hastings for the rest of her life. Whistler began to entertain lavishly.

September: Painting Nocturnes of Cremorne Gardens in Chelsea (YMSM 163–9) of which the most important, 'Nocturne in Black and Gold: The Falling Rocket' (no.58), was exhibited at the Dudley Gallery in November.

1876

March: Worked on the hall (YMSM 175) of Leyland's London house, 49 Princes Gate. By September Whistler was working on the decoration of the dining room in a peacock design (YMSM 178; see pp.164–5).

1877

9 February: Newspaper critics visited the completed Peacock Room, which Whistler called 'Harmony in Blue and Gold' (YMSM 178). Leyland had commissioned Whistler only to retouch some details, and, annoyed by the publicity, paid half the 2,000 guineas Whistler expected.

May: At the newly opened Grosvenor Gallery Whistler exhibited eight paintings, including 'Nocturne in Black and Gold: The Falling Rocket', painted two years previously. This led John Ruskin to write in *Fors Clavigera* that he 'never expected to hear a coxcomb ask two hundred guineas for flinging a pot of paint in the public's face'; Whistler sued Ruskin for libel.

September: Commissioned E.W. Godwin to build him the White House in Tite Street, to be large enough for him to open an atelier. The Metropolitan Board of Works objected to Godwin's designs, and revisions and delays engendered higher costs than anticipated.

1878

March: Exhibited 'The Coast of Brittany' (no.39) at the first exhibition of the Society of American Artists in New York.

30 April: Private view of exhibition of Sir Henry Thompson's blue and white Nankin porcelain for which Whistler and Thompson illustrated a catalogue (see no.83).

May: Exhibited seven paintings at the Grosvenor Gallery including a portrait of Maud, 'Arrangement in White and Black' (YMSM 185), and 'Nocturne: Grey and Gold – Chelsea Snow' (YMSM 174). In a letter to the *World* on 22 May Whistler proclaimed his aesthetic theories: 'my combination of grey and gold is the basis of the picture … the picture should have its own merit, and not depend upon dramatic, or legendary, or local interest'.

June: An exhibition stand designed by Whistler and Godwin shown at the Paris Exposition Universelle (YMSM 195).

25 June: Tenancy of 2 Lindsey Row (96 Cheyne Walk) ended and Whistler moved to the White House.

July: The London printer Thomas Way taught Whistler the principles of lithography (see nos.55, 67).

5 September: Finishing portrait of Rosa Corder (YMSM 203; see no.66) for Charles Augustus Howell.

25–6 November: In his libel action against Ruskin, Whistler was awarded a farthing's damages without costs and found himself in desperate financial straits.

December: Published *Whistler v. Ruskin: Art and Art Critics*, dedicated to Albert Moore, the first of a series of pamphlets bound in brown paper.

1879

2 February: Birth of Maud's child, Maud McNeill Whistler Franklin.

May: Exhibited 'Arrangement in Brown and Black: Portrait of Miss Rosa Corder' (see no.66) and 'Harmony in Yellow and Gold: The Gold Girl – Connie Gilchrist' (YMSM 190) among five oils, and several etchings and drawings at the Grosvenor Gallery.

7 May: Auction sale of Whistler's paintings, etchings, drawings, Nankin porcelain, Japanese items, and household effects held at the White House.

8 May: Declared bankrupt. Bailiffs took possession of the White House.

June: Creditors appointed a committee of examiners composed of Whistler's chief creditors – Leyland, Howell and Thomas Way. Whistler destroyed many pictures to prevent their falling into the hands of the bailiffs. His friends, including Howell and Way, acquired paintings, some of which were later returned to Whistler. Many were never recovered.

September: Left for Venice with Maud Franklin, and a commission from the Fine Art Society for twelve etchings (see no.104). He stayed for more than a year, some of the time in the Casa Jankowitz on the Riva Schiavoni, and attracted a circle of American art students living in Venice, including Harper Pennington (see no.123).

18 September: The White House sold to the art critic Harry Quilter for £2,700.

1880

12 February: Sale of Whistler's effects at Sotheby's included some prints and pictures and the rest of his collection of porcelain.

2 May: In spite of the cold weather he had already completed about sixty pastels and many fine etchings. While in Venice he made fifty etchings, over one hundred pastels, but few paintings.

November: Returned to London. He rented rooms at 65 Regent Street from the Fine Art Society to print the Venice etchings.

December: Exhibited the twelve 'Etchings of Venice' at the Fine Art Society, including 'The Zattare; harmony in blue and brown' (no.112).

1881

29 January: Private view of 53 *Venice Pastels* at the Fine Art Society, including 'The Zattare; harmony in blue and brown' (no.112).

31 January: Whistler's mother died at Hastings.

22 March: Leased flat and studio at 13 Tite Street.

May: Exhibited 'Harmony in Grey and Green: Miss Cicely Alexander' (no.62) at the Grosvenor Gallery.

Designed a trellis for Lady Archibald Campbell at Coombe Hill Farm (no.91).

26 August: Alan Cole saw Whistler at work on three portraits of Lady Meux (YMSM 22–30; see nos.124–6).

Whistler became friendly with Oscar Wilde.

August–September: Painting watercolours in Jersey and Guernsey, London and, while visiting Howell, at Selsey Bill (M 853–61; no.138).

1882

Working on a number of portraits including three of Lady Archibald Campbell (YMSM 240–2; no.130).

May: Portrait of Lady Meux (no.124) and three Venice etchings exhibited at the Salon; seven paintings at the Grosvenor Gallery including 'Nocturne in Black and Gold: Entrance to Southampton Water' (YMSM 179).

Met Walter Sickert, then at the Slade School, which he left to become Whistler's pupil and assistant.

Winter: A visit to Dordrecht, Amsterdam and Haarlem, painting watercolours. The first

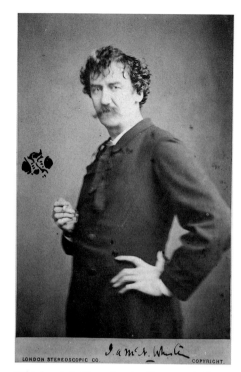

Whistler, 1878 Photo: London Stereoscopic Co.
Library of Congress, Prints and Photographs Division, Pennell Collection

'Spy' (Sir Leslie Ward), 'A Symphony' (caricature of Whistler) Lithograph, *Vanity Fair*, 12 Jan. 1878
Private Collection/Bridgeman Art Library, London

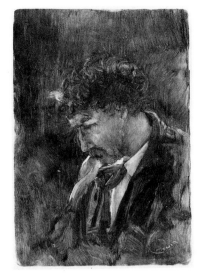

Charles Abel Corwin, 'Portrait of Whistler in Venice' 1880 Monotype *The Metropolitan Museum of Art, New York. The Elisha Whittelsey Collection, The Elisha Whittelsey Fund, 1960*

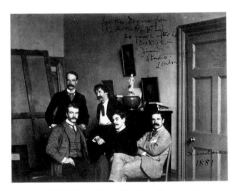

A group in Whistler's studio, Tite Street, 1881. Photo: The Hon. F. Lawless *Library of Congress, Prints and Photographs Division, Pennell Collection*

Whistler, with Mortimer Menpes standing, 1880s *Library of Congress, Prints and Photographs Division, Pennell Collection*

watercolour Whistler exhibited in America, 'Snow' (M 877) dates from this trip.

1883

17 February: Private view of fifty-one etchings, mostly of Venice, at the Fine Art Society. Each catalogue entry was followed by a quotation from earlier criticisms.

7 May: Whistler was in Paris. At the Salon the portrait of his mother (no.60) was awarded a third-class medal, and enthusiastically reviewed by Théodore Duret, whose portrait Whistler also painted (no.127). Paintings exhibited at the Galerie Georges Petit included Nocturnes (see no.46). Nocturnes also exhibited in London, at the Grosvenor Gallery (YMSM 100, 169).

Over the next two years, brief visits to the coast resulted in many watercolours, at Southend-on-Sea, Essex (M 885–92), Liverpool, Westgate, etc. Painted studies of Maud Franklin and Milly Finch. who posed when Maud was ill (nos.132–4).

Summer: Visited Paris, and possibly Dieppe. Painted watercolours of Dordrecht, 'Off the Dutch coast' (M 940; no.143), and Nocturnes of Amsterdam (M 944–6).

1884

January: At St Ives, Cornwall, with his pupils Mortimer Menpes and Walter Sickert. Painted small seascapes in oil and watercolour (see YMSM 26–82; no.140) which show this as an important period of development for Whistler as well as for his pupils.

January–February: First exhibition of the Société des XX, Brussels, included four paintings by Whistler and Venice etchings. Whistler spent some time in Holland around Dordrecht painting and etching and possible visited Le Havre and Honfleur.

May: Exhibited portraits of Cicely Alexander and Thomas Carlyle (nos.61–2) at the Salon, and a newly completed portrait of Lady Archibald Campbell at the Grosvenor Gallery (no.130).

17 May: Opening of one-man exhibition, 'Notes' – 'Harmonies' – 'Nocturnes', at Dowdeswells', the first showing of his watercolours in any quantity. The catalogue contained Whistler's important 'Proposition – No.2', beginning 'A Picture is finished when all trace of the means used to bring about the end has disappeared'.

July: Painted Lady Archibald Campbell in *As You Like It* (YMSM 317), at Coombe Hill Farm.

13 July: Joseph Pennell, his future biographer, visited Whistler and was shown the portrait of Pablo de Sarasate (YMSM 315).

11 October: Leased studio at 454A Fulham Road, and moved in during December.

21 November: Elected member of the Society of British Artists, and exhibited his portrait of Mrs Huth (no.63) and a recent watercolour of Dordrecht in its Suffolk Street galleries. He exhibited regularly at their summer and winter exhibitions.

1 December: Opening of exhibition of Dublin Sketching Club, which included twenty-six paintings by Whistler, mostly watercolours.

1885

20 February: Delivered the 'Ten O'Clock' lecture in Princes Hall, and repeated it elsewhere on several occasions later in the year.

May: Portraits of Lady Archibald Campbell and Théodore Duret (nos.130, 127) exhibited at the Salon.

Summer: Sent his portrait of Sarasate and seven small seascapes of Holland (see YMSM 299–300) and northern France to the SBA. Whistler and Maud Franklin were living at the 'Pink Palace', The Vale, Chelsea.

August: Went to Belgium and Holland with the American artist William Merritt Chase, visiting Antwerp, Haarlem and the International Exhibition in Amsterdam.

September: Stayed with Walter Sickert and his wife in Dieppe, and painted 'Variations in Violet and Grey – Market Place, Dieppe' (no.146). Possibly also visited Paris.

Winter: Sent his portrait of Mrs Cassatt to the SBA (no.128). Pastels of nude and draped women (M 1067–8, 1070–2, 1074–5) had mixed reviews. Since J.C. Horsley RA had criticised the use of nude models, Whistler added a sign reading 'Horsley soit qui mal y pense' to 'Note in Violet and Green' (M 1074).

1886

April: Set of *Twenty-Six Etchings of Venice* issued by Dowdeswells' in London. Whistler completed the limited edition of thirty sets by 16 July 1887.

May: Second one-man exhibition, 'Notes' – 'Harmonies' – 'Nocturnes', at Dowdeswells'

included many watercolours, such as 'Arrangement in blue and silver – The Great Sea' (no.148) and pastels, such as 'Violet and Blue (Lapis Lazuli)' (M 1070). Exhibited the portrait of Pablo de Sarasate at the Paris Salon and in Brussels.

1 June: Elected President of the SBA. Designed a velarium for the galleries (see no.93). Took office in December and set out autocratically to reform the Society.

6 October: Death of E.W. Godwin. Whistler continued the portrait of his widow Beatrice (YMSM 253), which was sent to the SBA winter exhibition.

1887

May: Fifty small oils, watercolours and pastels exhibited at the *Exposition Internationale de Peinture*, Galerie Georges Petit, in Paris, included recent pictures of Dieppe (YMSM 328–30, 332–4), 'Variations in violet and grey – Market Place, Dieppe' (no.146) and portraits of Maud Franklin – including possibly his last portrait of her (YMSM 357).

June: *Notes*, a set of six lithographs, published in London by Boussod, Valadon & Cie. Worked on etchings of Chelsea and the East End of London (K 257–301).

20 June: On the occasion of Queen Victoria's Jubilee, Whistler sent her an illuminated Address on behalf of the SBA (M 1129–31).

27 July: A set of etchings done in one day at the Naval Review at Spithead (K 316–29) was also presented in a bound volume as a Jubilee Year Memorial. The Society received a Royal Charter, thus becoming the Royal Society of British Artists (RBA).

Autumn: Visited Holland and Belgium with his brother and sister-in-law, Dr and Mrs William Whistler, stopping at Brussels, Ostend and Bruges. Made a series of etchings of Brussels (K 355–67).

1888

February: Opening of Société des XX exhibition in Brussels. Whistler exhibited two oils (no.56; YMSM 181) and pastels, with recent etchings of London (see K 287–93).

26 April: Patented his design for a velarium (no.93) for use in exhibitions. To improve the standard of the RBA Whistler had the galleries redecorated and hung exhibitions spaciously. Many members objected.

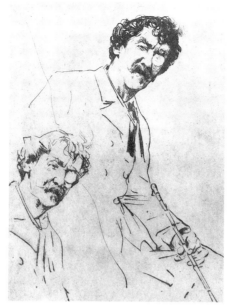

Etching of Whistler by Mortimer Menpes 1885
Whistler Collection, Glasgow University Library

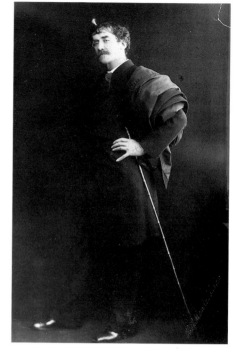

Whistler, 1885–6 Photo: H.J. Mendelsohn
Whistler Collection, Glasgow University Library

Whistler and W.M. Chase, *c*.1885
Detail of photograph published in Menpes 1904
Library of Congress, Prints and Photographs Division, Pennell Collection

Whistler in his Fulham Road studio, *c*.1884–8
Library of Congress, Prints and Photographs Division, Pennell Collection

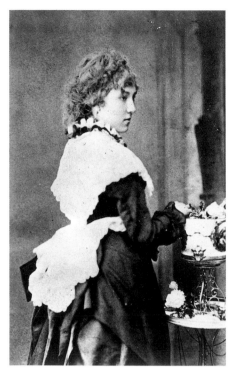

Beatrice Whistler, late 1880s *Whistler Collection, Glasgow University Library*

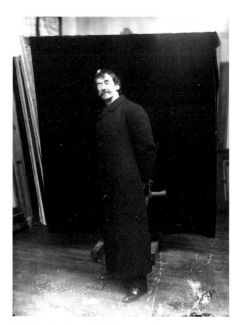

Whistler in his studio *Library of Congress, Prints and Photographs Division, Pennell Collection*

May: Exhibited Nocturnes, etchings and drawings at the Galerie Durand-Ruel in Paris, with 'The Fur Jacket' (YMSM 181).

June: At the first exhibition of the New English Art Club Whistler showed an early oil (YMSM 44) and a recent etching of Brussels.

4 June: Resigned as President of the RBA but retained the post until November. Menpes, Sickert, Alfred Stevens, Theodore Roussel and others also resigned.

13 June: In Paris, Monet introduced Whistler to Stéphane Mallarmé, who agreed to translate the 'Ten O'Clock' lecture into French, and became a regular correspondent and a close friend. Gave up his house in The Vale and the studio in the Fulham Road and lived for a short time at 14 Upper Cheyne Row before moving to the Tower House, Tite Street.

July: Invited to exhibit at the third *Internationale Kunst-Ausstellung* in Munich, he sent thirteen oils, thirty etchings, twenty watercolours and seven pastels, many borrowed from protesting owners. He was awarded a second-class medal and thanked the committee for the 'second-hand compliment'.

11 August: Married Beatrice Godwin, widow of E.W. Godwin, Maud having been rather abruptly abandoned. The couple spent a working honeymoon travelling in France, to Boulogne, Paris, Chartres, down the Eure and Loire to Tours in September, and then to Loches (M 1176–88, no.150). Whistler made a 'Renaissance Set' of etchings (K 368–402) and taught his wife to etch. They returned to London at the beginning of November. Whistler started a series of portraits of Beatrice's sister Ethel Philip (nos.196–8).

3 November: Elected honorary member of the Royal Academy of Fine Arts in Munich.

1889

March: Exhibition of his oils, watercolours and pastels held at Wunderlich's in New York made a big impact on American collectors: Charles L. Freer of Detroit, Howard Mansfield (see nos.145, 150), and H.H. Havemeyer bought watercolours.

28 April: Banquet for Whistler in Paris was followed on 1 May by a dinner in London to celebrate the award of a first-class medal at Munich and the Cross of St Michael of Bavaria.

May: Retrospective exhibition in the College for Working Men and Women, London,

badly organised by Sickert, included recent shop-fronts, and major portraits (nos.60–1, 124, 158). Exhibited the portrait of Lady Archibald Campbell (no.130) and 'The Balcony' (YMSM 56) at the Paris Exposition Universelle, and was awarded a gold medal.

4 September: The Whistlers left London to spend nearly two months in Amsterdam, and he made a set of etchings (K 403–16; see nos.164–7). Awarded a gold medal at the International Exhibition in Amsterdam. Returned via Paris to London. Made a Chevalier of the Légion d'Honneur.

1890

February: Moved to 21 Cheyne Walk. An unauthorised selection of Whistler's correspondence called *The Gentle Art of Making Enemies*, edited by Sheridan Ford, was published in Ghent. Whistler's version appeared in June, published by William Heinemann in London (see no.97).

March: Met C.L. Freer, who formed a major collection of Whistler's work.

May: Exhibited two Nocturnes at the Paris Salon (YMSM 76, 169) and several paintings at the Brussels Salon. The Pettigrew sisters posed for pastels such as 'The Arabian' (M 1310) and 'Blue and Violet: Iris' (no.179).

1891

13 February: Comte Robert de Montesquiou-Fezensac asked Whistler to paint his portrait (YMSM 398). He posed over a hundred times before it was completed. Montesquiou and Whistler had met about 1887 and corresponded regularly for several years.

2 April: The Corporation of Glasgow were persuaded by local artists to buy the portrait of Carlyle (no.61) for 1,000 guineas. This was the first of Whistler's pictures to be bought for a public collection.

15 May: Sent two paintings to the first exhibition of the Société Nationale des Beaux-Arts, Champs de Mars (no.44; YMSM 203). He stopped exhibiting at the Salon. Spent summer in Paris working on lithographs – *Songs on Stone*.

August: On hanging committee of autumn exhibition at Walker Art Gallery, Liverpool.

October: In Belgium to testify in the lawsuit with Sheridan Ford. Worked on lithographs in Paris.

2 November: Returned to London. Whistler's portrait of his mother (no.60) was bought for the Musée du Luxembourg for 4,000 francs, largely through the efforts of Mallarmé, Duret and Roger Marx.

1892

January: Made an Officier of the Légion d'Honneur. Stayed at Hôtel Foyot in Paris until February, painting Montesquiou.

19 March: Private view of important retrospective exhibition, forty three *Nocturnes, Marines, Chevalet Pieces*, at the Goupil Gallery in London. As a result of the public recognition of his work Whistler was given more commissions than he could fulfil, and many earlier patrons sold his paintings for large profits. After this he tried to ensure that most of his work left England, by encouraging collectors such as C.L. Freer.

April: Moved to 110 rue du Bac in Paris and acquired a studio at 186 rue Notre-Dame-des-Champs. Awarded a gold medal at the World's Columbian Exposition in Chicago.

May: Exhibited a portrait of Lady Meux (YMSM 229) and five Nocturnes with the Société Nationale des Beaux-Arts (see no.56).

June: At the sixth Internationale Kunst-Ausstellung in Munich Whistler was awarded a first-class gold medal for 'The Fur Jacket' (YMSM 181). The committee of the Munich Pinakothek tried unsuccessfully to buy 'The Little White Girl' (no.15) from its owner.

July: Planned a portrait of the Duke of Marlborough but his death prevented it. In Paris made designs for Mallarmé's *Récréations Postales* (M 1341) and Montesquiou's *Les Chauves souris* (M 1353–4).

November: Drew Loie Fuller as 'Le Papillon' (no.182).

1893

May–June: Painted small portraits in Paris, including the New York dealer Edward G. Kennedy of Wunderlich's (YMSM 404).

Summer: Printed etchings with Pennell, and visited St Denis and Fontainebleau. Met and disliked Aubrey Beardsley but came to admire his work.

July: The Whistlers visited Vitré, Lannion and Paimpol in Brittany, and by the middle of August were at Perros Guirec, Côtes-du-Nord

(see no.151). Did some etchings and painted seascapes 'out in the full sea' (YMSM 411–13; no.153).

October: Returned to Paris. Worked on lithographs (see no.186) including a portrait of Mallarmé as frontispiece for *Vers et Prose* (Paris, 1893) (no.186).

18 December: 63rd exhibition of the Pennsylvania Academy of the Fine Arts included 'La Dame au brodequin jaune' (no.130). It was bought for the Wilstach Collection in 1894, the first work bought for an American public collection.

1894

9 January: Lady Eden started to pose in Paris for a small full-length portrait (YMSM 408).

March: Instalments of George Du Maurier's novel *Trilby* appeared in *Harper's Magazine*. Whistler, annoyed at the references to himself as Joe Sibley, 'the Idle Apprentice', protested. Harper's apologised, the references were made less explicit and drawings of Whistler deleted when the book was published in 1895.

March–April: The portrait of Sarasate (YMSM 315) was Whistler's main contribution to international exhibitions in Hamburg and Antwerp.

April–May: Painting portraits of his sister-in-law Ethel Philip at 110 rue du Bac (see nos.196–8).

May: Exhibited recent seascapes (see no. 153) and portraits of Mrs Sickert, Montesquiou and Lady Eden (YMSM 338, 398, 408) at the Société Nationale des Beaux-Arts.

June: Elected honorary member of the Royal Scottish Watercolour Society

December: Awarded Temple Gold Medal at 64th annual exhibition of the Pennsylvania Academy of the Fine Arts.

Mrs Whistler's health deteriorated and he took her to London for medical advice. They stayed at Long's Hotel until early in 1895. Whistler worked in Sickert's studio at 13 Robert Street until March 1895.

1895

4 March: Sir William Eden brought an action against Whistler for not handing over the portrait of Lady Eden (YMSM 408) because Whistler was not satisfied with the manner and amount of payment for it. Judgement

Whistler in his Tite Street studio, 1890s
Whistler Collection, Glasgow University Library

Whistler, 1890s *Whistler Collection, Glasgow University Library*

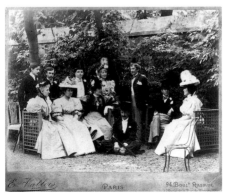

Wedding of Ethel Philip and Charles Whibley, 110 rue du Bac, Paris, July 1895. Photo: E. Vallois
Whistler Collection, Glasgow University Library

Whistler, 1890s *Whistler Collection, Glasgow University Library*

Whistler's studio, 1890s Photo: George P. Jacomb-Hood *Library of Congress, Prints and Photographs Division, Pennell Collection*

went against Whistler but this was reversed after he appealed, and he was allowed to keep the picture.

April: Won honours at the Esposizione Internazionale in Venice and a gold medal at Antwerp.

June: Painting a self-portrait, in the pose of Velázquez's 'Pablo de Valladolid', in Paris (no.205).

August: On holiday at Bagnole-sur-Orne, a spa in Normandy.

15 September: Whistler took his wife to Lyme Regis in Dorset and stayed on after she left, late in October, working on etchings, lithographs (see no.191) and paintings, including 'The Little Rose of Lyme Regis' (no.190) until he had resolved to his satisfaction his artistic problems. The artist Arthur Studd was working there too until 11 November. Whistler left at the end of November.

December: Exhibition of seventy-five lithographs at The Fine Art Society.

Winter 1895–6: Took a flat in De Vere Hotel, opposite Kensington Gardens.

1896

January–March: Beatrice Whistler was very ill. They stayed in the Savoy Hotel and Whistler worked on lithographic portraits and views of the Thames (no.193–5).

February: John Singer Sargent lent Whistler his studio at 76 Fulham Road, London.

March: Took studio at 8 Fitzroy Street. The Whistlers moved to St Jude's Cottage on Hampstead Heath.

10 May: Beatrice Whistler died of cancer. For a while Whistler made his home with William Heinemann at 4 Whitehall Court. Over the next five years he stayed frequently at Garlant's Hotel, or with the Birnie Philips. He adopted his sister-in-law Rosalind Birnie Philip as his ward, and made her his executrix. In emotional turmoil, he quarrelled with old friends, including T.R. Way.

14 July: Went with the dealer E.G. Kennedy to Honfleur. He was depressed and restless, wished that he had been a Catholic, sketched a shrine (M 1475) and painted the Church of St Catherine (YMSM 455).

September: Spent two weeks painting around Dieppe and Calais. Visited Canterbury and Rochester with the Birnie Philips.

Autumn: Designed cover and publicity for Charles Whibley's *Book of Scoundrels* which was published by Heinemann (M 1479–81).

12 October: Sickert failed to apologise to Whistler for associating with Sir William Eden and they became estranged.

5 November: Opening of first annual exhibition at Carnegie Institute, Pittsburgh, included the portrait of Sarasate (YMSM 315) which was bought by the Institute on 30 November. Exhibited a watercolour 'Rose and Silver: Portrait of Mrs Whibley' (M 1415) with the Society of Portrait Painters in London.

Christmas: Went to Bournemouth. Visited Beardsley at Boscombe and was distressed to see how ill he was.

1897

January: Working at 8 Fitzroy Square, he drew the housekeeper, Mrs Willis and her daughter Lizzie (M 1500–3). Later he painted portraits of Lizzie (YMSM 475–7; see no.200) and another local girl, Lillie Pamington (see YMSM 464).

February: Contributed to a watercolour exhibition organised by Diaghilev in St Petersburg (M 1485–6).

2 April: Negotiated the lease of 2 Hinde Street, Manchester Square, as premises for the Company of the Butterfly, formed to sell Whistler's work. It was not successful and operated only from 1898 to 1901.

April: Whistler supported Pennell in his successful libel action against Sickert, who had written that Pennell's method of drawing on transfer paper instead of directly on to the stone was not true lithography.

May: Exhibited three oils at the Société Nationale des Beaux-Arts. Visited Paris.

18 May: George W. Vanderbilt commissioned Whistler to paint his portrait. It was started in London in June (no.199).

July: In Dieppe with Pennell and Kennedy. He joined the Birnie Philips in Etretat, and painted the sea, a shop, and a local baby (YMSM 482–4). The Pennells began to keep a journal about their relations with Whistler.

September: Returned to Paris.

20 October: Visited Valvins, Seine-et-Marne, Mallarmé's country house, and painted Mallarmé's daughter Geneviève (no.187).

28 October: Ill in bed at Garlant's hotel in London.

15 December: Vanderbilt sat to Whistler in Paris. He did not receive the portrait until after Whistler's death (no.199). Whistler's appeal in the case with Sir William Eden was heard in Paris. The verdict went in Whistler's favour and he was allowed to keep the portrait of Lady Eden provided it was made unrecognisable (YMSM 408).

1898

Working on portraits of himself (YMSM 440; no.204) and Miss Birnie Philip (YMSM 478–9) but his health was poor. The Carrington sisters posed seated or dancing in the studio (M 1528–31; see no.183).

16 February: At the third meeting of the International Society of Sculptors, Painters and Gravers (ISSPG) Whistler was unanimously elected chairman of the executive council. He controlled its decisions from Paris.

23 April: Elected President of the ISSPG. Whistler attended the opening of the first exhibition on 16 May at the Skating Rink, Knightsbridge. It included works by Rodin, Monet, Manet, Sisley, Toulouse-Lautrec, Bonnard, Vuillard, and, from Germany, Dill, Klinger, Lieberman, von Stuck, Thoma, von Habermann and von Uhde. Whistler exhibited nine oils, including a self-portrait (no.204), and several drawings, plus three etchings by his wife.

5 June: Staying at the Hôtel Chatham, rue de Tournon, Paris. He was in Paris most of the summer, with brief visits to the Pennells in London, and, in the middle of July, to Dunster in Somerset.

9 September: Death of Mallarmé. Whistler, ill, and in London, was very upset.

October: Returned to Paris. Mlle Carmen Rossi, his model since her childhood, had opened an academy at 6 Passage Stanislas, and Whistler had undertaken to visit it with the American sculptor F. MacMonnies. Students of all nationalities, particularly Americans, rushed to join it. Whistler's 'Propositions' and 'Addresses' to the students were hung on the walls.

17 December: Dined in London with Albert Ludovici, who was contacting French artists on behalf of Whistler for the next exhibition of the ISSPG.

1899

January: Exhibited on Diaghilev's invitation at the first *World of Art Exhibition* at St Petersburg. Some of his pictures were later bought by the Russian collector Sergei Shchukin (YMSM 274, 310, 380).

March: Visited Italy for the marriage of William Heinemann at Porto d'Anzio. In Rome he admitted the elegance of Raphael's Loggie but was unimpressed by the Stanze and Michelangelo's Sistine Chapel.

9 March: Was taken round the galleries in Florence. Returned to Paris several days later.

7 May: Opening of second International Exhibition or 'Art Congress' in Knightsbridge. Whistler exhibited six oils including 'Rose and Gold: The Little Lady Sophie of Soho' (YMSM 504) with four drawings (M 1582–3) and a special show of his etchings.

13 May: His account of the Eden case, *Eden versus Whistler: The Baronet and the Butterfly*, was published in Paris (see no.98).

June: Mrs Vanderbilt sat for her portrait (YMSM 515) in Paris. Whistler was staying at the Hôtel Chatham early in July.

20 July: Articled Miss Inez Bate (later Mrs Clifford Addams), one of the first students at the Académie Carmen, as his legal apprentice. Suffered from recurrent illness.

22 July: Convalescing at Pavillon-Madeleine, Pourville-sur-Mer near Dieppe with the Birnie Philips (M 1591–4). At some time he painted watercolours at Belle-Ile (M 1595–7). Made flying visits to Amsterdam, Dordrecht, and possibly Flushing (M 1590; no.172) with Ludovici in August, and to London and Paris in September. He left the opening of the Académie Carmen to Miss Bate acting under his command.

26 October: Returned to Paris. Stayed at the Hôtel Chatham for most of the winter.

December: Paintings acclaimed in exhibition at the Galerie Georges Petit.

1900

15 January: Elected honorary academician of Academy of St Luke, Rome.

February: His brother Dr William Whistler died. Whistler returned briefly to London and stayed with the widow. On 10 March the *British Medical Journal* reproduced Whistler's litho-

Whistler in his Paris studio, showing 'Blue and Silver: Screen, with Old Battersea Bridge' made for Leyland, 1890s *Charles Lang Freer Papers, Freer Gallery of Art, Smithsonian Institution, Washington, DC*

Whistler sketching in Corsica, 1901
Photo: William Heinemann, *from E.R. and J. Pennell: The Life of James McNeill Whistler, London 1908*

graph 'The Doctor – Portrait of my Brother' (w 78) as frontispiece to his obituary.

15 March: Staying with the Heinemanns in Norfolk Street, Mayfair.

April: In Paris, where in May at the request of the American Commissioner he showed 'The Little White Girl' (no.15), a self-portrait (no.205) and a portrait of Ethel Whibley, 'Mother of Pearl and Silver: The Andalusian' (no.196), at the Exposition Universelle, was awarded a Grand Prix for paintings and another for etchings. After the exhibition he rubbed down the self-portrait and never completed it to his satisfaction.

3 May: Returned to London and stayed with the Heinemanns.

28 May: Heinemann asked the Pennells to write the authorised life of Whistler.

June–July: Living at Garlant's Hotel in London except for a trip to Amersham in the middle of June.

10 August: Went with an artist friend, Jerome Elwell, to Domburg in Holland for a week and painted several watercolours (M 1611–4; no.155). Then joined the Birnie Philips at Sutton near Dublin for three weeks and painted some small panels (YMSM 537–9) and watercolours (M 1619–20).

7 September: Returned to London and stayed with the Heinemanns.

October: In its third and final year the Académie Carmen was opened by Mrs Addams with a life class for women only. Whistler was in Paris at the end of October, but he rarely visited the Académie and it was finally closed on 6 April 1901.

30 October: Returned to London. Stayed with the Heinemanns and worked on a portrait of Mrs Heinemann (YMSM 531).

16–17 November: Ill in bed at Garlant's Hotel.

15 December: Whistler's weakness had become a serious illness and he was ordered to go away by sea. He spent Christmas and New Year in Algiers and Tangiers which he found very cold and 'entirely too Eastern' (M 1643–52). Ill for three weeks in Marseilles and then sailed for Corsica.

1901

Stayed in Hotel Schweizerhof, Ajaccio. Did many sketches and watercolours (M 1653–96, no.173), several etchings and a few paintings in Corsica (YMSM 544–6).

April: Exhibited seven small paintings and pastels including 'Phryne the Superb!' (YMSM 490) at the *International Exhibition of Sculptors, Painters and Gravers*. In Buffalo and Dresden he was awarded gold medals, and in Paris elected honorary member of the Académie des Beaux-Arts.

1 May: Returned by boat from Corsica via Marseilles. Stayed first in the Hans Crescent Hotel in London, but returned to Garlant's Hotel in July.

July: Visited Dieppe.

September: In Garlant's Hotel in poor health. Early in October he closed the studio in Paris and sold 110 rue du Bac.

December: The Birnie Philips took Whistler to 7 Marlborough Street, Bath, to convalesce during the winter months.

1902

January: Awarded Gold Medal of Honor at Pennsylvania Academy of the Fine Arts.

March: Met Richard A. Canfield, who bought many of Whistler's late works and sat during the next year for his portrait, 'His Reverence' (no.202).

25 March: Leased 74 Cheyne Walk from the architect C.R. Ashbee and lived there with the Birnie Philips.

May: Five paintings including the newly finished 'Grenat et or: Le Petit Cardinal' (YMSM 469) and the oval portrait of Mrs Vanderbilt, 'Ivory and Gold' (YMSM 515) exhibited at the Société Nationale des Beaux-Arts. C.L. Freer sat to Whistler at the Fitzroy Street studio (YMSM 550).

16 June: Carmen Rossi, who for months had taken work from Whistler's studio and sold it in Paris and Rome, agreed to sell one portrait back to him (YMSM 505). He refused to prosecute her.

July: While on holiday with Freer Whistler became seriously ill. Stayed at the Hôtel des Indes, The Hague. Convalescent, he wrote to the *Morning Post* on 3 August to congratulate them on the premature obituary they had published. Visited Dordrecht, Scheveningen, the Mauritshuis and galleries at Haarlem.

8 September: Returned to London, painted portraits of Rosalind Birnie Philip and his model Dorothy Seton (YMSM 551–2). Vanderbilt tried to arrange sittings for his portrait but neither it nor that of Freer was completed.

8 November: Planning a major retrospective of his work.

1903

January–April: Staying sometimes in Bath at 7 Marlborough Street.

April: Received honorary degree of Doctor of Laws from the University of Glasgow but was too ill to attend the ceremony.

30 June: Canfield told Duret in Paris that Whistler's health had improved and he had been working on his portrait (no.202), but his condition deteriorated quickly.

17 July: Death of Whistler.

23 July: Buried in Chiswick Cemetery. His pallbearers were Théodore Duret, Sir James Guthrie, John Lavery, Edwin A. Abbey, George Vanderbilt and C.L. Freer.

1904

Memorial exhibition of Whistler's work in Boston, Massachusetts organised by Copley Society, included 184 oil paintings, watercolours and pastels and 315 etchings, drypoints and lithographs.

1905

About seven hundred and fifty works were exhibited at the memorial exhibition, *Paintings, Drawings, Etchings and Lithographs*, by the ISSPG in London and about four hundred and forty in the Ecole des Beaux-Arts exhibition, *Oeuvres de James McNeill Whistler*, in Paris.

General Index

Index of Catalogued Works

Lenders

Photographic Credits

Addison Gallery of American Art, Andover; Amon Carter Museum, Fort Worth; Ashmolean Museum, Oxford; The Barber Institute of Fine Arts, Birmingham; P. de Bay; Dean Beasom; Museum of Fine Arts, Boston; The British Museum, London; Christopher Burke; Richard Carafelli; The Carnegie Museum of Art, Pittsburgh; Paul Carter; The Art Institute of Chicago; Cincinnati Art Museum; Sterling and Francine Clark Art Institute, Williamstown; Geoffrey Clements; The Corcoran Gallery of Art, Washington; Courtauld Institute Galleries, London; Davison Art Center, Middletown; The Detroit Institute of Arts; Dornac; Fitzwilliam Museum, University of Cambridge; The Freer Gallery of Art, Washington; Gilcrease Museum, Tulsa; Glasgow Museums; Glasgow University Photographic Unit; Harvard University Art Museums; Béatrice Hatala; Greg Heins; Helga Photo Studio; Herbert F. Johnson Museum of Art, Ithica; The Cecil Higgins Art Gallery, Bedford; Hood Museum of Art, Hanover; Honolulu Academy of Art; Hunterian Art Gallery, Glasgow; The National Gallery of Ireland, Dublin; Isabella Stewart Gardner Museum, Boston; Frédéric Jaulmes; Becket Logan; Los Angeles County Museum; Ken McKnight; Mead Art Museum, Amherst; Media Services Photographic; Brian Merrett, MMFA; The Metropolitan Museum of Art, New York; The Montclair Art Museum; Munson-Williams-Proctor Institute Museum of Art, Utica; Owen Murphy; New Orleans Museum of Art; The New York Public Library; Nick Nicholson; NMAA; Edward Owen; Stephen Petergorsky; Philadelphia Museum of Art; Precision Chromes, inc; Service photographique de la Réunion des Musées Nationaux, Paris; Rijksmuseum, Amsterdam; Clive Russ; The Saint Louis Art Museum; Museum of Fine Arts, Saint Petersburg; Sotheby's, London; Terra Museum of American Art, Chicago; The Taft Museum, Cincinnati; Tate Gallery, London; The Toledo Museum of Art; The Victoria & Albert Museum, London; Wadsworth Atheneum, Hartford; National Museum of Wales, Cardiff; Tony Walsh; The Walters Art Gallery, Baltimore; Paul Warchol; The Warner Collection of Gulf States Paper Corporation, Tuscaloosa; Library of Congress, Washington; National Gallery of Art, Washington; National Museum of American Art, Smithsonian Institution, Washington; John Webb; Westmoreland Museum of Art, Greensburg; Graydon Wood; Yale Center for British Art; Yale University Art Gallery

Ways of Giving to the Tate Gallery

The Tate Gallery attracts funds from the private sector to support its programme of activities in London, Liverpool and St Ives. Support is raised from the business community, individuals, trusts and foundations, and includes sponsorships, donations, bequests and gifts of works of art. The Tate Gallery is recognised as a charity under Inland Revenue reference number x780551.

Trustees
Dennis Stevenson CBE (Chairman)
The Countess of Airlie CVO
Lord Attenborough CBE
The Hon. Mrs Janet de Botton
David Gordon
Christopher Le Brun
Sir Richard Carew Pole
Michael Craig-Martin
Richard Deacon
Bamber Gascoigne
Paula Ridley
David Verey

Donations

There are a variety of ways through which you can make a donation to the Tate Gallery.

Donations All donations, however small, will be gratefully received and acknowledged by the Tate Gallery.

Covenants A Deed of Covenant, which must be taken out for a minimum of four years, will enable the Tate Gallery to claim back tax on your charitable donation. For example, a covenant for £100 per annum will allow the Gallery to claim a further £33 at present tax rates.

Gift-Aid For individuals and companies wishing to make donations of £250 and above, Gift-Aid allows the gallery to claim back tax on your charitable donation. In addition, if you are a higher rate taxpayer you will be able to claim tax relief on the donation. A Gift-Aid form and explanatory leaflet can be sent to you if you require further information.

Bequests You may wish to remember the Tate Gallery in your will or make a specific donation In Memoriam. A bequest may take the form of either a specific cash sum, a residual proportion of your estate or a specific item of property, such as a work of art. Certain tax advantages can be obtained by making a legacy in favour of the Tate Gallery. Please check with the Tate Gallery when you draw up your will that it is able to accept your bequest.

American Fund for the Tate Gallery The American Fund was formed in 1986 to facilitate gifts of works of art, donations and bequests to the Tate Gallery from the United States residents. It receives full tax exempt status from the IRS.

Individual Membership Programmes

FRIENDS OF THE TATE GALLERY

The Friends share in the life of the Gallery and contribute towards the purchase of important works of art for the Tate.

Privileges include free unlimited entry with a guest to exhibitions; *tate: the art magazine*; previews, events and art courses; 'Late at the Tate' evening openings; exclusive Friends Room. Annual rates range from £22 to £30.

Tate Friends St Ives offers a local events programme and full membership of the Friends of the Tate Gallery.

FELLOWS

The Fellows support the acquisition of works of art for the British and Modern Collections of the Tate Gallery. Privileges include invitations to Tate Gallery receptions, curatorial talks and behind-the-scene tours, complimentary catalogues and full membership of the Friends. Annual membership ranges from £100 to £500.

The Friends of the Tate Gallery are supported by Tate & Lyle PLC.

Further details on the Friends and Fellows in London and St Ives may be obtained from:

Friends of the Tate Gallery
Tate Gallery
Millbank
London SW1P 4RG

Tel: 071-887 8752

PATRONS OF THE TATE GALLERY

The Patrons of British Art support British painting and sculpture from the Elizabethan period through to the early twentieth century in the Tate Gallery's collection. They encourage knowledge and awareness of British art by providing an opportunity to study Britain's cultural heritage.

The Patrons of New Art support contemporary art in the Tate Gallery's collection. They promote a lively and informed interest in contemporary art and are associated with the Turner Prize, one of the most prestigious awards for the visual arts.

Annual membership of the Patrons ranges from £350 to £750, and funds the purchase of works of art for the Tate Gallery's collection.

Privileges for both groups include invitations to Tate Gallery receptions, an opportunity to sit on the Patrons' acquisitions committees, special events including visits to private and corporate collections and complimentary catalogues of Tate Gallery exhibitions.

Further details on the Patrons may be obtained from:

The Development Office
Tate Gallery
Millbank
London SW1P 4RG

Tel: 071-887 8743

Corporate Membership Programme

Membership of the Tate Gallery's Corporate Membership Programme offers companies outstanding value-for-money and provides opportunities for every employee to enjoy a closer knowledge of the Gallery, its collection and exhibitions.

Membership benefits are specifically geared to business needs and include private views for company employees, free and discount admission to exhibitions, discount in the Gallery shop, out-of-hours Gallery visits, behind-the-scenes tours, exclusive use of the Gallery for corporate entertainment, invitations to VIP events, copies of Gallery literature and acknowledgment in Gallery publications.

TATE GALLERY CORPORATE MEMBERS

Partners
ADT Group PLC
The British Petroleum Company plc
Ernst & Young
Glaxo Holdings p.l.c.
Manpower PLC
Unilever

Associates
BUPA
Channel 4 Television
Drivers Jonas
Global Asset Management

Herbert Smith
Lazard Brothers & Co Limited
Linklaters & Paines
Merrill Lynch
Refco Overseas Ltd
Salomon Brothers
Schroders plc
S.G. Warburg Group
THORN EMI

Corporate Sponsorship

The Tate Gallery works closely with sponsors to ensure that their business interests are well served, and has a reputation for developing imaginative fund-raising initiatives. Sponsorships can range from a few thousand pounds to considerable investment in long-term programmes; small businesses as well as multi-national corporations have benefited from the high profile and prestige of Tate Gallery sponsorship.

Opportunities available at Tate Gallery London, Liverpool and St Ives include exhibitions (some also tour the UK), education, conservation and research programmes, audience development, visitor access to the Collection and special events. Sponsorship benefits include national and regional publicity, targeted marketing to niche audiences, exclusive corporate entertainment, employee benefits and acknowledgment in Tate Gallery publications.

TATE GALLERY LONDON: PRINCIPAL
CORPORATE SPONSORS (alphabetical order)

The British Land Company PLC
 1993, *Ben Nicholson**
The British Petroleum Company plc
 1990–4, *New Displays*
Channel 4 Television
 1991–3, The Turner Prize
Ernst & Young
 1994, *Picasso: Sculptor/Painter**
Pearson plc
 1992–5, Elizabethan Curator Post
Reed Elsevier
 1994, *Whistler*
Tate & Lyle PLC
 1991–5, Friends Relaunch Marketing Programme
Volkswagen
 1991–4, The Turner Scholarships

TATE GALLERY LONDON: CORPORATE
SPONSORS (alphabetical order)

ABN AMRO Bank
 1994, *Turner's Holland*
AFAA, Association Française d'Action Artistique, Ministère de Affaires Etrangères, The Cultural Service of the French Embassy, London
 1993, *Paris Post War: Art and Existentialism 1945–55*
Agfa Graphic Systems Group
 1992, *Turner: The Fifth Decade**

Beck's
 1994, *Rebecca Horn*
 1992, *Otto Dix*
Blackwall Green Ltd
 1994, Frames Conservation
The British Printing Company Ltd
 1994, sponsorship-in-kind
Calor Gas
 1994, *Turner's Holland*
Clifton Nurseries
 1991–4, Christmas Tree (in kind)
Deutsche Bank A.G.
 1994, *Rebecca Horn*
Digital Equipment Co Limited
 1991–2, *From Turner's Studio*
 1993, Library and Archive Computerisation
Alfred Dunhill Limited
 1993, *Sir Edward Burne-Jones: Watercolours and Drawings*
The German Government
 1992, *Otto Dix*
The Hiscox Group
 1994, Friends Room
The Independent
 1992, *Otto Dix* (in kind)
 1993, *Paris Post War: Art and Existentialism 1945–55*
 1994, *Rebecca Horn* (in kind)
KPMG Management Consulting
 1991, *Anthony Caro: Sculpture towards Architecture**
Lloyd's of London
 1991, Friends Room
Makro
 1994, *Turner's Holland*
Nuclear Electric plc
 1993, *Turner: The Final Years*
 1994, *The Essential Turner*
SRU Limited
 1992, *Richard Hamilton**
Sun Life Assurance Society plc
 1993, *Robert Vernon's Gift*
THORN EMI
 1993, *Turner's Painting Techniques*
TSB Group plc
 1992, *Turner and Byron*
 1992–5, *William Blake* display series

TATE GALLERY LIVERPOOL: CORPORATE
SPONSORS (alphabetical order)

AIB Bank
 1991, *Strongholds*
American Airlines
 1993, *David Hockney*
Beck's
 1993, *Robert Gober*
British Alcan Aluminium plc
 1991, *Dynamism*
 1991, *Giacometti*
Canadian High Commission, London and Government of Canada
 1993, *Elective Affinities*
Cultural Relations Committee, Department of Foreign Affairs, Ireland
 1991, *Strongholds*
David M Robinson Jewellery
 1994, *Venus Re-Defined*
English Estates
 1991, Mobile Art Programme

Ibstock Building Products Ltd
 1993, *Antony Gormley*
Korean Air
 1992, *Working with Nature* (in kind)
The Littlewoods Organisation plc
 1992–5, *New Realities*
Merseyside Development Corporation
 1992, *Myth-Making*
 1992, *Stanley Spencer*
MOMART plc
 1991–4, The Momart Fellowship
NSK Bearings Europe Ltd
 1991, *A Cabinet of Signs: Contemporary Art from Post-Modern Japan*
North West Water Group PLC
 1994, Corporate Membership Brochure
Ryanair
 1991, *Strongholds* (in kind)
Samsung Electronics
 1992, *Working With Nature*
Volkswagen
 1991, Mobile Art Programme (in kind)

TATE GALLERY ST IVES: CORPORATE
SPONSORS

First Class Pullman, InterCity*
 1993–4, Annual Displays
South Western Electricity plc (SWEB)*
 1993–4, Education Programme

*denotes a sponsorship in the arts, recognised by an award under the Government's Business Sponsorship Incentive Scheme, administered by the Association for Business Sponsorship of the Arts.

Tate Gallery Founding Benefactors
(date order)

Sir Henry Tate
Sir Joseph Duveen
Lord Duveen
The Clore Foundation

Tate Gallery Principal Benefactors
(alphabetical order)

American Fund for the Tate Gallery
Calouste Gulbenkian Foundation
Friends of the Tate Gallery
The Henry Moore Foundation
National Art Collections Fund
National Heritage Memorial Fund
The Nomura Securities Co., Ltd
Patrons of New Art
Dr Mortimer and Theresa Sackler Foundation
St Ives Tate Action Group
The Wolfson Foundation and Family Charitable Trust

Tate Gallery Benefactors
(alphabetical order)

The Baring Foundation
Bernard Sunley Charitable Foundation
Gilbert and Janet de Botton
Mr Edwin C. Cohen
The Eleanor Rathbone Charitable Trust
Esmée Fairbairn Charitable Trust
Foundation for Sport and the Arts
GEC Plessey Telecommunications
The Getty Grant Program
Granada Group plc
The Paul Hamlyn Foundation
John and Olivia Hughes
The John S. Cohen Foundation
The John Ellerman Foundation
The Kreitman Foundation
John Lewis Partnership
The Leverhulme Trust
Museums and Galleries Improvement Fund
Ocean Group plc (P.H. Holt Trust)
Patrons of British Art
Peter Moores Foundation
The Pilgrim Trust
Mr John Ritblat
The Sainsbury Family Charitable Trusts
Save & Prosper Educational Trust
SRU Limited
Weinberg Foundation

Tate Gallery Donors
(alphabetical order)

LONDON

Professor Abbott
The Andy Warhol Foundation for the Visual Arts,
 Inc
Lord Attenborough CBE
BAA plc
Friends of Nancy Balfour OBE
Balmuir Holdings
The Hon. Robin Baring
B.A.T. Industries plc
Nancy Bateman Charitable Trust
Mr Tom Bendhem
Mr Alexander Bernstein
Janice and David Blackburn
Michael and Marcia Blakenham
Miss Mary Boone
The Britwell Trust
Card Aid
Carlsberg Brewery
Mr Vincent Carrozza
Mrs Beryl Carpenter
Cazenove & Co Charitable Trust
Charlotte Bonham Carter Charitable Trust
Christie, Manson & Woods Ltd
The Claire Hunter Charitable Trust
The Clothworkers Foundation
Mrs Elisabeth Collins
Mr R.N. Collins
Giles and Sonia Coode-Adams
Mrs Dagny Corcoran
C.T. Bowring (Charitable Trust) Ltd
Cognac Courvoisier
Mr Edwin Cox

Anthony d'Offay Gallery
Mr and Mrs Kenneth Dayton
Mr Damon and The Hon. Mrs de Laszlo
Madame Gustava de Rothschild
Baroness Liliane de Rothschild
Deutsche Bank AG
Miss W.A. Donner
Mr Paul Dupee
Mrs Maurice Dwek
Elephant Trust
Eli Broad Family Foundation
Elizabeth Arden Ltd
European Arts Festival
Evelyn, Lady Downshire's Trust Fund
Roberto Fainello Art Advisers Ltd
The Flow Foundation
First Boston Corporation
Foreign & Colonial Management Limited
Miss Kate Ganz
Mr Henry Geldzahler
Mr and Mrs David Gilmour
The German Government
Goethe Institut
Sir Nicholas and Lady Goodison Charitable
 Settlement
Mr William Govett
Mr and Mrs Richard Grogan
Gytha Trust
Mr and Mrs Rupert Hambro
Miriam and Peter Haas Foundation
Mrs Sue Hammerson
The Hon. Lady Hastings
The Hedley Foundation
Mr and Mrs Michael Heseltine
Mr Rupert Heseltine
Horace W. Goldsmith Foundation
Mr Robert Horton
Hurry Armour Trust
Idlewild Trust
The Italian Government
Sir Anthony and Lady Jacobs
Mrs Gabrielle Keiller
James and Clare Kirkman Trust
Knapping Fund
Mr and Mrs Richard Knight
Mr and Mrs Jan Krugier
The Leche Trust
Robert Lehman Foundation, Inc
The Helena and Kenneth Levy Bequest
Mr and Mrs Gilbert Lloyd
Mr and Mrs George Louden
Mr and Mrs Lawrence Lowenthal
Mail on Sunday
Mr Alexander Marchessini
The Mayor Gallery
Midland Bank Artscard
Mr and Mrs Robert Mnuchin
The Monument Trust
Mr Peter Nahum
Mr and Mrs Philip Niarchos
Dr Andreas Papadakis
The Paradina Trust
Mr William Pegrum
Philips Fine Art Auctioneers
The Earl of Plymouth
Old Possum's Practical Trust
The Hon. Mrs Olga Polizzi
Paul Nash Trust
Peter Samuel Charitable Trust
Mr Jean Pigozzi

Sir Gordon Reece
Reed International P.L.C.
Richard Green Fine Paintings
Mrs Jill Ritblat
Rothschild Bank AG
Mrs Jean Sainsbury
The Hon. Simon Sainsbury
Sebastian de Ferranti Trust
Schroder Charity Trust
Ms Dasha Shenkman
South Square Trust
Mr A. Speelman
Standard Chartered Bank
Mr and Mrs Bernhard Starkmann
The Swan Trust
Sir Adrian and Lady Judith Swire
Mrs Barbara Thomas
Time-Life International Ltd
The 29th May 1961 Charitable Trust
Lady Juliet Townsend
Mr Barry and The Hon. Mrs Townsley
The Triangle Trust
U.K. Charity Lotteries Ltd
Mrs Anne Uribe-Mosquera
Visiting Arts
Mr and Mrs Leslie Waddington
Waley-Cohen Charitable Trust
Mr Mark Weiss
Weltkunst Foundation
Mrs Alexandra Williams
Nina and Graham Williams
Willis Faber plc
Mr Andrew Wilton
Thomas and Odette Worrell
The Worshipful Company of Fishmongers
The Worshipful Company of Goldsmiths
The Worshipful Company of Grocers
The Worshipful Company of Mercers
Mrs Jayne Wrightsman

and those donors who wish to remain anonymous

LIVERPOOL (alphabetical order)

The Baring Foundation
David and Ruth Behrend Trust
Ivor Braka Ltd
The British Council
British Telecom plc
Calouste Gulbenkian Foundation
Mr and Mrs Henry Cotton
English Estates
European Arts Festival
Goethe Institut, Manchester
Mrs Sue Hammerson OBE
Mr John Heyman
Liverpool Council for Voluntary Services
Merseyside Development Corporation
Momart plc
The Henry Moore Foundation
Ocean Group plc (P.H. Holt Trust)
Eleanor Rathbone Charitable Trust
Tate Gallery Liverpool Supporters
Bernard Sunley Charitable Foundation
Unilever
Visiting Arts

and those donors who wish to remain anonymous

ST IVES (alphabetical order)

Donors to the Appeal coordinated by the Steering Group for the Tate Gallery St Ives and the St Ives Action Group.

Viscount Amory Charitable Trust
Barbinder Trust
Barclays Bank PLC
The Baring Foundation
BICC Group
Patricia, Lady Boyd and Viscount Boyd
British Telecom plc
Cable and Wireless plc
Carlton Communications
Mr Francis Carnwath
Christie, Manson & Woods Ltd
Mr Peter Cocks
John S. Cohen Foundation
Miss Jean Cooper
D'Oyly Carte Charitable Trust
David Messum Fine Paintings
Dewhurst House
Dixons Group plc
Mr Alan Driscoll
The John Ellerman Foundation
English China Clays Group
Esmee Fairbairn Charitable Trust
Foundation for Sport and the Arts
J. Paul Getty Jr Charitable Trust
Gimpel Fils
Grand Metropolitan Trust
Ms Judith Hodgson
Sir Geoffrey and Lady Holland
Mr and Mrs Philip Hughes
Mr Bernard Jacobson
Mr John Kilby
Lloyds Bank plc
Lord Leverhulme's Trust
The Manifold Trust
The Mayor Gallery
Marlborough Fine Art
Mercury Asset Management plc
Meyer International plc
The Henry Moore Foundation
National Westminster Bank plc
New Art Centre
Pall European Limited
The Pilgrim Trust
The Joseph Rank (1942) Charitable Trust
Mr Roy Ray
The Rayne Foundation
Royal Bank of Scotland
The Sainsbury Family Charitable Trusts
Mr Nicholas Serota
Mr Roger Slack
Trustees of the Carew Pole Family Trust
Trustees of H.E.W. Spurr Deceased
South West British Gas
South West Water plc
South Western Electricity plc
Sun Alliance Group
Television South West
The TSB Foundation for England and Wales
Unilever
Mrs Angela Verren Taunt
Weinberg Foundation
Wembley plc
Western Morning News, West Briton, Cornish Guardian and The Cornishman

Westlake & Co
Mr and Mrs Derek White
Mr and Mrs Graham Williams
Wingate Charitable Trust
The Worshipful Company of Fishmongers
The Worshipful Company of Mercers
Mrs Monica Wynter

and those donors who wish to remain anonymous